Five Centuries of Sienese Painting

Five Centuries of Sienese Painting

From Duccio to the Birth of the Baroque

GIULIETTA CHELAZZI DINI

ALESSANDRO ANGELINI

BERNARDINA SANI

With 389 illustrations, 247 in colour

Thames and Hudson

Translated from the Italian *Pittura senese* by
Dr Cordelia Warr

First published in Great Britain in 1998 by
Thames and Hudson Ltd, London

Published in the United States and Canada under the title
Sienese Painting

Copyright © 1997 Federico Motta Editore SpA
English translation copyright © 1998 Thames and Hudson Ltd,
London, and Harry N. Abrams, Inc., New York

British Library Cataloguing-in-Publication Data

A catalogue record for this book is available from the
British Library

ISBN 0-500-23756-5

Printed in Italy

1001658630

Contents

Foreword

During the twelfth and thirteenth centuries Siena was a prosperous city owing to the entrepreneurial prowess of its merchants and bankers who worked throughout Europe journeying to Flanders, France and England. From the beginning of the fourteenth century, the Sienese economy steadily declined but despite this, the Golden Age of Sienese art, above all in painting and goldsmithery, dawned at the end of the thirteenth century. It was at this time that Duccio di Buoninsegna, an artist who succeeded in combining the Byzantine and Western Gothic styles, embarked on his career. Sienese art was at its height by the beginning of the fourteenth century, with the most prestigious courts in Europe contending for the services of painters such as Duccio, Simone Martini and the Lorenzetti brothers. Although the splendour of the fourteenth century was never to be repeated in Sienese painting, subsequent generations of artists also achieved a high level of success with extremely intense and personal paintings. These artists include Sassetta, Domenico di Bartolo and the versatile Francesco di Giorgio Martini and his contemporaries. In the first half of the sixteenth century, painters such as

Baldassarre Peruzzi, Sodoma and Domenico Beccafumi drew their inspiration from works that were then being commissioned in Rome – the centre of artistic activity in Italy at the time and the site of some of Raphael's most important works. Their painting resulted in a brilliant local variant of the Mannerist style. Later in the sixteenth century, Francesco Vanni and Ventura Salimbeni were strongly influenced by the work of Federico Barocci, but nevertheless produced highly original works, employing a sensitivity to colour that was characterized by its magical changes of hue. During his early career, Rutilio Manetti's art looked to the abstract and sophisticated painting of the late Sienese Mannerists but his style changed radically when he came into contact with the work of Caravaggio. The last great flowering of independent Sienese art can be seen in Bernardino Mei's mid-seventeenth-century works for churches and private galleries in Siena and in Rome. The paintings demonstrate Mei's mastery of the exuberant Baroque style.

These are the artists whose works are discussed in the present volume. Our examination of painting in Siena

ends with the pontificate of the Sienese Alexander VII rather than including the Enlightenment, as Lanzi had done in his *Storia pittorica dell'Italia*. The decision to omit the Enlightenment and the revival of early Sienese painting stems from our belief that the Sienese school of art, although affected by developments outside the city, remained essentially intact until the end of the seventeenth century. After this date, however, it becomes difficult to talk about a Sienese school of painting in the strictest sense. The originality of Siena's extraordinary pictorial tradition can only be understood when external influences, which were then assimilated by Sienese artists, are considered. The most influential Florentines include Cimabue and Giotto in the thirteenth and fourteenth centuries and Donatello and Masaccio in the fifteenth. At the turn of the sixteenth century the art at the court of Urbino and the painting of Perugino, Raphael and Michelangelo filtered through to Siena. Sixteenth-century classical Roman antiquarian interests pervaded Sienese art, only to be overtaken by the naturalism and classicism of the seventeenth century. The richness of Sienese art developed from the continual flow of artistic influences from outside the city and even from outside Italy.

By drawing together these various elements, the result of cultural exchanges and interaction, we have attempted to give a coherent picture of five centuries of Sienese art, from 1250 to 1700, taking into account the research on the subject that has been published in recent decades. Much of this work, which is known to the public in the form of articles in specialist periodicals and above all in exhibition catalogues, has provided a solid base for the philological character of the book. In analyzing the paintings discussed we have considered both historical and social factors — through an examination of commissions, institutions and the movements of the artists — although the development of style has remained our primary concern. We have therefore tried to provide a history of Sienese painting that is closely linked to the history of the city.

GIULIETTA CHELAZZI DINI
ALESSANDRO ANGELINI
BERNARDINA SANI

GIULIETTA CHELAZZI DINI

Sienese Painting from 1250 to 1450

Art in Siena before Duccio di Buoninsegna

In 1299 the calligrapher and miniaturist Master Giovanni was director of works for the building of the Palazzo Pubblico in Siena.[1] That he could be appointed to this position is an indication of the overlap that existed among different areas of the arts. The episode, which is not an isolated one, demonstrates that, particularly in Siena, there was no difference in status among the arts. It also shows that the roles of artists could be interchanged without compromising the finished work. The possibility of moving from one trade to another was facilitated by the high grade of technical training in the various fields of artistic expertise. This allowed artists to work in gold, as well as make seals, paint both large panels and miniatures, design buildings and execute sculpture without distinguishing between the different art forms. For example, there is a tradition that the painter Lippo Memmi, Simone Martini's closest collaborator, designed the crowning element in travertine of the Torre del Mangia of the Palazzo Pubblico. Duccio di Buoninsegna, who at the beginning of the fourteenth century painted the enormous double-sided high altarpiece for Siena Cathedral, was another medieval artist/artisan who was prepared to carry out any type of work, including that which would today be defined as belonging to the realm of the minor arts. In 1278 he decorated twelve boxes in which to keep the registers of the Comune. Following this, Duccio also painted some small frontispieces for the account books of the office of the Biccherna, which dealt with the finances of Siena. Similarly, Simone Martini, at the height of his career, received a payment on 31 December 1327 for the decoration of two *pali*.[2] These were probably two standards for the duke of Calabria, Charles of Anjou, and his wife, Mary of Valois. Nor did Ambrogio Lorenzetti feel it was beneath him to paint a sculpted angel and a candelabrum for the cathedral in July 1339.[3] In 1344 Ambrogio also painted the cover for the registers of the second semester of that year for the Gabella, the Comune's tax office. Ambrogio accepted these commissions despite the fact that he was held in even higher regard than his brother Pietro and had already become the *de facto* official painter of the Comune of Siena, following Simone Martini's departure for Avignon in 1336.

Guido da Siena and the Byzantine Tradition

Duccio's development is best understood in the context of the artistic environment in Siena in the second half of the thirteenth century. Guido da Siena was one of the leading painters at this time and his *Maestà* (Virgin in Majesty) painted for the church of San Domenico is indicative of the type of art that surrounded Duccio at the beginning of his career. For a long time the painting was believed to have been executed in 1221 – the date given in the inscription at the base of the painting. However, this date probably refers to an important year for the Dominican Order rather than the year in which Guido da Siena painted the *Maestà*. St Dominic, founder of the order, died in 1221.[4] In the mid-seventeenth century the Sienese Isidoro Ugurgieri Azzolini used the date of the inscription in order to disprove Vasari's assertion that the Florentine school of painting had preceded the Sienese.[5] However, in 1859, Milanesi proved that Guido da Siena had, in fact, worked in the second half of the thirteenth century.[6] His *Maestà*, in the grandeur of its composition and in the accentuation of its outlines, was an undoubted influence on Coppo di Marcovaldo's *Madonna del Bordone*, painted in 1261

p. 11
Guido da Siena, *Maestà*.
San Domenico, Siena.

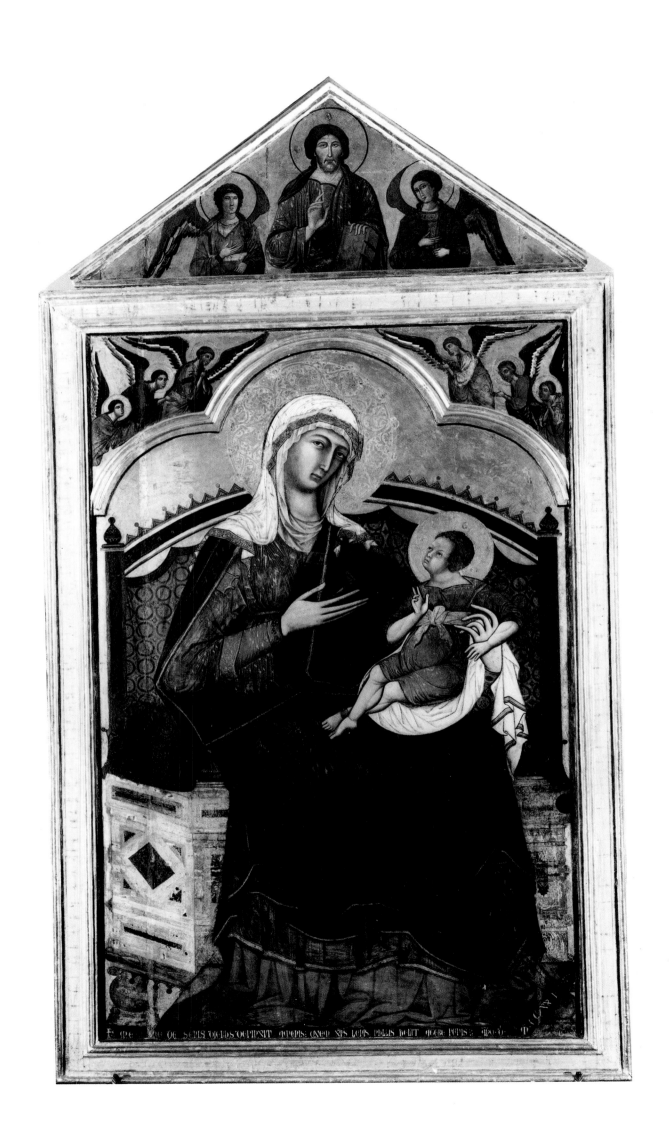

for the Servite church in Siena. It is possible that Coppo, who came from Florence, may have used the painting as a ransom to get out of prison after his capture in the Battle of Mont-aperti on 4 September 1260 in which the Sienese defeated a larger Florentine army. Unfortunately Guido da Siena's *Maestà* is one of the many examples of a painting that was later altered to suit the taste of the early fourteenth century. At this time a follower of Duccio, or perhaps even Duccio himself, repainted the face and hands of the Virgin and Child.[7] A similar fate was endured by Coppo di Marcovaldo's *Madonna del Bordone*. The original parts of Guido's *Maestà* show some stiffness in the drawing, Byzantine stylizations and a colour scale that alternates brilliant, clear tones, such as delicate violets, lavender blues and pale pinks, with darker tones. This, combined with the fourteenth-century alterations, makes the continued fame of the work difficult to understand.

Luciano Bellosi has recently reappraised Guido da Siena's artistic personality and identified other artists working at the same time.[8] Bellosi's research has provided a detailed picture of Sienese art before the beginning of Duccio's career when painting was dominated by the influence of the Florentine artist Cimabue. Bellosi succeeded both in discovering the names of some previously unknown artists and in attributing to them works that had been conveniently grouped together under a single name. He did this by systematically examining the small painted wooden panels that used to protect the Biccherna registers. Starting from 1257, the *camarlingo* and the *provveditori*, magistrates of the Biccherna, had commissioned such panels and a large number of them have survived. Since the payments to the painters were documented it is possible to relate their names to individual Biccherna panels. On the basis of stylistic analysis, Bellosi went on to attribute larger works to the painters identified in this way.

Guido da Siena, *Maestà*, detail.
San Domenico, Siena.

Rinaldo da Siena,
Enthroned Christ and the Virgin.
Convent of the Poor Clares, Siena.

Cimabue's Influence in Siena: Rinaldo da Siena, Dietisalvi di Speme and Guido di Graziano

The practice of decorating the Biccherna panels continued and was extended to the other tax office, that of the Gabella. In the mid-fifteenth century the decision was made to carry on decorating the covers, but instead of using them to protect the registers they were hung on the walls of the offices.[9]

Bellosi's research enabled him to name Rinaldo da Siena, an artist previously known only as the Master of the Poor Clares. Rinaldo was a contemporary of Guido da Siena and shows some traces of Guido's style in his works. However, his work is of a much higher quality and was also influenced by Cimabue. Rinaldo da Siena was the painter of the Biccherna cover for the second semester of 1278. It shows *Don Bartolomeo de Alexis, Monk of San Galgano* (Staatliche Museen, Berlin).[10] The name by which Rinaldo da Siena was previously known was derived from the *Enthroned Christ and the Virgin* from the convent of the Poor Clares in Siena. Another work attributed to Rinaldo da Siena is the painted cross in the Museo Civico in San Gimignano which has a rather unusual iconography. On the end panels of the arms of the cross are the busts of two fierce prophets. The grieving Virgin and St John, who usually occupy the head of the cross, are represented on the large panel to the side of Christ's body. The treatment of Christ's face, of almost cubic composition, makes him appear even grimmer than the figure of Christ in Cimabue's *Crucifix* in the church of San Francesco in Arezzo. The frescoes depicting the *Stories of Noah* and the *Sacrifice of Isaac* in the Upper Church of San Francesco in Assisi are also attributed to Rinaldo da Siena.[11] Their style confirms their Sienese origin.[12]

With regard to Vigoroso da Siena, the dossal in the Galleria Nazionale dell'Umbria in Perugia shows the influence of Cimabue's early style. Characterized by the use of melancholy and dark tones, the dossal is the only work by Vigoroso da Siena that has both a signature and a date – 1291.[13]

Vigoroso da Siena,
Madonna and Child with Saints.
Galleria Nazionale
dell'Umbria, Perugia.

The influence of Cimabue is also reflected in the work of another Sienese painter, Dietisalvi di Speme. Dietisalvi is documented from 1259 to 1291 and a consistent group of works that were all previously given to Guido da Siena or to his circle have since been reattributed to Dietisalvi. His work was identified by means of some documents recording payment for the decoration of the Biccherna panels. The panels are those of 1264 depicting *Ildebrandino Pagliaresi*, of 1270 depicting *Ranieri Pagliaresi* and of 1282 depicting *Don Ghiffolino, a Monk from San Donato*. Cimabue's influence can be seen in the way Dietisalvi softens the hard lines used by Guido da Siena. The dense use of paint, which at times is spread with small touches of the brush, achieves surprising effects in Dietisalvi's work, as in the *Galli-Dunn Madonna and Child* (Pinacoteca, Siena) which was previously attributed to Guido da Siena. Other works that have been ascribed to Dietisalvi di Speme include the *Madonna of St Bernardino*, probably painted in 1262, the *St Clare Diptych*, and the exterior panels of the *Blessed Andrea Gallerani Diptych* (Pinacoteca, Siena).

Bellosi's extensive study of the small Biccherna panels also enabled him to identify Guido di Graziano, an artist mentioned in various documents but without any secure works, with the Master of the St Peter dossal. This master was named after the painting in the Pinacoteca in Siena showing *St Peter Enthroned* surrounded by scenes from his life and from the life of Christ. Before Bellosi's identification of Guido di Graziano both Brandi and Carli[14] had attributed the work to Guido da Siena and it was held to be 'the masterpiece of Sienese painting of the thirteenth century before [the arrival of] Duccio'.[15] In the painting, which was an altar frontal, Guido di Graziano shows a style very different from that of Guido da Siena. He uses a flowing line and delicate colours that vary from the soft pale pink and ice blue of the protagonists' clothes in the small lateral scenes to the cyclamen pink and the ochre of the buildings in the background. His extremely refined use of tones is new in monumental Sienese art but can be found in miniatures of the time.

Guido di Graziano is also responsible for some of the most delicate miniatures of the last two decades of the thirteenth

Dietisalvi di Speme,
Ildebrandino Pagliaresi,
Biccherna panel, 1264.
Archivio di Stato, Siena.

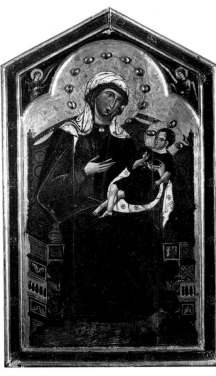

Dietisalvi di Speme,
Galli-Dunn Madonna and Child.
No. 587, Pinacoteca, Siena.

Guido di Graziano, *Don Guido*,
Biccherna panel, 1280.
Archivio di Stato, Siena.

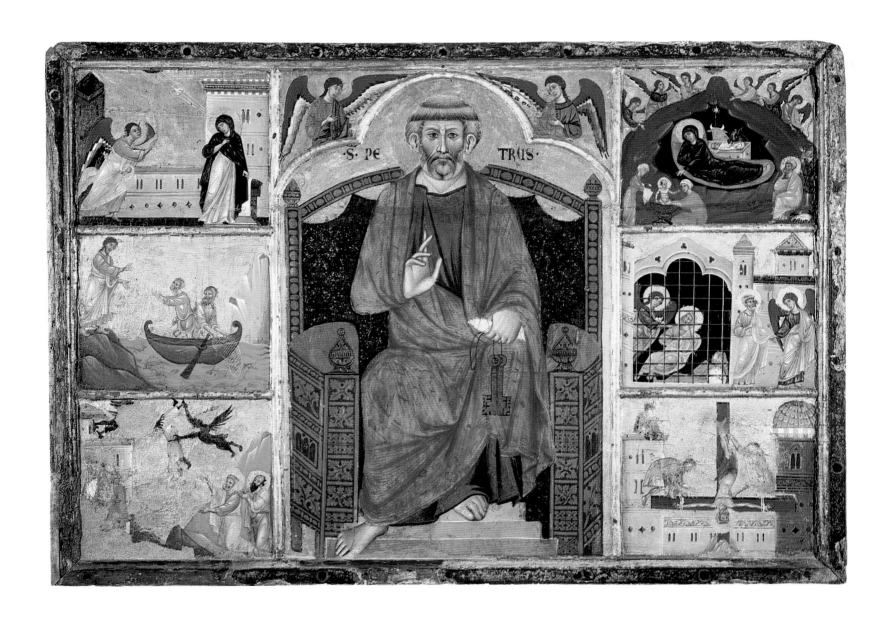

Guido di Graziano,
St Peter Enthroned.
Pinacoteca, Siena.

century. These were executed for the choir books of Siena Cathedral and for the *Tractatum de creatione mundi* in the Biblioteca Comunale (MS. H.VI.31). The way in which the birds in the *Creation of the Birds and the Fish* are quickly sketched in and stand out against the background of the miniature in the manuscript in the Biblioteca Comunale is repeated in scenes from a panel in the Pinacoteca in Siena. This is *St Francis Preaching to the Birds*, part of the larger panel of *St Francis and Eight Scenes from his Life*. The similarity of style between the St Francis panel and the miniatures from the Biblioteca Comunale has allowed this work to be attributed to Guido di Graziano, despite some damage to the pictorial surface.

Notes

The following abbreviations have been used in the notes:

ASC = Archivio Storico Capitolino, Rome
ASS = Archivio di Stato, Siena
ASV = Archivio Storico del Vicariato, Rome
BCS = Biblioteca Comunale, Siena

1 F. Bologna, 'Nascita dell'arte senese' in *Il Gotico a Siena*, exhibition catalogue, Florence 1982, pp. 32–36.
2 P. Bacci, *Fonti e commenti per la storia dell'arte senese*, Siena 1944, pp. 153–154.

3 Siena, Archivio dell'Opera del Duomo, *Libri d'entrata e uscita ad annum* (see V. Lusini, *Il Duomo di Siena*, Siena 1911, I, p. 238, note 6).
4 J.H. Stubblebine, *Guido da Siena*, Princeton 1964.
5 I. Ugurgieri Azzolini, *Le Pompe sanesi*, Pistoia 1649, I, pp. 654–655; II, p. 329.
6 G. Milanesi, 'Della vera età di Guido pittore senese e della sua celebre tavola in San Domenico a Siena' in *Giornale storico degli archivi toscani*, 1859, III, pp. 3–13.
7 P. Toesca, *Il Medioevo*, Turin 1927, II, p. 993.
8 L. Bellosi, 'Per un contesto cimabuesco senese: a) Guido da Siena e il probabile Dietisalvi di Speme' in *Prospettiva*, 1991,

61, pp. 6–20; idem, 'Per un contesto cimabuesco senese: b) Rinaldo da Siena e Guido da Graziano' in *Prospettiva*, 1991, 62, pp. 15–28.
9 *Le Biccherne. Tavole dipinte delle magistrature senesi (secoli XIII–XVIII)*, Rome 1984, pp. 2ff. and 31.
10 The *camarlingo* in office, always chosen from among the most important monks from the convent of San Galgano, was usually represented on the Biccherna panels.
11 R. Longhi, 'Giudizio sul Duecento' in *Proporzioni*, 1948, II, p. 36. Printed in *Opere complete di Roberto Longhi*, Florence 1974, VII, pp. 1–53.

12 F. Bologna, *La pittura italiana delle origini*, Rome 1962, pp. 123–124; idem, in *Il Gotico a Siena*, p. 35.
13 L. Bellosi, 'Duccio di Buoninsegna' in *Enciclopedia dell'arte medievale*, Rome 1994, V, pp. 738–750. For Vigoroso da Siena, see A. Conti, 'Appunti pistoiesi' in *Annali della Scuola Normale di Pisa*, 1971, pp. 109–124, especially pp. 113–114, note 3.
14 C. Brandi, *La Regia Pinacoteca di Siena*, Rome 1933, p. 110; E. Carli, *I Capolavori dell'arte senese*, exhibition catalogue, Florence 1946, p. 25.
15 P. Torriti, *La Pinacoteca nazionale di Siena. I dipinti dal XII al XV secolo*, Genoa 1977, pp. 41–43.

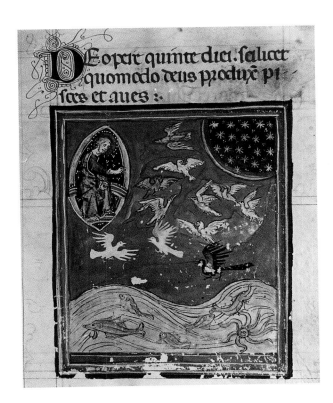

Guido di Graziano, *Creation of the Birds and the Fish*, miniature from the *Tractatum de creatione mundi*. MS. H.VI.31, fol. 83, Biblioteca Comunale, Siena.

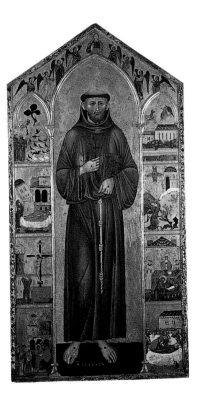

Guido di Graziano, *St Francis and Eight Scenes from his Life*. Pinacoteca, Siena.

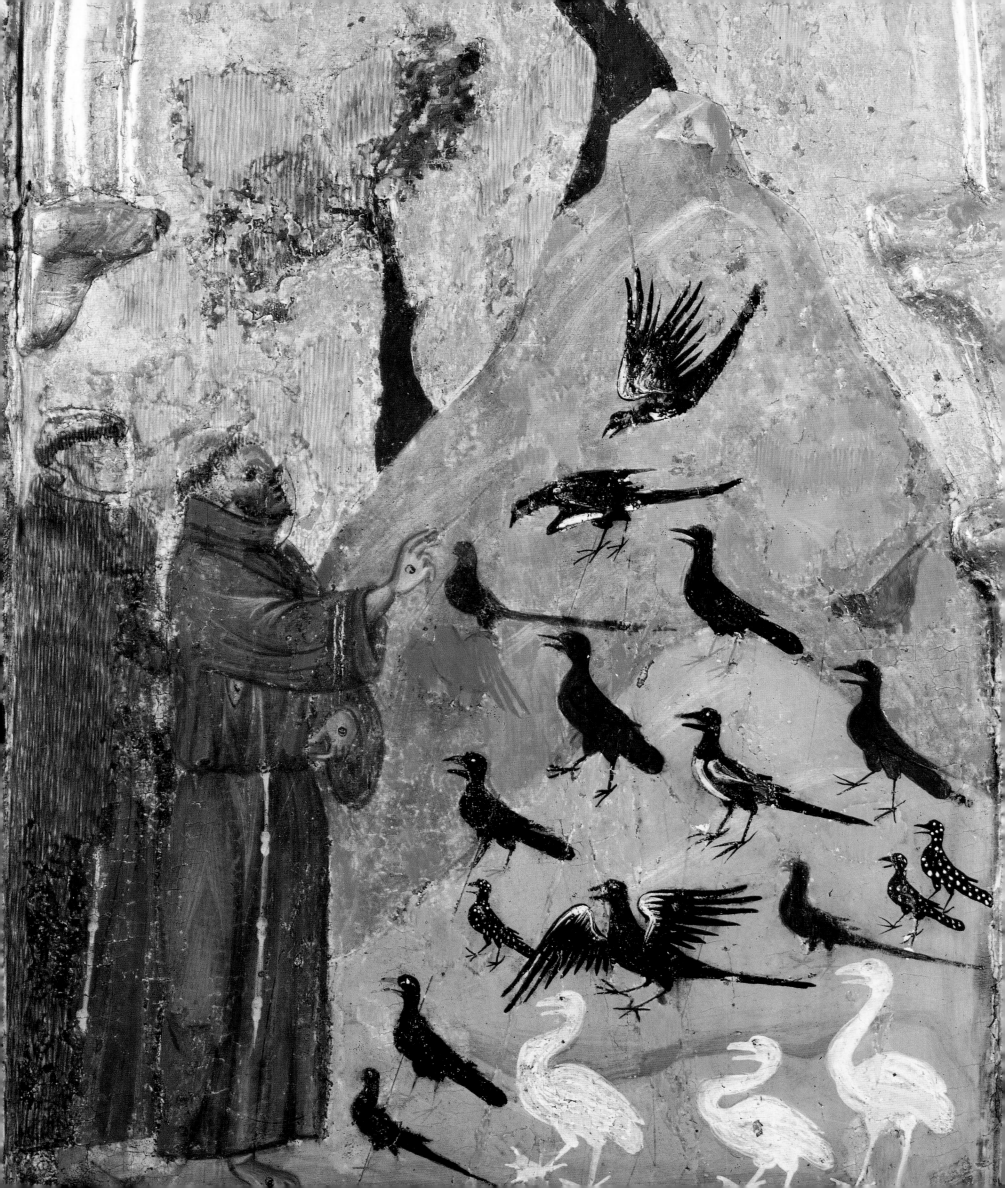

Painting in the
First Half of the Fourteenth Century

Duccio di Buoninsegna

Duccio di Buoninsegna is unanimously regarded as the founder of Sienese painting. However, until recently, understanding his artistic training was problematical. There was some controversy about whether Duccio was trained in Siena or in Florence. Some art historians believed that Duccio developed his style from looking only at the works of Guido da Siena and his followers. Others, on the contrary, maintained that a knowledge of the latest artistic trends outside his native city would inevitably have influenced him.

We do not know, as is the case for the majority of artists at this time, the date of Duccio's birth. However, it is possible to place it around 1255 since the first recorded payment made to him was by the Comune of Siena in 1278. This was for the painting of twelve coffers in which various documents of the Comune were to be kept. The payment suggests that at that date Duccio had already come of age and was in a position to earn his own living. Other documents relating to this type of work and recording payments from the Comune confirm Duccio's presence in Siena at this time. Sometimes these documents refer to the small wooden panels used to cover the registers of the Biccherna but more frequently to the registers of the *camarlingo* and of the four superintendents (1279, 1282, 1285, 1291, 1292, 1294 and 1295). At other times, as in 1286, the payments relate to decorations *in libris camerari*, a formula that may refer to works in miniature. This is an area in which Duccio probably worked fairly regularly, as did many other

Sienese painters. Unfortunately, no miniature painted by Duccio and documented in the archives has survived. Works such as the *Madonna of the Franciscans* (Pinacoteca, Siena), however, give some indication of their style, not only because of the tiny dimensions of the panel but also because of the composition of the figures.

Documents which record a number of fines, sometimes for a considerable amount, have survived. These attest to the non-conformist nature of Duccio's character. In 1302 he refused to go to war and he often contracted fairly large debts, such as those of 1302 and 1313 for example. That Duccio was not a good financial administrator, despite what must have been substantial earnings, is shown by the fact that on his death in 1319 his seven children preferred to renounce their inheritance.[1]

The quantity of documents relating to lost works and to the disordered life of the painter is matched by the lack of information about the works that have survived. The only exception is the *Maestà* for Siena Cathedral, which is the best known of all Duccio's works and was painted at the height of his career.

For many years the documentation relating to his first secure work, the *Rucellai Madonna*, was ignored. Father Vincenzo Fineschi discovered the contract in 1790[2] but it was only in 1889 that Wickhoff connected it with the *Rucellai Madonna*.[3] In the sixteenth century Vasari had attributed the painting to Cimabue on the basis of a local tradition dating to the fourteenth century. The document commissioning the large panel of the Virgin and Child enthroned with six angels, painted by Duccio for the Confraternity of the Laudesi of Santa Maria Novella in Florence, is dated 15 April 1285.

Although Wickhoff had been correct in pointing out the relationship of the document to the panel, some art historians continued to attribute the work to Cimabue while others wanted to create an anonymous master known as the Master of the Rucellai Madonna.[4] This master was believed to be either a follower of a Cimabue-influenced Duccio[5] or a follower of a Duccio-influenced Cimabue.[6]

The problem was finally resolved when Weigelt[7] proved in 1930 that the painting could be securely identified with the document of 1285, since St Peter Martyr is included among the saints placed within the thirty roundels painted on

Duccio di Buoninsegna,
Rucellai Madonna, detail.
Uffizi, Florence.

p. 21
Duccio di Buoninsegna,
Rucellai Madonna.
Uffizi, Florence.

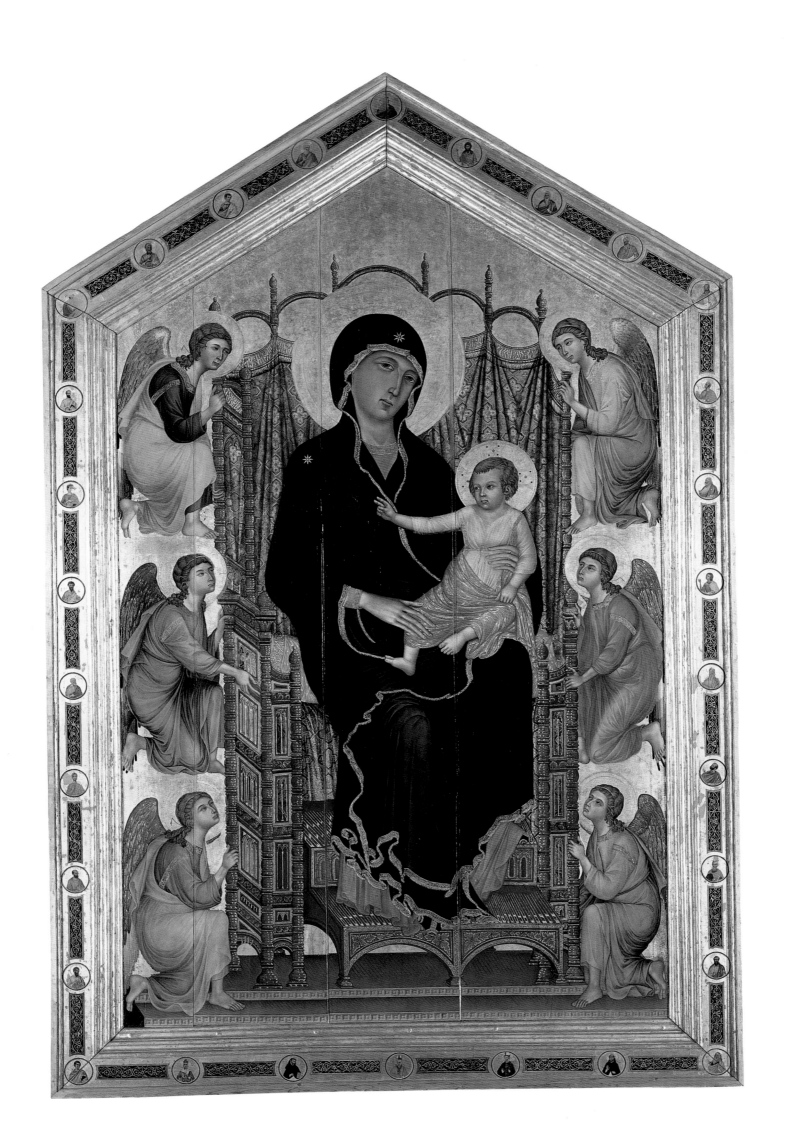

the frame. St Peter Martyr founded the confraternity that had given the commission to Duccio. The other roundels contain Christ, saints, apostles and prophets.

Cimabue's influence on Duccio was very strong at the time of the *Rucellai Madonna*. Close comparisons can be made between the works of the two artists, particularly with Cimabue's *Maestà* (Louvre, Paris) which was painted *c.* 1270–1275 for the church of San Francesco in Pisa. The confusion between the two artists and the original attribution of the *Rucellai Madonna* to Cimabue is understandable, given that for a long time Duccio's style was only known through the *Maestà* from Siena Cathedral. The *Maestà* represents a later period in Duccio's career and its style is both different and more complex because of influences encountered after the painting of the *Rucellai Madonna*.

In fact, the *Rucellai Madonna* is similar to Cimabue's *Maestà* not only in the arrangement of figures, in the similar form and slanting position of the wooden throne and in the confident gesture of the blessing Child, but also in the decoration of the gabled panel with roundels. Nevertheless, there are significant differences in Duccio's work. These can be

seen in the more tender, sweet and human glance of the Virgin as well as in the less imperious gesture of the blessing Christ Child. The variations are also evident in the position of the kneeling angels who lift the throne and, above all, in the Gothic elegance of the linear rhythms in the twisting border of the Virgin's mantle. For the first time, elements of Gothic architecture are placed in the structure of the throne, such as the slim, elegant biforate windows. The most significant difference, however, is in the artists' choice of colours. Duccio uses clear and luminous colours in contrast to the dark shades favoured by Cimabue. They include the soft shades of violet, pink, light green and blue which form the delicate clothes of the angels.

Both Adolfo Venturi[8] and Roberto Longhi[9] noted Duccio's links with Cimabue in 1907 and 1948 respectively. On the basis of various comparisons with Cimabue's work, Longhi believed that Duccio was 'not merely a pupil but was almost the creation of Cimabue'. He also claimed that Duccio worked with Cimabue in the Upper Church of San Francesco in Assisi some time before the completion of the *Rucellai Madonna*. In Longhi's view, Duccio had worked on an

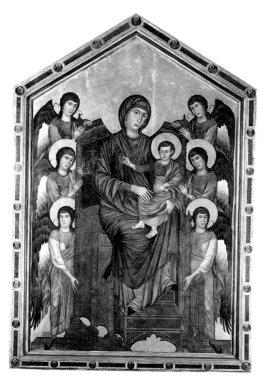

Cimabue, *Maestà*.
Louvre, Paris.

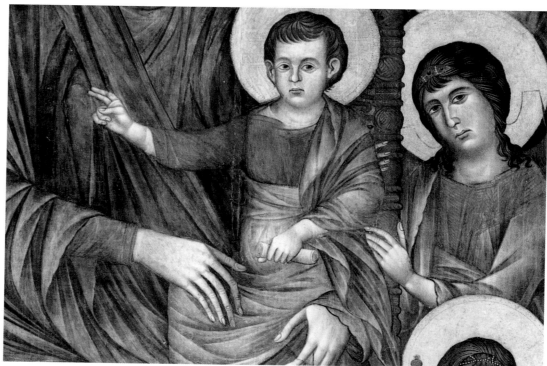

Cimabue, *Maestà*, detail.
Louvre, Paris.

angel in the large south window of the transept; on the *Vision of God Enthroned* from the Apocalypse scenes; on the *Expulsion from Paradise*; on the figure of Adam from the *Creation*; and on the *Journey to Calvary*. Finally, he worked with Cimabue on the *Crucifixion*.

Longhi also believed that the crucifix from the Orsini Castle at Bracciano (Odescalchi Collection, Rome) was the result of a collaboration between Cimabue and Duccio. This painting has since been attributed to Duccio alone[10] but Longhi's theory indicates the strength of his conviction that Duccio was Cimabue's pupil.

The *Bracciano Crucifix* is unusual because it follows the Byzantine tradition of painting, which was already out of date by the second half of the thirteenth century in Italy. The iconography is that of *Christus triumphans*, showing Christ alive and with eyes open, rather than of *Christus patiens*, which presents the dead Christ. At this time the iconography of *Christus patiens* had been customary in Italy for around fifty years. The depiction of a Christ who was still alive was probably due to a particular request from the commissioner. The thin white body of Christ, evidently classically inspired

because of the balance of the forms delicately bathed in light and the carefully gauged position of the limbs, was painted with great attention to naturalistic detail as can be seen in the soft application of colour. The transparent material of the loincloth, like the material wrapped around the angels in the *Rucellai Madonna*, locks itself into elegant Gothic rhythms around Christ's slender hips.

Byzantine stylization (which had already enjoyed great success in Italy in the impassioned interpretations of Giunta Pisano during the first half of the thirteenth century and in Cimabue's dramatic cross in Arezzo, painted between 1268 and 1271) is surpassed in Duccio's *Bracciano Crucifix*. Duccio also succeeded in painting the anatomy with delicate modelling caressed by a light that seems to glide over the forms.

The *Crevole Madonna* (Museo dell'Opera del Duomo, Siena) is similar in style to the *Rucellai Madonna* but earlier in date. It originally came from the church of Santa Cecilia in Crevole. The composition obeys certain Byzantine schemes that had already been tried and tested in Italian painting, such as the blue mantle crossed by gold highlights, the dark indentation between the eyebrows, the accentuated eye-sockets,

Duccio di Buoninsegna,
Crevole Madonna, detail. Museo
dell'Opera del Duomo, Siena.

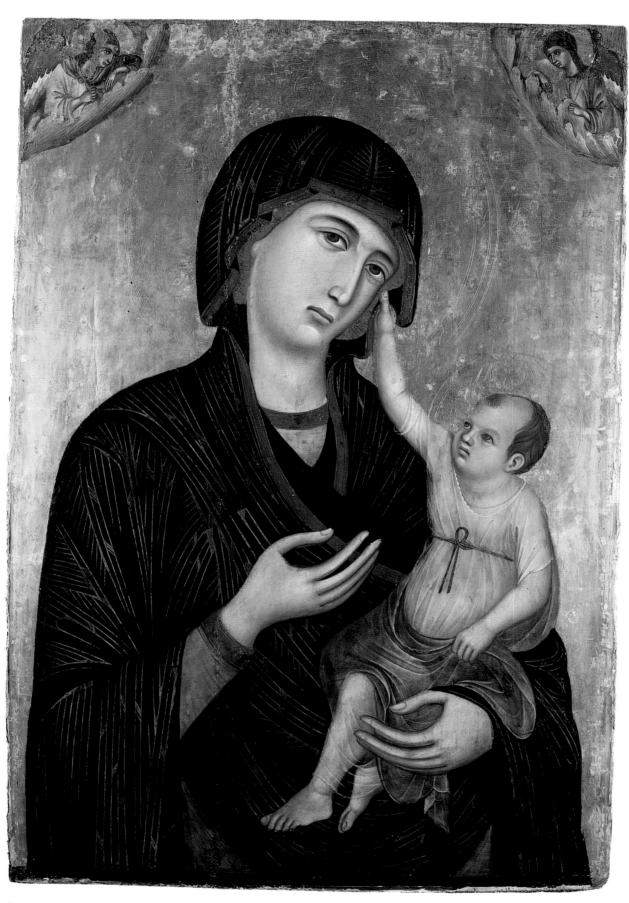

Duccio di Buoninsegna,
Crevole Madonna. Museo
dell'Opera del Duomo, Siena.

the dome-shaped form of the Virgin's head and the typical stylized form of her hands, the presence of the maphorium (the red oriental cap underneath the mantle), the pronounced baldness of the Christ Child, and the apparition of the two small angels who face each other at the top of the painting over a light ribbon of clouds. However, there are other elements that challenge the Byzantine schema and make the divine figures more human. Duccio emphasizes the tenderness of the Virgin and Child in the little strokes of light on their upper lips and above all in the affectionate gesture of the Christ Child as he reaches out to grasp his mother's mantle. This is a motif that enjoyed enormous success in fourteenth-century Sienese art. Duccio also added other elements such as the refined drawing of the two haloes incised with a burin, the elegant folds of Christ's violet mantle and the transparency of his ivory tunic.

Longhi[11] believed that the *Gualino Madonna* (Galleria Sabauda, Turin) was painted while Duccio was still working with Cimabue, possibly before the *Rucellai Madonna*. This painting undoubtedly has close ties with Cimabue's *Maestà* from the church of the Servi in Bologna.[12]

Duccio's great influence apart from Cimabue was Byzantine art. This was a fundamental component during his formative years and permeated his art right up until his most demanding work – the double-sided *Maestà* that he painted for Siena Cathedral.[13] By the time of this work it is not easy to identify the individual sources on which Duccio drew. He would have had access to the art of the Byzantine Empire through the illuminated manuscripts that were circulating in Italy at the time. Many of these manuscripts would have come through the university city of Bologna, a centre not only for the production of legal texts, but also for the buying and selling of Byzantine illuminated manuscripts, both sacred and profane.

Certain of Duccio's stylistic characteristics, such as the chiaroscuro of the faces of the three Franciscan monks in the small *Madonna of the Franciscans* (Pinacoteca, Siena), can be associated with the wave of Byzantine influence that was sweeping Bolognese illumination at the end of the thirteenth century,[14] as seen in the *Bible of Clement VII* (cod. Lat. 18, Bibliothèque Nationale, Paris). Some of the miniatures for this Bible may have been executed by Jacopino da Reggio.[15]

Not only their manuscripts, but Byzantine artists themselves were also present in Italy at the end of the thirteenth century. It is possible, for example, that the *Kahn Madonna* (National Gallery of Art, Washington, D.C.) was painted in Siena by an artist who came from Constantinople.[16]

Duccio was also influenced by Gothic art, evidence of which is already present in early works such as the *Rucellai Madonna*. In order to explain the influence of the French Gothic there have been attempts to identify Duccio with a certain 'Duch de Siene' and a 'Duche le lombart' who appear in two Parisian tax documents[17] and indicate his presence in the parish of Saint-Eustache in 1296 and 1297. However, this person is not described in the documents as a painter, although he lived in a street called the 'rue aus praescheeurs' (rue des Precheurs), inhabited largely by painters.

It seems to me more probable that Duccio, who had worked on the frescoes in the nave of the church of San Francesco in Assisi with Cimabue, was influenced by the frescoes in the right transept that had been executed in the 1270s by a Northern artist who had clearly been trained in the Anglo-French Gothic style. Even if, as some art historians believe, Duccio did not work with Cimabue in Assisi, he must have visited San Francesco, which at that time was both the greatest artistic centre in Italy and one of the most important places of pilgrimage in Europe.

Duccio could also have seen the Gothic style of the wooden crucifix from the Chapel of the Pura in the church of Santa Maria Novella in Florence.[18] The four large multi-lobed panels at the ends of the cross, with scenes from the Passion of Christ, are extraordinary examples of the French Gothic style as practised in England. However, it is not known whether this cross was in Santa Maria Novella when Duccio was painting the *Rucellai Madonna*.

Duccio's familiarity with works such as the crucifix from the Chapel of the Pura and illuminated French manuscripts of the last two decades of the thirteenth century, like those of Master Honoré, explain the style of the *Madonna of the Franciscans*. This work has the dimensions and the layout of a page from an illuminated manuscript and clearly shows the influence of French Gothic art.

The idea of the light green drape in the background with small geometric designs in white is borrowed from French

Late thirteenth-century English artist, wooden crucifix. Chapel of the Pura, Santa Maria Novella, Florence.

Master Honoré, *Annointing of David* and *David and Goliath*, miniature from the *Breviary of Philip le Bel*. MS. lat. 1023, fol. 7v, Bibliothèque Nationale, Paris.

Duccio di Buoninsegna,
Madonna of the Franciscans.
Pinacoteca, Siena.

miniatures. This material, which almost completely replaces the gold ground, is held in position by four angels. The Virgin's cloak has a fine undulating gold border similar to the restless line that runs across the clothes of Christ in the Passion scenes from the crucifix in the Chapel of the Pura. The mantle becomes wider at the base, opening out to protect the three tiny Franciscans kneeling in a fan arrangement at the Virgin's feet.

Duccio could also have encountered Gothic art even closer to Siena. The Cistercian abbey of San Galgano was constructed between 1224 and 1288. Its architecture is among the most faithful examples of French Gothic to be found in Italy. In Siena, Duccio would have seen the Gothic-inspired works of Nicola Pisano. In the middle of the thirteenth century Nicola supervised the construction of the cathedral and sculpted the cathedral pulpit with his son Giovanni and Arnolfo di Cambio.

Giovanni Pisano, the greatest and most original artist working in the Gothic style in Italy, was architect and sculptor for Siena Cathedral, where he was *capomaestro* from 1284 to 1296. During this time he brought the lower part of the façade to life with a series of prophets, philosophers and sibyls that are extremely Gothic in inspiration (Museo dell'Opera del Duomo, Siena).

In addition to working with Cimabue in Assisi, Duccio may have collaborated with him on two other works: the *Bracciano Crucifix* and the *Madonna of the Servi* (Bologna). There are echoes of the latter in Duccio's small *Maestà* in Berne (Kunstmuseum), in the tender gesture of the standing Christ Child who stretches forward to embrace the Virgin's neck.[19] The small dimensions of this painting[20] indicate that it was intended for private use and that it may have formed one leaf of a diptych. Like Duccio's circular window for Siena Cathedral of almost the same date, it shares similar spatial interests with the work of Giotto. This can be seen in the architectonic throne that replaces Cimabue's high-backed seats, as well as in the convincing positioning of the footrest on which the angel in the first row on the left places his foreshortened feet.

Master of Badia a Isola,
Maestà. Santi Salvatore e Cirino,
Badia a Isola, Monteriggioni.

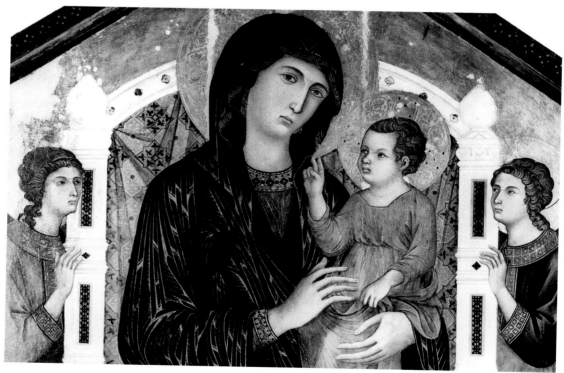

Master of Badia a Isola, *Maestà*,
detail. Santi Salvatore e Cirino,
Badia a Isola, Monteriggioni.

The Master of Badia a Isola, Duccio's First Pupil

The *Maestà* in the church of Santi Salvatore e Cirino in Badia a Isola (Monteriggioni, near Siena) was probably painted soon after Duccio's *Berne Maestà*. It was executed by an anonymous master who has taken his name from this work. The style of the painting shows him to be one of Duccio's first pupils. He emphasizes the architectural quality of the throne, which is covered with Cosmati work, although he retains a Byzantine effect through the gold striations on the Virgin's mantle, the indentation at the top of her nose and the pronounced dark rings around her eyes. Nevertheless, these effects have been softened and are reminiscent of Duccio's *Crevole Madonna*. The similarity is such that some art historians have identified the Badia a Isola Master with the young Duccio.

Like the *Berne Maestà*, the small[21] *Madonna and Child*, previously in the Stoclet Museum, Brussels, reveals similarities with the work of Giotto in its spatial solutions. Duccio was about ten years older than Giotto but both had been trained in Cimabue's workshop. The figure of the Virgin emerges above a marble window sill, supported by brackets, that is strongly influenced by the architectonic framing of the scenes from the life of St Francis attributed to Giotto in the Upper Church in Assisi. This makes it clear that Duccio was aware of Giotto's innovations and was also capable of adapting them to his own needs.

Among the few works attributed to Duccio that can be dated with certainty is the round stained-glass window from the apse of Siena Cathedral. An expert glazier executed the design between 1287 and 1288.[22] The window is subdivided into nine compartments, of which five form a Greek cross, while the other four are placed in the corners to complete the circle. In the three compartments that form the central vertical register, three stories of the Virgin are represented. From bottom to top, these are the *Death of the Virgin*, the *Assumption* and the *Coronation*. To either side of the central compartment are the four patron saints of Siena: *Bartholomew, Ansanus, Crescentius* and *Savinus*. The four spandrels contain the evangelists seated on thrones and accompanied by their

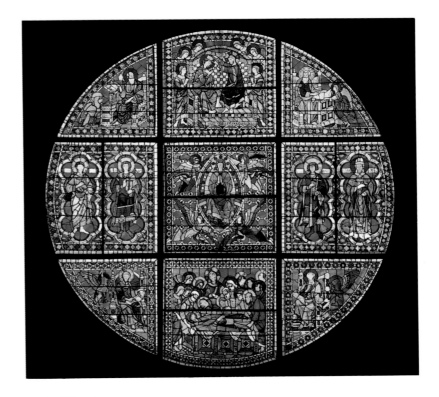

Duccio di Buoninsegna, stained-glass window. Siena Cathedral.

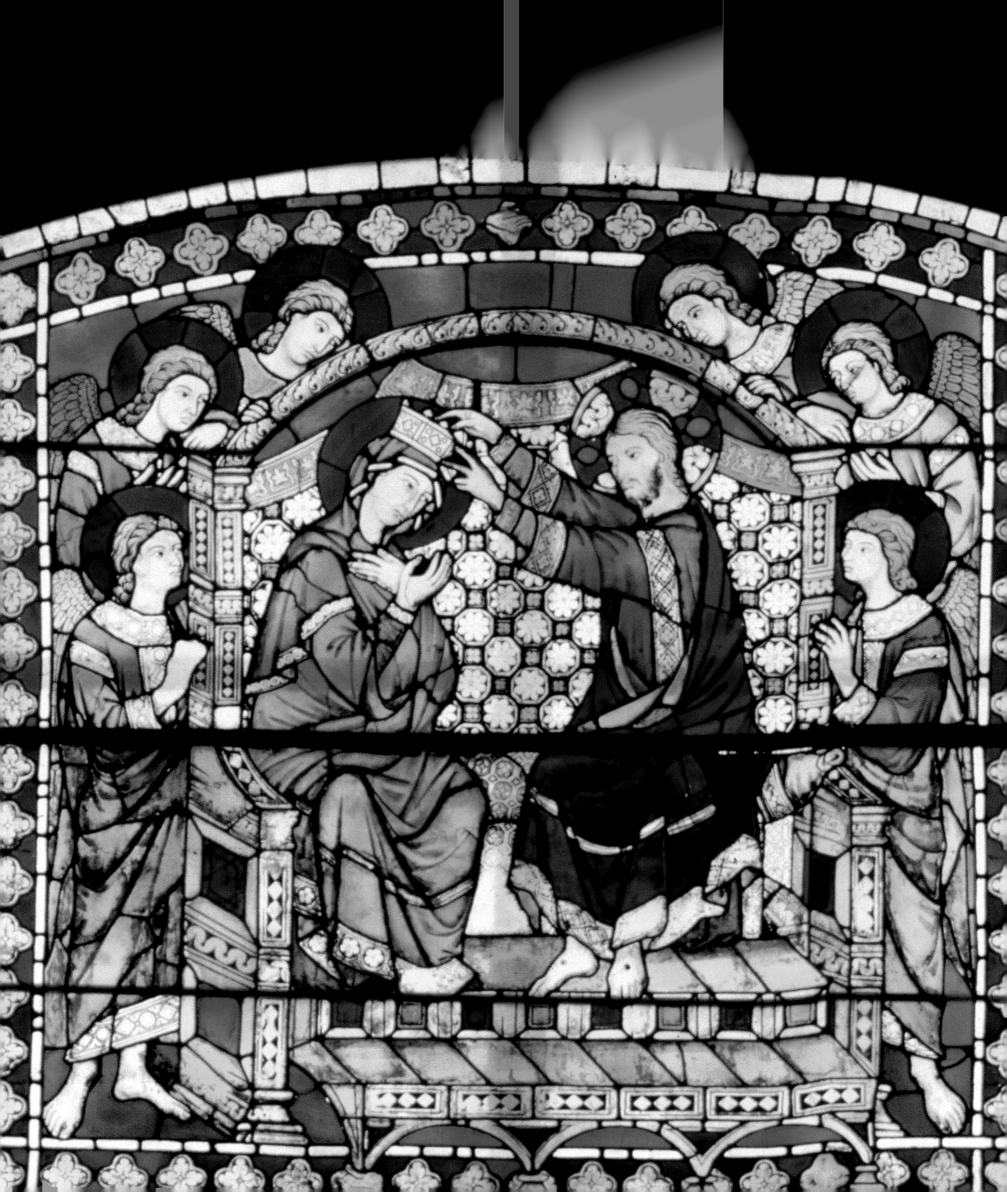

attributes. Giotto's influence can be seen in the construction of the vast throne in the *Coronation of the Virgin*; in the sarcophagus in the *Death of the Virgin*; and in the three-dimensionality of the thrones of the evangelists. Other aspects of Giotto's style are evident in the inclined heads and gentle expressions of the angels who appear above the throne in the *Coronation of the Virgin*.[23] Duccio used similar angels in a *Virgin and Child* (Galleria Nazionale dell'Umbria, Perugia), a work that was originally the centre of a polyptych painted for the church of San Domenico in the same city. That it is one of Duccio's later works is suggested by the small dimensions of the angels, which are similar in size to those in the *Maestà* from Siena Cathedral. In the window, which shows the influence of both Cimabue and Northern Gothic art, the delicate facial features and the melancholy glance of the Virgin in the *Coronation* are typical of Duccio.

The attribution of the design of the window to Duccio is also supported by the iconography. The presence of St Bartholomew among the protectors of Siena challenges the traditional theory that Jacopo da Castello, named in a document of 1369, executed the window. By the time that Duccio painted the *Maestà*, in the early fourteenth century, St Victor had already replaced St Bartholomew as one of the patron saints of Siena. Jacopo da Castello was, in fact, the master glazier who carried out the first of a number of restorations.

The ascription of the window's design to Duccio is not completely uncontested as it has also been attributed to Cimabue.[24] There are some stylistic characteristics in the design which recall the work of Cimabue but these can be explained by Duccio's training.

The prominence of the scenes from the life of the Virgin in Duccio's window form the first part of an iconographic programme within the cathedral intended to glorify the Virgin, to whom the building was dedicated. The programme continued with Duccio's *Maestà* painted for the high altar and reached its conclusion with the four altarpieces dedicated to the patron saints of Siena. Three of these were executed by the most influential Sienese artists of the first half of the fourteenth century. Simone Martini and Lippo Memmi painted the *Annunciation* (Uffizi, Florence) for the altar dedicated to St Ansanus. Pietro Lorenzetti completed the *Birth of the Virgin* (Museo dell'Opera del Duomo, Siena)

p. 30
Duccio di Buoninsegna,
Coronation of the Virgin, detail from
the stained-glass window.
Siena Cathedral.

p. 32
Segna di Buonaventura,
*Virgin and Child with SS. Gregory and John
the Baptist*. Collegiata of San Giuliano,
Castiglion Fiorentino.

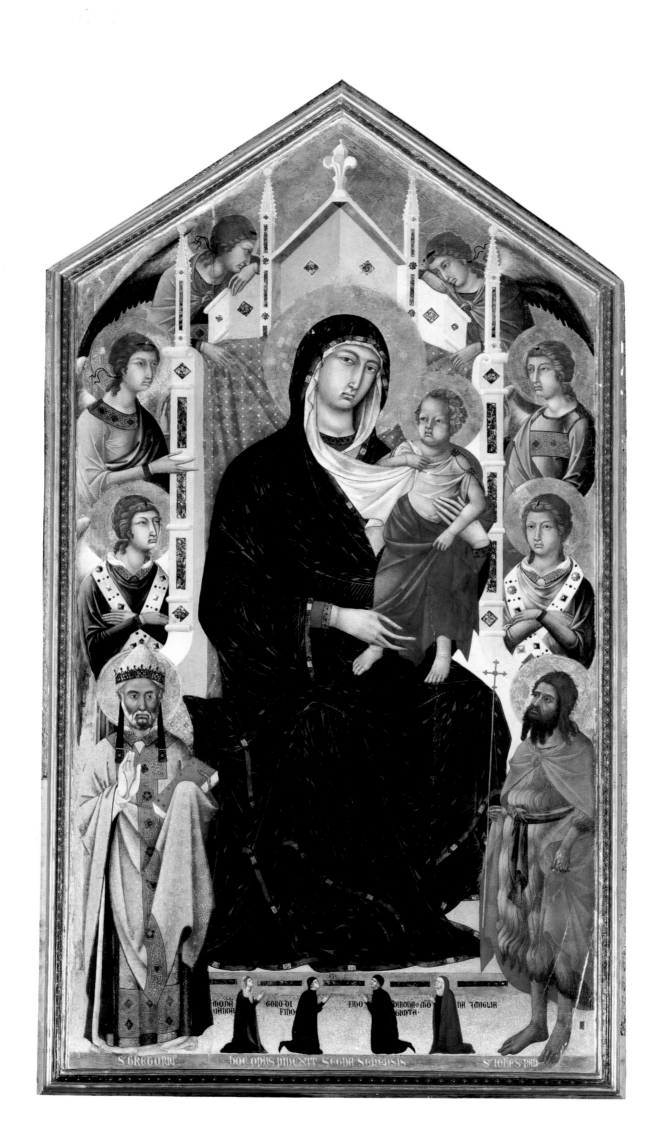

for the altar of St Savinus in 1342, the same year in which his brother Ambrogio painted the *Presentation in the Temple* (Uffizi, Florence) for the altar of St Crescentius. The last of these four altarpieces, for the altar of St Victor, depicted the *Nativity* and was painted by Bartolomeo Bulgarini in *c.* 1351.[25]

Duccio was paid forty-eight lire on 4 December 1302 by the Comune of Siena for a *Maestà* that has since been lost. From the documents it appears that the painting had a predella, which would make it one of the earliest examples of an altarpiece with a predella. It was destined for the altar of the Chapel of the Nine – the government that ruled Siena from 1287 to 1355 – on the first floor of the Palazzo Pubblico and

the commission confirms Duccio's importance in Siena. The *Maestà* of 1302 must have represented a decisive phase in Duccio's stylistic development and its loss has made it impossible to understand exactly how Duccio's art evolved during the first years of the fourteenth century. Little is known of the period between the relatively early works of the late thirteenth century and the *Maestà* from the cathedral, which was painted when Duccio was at the height of his career.

It seems that the *Maestà* of 1302 constituted a prototype for Duccio's followers and inspired a series of paintings of the same subject. It is by means of these works that art historians have sought to reconstruct the appearance of the lost work.[26]

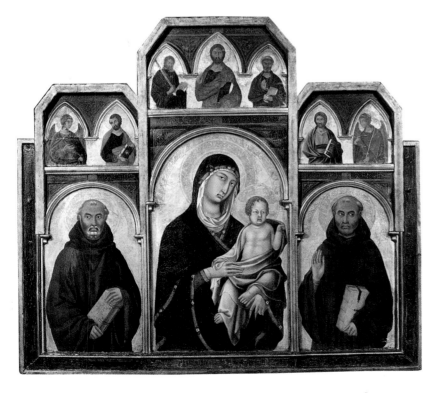

Segna di Buonaventura,
Madonna and Child with Saints.
Metropolitan Museum of Art, New York.

Segna di Buonaventura,
St John the Evangelist. Metropolitan
Museum of Art, New York.

Duccio's Workshop: Segna di Buonaventura,
the Master of Città di Castello and Ugolino di Nerio

One of the works that may have used Duccio's 1302 *Maestà* as a source was the *Virgin and Child with SS. Gregory and John the Baptist* signed by Segna di Buonaventura. The painting comes from the Collegiata in Castiglion Fiorentino and shows four small worshippers at the foot of the Virgin. Segna di Buonaventura, a cousin of Duccio, is one of the most eminent and interesting artists to emerge from Duccio's workshop and his work is often marked by a solemn magnificence.[27] Segna had two sons who were also painters: Francesco, who is known only through archival documents and Niccolò, who was Segna's pupil and whose career must have started between 1325 and 1330. Niccolò di Segna painted the famous polyptych of the *Resurrection* (Pinacoteca Comunale, Sansepolcro) for the Confraternity of San Bartolomeo in Sansepolcro.[28]

Between 1319 and 1321, Segna di Buonaventura restored Duccio's *Maestà* of 1302 and while doing so he would have had the opportunity to examine the painting carefully.

Unfortunately, the documents recording the payments for the *racchonciatura* of the work do not indicate what caused the damage that necessitated the restoration.

Another panel that must reflect elements of Duccio's 1302 *Maestà* is the *Enthroned Madonna with Six Angels* (Galleria Comunale, Città di Castello) attributed to the Master of Città di Castello. Some of the iconography in the painting is similar to that used by Segna di Buonaventura in his *Virgin and Child with SS. Gregory and John the Baptist*. The Master of Città di Castello, a follower of Duccio, had a remarkable sensitivity to colour that distinguishes his work from that of Duccio's other followers.

Ugolino di Nerio, Duccio's closest follower, is documented from 1317 to 1327. Like Segna di Buonaventura, he must have had a prominent role within his master's workshop. His fame was such that he was given two prestigious commissions for large polyptychs for Florentine churches.[29]

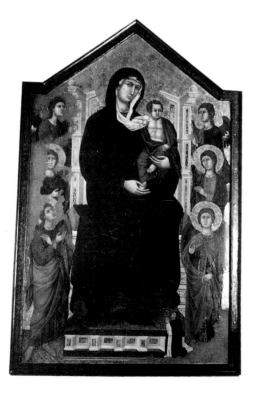

Master of Città di Castello,
Enthroned Madonna with Six Angels.
Galleria Comunale, Città di Castello.

Ugolino di Nerio,
SS. Paul, John the Baptist and Peter.
Gemäldegalerie, Staatliche Museen, Berlin.

One was the high altarpiece for the Franciscan church of Santa Croce and the other for the Dominican church of Santa Maria Novella. It was rare for an artist from outside Florence to receive such important commissions. Unfortunately, the altarpiece painted for Santa Maria Novella has been completely destroyed while the Santa Croce one has only survived in parts (Gemäldegalerie, Staatliche Museen, Berlin; National Gallery, London; Johnson Collection, Philadelphia Museum of Art, Philadelphia; and the Lehman Collection, Metropolitan Museum of Art, New York).

The small *Crucifixion with St Francis* (no. 34, Pinacoteca, Siena) probably dates from a late period in Ugolino di Nerio's career because of the more marked plastic quality of the work. Its pathos is so intense and moving as to make it one of the artist's greatest accomplishments. The density and brightness of the colours, similar to those of an enamel, are also notable.

Séroux d'Agincourt commissioned a drawing of Ugolino di Nerio's Santa Croce polyptych between 1785 and 1789, while it was still almost complete. Judging by a comparison with the surviving panels, the copy is very accurate and has been fundamental in the reconstruction of the original appearance of the polyptych.[30]

Ugolino di Nerio's work is always characterized by extreme elegance of form and by a very subtle application of paint. At times this tends to academicize the work of Duccio, to whose style Ugolino di Nerio stayed faithful for many years. Like Duccio, Ugolino was strongly influenced by the Gothic style, possibly transmitted to him through Simone Martini's early paintings.

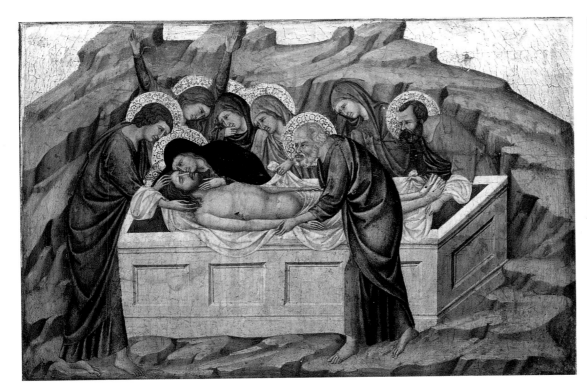

Ugolino di Nerio,
Burial of Christ. Gemäldegalerie,
Staatliche Museen, Berlin.

Ugolino di Nerio,
Burial of Christ, detail. Gemäldegalerie,
Staatliche Museen, Berlin.

The Maestà in Siena Cathedral

The *Maestà* is the masterpiece of Duccio's mature career. The Florentine sculptor Ghiberti in the second book of his *Commentari*, written around the middle of the fifteenth century, remembers the enormous multipanelled painting on the high altar of Siena Cathedral.[31] The altarpiece is 370 cm high and 450 cm wide. On the front face, which looked out towards the lay congregation, is the *Enthroned Madonna Surrounded by Angels and Saints*. The back face, which was turned towards the clergy and so seen at close quarters, contains twenty-six episodes from the *Passion of Christ*. The back predella contains scenes from the *Ministry of Christ* while in the pinnacles are scenes showing *Christ's Appearances after the Resurrection*. The front predella contains scenes from the *Early Life of Christ* and the front pinnacles show the *Last Days of the Virgin*.[32]

The first document relating to the great double-sided altarpiece is dated 9 October 1308. It is a contract between Jacopo di Giliberto Marescotti, *operaio* of the cathedral works – a position equivalent to that of director – and Duccio. The exact meaning of this document is unclear and, since some passages refer to a previous contract, it is possible that it is not the original commission but a subsequent contract between the *operaio* and the painter that was drawn up to clarify the terms of the first agreement.[33] That the document of 1308 does not indicate the year that work began on the *Maestà* is supported by the fact that it was finished in 1311. Duccio could not have completed such a large painting in the space of only three years. Although he certainly had help from the members of his workshop, their participation cannot have been that extensive, as Duccio's personal style is clearly recognizable in every part of the work.

On 9 June 1311 the citizens of Siena, including the most important representatives of the religious community and the Comune, together with 'trumpet players, bagpipes and castanet players' – the cost of whom was partially paid for by the Comune – led the panel in procession from Duccio's workshop in Stalloreggi to the cathedral. The event is related by

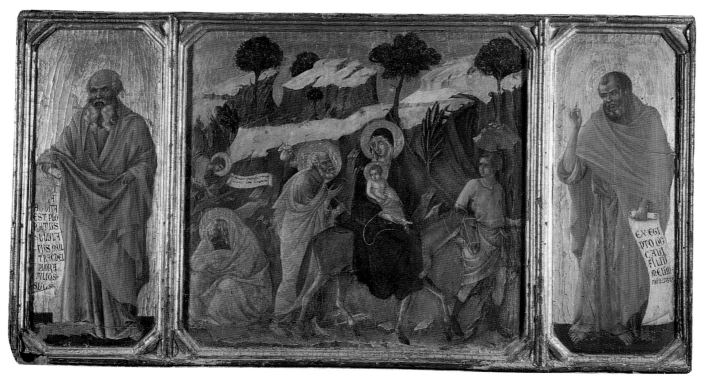

Duccio di Buoninsegna,
Flight into Egypt, detail from the
predella of the *Maestà*. Museo
dell'Opera del Duomo, Siena.

pp. 37–38
Duccio di Buoninsegna, *Entry into Jerusalem, Christ Washing the Feet of the Apostles, Last Supper, Judas Receiving the Thirty Pieces of Silver* and *Christ Taking Leave of the Apostles*. Scenes from the *Passion of Christ* on the back face of the *Maestà*. Museo dell'Opera del Duomo, Siena.

pp. 39–42
Duccio di Buoninsegna, *Maestà*, detail of the front face. Museo dell'Opera del Duomo, Siena.

pp. 43–44
Duccio di Buoninsegna, *Burial of Christ, Deposition from the Cross, Three Marys at the Sepulchre, Descent into Limbo, Meeting at Emmaus* and *Noli me tangere*. Scenes from the *Passion of Christ* on the back face of the *Maestà*. Museo dell'Opera del Duomo, Siena.

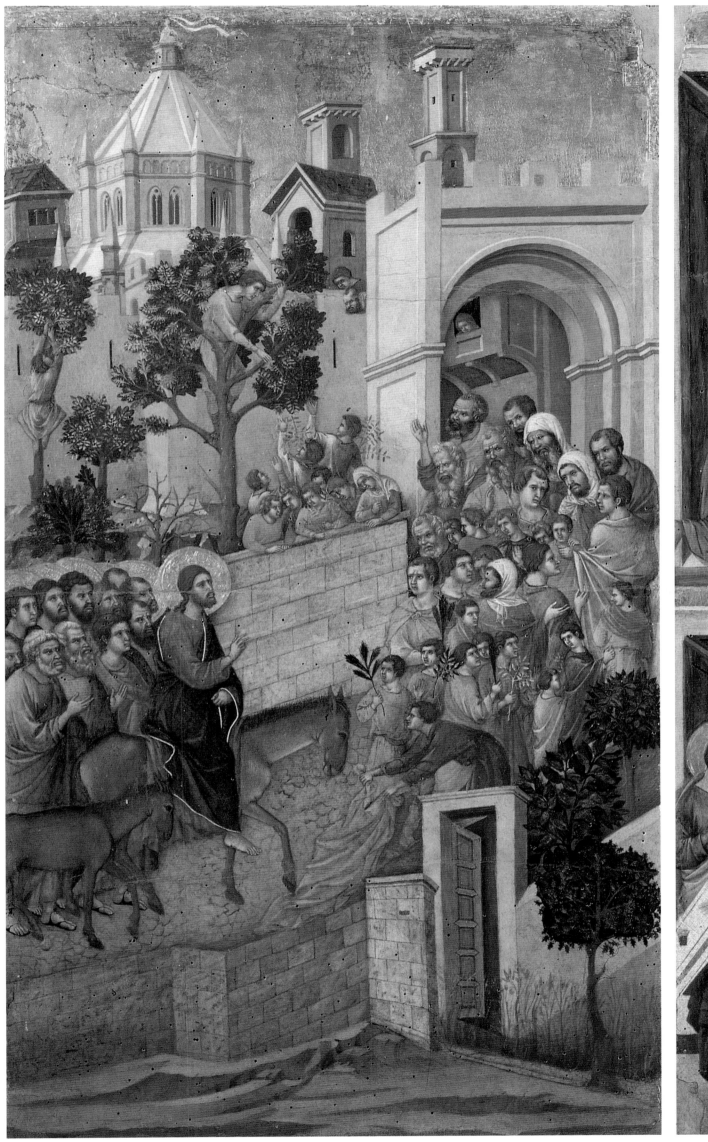
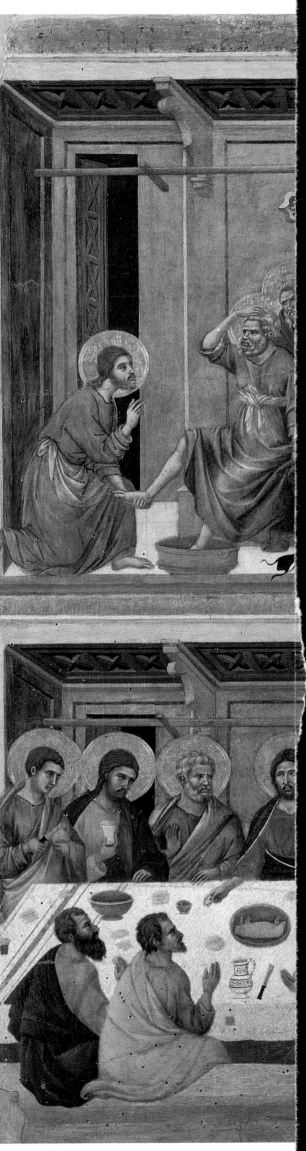

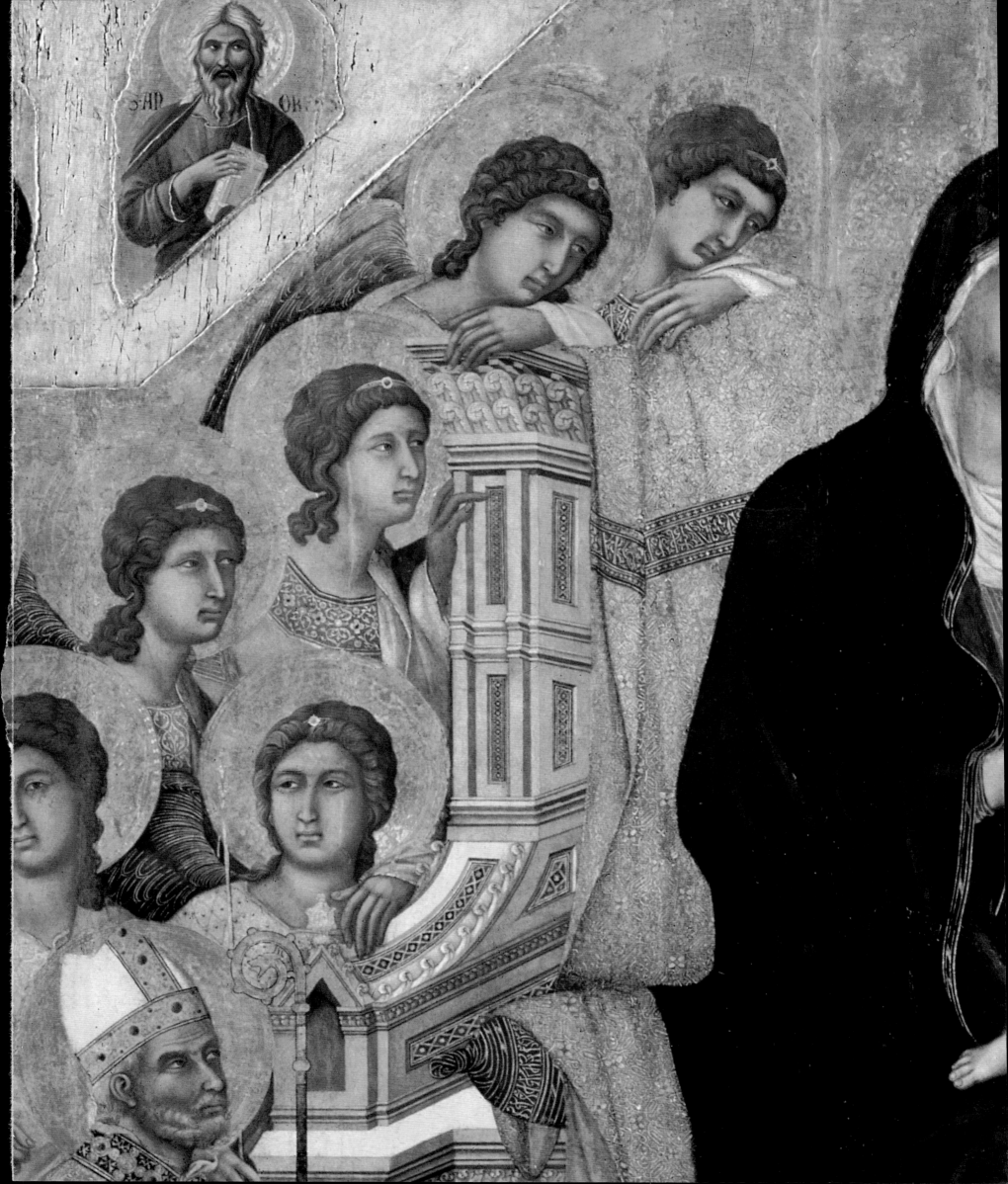

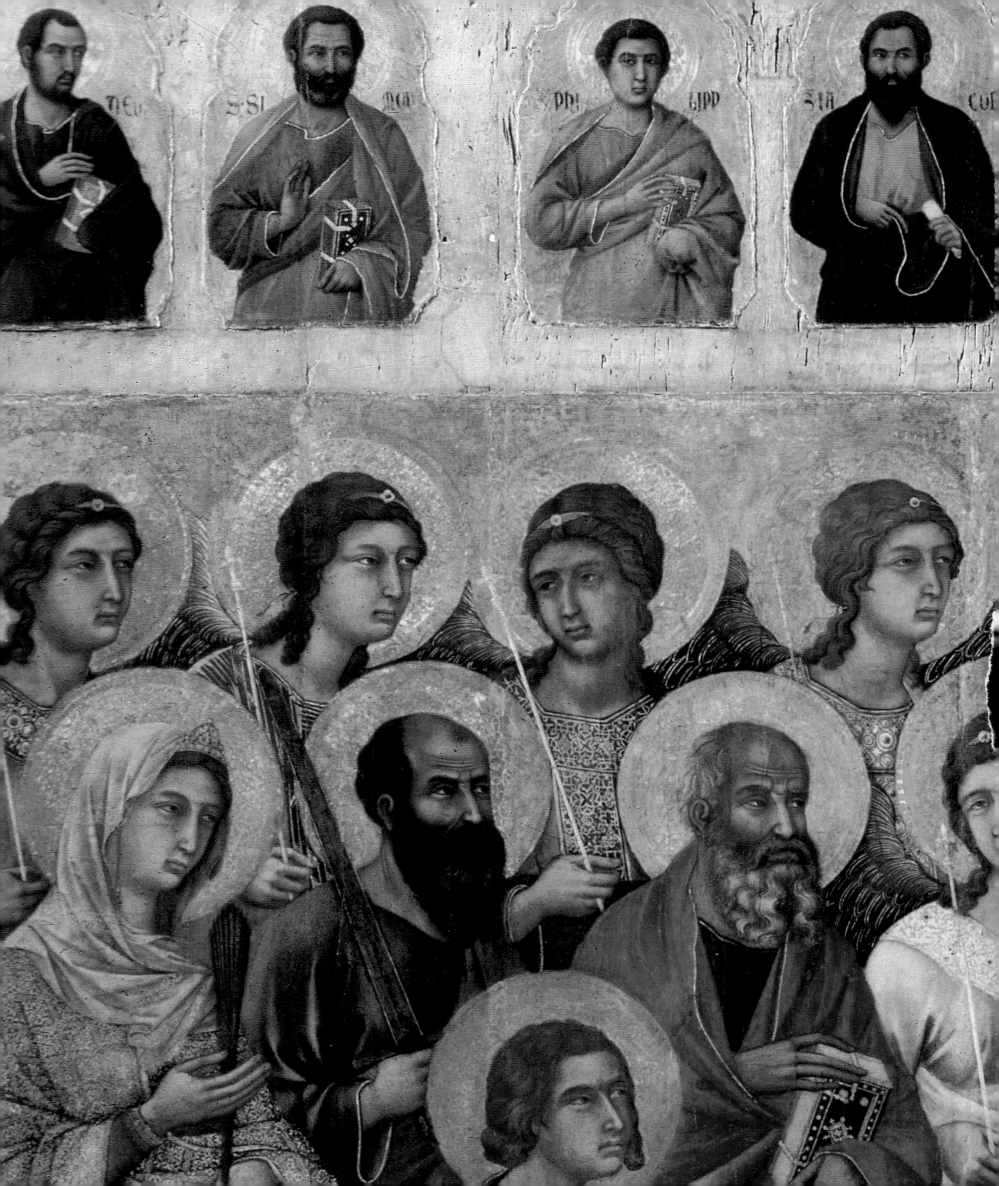

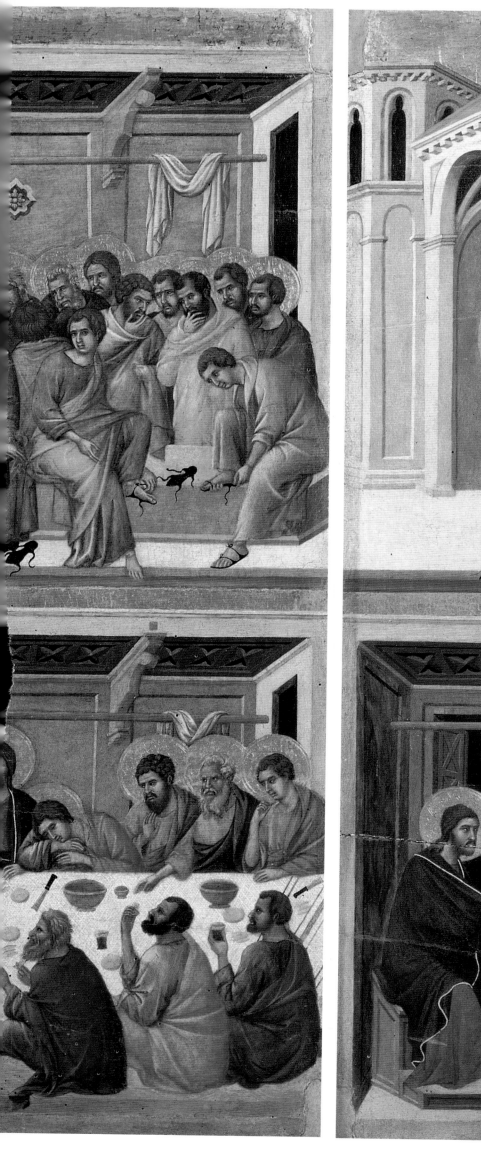
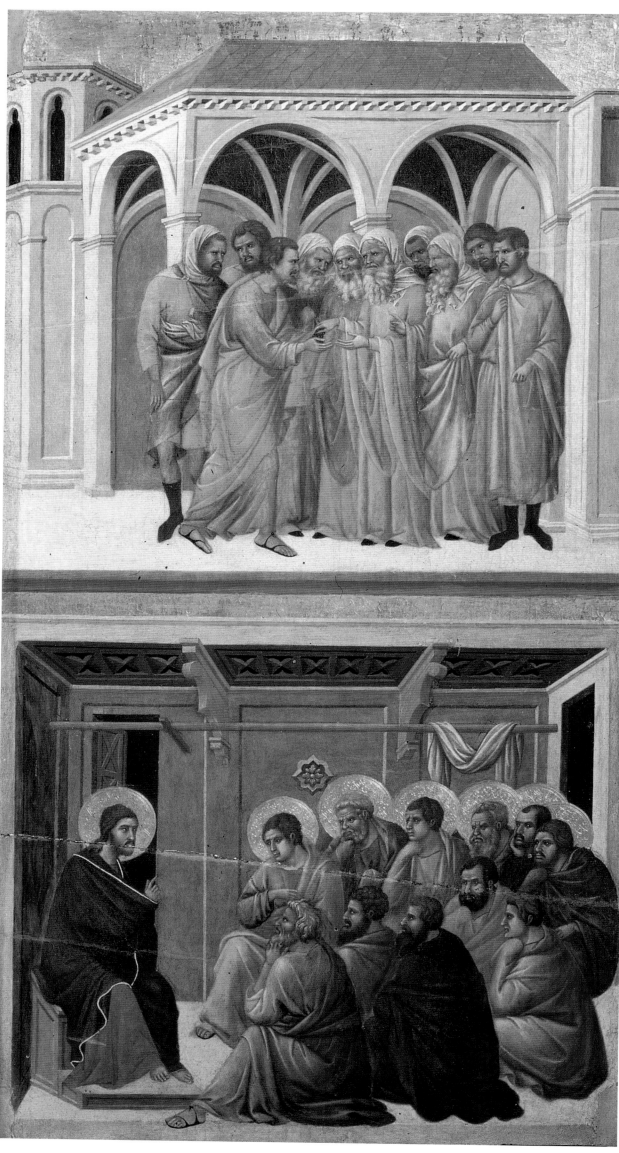

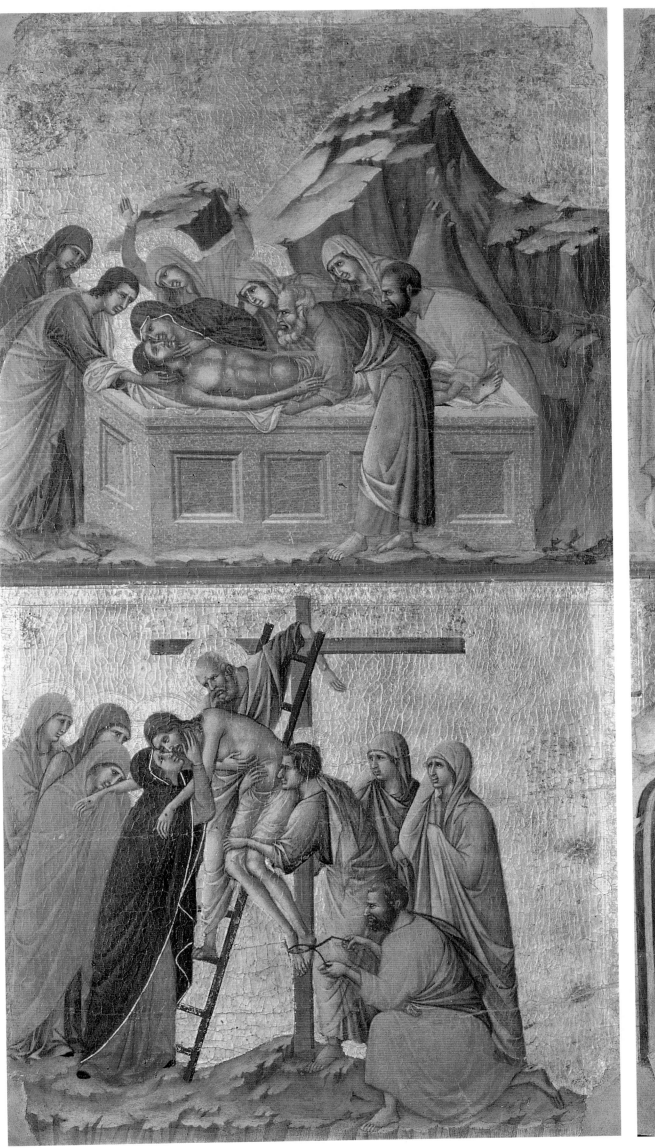
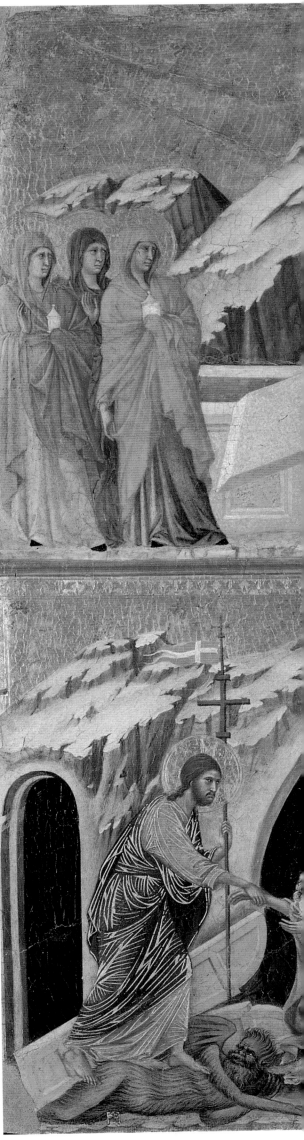

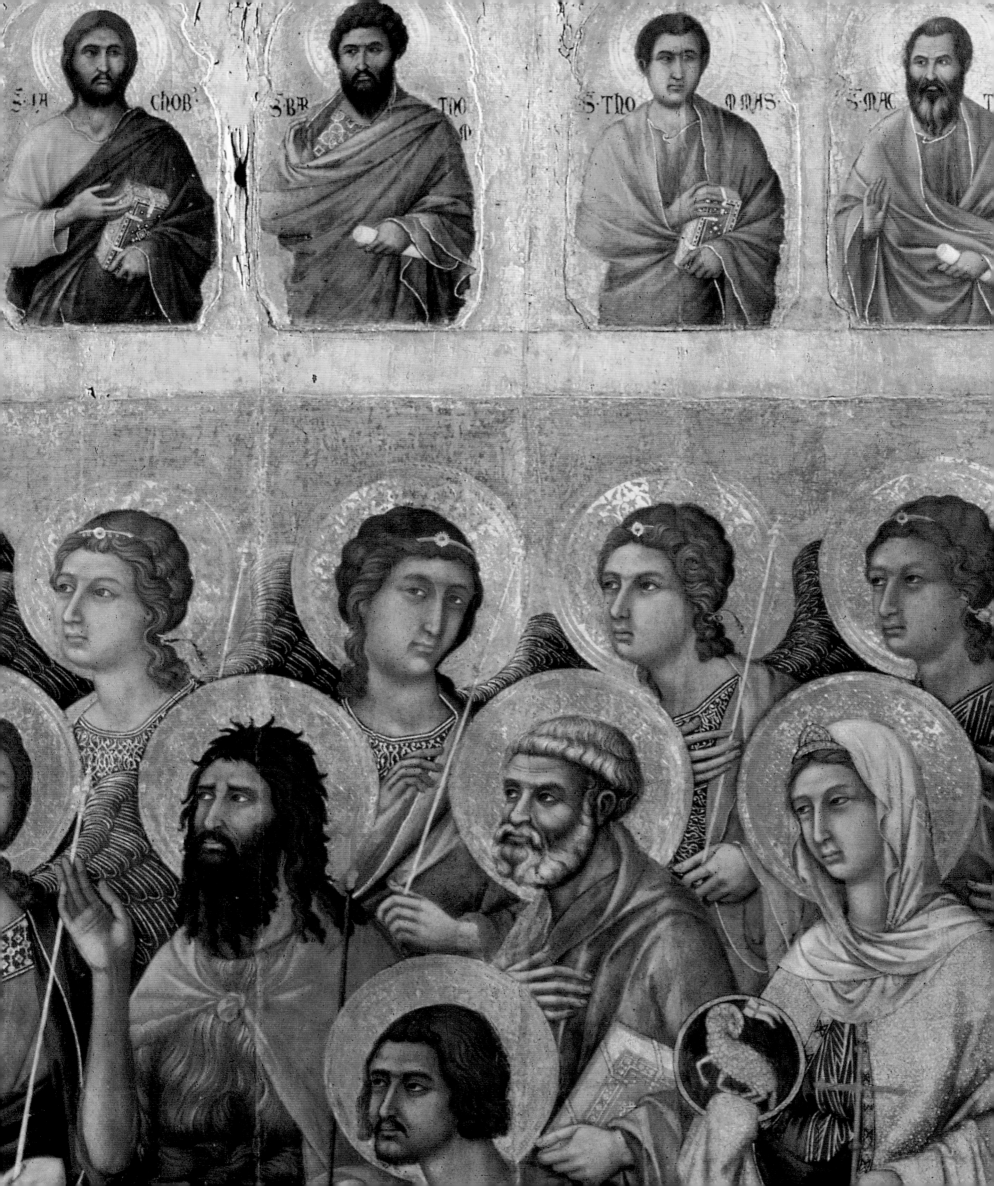

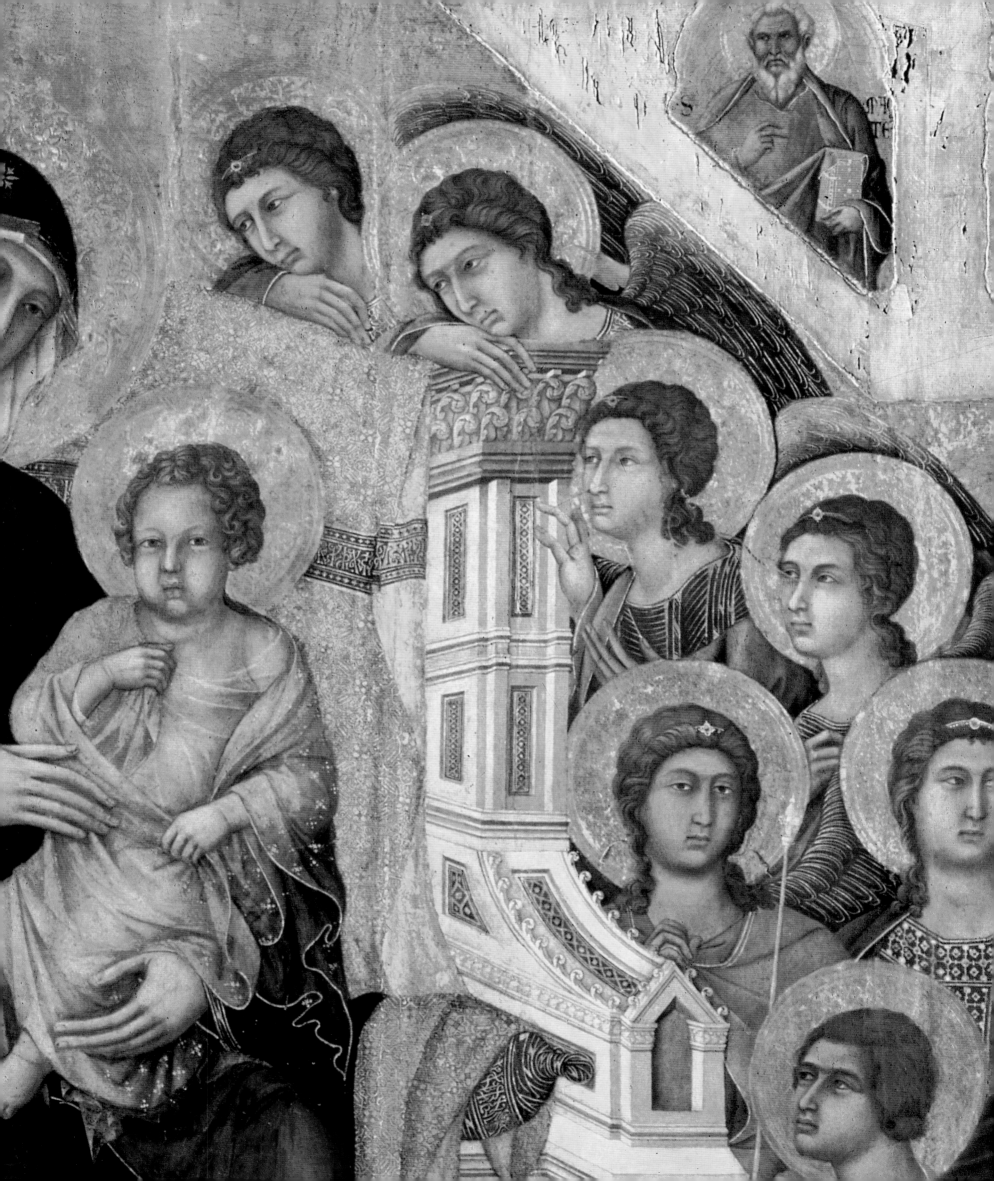

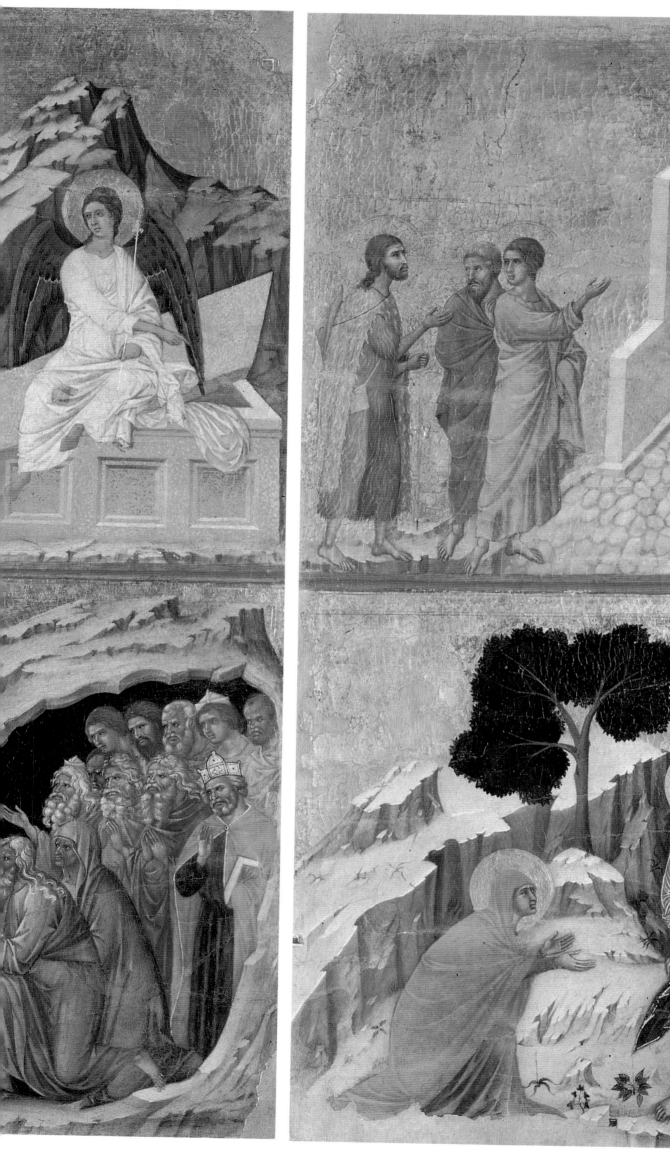
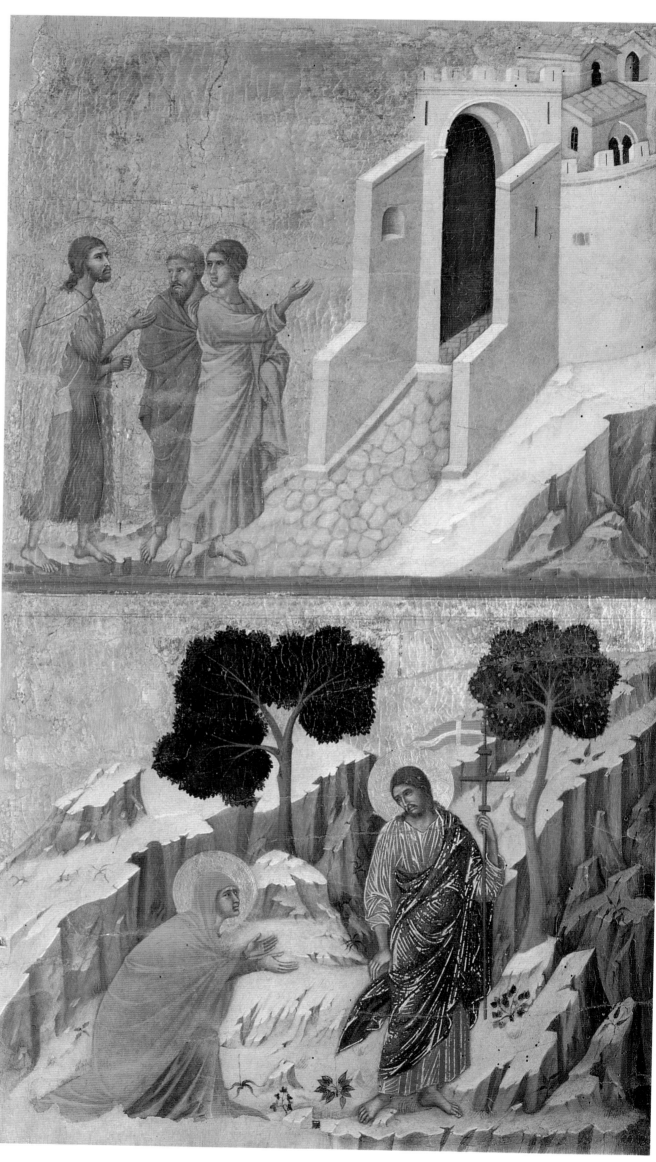

Agnolo di Tura del Grasso in his *Cronaca Senese*.[34] However, it is possible that at this date the complete *Maestà* was still unfinished and that only the main part was transported to the cathedral.

In the works immediately preceding the *Maestà*, for example *Dossal 28* (Pinacoteca, Siena), Duccio introduced a solemn and grandiose style which he then developed in the *Maestà* and continued to use in his later works.[35] In the *Maestà*, Duccio's style moved away from the Gothicism of the *Madonna of the Franciscans* towards a more classical style influenced by the latest waves of neo-Byzantine culture to reach Italy.

The number of scenes and a close examination of their stylistic development suggests that the execution of the *Maestà* must have taken Duccio more than three years. For example, the more advanced spatial experimentation in *Christ and the Samaritan* and in the *Healing of the Blind Man* on the back predella indicates that this section of the altarpiece must have been the last to be completed (probably after 1311).[36] It is possible that some of the *Passion of Christ* scenes were executed before the main front panel of the *Virgin and*

Child as they show stylistic similarities to the Stoclet *Madonna and Child* in their Giottesque spatial solutions. The back pinnacle panels, showing *Christ's Appearances after the Resurrection*, and the scenes from the *Last Days of the Virgin*, which form the front pinnacles, also appear to have been painted at the same time as the *Passion of Christ* scenes, although some of the individual figures are depicted with a greater degree of monumentality.[37]

Duccio's use of space improves in the panels from the *Maestà* that were executed towards the end of the work. In the scene of *Pilate Washing his Hands*, Duccio places the Roman governor at the back of the picture space. However, possibly in order the emphasize the main action, Pilate's hands pass in front of the small twisted column, the base of which stands at the very front of the scene. These inconsistencies in the rendering of space indicate that the scene was one of the earlier ones to be painted. It cannot be contemporary with the rear predella scenes in which Duccio demonstrates a mastery of the realistic definition of space.[38]

In some of the panels from the back of the *Maestà*, Duccio experiments with the depiction of landscapes,[39] as in the

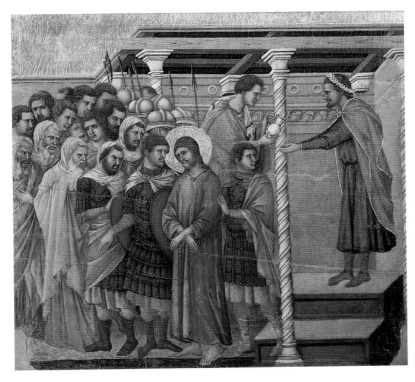

Duccio di Buoninsegna, *Pilate Washing his Hands*, scene from the *Passion of Christ* on the back face of the *Maestà*. Museo dell'Opera del Duomo, Siena.

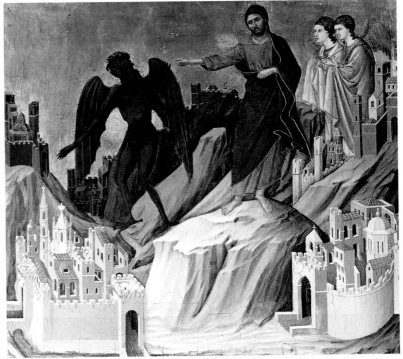

Duccio di Buoninsegna, *Temptation of Christ*. Frick Collection, New York.

pp. 46–47
Duccio di Buoninsegna, *Maestà*, front face. Museo dell'Opera dell Duomo, Siena.

pp. 48–49
Duccio di Buoninsegna, *Passion of Christ*, back face of the *Maestà*. Museo dell'Opera del Duomo, Siena.

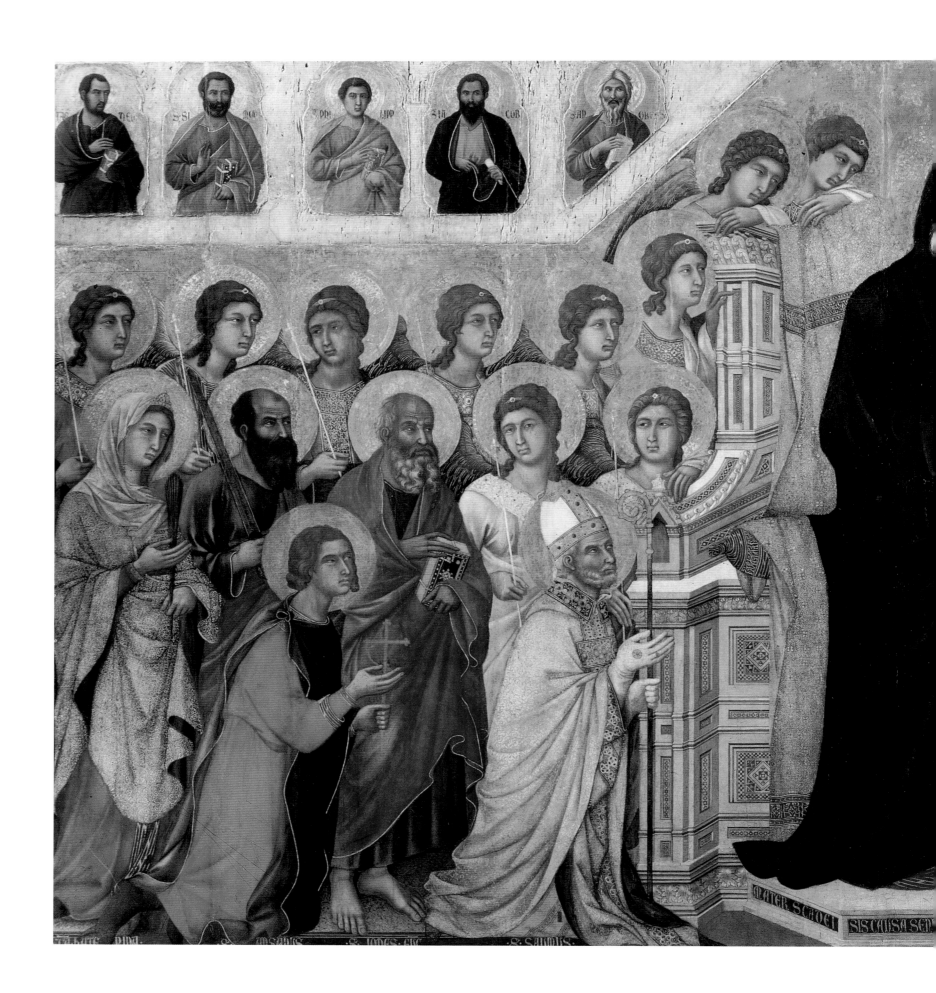

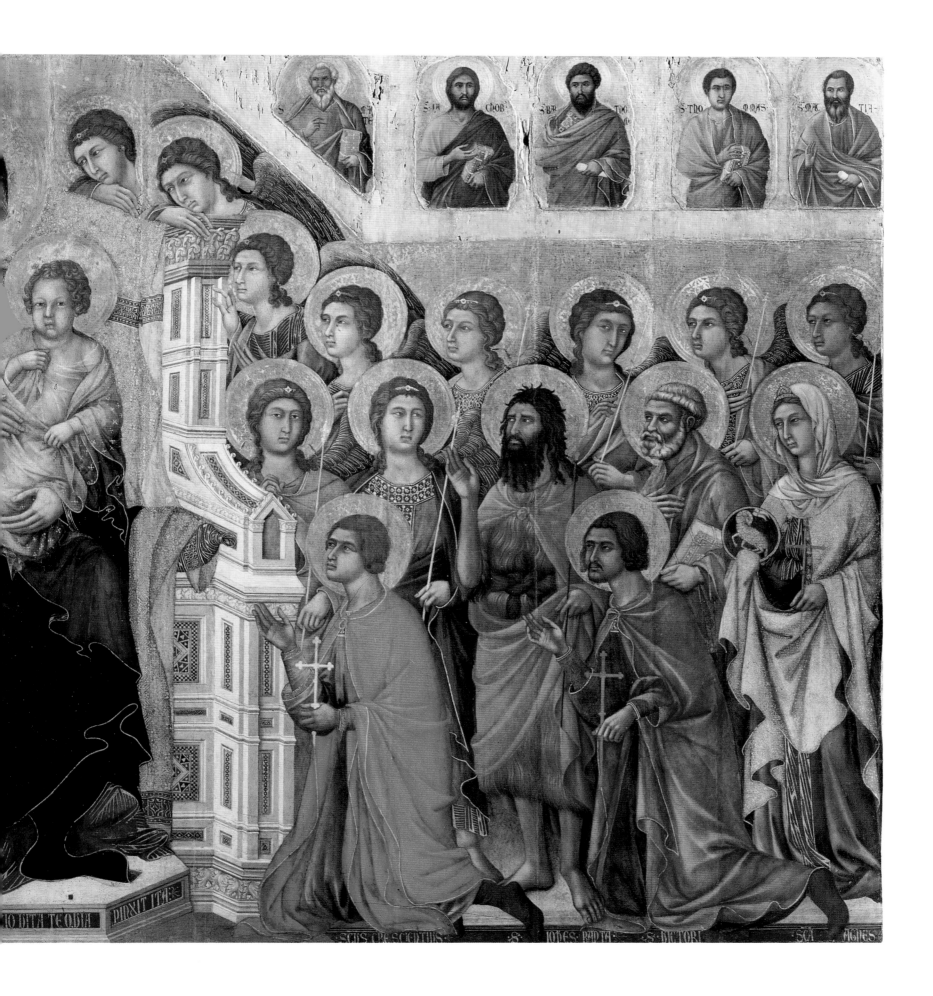

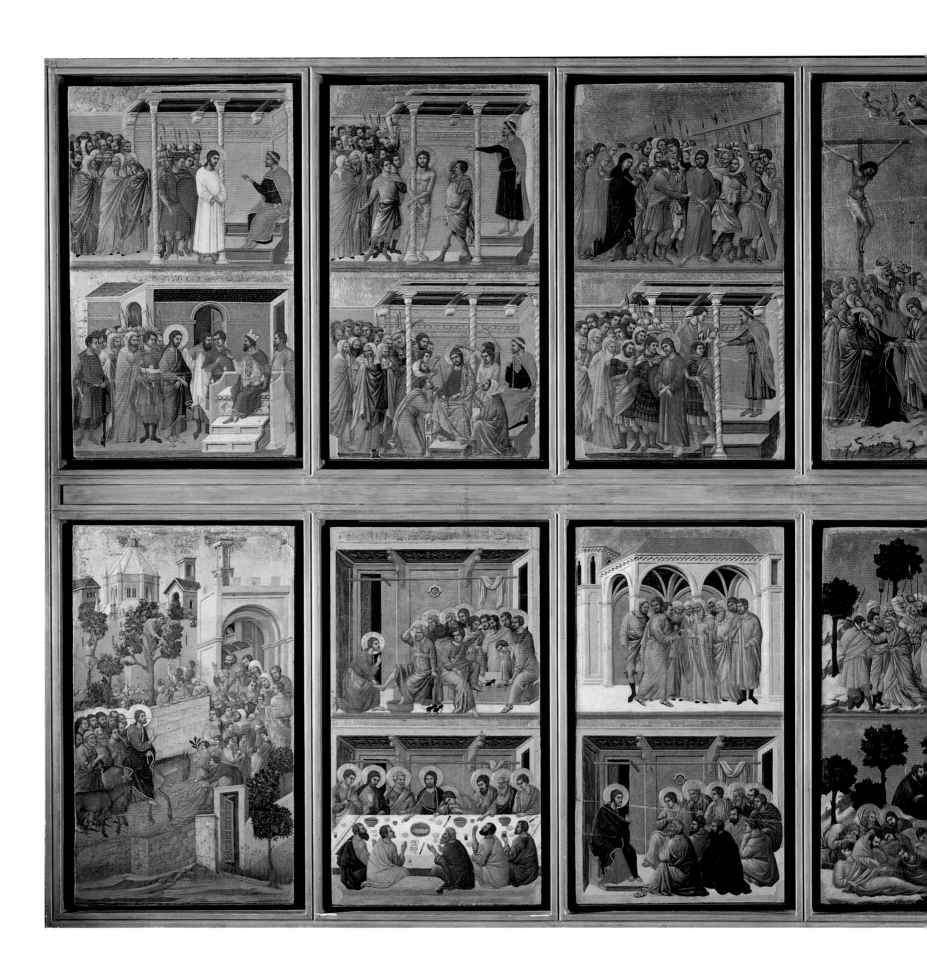

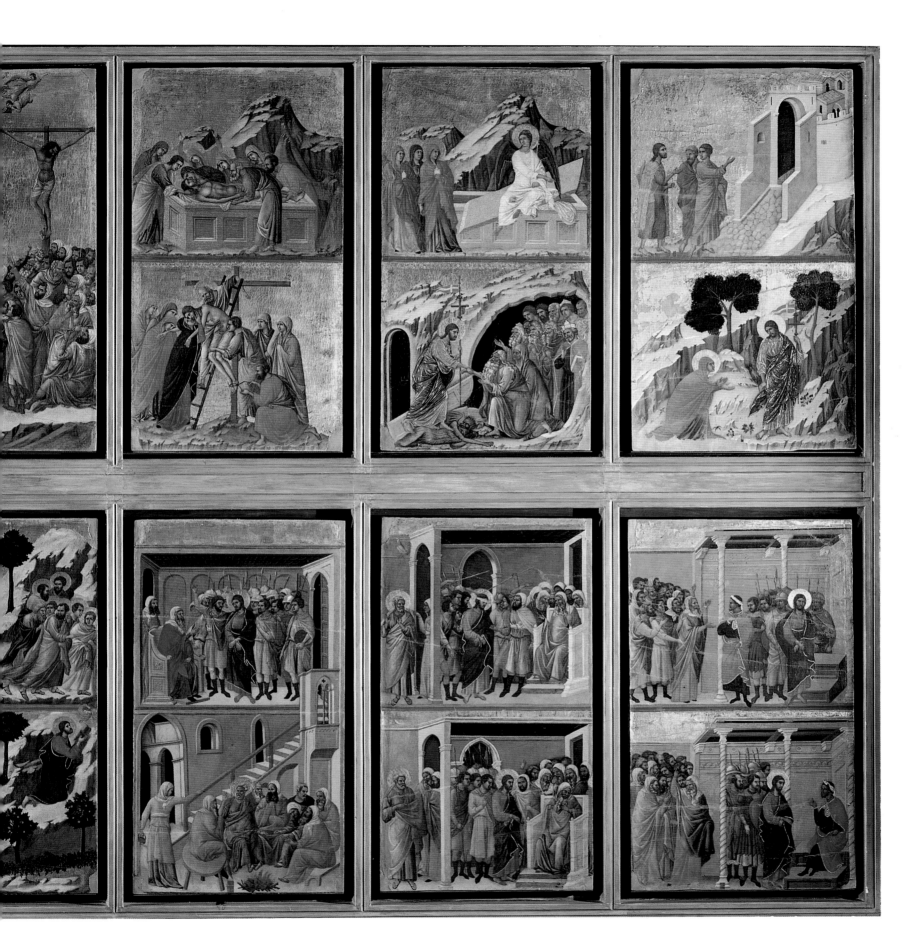

Entry into Jerusalem, the *Temptation on the Temple*, *Christ and the Samaritan* and the *Healing of the Blind Man*. His innovations in rendering landscape were brought to fruition by other great Sienese artists. Duccio's views of cities were remembered and developed by Simone Martini in the St Martin Chapel in Assisi (*c.* 1314–1316) and they gained greater prominence in the scenes from the altarpiece of the Blessed Agostino Novello (*c.* 1324). Pietro Lorenzetti learnt a great deal from them, as can be seen in the frescoes in the left transept of the Lower Church in Assisi (*c.* 1315–1317). Finally, it was Ambrogio Lorenzetti's famous architectural views in the scenes of *Good Government* (1338–1339) that he painted in the Palazzo Pubblico in Siena which so developed the portrayal of landscape as to leave even the modern observer amazed and astounded.

The *Maestà* had great civic as well as religious value since the city of Siena was dedicated to the Virgin. The work also underlines Duccio's awareness of his own artistic capacities as is shown by his signature on the footrest of the throne: MATER SANCTA DEI/ SIS CAUSA SENIS REQUIEI/ SIS DUCCIO VITA/ TE QUIA PINXIT ITA (Holy

Mother of God be thou the cause of peace for Siena, and, because he painted thee thus, of life for Duccio).[40]

The plea emphasizes the artist's religious faith and his certainty that the work justified his asking for heavenly mercy both for himself and for his city. In this respect the inscription assumes a special value and is linked to the presence of the four patron saints of Siena, Ansanus, Savinus, Crescentius and Victor, who are kneeling in the foreground and who personify the city, acting as intercessors with the Virgin.

In 1505 the *Maestà* was removed from the high altar of the cathedral and on 1 August 1771 it was dismembered. The main panel was cut vertically into seven pieces, destroying the frame, and the two sides were separated with a saw. This damaged the pictorial surface, particularly the Virgin's right cheek and her mantle. Some of the sections were then dispersed but fortunately few parts have been lost.[41]

The double-sided altarpiece in the cathedral in Massa Marittima, the *Madonna of Mercy*, is almost a copy of Duccio's *Maestà*, although it is less complex and has smaller dimensions. In a document dated 8 January 1316 the Comune of Massa Marittima authorizes the person in charge of the

Duccio di Buoninsegna (?),
Surrender of the Castle of Giuncarico. Sala del
Mappamondo, Palazzo Pubblico, Siena.

Opera di San Cerbone (the workshop responsible for the maintenance of the cathedral) to advance the money for its completion. The Massa Marittima *Madonna of Mercy* has been attributed to a number of different artists including Segna di Buonaventura, Duccio and Simone Martini.[42] It has even been suggested that a different master was responsible for each side.[43]

During the 1979 restoration of Simone Martini's *Guidoriccio da Fogliano* in the Sala del Mappamondo in Siena's Palazzo Pubblico, a fragmentary fresco showing the *Surrender of the Castle of Giuncarico* on 29 March 1314 was discovered on the lower part of the wall. This fresco formed part of a series, commissioned by the Comune, representing the conquests of the Sienese army.[44] The frescoes commemorated the government's policy of territorial expansion at the beginning of the fourteenth century. In 1345 Ambrogio Lorenzetti installed his famous *Mappamondo* (the map of the world from which the room took its name) on the part of the wall on which the *Surrender of the Castle of Giuncarico* was found. Traces of the map which rotated on a pivot can still be seen. Before Ambrogio set the *Mappamondo* in place, the *Surrender of the Castle of Giuncarico* must first have been covered over with a layer of azurite, clearly as an act of *damnatio memoriae* for which we do not know the reason.

The attribution of the fresco has proved problematical. Memmo di Filippuccio and Pietro Lorenzetti have been suggested, as has Simone Martini, assuming that he was not responsible for the *Guidoriccio da Fogliano*.[45] The fresco has also been attributed to Duccio on the basis of comparisons of the buildings inside the stockade and of the type of rocks in the landscape with similar representations in the scenes on the back of the *Maestà*.[46] Convincing similarities can be found both in terms of execution and of style but not, I believe, in terms of figures. In the *Surrender of the Castle of Giuncarico* the figures have a monumentality that does not exist in Duccio's other works, not even in the last scenes executed for the *Maestà*. It would therefore be unwise to make any judgment about the attribution.

pp. 52–53
Simone Martini, *Maestà*.
Sala del Mappamondo,
Palazzo Pubblico, Siena.

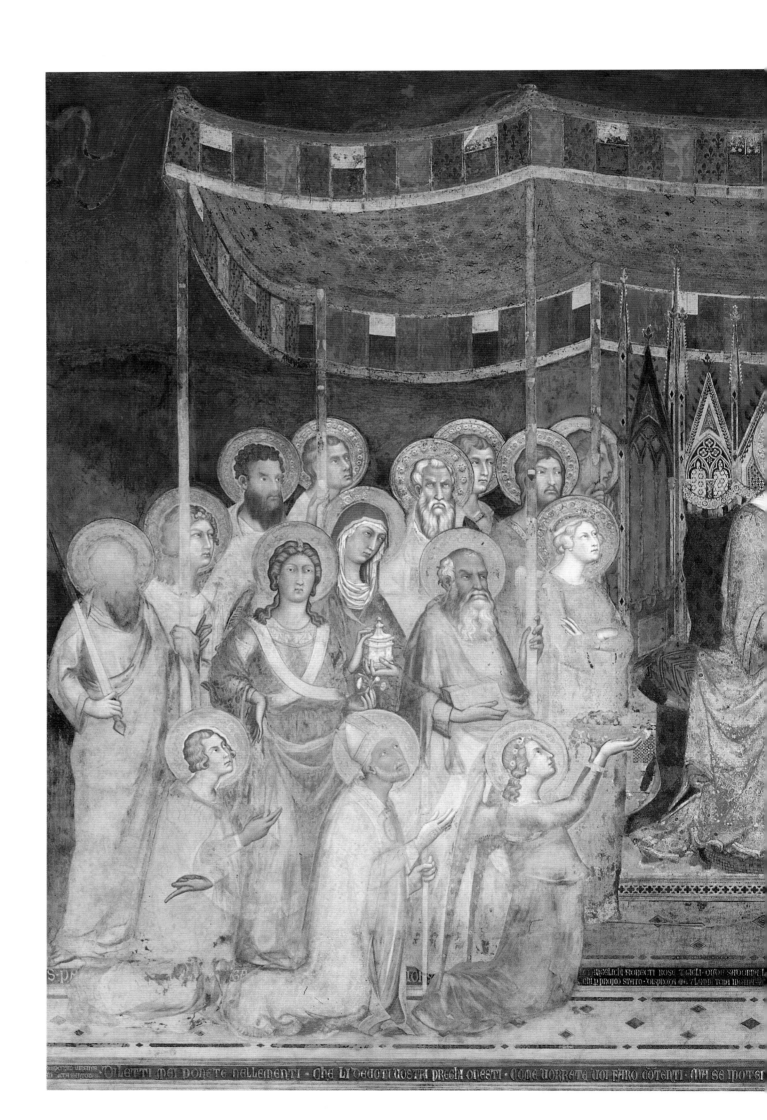

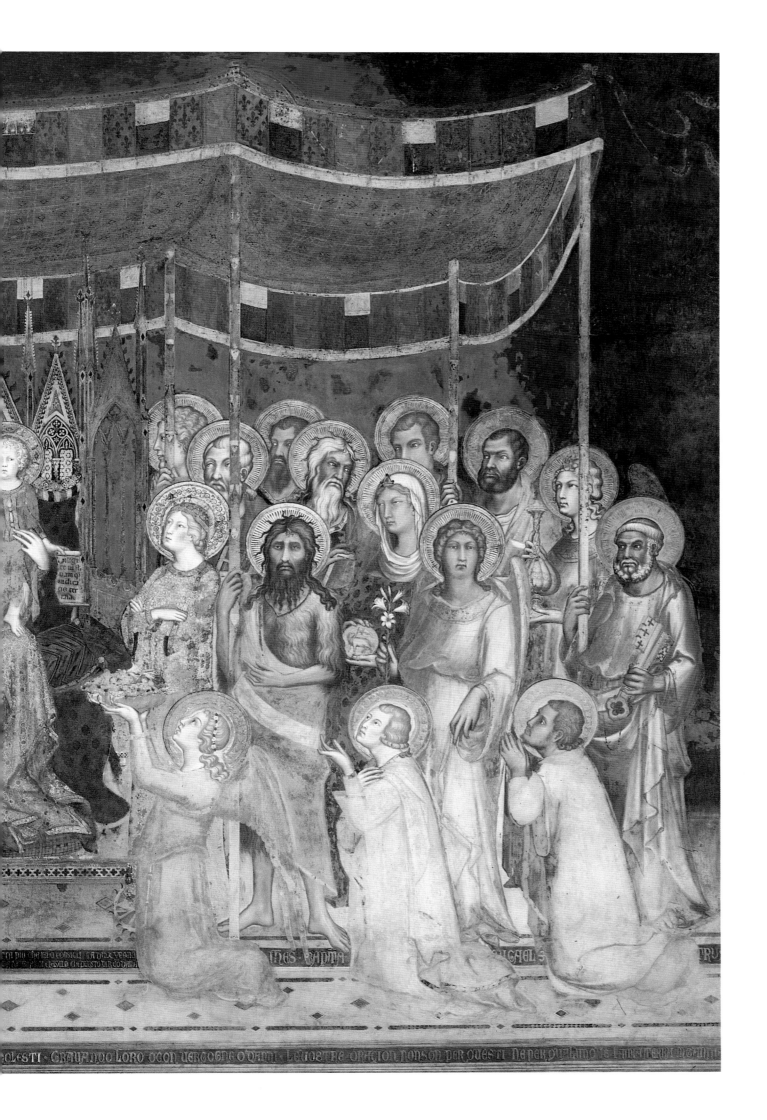

Simone Martini

THE *MAESTÀ* OF 1315

Simone Martini was the most influential fourteenth-century Sienese painter and probably began his career in Duccio's workshop at the turn of the century.[47] The first parts of his *Maestà*, painted in the Sala del Mappamondo, clearly show the influence of Duccio. This can be seen in the *Blessing Christ* and the busts of the prophets in the medallions of the decorative strip at the top; in the evangelists Mark and John in the roundels of the upper corners; and, finally, in the six prophets, three on each side strip. The facial types and the flesh tones reflect Duccio's style and are not as luminous and transparent as they are in later parts of the same work. However, I believe that Simone Martini's being Duccio's pupil does not justify the attempts to trace the first signs of his activity to the *Passion of Christ* sequence on the back of the *Maestà*[48] in Siena Cathedral as these scenes fall completely within the range of Duccio's style.[49]

In Simone Martini's painting, the composition of the scene, the positioning of the celestial court to either side of the enthroned Virgin and Child and the placing of the kneeling patron saints of Siena in the foreground reflect the arrangement of Duccio's *Maestà*. Simone's *Maestà* also echoes that of Duccio in the civic value of the representation. He painted the seal of the Sienese Comune in the third tondo from the left, underneath the lower decorative band. It shows the Madonna and Child with two kneeling angels holding candlesticks and reproduces the seal executed by the great Sienese goldsmith Guccio di Mannaia in 1298.

Although Simone's *Maestà* is faithful to Duccio's version in many respects – something that may have been stipulated in the commission – it also contains some important innovations. Simone introduced various compositional elements, such as the baldachin, that are used to provide precise spatial references. The baldachin is masterfully placed, receding into the depth of the picture plane, and its undulating material

Simone Martini, *Maestà*, detail of
the frame. Sala del Mappamondo,
Palazzo Pubblico, Siena.

p. 55
Simone Martini, *Maestà*, detail.
Sala del Mappamondo,
Palazzo Pubblico, Siena.

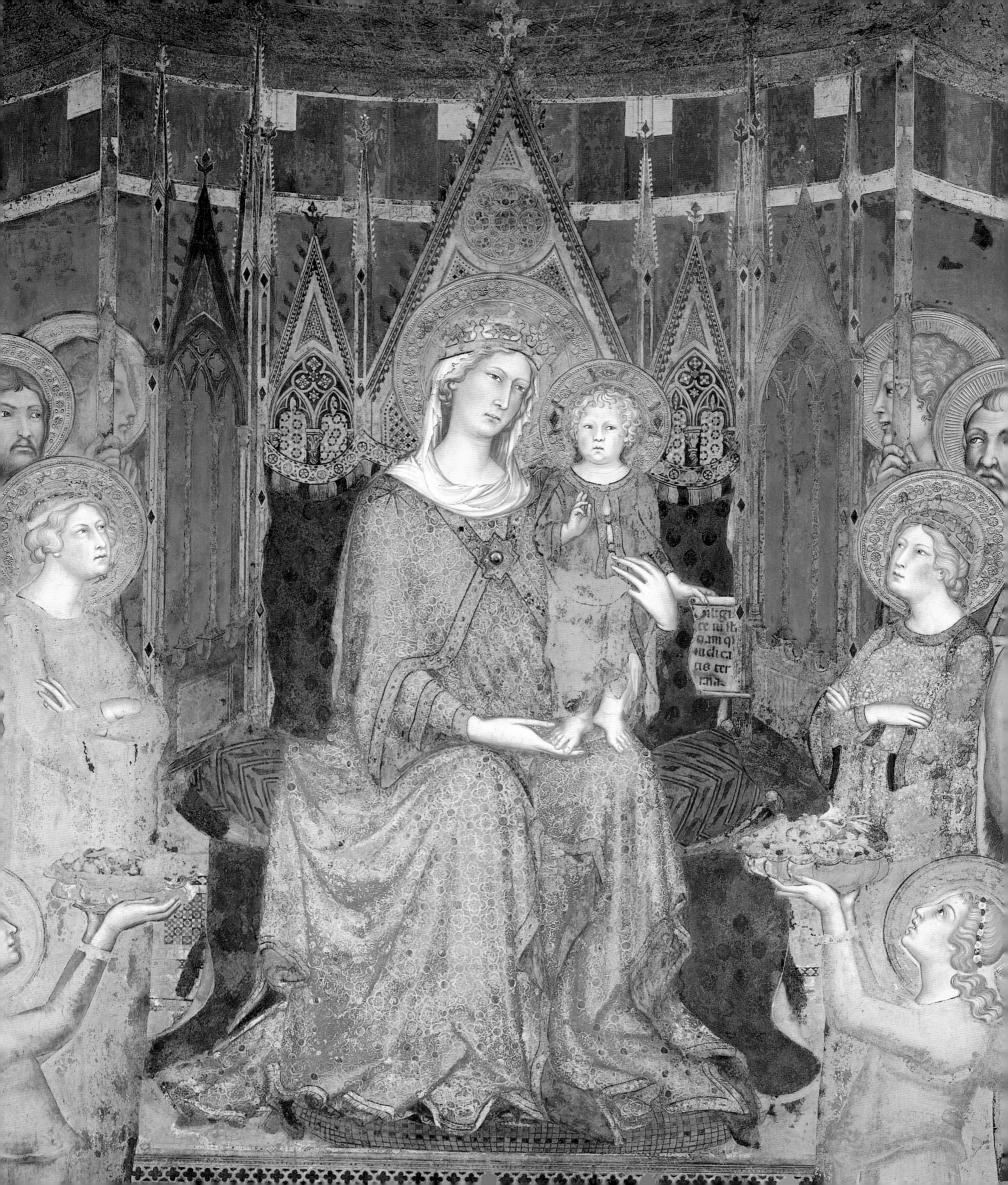

indicates the slow movement of the saints beneath, stressing their secular and courtly appearance.

It was probably with the intention of emphasizing the material and profane aspect of the painting, akin to a court scene, that Simone introduced some technical tricks which have been exposed by recent restoration. This has unearthed his employment of unusual materials, which he used to increase the luminosity of the painting as well as to give material substance to the pictorial surface.[50] When work on the fresco had already begun, he introduced haloes in relief, adorning them with flowers and using moulds pressed into the damp mortar. Some members of the group of saints on the right have more traditional haloes that were executed earlier than those done in relief.

The effects obtained by these moulds must have pleased Simone Martini because he used them throughout his career. He went on to perfect the technique and to employ more complex patterns of intertwining leaves. Haloes created in this way can be seen in the St Martin Chapel in the Lower Church of San Francesco at Assisi as well as in the series of saints in the right transept. Simone's invention was adopted by Lippo Memmi in his *Maestà* of 1317, frescoed in the Palazzo Civico of San Gimignano. Lippo's knowledge of the technique supports the theory that he was one of Simone's assistants on the *Maestà* in the Sienese Palazzo Pubblico.

Simone Martini used gilded metallic objects, painting in relief and even coloured glass in the *Maestà* to maximize the effects of light reflection, as seen in the poles that support the baldachin and in the Virgin's gilded throne. The unusual structure of the throne recalls Northern Gothic cathedrals, while its base, executed in fretwork, is reminiscent of a precious reliquary such as that of the Holy Corporal at Orvieto. Simone even applied an opal-coloured crystal button to make the preciousness of the clasp that closes the Virgin's mantle more immediate. This taste for the inclusion of three-dimensional elements forced Simone to give greater emphasis to certain details. He applied real paper on which texts were written with real ink to Christ's scroll and to St Jerome's open manuscript in the first roundel of the lower decorative band, pasting them into the fresh plaster.[51]

There is an irregular horizontal break in the plaster of the fresco which cuts across the upper step of the Virgin's throne,

p. 56
Simone Martini, *Maestà*, detail.
Sala del Mappamondo,
Palazzo Pubblico, Siena.

which shows that Simone interrupted work on the *Maestà* for some time. According to the inscription at the base of the painting it was completed in 1315 and since it was only possible to work in fresco in the summer months, from April to December, the *Maestà* must have been started in 1312 or 1313. There are significant similarities between the later parts of the *Maestà* and the cycle of frescoes in the St Martin Chapel in the Lower Church of San Francesco in Assisi that indicate that the two works were done at the same time. It is therefore probable that Simone, in the period in which he interrupted work on the *Maestà*, travelled to Assisi to start the decoration of the St Martin Chapel.

In 1321 Simone is documented as doing further work on the *Maestà*. He repainted the heads and hands of the Virgin, the Christ Child, SS. Ursula, Catherine, Ansanus and Crescentius as well as the kneeling angels who offer gilded bowls overflowing with roses and lilies. These areas can easily be identified, not only because the flesh tones are more luminous and transparent than those executed in 1315, but also because signs of the previously larger heads are still clearly visible.[52] It is not evident why Simone Martini made these changes but it is possible that, conscious of his own artistic development during the intervening period, he decided to update the fresco.

Below the lower decorative band of the *Maestà* there are various inscriptions which assume the form of a dialogue between the four patron saints and the Virgin. In their role as intermediaries between the Comune and the Mother of God, the saints request peace, prosperity and protection for the City of Siena. The inscription, which is now incomplete and damaged, begins on the first step of the throne:

> *Li angelichi fiorecti, rose e gigli*
> *Onde s'adorna lo celeste prato,*
> *Non mi dilettan' più ch'e' buon consigli*
> *Ma talor veggio chi per proprio stato*
> *Disprezza me e la mia terra inganna:*
> *E quando parla peggio è più lodato;*
> *Guardi ciascun cui questo dir condanna.*

(The angelic flowers, the rose and lily
With which the heavenly fields are decked
Do not delight me more than righteous counsel

But some I see who for their own estate
Despise me and deceive my land
And are most praised when they speak worst.
Whoever stands condemned by this my speech take heed.)

But if the powerful do harm to the weak,
Weighing them down with shame or hurt.
Your prayers are not for these
Nor for whoever deceives my land.)[53]

Unfortunately the second part of the dialogue has been lost. It was written in the scrolls held by the kneeling patron saints of Siena. Only the Virgin's reply remains:

Responsio Virginis ad dicta sanctorum:
Dilecti miei, ponete nelle menti
Che li devoti vostri preghi onesti:
Come vorrete voi farò contenti.
Ma se i potenti a' debil fien molesti:
Gravando loro con vergogna o danni.
Le vostre orazion non son per questi
Né per qualunque la mia terra inganni.

(*The reply of the Virgin to the words of the saints:*
My beloved, bear it in mind
When your just devotees make supplication
I will make them content as you desire,

The triplet that refers to the completion of the work is stamped on the plaster below the lower decorative band:

Mille trecento quindici [era] volto
et delia avia ogni bel fiore spinto
et iuno gia gridava imi rivolto.[54]

The verse describes how the year 1315 was passing and Delia, or Diana (springtime), had caused the flowers to bloom while Juno, to whom the month of June was dedicated, was about to turn over, that is, was about to enter the second half. The date becomes more and more precise with each line and we learn that the inscription was placed beneath the fresco in the middle of June 1315.[55]

The lines of the triplet are misaligned on the left. This may indicate that there was another verse on the opposite side and that a large object originally stood between the two verses,

perhaps a stage.[56] The letters of the triplet are not painted but incised with punches on fresh plaster in an area previously coloured dark red. This creates the illusion that they have been sculpted on a porphyry slab, imitating perhaps an antique inscription. Simone adopted the same procedure for his signature, which he placed just beneath the date and which only survives in a fragmentary form: S... A MAN DI SYMONE....[57]

THE ST MARTIN CHAPEL IN ASSISI

As I have mentioned, it is likely that work on the scenes in the St Martin Chapel in the Lower Church of San Francesco in Assisi was started before the *Maestà* was completed. The few documents available seem to confirm this hypothesis which is based mainly on the marked stylistic affinity between the two works.[58]

During his stay in Assisi Simone would have been able to see Giotto's fresco cycle[59] of the life of St Francis in the Upper Church and he later used its innovations in the representation of space and of the human body when he returned to Siena to complete the *Maestà*. The influence of Giotto can

be seen, for example, in the figures of SS. Jerome and Matthew. Here, for the first time, Simone uses sophisticated foreshortening and the figures are barely contained by the tondi of the lower band.

Simone Martini encountered various examples of the Gothic style of Northern Europe in Assisi. These include the frescoes executed around 1270 on the walls of the right transept of the Upper Church by an Anglo-French artist and goldsmiths' works, such as the chalice made by Guccio di Mannaia.[60] The treasury of San Francesco also contained manuscripts from across the Christian world, some of which were executed by miniaturists trained in a Gothic style.

Gentile Partino da Montefiore, the commissioner of the frescoes in the St Martin Chapel, was a Franciscan friar who was prominent in the papal court which transferred from Rome to Avignon in 1309. He was made cardinal priest of Santi Silvestro e Martino ai Monti in 1298 by Boniface VIII and undertook important assignments for the papacy. In 1307 he was sent to Buda to ensure the succession of Charles Robert of Anjou to the Hungarian throne. Charles Robert was the son of Charles Martel, who had been the legitimate

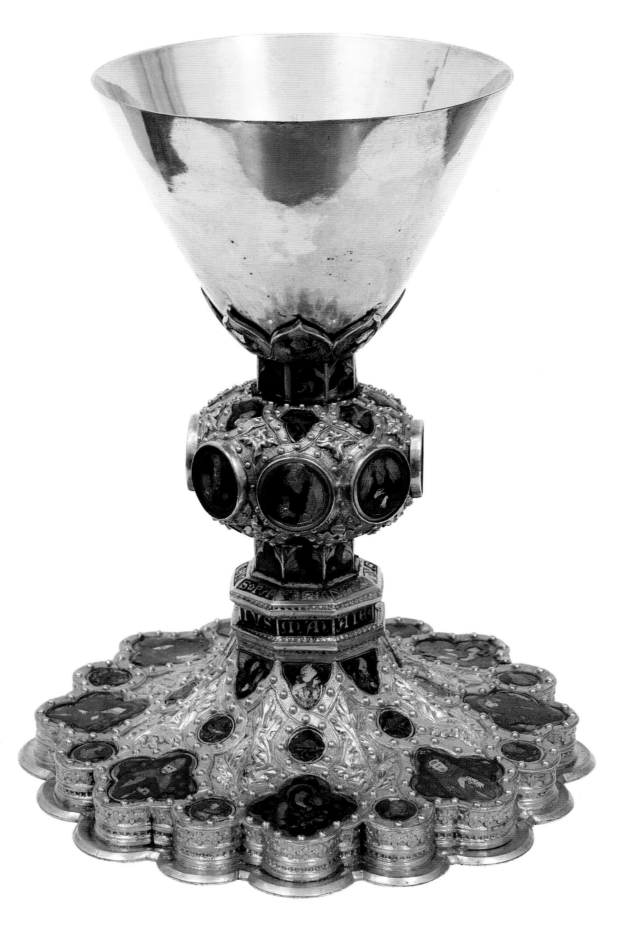

Guccio di Mannaia,
Chalice of Nicholas IV.
Treasury of San Francesco, Assisi.

heir to the throne of Naples. In 1312 Cardinal Gentile was entrusted with the job of transporting the papal treasury, which was then at Perugia, to Avignon. During this undertaking he stayed in Siena for some time and it is possible that he met Simone Martini.[61] He then travelled to Lucca where he died on 27 October 1312. His body was buried in the St Louis Chapel in the Lower Church of San Francesco as the St Martin Chapel may not have been completed or consecrated at that time.[62] The papal treasury never reached Avignon as it was sacked in June 1314 by Uguccione della Faggiola.

Shortly before dying, Gentile da Montefiore had left the enormous sum of six hundred florins to the friars in Assisi. This was probably intended for the decoration of the St Martin Chapel in which the cardinal's coat of arms appears conspicuously in the window jambs and in other areas of the chapel.

In an enterprise of this sort it was usual to complete the stained-glass windows before beginning the frescoes, thereby allowing the painter to consider the effect of the light filtered through the coloured panes of glass and adjust his work accordingly. It is likely that this procedure was followed in the St Martin Chapel and that the stained glass was completed in 1312.

St Martin, to whom the chapel is dedicated, was a knight in the Roman army and, later, bishop of Tours in France.[63] Representations of his life are rare in Italy but the subject was ideally suited to the talents of Simone Martini. The narrative provided the excuse to portray a secular and knightly tale and allowed Simone to indulge his talent for rich decorative effects. Unfortunately, as in the *Maestà* in Siena, Simone's numerous retouchings *a secco* have been lost with time, but the overall condition of the frescoes is good.

The ten episodes from the life of St Martin unfold along the walls and vaults of the chapel.[64] Simone uses pale and luminous colours and his evident interest in space and volume demonstrates the influence of Giotto, whose work he would have seen in the cycle of the *Infancy of Christ* in the right transept of the Lower Church, which was painted around 1310.[65] Giotto's influence is especially noticeable when the scenes from the life of St Martin are compared with the early parts of Simone's *Maestà* in Siena which owe little or nothing to Giotto.

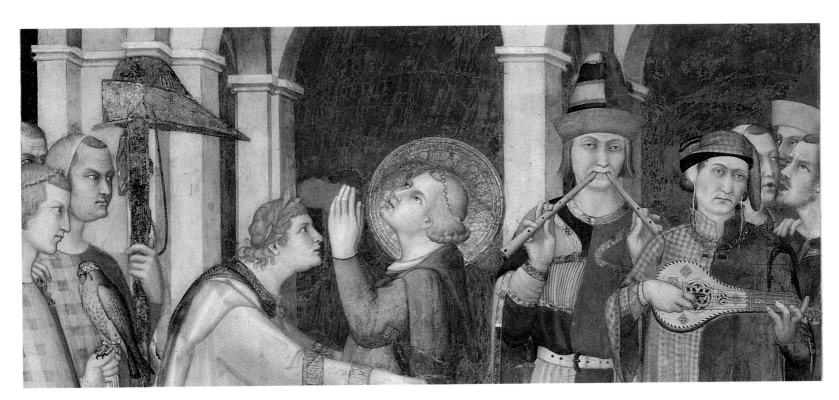

p. 62
Simone Martini,
Dream of St Martin. St Martin Chapel,
Lower Church of San Francesco, Assisi.

Simone Martini,
Knighting of St Martin, detail.
St Martin Chapel, Lower
Church of San Francesco, Assisi.

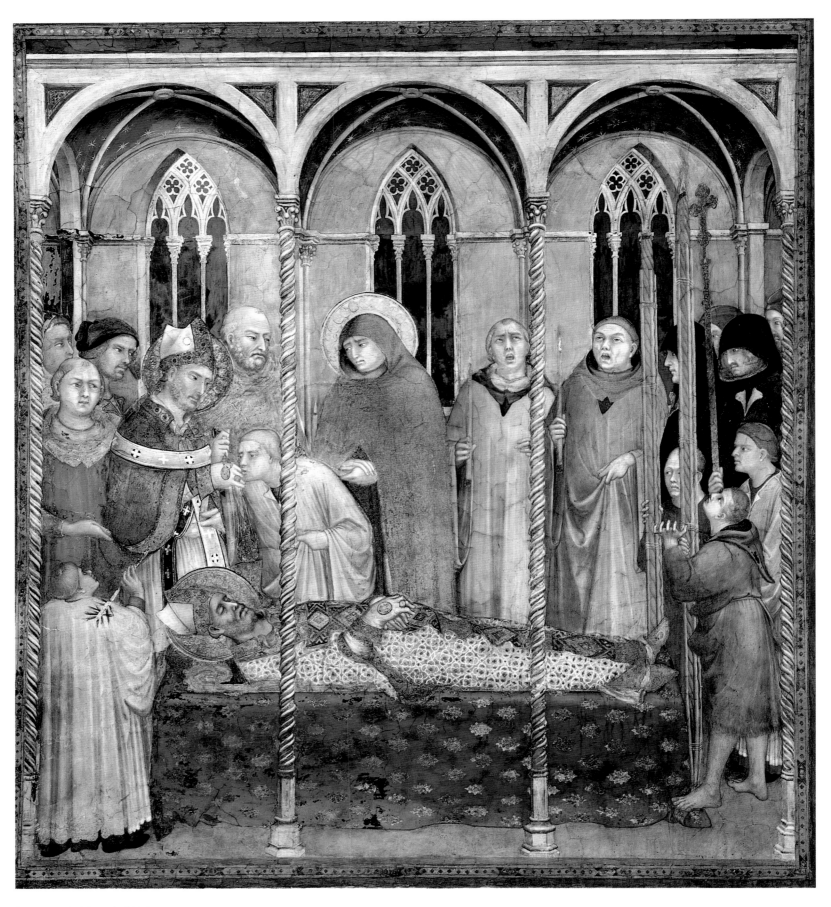

Simone Martini, *Funeral of St Martin*.
St Martin Chapel, Lower Church of
San Francesco, Assisi.

Simone added Giottesque qualities to the elegance of the Gothic style which is evident in the sinuous line used to define the figures and draperies. He was also talented at representing character and his frescoes contain a wide variety of social and physiognomical types. These include the gaudily dressed flute and lute players in the *Knighting of St Martin* as well as the two men, one older one younger, who attentively follow the rite from the extreme left of the same scene. In the *Renunciation of Arms* Simone depicts a blond lansquenet with a sparse beard painted with quick and free strokes, while in the *Raising of the Child* he portrays a man with long sideburns and dazzling blue clothes, captured with an expression of incredulity. The hooded youths who assist on the right of the *Funeral of St Martin* as well as the realistic portrait of Cardinal Gentile da Montefiore in the votive fresco demonstrate Simone's descriptive ability. This type of fresco featuring the donor had not been used for centuries because it extolled the individual and went against the fundamental disinterest in the self that was a mark of the Middle Ages. The votive portrait, like the other frescoes in the cycle, illustrates Simone's psychological insight, which can also be seen in the *Dream of St Ambrose* where Simone portrays the saint as though he has fallen asleep. His careful observation of reality is evident in the painting of Ambrose's head slumped on to the back of his gloved hand.[66]

Simone paid similar attention to the paired saints on the soffit of the entrance arch to the chapel. These saints are placed inside fictive biforate windows with trefoil arches set one on top of the other. The bodies of the saints appear solid beneath their abundant drapery which is marked by a detailed formal elegance. The diverse positions and slow gestures of the saints seem to allude to a private conversation between members of a royal court. The presence of St Louis of Toulouse suggests that the saints in the entrance soffit were painted at the end of the project since St Louis was canonized on 17 April 1317.

The extraordinary series of paired saints is one of Simone's greatest achievements. The eight saints were originally identified by inscriptions. From the bottom left they are: *St Clare* with *St Elizabeth of Hungary*, *St Louis of France* with *St Louis of Toulouse*, *St Anthony of Padua* with *St Francis* and *St Mary Magdalen* with *St Catherine of Alexandria*. These

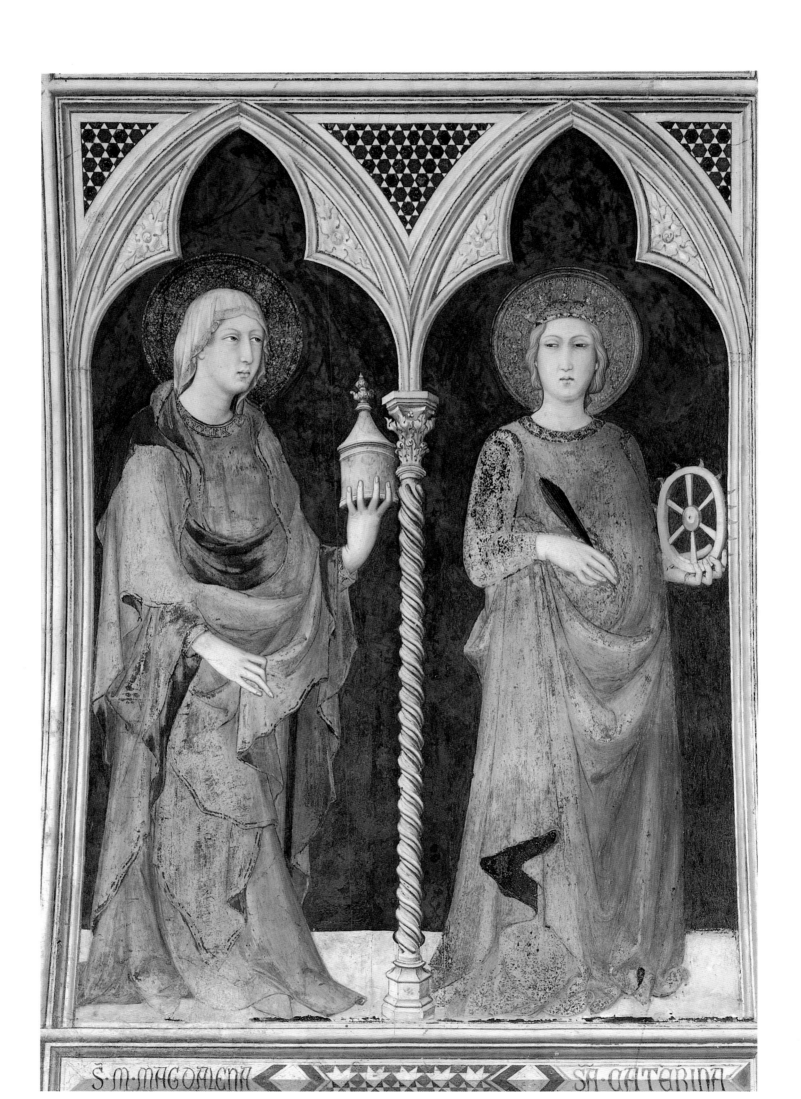

S·M·MAGDALENA SA·CATARINA

last two must have attracted the attention of the Sienese sculptor Tino di Camaino as their forms are reflected in the delicately bending bodies and in the easy fall of the drapery folds in the funerary monument of Cardinal Riccardo Petroni in Siena Cathedral, sculpted between 1317 and 1318.[67] In Assisi, Tino di Camaino would also have seen Pietro Lorenzetti's *Crucifixion* in the left transept of the Lower Church, from which he took a detail for his bas-relief of the same subject in the abbey of Cava dei Tirreni.[68]

Three saints from the same royal family are represented in the St Martin Chapel. They are *St Louis of France*, *St Louis of Toulouse* and *St Elizabeth of Hungary*, all of whom were related to Robert of Anjou, who became king of Naples in 1309. This has led to the suggestion that it was Robert who supplied the funding for the decoration of this part of the St Martin Chapel.

THE *ST LOUIS OF TOULOUSE ALTARPIECE*

The *St Louis of Toulouse Altarpiece* represents the apex of Simone Martini's art in terms of its sophisticated elegance and evocation of a courtly atmosphere. The main panel of the gabled altarpiece shows St Louis crowning his younger brother Robert of Anjou. In the predella are five episodes from the life of the saint.[69] The scenes display an innovative use of perspective and, in this respect, they recall the scenes in the St Martin Chapel in Assisi and reflect the influence of Giotto.

It is probable that the panel was commissioned shortly after St Louis was canonized by John XXII in April 1317. After the death of his elder brother Charles Martel, Louis of Anjou was the legitimate heir to the Neapolitan throne. However, in January 1296 he had renounced his claim and in June had entered the Franciscan Order. This led to Robert's ascent to the throne but there were numerous challenges to his succession, among them that of Charles Robert, the son of Charles Martel. With the help of Pope Clement V who sent Cardinal Gentile da Montefiore to Hungary as papal legate with the aim of placing Charles Robert on the Hungarian throne, Robert of Anjou succeeded in diverting Charles Robert's attention elsewhere. Cardinal Gentile accomplished a political mission which had seemed all but impossible at the outset and returned to Italy only after

p. 66
Simone Martini,
SS. Mary Magdalen and Catherine of Alexandria. St Martin Chapel, Lower Church of San Francesco, Assisi.

Charles Robert had been crowned king of Hungary on 27 August 1310.[70]

Both the style of the panel, which is close to that of the St Martin Chapel, and the political and religious events to which the iconography of the altarpiece relates date the work to *c.* 1317. However, a document dating from that year that was believed to prove Simone Martini's presence in Naples cannot, in fact, have referred to the painter. The document mentions the payment of fifty ounces of gold on the orders of Robert of Anjou. This payment was believed to include money for the altarpiece and yet the Simone Martini in the document is described as a '*miles*' (knight) and not as a painter.[71]

The panel, signed by Simone in the predella, was originally destined for an altar in the Neapolitan church of Santa Chiara.[72] The church was particularly dear to Robert of Anjou, who had founded it in 1310 with his second wife, Sancia of Majorca. Santa Chiara, with its attached convent of Poor Clares, soon became a sort of St Denis for the Neapolitan Angevins. Robert had the remains of his closest relations buried there, including his only son, Charles of Calabria,

who predeceased his father. Tino di Camaino, the most gifted Sienese sculptor of the fourteenth century, executed Charles of Calabria's magnificent sepulchral monument between 1322 and 1333. Robert himself planned in advance that Santa Chiara would be the site of his own burial, which took place in 1343.

The *St Louis of Toulouse Altarpiece* is unusual in its choice of subject. St Louis is shown almost absent-mindedly placing the crown on the head of his brother Robert. This is an act of political propaganda, clearly requested by the patron to legitimate his appropriation of the Neapolitan throne.

Simone Martini's elegant Gothic lines emphasize the translucent enamels and pieces of precious engraved glass that have been applied to the panel. The saint leans almost imperceptibly to the left, causing his body to twist slightly, accentuating the gesture of his hand which places the crown on his brother's head. This, together with the refined asymmetry of the hovering angels, provides a sense of slow movement which animates the painting in a surprising way.

The frame is original and covered with the lilies of France, even on the rear face. Simone's inventiveness can be

p. 69
Simone Martini,
St Louis of Toulouse Altarpiece.
Museo di Capodimonte, Naples.

seen throughout the painting. He translated the difficult requests of the royal commissioner into visual form and also succeeded in underlining, with extreme sensitivity, the political intent of the gabled panel.

THE *SANT'AGOSTINO POLYPTYCH* IN SAN GIMIGNANO

Of the numerous polyptychs executed by Simone Martini in the years after the *St Louis of Toulouse Altarpiece*, that for the friars of Sant'Agostino in San Gimignano appears to be the first. The polyptych, which was dismembered sometime after 1785, originally consisted of seven panels. This can be deduced from the unusual position of the angels inside a triangular space above the figures in the main register. (The arrangement is similar to the slightly later polyptychs from Pisa and Orvieto.)[73] Only five of the seven panels survive. he central panel depicted the *Virgin and Child* (Wallraf Richartz Museum, Cologne), while to either side stood *St Geminianus*, the *Archangel Michael*, *St Augustine* (Fitzwilliam Museum, Cambridge) and *St Catherine* (private collection, Florence).

The placing of the figures, in particular SS. Geminianus and Augustine, and the solidity of the bodies, clearly influenced by Giotto (already noted in the *Life of St Martin* and in the predella of the *St Louis of Toulouse Altarpiece*), persist. This style was toned down in later paintings where Simone preferred to employ a sinuous and linear Gothic style.

The polyptych was probably painted before the *St Louis of Toulouse Altarpiece*. In my opinion 1317 is the latest possible date because of the thirteenth-century structure of the polyptych, which does not include pinnacles of the type used in the slightly later Pisa and Orvieto polyptychs. There are also clear reflections of this work in Lippo Memmi's *Maestà* from the Palazzo Civico in San Gimignano, which was painted in 1317.[74]

In the *Sant'Agostino Polyptych* Simone Martini experimented with new decorative effects, such as the contrast between gold and silver, to make his work more sumptuous. He was probably inspired by the works of contemporary goldsmiths. He achieved these effects by alternating silver and gilded-silver, in both the inscriptions and the spandrels of the pointed arches. The precious materials complement the

brilliant azure and luminous white used in other parts of the work. The original effect must have been breathtaking.

<div align="center">

THE SANTA CATERINA POLYPTYCH IN PISA

</div>

The seventeenth-century *Annals* of the Dominican convent of Santa Caterina in Pisa[75] recount that Tommaso da Prato, prior from 1320 to 1324, commissioned the *Santa Caterina Polyptych* for the main altar and that it was in place by 1320.[76]

Among the numerous polyptychs by Simone Martini, that in Pisa is the only one that has been preserved in an almost complete state. However, both the frame and the architectonic decoration have suffered considerable damage because of the dismemberment of the altarpiece. Of the small twisted columns originally placed to either side of the panels in the main register only that between *St John the Evangelist* and the *Virgin* is original and the order of the panels remains controversial. A fire in the church of Santa Caterina in 1651 damaged the picture surface. The central *Virgin and Child* has been darkened and the entire polyptych has lost some of its brilliance. The altarpiece is signed only by Simone, but taking

into consideration the size of the work – it contains over forty half figures – it is probable that he had some help. As in the St Martin Chapel, however, it is not possible to make any distinction between the various hands since Simone's watchful guidance ensured the stylistic unity of the work.

The form of the polyptych can be compared with Duccio's *Polyptych Number 47*, which originally came from the Ospedale di Santa Maria della Scala in Siena (Pinacoteca, Siena). In both the compositional arrangement and the sequence of saints and prophets in the panels of the main and upper registers, Simone has freely followed Duccio's *Maestà*.

Simone faced a number of difficult compositional problems in this work. He had, for example, to avoid repetition with such a large number of figures. It was probably for this reason that he continually varied the type and colour of the draperies, the gestures of the saints and prophets, and the figures' relationship to the space they occupy. Simone also altered the position of the torsos and hands of the saints and their dimensions. Compared to the saints depicted in the *Sant'Agostino Polyptych* (Fitzwilliam Museum, Cambridge), each figure inhabits more space and the heads are smaller in

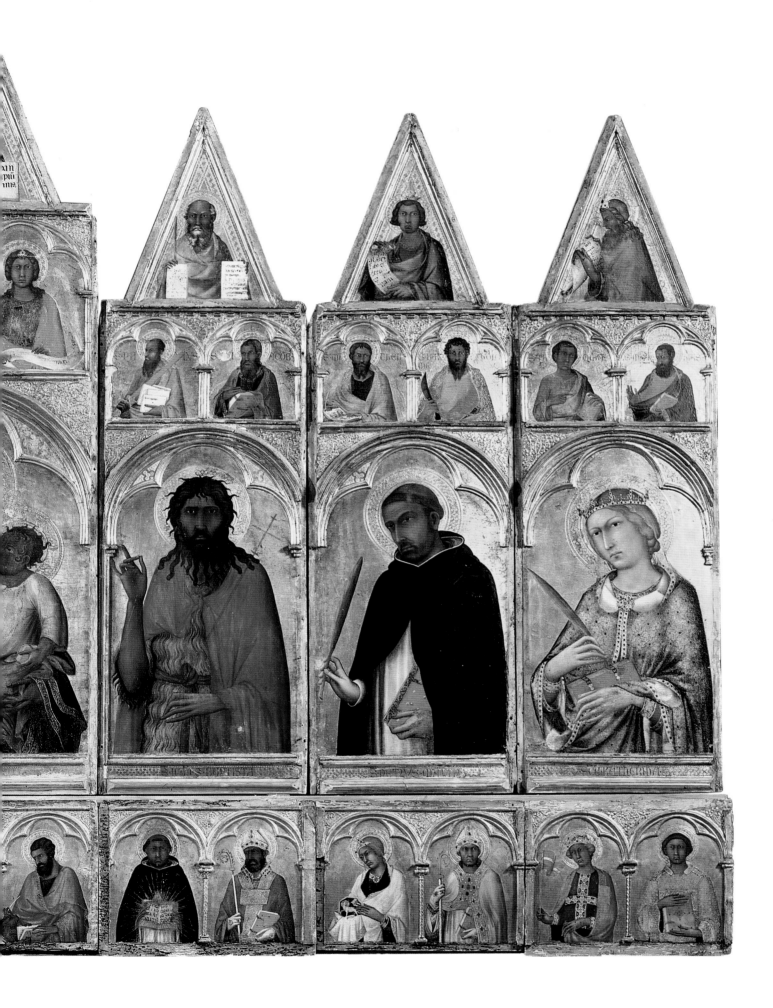

relation to the bodies which are more slender, accentuating their Gothic influences.

In the *Santa Caterina Polyptych*, twenty-nine of the figures are holding books or scrolls which they write in, consult, or show to the viewer. St Mark, who is represented immediately to the right of the central figure of Christ at the bottom of the altarpiece, is particularly memorable. Simone has delighted in representing the lion grasping the gospel with his paw and being called to order by a gentle tap on the ear from the evangelist's pen. The *Santa Caterina Polyptych* must have been one of the most splendid fourteenth-century altarpieces owing to the variety and liveliness of its colours. Scarlet, ultramarine and light green predominate in the panels. The worshipper approaching the altar would have been presented with a rich text that could be admired both for the inventiveness of the figures and for the numerous inscriptions on the gold ground and on the frames. The complexity and the variety of the work and, in particular, the intensely beautiful and melancholy figures also found in the Orvieto polyptychs were taken as a model by Lippo Memmi.

THE ORVIETO POLYPTYCHS

At the beginning of the 1320s Simone Martini went to Orvieto. During his stay there he completed three polyptychs, all of slightly smaller dimensions than those of the *Santa Caterina Polyptych*. Only fragments of these polyptychs have survived but each contained a central Virgin and Child. From the iconography and from the direction the figures face it is possible to deduce that, in each case, there were three saints to either side of the central panel.

The polyptych painted for the church of San Domenico (Museo dell'Opera del Duomo, Orvieto) is the only one of the three with a signature and a date, but both of these are now fragmentary. The date reads MCCCXX… and the remaining space in the inscription could have been filled by either one or two Roman numerals – I, II or IV. This means that that the work could have been completed in either 1321, 1322 or 1324. It has been suggested that Lippo Memmi worked with Simone Martini on the central panel.

The *San Domenico Polyptych* is mentioned in one of the convent's chronicles. The commissioner was Trasmondo

Monaldeschi, bishop of Soana between 1312 and 1330, who paid one hundred florins for the work.[77] He was particularly devoted to Mary Magdalen, at whose feet he is represented in the polyptych. The *San Domenico Polyptych* contains figures that are more monumental than those in the *Santa Caterina Polyptych* and the decoration of the haloes and the inscriptions is more sophisticated. The vertical accentuation of the ogival arches and the greater space reserved for the figures, which are slimmer than those in the polyptych in Pisa, lead me to believe that the inscription containing the date once read MCCCXXIV.

Only five panels from the *San Domenico Polyptych* survive[78] but it must originally have contained seven, as the figure of *St Paul* would have been paired with a missing *St Peter* and the panel of *St John the Baptist* with a missing *St John the Evangelist*.[79] From left to right the correct sequence of saints would therefore have been *St Paul*, *St Lucy* and *St John the Evangelist* on the left of the *Virgin and Child*, and *St John the Baptist*, *St Catherine of Alexandria* and *St Peter* on the right. In fact, by arranging the panels in this order, even the pinnacles assume a more coherent arrangement, flanking the *Apocalyptic Christ* above the central panel. The poor state of conservation of the figures in the main panels has led some art historians to doubt Simone's authorship, but the *Virgin and Child*'s strong compositional and stylistic links with the *Santa Caterina Polyptych* confirm that the work is by Simone. His hand can be identified in the fine drawing of the Virgin's white veil, in the tender and affectionate gesture of the Christ Child and in the intertwining of the Virgin's hands with Christ's feet. Simone creatively introduced innovations in the pinnacles, where he represented a condensed *Universal Judgment*. In the panels to either side of the *Apocalyptic Christ* are angels; those nearer the centre carry the symbols of the Passion while the two at either end blow on long trumpets. The fluidity of the Gothic line which emphasizes the unfolding of the draperies, the drawing of the hands with their long, thin fingers, as well as Simone's compositional invention makes this work one of his greatest paintings.

The second of Simone's Orvieto polyptychs was painted for the church of San Francesco. The central panel of the *Virgin and Child* is surmounted by a three-pointed pinnacle with the *Blessing Christ*, flanked on one side by a cherub with

a candle and on the other by a seraph with an open book (Museo dell'Opera del Duomo, Orvieto). There are two other half figures of angels in the two medallions to either side of the central pinnacle. The attributes of these angels – they hold a globe and a sceptre – identify them as thrones, the rank of angels who surround and sustain God in perpetual adoration. Originally the polyptych may have consisted of seven panels. The surviving fragments indicate that it contained a representation of the hierarchy of the angels, known in the Middle Ages through the *De prefatione* of William Durandus in his treatise on the *Rationale divinorum officiorum* and through Chapter 140 of Jacobus de Voragine's *Leggenda aurea, De Sancto Michaele archangelo.*[80]

A slender and melancholy saint, perhaps *St Catherine* (National Gallery of Canada, Ottawa), may once have formed one of the left-hand panels of the *San Francesco Polyptych.*[81] Fake pearls and precious stones made of wax decorate the border of her mantle and the neck of her tunic. The polyptych may also have contained four medallions, each housing a prophet, which have recently been identified as being by Simone Martini.[82]

The third altarpiece that Simone painted while in Orvieto was for the church of Santa Maria dei Servi (Isabella Stuart Gardner Museum, Boston). As previously mentioned, Lippo Memmi may have worked with Simone Martini on these three altarpieces, even on the central compartment of the *San Domenico Polyptych* which was signed by Simone himself. Simone's signature here is not, therefore, an indication that it is a completely autograph work. There are no contemporary sources providing precise information on how the *bottega* (workshop) of an artist functioned in the fourteenth century or on the part normally played by a *chompagno* (assistant).[83] Many paintings signed by the head of the workshop could have been partially executed by an assistant whom the master trusted. Workshops in Florence functioned in the same way as those in Siena and so some paintings signed by Giotto were to a large extent executed by his pupils. Giotto's signature only guarantees that the product came from his workshop.[84] In a certain sense it is the equivalent of a modern factory stamp.

The case of the *Madonna del Popolo* from Santa Maria dei Servi in Siena, signed on the frame LIPPUS MEMI...

Lippo Memmi,
Madonna del Popolo, detail.
Santa Maria dei Servi, Siena.

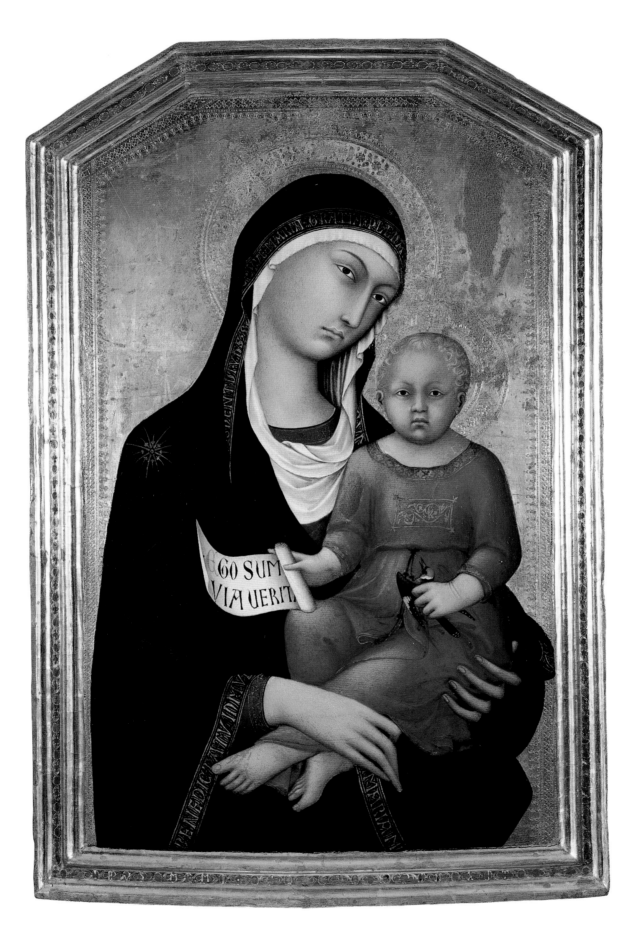

Lippo Memmi,
Madonna del Popolo.
Santa Maria dei Servi, Siena.

Simone Martini,
Blessed Agostino Novello Altarpiece.
Pinacoteca, Siena.

PINXIT, opens up other possibilities for the way workshops may have functioned. The extraordinarily fine quality of the painting cannot be found in any of Lippo Memmi's other works. The painting contains subtle chiaroscuro in the delicate modelling of the Virgin's right hand and her face. There is also an extremely refined harmony of colour in the clothing of the Christ Child. These characteristics point to the intervention of Simone Martini, even though his brother-in-law Lippo signed the painting. It could be that the commissioner ordered the painting from Memmi, who then benefitted from the help of Simone Martini when it was executed in their joint workshop.

The *Madonna del Popolo* is not that distant in style from the *San Francesco Polyptych* and the *San Domenico Polyptych*. There is, however, a greater self-confidence in the definition of the figures and a more mature treatment of the chiaroscuro that imply a slightly later date.

Paintings that are signed by two artists are unusual. The *Annunciation* in the Uffizi, signed by both Simone Martini and Lippo Memmi, is one example to which I shall return. Another example is *Polyptych Number 51* (Pinacoteca, Siena)

which is signed by Niccolò di Ser Sozzo and Luca di Tommè. In both paintings the parts completed by each master are recognizable only by the expert eye of a connoisseur.

THE *BLESSED AGOSTINO NOVELLO* ALTARPIECE

In the *Madonna del Popolo* the artist used short parallel brushstrokes to obtain a delicate chiaroscuro effect in the faces of the Madonna and Child that gives a convincing effect of three-dimensionality. A similar technique is found in the *Blessed Agostino Novello Altarpiece* (Pinacoteca, Siena).[85] The panel contains a central figure of Agostino Novello with four scenes of posthumous miracles arranged to either side.

No documents survive to indicate the date of the panel, but the style of the painting points to between 1324 and 1328 and it is probable that Simone used an assistant in the narrative scenes. The painting was originally placed on Agostino Novello's tomb in the church of Sant'Agostino in Siena. In the form of a sarcophagus supported by brackets, the tomb itself contained four panels with scenes from the life of the Blessed Agostino.[86] The unusual polygonal line of the upper

Simone Martini,
Miracle of the Boy Attacked by a Dog, detail
of the *Blessed Agostino Novello Altarpiece*.
Pinacoteca, Siena.

frame of the painting mirrors the shape of the *arcosolium* above the tomb.

Agostino Novello died in 1309 and Simone Martini had to invent a new iconography for the miracles that were depicted in the panel. In the altarpiece Agostino Novello is represented with a saint's halo rather than with the emanating rays befitting someone who only has the title of blessed. This followed a tendency, apparent since the end of the thirteenth century and exclusively in cities, to promote the canonization of local holy people. In most cases, these religious figures had died only recently and were remembered by the local population for both their religious activity and their healing powers.[87] In the *Blessed Agostino Novello Altarpiece* it is the protagonist's healing powers that are emphasized.

Each of the four lateral scenes shows a healing miracle, three of them relating to incidents which happened to children. In every scene Simone Martini has depicted both the completed miracle and the most dramatic moment of the story. Three of the four scenes take place on Sienese streets, which Simone shows with balconies and roof terraces painted in delicate pink tones. He even depicts the interior of

a respectable two-storey dwelling. The top right scene of a young man falling from his horse is the exception as it takes place in a landscape setting. Agostino Novello swoops in between the mountain peaks with their inaccessible castles to save the young man. The town scenes show a realistic and spacious conception of architecture, similar to that found in the St Martin Chapel and in the predella of the *St Louis of Toulouse Altarpiece*. Such architectural constructions were later depicted by Pietro and Ambrogio Lorenzetti.

A completely different type of painting is the tiny panel of *St Ladislaus* (Museo di Santa Maria della Consolazione, Altomonte).[88] Its iconography is unusual in representing an isolated saint rather than the Madonna and Child or Christ. The work measures 54.5 cm by 21.5 cm and has an inscription which identifies the saint as S. LADISLAUS REX UNGARIE. It probably formed the left-hand panel of a diptych and was painted by Simone Martini in Siena around 1326 for Filippo di Sangineto, whose coat of arms – argent, a fess azure and a label of five points gules – is shown on the reverse of the panel.[89] Filippo di Sangineto was the first count of Altomonte and a dignitary of the Angevin court. He

Simone Martini,
Miracle of the Baby who Fell from his Cot, detail
of the *Blessed Agostino Novello Altarpiece*.
Pinacoteca, Siena.

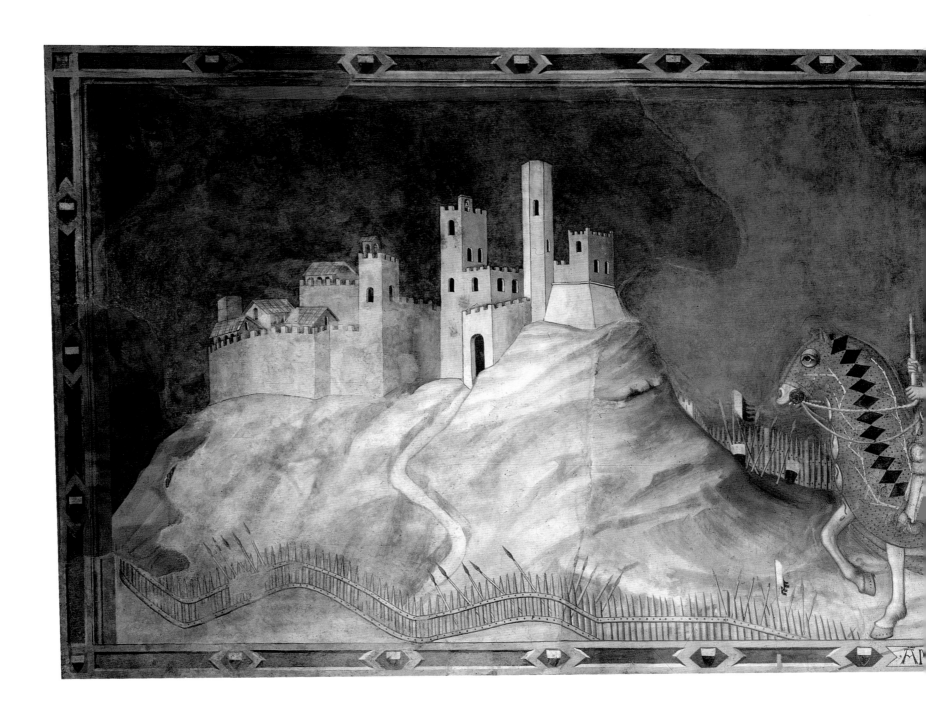

Simone Martini,
Guidoriccio da Fogliano. Sala del
Mappamondo, Palazzo Pubblico, Siena.

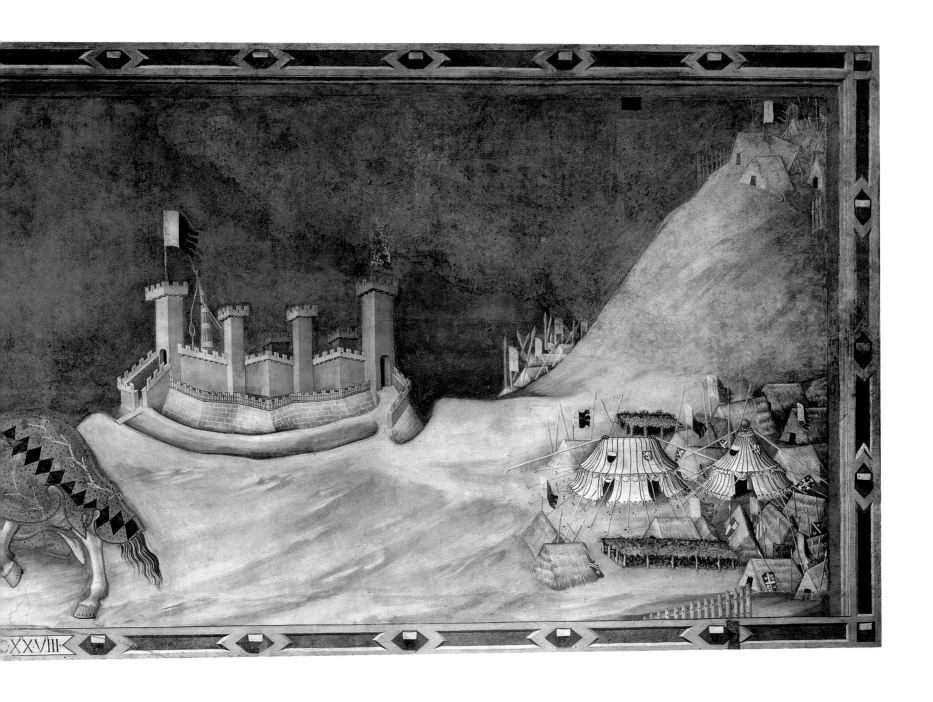

accompanied Charles of Calabria, the son of Robert of Anjou and the heir to the Neapolitan throne, first to Siena in 1326 and then to Florence. After Charles of Calabria's departure from Florence, Filippo remained in Tuscany as his vicar until 1328.

The figure of *St Ladislaus*, austere and imposing even within the small dimensions of the panel, is shown inside an extremely elaborate, punched framework which seems to brush against the voluminous construction of the body. The left side of the king's torso recedes slightly in depth and creates the impression that the figure is turning. The movement of the ermine-lined mantle also helps to define the space around it. The central positioning of the staggered feet emphasizes the distance that, as is the case in the *Blessed Agostino Novello Altarpiece*, separates the figure from the gold background.

Simone shows himself, here as elsewhere, eager to satisfy his commissioners by tailoring the iconography of his design to suit the requests of his patron. This was the case in the *St Louis of Toulouse Altarpiece* where Simone succeeded in interpreting and in rendering visually the political significance of the saint crowning his younger brother king. Later, he employed completely unprecedented and innovative means to represent the *Virgilian Allegory*, painted for Petrarch. Simone's talent was such that, by imbuing the gestures and the expressions of the protagonists with emotion in a 1342 panel (Walker Art Gallery, Liverpool), he was able to turn a simple *Holy Family* into an argument between Jesus and his parents.

The figure of *St Ladislaus* is echoed in the *Annunciation* altarpiece for Siena Cathedral painted in 1333, in which Lippo Memmi adopted it for his *St Ansanus*.[90] There are striking similarities between the two saints, in the fall of their mantles, in the arrangement of the folds of their clothes, and in the position of their left hands and the pedestals. I believe that Lippo Memmi referred to a drawing by Simone Martini that had already been used for *St Ladislaus*. The similarities between the two figures suggest that Simone Martini could not have painted the *St Ladislaus* whilst he was in Avignon, between 1336 and his death in 1344.

p. 85
Simone Martini,
Guidoriccio da Fogliano, detail. Sala del
Mappamondo, Palazzo Pubblico, Siena.

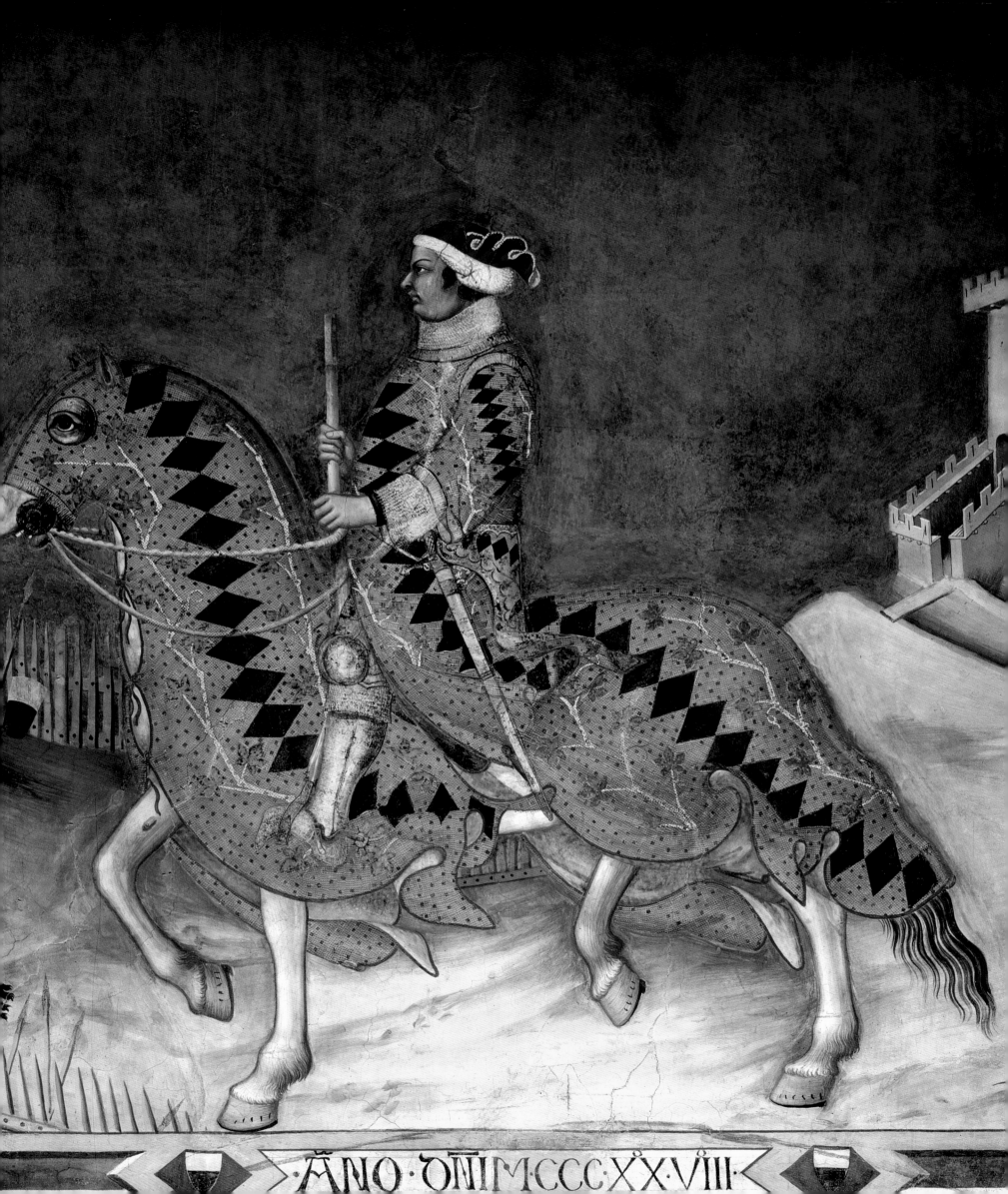

ᛘNO · �ᛘ · MCCC · XX · VIII

GUIDORICCIO DA FOGLIANO

Simone Martini's *Guidoriccio da Fogliano* was painted on the wall opposite the *Maestà* in the Sala del Mappamondo of the Palazzo Pubblico. Documents of 1330 record payment for the fresco.[91]

The work is unique in its representation of a single knight in such large dimensions. Guidoriccio's clothes match the caparison of his horse, which trots along the edge of a barren landscape. To the left of the landscape is a walled city beside a many-towered castle, perhaps Montemassi. At the centre of the fresco, another castle flies the black-and-white Sienese flag and there is also a camp pitched on the extreme right.

The unusual subject matter and the fact that the fresco appears to glorify one person rather than the Comune of Siena has led to the proposal that Simone may not have executed the work as was previously believed. It has been suggested that the fresco was painted at the end of the fourteenth or the beginning of the fifteenth century and some claim it to be an imitation from the eighteenth century.[92] That the fresco is mentioned in sources from the sixteenth century onwards rules out the eighteenth-century-imitation hypothesis. Furthermore, the plaster on which the work was painted is covered at the bottom edges by Sodoma's frescoes of *St Ansanus* at the left and *St Victor* at the right.[93]

I believe the painting to be the work of Simone Martini because of the quality of its execution and certain technical aspects. Punches and metal foil have been used in a manner similar to that in which Simone employed them in his *Maestà*. There are also technical similarities to the frescoes in the St Martin Chapel in Assisi.[94]

THE ANNUNCIATION OF 1333

The *Annunciation* (Uffizi, Florence) was painted in 1333 in collaboration with Lippo Memmi for the altar of St Ansanus in Siena Cathedral. A fragment of the original inscription has been inserted into the nineteenth-century frame and reads as follows: SYMON MARTINI ET LIPPUS MEMMI DE SENIS ME PINCXERUNT ANNO DOMINI MCCC-XXXIII. It is probable that the lateral panels of *St Ansanus* and *St Margaret* (?) were painted by Lippo Memmi and that the *Annunciation* was painted by Simone Martini.[95]

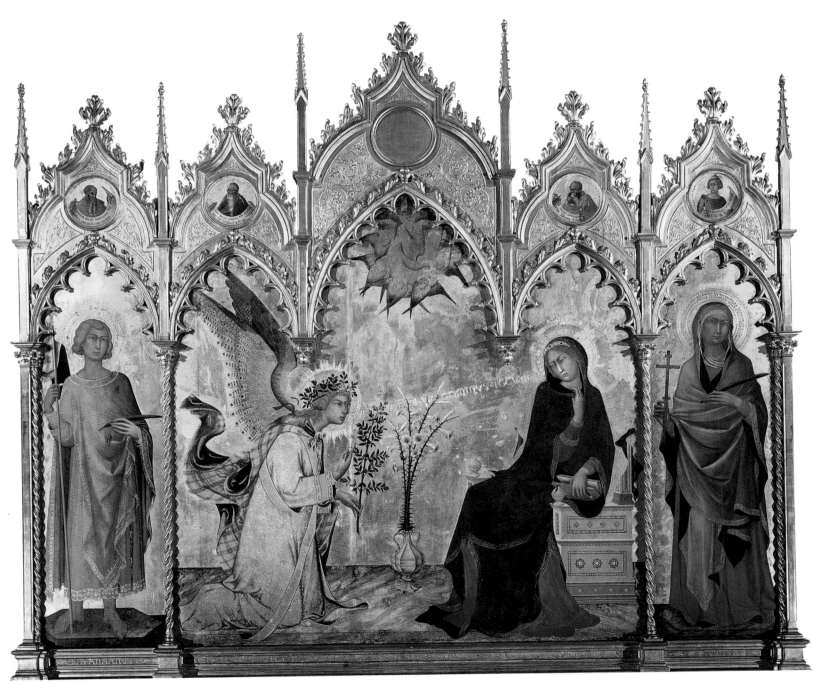

Simone Martini and Lippo Memmi,
Annunciation. Uffizi, Florence.

pp. 88–89
Simone Martini, *Annunciation*,
detail. Uffizi, Florence.

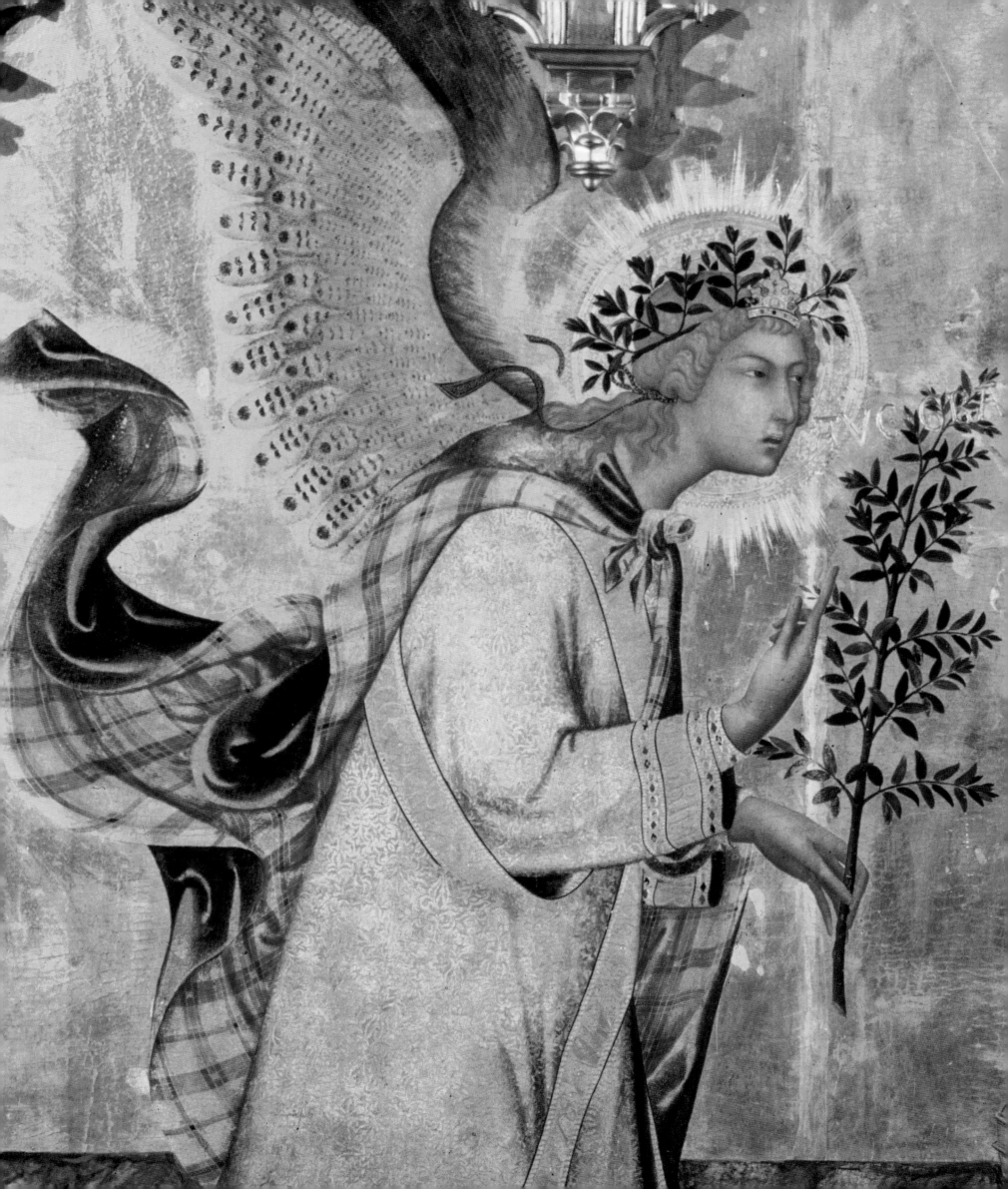

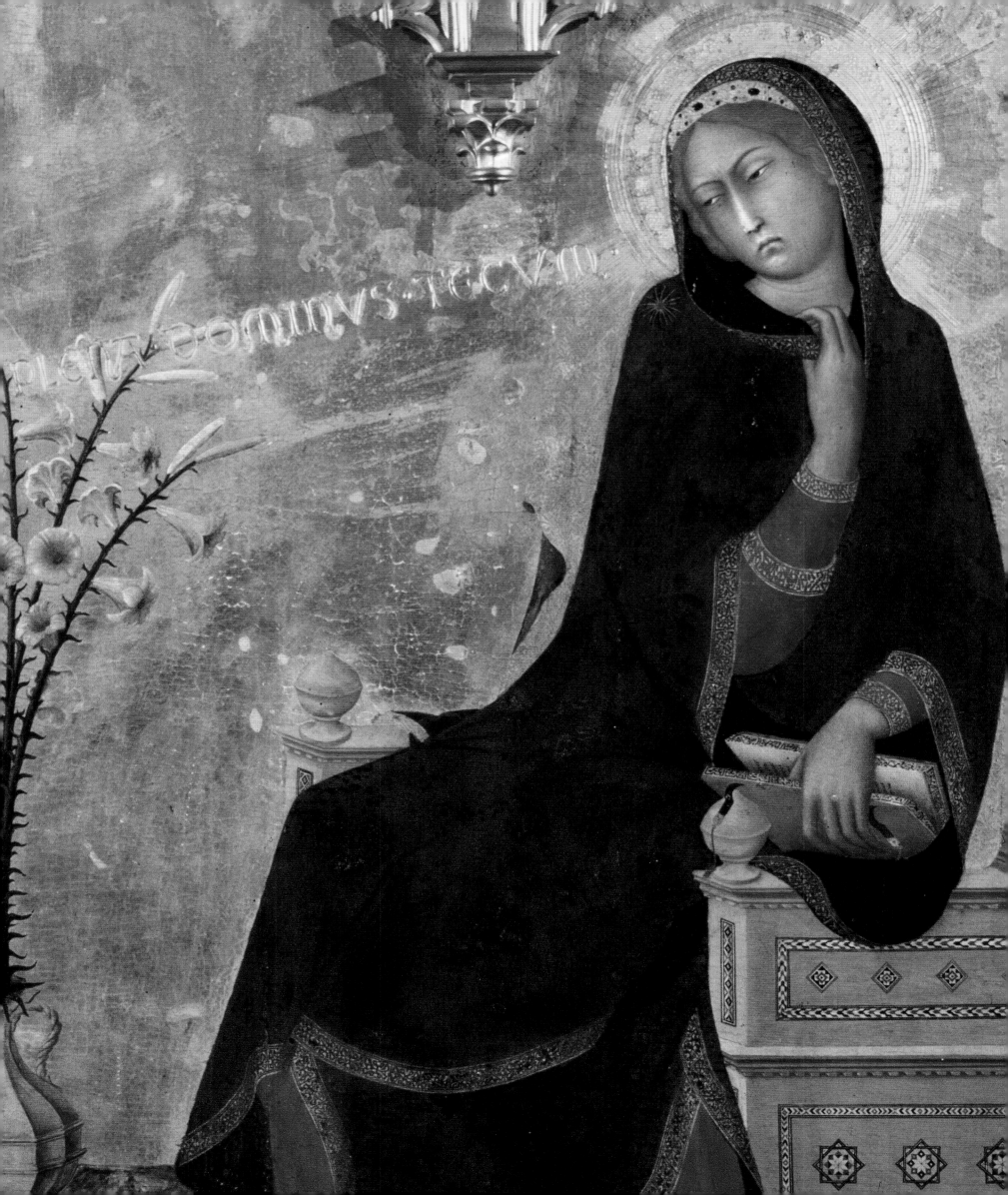

To the left of the central panel, the angel Gabriel has only just alighted and his cloak still swirls behind him. He turns to the Virgin with his mouth half open and his greeting is spelt out in gold relief against the gold ground: AVE MARIA GRATIA PLENA DOMINUS TECUM (Hail Mary, full of grace, the Lord is with thee). Gabriel's message continues on the ornate borders of his garment. Mary's response is to draw back in shock, twisting her body away from Gabriel and protecting herself with her cloak.

The *Annunciation* represents a transitional phase in Simone's work that leads up to his final period in Avignon. The influence of Gothic art is still evident in the abstract and nervous line that defines and yet flattens the Virgin's body. However, Simone emphasizes the three-dimensionality of Gabriel and gives a very naturalistic rendering of the faceted vase containing lilies painted with precious lakes.

Although Simone Martini was not the official painter of the Comune of Siena, he held this position *de facto* for a period of eighteen years (1315–1333), during which he continually received commissions of varying importance and for a range of purposes from the Comune. The extant documents

testify that, apart from the works previously discussed, Simone also painted a *Crucifixion*, perhaps in fresco, in the Chapel of the Nine; two unidentified paintings in the house of the Nine and the Sala dei Pilastri; as well as a *St Christopher* and the coat of arms of the *podestà* Mulazzo de' Mulazzi da Macerata in the Sala della Biccherna. Other documents indicate that Simone undertook more modest commissions, such as two standards painted in 1327 with the Angevin coat of arms for the City of Siena to be presented to the heir to the Neapolitan throne, Charles of Calabria, on the occasion of his visit to Tuscany.[96]

It has proved difficult to trace any works painted by Simone Martini before the *Maestà* in the Palazzo Pubblico. However, a *Virgin in Glory with Music-making Angels* from the oratory attached to the church of San Lorenzo in Ponte in San Gimignano shows many of Simone Martini's stylistic characteristics and was probably painted between 1311 and 1314. The style of the fresco also suggests Simone Martini's early association with Memmo di Filippuccio, the 'civic' painter of San Gimignano and his future father-in-law, although it cannot be proved that Simone Martini came from

Simone Martini,
Virgin and Child. No. 583,
Pinacoteca, Siena.

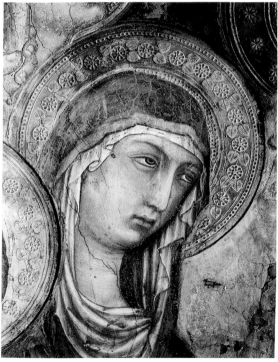

Simone Martini,
St Mary Magdalen, detail of the *Maestà*.
Sala del Mappamondo,
Palazzo Pubblico, Siena.

p. 91
Simone Martini (?) and Memmo di
Filippuccio (?), *Madonna della Misericordia*.
Pinacoteca, Siena.

San Gimignano. The work has been very badly damaged; of the original, only the Virgin's face has been preserved. The rest of the composition was completely repainted in 1413 by a Florentine painter, Cenno di Francesco di Ser Cenni.[97]

Another early work by Simone Martini is a panel of the *Virgin and Child* (no. 583, Pinacoteca, Siena).[98] The head of the Virgin is very similar to that of *St Mary Magdalen* in the Palazzo Pubblico *Maestà* in its confident rendering of form and in its treatment of the pictorial surface. A *Madonna della Misericordia* (Pinacoteca, Siena) has also been attributed to Simone Martini. The panel was previously attributed to Niccolò di Segna but Simone's hand can be discerned in the figure of the Virgin, while the group of worshippers may testify to Memmo di Filippuccio's collaboration.

Simone Martini in Avignon (1336–1344)

In 1336, at the height of his career, Simone left Siena to move to Avignon where he remained for the rest of his life. We do not know why he transferred to the City of the Popes but it seems reasonable to assume that it was at the request of an eminent cardinal at the papal court.[99]

The exact date of Simone's departure is uncertain but we know that he was already in Avignon in November 1336 since Petrarch refers to him in some sonnets that have been dated before then.[100] Petrarch formed a close friendship with Simone Martini, which is reflected in his letters to his friends and in his sonnets such as 'Per mirar Policleto a prova fiso'

('No matter how hard Polyclitus looked') and 'Quando giunse a Simon l'alto concetto' ('When Simone received the high idea'), which praises Simone for his famous portrait of Laura which had been executed on paper in Avignon.[101] Petrarch also commissioned Simone to illuminate the frontispiece of his manuscript of the works of Virgil.

It is possible that Simone's move to Avignon was prompted by the success of Pietro and Ambrogio Lorenzetti in Siena. When he moved there in 1336 taking his brother Donato and some other helpers with him, Simone probably left Lippo Memmi in charge of his workshop in Siena.

Simone Martini,
Way to Calvary, detail of a panel from
the *Orsini Polyptych*. Louvre, Paris.

I believe that the small *Orsini Polyptych* was completed shortly before his departure for Avignon. Stylistically the work is difficult to date accurately since it shows the influence of Duccio that was present throughout Simone's career. Dates have been suggested which range from before the Palazzo Pubblico *Maestà* right through to the period in Avignon. That the work was finished before 1336 is supported by the fact that the *Reliquary of the Holy Corporal*, executed by Ugolino di Vieri in 1338, reflects some of the compositional elements of the *Orsini Polyptych*. The frescoes in the Collegiata in San Gimignano, that can be dated before the end of the 1340s and have been attributed to the Memmi family, also contain echoes of the *Orsini Polyptych*.[102]

I therefore believe the most convincing hypothesis to be that Cardinal Napoleone Orsini gave the commission to Simone Martini while he was still resident in Siena. The Orsini arms are visible on the back of the *Way to Calvary* and were probably also originally on the reverse of the *Burial of Christ*. Napoleone Orsini himself is represented kneeling at the foot of the cross in the *Deposition from the Cross*. Simone would then have delivered the finished polyptych to Cardinal

Orsini in Avignon since the cardinal was frequently present at the papal court. He also painted a portrait for Cardinal Orsini which has since been lost but which must have been painted before March 1342 – the date of Napoleone Orsini's death.[103]

At the end of the fourteenth century the cardinal's heirs gave the *Orsini Polyptych* to the charterhouse of Champmol in Dijon and it was later dismembered. The work was composed of four panels containing the *Angel Gabriel*, the *Virgin Annunciate*, the *Crucifixion* and the *Deposition from the Cross* (Musées Royaux des Beaux-Arts, Antwerp), the *Way to Calvary* (Louvre, Paris) and the *Burial of Christ* (Staatliche Museen, Berlin). The gold ground of the *Burial of Christ* was replaced in the nineteenth century by a romantic landscape. The polyptych still has a fragmentary signature on its frame – PINXIT SYMON – half of which is under the *Crucifixion* and half under the *Deposition from the Cross*.

Some of the Passion scenes echo Duccio's compositions on the back of his *Maestà* for Siena Cathedral, which could mean that the *Orsini Polyptych* was painted early in Simone Martini's career. However, the nervous quality of the line and the drama of the scenes are very different from Duccio's style.

Simone Martini, *Burial of Christ*,
detail of a panel from the *Orsini Polyptych*.
Gemäldegalerie, Staatliche Museen, Berlin.

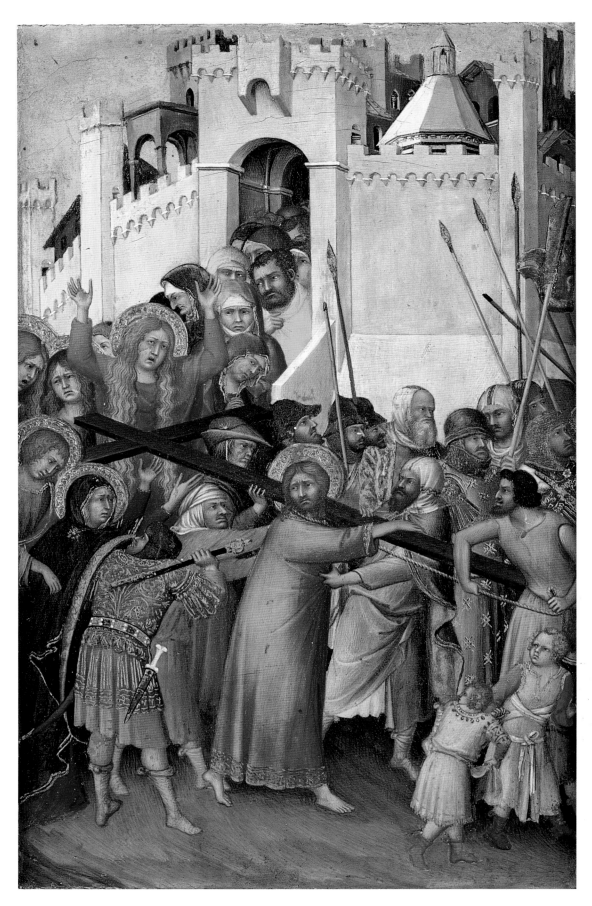

Simone Martini,
Way to Calvary, panel from the
Orsini Polyptych. Louvre, Paris.

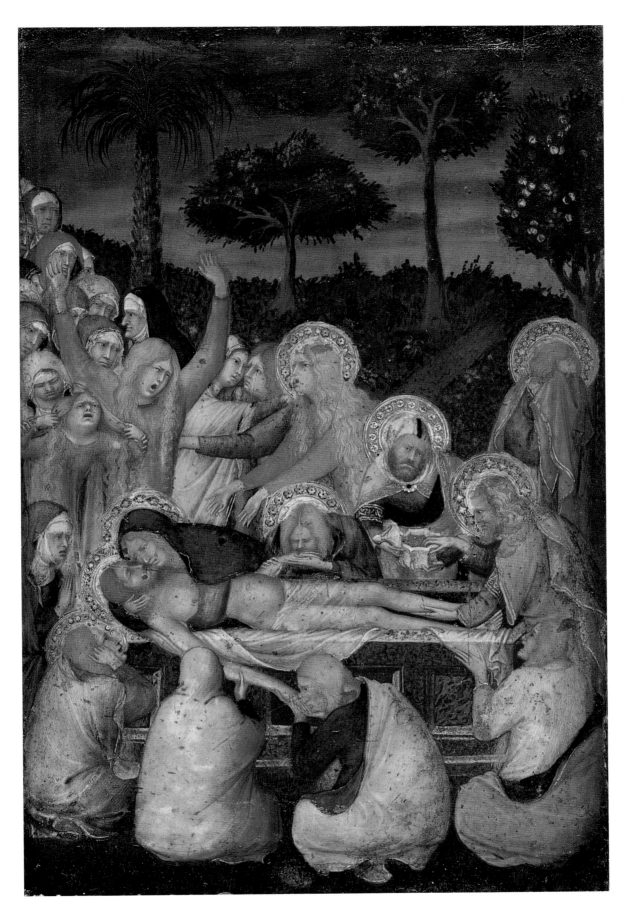

Simone Martini,
Burial of Christ, panel from the *Orsini
Polyptych*. Gemäldegalerie, Staatliche
Museen, Berlin.

The main comparisons that can be made with Duccio's *Maestà* are therefore based on iconography and not style.

Simone uses the crowd in the four Passion scenes to emphasize the drama of the narrative and accentuate the sense of pathos. The two figures of the *Angel Gabriel* and the *Virgin Annunciate* share the subtle disquiet of the 1333 *Annunciation* but do not have the rarified formal abstraction of the earlier work. The figure of the *Virgin Annunciate* faithfully follows the Virgin painted for Siena Cathedral but does not attain her extreme elegance and abstraction although she does express the same fear. Gabriel's wings are made of soft birds' feathers and his appearance is less imposing than in the Uffizi *Annunciation*.

Simone Martini appears to have executed few paintings during his eight-year stay in Avignon but all testify to his creativity and ability to invent new iconographies for his patrons. Among such works, the *Virgilian Allegory* stands out. It is the frontispiece to Petrarch's manuscript of Virgil's works with a commentary by Servius, a rhetorician of the fourth century. In 1326 it was stolen from Petrarch and only recovered twelve years later. It was probably shortly after this that

Simone Martini was commissioned to paint the frontispiece, which portrays Virgil sitting in a flowery meadow against the trunk of a tree with his manuscript open on his lap while he lifts his pen in a moment of inspiration. Servius draws back the translucent curtain revealing Virgil to Aeneas. Virgil's pale cloak, lightly shaded with azure, is silhouetted against the luminous blue background, as is the thin curtain held by Servius.

Simone has used almost monochrome hues that echo the *grisailles* found in contemporary French miniatures.[104] In the lower part of the miniature he painted a peasant pruning a twisted and leafless shrub and a shepherd milking one of his sheep. The shepherd and the peasant allude to the *Georgics* and to the *Bucolics*, just as the presence of Aeneas is a reference to the *Aeneid*. In the centre of the page winged hands hold two scrolls containing two pairs of rhymed hexameters:

> *Ytala praeclaros tellus alis alma poetas*
> *Se tibi Graecorum dedit hic attingere metas*
>
> *Servius altiloqui retegens archana Maronis*
> *Ut pateant ducibus pastoribus atque colonis.*[105]

Simone Martini,
Virgilian Allegory, frontispiece.
Biblioteca Ambrosiana, Milan.

Simone Martini, *Holy Family*.
Walker Art Gallery, Liverpool.

Two other rhymed hexameters at the base of the miniature testify to the high esteem in which Simone was held by Petrarch and confirm that the miniature was painted by him:

Mantua Virgilium qui talia carmina finxit
Sena tulit Symonem digito qui talia pinxit.[106]

The frontispiece shows Simone's amazing capacity to render an allegorical subject through visual means. To do so he abandons a convincing rendering of space and places the figures in a meadow that climbs up the page rather than receding into the distance. Yet the work still shows evidence of Simone's sharp observation of reality, in details such as the milk spraying from the sheep's udder, drops of which splash off the edge of the shepherd's bucket.

Another work painted during Simone's period in Avignon is the small panel of the *Holy Family* (Walker Art Gallery, Liverpool). That this painting was intended as a single panel is confirmed by the frame bearing no signs of attachment to other lateral panels. The work is signed and dated 1342 and is typical of Simone's work in its unusual iconography. It shows Jesus as a young boy, having returned from the dispute with the Pharisees in the temple, being rebuked by the Virgin for having disappeared without telling her where he was going. Both Mary's gestures and her facial expression clearly communicate her fear at the thought of having lost her son. Wrapped in a violet mantle over a light red tunic delicately ornamented with gold, the figure of Joseph echoes this fear. Joseph's head tilts in the opposite direction to the position of his feet to form an S-shape. This stance was popular at the end of the fourteenth and beginning of the fifteenth centuries among artists working in the International Gothic style.

In the *Holy Family* Simone stressed the psychological expressiveness of the figures and the unfolding of the narrative to a greater extent than he had done in his earlier works. This was a logical progression from the interests that he had begun to show in the figure of the Virgin in the 1333 *Annunciation* and that he had later developed in the *Orsini Polyptych*. Simone's psychological insight and emphasis on narrative influenced Matteo Giovannetti in the cycle of frescoes painted between 1343 and 1346 in the Papal Palace in Avignon.

It seems that Simone was the first to paint the Virgin of Humility. This subject became exceptionally successful not only in Italy but also throughout Europe. Simone frescoed his *Virgin of Humility* in the external lunette of the west door of the church of Notre-Dame-des-Doms in Avignon. Above it was the *Blessing Saviour*, with a globe in his left hand, adored by six angels. The two frescoes have greatly deteriorated but it has been possible to recover the *sinopie* (underdrawings) which clearly show Simone Martini's compositions (Papal Palace, Avignon). The frescoes were commissioned by Cardinal Jacopo Stefaneschi, who is represented kneeling at the foot of the Virgin.[107]

Simone Martini's Workshop: the Master of Palazzo Venezia, the Master of the Straus Madonna and Naddo Ceccarelli

The Master of Palazzo Venezia, the Master of the Straus Madonna and Naddo Ceccarelli were all trained under Simone Martini and were influenced by different elements of his style depending on when they entered his workshop. Their work also shows traces of Lippo Memmi, which has led to some confusion in identification.[108]

The Master of Palazzo Venezia shows Simone Martini's influence in his subtle elegance and rich decoration, which are found in Simone's 1333 *Annunciation*, while his delicate use of colour seems to have been taken from Lippo Memmi. His work is characterized by an elongation of forms; by the almost complete abolition of volume to the extent that his two-dimensional figures are silhouetted against a gold background which has been richly worked on with punches in elegant and sinuous outlines; by the slightly harsh lines of the facial features; and by his extremely delicate colours. He seems to have trained in the 1320s, but was particularly influenced by

Simone's works that were executed from 1333 onwards.[109] He takes his name from a painting of the *Virgin and Child* that used to be displayed in Palazzo Venezia in Rome (now in the Galleria Nazionale di Palazzo Barberini, Rome). This painting originally formed the centre of a polyptych of which only two of the lateral panels have survived – those showing *St Peter* and *Mary Magdalen* (National Gallery, London). The Master of Palazzo Venezia has also been attributed with a *Virgin and Child* in Cleveland, Ohio, a *St Agnes* (Worcester Art Museum, Massachusetts), a *St Lucy* and *St Catherine* (Berenson Collection, Villa I Tatti, Settignano), a *Madonna with Four Saints* in Berlin (no. 1071A) and a *Mystic Marriage of St Catherine* (Pinacoteca, Siena).

However, not all of these attributions are uncontested and some of them, for example the *St Agnes*, have been attributed either to another anonymous follower of Simone Martini, the Master of the Straus Madonna, or to Barna da Siena. The

Master of the Straus Madonna takes his name from a *Virgin and Child* (Houston Museum of Fine Arts, Texas) that was once in the Straus Collection in New York.

The Master of Palazzo Venezia's most accomplished work is the *Enthroned Virgin and Child with the Archangels Michael and Gabriel, Four Angels and Two Prophets* (Berenson Collection, Villa I Tatti, Settignano).[110] The panel shows the artist's delight in rich effects, particularly in the depiction of cloth. The Virgin's tunic appears to be made of silk embroidered with gold, an effect which flattens her form. The Master of Palazzo Venezia has covered the gold ground with a cloth of honour held up by two angels and also attached to the bottom part of the frame of the central pinnacle. This gives an ambiguous sense of space to the gold ground of the pinnacles, which almost seem to form small apses.

The *Annunciation and Six Saints* in Berlin has been attributed to the Master of the Straus Madonna. It forms one half of a diptych with the *Crucifixion* and the *Lamentation over the Dead Christ* in Oxford. The Master of the Straus Madonna's most successful painting, however, is the *Mystic Marriage of St Catherine of Alexandria* (Museum of Fine Arts, Boston),

because of the innovation in its composition, the elegance of its line and the subtlety of the modelling and of the ornamentation. Among the works ascribed to the Master of the Straus Madonna is the *Mystic Marriage of St Catherine of Alexandria* (no. 108, Pinacoteca, Siena). The same group of paintings has also been attributed to Donato Martini, Simone's brother.[111] Documents from 1318 until his death in 1347 testify to Donato's activity as an artist but no secure work has survived.

Naddo Ceccarelli seems to have followed Simone Martini to the south of France. He is not documented but we know of a lost painting that he signed and that was once in Avignon. Naddo Ceccarelli's signature on a diptych, consisting of a *Virgin and Child* dated 1347 and an *Ecce Homo* (Liechtensteinische Staatliche Museen, Vaduz), testifies to his existence. These works are characterized by a slightly frozen elegance, defining a style which has been used to attribute other works to him. These include a small reliquary with the *Virgin and Child* (Walters Art Gallery, Baltimore), two panels of the *Virgin and Child* in Budapest and in the Museo Horne in Florence, a diptych (nos. 194 and 196, Pinacoteca, Siena) and a polyptych (no. 115, Pinacoteca, Siena). The most

Master of Palazzo Venezia, *Enthroned Virgin and Child with the Archangels Michael and Gabriel, Four Angels and Two Prophets*. Berenson Collection, Villa I Tatti, Harvard Center for Renaissance Studies, Settignano.

Master of Palazzo Venezia, *Enthroned Virgin and Child with the Archangels Michael and Gabriel, Four Angels and Two Prophets*, detail. Berenson Collection, Villa I Tatti, Harvard Center for Renaissance Studies, Settignano.

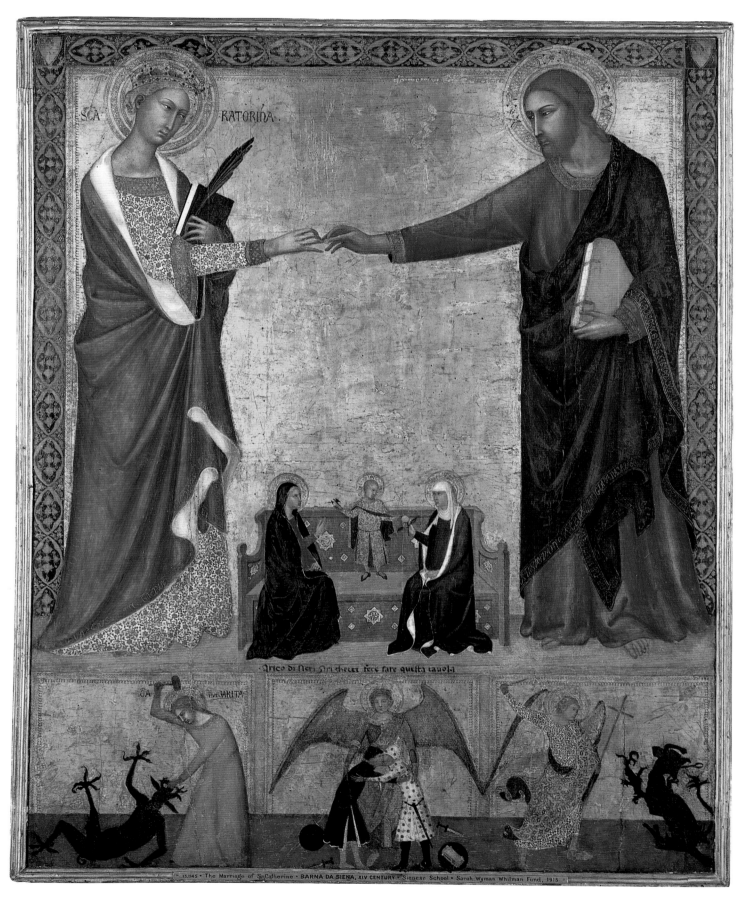

Master of the Straus Madonna (?),
Mystic Marriage of St Catherine of Alexandria.
Museum of Fine Arts, Boston.

notable of these paintings is the *Ecce Homo*, which is inspired by the central predella panel of Simone Martini's 1320 *Santa Caterina Polyptych*. Naddo Ceccarelli uses a very ornate frame decorated with clusters of vegetation in relief and eight small medallions with saints. On the panel itself he applies richly punched and engraved decoration. His *Adoration of the Magi* in Tours, which is surmounted by two pinnacles showing the *Annunciation*, can be dated between 1335 and 1338. It is painted on two wings of a diptych in the same fashion as the *Madonna and Child with Saints* attributed to Ambrogio Lorenzetti (National Museum, La Valletta, Malta).[112] Having

probably returned to Siena after the death of Simone Martini, Naddo Ceccarelli's late works were influenced by Pietro and Ambrogio Lorenzetti. The *Polyptych Number 115* (Pinacoteca, Siena) displays monumental aspects which demonstrate a knowledge of Pietro Lorenzetti's works,[113] and the *Madonna of St Martin* resembles Ambrogio's *Madonna del Latte*. The influence of Pietro Lorenzetti can also be seen in Naddo Ceccarelli's *Standing Madonna and Child* (Walters Art Gallery, Baltimore) which formed the central part of a reliquary and is very similar to Pietro's painting in the Berenson Collection in Settignano.[114]

Naddo Ceccarelli, *Ecce Homo*.
Liechtensteinische Staatliche
Museen, Vaduz.

Lippo Memmi, *Maestà*.
Palazzo Civico, San Gimignano.

The Memmi Family and the Problem of Barna da Siena

A thorough study of Simone Martini's workshop and associates must take into account the artistic situation in San Gimignano, where members of the Memmi family worked as well as the painter known as Barna da Siena. The identification of Barna da Siena is closely linked with the frescoes of New Testament scenes in the Collegiata.

I have already briefly mentioned Lippo Memmi, son of Memmo di Filippuccio, the 'civic' painter of San Gimignano. The *Maestà* of 1317 with the *podestà* Nello di Mino dei Tolomei kneeling at the feet of the Virgin in the Palazzo Civico in San Gimignano is his first secure work. It is both signed and dated and reveals such close links with Simone Martini's *Maestà* of 1315 as to suggest that Lippo was one of Simone's assistants when he painted the Palazzo Pubblico *Maestà*. It is likely, however, that Lippo had previously received some training in his father's workshop as, according to the documents, his *Maestà* was completed with the help of Memmo di Filippuccio, who had been responsible for a

number of important commissions in San Gimignano. Yet the style of the San Gimignano *Maestà* leads me to believe that it was completed by Lippo alone. Its artistic significance lies in the introduction of the richly clothed and courtly figures used by Simone Martini. Such figures were unprecedented in the severe and stark language of San Gimignano art. Memmo di Filippuccio's plain and unadorned style derives from the frescoes in Assisi, although he was not unaware of Duccio's Gothic linearity, as can be seen in the *Oristano Dossal*.[115]

The similarity between the broad upper parts of the heads in the *Madonna dei Raccomandati* from Orvieto Cathedral and the heads of the saints and angels in the San Gimignano *Maestà* confirms that they were completed at almost the same time, but the draperies indicate that the *Madonna dei Raccomandati* preceded the *Maestà*.[116] The Madonna is signed LIPUS DE SENA NATUS NOS PINXIT AMENA and it has been suggested that the Lippo of the inscription is not Lippo Memmi. Although this is unlikely, there are certainly

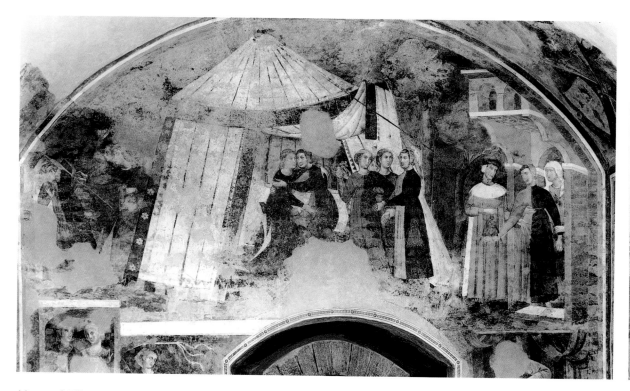

Memmo di Filippuccio,
Tale of the Dissolute Young Man.
Palazzo Civico, San Gimignano.

Lippo Memmi, *Maestà*, detail.
Palazzo Civico, San Gimignano.

some elements of the composition which show that an assistant worked on the painting. The worshippers kneeling under the great dome of the Virgin's mantle, for example, have strongly caricatured faces and, despite being grouped together in daring foreshortening, are delineated with weaker drawing. Lippo's assistant has been identified as Tederico, or Federico, Memmi.[117] He was Lippo's brother and is described as a painter in documents, although it is not possible to attribute with certainty any works to him.

Lippo Memmi never outgrew the influence of Simone Martini. He has been characterized as merely a helper who faithfully followed the directions from the head of the workshop and showed no capacity for autonomous expression. In other words, most of the work that is stylistically closest to Simone Martini, but does not share its qualities, belongs to Lippo Memmi. His secure works, either documented or signed, are very few. Besides those already mentioned are a signed *Madonna and Child* in Altenburg; a *Madonna and Child* (no. 1081 A, Staatliche Museen, Berlin) with an *Angel Gabriel* in the pinnacle, signed and dated 1333; a panel from a diptych showing *St John the Baptist* (Golovin Collection, New York);

the *Annunciation* of 1333 (Uffizi, Florence), on which he worked with Simone Martini; and the signed *Madonna del Popolo* from the church of Santa Maria dei Servi in Siena. The fragmentary fresco of the *Enthroned Madonna and Child with an Angel and St Paul* (Pinacoteca, Siena), previously in the cloister of San Domenico, reflects the style of Barna da Siena, whom I will discuss later, more than that of Simone Martini. According to Chigi (1625) this painting was signed and dated MCCCL.., but the transcription may not be accurate.[118]

Many of Lippo Memmi's works do not vary in style. The similarity to Simone Martini is such that Bellosi writes about 'Lippo Memmi's unconditional adherence to Simone Martini's ideas, allied with a capacity to re-elaborate them with a refinement that is very close to that of his model'.[119]

Among Lippo Memmi's documented works that have not survived is a triptych painted in Siena in 1334 and commissioned by 'Misser Bruno', the rector of the Ospedale di Santa Maria della Scala.[120] Memmi, together with his brother Federico, also executed a painting in 1347 that was intended for the Chapel of St Ursin in the church of St François in Avignon.

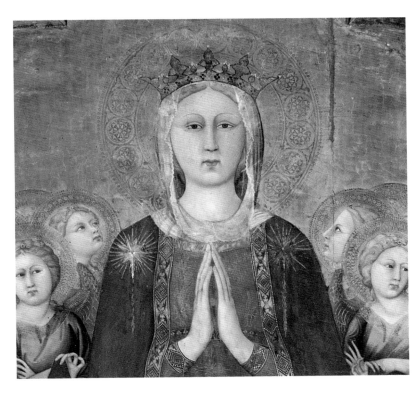

Lippo Memmi,
Madonna dei Raccomandati, detail.
Orvieto Cathedral.

Lippo Memmi, *Madonna
dei Raccomandati*.
Orvieto Cathedral.

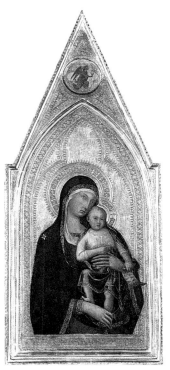

Lippo Memmi, *Madonna
and Child*. No. 1081 A,
Gemäldegalerie, Staatliche
Museen, Berlin.

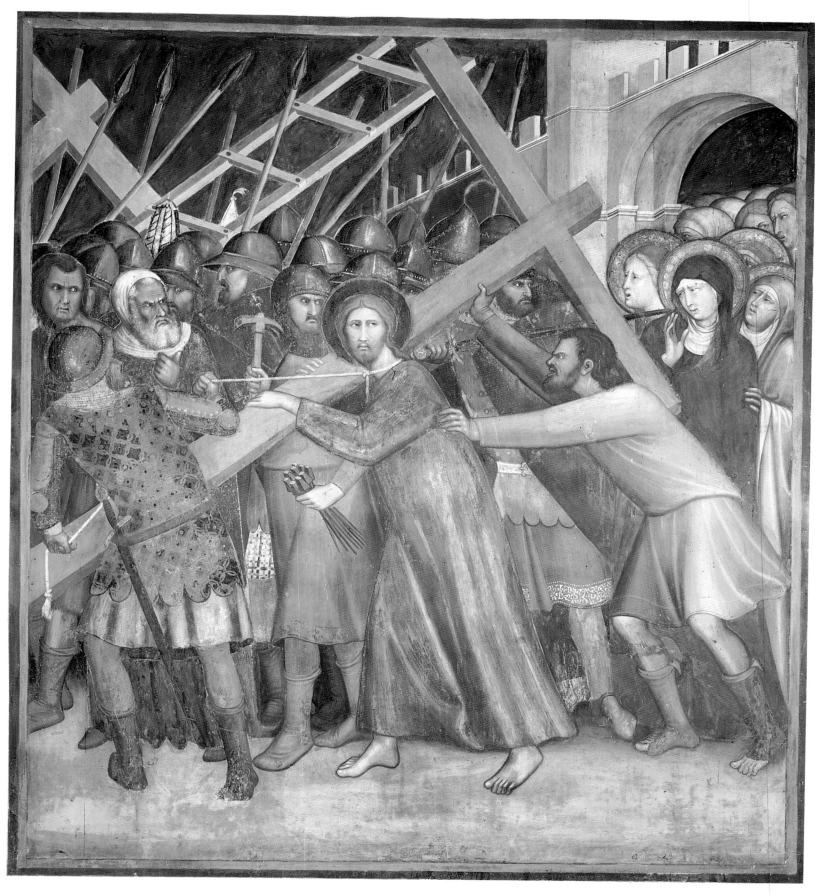

Memmi family, *Way to Calvary*,
scene from the New Testament.
Collegiata, San Gimignano.

Memmi's paintings are closely related to those attributed to the artist known as Barna da Siena. But research by Gordon Moran has shown that Barna never existed.[121] Following this discovery some art historians have transferred almost all the works previously attributed to Barna to Lippo Memmi.

The first and strongest supporter of the hypothesis that Barna da Siena was, in fact, Lippo Memmi was Caleca.[122] He believed the scenes from the New Testament on the right wall of the Collegiata in San Gimignano – completed before 1440[123] – to have been painted by Memmi. His theory is supported by writing scratched on the wall, perhaps in the fourteenth century, that reads LIPPUS DE SENIS PI[N]SIT.[124] If the frescoes in the Collegiata could be attributed to Lippo Memmi, it followed, for Caleca, that the other works once believed to have been painted by Barna da Siena should also be given to Memmi.

This opinion is not universally accepted because a number of characteristics differentiate the group of works traditionally given to Lippo Memmi from those that form the catalogue of Barna da Siena. Foremost among the art historians who challenged Caleca's view was Volpe, who argued that the name of Barna should be retained as a convenient label under which the frescoes in the Collegiata and other associated works could be grouped.[125]

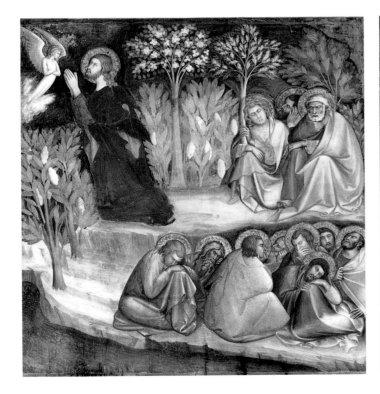

Memmi family, *Christin in the Garden of Gethsemane*, scene from the New Testament. Collegiata, San Gimignano.

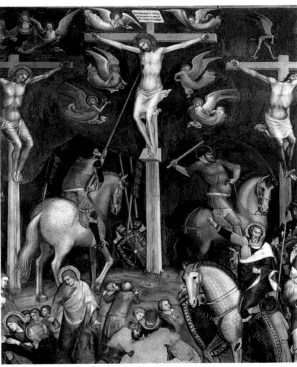

Memmi family, *Crucifixion*, scene from the New Testament. Collegiata, San Gimignano.

The Master of the Rebel Angels: Simone Martini?

Another work that has been attributed to Lippo Memmi is a problematic and extraordinary double-sided panel showing *St Martin and the Beggar* on one side and the *Fall of the Rebel Angels* on the other (Louvre, Paris).[126] Stylistically, the painting bares traces of a number of Sienese painters including Duccio, Simone Martini, Barna da Siena and Ambrogio and Pietro Lorenzetti. The original way in which the artist incorporated these influences means that it is impossible to attribute the panel to a known Sienese painter and therefore the name of the Master of the Rebel Angels has been coined.[127]

The panel may originally have constituted part of a portable altarpiece similar to the *Orsini Polyptych*. New theories about the design of the painting and the possible commissioner have recently been proposed, but no concrete evidence has emerged.[128] There have also been unconvincing attempts to name the Master of the Rebel Angels. On the basis of an analysis of the punchmarks, the *Fall of the Rebel Angels* has been attributed to Lippo Memmi.[129] However, this attribution is not entirely convincing as Memmi never achieved the same high quality of the Louvre panel in his other paintings. For the other side of the panel, which depicts *St Martin and the Beggar*, the name of Giovanni da Milano has been put forward. Thick paint has been applied in this scene and parts of the composition seem almost pointillist in their effect, making the painting markedly different from the *Fall of the Rebel Angels*. Naddo Ceccarelli has also been suggested as the painter of the panels.

Some art historians have seen similarities between the Louvre panels and paintings attributed to the Master of the Straus Madonna. The *Mystic Marriage of St Catherine of Alexandria* (Museum of Fine Arts, Boston) has been singled out as most resembling the style of the Louvre panels. I do not find the comparisons convincing, however, since the Master of the Straus Madonna does not have the imagination and subtlety of execution found in the two Louvre paintings.

p. 110
Simone Martini (?),
Fall of the Rebel Angels.
Louvre, Paris.

In my opinion, it is more likely that both the *Fall of the Rebel Angels* and *St Martin and the Beggar* are by Simone Martini, even though the figures on the two sides of the panel are on a different scale. The upper part of the *Fall of the Rebel Angels* contains a perspectival construction that is unequalled in the fourteenth century and must have been executed by an artist particularly interested in the rendering of space. There is a concentric view of the seats, with those on the right empty because the rebel angels have abandoned them while good angels occupy those on the left. The conception of the composition is extraordinary. The starry sky is painted as a vault on which the six armed angels stand. The angels guard Paradise, completely oblivious to the dramatic struggle unfolding below. In this battle the Archangel Michael and two other archangels, all portrayed in difficult foreshortening, are fighting with the rebel angels. The rebels have been transformed into black devils who fly headlong down into the darkness of the earth which is silhouetted against the gold ground. The revolving spatial arrangement of the two protagonists in *St Martin and the Beggar* is equally innovative. The saint is portrayed in the act of dividing his cloak with his sword. It is these new and disconcerting concepts, combined with the subtle delicacy of execution, that call to mind Simone Martini, in particular during his stay in Avignon, a time when he developed a number of new compositional and iconographical ideas.

The Master of the Aix Panels

The Master of the Aix Panels was given his name from two small paintings showing the *Annunciation* and the *Nativity* in Aix-en-Provence. He came into contact with Simone Martini while he was in Avignon. An *Adoration of the Magi* (Metropolitan Museum of Art, New York) has also been attributed to the Master of the Aix Panels because it is identical in style, in dimensions and also in the design of the punches.[130] However, technical considerations seem to exclude the possibility that these three panels once formed a triptych.[131] There was probably at least one other small panel in the group which has since been lost. Its subject may have been the *Presentation in the Temple*, which would have completed a cycle of scenes from the infancy of Christ. The Master of the Aix Panels probably had access to and was influenced by the *Orsini Polyptych*.

The commissioner of the Aix panels may have been Robert of Anjou, king of Naples. In the eighteenth century Fauris de Saint-Vincens, who had bought the two panels from the Poor Clares in Aix, noted that the Angevin and the Aragonese coats of arms had been painted on the back of both panels, but neither is visible today. In 1312 Robert of Anjou had founded, together with his wife Sancia of Majorca-Aragon, the convent of the Poor Clares in Aix and it may be that the panels were a gift to the nuns from the royal family. This would mean that the three small panels were probably painted before 1343, the date of Robert's death, and certainly not after 1345, the date of Sancia's death.

The Master of the Aix panels has been identified as Lippo Memmi, Ambrogio Lorenzetti, Naddo Ceccarelli and even Bartolo di Fredi or Andrea di Bartolo. The most likely suggestion seems to be that he was a Sienese painter who was active in Provence and belonged to the entourage of Simone Martini. The three panels reflect the style created in Avignon at the beginning of the 1340s by Matteo Giovannetti, an artist who had been trained in Siena.[132] The rich and refined style achieved by the Master of the Aix panels also demonstrates

inspiration drawn from Simone Martini. The attention to everyday life in the depiction of the shepherds with their flocks on the grassy slopes, as well as the evident joy in the construction of fantastic buildings, recalls, in part, the frescoes in the Tour de la Garde-Robe in the Papal Palace which were executed in 1343.

There are similarities between the small castle in the background of the Master of the Aix Panel's *Adoration of the Magi* and the one Giovannetti painted in the Papal Palace in the background of the *Dispute of St John with the Priests*, located on the northern wall of the St John Chapel. It therefore seems that the Master of the Aix Panels did indeed visit Avignon.[133]

Matteo Giovannetti,
St Hermagoras and a Worshipper.
Museo Correr, Venice.

Matteo Giovannetti,
St Hermagoras and a Worshipper,
detail. Museo Correr, Venice.

Matteo Giovannetti: an Italian Painter at the Court of Avignon

Matteo Giovannetti was probably born in Viterbo at the turn of the fourteenth century and his presence in the city is noted in a document of 1336 that mentions him as the prior of the church of San Martino. His style seems to derive from Simone Martini's Orvieto polyptychs.[134]

We know nothing about Matteo Giovannetti's career until, past forty, he arrived in Avignon. He stayed in the city for around fifteen years, during which time he executed some of the most prestigious commissions from the papal court. The first document testifying to his presence in Avignon is dated 23 September 1343 and records his part in the decoration of the walls of the Tour de la Garde-Robe. Unfortunately it is now difficult to establish exactly which parts were painted by Matteo Giovannetti. Between 1344 and 1345 he painted the frescoes in the Chapel of St Martial for Clement VI and also those, since lost, in the Chapel of St Michael. Following this, Giovannetti decorated various parts of the Papal Palace. Among the commissions which he received was that for the Salle d'Audience des Contredites (1352–1353). In this room he painted an enormous *Last Judgment* which has since been almost completely destroyed. However, it is still possible to admire the prophets dressed in shining clothes that are painted in brilliant and clear tones, such as vivid azure and luminous white. The prophets, who are holding scrolls, seem to have no bodily substance and move elegantly and easily against the star-covered heavenly vault.

Matteo Giovannetti also received various commissions from some of the most important cardinals for their residences in Avignon. He also painted mural decorations for Innocent VI and the frescoes for the Chapel of St John the Baptist (*c.* 1355–1356) in the charterhouse of Villeneuve-les-Avignon. Of his numerous works, the only frescoes which are still wholly or partially extant are those in the Chapel of St Martial, the Chapel of St John the Baptist, the Salle d'Audience des Contredites in the Papal Palace and the Chapel of

St John in the charterhouse in Villeneuve. On the basis of his Avignon frescoes, some panel paintings have been attributed to Giovannetti, but if the documents are to be believed, he must have painted many more.

One of the paintings attributed to Matteo Giovannetti is a now-dismembered double-sided triptych, probably painted between 1340 and 1350.[135] The central panel contains a *Madonna and Child* (previously in the Fodor Collection, Paris), while *St Hermagorus* and *St Fortunatus* (Museo Correr, Venice) inhabit the side panels. The other face of the triptych also has a central *Madonna and Child* flanked by *St Catherine* and *St Anthony Abbot*.[136] Other paintings attributed to Giovannetti are the *Crucifixion with SS. Augustine and Dominic* and the *Madonna and Child with a Donor* (private collection, New York). These complete the list of Matteo Giovannetti's known panel paintings.

Matteo Giovannetti's style is extremely original. It echoes that of Simone Martini but also shows an awareness of Tuscan art, in particular Florentine art and the paintings of Ambrogio Lorenzetti. His earliest surviving works, the frescoes of the life of St Martial (1344–1345), display an exceptional ability to represent daily life. The scenes are thronged with people, each of whom is individually characterized. Giovannetti has given us a series of incomparable portraits, complete with physical defects and accentuated features that border on caricatures. His main skill lay in inventing fantastic buildings with complex perspective arrangements. In his later works Giovannetti reduced the number of people in his scenes, giving his protagonists dimensions that are almost classical and monumental. He also refined his colours, limiting them to only a few tones, as in the desolate and silent *Deposition of the Body of the Baptist* that he painted in the Chapel of St John the Baptist in the charterhouse of Villeneuve-les-Avignon.

Giovannetti followed Pope Urban V to Rome, where he finished his brilliant career. The pope commissioned him to paint two chapels in the Vatican Palace which he completed between 1367 and 1368. Unfortunately, neither of these chapels has survived.

Pietro Lorenzetti

THE FRESCOES IN ASSISI

While Simone Martini's style is characterized by sumptuous elegance and refined formal expression, which create an air of exquisite courtly worldliness, Pietro Lorenzetti's painting, at the beginning of his career, can be recognized by an agonizing sense of drama.[137] One of his earliest works is the fresco cycle of the *Passion of Christ* in the left transept of the Lower Church of San Francesco in Assisi. Its date and the attribution to Pietro Lorenzetti were proposed for the first time by Cavalcaselle,[138] who also attributed other frescoes in the Lower Church to Pietro Lorenzetti. These were the *Madonna and Child with SS. Francis and John the Evangelist*, the four busts of saints on the end wall, the *Stigmatization of St Francis* and the *Hanged Judas*. In the 1885 edition of his *History* Cavalcaselle completed the list by adding the fresco in the St John Chapel (or Orsini Chapel) of the *Madonna and Child with SS. Francis and John the Baptist*. He proposed a date of around 1320

because of stylistic similarities with Pietro Lorenzetti's polyptych in the Pieve in Arezzo, commissioned in that year by Bishop Guido Tarlati.

Cavalcaselle's attribution and dating of the frescoes finally challenged those of Vasari, who had attributed the majority of the *Passion Cycle* to Puccio Capanna, a follower of Giotto. Vasari had made an exception for the *Crucifixion*, which he believed to be by the Roman painter Pietro Cavallini, and the *Stigmatization of St Francis*, which he thought was by Giotto. The attribution of the whole cycle to Pietro Lorenzetti was not generally accepted until Volpe's work on the artist.[139] Volpe provided a convincing and logical reconstruction of Pietro Lorenzetti's artistic career and fully endorsed the critical judgment formulated by Cavalcaselle.

A consideration of Pietro Lorenzetti's decoration of the left transept must take into account the frescoes by Giotto and his pupils on the adjacent vaults and in the right transept. From an investigation of the way in which the various layers

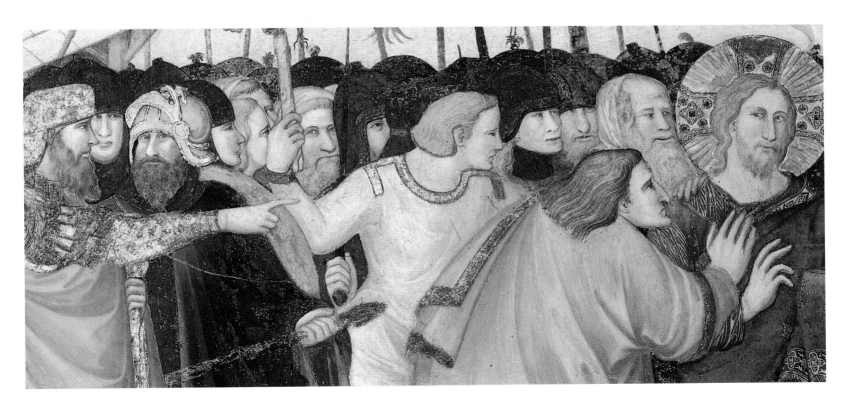

Pietro Lorenzetti,
Betrayal of Christ, detail of a scene from
the *Passion Cycle*. Left transept, Lower
Church of San Francesco, Assisi.

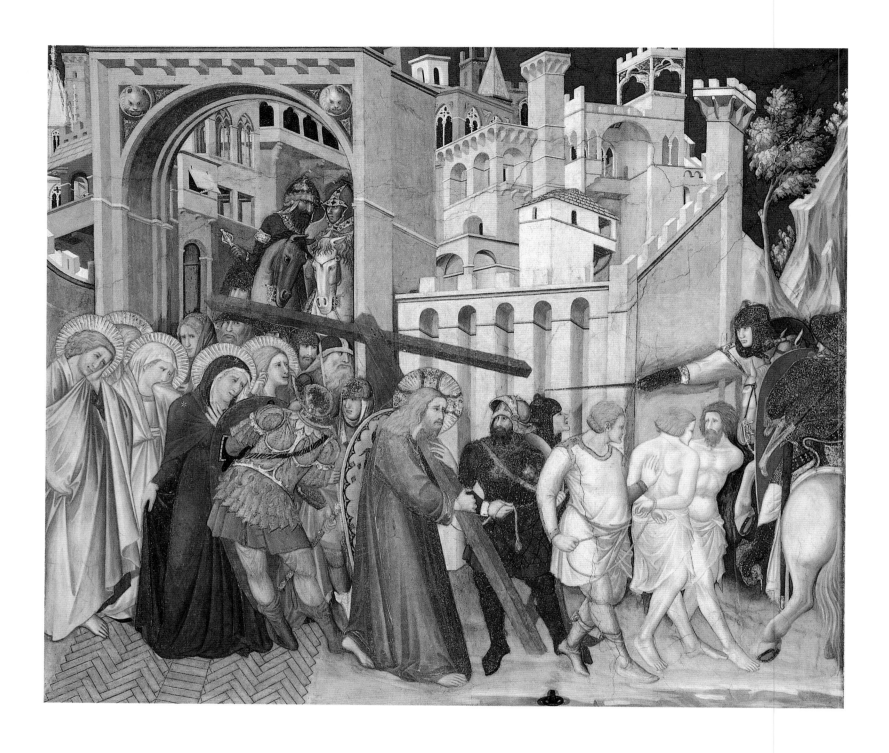

Pietro Lorenzetti, *Way to Calvary*,
scene from the *Passion Cycle*. Left transept,
Lower Church of San Francesco, Assisi.

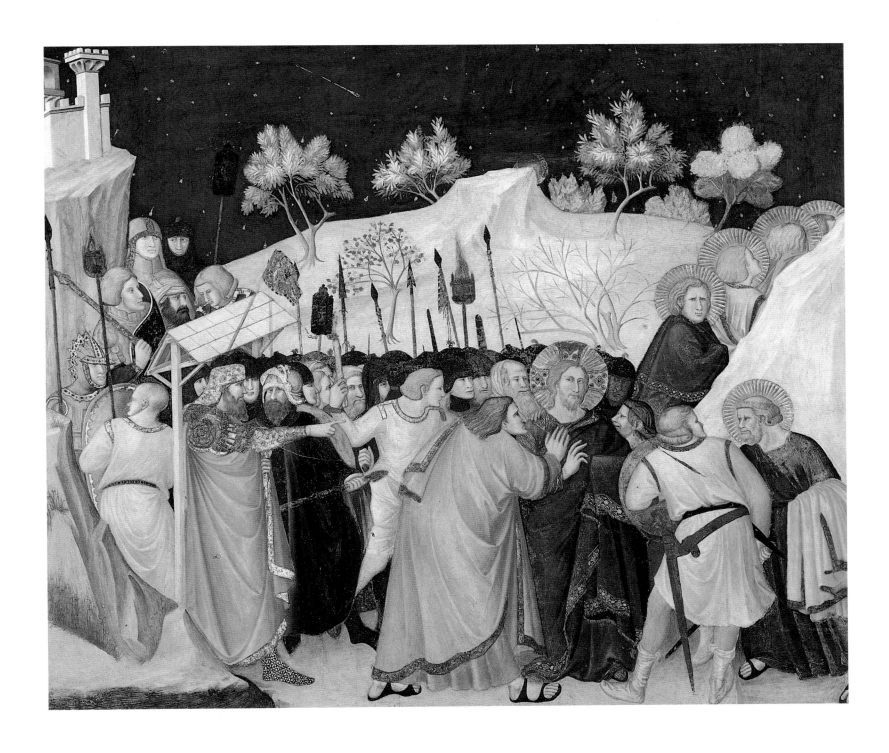

Pietro Lorenzetti, *Betrayal of Christ*,
scene from the *Passion Cycle*.
Left transept, Lower Church
of San Francesco, Assisi.

pp. 120–121
Pietro Lorenzetti, *Deposition from the Cross*,
detail of a scene from the *Passion Cycle*.
Left transept, Lower Church of San
Francesco, Assisi.

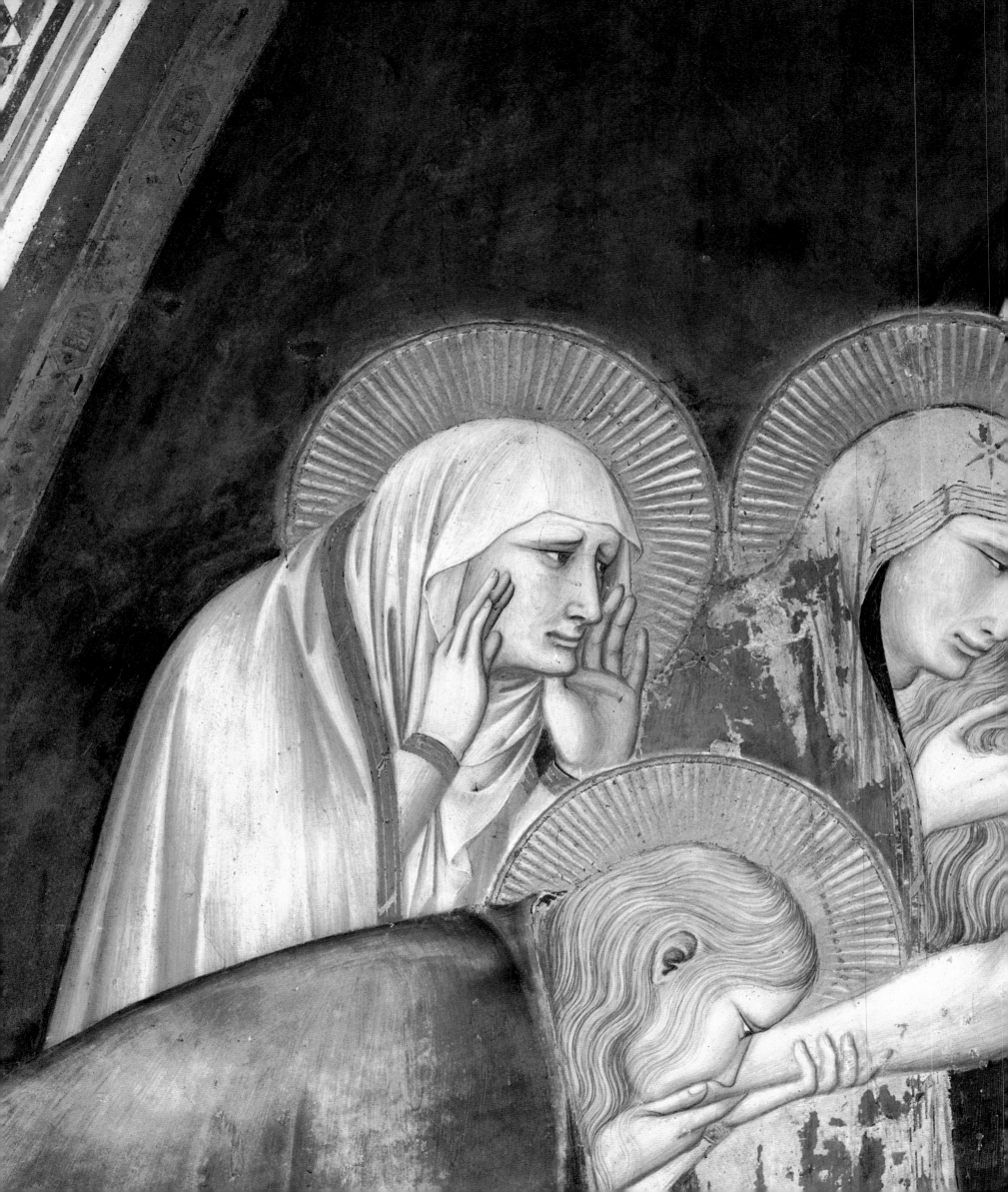

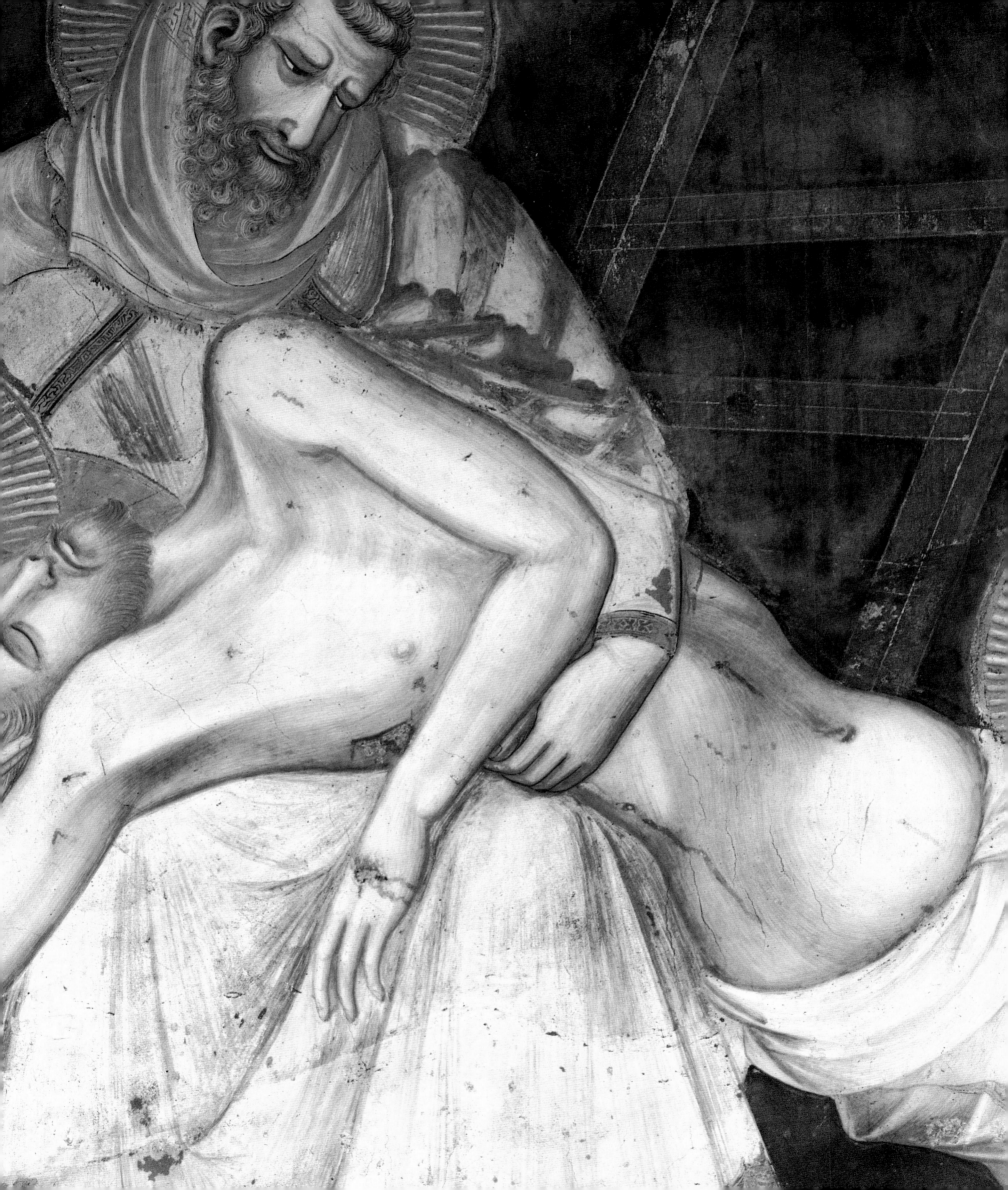

of plaster are placed on top of each other, it appears that the decoration of the right transept preceded Lorenzetti's work. This technical evidence is supported by Pietro Lorenzetti's style in the left transept, which clearly shows the influence of Giotto and his pupils.

Pietro Lorenzetti's first painting in Assisi was probably the *Madonna and Child with SS. Francis and John the Baptist*, completed between 1310 and 1315, in the chapel dedicated to the Baptist. The fresco shows the figures as though inside a portico. The foreshortened ogival arches of the portico are embellished with angels who, in the central arch, adore the Madonna and Child and, in the lateral arches, look out towards the spectator. A parapet truncates the figures a little below the waist, suggesting that they are addressing their worshippers from a loggia.

The two major influences on the art of Pietro Lorenzetti are already evident in this early work. The first is Duccio, whose style Lorenzetti had encountered in Siena, and the second is Giotto, whose frescoes he had seen in Assisi. These two influences are joined with that of Cimabue and can be detected in the dishevelled heads of the old people mixed in among the crowd in the *Entry of Christ into Jerusalem* and in the *Washing of the Feet*. There are also quotations from Giovanni Pisano's sensitive expressionism, such as the affectionate conversation between the Virgin and her Son in the *Madonna and Child with SS. Francis and John the Baptist*. It is the weave of these influences which forms the cloth from which Pietro Lorenzetti fashioned the *Passion Cycle*.

The first six scenes from the Passion – the *Entry of Christ into Jerusalem*, the *Last Supper*, the *Washing of the Feet*, the *Betrayal of Christ*, the *Flagellation* and the *Way to Calvary* – are characterized by their use of strong and boldly matched colours whose dazzling tones and 'brilliant mineral purity' still make an impression today. Equally admirable is the unprecedented painting of a realistic sky in two of the scenes. In the night sky of the *Last Supper* and that of the *Betrayal of Christ*, Pietro Lorenzetti has gone so far as to depict the constellations, a crescent moon and even shooting stars.

The *Last Supper* is dominated by the upper room described in the Bible. Lorenzetti painted it in a very unusual manner, as a centralized hexagonal construction with a ceiling that has been skilfully foreshortened. The apostles talk

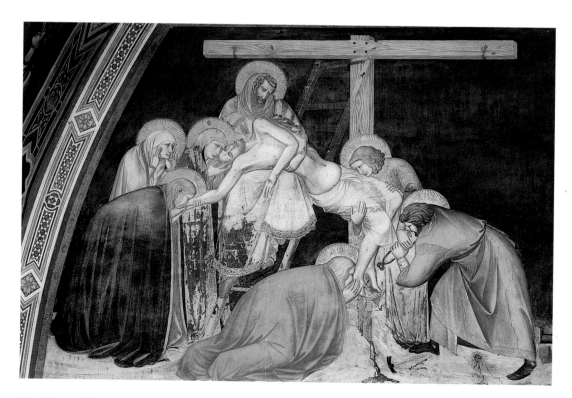

Pietro Lorenzetti,
Deposition from the Cross, scene from the
Passion Cycle. Left transept, Lower Church of
San Francesco, Assisi.

Pietro Lorenzetti,
*Enthroned Madonna and Child with Four
Angels*. Museo Diocesano, Cortona.

excitedly and suspiciously in pairs while Christ, who is in the centre of the composition, gazes intently at Judas, offering him the broken bread. To the left of the main scene Lorenzetti has included a kitchen, complete with a crackling fire and a scullery boy drying the bread boards while another servant whispers to him over his shoulder about what is happening in the next room. The most extraordinary aspect of the kitchen's depiction is the rendering of the light emanating from the fire. It strikes the upper parts of the shelves on the back wall and casts shadows, which can be seen behind the cat curled up in front of the fire and the small dog licking a plate.

Pietro Lorenzetti also paints shadows in other scenes of the Assisi *Passion Cycle*. These include those cast on the walls in the background of the *Entry of Christ into Jerusalem* and, in an even more amazing way, on the mock wooden seat covered with ermine under the *Deposition*. In my opinion Bellosi is right to link Lorenzetti's advances in the observation and knowledge of natural phenomena 'with certain naturalistic currents of Franciscan learning and thought, above all those deriving from the University of Oxford and the great figure of Roger Bacon'.[140]

The *Betrayal of Christ* and the *Deposition from the Cross* best demonstrate Pietro Lorenzetti's ability to depict intense emotion, sometimes agonized, at other times dramatic and impassioned, but always sustained by an impressive creative imagination. The culminating moment in the *Betrayal of Christ* unfolds in the foreground. The figure of Judas is identified by his splendid vermilion cloak and made memorable by his grotesque features. The shiver running through the crowd of armed men emphasizes the central action. Lorenzetti's inventiveness can also be found in the impassioned discussion between St Peter and the soldier with his back to us. In the background, one can imagine the subdued hum of the voices of the frightened apostles, who hasten along the path leading between the ivory-coloured hills which will hide them from the soldiers.

The *Deposition from the Cross*, hemmed in by the structure of the vault, unfolds completely on a horizontal axis. Perhaps to give greater immediacy, Pietro places the long white expressionistically dislocated body of Christ along the central axis. The composition shows the extraordinary technical ability and the astounding maturity that Pietro Lorenzetti

achieved in his early work. Within the compact composi-
tional structure Lorenzetti has given the mourners slow and
measured movements, depicting the mass of their bodies in
a simplified structure that is reminiscent of Giotto. The
figures of the kneeling Mary Magdalen and of the other
young Mary who kisses the hand of Christ add to the pathos
of the fresco.

The *Crucifixion* is on a more grandiose scale, being four
times the size of the paintings in the vault. Unfortunately, it
was badly damaged at the base when an altar was placed there
at the beginning of the seventeenth century. The altar also
almost destroyed the fresco underneath the *Crucifixion* that
represented a series of saints. The only one to survive today is
St Victor. The lost parts of the *Crucifixion* included the scene of
the soldiers at the foot of the cross drawing lots for Christ's
clothes and the base of the crucifix.

Despite the considerable damage suffered by the fresco, it
is still possible to appreciate it as one of Pietro Lorenzetti's
greatest achievements. In the crowded composition he
demonstrates his mastery of narrative, while at the same time
painting with an incredible freedom of expression. The

composition is unusually packed with events that include the
representation of the good and bad thieves for the first time
in a frescoed crucifixion scene. The group of the fainting
Virgin supported by the three Marys made such an impres-
sion on the Sienese sculptor Tino di Camaino that he used it
a few years later, in the *Crucifixion* in the abbey of Cava dei
Tirreni, with only a few variations.[141] Pietro's depictions of
some aspects of wealthy secular life, such as the elegant cloth-
ing and the courtly appearance of the knights, seem to derive
from Simone Martini's frescoes in the nearby St Martin
Chapel.

A little later, but still before 1320, Lorenzetti finished the
cycle with scenes from after Christ's death. These are the
Descent into Limbo and the *Resurrection*. The remaining fres-
coes in the transept – the *Madonna of the Sunset*, the *Hanged
Judas* and the *Stigmatization of St Francis* – were painted after
an interruption of several years, as is evident from their style
which is close to that of Pietro's 1329 *Carmelite Altarpiece*.

Before painting the *Arezzo Polyptych* in 1320, Pietro
Lorenzetti signed an *Enthroned Madonna and Child with Four
Angels* for the cathedral in Cortona.[142] The old-fashioned

decoration of the haloes points to a date before 1315.[143] The signature is important because it helps to confirm the much-debated attribution of the frescoes in Assisi to Pietro. The similarity in style between the Cortona *Enthroned Madonna and Child with Four Angels* and the mock triptych in the St John Chapel in the Lower Church enables the start of Pietro's work in Assisi to be dated between 1310 and 1315.

The interruption to the completion of the Assisi frescoes was probably due to the disturbances caused by the Ghibelline rebellion, headed by Muzio di Francesco from Assisi, which began on 19 September 1319. The rebels revolted again in August 1321 but were put down on 29 March 1322, the date when Assisi surrendered to the Guelph forces. Pope John XXII's interdict was a decisive factor in turning the situation in favour of the Guelphs. The pope ordered that the churches should be closed, that no religious ceremony was to be celebrated and that even the bells should be silenced. He also commanded the confiscation of all the rebels' goods. Severe punishments were inflicted on those who had been defeated and the documents show that these included a number of friars and the vicar from the convent of San

Francesco.[144] Although activity in San Francesco may have been interrupted during the bloodiest period of the uprising, the total suspension of work may not have lasted long.[145]

Volpe believed that the events in Assisi influenced Pietro Lorenzetti's style. The *Crucifixion*, completed before the rebellion, and the scenes from after the death of Christ, completed after the rebellion, show significant differences in their conception. Although it is difficult to judge the effect of historical events on the creative process, a comparison between the *Crucifixion* and the scenes from after the death of Christ allows us to evaluate their mental and stylistic distance from one another. The former, according to Volpe, is characterized by a 'Gothic richness in colour and narrative', while the latter shows a 'bleak and severe sense of direction'. This demonstrates that an interval of time, however brief, separates the two works. The same 'bleak and severe' style can be seen a little later in the *Crucifixion* in the church of San Francesco in Siena, which originally formed part of a group of scenes for the church and adjacent convent, most of which have now been lost. The other paintings are an extremely majestic *Resurrected Christ* (Pinacoteca, Siena) and the frescoes by

Pietro Lorenzetti, *Madonna and Child*. Pinacoteca, Siena (originally from the Pieve of Santi Leonardo e Cristoforo, Monticchiello).

Pietro Lorenzetti, *Madonna and Child*, detail. Pinacoteca, Siena (originally from the Pieve of Santi Leonardo e Cristoforo, Monticchiello).

Ambrogio Lorenzetti in the chapter room and choir. The fainting Virgin supported by the three Marys on the left of the San Francesco *Crucifixion* has been compared with the same group in a *Crucifixion* incised on a small marble slab in the church of San Pellegrino alla Sapienza in Siena.[146] The *Crucifixion* in San Pellegrino has been attributed, with some reservations, to the great Sienese goldsmith Guccio di Mannaia, who probably invented translucent enamel, and a date between 1310 and 1315 has been proposed.

We know Guccio di Mannaia through his only signed work – the famous chalice covered with translucent enamels executed for Nicholas IV, pope from 1288 to 1292, who gave it to San Francesco in Assisi. The *Crucifixion* on the marble slab is remarkably similar to that on one of the enamels from the Assisi chalice. Both works are dependent on the numerous crucifixes that Giovanni Pisano produced. However, the group of the three Marys in the composition from San Pellegrino also reflects Giotto's *Crucifixion* in the right transept of the Lower Church in Assisi, both in its iconography and in the solid structure of the bodies. This surpasses the references to the early art of Giotto in the chalice. It is not possible to

gauge how the art of Guccio di Mannaia matured during the twenty years or so between the chalice and the small marble slab, and so the marble *Crucifixion* cannot be attributed to him with certainty. The similarity to Pietro Lorenzetti's *Crucifixion* leads me to believe that the work may have been executed following a drawing supplied by Pietro around 1315.

Guccio di Mannaia is also known from documentary sources as an engraver of seals. Elisabetta Cioni's attribution of the mould for the seal of the Società dei Raccomandati al Santissimo Crocifisso di Siena (Palazzo Venezia, Rome) to Guccio di Mannaia seems to indicate that Guccio's style was not evolving towards that shown in the *Crucifixion* from San Pellegrino alla Sapienza.[147] The mould must have been designed after the society was founded in 1295.

In Pietro Lorenzetti's *Madonna and Child* from the Pieve of Santi Leonardo e Cristoforo in Monticchiello, there are clearly still some traces of Duccio, suggesting a date close to that of the Cortona *Enthroned Madonna and Child with Four Angels*, a couple of years before 1320. The old-fashioned manner of engraving the haloes, similar to those done in the thirteenth century, confirms the early date of the painting.[148]

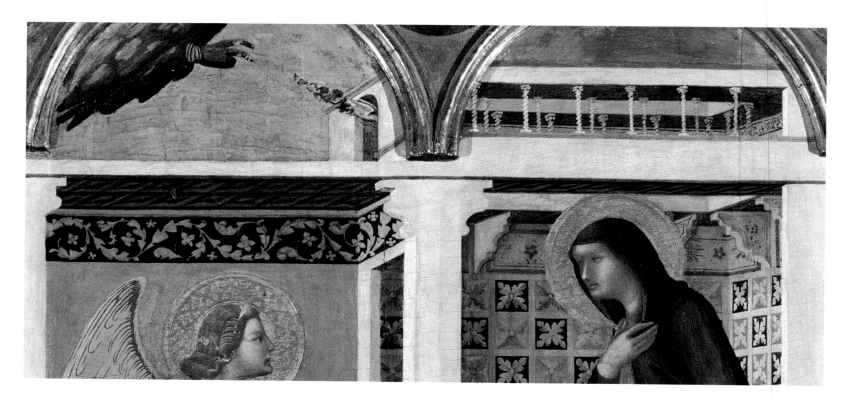

Pietro Lorenzetti, *Annunciation*, detail of the *Arezzo Polyptych*. Pieve of Santa Maria, Arezzo.

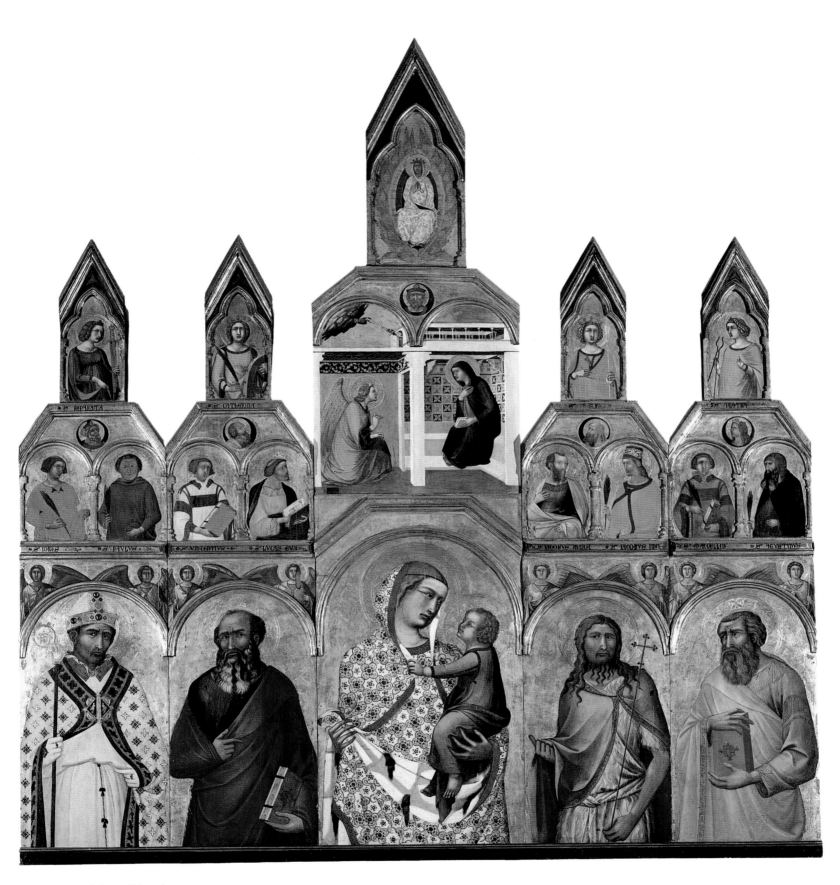

Pietro Lorenzetti, *Arezzo Polyptych*.
Pieve of Santa Maria, Arezzo.

Pietro abandoned this method in the period following the execution of the *Arezzo Polyptych*, commissioned in 1320, in which engraved haloes still appear but enriched by more complex designs. In using decorative punches Pietro was following the example of Simone Martini, who used this type of mould for the first time in the *Santa Caterina Polyptych* of 1319–1320.

The painting of the *Madonna and Child* from Monticchiello (Pinacoteca, Siena) once formed the central part of a polyptych composed of *St Agatha* (?) (Musée de Tessé, Le Mans) and of *SS. Leonard, Catherine and Margaret* (?) (Museo Horne, Florence).[149] The Virgin, whose vivid eyes appear as newly shelled almonds with shining brown irises contrasting with the white around them, wears a fine veil which covers her forehead in an uncommon fashion. The line of her mantle emphasizes the beauty of her features as she directs her gaze towards the Christ Child. Jesus' head is shown in profile and Lorenzetti has given him an unusually thick head of blond hair. The positioning of the head is similar to the heads of some of the figures by Simone Martini in the St Martin Chapel. Jesus is wrapped in a bright yellow-gold

mantle and stretches his sturdy neck out as far as possible, trying to look into his mother's eyes. All of this, even down to the drawing of the long and almost disjointed fingers of the Virgin's left hand, recalls the Cortona *Enthroned Madonna and Child with Four Angels*.

The figure of *St Agatha*, who shares the same facial model as the Virgin, is one of Lorenzetti's most memorable representations of a woman, owing to the subtlety with which he portrays the elaborate and elegant hairstyle. St Agatha's hair is gathered into a thick plait from which a few wisps escape. Lorenzetti has skilfully articulated the fingers that hold the slender cross while the left hand lifts the edges of the yellow-orange draperies.

In addition to these elegant figures, Pietro Lorenzetti was also capable of extremely dramatic representations such as the *Winthrop Crucifixion* (Fogg Art Museum, Cambridge, Massachusetts). This work was completed around the same time as the Monticchiello *Madonna and Child*. Similarities between the two works lie in the engraving of the friezes and haloes.[150] The use of this technique indicates that both were painted early in Lorenzetti's career. The *Winthrop Crucifixion*

Pietro Lorenzetti, *Virgin and Child*, detail of the *Arezzo Polyptych*. Pieve of Santa Maria, Arezzo.

Pietro Lorenzetti, *St John the Baptist*, detail of the *Arezzo Polyptych*. Pieve of Santa Maria, Arezzo.

p. 129
Pietro Lorenzetti, *Carmelite Altarpiece*, detail. Pinacoteca, Siena.

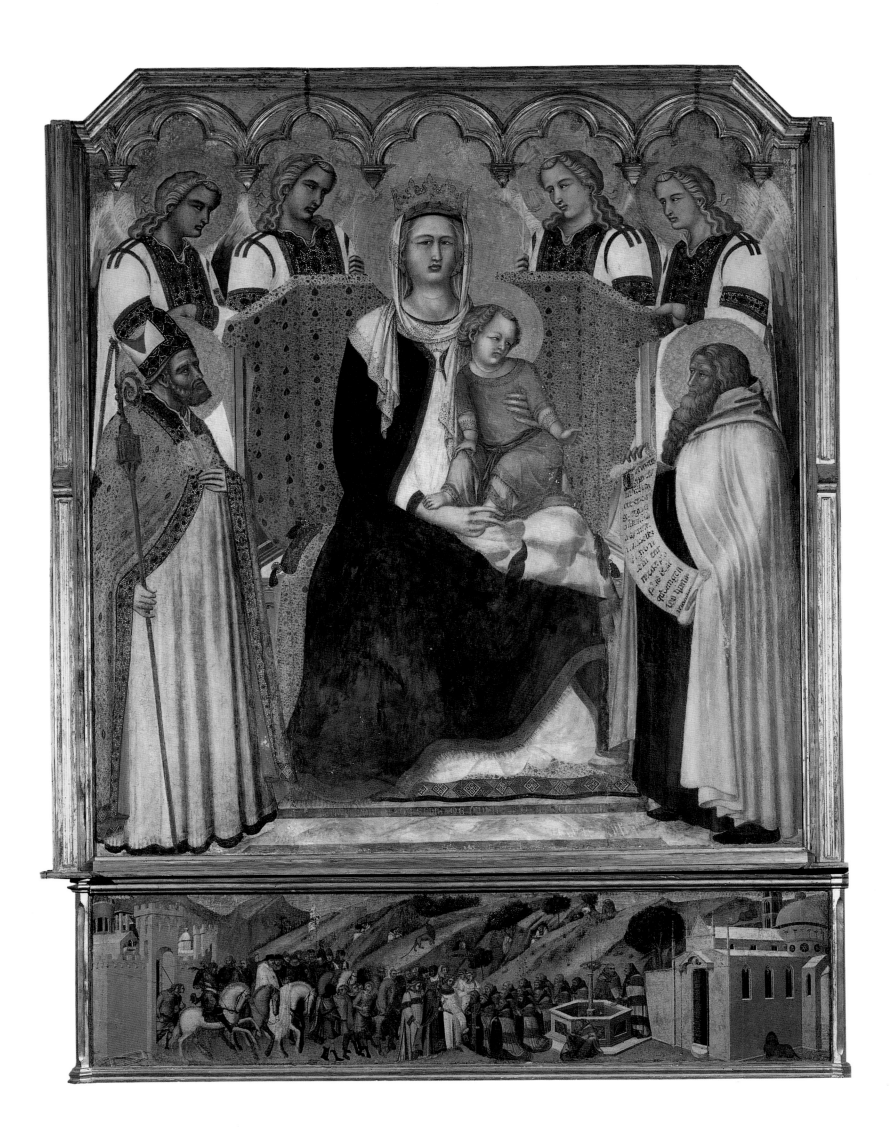

also shows parallels, particularly in the loincloth, with the great cross in the Museo Diocesano in Cortona that has been attributed to Lorenzetti.[151] The *Cortona Cross* comes from the local church of San Marco and was probably executed before the *Arezzo Polyptych* and shows the influence of Giotto.

THE AREZZO POLYPTYCH

The polyptych in the Pieve of Santa Maria in Arezzo was commissioned by the Ghibelline Bishop Guido Tarlati, who had been implicated in the revolt against Pope John XXII led by Muzio di Francesco and centred in Assisi.[152] It may be that Pietro Lorenzetti had met Bishop Tarlati during the rebellion as he was then painting the *Passion Cycle* in San Francesco.

The contract for the painting, drawn up on 17 April 1320, has survived. It gives a precise description of the work to be done and enables a complete reconstruction of the polyptych. According to the document, the parts that are now missing are '*duae columnae quarum qualibet debeat esse ampla medio brachio, et in qualibet esse debeant VI figure laborate de auro*' (two columns which must measure half a *braccio* wide and in which there must be six figures worked in gold).[153]

The *Arezzo Polyptych* has a complex format similar to Simone Martini's *Santa Caterina Polyptych*. It is made up of two registers of saints who are shown in three-quarter length. The central panel of the main register represents the *Virgin and Child*, while that of the upper register shows the *Annunciation*. The five pinnacles contain four figures of saints placed to either side of a central *Assumption of the Virgin*. When Vasari described the *Arezzo Polyptych* in his *Lives of the Painters, Sculptors and Architects*, he also mentioned a predella containing 'many small figures [...] all really fine and executed in the best style'. This predella has since been lost. Lorenzetti signed the work on the lower frame, and following the restoration carried out in 1979 another inscription – PETRUS ME FECIT – was uncovered on the sword held by *St Reparata*, who is in the pinnacle above *St Donatus* on the left of the altarpiece.[154]

The figures in the main register, especially the *Virgin and Child* and the *St John the Baptist*, are composed with wide, sweeping, Giottesque rhythms in their drapery. Lorenzetti had previously been influenced by Giotto in the Assisi frescoes and in other earlier works. In the *Arezzo Polyptych* Pietro

Pietro Lorenzetti, detail from the predella of the *Carmelite Altarpiece*. Pinacoteca, Siena.

Lorenzetti seems to have surpassed his training in Duccio's workshop and to attain his own personal artistic language. The only exceptions are the pairs of severe angels that look out from the tops of the arches of the main register, still recalling Duccio's style. The other figures, although grave and solemn, possess an energy and a controlled tension which betray reflections of the Gothic style and expressive drive of Giovanni Pisano's sculpture, which was to be a fundamental component in Pietro's style for much of his career. The intense glances of the saints and the lively conversation between mother and son are derived from Giovanni Pisano's female prophets on the façade of Siena Cathedral and from his many representations of the Virgin and Child.

The saints are clothed in rich colours of the type that we have already seen in Assisi. The tones vary from the deep yellow of St Matthew's cloak to the light green and violet in St John the Baptist's cloak and from the aubergine violet of St John the Evangelist to the fuchsia red wrapped around Gabriel and his wings, as he makes his announcement to the Virgin. But more striking than these are the Virgin's splendid white mantle, lightly shaded with azure, and the white, tinged with a delicate coating of pale green, that is found in St Donatus's mantle.

The influence of the Sienese sculptor Tino di Camaino, who encouraged Pietro Lorenzetti to tone down Giovanni Pisano's Gothic style, is also visible in the *Arezzo Polyptych*.[155] Pisano's influence is, however, still strong in the fragmentary fresco of the *Crucifixion* in San Francesco in Siena, which I have already mentioned. This is most noticeable in the figure of St John, who appears to be almost sculpted. Traces of Giovanni Pisano led Volpe to date the fresco around 1322 although most art historians have dated it after 1330. Volpe's early dating of the fresco is consistent with the belief that Lorenzetti's citations of Pisano's art become weaker with the passing of the years.[156] Here, the strong reference to his sculpture leads me to conclude, with Volpe, that the *Crucifixion* was completed early in Pietro Lorenzetti's career.

THE CARMELITE ALTARPIECE

There is a break of about seven years between the last works considered and the altarpiece from the Carmelite church in Siena, dated 1329 on the base. In the intervening period there

Pietro Lorenzetti, detail from the predella of the *Carmelite Altarpiece*. Pinacoteca, Siena.

is no mention of Pietro Lorenzetti in documentary sources and no paintings have survived.

Although the *Carmelite Altarpiece* is no longer complete, the majority of its panels still survive.[157] The central panel depicts the *Enthroned Virgin and Child with St Nicholas of Bari and the Prophet Elijah* (Pinacoteca, Siena). Flanking them were the *Prophet Elisha* and *St John the Baptist* (Norton Simon Art Foundation, Los Angeles).[158] The extreme lateral panels depict an absorbed and melancholy *St Agnes* and an imposing and regal *St Catherine of Alexandria* (Pinacoteca, Siena). The bright tones of their clothing forming large expanses of colour ranging from orange-red to dark cadmium draw attention to the figures. Two pinnacle panels (Pinacoteca, Siena) also survive and it is possible that the altarpiece originally contained other figures that have not been traced.[159]

The predella of the polyptych depicts the legend according to which the Carmelite Order was founded by Elijah, who is shown to the right of the Virgin. The prophet is clearly identified by his name written at his feet and by the verse on the scroll held in his hands. The predella presents the *Dream of Sobac* and the *Carmelite Hermits at the Well of Elijah*, with the central and largest of the predella panels showing *Patriarch Albert of Jerusalem Giving the Rule to St Brocard*. Other scenes narrate more recent events in the history of the order: the *Approval of the Rule by Pope Honorius III* (1226) and *Pope Honorius IV Granting the White Mantle* (1286).

The *Carmelite Altarpiece* demonstrates 'how the expressive tension suffered by the artist around 1320 was resolved into a monumental solution by 1329'.[160] Pietro Lorenzetti was probably influenced in this work by a knowledge of current Florentine art that would have reached him through his brother Ambrogio, who made frequent and prolonged trips to Florence during this period. In Santa Croce Giotto had finished the fresco decoration of the Peruzzi Chapel before 1315 and that of the Bardi Chapel by 1325. Maso di Banco was also working in Santa Croce at this time.[161]

Some aspects of the *Carmelite Altarpiece*, however, bear no relationship to Florentine painting. This is true of the central *Patriarch Albert of Jerusalem Giving the Rule to St Brocard* in which the landscape is depicted with exceptional skill and is narrated 'more with colour and with the moving appearance of images than with formal certainties'.[162] At Assisi Pietro had

already demonstrated his capacity for representing architectural aspects of the urban landscape, as can be seen in the *Entry of Christ into Jerusalem* and the *Way to Calvary*,[163] which became direct precedents for the famous view of the city in the *Good Government* fresco, painted between 1338 and 1339 by Ambrogio Lorenzetti in the Palazzo Pubblico in Siena. Pietro's work at Assisi also shows that he was an attentive observer of the night landscape, as in the *Betrayal of Christ* with its bleak tufa hills. This interest in natural phenomena was later developed in the two illuminated pages of the Dante manuscript in Perugia.

In the interiors of the predella of the *Carmelite Altarpiece*, Pietro's use of perspective shows Giottesque qualities. Giotto's art had already affected that of Ambrogio Lorenzetti in the fresco of the *Reception of St Louis by Boniface VIII* in San Francesco in Siena which had been 'constructed with the same daring engineering of arches and vaults, both foreshortened'.[164]

Three pinnacled panels of *St Bartholomew*, *St Cecilia* and *St John the Baptist* from the Pieve of Santa Cecilia in Crevole have been attributed to Pietro Lorenzetti on stylistic grounds.

The names of the saints are inscribed on their gold haloes. In the pinnacles, *St Agnes*, *St Catherine* and *St Anne* are represented respectively. The three panels must once have formed part of a polyptych with a central Virgin and Child and another panel to the left of the figure of *St John the Baptist*. At the base of the panels is an original but fragmentary piece of writing which provides both the name of the commissioner, a certain LAURENTIUS PLEBANUS, and the date MCCCXXXII.

The date is useful for evaluating the development of Pietro's style immediately after the *Carmelite Altarpiece*. The fragmentary polyptych also has stylistic links with a group of paintings completed by Pietro around the same time and previously attributed to the Master of the Dijon Triptych.[165] The panels are mostly small altarpieces or diptychs and include an *Enthroned Madonna with SS. Agnes and Catherine of Alexandria* (Museo Poldi Pezzoli, Milan) and a reliquary showing a *Standing Madonna and Child with an Adoring Franciscan* (Berenson Collection, Villa I Tatti, Settignano). This was once part of a double-sided panel with the *Blessing Christ Enthroned and a Franciscan Friar* (private collection, New York).[166]

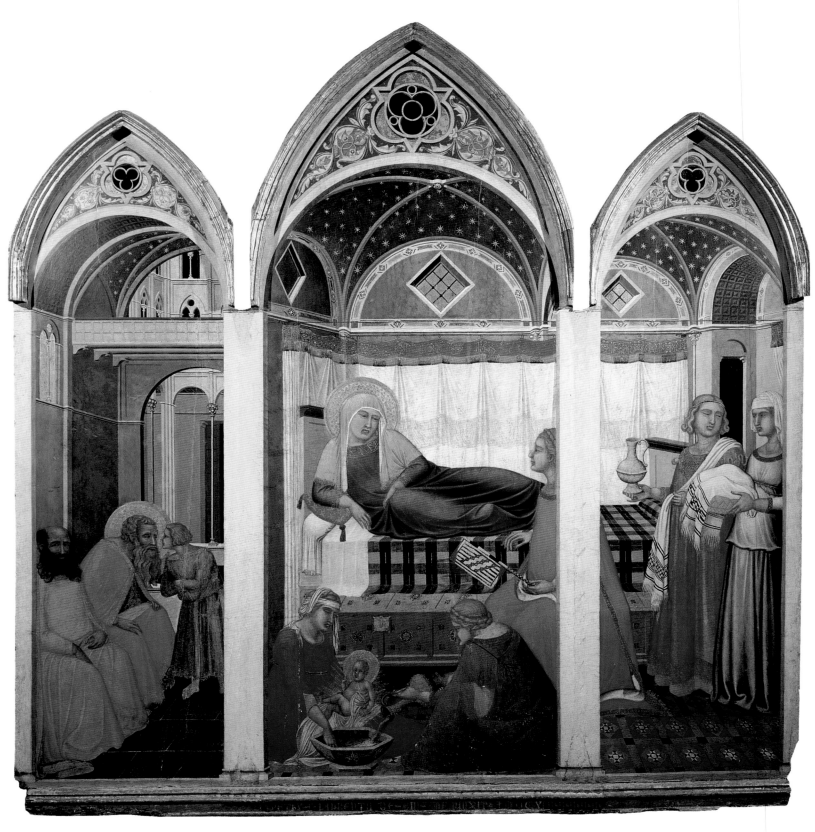

Pietro Lorenzetti, *Birth of the Virgin*,
scene from the *St Savinus Altarpiece*.
Museo dell'Opera del Duomo, Siena.

THE *ST SAVINUS ALTARPIECE*

After the *Annunciation* by Simone Martini and Lippo Memmi, painted in 1333 for the altar of St Ansanus, the *operai* of Siena Cathedral commissioned Pietro Lorenzetti to execute the *St Savinus Altarpiece*.[167] St Savinus was, together with SS. Ansanus, Crescentius and Victor, one of the four patron saints of Siena. The commission was given in November 1335 and Pietro was to be paid 140 gold florins of which he was immediately given an advance of thirty florins. The polyptych was composed of a central panel showing the *Birth of the Virgin* (Museo dell'Opera del Duomo, Siena), two side panels with the figures of *St Savinus* and *St Bartholomew* which have been lost and a predella of which only one panel has survived, that of *St Savinus before the Governor Venustianus* (National Gallery, London). In December 1335 a certain Ciecho, master of grammar, was paid a florin for translating the legend of St Savinus from Latin. This implies that Pietro, who could not have known Latin, was then able to choose the most important scenes from the life of the saint and represent them on the predella.

The commissioning of the altarpiece in 1335 is documented in the cathedral inventory of 1429 published by Peleo Bacci.[168] Pietro Lorenzetti did not sign and date the finished work until 1342 and the intervening seven years make it difficult to place the work accurately within Pietro's artistic career. Like the *Blessed Humility Polyptych*, the *St Savinus Altarpiece* was probably begun shortly after the commission was awarded and completed only just before delivery.

In 1335 the two Lorenzetti brothers had only just finished the frescoes on the façade of the Ospedale di Santa Maria della Scala in Siena. Unfortunately, these were destroyed in the eighteenth century after the canopy that protected them was removed in 1720. There is now some debate about their exact subject matter and arrangement.

The frescoes are first described by Ghiberti in his second book of the *Commentari* (*c.* 1450),[169] in which he attributes them to Ambrogio Lorenzetti and Simone Martini without mentioning Pietro Lorenzetti. Ghiberti says that Ambrogio 'painted on the façade of the hospital two scenes and they were the first: one is when Our Lady was born, the second, when she went to the temple, and they were very excellently

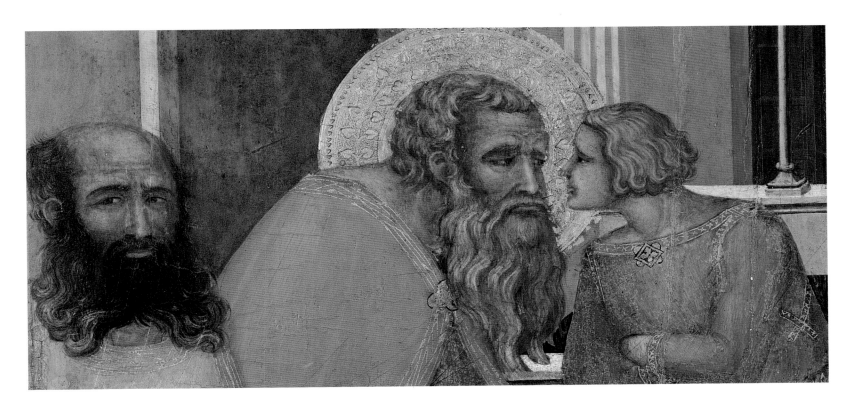

Pietro Lorenzetti, *Birth of the Virgin*, detail
of a scene from the *St Savinus Altarpiece*.
Museo dell'Opera del Duomo, Siena.

done'. He goes on to say that Simone Martini painted 'on the façade of the hospital two stories: [one] of how Our Lady was married, the other of how she was visited by many women and virgins, [which is] very much adorned with buildings and figures'.[170]

Vasari, in his *Lives of the Painters, Sculptors and Architects*, does not mention Simone Martini at all and instead attributes the entire cycle to the Lorenzetti brothers. According to him, Pietro painted the scenes 'in La Scala, a hospital of Siena, in which he imitated [so] successfully the style of Giotto.... In these scenes he represented the Virgin mounting the steps of the Temple, accompanied by Joachim and Anna, and received by the priest; then her marriage, both remarkable for good ornamentation, well-draped figures with simple folds of the clothes, and a majesty in the carriage of the heads, while the disposition of the figures is in the finest style'.[171] In the life of Ambrogio Lorenzetti, Vasari says that 'On the front of the great hospital he did in fresco the Nativity of Our Lady, and when she goes among the virgins to the Temple'.[172]

The façade frescoes of the Ospedale di Santa Maria della Scala were very influential and equally as important as Giovanni's Pisano's marble figures on the cathedral façade. Ghiberti, who is the most reliable of our sources, must have seen the decoration of the façade of the Ospedale with his own eyes,[173] while Vasari, on the other hand, probably relied on second-hand information. If he had actually seen the frescoes, he would almost certainly have noticed the inscription along the base stating that Pietro and Ambrogio Lorenzetti were brothers. Instead, in his *Lives of the Painters* he says that Pietro's surname was Laurati. The inscription, recorded by Ugurgieri in 1649, reads as follows: HOC OPUS FECIT PETRUS LAURENTII ET AMBROSIUS EIUS FRATER MCCCXXXV (This work was made by Pietro Lorenzetti and Ambrogio his brother, 1335).[174]

When Pietro painted the *Birth of the Virgin* for the *St Savinus Altarpiece*, his brother had only recently completed a fresco of the same subject for the Ospedale della Scala. For Ambrogio, as we know from copies of the fresco, the theme provided the opportunity for a refined narration of the scene including various domestic details. Pietro marked out the composition as though the events were taking place in a temple, presenting the figures as solemn and threatening

witnesses. The way in which he used architecture to divide up the space makes the iconography of all Gothic altarpieces seem obsolete.[175]

The Ospedale della Scala frescoes were a major source for Sienese painters in the second half of the fourteenth and in the fifteenth century. Their role as a constant point of reference confirms the regard and esteem in which subsequent generations held the three great painters of the early fourteenth century. Both direct quotations and more liberal derivations proliferated from these frescoes.[176] For example, Bartolo di Fredi's *Birth of the Virgin* in the church of Sant'-Agostino in San Gimignano reflects Ambrogio's fresco from the Ospedale in the movement of the figures – albeit interpreted by a modest provincial painter.

In many fourteenth- and fifteenth-century commissions, it was the donor himself who asked the artist to refer to the famous frescoes. In 1449, for example, Sano di Pietro signed a contract in which he undertook to use the same subject matter as that in the five scenes above the doors of the Ospedale, placing the Assumption in the centre with two scenes to either side.[177]

Working together on the scaffolding of the Ospedale di Santa Maria della Scala probably drew Pietro and Ambrogio Lorenzetti's styles closer to each other, as can be seen in other works of the same period. They may also have shared a workshop during these years.[178]

A comparison between Pietro's *Birth of the Virgin* in Siena Cathedral and Ambrogio's remarkable ideas for the same subject, transmitted through Bartolomeo di Fredi's poor translation, allows us to assess the different styles and concerns of the two artists. Ambrogio can be characterized as a somewhat eclectic painter, intellectually receptive to a great number of influences but keeping his distance from them. This makes it difficult to categorize his art. Pietro, on the other hand, seems more representative of his age.[179]

THE BLESSED HUMILITY POLYPTYCH

The *Blessed Humility Polyptych* was painted for the high altar of the church of San Giovanni Evangelista in Florence, which belonged to a convent of Vallombrosan nuns. The altarpiece was commissioned in honour of the founder, Rosanese, who took the name of Humility when she became a nun.

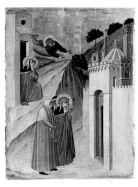
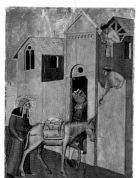
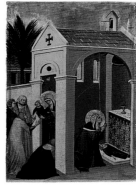
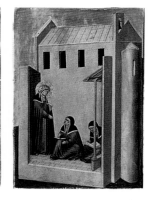
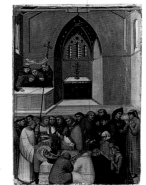

Pietro Lorenzetti,
Blessed Humility Polyptych.
Uffizi, Florence.

The convent of San Giovanni Evangelista was destroyed in 1529 and in 1534 the nuns were transferred to San Salvi, taking the polyptych with them. Richa described the great altarpiece as having a central representation of St Humility surrounded by thirteen scenes from her life.[180] He also transcribed the inscription 'at the bottom of the panel in fourteenth-century letters' which read: *Hec sunt miracula Beate Umilitatis prime abbatisse et fundatricis huius venerabilis monasteri et in isto altari est corpus eius.* (Here are the miracles of the Blessed Humility, the founder and first abbess of the venerable convent and her body is in this altar.)

By the time the altarpiece entered the Gallerie di Firenze in 1808, it was already partially fragmented.[181] Two of the pinnacles and two of the scenes from Humility's life were probably already missing. The scenes would have been those that were originally underneath the central panel of Humility showing *Humility Curing the Nasal Haemorrhage of a Nun* and the *Miracle of the Ice in August* (Staatliche Museen, Berlin).[182] When the polyptych was exhibited in the Accademia in 1842, the pinnacles and the predella were missing, owing to an arbitrary restoration carried out the previous year. The order of the scenes was also changed at that time. Moreover, an inscription in neo-Gothic handwriting, repeating the lost original, was put in place of the missing scene under the figure of Humility. To this was added a date that is difficult to read – A.M.CCC.X [V or L] I – and could be interpreted as either 1316 or 1341. If the earlier date is assumed correct, it becomes difficult to understand Pietro Lorenzetti's early development as evidenced in the *Orsini Chapel Triptych* and the *Passion Cycle* in Assisi. It was not until 1954 that an attempt was made at an accurate reconstruction.

In 1913 Carmichael discovered an eighteenth-century drawing of the altarpiece that had been enclosed with the acts of Humility's canonization process.[183] The drawing reproduced the entire painting, with the exception of the predella, as it looked before the various tamperings. This, together with a close reading of Humility's official legend written in 1332, enabled Marcucci to reconstruct the original arrangement of the scenes.[184] The order originally followed the sequence of events narrated in the official legend and this meant that Pietro Lorenzetti must have painted them after 1332. The probable commissioner, the Blessed Margaret, died

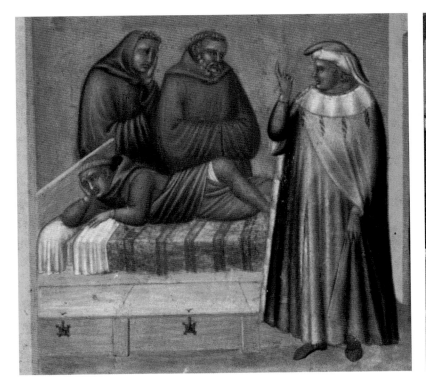

Pietro Lorenzetti,
Vallombrosan Monk with a Gangrenous Leg,
detail from the *Blessed Humility Polyptych*.
Uffizi, Florence.

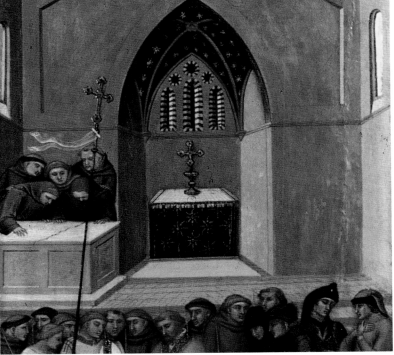

Pietro Lorenzetti,
Funeral of the Blessed Humility, detail
from the *Blessed Humility Polyptych*.
Uffizi, Florence.

in 1330, which constitutes a *terminus post quem* because it is improbable that Margaret would have been represented on the altarpiece before her death.[185]

The altarpiece was made up of a central panel, showing the Blessed Humility with the Blessed Margaret kneeling at her feet, with thirteen scenes arranged around it. These scenes can be read from left to right and top to bottom. The first scene, at the top left of the altarpiece, is *Humility and her Husband Ugolotto Decide to Separate in order to Live a Holy Life*. This is followed by *Ugolotto Taking the Religious Habit* and, to the right hand side of the central figure, *Humility Reading in the Refectory of Santa Perpetua*. Humility was illiterate when she entered the convent of Santa Perpetua but was miraculously inspired by the Holy Spirit to read. The final scene from the upper register shows a *Vallombrosan Monk with a Gangrenous Leg* that he refused to have amputated. This is followed by the first scene of the middle register with *Humility Healing the Monk with the Gangrenous Leg*. We are then shown *Humility Leaving the Convent of Santa Perpetua*. Miraculously, she was helped to leave by St John the Evangelist and then crossed the River Lamone barefoot. To the right of the

central figure is *Humility Arriving in Florence with her Companions* followed by *Humility Helping to Construct the Convent of San Giovanni Evangelista*. From left to right the bottom register contains five scenes: *Humility Resuscitating a Child*, *Humility Dictating her Sermons*, *Humility Curing the Nasal Haemorrhage of a Nun*, the *Miracle of the Ice in August* and, finally, the *Funeral of the Blessed Humility*.

The predella contained seven tondi. The central *Pietà* was flanked by the *Virgin* and *St John*. On the left were *St Benedict* and *St Paul* and on the right *St Peter* and *St John Gualberto*.

Volpe believed that Ambrogio Lorenzetti was involved in executing part of the *Blessed Humility Polyptych*. Once the fictitious date of 1341 had been removed, Volpe re-examined Pietro Lorenzetti's career until 1343, the date of the *Pistoia Madonna*, which I will consider shortly. He believed that the stylistic gap between the *Pistoia Madonna* and the *Blessed Humility Polyptych* did not result from a difference in the date of their execution but from Ambrogio Lorenzetti's involvement. Volpe could only understand the painting if Ambrogio's presence was admitted, since the polyptych contains the 'sharp contrasts of form' and 'the complex formal structure'

Pietro Lorenzetti, miniature from the first canto of Dante's *Divine Comedy: Inferno*. MS. L. 70, fol. 2, Biblioteca Comunale Augusta, Perugia.

Pietro Lorenzetti, *Humility Leaving the Convent of Santa Perpetua*, detail from the *Blessed Humility Polyptych*. Uffizi, Florence.

that are typical of Ambrogio's painting. These can be seen in the first, second and fourth scenes, while Pietro's 'calm and powerful' mode of expression is evident in *Humility Reading in the Refectory of Santa Perpetua* and *Humility Dictating her Sermons*.[186]

PIETRO LORENZETTI AS A MINIATURIST

Pietro Lorenzetti's activity as a miniaturist was recently confirmed when two pieces of parchment added to a manuscript of Dante's *Inferno* with a commentary by Jacopo della Lana (MS.L.70, Biblioteca Comunale Augusta, Perugia) were attributed to him.[187] These miniatures illustrate the first canto of the *Inferno* in eight consecutive episodes.

The scenes are memorable because of the close interpretation of the text and the accurate rendering of the individual episodes such as Dante waking in the '*selva oscura*' (dark wood) and his meeting with the three wild beasts – the leopard, the lion and the wolf. In the first miniature the scenes should be read from the bottom left, continuing to the right and upwards. The exceptional quality of the miniatures is best appreciated in the second and better-conserved piece of parchment. Here, followed by the wolf, which is represented at the edge of the miniature with wide-open jaws, Dante falls to his knees at the feet of Virgil and turns to point with outstretched arm at the menacing creature. Having been reassured by Virgil, Dante – always in brilliant azure clothes – follows closely in the footsteps of his guide – wrapped in a light pink cloak – as they climb a difficult path between barren hills. Equally successful is the depiction of dawn as described by Dante in the first canto – a blue sky dotted with stars together with the moon and the rising sun. These naturalistic observations bring to mind the night skies in the early frescoes of the *Last Supper* and the *Betrayal of Christ* in Assisi. Grey hills stand out against the blue sky. They appear to be made of tufa and are rounded at the summit, eroded and smoothed by water and perhaps also by the force of the wind over the centuries. Their sides are lined with numerous and continuous whitish crests. In the rendering of the tufa, the barren hills in the miniatures resemble some of the sheer mountains in the scenes from the life of the Blessed Humility, such as *Humility Arriving in Florence with her Companions*. Also comparable is the whitish rock on the river bank in the panel of *Humility Leaving the Convent of Santa Perpetua*.

I have discovered one other miniature by Pietro Lorenzetti in a thirteenth-century manuscript completed in the fourteenth century, the *Sequentiae missarum* (G.III.2, Biblioteca Comunale, Siena).[188] The manuscript comes from Siena Cathedral and contains a number of historiated initials painted by a thirteenth-century miniaturist whose work can be seen in other choir books from the cathedral. It also contains an initial (on fol. 86) with four saints that is probably by Bartolomeo Bulgarini. The miniature by Pietro Lorenzetti is on a folio that shows *St Agnes* inside a pink initial A. The *St Agnes* predates the two Dante miniatures. The subtly drawn face; the fine dark ribbon which ties back her flaxen hair covered by a transparent veil; the delicate shading on the clothes, especially on the orange-red cloak lined with soft green; and the way the book is held by the well-articulated hands suggesting spatial depth all substantiate the attribution to Pietro. The style of the miniature is similar to that of the female figures in the *Arezzo Polyptych*, commissioned by Bishop Guido Tarlati in 1320. There is also an affinity with the *St Agatha* (Musée de Tessé, Le Mans), at one time part of the Monticchiello *Madonna and Child* that suggests an earlier date. The drawing of the halo, which is engraved rather than punched, supports this.

PIETRO LORENZETTI'S LAST WORKS

One of Pietro Lorenzetti's last works is the *Enthroned Madonna and Child* from the church of San Francesco in Pistoia (Uffizi, Florence) which was almost certainly painted in 1343.[189] The painting's classical purity and exactitude of expression were influenced by the work of both Giotto and Maso di Banco. In it Pietro succeeded in reconciling the Sienese tradition for clarity of colour with the Florentine emphasis on form.

Vasari must have seen this work and in his *Lives of the Painters* he speaks of a predella that has not survived, in

which he describes there being scenes with 'certain small figures'. He also says that the panel was signed PETRUS LAURATI DE SENIS from which he mistakenly took Pietro's surname.

After 1345, the date of the frescoes in the St Michael Chapel in Castiglione del Bosco, no other works by Pietro Lorenzetti are documented. He, like his brother Ambrogio, probably fell victim to the devastating plague that raged throughout Europe in 1348. It is possible that Pietro spent the last years of his life in Castiglione del Bosco.[190] We know that in 1342 he bought some land in nearby Bibbiano for the sculptor Tino di Camaino's orphaned children to whom in 1344 he also sold a small piece of land. The St Michael Chapel contains a simply composed *Annunciation*, with a Giottesque sense of spatial construction, flanked by three saints. The saints' names as well as the date of the fresco are still visible on the decorative band running beneath the imposing, but now damaged, figures.

Ambrogio Lorenzetti

The documentary information on the life and works of Ambrogio Lorenzetti is as scarce as that which we have for Duccio di Buoninsegna, for Simone Martini and for Ambrogio's elder brother, Pietro.[191]

Ghiberti defined Ambrogio Lorenzetti as a 'learned painter', an 'extremely famous and distinctive artist' and 'a man of great intelligence'. He also said that Ambrogio 'was very noble in the art of drawing and an expert in theory'.[192] Vasari, after having affirmed that 'in his youth he had devoted himself to letters… [and] associated with men of letters and of worth', added that 'The manners of Ambrogio were in every respect meritorious, and rather those of a gentleman and a philosopher than an artist'.[193]

Adjectives such as 'anarchic', 'brilliant' and 'inventive' are found frequently in modern works on Ambrogio Lorenzetti. He was gifted with an 'unusual breadth of interests' and was an extraordinary innovator, both compositionally and iconographically.

Ghiberti described Ambrogio's depiction of a storm in the fresco of the *Martyrdom of the Franciscan Saints in Tana*, which he painted in the cloister of San Francesco in Siena, as follows:

He [Ambrogio] was a most noble composer. Amongst whose works is a very large and well made story which occupies the entire wall of a cloister at the Friars Minor.... There is the Sultan seated in the Moorish manner.... There is the executioner of justice with a great many armed men.... After the decapitations of the monks [sic] there arises a storm with much hail, flashes of lightning and thundering earthquakes; it seems as if it were possible to see painted heaven and earth in danger. It seems as if all were trying with much trembling to cover themselves up: the men and the women are pulling their clothes over their heads, and the armed men are holding the shields over their heads. The hailstones are so thick on the shields that they seem actually to bounce on the shields with the extraordinary winds. The trees are seen bending even to the ground as if they were breaking, and each person seems to be fleeing. For a painted story it seems to me a marvellous thing.[194]

The fresco was whitewashed during the eighteenth century and for a long time was believed to be completely lost. A fragment, however, was recently retrieved during restructuring work on the cloister which has confirmed the veracity of Ghiberti's detailed description.[195]

The fresco, which was probably completed in 1336, shows the martyrdom of three Franciscans on 9 April 1321, namely Tommaso da Tolentino and Iacopo and Demetrio da Padova. The hagiographical sources also describe a storm, accompanied by claps of thunder and hail, that broke out after the execution as a sign of divine wrath.[196]

Ghiberti's admiration for Ambrogio Lorenzetti was such that at the end of the account of his works he continued: 'Master Simone Martini was a very noble painter and very famous. The Sienese painters believe that he was the best, but to me Ambrogio Lorenzetti appears much better and much more learned than any of the others.'

The opinions of Ghiberti and Vasari have stood the test of time. Ambrogio Lorenzetti is still considered to be an artist unparalleled in the fourteenth century. He painted the *Good and Bad Government* in the Sala dei Nove in Siena's Palazzo

Pubblico, translating the complicated scheme into allegorical form and thereby proving his vast knowledge, both religious and secular. It was also Ambrogio who painted the *Mappamondo* in the Palazzo Pubblico and who, as reported by Ghiberti, made a drawing of an antique statue of Venus with a dolphin (by the sculptor Lysippus) found near the house of the Malavolti when the fountain in the Campo in Siena was being constructed. Furthermore, Ambrogio did not limit himself to art. Having been elected to the Consiglio dei Paciari, he gave a public speech on 2 November 1347.[197]

THE *VICO L'ABATE MADONNA*

Ambrogio Lorenzetti's first known work is unusual in that it does not show the reliance on Duccio found in the early works of other Sienese painters of the first half of the fourteenth century. Instead it is more sympathetic to the artistic climate in Florence as seen in the work of Giotto and his pupils. The painting shows a Madonna and Child enthroned, dated 1319 (Museo d'Arte Sacra, San Casciano) and was probably painted for the church of Sant'Angelo di Vico l'Abate, a short distance from Florence.[198]

The inscription visible at the base of the painting – A.D. M.CCCXVIIII. PER RIMEDIO DE LANIMA DI BURNACIO… DUCIO DA TOLANO FECELA FARE BERNARDO FIGLIUOLO BURNA – tells us that a certain Bernardo commissioned the work for the salvation of the soul of his father, Burnaccio di Tolano. Tolano is very near to the church of Vico l'Abate.

Giotto's influence can be seen in the structure of the throne, which is decorated with red, black and white marble in the manner of the Cosmati, as well as in the confident and powerful structure of the bodies. Unlike Simone Martini and Pietro Lorenzetti, Ambrogio quickly outstripped his training with Duccio. In Florence he would have come into close contact with the work of Giotto and his pupils, although he probably already knew Giotto's cycle of the life of St Francis in the Upper Church of San Francesco in Assisi.[199]

Pietro Lorenzetti may also have been in Florence around 1320 or a little earlier to paint the *St Lucy* for the church of Santa Lucia de' Magnoli.[200] Sadly, due to nineteenth-century repainting, the work is now almost completely destroyed, with the exception of the saint's face. If Pietro was

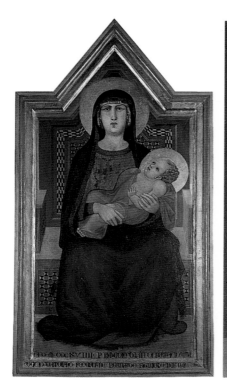

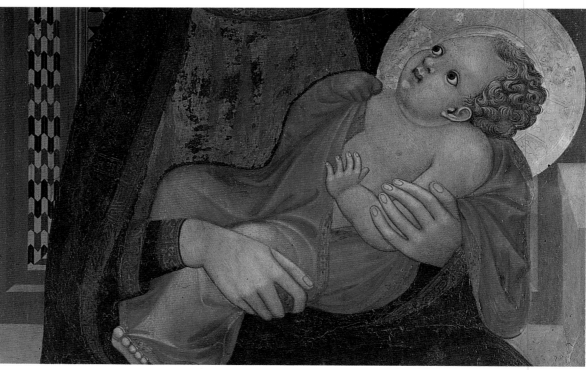

Ambrogio Lorenzetti,
Vico l'Abate Madonna. Museo
d'Arte Sacra, San Casciano, Florence.

Ambrogio Lorenzetti,
Vico l'Abate Madonna, detail. Museo
d'Arte Sacra, San Casciano, Florence.

in Florence *c.* 1320, he may well have been accompanied by Ambrogio who, taking advantage of the fame that his brother was acquiring in the city, would have been in a favourable position to obtain the commission for the *Vico l'Abate Madonna*.

The simple, essential definition of the Virgin and Child is the most striking aspect of the *Vico l'Abate Madonna*. The extremely vivacious baby, completely contained by a sinuous line, derives from the work of Simone Martini. He is enfolded in red drapery and his large round eyes are turned towards his mother, whose hands can scarcely restrain him. The pyramidal mass of the Virgin, on the other hand, is circumscribed by a sharp and concise line recalling the work of Giotto. Ambrogio has seated her frontally in the confidently defined space of her throne with a fixed gaze that makes her seem like a Byzantine icon.

AMBROGIO LORENZETTI IN FLORENCE

A document of 1321 tells us that Ambrogio Lorenzetti was in Florence that year. He was detained on 30 May 1321 because of an unpaid debt for '*unam guarnachiaum de saia de Camo ad usum mulieris*' (a woman's cloak made out of Caen twill).[201] Ambrogio's presence in the city may indicate another Florentine commission that has since been lost. It certainly testifies to Ambrogio's wish to keep up to date with Giotto's work. Ambrogio returned to Siena before 1324 and lived in the *contrada* of Camporegio, where, on 2 January of that year, he sold part of a piece of land that he owned, declaring the official price to the office of the Gabella.[202] He was once again in Florence between 1328 and 1330 when he matriculated in the artists' guild, the *Arte dei Medici e Speziali*, and this proves that he was active as a painter in Florence.[203]

THE *SAN PROCOLO TRIPTYCH*

In 1332 Ambrogio Lorenzetti was in Florence for the fourth time, painting a now-dismembered triptych for the church of San Procolo. The central part depicts the *Madonna and Child*; *St Nicholas* and *St Proculus* were placed to either side. The *Madonna and Child* originally bore an inscription at the bottom documented by Cinelli in 1677: AMBROSIUS LAURENTIJ DE SENIS 1332. Richa reported in 1754 that there were two other side panels showing *St John the Baptist*

and *St John the Evangelist* as well as a predella with scenes from the life of St Proculus, but these have since been lost.[204] When compared with the *Vico l'Abate Madonna*, the *San Procolo Triptych* contains more Gothic elements and there are clear signs of Simone Martini's influence.

It has been suggested that having matriculated in the *Arte dei Medici e Speziali*, Ambrogio Lorenzetti stayed in Florence until he painted the *San Procolo Triptych*. The work is of particular importance because it can be securely dated and therefore constitutes a point of reference in Ambrogio Lorenzetti's early career. It also testifies to Ambrogio's difficult task of adapting his Sienese training to the spatial rationality and rigour of construction that characterized Florentine art.[205]

The face of the Virgin has a classical beauty that is rare in Ambrogio's representations of women. This beauty is refined by a transparent veil that falls to either side of her face and which is tightly twisted under her throat like a necklace. The Virgin wears a crimson-red robe, partially covered by a cloak, with a wide and sumptuous border in which multicoloured gems and pearls sparkle. The cloak falls vertically from the top of her head, parallel to the defined outline of the figure. In a motif reminiscent of Pietro Lorenzetti, the thoughtful and intense gaze of the Virgin is turned towards her son. Oblivious to this, Jesus is kicking vigorously. His right hand tightly grasps the forefinger of the Virgin – a tender and affectionate gesture – while with his left hand he grabs the edge of his swaddling clothes. In this triptych Ambrogio Lorenzetti attained a classical restraint that, together with the expressive gestures of the figures, recalls the neo-attic style.

THE SUBJECT OF THE MADONNA AND CHILD

There are other paintings by Ambrogio that stylistically appear to precede the *San Procolo Triptych*. One of them, the *Cagnola Madonna* (Brera, Milan), still has engraved haloes and a restless and vivacious child similar to that in the *Vico l'Abate Madonna*. Christ's foreshortened feet wriggle out from the tightly bound swaddling clothes, which are alternately white and aubergine violet.

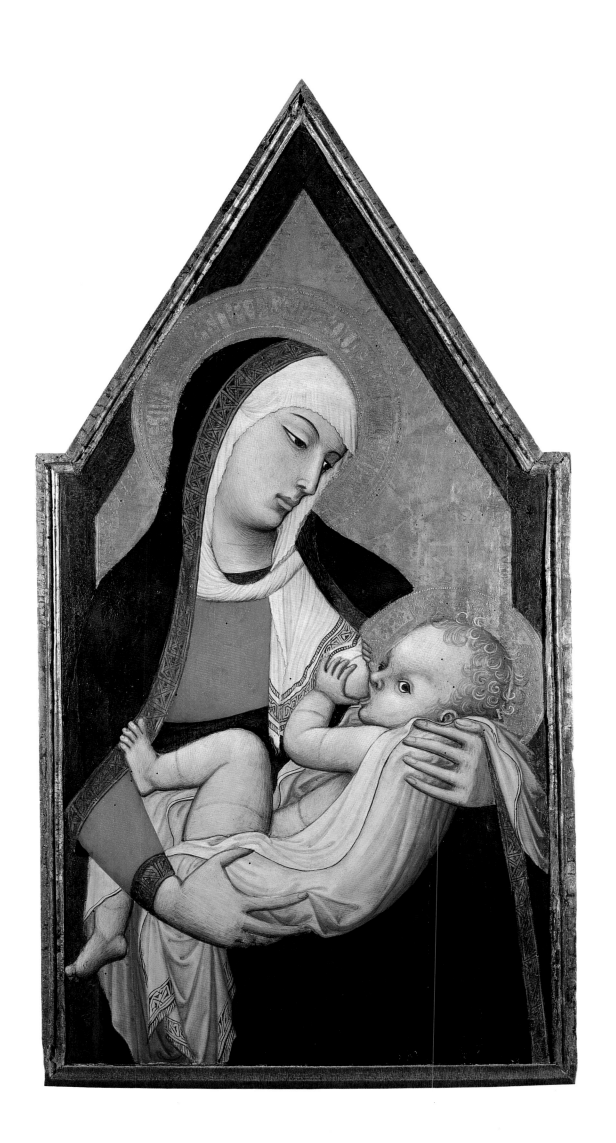

Rowley observed the similarity between the head of the *Cagnola Madonna* and the heads habitually painted by Pietro Lorenzetti.[206] This is an important comparison because Pietro's influence on his brother is generally only noted in Ambrogio's later works.

Volpe believed that the very beautiful *Madonna and Child* from the Metropolitan Museum of Art in New York was painted by Ambrogio Lorenzetti early in his career.[207] Unfortunately the panel is not in a good state of conservation. The Christ Child once held a small bird in his right hand that has now almost completely disappeared. However, the work is still outstanding because of Ambrogio's humanizing of the divine group. He represents the Virgin as though she was any mother who restrains her son by means of his clothes, fearing lest he escape her arms with a sudden and energetic movement.

One of Ambrogio's most famous and admired paintings of the Madonna and Child is the so-called *Madonna del Latte* (Palazzo Arcivescovile, Siena). It was probably painted around the time of the *San Procolo Triptych* of 1332 with which it has certain stylistic similarities. These can be seen in the sharp line that defines the edges of the figures and in the fluent movement of the folds of the Child's drapery – depicted in delicate pink shot with red. The panel also shows a closeness to Gothic art that is typical of Ambrogio Lorenzetti's early activity.

Ambrogio's innovatory brilliance is shown in placing the Virgin outside the central axis of the painting. She appears to lean on a door-jamb in order to support the great weight of the Child whom she is breastfeeding. Jesus kicks and turns his curious gaze towards the observer, while the Madonna looks at him lovingly and holds him in her beautiful hands.

THE FRESCOES IN THE CHAPTER HOUSE OF SAN FRANCESCO IN SIENA

Two frescoes by Ambrogio Lorenzetti from the chapter house of the Franciscan convent in Siena survive from the early 1320s. These depict the *Martyrdom of the Franciscans* and the *Reception of St Louis of Toulouse by Boniface VIII*. Pietro Lorenzetti was working in San Francesco in the same period, frescoing a dramatic *Crucifixion* and *Resurrection*. Of the *Resurrection* only the impressive figure of Christ, wrapped in a

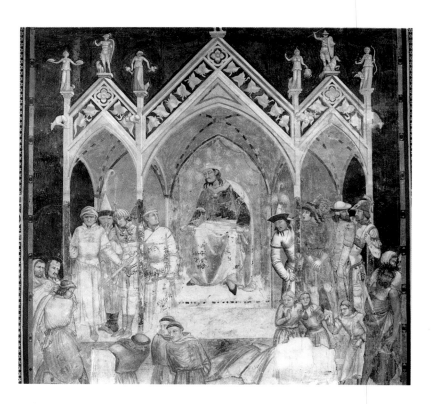

Ambrogio Lorenzetti,
Martyrdom of the Franciscans.
San Francesco, Siena.

shining white shroud delicately modelled by the light, has been recovered (Museo dell'Opera del Duomo, Siena). The other frescoes by Ambrogio and Pietro were moved from the chapter house to the church in 1857.

Despite its poor state of conservation, the *Martyrdom of the Franciscans* has always been admired. The architecture depicted in the fresco is surmounted by small monochrome statues with allegories and mythological characters that demonstrate Ambrogio's knowledge of antique classical art. Ambrogio also achieves a new expressiveness in his representation of the spectators, among whom are many of oriental origin. These figures are particularly striking because of both their facial features and their exotic clothing. Ambrogio may been drawing on first-hand experience as there were various people of African, Tartar, Asian and Oriental origin in Italy and above all in Tuscany during the fourteenth century.[208]

The *Reception of St Louis of Toulouse by Boniface VIII* takes place inside the Papal Palace. Ambrogio has defined the space in a coherent and organized manner. The attentive faces are drawn within the perspective structure with precision. The facial features of the pope, seated solemnly under an arch to

the far left of the composition, are not those of Boniface VIII, as required by the subject matter, but those of John XXII, who was pope at the time the fresco was being executed.[209] The painting has a number of similarities with Giotto's *Apparition in Arles* in the Peruzzi Chapel in Santa Croce as well as the fresco of the same subject in the Upper Church of San Francesco in Assisi.

The composition consists of a long bench parallel to the picture plane on which sit seven cardinals seen from behind. Their solid outlines emerge a little above the shoulder rest of the bench and they wear wide-brimmed cardinals' hats. In front of them and facing the spectator is another row of cardinals and Robert of Anjou, king of Naples. Robert, second from the left and wearing a crown, is immediately recognizable because of his characteristic profile as, with his chin resting on the palm of his hand, he follows the ceremony. At the back of the scene a group of fashionably clothed young people talk quietly among themselves. Their secular clothes introduce an element of worldly elegance that is reminiscent of Simone Martini's frescoes in the St Martin Chapel in Assisi.

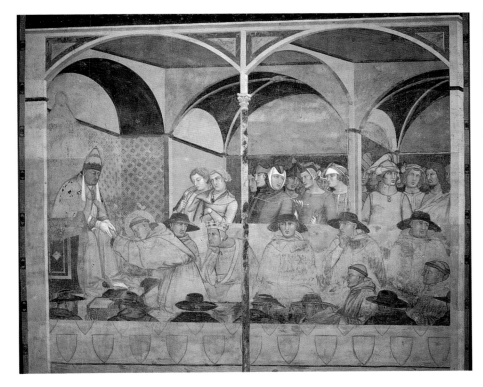

Ambrogio Lorenzetti,
Reception of St Louis of Toulouse by Boniface VIII. San Francesco, Siena.

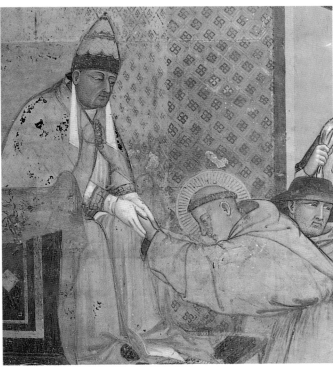

Ambrogio Lorenzetti,
Reception of St Louis of Toulouse by Boniface VIII, detail. San Francesco, Siena.

Many areas of colour have now been lost but still remaining are the red of the cardinals' hats and the flame-red clothes of a young man in the background, who wears a white-lined cap and turns to talk to an elegantly dressed youth behind him. Further to the right stands a man dressed in splendid azure drapery with vertical white stripes that matches the material of his headdress.

The fresco was probably painted in *c.* 1324.[210] It was certainly completed before the last two scenes from the predella of Pietro's 1329 *Carmelite Altarpiece* because the *Approval of the Rule by Pope Honorius III* and *Pope Honorius IV Granting the White Mantle* are both clearly influenced by the *Reception of St Louis of Toulouse by Boniface VIII*. The fresco shows Ambrogio's ability to define strongly foreshortened architectural perspectives and to place figures accurately within that space. The similarities between the young cardinal seated in the centre of the room and the head of the 1319 *Vico l'Abate Madonna* also help to determine an early date for the frescoes in the chapter house.[211]

The great painted cross (no. 598, Pinacoteca, Siena) originally from the Carmelite church also forms part of Ambrogio

Lorenzetti's early oeuvre and was certainly painted before the *San Procolo Triptych* of 1332.[212] The figure of Christ still reflects Giotto's style but there are differences in the lighter modelling of the body, in the detail of the half-shut eyelids and, finally, in the gleaming decoration of the gold ground. As in the *Cagnola Madonna* and the *Madonna and Child* (Metropolitan Museum of Art, New York), the irreparable damage to the picture surface fortunately does not prevent our appreciation of the very personal language with which Ambrogio expressed himself during the first ten years of his artistic activity.

THE FOUR SCENES FROM THE LIFE OF ST NICHOLAS

The four scenes from the life of St Nicholas (Uffizi, Florence) come from the Florentine church of San Procolo.[213] They are painted on two panels with two scenes on each and probably originally formed part of a dossal with a full-length figure of St Nicholas in the centre, an arrangement similar to that of Pietro Lorenzetti's *Blessed Humility Polyptych*.[214] The scenes show the *Gift of Gold to a Destitute Family*, the *Consecration of*

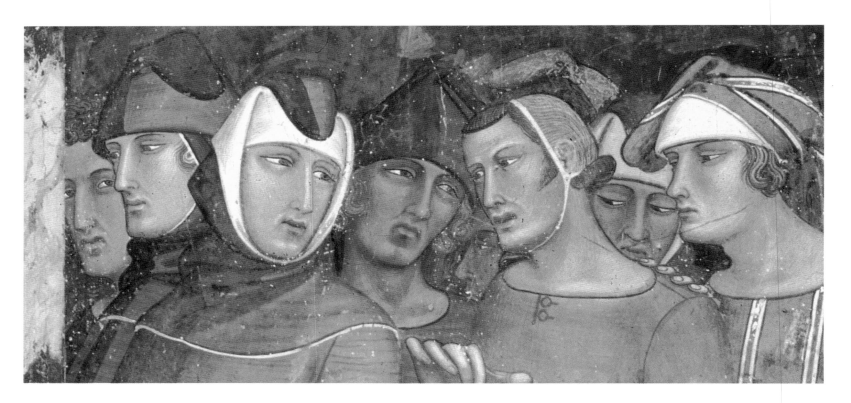

Ambrogio Lorenzetti,
Reception of St Louis of Toulouse by Boniface VIII, detail. San Francesco, Siena.

p. 151
Ambrogio Lorenzetti, *Raising of a Child Strangled by the Devil* and *St Nicholas Saving the City of Myra from Famine*. Uffizi, Florence.

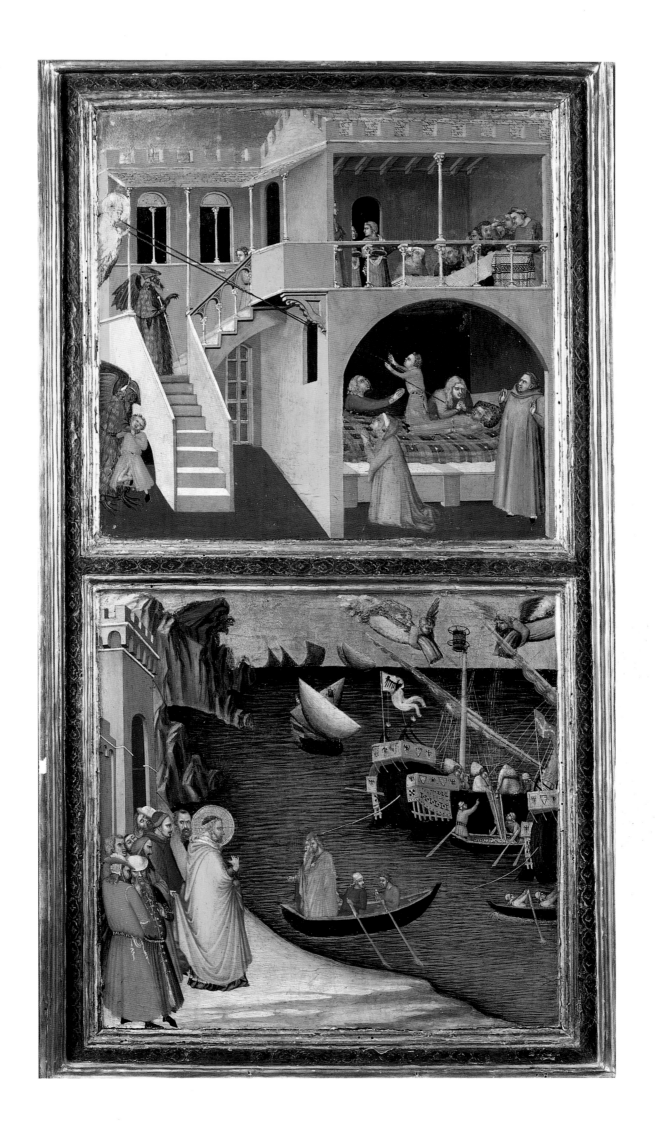

St Nicholas as Bishop of Myra, the *Raising of a Child Strangled by the Devil*, and *St Nicholas Saving the City of Myra from Famine*.

The panels are neither signed nor dated and their attribution to Ambrogio Lorenzetti rests on the evidence of Ghiberti and Vasari. In his *Commentari* Ghiberti relates that Ambrogio had painted 'a panel and chapel' (*una tavola e una cappella*) in San Procolo but he does not specify the subjects. In the second edition of the *Lives of the Painters* Vasari describes 'a picture and the life of St Nicholas in small figures in a chapel, [painted] to please some of his friends who were anxious to see the manner of his work'. Vasari adds that 'in the predella he painted his portrait'.[215]

The style of the panels points to a date after the *San Procolo Triptych* of 1332 and before 1335, although Volpe dated them before the triptych and proposed that they may have been 'a worthy and amazing *pièce de réception* for his matriculation with the Florentine Guild of the Medici e Speziali'.[216]

Ambrogio Lorenzetti's mastery of the illusionistic rendering of interior space and his skill in the representation of landscape are evident in these panels. His ability must have

been admired by contemporary Florentine artists as well as by Vasari in the sixteenth century. For Sienese artists, on the other hand, Ambrogio's importance lay in having introduced the fashion for small altarpieces and tabernacles into the city. His style also influenced his brother Pietro Lorenzetti between 1335 and 1340.[217]

In the *Consecration of St Nicholas as Bishop of Myra*, Ambrogio's descriptive precision is astounding. The representation of the three-aisled church is complete down to the smallest detail. Ambrogio used this type of church interior again, but in a more amply articulated form, in the *Presentation in the Temple* of 1342. The interior of the church in which St Nicholas is being consecrated boasts details such as the sculpted capitals on the slender aisle columns, the stairs leading to the presbytery, the Gothic biforate windows, the vaults and the slender arches and even a triptych shining with gold on the high altar.

The same mastery of interior space is shown in the *Raising of a Child Strangled by the Devil*. The event takes place in a two-storey middle-class house. Ambrogio has arranged the composition in such a way as to make the first floor,

Ambrogio Lorenzetti, *St Nicholas
Saving the City of Myra from Famine*,
detail. Uffizi, Florence.

where the narrative starts, the outside of the house, where the devil strangles the child and, finally, the ground-floor bedroom all perfectly visible. The first-floor room houses a table spread for a banquet around which are seated the guests, foreshortened from below. The back of the ground-floor bedroom is cast in shadow, accentuating the astounded parents and relatives who give thanks to St Nicholas for having saved the child.

In *St Nicholas Saving the City of Myra from Famine* Ambrogio has represented a seascape so daring and remarkable that it was not equalled throughout the fourteenth century. The St Nicholas panels were well known a century later and remained influential. Fra Angelico drew on Lorenzetti's panels when he painted the predella of the *Perugia Altarpiece* in 1437 (Pinacoteca Vaticana, Rome). This can most clearly be seen in Fra Angelico's *St Nicholas Meeting an Imperial Emissary* and *St Nicholas Saving a Boat from Shipwreck*. Sienese artists such as Pietro di Giovanni d'Ambrogio were also inspired by the Lorenzetti scenes.[218] Pietro di Giovanni adapted *St Nicholas Saving the City of Myra from Famine* in the panel he painted of the *Departure of St Augustine* (?) (Gemäldegalerie, Staatliche Museen, Berlin).[219] In doing so he took the essential structural and compositional elements from Ambrogio's scene but removed their miraculous significance. The panel, together with the *Entrance of Christ into Jerusalem* (Pinacoteca Giuseppe Stuard, Parma), once formed part of the predella of a now-dismembered triptych with a central *Madonna and Child* (Brooklyn Museum, New York).[220]

The solid and solemn figure of the saint, with his dazzling crimson mantle, stands in the foreground at the left of *St Nicholas Saving the City of Myra from Famine* yet our attention is captured by the vast spread of the greenish-azure sea that covers three-quarters of the picture surface. In the port, three large and richly ornamented ships are moored. Men in the ships and in small boats nearby hurry to unload the grain that will save the inhabitants of Myra while flying angels with enormous azure grain sacks pour more supplies into the ships. At the bottom right of the composition two sailors in a heavily laden boat pull strenuously on their oars as they row the grain towards the bank. On the horizon, silhouetted against a gold sunset, the wind-filled sails of other vessels are visible.

Ambrogio Lorenzetti, *Annunciation*. San Galgano, Montesiepi.

THE FRESCOES IN MONTESIEPI

In 1334 Ambrogio Lorenzetti witnessed a document relating to the Cistercian abbey of San Galgano.[221] Next to the abbey, on the walls of a Gothic chapel backing against the Romanesque rotunda, Ambrogio painted a now badly deteriorated narrative cycle in fresco.[222] The scenes, with their unusual iconography, depict the life of St Galganus and the Archangel Michael.[223] The episodes that can be identified include the *Archangel Michael Leading St Galganus to the Heavenly Court* and the *Vision of St Galganus in Rome*, in the background of which is a curious view of the Castel Sant'-Angelo as it was represented throughout the fourteenth century.[224] Part of a procession of angels and saints has also survived but the narrative subject can no longer be identified.

Above the altar and a little below an unusual *Maestà* Ambrogio painted the *Annunciation*, exploiting the way the window interrupts the continuity of the wall to give the scene a completely new emphasis. Lorenzetti placed the protagonists to either side of the window jambs – an idea which was later copied by Lippo Vanni in his fresco of the same subject in the church of San Leonardo al Lago, near Siena. On the left is the Archangel Gabriel, who kneels with his immense wings still unfolded, while the Virgin inhabits an austere room on the right.

When the fresco was removed in 1966, the *sinopia* (underdrawing) was uncovered and Ambrogio's original and more audacious project was brought to light. The *sinopia* shows the Virgin who, having been frightened by the arrival of Gabriel, throws herself suddenly to the ground, grabbing the column with both hands.[225] The choice of iconography remains a mystery but it could be that Lorenzetti knew of the medieval tradition according to which the pilgrims who went to Nazareth were shown where the Virgin received Gabriel's message and the column that she clutched in her fear.[226]

The proposed iconography of the *Maestà*, like that of the *Annunciation*, was too daring for the commissioner and the figure of the Virgin was therefore modified. In the *sinopia* she is represented as a queen, with a sceptre in her right hand and a globe in her left. She was later transformed by one of Ambrogio's followers into a more conventional and acceptable mother, with the Christ Child on her lap.

Ambrogio Lorenzetti,
Annunciation, sinopia.
San Galgano, Montesiepi.

Ambrogio introduced a number of other iconographic innovations in the Montesiepi *Maestà*. Eve, languidly stretched out in the foreground at the feet of the Virgin, is represented with luxuriant red hair and her arms and shoulders are covered with a goat skin, which also alludes to the sin of luxury. In her right hand she holds a scroll on which a long inscription describes Mary as the new Eve and in her left hand she holds up a small branch of a fig tree. Even the saints and the allegorical figures encircling the Virgin present new iconographic elements.

Two magnificent female figures kneel to either side of the Virgin's throne. The one on the left carries a large straw basket and offers a bunch of flowers to Mary, while the one on the right, crowned and dressed in red, gives a heart to the Virgin. Both figures represent Charity – the young woman to the left is *Amor Proximi* and the one to the right is *Amor Dei*.[227]

The Montesiepi frescoes were probably painted between 1334 and 1336.[228] They are similar in style to Ambrogio's *Maestà* in the church of Sant'Agostino in Siena, dated before Pentecost 1338 which is when the General Chapter of the Order of Augustinian Hermits met in the convent of Sant'-Agostino.

The Frescoes in the Chapter House of Sant'Agostino in Siena

Ghiberti does not mention the *Maestà* but he does recall with enthusiasm a cycle of frescoes by Ambrogio in Sant'Agostino, which have since been destroyed.[229] Judging by Ghiberti's description, these frescoes must have been both unusual and spectacular. The architecture was represented in such a way that the figures seemed to enter and exit the scenes:

At the friars of Sant'Agostino he painted the Chapter House: in the vault are depicted the stories of the Credo; on the main wall are three stories. The first is how St Catherine is in a temple, with the tyrant seated up on high, questioning her, while a festival seems to be celebrated on that day in that temple; there are many people painted in and outside of it. There are priests sacrificing at the altar. The story is on a large scale and very excellently made. On the opposite side is depicted how St Catherine is disputing before the tyrant with his sages, and how

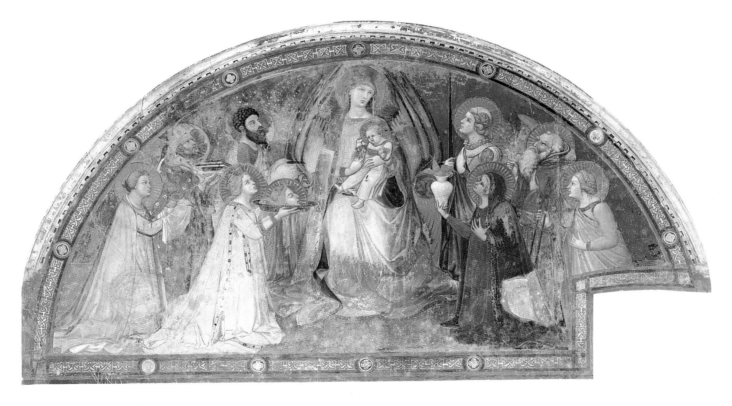

Ambrogio Lorenzetti, *Maestà*.
Sant'Agostino, Siena.

she seems to defeat them. There is shown how it seems that part of them are entering a library and are in search of books to overcome her.[230]

To achieve the new effects that Ghiberti describes Ambrogio would have had to solve the complex problem of organizing so many people within the spatial and architectural arrangement of the scenes.

The *Maestà* in Sant'Agostino, which was recovered in 1944, is similar in both iconography and style to the Montesiepi *Maestà*.[231] In the Sant'Agostino version, however, Ambrogio has introduced some new elements. The most striking of these are the form of the throne, composed of the flaming wings of seraphim, and the frightened expression of the Christ Child who pulls away from the baby sparrow struggling in Mary's hands.

Ambrogio Lorenzetti probably painted his *Massa Marittima Maestà* around 1335; only Volpe believed it to have been painted later. It was discovered in 1867 in an attic in the convent of Sant'Agostino in Massa Marittima.[232] This *Maestà* is impressive because of the variety and vivacity of its colours and the brightness of the numerous haloes that decorate the heads of the heavenly court. Among the angels, saints, apostles and prophets, each of whom Ambrogio drew separately,[233] is the patron saint of Massa Marittima, Cerbonius.

The *Massa Marittima Maestà*, mentioned by Ghiberti together with a chapel decorated in fresco,[234] contains a number of iconographic inventions designed to express various aspects of doctrine, and in this respect it is richer than any other *Maestà*.[235] These inventions were evidently inspired by the theological thought of the Augustinian commissioners.[236] It is probable that Ambrogio had an assistant while working on the *Massa Marittima Maestà* who would have executed the less important parts of the composition.

The unconventional nature of the painting means that the work is not considered to be among Ambrogio Lorenzetti's masterpieces.[237] The crowding of the figures seems excessive and some of the compositional solutions are too artificial, such as the three angels singing hosannas in the foreground and the winged throne which is not as successful as that in the Sant'Agostino *Maestà*. Vasari points out that Ambrogio used assistants to complete the painting and confirms Ghiberti's

pp. 157–158 and 163–164
Ambrogio Lorenzetti, *Effects of Good Government in the Town and Countryside*, details. Sala dei Nove, Palazzo Pubblico, Siena.

pp. 159–162
Ambrogio Lorenzetti, *Effects of Good Government in the Town and Countryside*. Sala dei Nove, Palazzo Pubblico, Siena.

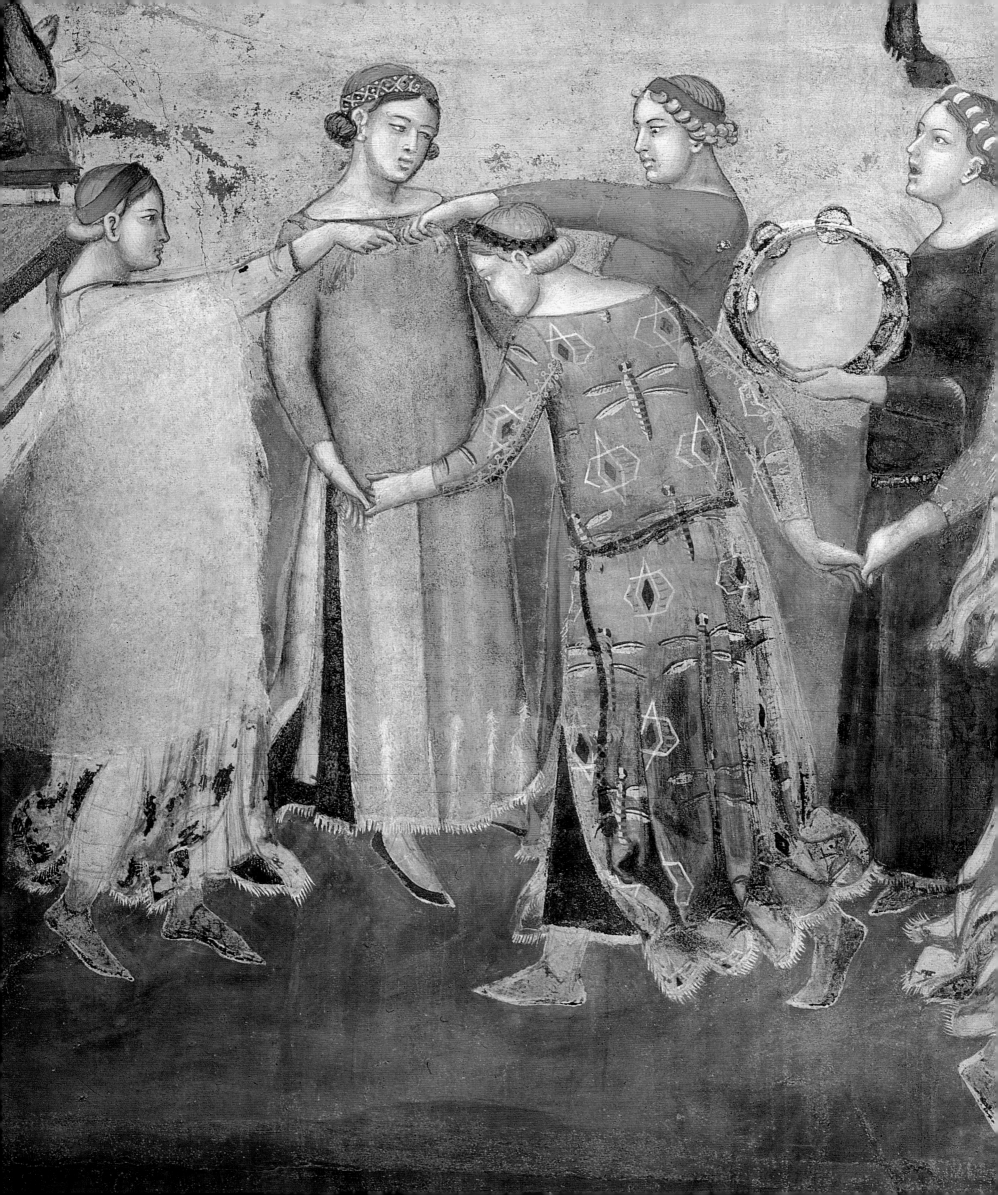

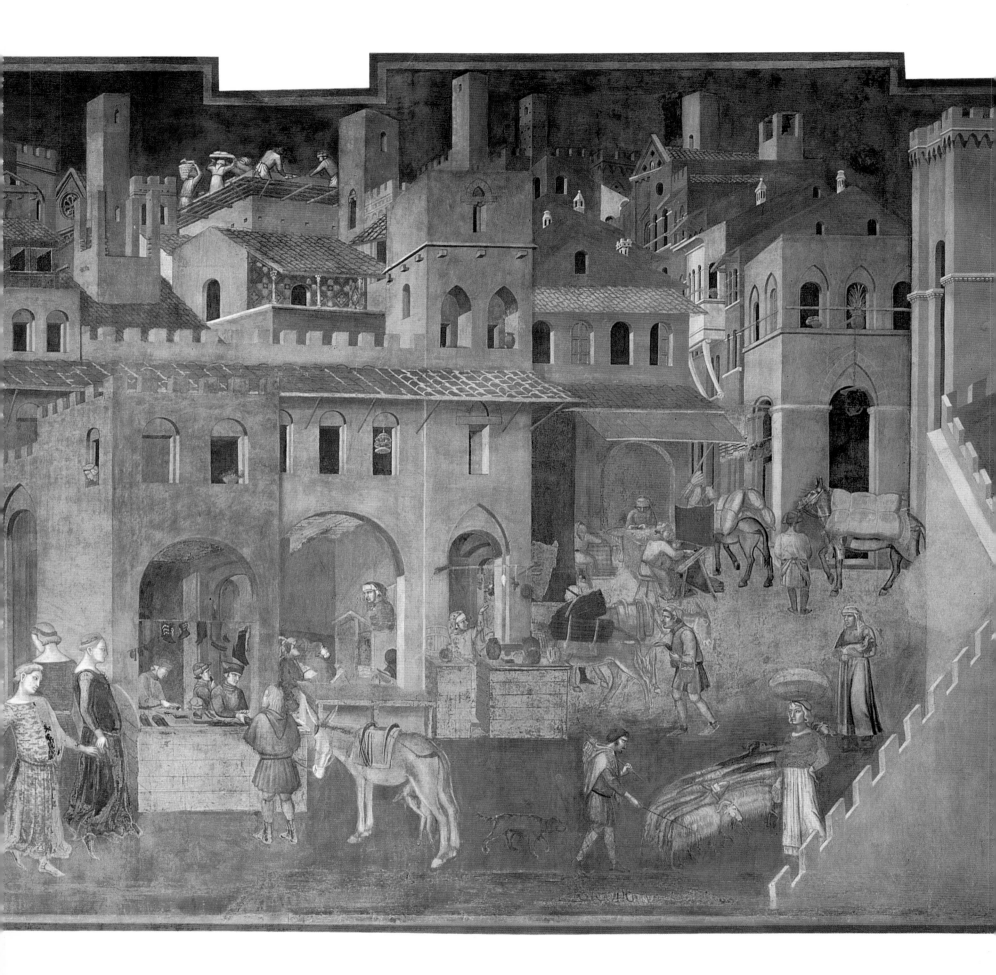

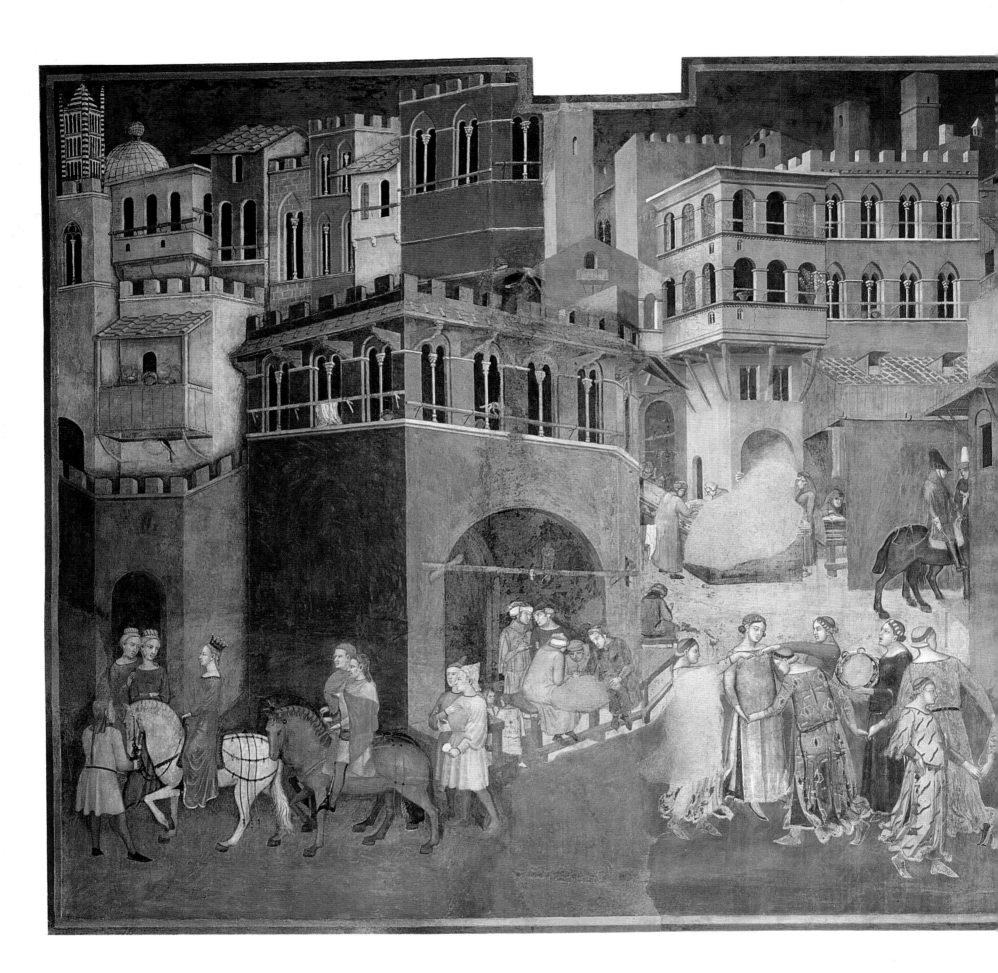

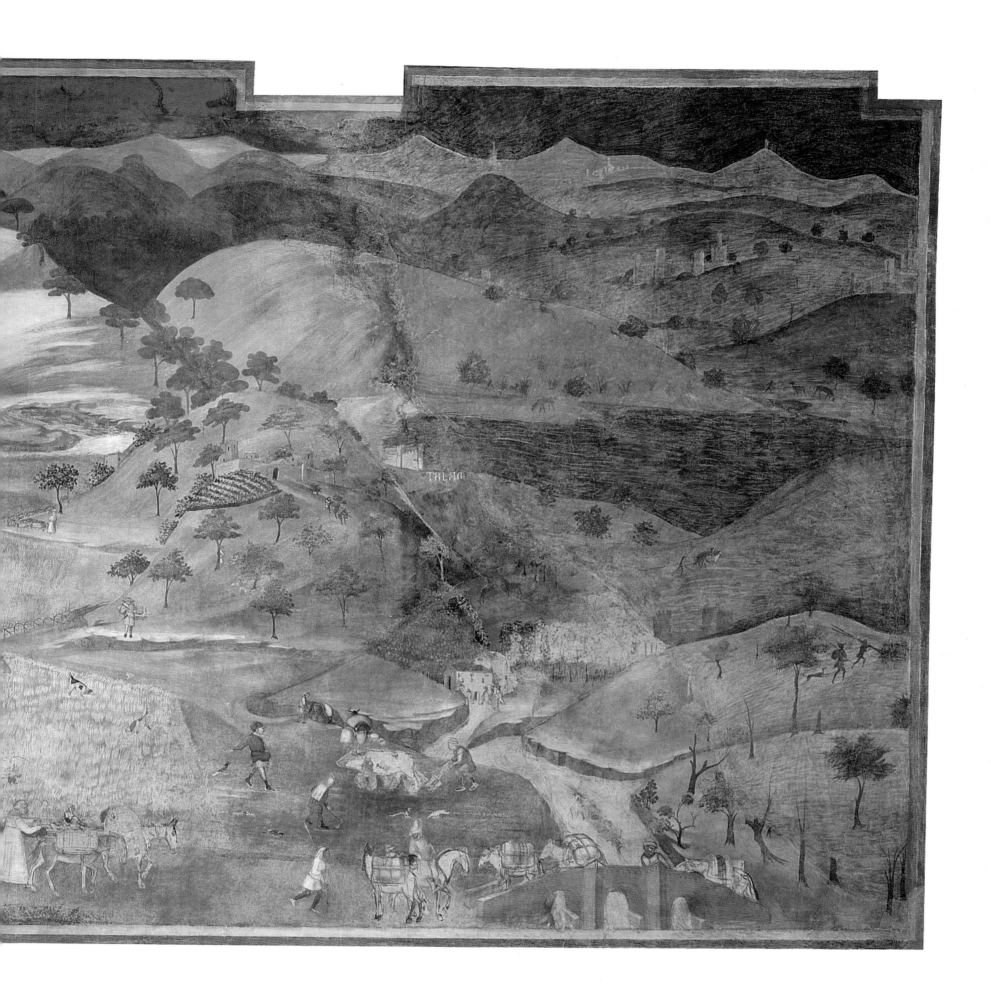

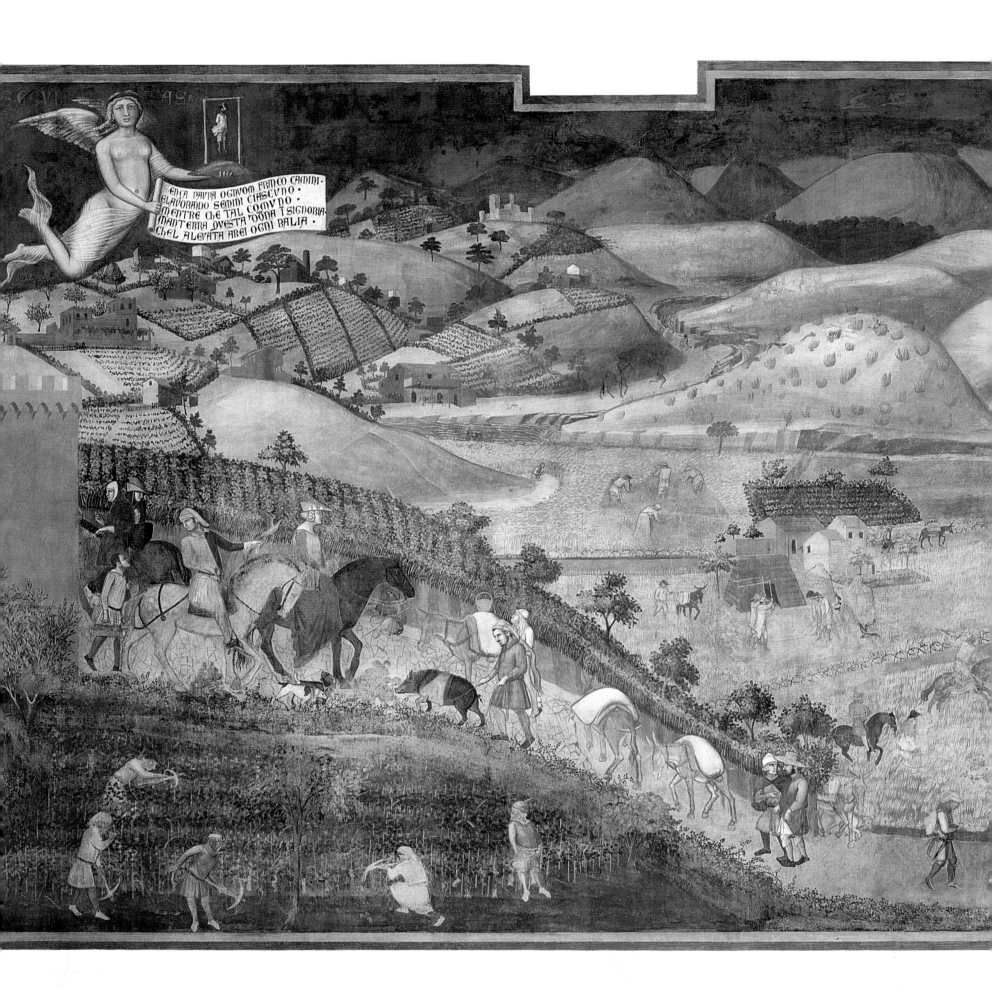

SECVRITAS

ENCA PAVRA OGNVOM FRANCO CAMINI.
ELAVORANDO SEMINI CIASCVNO.
MENTRE CHE TAL COMVNO.
MANTERRA QVESTA DONNA TSIGNORIA.
CHEL ALEVATA AREI OGNI BALIA.

information that Ambrogio had also frescoed a chapel in Massa Marittima. Unfortunately the chapel has never been found.[238]

It may be the innovative aspects of the painting that have led to its less than enthusiastic reception. Carli claimed that the work was painted entirely by Ambrogio on the basis of the revolutionary aspects of the composition, in particular the dense crowd of saints carrying the symbols of their martyrdom and the introduction of allegorical figures.[239] Faith, Hope and Charity sit on the steps leading up to the throne, each painted in the colour symbolizing their respective virtues – white, green and red.

The theological virtues in the *Massa Marittima Maestà* are undoubtedly among Ambrogio's greatest inventions and they herald the personifications that he would later paint in the *Good Government* frescoes in the Palazzo Pubblico in Siena.

Most of Ambrogio Lorenzetti's surviving works are undated and there is no documentary information about them. This means that it is difficult to reconstruct the relative chronology of the paintings and to understand Ambrogio's artistic development. The problem is amply demonstrated by

the reception of a triptych at one time in the abbey of Santi Giacomo e Cristoforo in Rofeno (Museo d'Arte Sacra, Asciano),[240] which may be the panel mentioned by Vasari in his life of Ambrogio Lorenzetti: 'At the very end of his life Ambrogio executed a much admired picture for Monte Oliveto of Chiusuri',[241] that is, at Monte Oliveto Maggiore.

It is significant that art historians have dated the work to diverse periods of Ambrogio's career. Carli believed that the painting was completed around 1330[242] but I believe that a date before the *San Procolo Triptych* is too early. Volpe dated the panels after 1340,[243] while according to Previtali the triptych was executed immediately after Lorenzetti's 1332 stay in Florence and was influenced by Simone Martini's 1333 *Annunciation*,[244] which was the cause of the 'sudden and unlooked-for renewal of the Gothic line'. I find Previtali's proposal the most convincing, although he does not take into account the Gothic aspects of the Madonna's head in the central pinnacle above the Archangel Michael. It is similar in style to the Madonna in the *San Procolo Triptych* of 1332.

The Archangel Michael poised to kill the dragon clearly demonstrates Ambrogio's powers of invention. The figure is

pp. 166–167
Ambrogio Lorenzetti,
Good Government. Sala dei Nove,
Palazzo Pubblico, Siena.

SANG...

PAX

CONCORDIA

AMBROSIVS · LAVRENTII · DESENIS · H

GRAMATICA

articulated in space in frenetic Gothic rhythms and its unusual conception has been defined as 'a characteristic fifteenth-century bit of late Gothicism with its mannered curves and patternization'.[245]

THE GOOD GOVERNMENT FRESCOES

Ambrogio Lorenzetti painted the frescoes representing *Good and Bad Government and their Effects in the Town and Countryside* in the Sala dei Nove of the Palazzo Pubblico in Siena between 1338 and 1339.[246] The first payment for the frescoes is dated 26 February 1338 and a regular series of entries records payments to Ambrogio in the following months. The last of these, on 29 May 1339, states that Ambrogio was given fifty-five gold florins 'as the remaining part of his salary… for the paintings that he did in the palace of the Lords Nine'.[247]

In less than eighteen months Ambrogio had completed the decoration of three walls of the large council room on behalf of the administrators of the Comune of Siena. The commission effectively confirmed his standing as the most highly esteemed artist in the city and, in a certain sense, as the official painter of Siena.

Ambrogio was certainly a very skilled practitioner of the fresco technique. Both Ghiberti and Vasari record cycles of his frescoes that have since been lost, and if their evidence can be believed, Ambrogio must have worked much more in fresco than other artists of his period, including Simone Martini and Pietro Lorenzetti.[248]

The frescoes in the Sala dei Nove have a complex iconographical programme encompassing allegorical, historical and doctrinal aspects. Ghiberti referred to the works as '*la pace e la guerra*' (war and peace). His concise and lively passage about the paintings confirms that he had seen the frescoes with his own eyes: 'In the Palace of Siena are painted by his [Ambrogio's] hand peace and war, and that which pertains to peace, how the merchant caravans travel safely in utmost safety, and how they leave them in the woods and how they return for them. Also the extortions made during war are perfectly indicated'.[249]

The modern title of the cycle – *Good and Bad Government and their Effects in the Town and Countryside* – was only coined in 1809 by Lanzi, who defined the frescoes as 'a poem of moral teaching'.[250] He did not, however, believe them to be

Ambrogio Lorenzetti, *Effects of Good Government in the Town*, detail. Sala dei Nove, Palazzo Pubblico, Siena.

Ambrogio's masterpiece and compared them unfavourably with the frescoes that the artist had painted in the Campo Santo in Pisa. Despite this, Lanzi thought that Ambrogio was a great artist and judged his other works much more positively, seeing him as a precursor to Fra Angelico in the fifteenth century.

The complex didactic programme in the Sala dei Nove needed to be immediately understood by the observer.[251] The frescoes show the practical means of realizing the perfect city-state and also the virtues required to be a good supporter of that state and an upholder of the common good. Ambrogio's images are explicit and exemplary. They are the natural development of his training and previous paintings. In contrast to his brother Pietro, Ambrogio liked to reveal forms in a concise and simple manner that rarely concentrated on the effect of light on colour for its own sake.[252] This is true of the *Good Government* which glows in the diffused light entering from the windows opposite. Ambrogio avoids indulging in the effects of light and shade that were so dear to Pietro, as can be seen in the left transept of the Lower Church of San Francesco in Assisi.

The majority of the personifications of moral and civic subjects are in the *Good Government*. The commissioners of the fresco intended it to be a didactic work and Ambrogio Lorenzetti rose to the challenge by translating a complex moral discussion into painting.

It is not only because of its scale in comparison to the other figures that the Comune of Siena dominates *Good Government*. The letters around his head, C.S.C.V. (*Commune Senarum Civitas Virginis* [The Comune of Siena the City of the Virgin]), identify the figure seated on a throne as the Comune of Siena. Ambrogio has represented the Comune as a middle-aged man with an air of authority, holding in his right hand a sceptre and in his left hand a shield bearing the seal of the City of Siena with the Virgin and Child. Around his head hover the theological virtues of Faith, Hope and Charity and at his feet sits the wolf with the twins Senius and Ascanius, the legendary founders of the city. Siena had always maintained her Roman origins and there is a clear parallel with the twins Romulus and Remus founding Rome. On a long bench – the shoulder rest of which is covered with a sumptuous piece of cloth decorated with geometric motifs –

Ambrogio Lorenzetti, *Effects of Good Government in the Town*, detail. Sala dei Nove, Palazzo Pubblico, Siena.

are Peace, Fortitude and Prudence to the left of the Comune of Siena while Magnanimity, Temperance and Justice sit to the right.[253]

Ambrogio's interest in classical sculpture is clear from his representation of the Virtues, especially the beautiful figure of Peace resting her serene head on her hand. She has blond tresses and Ambrogio has painted a small olive branch wound around her head. Her reclining body is subtly modelled and can be seen through her thin white, densely pleated tunic. At the far left, isolated for emphasis, sits Justice on a throne. Aristotle believed Justice to be the most important of the Virtues and Ambrogio has painted her twice in the *Good Government*, at both the far left and the far right of the fresco. The left-hand figure of Justice is a young woman wearing a flame-red tunic with rich gold trimmings around the neck and arms. Her loose plaits soften her facial features and fabulous jewels ornament her elaborate hairstyle. She lifts her eyes upwards to where the figure of Wisdom holds up the large set of scales of which Justice regulates the balance.

According to Aristotelian tradition justice is divided into two parts, distributive and commutative justice, both of which Ambrogio represents clearly and explicitly. Distributive Justice gives to each according to their merits and can be seen in action on the left balance of the scales. Here a winged figure dressed in red cuts off the head of a murderer with a long sword and at the same time crowns a victorious warrior who holds a palm and a sword in his hands. On the right balance of the scales, Commutative Justice is dressed in white and presides over commercial transactions. She reaches out to give two merchants various measuring instruments – a *staio* (equivalent to a bushel of grain) and two instruments for measuring length – which guarantee commercial honesty.[254] Two cords descend from the scales and are joined by the figure of Concord into a single rope, which she gives to the procession of the twenty-four citizens who go forth united towards the figure of the Comune of Siena.

At the bottom right of the fresco Ambrogio has painted Sienese warriors on foot and on horseback who keep watch over the security of the city and guard a group of prisoners. Beneath the twenty-four citizens is Ambrogio's signature, written, not without pride, in large capital letters – AMBROSIUS LAURENTII DESENIS HIC PINXIT

Ambrogio Lorenzetti, *Effects of Good Government in the Countryside*, detail. Sala dei Nove, Palazzo Pubblico, Siena.

UTRINQUE. The didactic value of the fresco is further enhanced by the presence of titular figures.[255]

To illustrate the effects of good government in the city and country, Ambrogio Lorenzetti repeats and enlarges the surprising definition of space that he employed in *St Nicholas Saving the City of Myra from Famine*. By representing a normal day in the life of his co-citizens, who are shown engaged in the most varied types of work, Ambrogio involves the observer in an incredible and unique spectacle.

The well-built city contains the familiar silhouette of the cathedral and *campanile* (bell tower), on a hill at the far left, and some aristocratic palaces. Life in the city continues serenely and people are able to go about their business without any hindrance because peace reigns. The range of activities and the variety of trades in the streets and piazzas are astounding. Ambrogio portrays artisans' workshops in detail with various objects on shelves or hung from the walls.

In the foreground, almost in the centre of the city, is a group of young Sienese citizens who dance in slow and rhythmic cadences. Their elegant clothes are decorated with extraordinary inventiveness.

The naked figure of Security hovers outside the city gate. She keeps watch over the land and guarantees the safety of the countryside in times of peace. Below her the Sienese landscape stretches out, enlivened on the left by a cavalcade of young men with falcons who are leaving the city gates early to go on a hunting expedition and are preceded by a young noblewoman on horseback. Further down the hill citizens head towards the city with their crops. Some carry eggs, another has a wild pig bred in the woods and others push unwilling donkeys laden with sacks, while in the fields some thresh grain, some plough and some sow.

This is perhaps the most original wall in the cycle. On it Ambrogio depicts the Sienese countryside extending as far as the Bay of Talamone. He has faithfully rendered the vast panorama and the scene is rightly regarded as the greatest fourteenth-century representation of an agricultural landscape in the whole of Europe.

Although he was capable of painting marvellous aerial views of the sea, as in *St Nicholas Saving the City of Myra from Famine*, realistic cityscapes and equally convincing representations of the pleasant hills of the Sienese countryside,

Ambrogio Lorenzetti, *Effects of Good Government in the Countryside*, detail.
Sala dei Nove, Palazzo Pubblico, Siena.

Ambrogio never drew these from nature. Nevertheless, it was Ambrogio Lorenzetti, more than any other fourteenth-century artist, who developed his interest in landscapes, seascapes and cityscapes and laid the foundation for what was to become a speciality of Sienese artists. Ambrogio's experiments expanded those already carried out by Duccio who had painted jewel-like miniature fortified cities in the scenes on the back face of the *Maestà* in Siena Cathedral and also in the *Surrender of the Castle of Giuncarico* in the Palazzo Pubblico.

Simone Martini had further developed this tendency in his incredible representations of streets and houses in the *Blessed Agostino Novello Altarpiece* and in the barren country-side of *Guidoriccio da Fogliano*. It seems likely that the artist was expected to reproduce reality as faithfully as possible. We know, for example, that before representing a castle in the Maremma that had been taken by the Sienese, Simone Martini went to visit it and this was probably not an isolated incident.[256] Pietro Lorenzetti also contributed to the genre of landscape painting in his extensive view of the countryside in the central predella panel of the *Carmelite Altarpiece*.

Although Ambrogio Lorenzetti did not reproduce urban and country scenes from life, his depiction of the city of Siena and the surrounding countryside in the Sala dei Nove is so unified that I believe it to be without precedent in the fourteenth century.

AMBROGIO LORENZETTI'S LAST WORKS

Very few works completed by Ambrogio after the frescoes in the Sala dei Nove have survived. However, those that can be attributed to the last years of his activity – either because of their style or because they are dated – still maintain the iconographic invention of Ambrogio's earlier paintings.

The *Allegory of Redemption* (Pinacoteca, Siena), which comes from the old Sienese convent of Monna Agnese, is exemplary in this regard. Ambrogio painted an aerial view as though the spectator were flying low over the countryside. In this landscape he represents the most important events in the history of the human race. These range from *Adam and Eve in the Terrestrial Paradise* and their *Expulsion from Paradise* to the *Crucifixion* – with which the first sin was redeemed – and the *Last Judgment*. The scenes show the influence of the fresco of

Ambrogio Lorenzetti,
Presentation in the Temple,
detail. Uffizi, Florence.

p. 173
Ambrogio Lorenzetti,
Presentation in the Temple.
Uffizi, Florence.

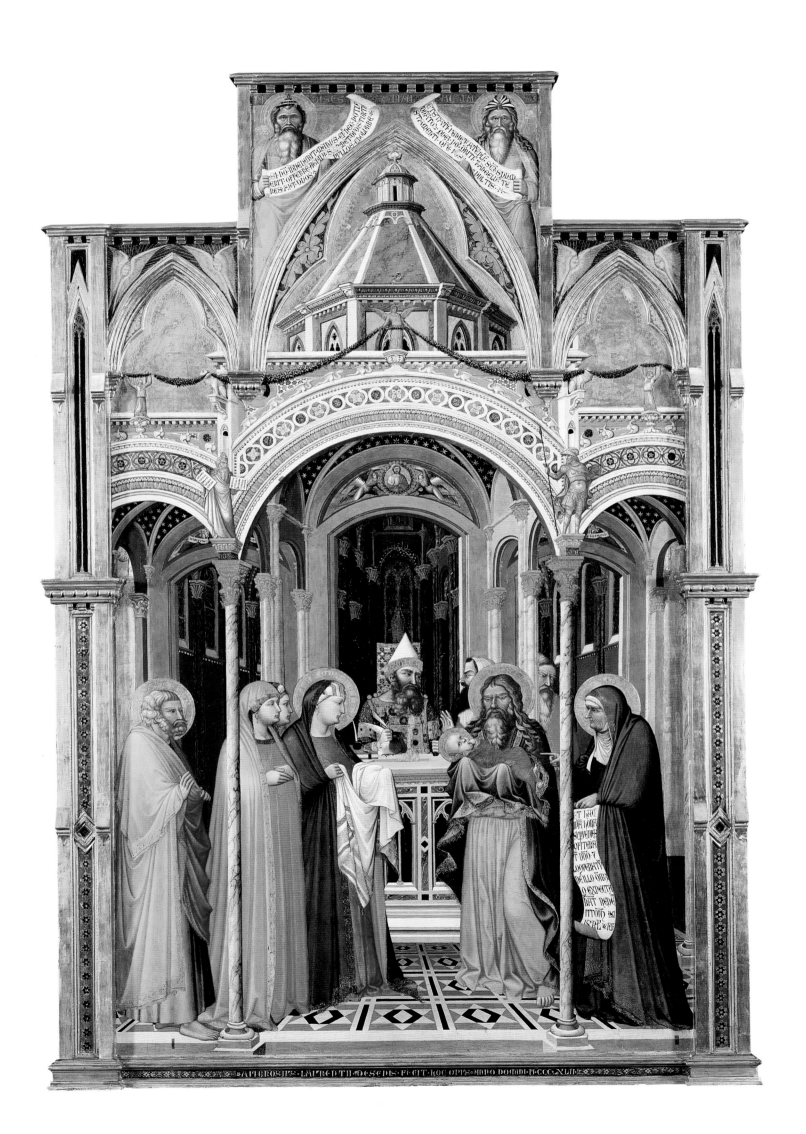

the *Triumph of Death* in the Campo Santo in Pisa, painted by Buffalmacco between 1338 and 1340. The painting originally formed part of a predella and it has been suggested that it belonged to Ambrogio's 1342 *Presentation in the Temple* (Uffizi, Florence).

In 1345 Lorenzetti's *Mappamondo* was installed in the Palazzo Pubblico. Ghiberti referred to this painting as a *cosmografia* but other sources describe it rather as a topographical map of the castles conquered by the Sienese. Unfortunately, this most unusual painting has not survived.

The *Presentation in the Temple* was the central panel of a triptych for the altar of St Crescentius, one of the four protectors of the City of Siena. When the relics of the four saints were removed from the crypt in preparation for the planned extension of Siena Cathedral, it was decided to dedicate an altar to each of them in the main body of the cathedral.[257]

The side panels of the altarpiece no longer exist but two cathedral inventories from 1429 and 1458 describe the triptych while it was still complete.[258] From them we know that the left panel contained St Crescentius holding his head in his hands and the right panel figured the Archangel Michael.

In the *Presentation in the Temple* Ambrogio has further developed the representation of the interior of a large church, which he first experimented with in the *Consecration of St Nicholas as Bishop of Myra*. The illusionistic construction of the architecture may have been inspired by the interior of Siena Cathedral, which has a similar arrangement of aisles and apse.[259] Ambrogio uses large areas of colour that transmit solemnity and dignity to the cloaked and weighty protagonists of the scene. Each of these figures stands in isolation, like a statue, as they anxiously await the words of prophecy.[260]

In the *Presentation in the Temple* Ambrogio's extraordinary ability in harmoniously distributing colours achieves a rare equilibrium. This has been interpreted as the result of the renewed influence of Pietro Lorenzetti's last works. At the time Pietro was completing the *Birth of the Virgin* for the altar of St Savinus. Both the *Birth of the Virgin* and the *Presentation in the Temple* were signed and delivered in 1342.[261]

Among Ambrogio Lorenzetti's last works is the *Maestà* now in the Pinacoteca in Siena (no. 65).[262] One of the most interesting innovations in this small panel is the unusual technique by means of which the angels who flank the Virgin

Ambrogio Lorenzetti,
Maestà. No. 65,
Pinacoteca, Siena.

Ambrogio Lorenzetti,
Maestà, detail. No. 65,
Pinacoteca, Siena.

seem to disappear into the light radiating from the background. This type of light effect was later used by Fra Angelico in the fifteenth century. Ambrogio's skill and his reputation as one of the greatest artists of the fourteenth century are evident in the lapis lazuli blue of the Virgin's mantle, in the large areas of flame red on the cloaks of the two figures in the foreground, in the splendid cobalt blue of *St Dorothy* (?) and, finally, in his advanced use of perspective.

The small *Maestà* was probably the central panel of a triptych. The two side panels have been identified as *St Martin and the Beggar* (Yale University Art Gallery, New Haven) and the *Gift of Gold to a Destitute Family* (Louvre, Paris).[263] The panels are uncommon both in shape and as subjects for the side panels of a triptych. However, I am not entirely convinced by the reconstruction of the triptych because the strokes of dense colour with which Ambrogio obtains almost impressionistic effects in the lateral panels are not consistent with the refined application of colour in the small *Maestà*.[264]

The *Annunciation* (Pinacoteca, Siena) painted for the magistrates of the Gabella in the second term of 1344 demonstrates the essential qualities of Ambrogio Lorenzetti's mature style.[265] It is the artist's last signed and dated work and reflects his continued interest in the depiction of space that he had explored throughout his career.[266] Ambrogio's understanding and mastery of this complicated subject remained unrivalled until scientific methods of representing space were formulated and recorded in Florence in the following century.

It has been suggested that the painting represents the *Annunciation of the Death of the Virgin*, rather than the *Annunciation*, as the angel holds a palm rather than a lily in his hand. The massive bodies of the two protagonists, dressed in pink and blue, fill the picture surface while their monumentality is expressed through their solemn gestures. (The Archangel Gabriel has two sets of wings that were added in the fifteenth century.)

Ambrogio Lorenzetti,
Annunciation.
Pinacoteca, Siena.

The Relationship between Painting and Goldsmithery in the Fourteenth Century

Simone Martini and the Lorenzetti brothers exerted considerable influence on contemporary goldsmithery. This is evident in the *Reliquary of the Holy Corporal* executed by Ugolino di Vieri and his assistants. The reliquary was commissioned in 1337 by the bishop of Orvieto, Tramo Monaldeschi, and by the canons of the cathedral. It was completed the following year.

As I explained earlier, the *Burial of Christ* in the *Reliquary of the Holy Corporal* was influenced by Simone Martini's version of the same subject in the *Orsini Polyptych*. The scenes from Christ's Passion on the back of the reliquary also reflect Pietro Lorenzetti's early frescoes in the Lower Church in Assisi. This is evident in the incisive lines, in the crowded scenes and in the excited and dramatic tone of the episodes.

The goldsmiths who were employed on the front face of the *Reliquary of the Holy Corporal* seem to have been influenced not only by Ambrogio Lorenzetti's solemnity and sense of volume but also by his spatially complex architectural structures.

The splendid translucent enamels of the *Frosini Reliquary*,[267] containing scenes from the life of St Galganus, were probably executed between 1300 and 1320.[268] The influence of Simone Martini's elegant Gothic rhythms, particularly those in his *Maestà* of 1315 in the Palazzo Pubblico, means that the date of the reliquary is probably nearer to 1320. The sharp line used in the scenes from the *Frosini Reliquary* also demonstrates a knowledge of the art of Ambrogio and Pietro Lorenzetti.

Notes

1 For the documents, see J.H. Stubblebine, *Duccio di Buoninsegna and his School*, Princeton 1979, pp. 191ff.

2 V. Fineschi, *Memorie istoriche che possono servire alle vite degli uomini illustri del Convento di Santa Maria Novella dall'anno 1221 al 1320*, Florence 1790, p. 19.

3 F. Wickhoff, 'Über die Zeit des Guido von Siena' in *Mitteilungen des Institutes für Österreiche Geschichtsforschung*, 1889, X, 2, p. 244.

4 W. Suida, 'Einige florentinische Maler aus der Zeit des Übergangs vom Duecento ins Trecento' in *Jahrbuch der Königlich preussichen Sammlungen*, 1905, XXVI, pp. 28–39.

5 G. De Nicola, review of C.H. Weigelt, *Duccio di Buoninsegna*, in *Bullettino senese di storia patria*, 1911, XVIII, pp. 432–433; E. Cecchi, *Trecentisti senesi*, Rome 1928, p. 48; B. Berenson, 'Missing Pictures of the Sienese Trecento' in *International Studio*, 1930, pp. 31–32.

6 P. Toesca, *Il Medioevo*, Turin 1927, II, p. 1012; L. Marcucci, *I Dipinti toscani del secolo XIII*, Rome 1958, pp. 64–68.

7 C.H. Weigelt, 'The Madonna Rucellai and the Young Duccio' in *Art in America*, XVIII, pp. 3–25 and 105–120.

8 A. Venturi, *Storia dell'arte italiana*, Milan 1907, pp. 63–80.

9 R. Longhi, 'Giudizio sul Duecento' in *Opere complete di Roberto Longhi*, Florence 1974, VII, pp. 1–53.

10 C. Volpe, 'Preistoria di Duccio', in *Paragone*, 1954, 49, pp. 4–22.

11 R. Longhi, 'Giudizio', p. 34.

12 C. Volpe, 'Preistoria di Duccio', pp. 4–22; F. Bologna, 'Ciò che resta di un capolavoro giovanile di Duccio. (Nuovi studi sulla formazione del maestro)' in *Paragone*, 1960, 125, pp. 3–31.

13 F. Bologna, 'Duccio' in *Dizionario biografico degli italiani*, 1992, p. 747.

14 L. Bellosi, 'Duccio' in *Enciclopedia dell'arte medievale*, Rome 1994, V, p. 743.

15 A. Conti, *La Miniatura bolognese. Scuole e botteghe, 1270–1340*, Bologna 1981, p. 14.

16 H. Belting, 'The "Byzantine" Madonnas: New Facts about their Italian Origin and some Observations on Duccio' in *Studies in the History of Art*, 1982, XII, pp. 7–22.

17 J.H. Stubblebine, *Duccio di Buoninsegna and his School*; F. Deuchler, *Duccio*, Milan 1984. The documents regarding Duccio's possible stay in Paris are published in Stubblebine, pp. 198–199.

18 L. Bellosi, 'Il pittore oltremontano di Assisi, il Gotico a Siena e la formazione di Simone Martini' in *Simone Martini*, conference proceedings, Siena, 27–29 March 1985, Florence 1988, pp. 39–47.

19 P. Toesca, 'Trecentisti toscani nel Museo di Berna' in *L'Arte*, 1930, XXXIII, pp. 5–15.

20 The panel measures 31.5 x 22.5 cm.

21 The panel measures 27 x 21 cm.

22 E. Carli, *Vetrata duccesca*, Florence 1946.

23 C. Volpe, *Simone Martini e la pittura senese. Da Duccio ai Lorenzetti*, Milan 1966, p. 4.

24 J. White, *Duccio. Tuscan Art and the Medieval Workshop*, London 1979, pp. 137–140.

25 E.H. Beatson, N.E. Muller and J.B. Steinhoff, 'The St Victor Altarpiece in Siena Cathedral: A Reconstruction' in *The Art Bulletin*, 1986, LXVIII, 4, pp. 610–631. See also K. Christiansen, 'The San Vittorio Altarpiece in Siena Cathedral' in *The Art Bulletin*, 1987, LXIX, p. 467. For information on the decorative programme in honour of the Virgin and on the altars of the four patron saints of Siena, see H. van Os, *Sienese Altarpieces. 1215–1460*, 2 vols, Groningen 1984 and 1990.

26 C. Brandi, *Duccio*, Florence 1951; J.H. Stubblebine, *Duccio di Buoninsegna and his School*.

27 F. Zeri, 'Un polittico di Segna di Buonaventura' in *Paragone*, 1958, 103, pp. 63–68.

28 See G. Damiani, in *Il Gotico a Siena*, Florence 1982, pp. 92–94. For the documents relating to the *Resurrection Polyptych*, see F. Polcri, 'Un nuovo documento su Niccolò di Segna autore del polittico della Resurrezione di Sansepolcro' in *Commentari d'arte*, 1995, 2, pp. 35–40.

29 C. Volpe, in *Il Gotico a Siena*, p. 141.

30 H. Loyrette, 'Une Source pour la reconstruction du polyptyque d'Ugolino da Siena à Santa Croce' in *Paragone*, 1978, 343, pp. 15–23.

31 L. Ghiberti, *I Commentari*, edited by J. von Schlosser, Berlin 1912, p. 43, describes it as a *Coronation of the Virgin*.

32 J. White, *Duccio. Tuscan Art and the Medieval Workshop*, p. 86.

33 J. Pope-Hennessy, 'A Misfit Master' in *New York Review of Books*, 1980, XXVII, 18, pp. 45–47; idem, 'Some Italian Primitives' in *Apollo*, 1983, CXVIII, pp. 10–15.

34 A. Lisini and F. Iacometti (eds), *Cronache Senesi*, XV, 6, of *Rerum italicarum scriptores*, Bologna 1939.

35 L. Bellosi, 'Duccio', p. 745.

36 A. Conti, review of J. White, *Duccio. Tuscan Art and the Medieval Workshop*, in *Prospettiva*, 1980, 23, pp. 98–101.

37 F. Bologna, 'Duccio', p. 748.

38 Ibid.

39 L. Bellosi, 'Duccio', p. 747.

40 J. White, *Duccio*, p. 100.

41 Ibid., pp. 80–136.

42 F.M. Perkins, 'Di alcune opere poco note di Ambrogio Lorenzetti' in *Rassegna d'arte*, 1904, IV, pp. 186–191; idem, 'The Sienese Exhibition of Ancient Art' in *The Burlington Magazine*, 1904, V, pp. 581–584; idem, 'Segna di Buonaventura' in U. Thieme and F. Becker, *Allgemeines Lexikon der Bildenden Künstler*, Leipzig 1936, XXX, pp. 449–450; C. Gamba, 'Di alcune pitture poco conosciute della Toscana' in *Rivista d'arte*, 1906, VI, pp. 45–47; F. Arcangeli, 'La "Maestà" di Duccio a Massa Marittima' in *Paragone*, 1970, 249, pp. 4–14; L. Coletti, 'The Early Works of Simone Martini' in *Art Quarterly*, 1949, XII, pp. 291–308.

43 E. Carli, *I Capolavori dell'arte senese*, exhibition catalogue, Florence 1947 (1946), p. 21; idem, *L'Arte a Massa Marittima*, Siena 1976, pp. 54–58; idem, *La Pittura senese del Trecento*, Venice 1981, p. 70.

44 For the decoration of the Sala del Mappamondo with the castles conquered by the Sienese, see E. Carter Southard, *The Frescos in Siena's Palazzo Pubblico, 1289–1539: Studies in Imagery and Relations to other Communal Palaces in Tuscany*, New York and London 1979.

45 G. Ragionieri, *Simone e non Simone*, Florence 1985; M. Seidel, '"Castrum pingatur in palatio". 1 Ricerche storiche e iconografiche sui castelli dipinti nel Palazzo Pubblico di Siena' in *Prospettiva*, 1982, 28, pp. 17–40.

46 L. Bellosi, '"Castrum pingatur in palatio". 2 Duccio e Simone Martini pittori di castelli senesi "a l'esemplo come erano"' in *Prospettiva*, 1982, 28, pp. 41–65.

47 A. Martindale, *Simone Martini*, Oxford 1988, pp. 14–17 and 204–209.

48 J.H. Stubblebine, *Duccio di Buoninsegna and his School*.

49 C. Volpe, in *Il Gotico a Siena*, p. 139.

50 For the innovations in the materials used by Simone Martini, which were brought to light during the recent restoration of the *Maestà*, and for the effect this has on its dating, see A. Bagnoli, 'I tempi della "Maestà". Il restauro e le nuove evidenze' in *Simone Martini*, Florence 1988, pp. 109–118.

51 Ibid.

52 P. Bacci, *Fonti e commenti per la storia dell'arte senese*, Siena 1944, p. 136. See also A. Martindale, *Simone Martini*, pp. 17ff. and 207ff.

53 J. White, *Duccio*, p. 96.

54 A. Martindale, *Simone Martini*, p. 208.

55 A. Bagnoli, in *Simone Martini*, p. 114.

56 A. Martindale, *Simone Martini*, p. 208.

57 After recent restoration, Bagnoli examined and confirmed the authenticity of Simone's signature, which had been much disputed in the past. See A. Bagnoli, in *Simone Martini*, p. 115.

58 A. Martindale, *Simone Martini*, pp. 19–23 and 174–181.

59 Translator's note: For the attributional problems surrounding the *St Francis Cycle* in the Upper Church, see A. Smart, *The Assisi Problem and the Art of Giotto*, Oxford 1971.

60 L. Bellosi, in *Simone Martini*, pp. 39–47.

61 F. Bologna, 'Simone Martini' in *I Maestri del colore*, Milan 1966, 119; idem, *Simone Martini. Affreschi di Assisi*, Milan 1968, p. 13.

62 I. Hueck, 'Die Kapellen der Basilika San Francesco in Assisi: die Auftraggeber und die Franziskaner' in *Patronage and Public in the Trecento* (Styria 1984), Florence 1986, pp. 81–104, especially pp. 96–98.

63 A. Martindale, *Simone Martini*, pp. 174–181.

64 Ibid., p. 174; L. Bellosi, in *Simone Martini*, pp. 39–47.

65 C. Volpe, *Pietro Lorenzetti*, Milan 1989, p. 36.

66 For recent suggestions relating to the iconography of the St Martin Chapel in the Lower Church of San Francesco in Assisi, see A. Garzelli, 'Peculiarità di Simone ad Assisi: gli affreschi della Cappella di San Martino' in *Simone Martini*, pp. 55–65.

67 For Simone Martini's influence on Tino di Camaino, see G. Kreytenberg, *Tino di Camaino*, Florence 1986; idem, 'Tino di Camaino e Simone Martini' in *Simone Martini*, pp. 203–209.

68 W.R. Valentiner, *Tino di Camaino. A Sienese Sculptor of the Fourteenth Century*, Paris 1935, pp. 6, 50 and 113ff.

69 A. Martindale, *Simone Martini*, pp. 192–194.

70 M.C. Gozzoli, *L'opera completa di Simone Martini*, Milan 1970, p. 90.

71 F. Aceto, 'Pittori e documenti della Napoli angioina: aggiunte e espunzioni' in *Prospettiva*, 1992, 67, pp. 53–65; F. Bologna, *I pittori alla corte angioina di Napoli (1266–1414)*, Rome 1969.

72 C. Bertelli, 'Vetri e altre cose nella Napoli angioina' in *Paragone*, 1972, 263, pp. 89–106.

73 For the attempts to reconstruct the San Gimignano polyptych, see K. Steinweg, 'Beitrage zu Simone Martini und seiner Werkstatt' in *Mitteilungen des Kunsthistorischen Institutes in Florenz*, 1956, XVII, pp. 161–168.

74 C. De Benedictis, in *Simone Martini e 'chompagni'*, exhibition catalogue, Florence 1985, pp. 47–50. For a different opinion, see A. Martindale, *Simone Martini*, pp. 200–202.

75 The *Annali* were published for the first time by F. Bonaini, *Memorie inedite intorno alla vita e ai dipinti di Francesco Traini*, Pisa 1846, p. 38.

76 For a new and convincing proposal regarding the reconstruction of the polyptych, see I. Hueck, 'Simone attorna al 1320' in *Simone Martini*, pp. 49–54. For the reassembly of the predella, see A. Caleca, in *Mostra del restauro delle opere delle provincie di Pisa e Livorno*, Pisa 1971, p. 22. For the iconography and the question of whether it should be dated 1319 or 1320, see J. Cannon, 'Simone Martini, the Dominicans and the Early Sienese Polyptych' in *Journal of the Warburg and Courtauld Institutes*, 1982, XLV, pp. 69–93.

77 A. Martindale, *Simone Martini*, pp. 7, 28 and 196.

78 P. Leone di Castris, *Simone Martini*, Florence 1989, pp. 72–73.

79 G. Previtali, Introduction to *Simone Martini e 'chompagni'*, p. 27; idem, 'Introduzione ai problemi della bottega di Simone Martini' in *Simone Martini*, pp. 151–166.

80 A. Martindale, *Simone Martini*, p. 29.
81 F. Bologna, *Simone Martini. Affreschi*.
82 M. Lonjon, 'Quatre médaillons de Simone Martini: la reconstitution du retable de l'église San Francesco à Orvieto' in *Revue du Louvre*, 1983, 3, pp. 199–211.
83 G. Previtali, in *Simone Martini e 'chompagni'*, pp. 11–32. Previtali had already addressed the problems surrounding Giotto's workshop in *Giotto e la sua bottega* (1967), Milan 1993, p. 93 and *passim*.
84 J. White, *Duccio*, p. 10.
85 A. Martindale, *Simone Martini*, pp. 211–214.
86 For the history and the iconography of the tomb, see A. Bagnoli and M. Seidel, *scheda* no. 7, in *Simone Martini e 'chompagni'*, pp. 56–72.
87 Ibid., p. 56.
88 G. Paccagnini, 'An Attribution to Simone Martini' in *The Burlington Magazine*, 1948, XC, pp. 75–80.
89 F. Bologna, in *Simone Martini e 'chompagni'*, pp. 73–76.
90 M.P. Di Dario Guida, 'Itinerari per la Calabria' in the guide from *L'Espresso*, Rome 1983, p. 174.
91 A. Martindale, *Simone Martini*, pp. 210–211.
92 A complete summary of the questions surrounding the fresco can by found in G. Ragionieri, *Simone e non Simone*.
93 L. Cateni, 'Testimonianze sul "Guidoriccio" anteriori al Della Valle' in *Prospettiva*, 1985, 41, pp. 46–50.
94 M. Seidel, '"Castrum pingatur in palatio"', pp. 17–40. L. Bellosi, '"Castrum pingatur in palatio"', pp. 41–65.
95 F. Bologna, in *Simone Martini e 'chompagni'*; A. Martindale, *Simone Martini*, pp. 41–43 and 187–190.

96 E. Carter Southard, *The Frescos in Siena's Palazzo Pubblico*, pp. XXI–XXX.
97 E. Carli, in G. Cecchini and E. Carli, *San Gimignano*, Siena 1962.
98 G. Chelazzi Dini, 'Un Capolavoro giovanile di Simone Martini' in *Prospettiva*, 1983–1984, 33–36, *Studi in onore di Luigi Grassi*, pp. 29–32.
99 A. Martindale, *Simone Martini*, pp. 171–173.
100 J. Brink, 'Francesco Petrarca and the Problem of Chronology in the Late Paintings of Simone Martini' in *Paragone*, 1977, 331, pp. 3–9.
101 A. Martindale, *Simone Martini*, pp. 183 and 191–192.
102 For the frescoes with scenes from the New Testament in San Gimignano and the related documents, see A. Bagnoli, *Simone Martini*, p. 116.
103 A. Martindale, *Simone Martini*, p. 184.
104 L. Bellosi, in *Il Gotico a Siena*, p. 184.
105 'Oh bountiful Italian soil, thou hast nourished [many] great poets/ But this man [Virgil] has enabled you to obtain the aims of the Greeks./ Servius [is here] uncovering the secrets of Maro the high-sounding,/ that they may be revealed to leaders, shepherds and farmers.' The translation is from A. Martindale, *Simone Martini*, Oxford 1988.
106 These lines can be translated as: 'Mantua bore Virgil, who fashioned such poetry/ Siena bore Simone who painted such works with his hand'.
107 For further information on the frescoes and their dating, see F. Enaud, 'Les fresques de Simone Martini à Avignon et leurs restaurations' in *Simone Martini*, pp. 211–224.
108 C.H. Weigelt, 'Minor Simonesque Masters' in *Apollo*, 1931, XIV, pp. 1–13.

109 C. Volpe, 'Precisazioni sul "Barna" e sul "Maestro di Palazzo Venezia"' in *Arte antica e moderna*, 1960, 10, pp. 149–158.
110 Ibid.
111 C. De Benedictis, 'Il Polittico della passione di Simone Martini e una proposta per Donato' in *Antichità viva*, 1976, XV, 6, pp. 3–11; idem, *La Pittura senese, 1330–1370*, Florence 1979, pp. 40ff. and 91; for the documents regarding Donato Martini, see G. Milanesi, *Documenti per l'arte senese*, Siena 1854, I, p. 216.
112 G. Previtali, in *Simone Martini*, p. 28.
113 M. Lonjon, in *L'Art gotique siennois*, Florence 1983, p. 192.
114 F. Zeri, *Italian Paintings in the Walters Art Gallery*, Baltimore 1976, p. 43.
115 J. White, *Duccio*, pp. 42–44.
116 L. Bellosi, 'Moda e cronologia. B) Per la pittura di primo Trecento' in *Prospettiva*, 1977, 11, p. 19.
117 M. Boskovits, 'Il Gotico senese rivisitato: proposte e commenti su una mostra' in *Arte Cristiana*, 1983, LXXI, 698, pp. 259–276.
118 See *Simone Martini e 'chompagni'*, pp. 103–104.
119 L. Bellosi, *Mostra di opere d'arte restaurate nelle province di Siena e Grosseto*, Genoa 1981, II, p. 28.
120 C. De Benedictis, *Mostra di opere d'arte restaurate nelle province di Siena e Grosseto*, Genoa 1979, I, p. 42.
121 G. Moran, 'Is the Name Barna an Incorrect Transcription of the Name Bartolo?' in *Paragone*, 1976, 311, pp. 76–80.
122 A. Caleca, 'Tre polittici di Lippo Memmi. Un'ipotesi sul Barna e la bottega di Simone Martini e Lippo' in *Critica d'arte*, 1976, 1, 150, pp. 49–59; ibid., 1977, 2, 151, pp. 55–80.

123 See C. Volpe, 'Precisazioni sul "Barna" e sul "Maestro di Palazzo Venezia"', pp. 149–158, for the dating of the San Gimignano frescoes.
124 P. Bacci, 'Il Barna o Berna, pittore della Collegiata di San Gimignano, è mai esistito?' in *La Balzana*, 1927, I, pp. 245–253.
125 C. Volpe, in *Il Gotico a Siena*, pp. 186–187. For the various opinions on this question, see C. Volpe, 'Precisazioni sul "Barna" e sul "Maestro di Palazzo Venezia"', pp. 149–158; E. Castelnuovo, 'Barna' in *Dizionario biografico degli italiani*, Rome 1964, VI, pp. 410–413; L. Bellosi, 'Moda e cronologia. B) Per la pittura di primo Trecento', p. 20; L. Bellosi, in *Simone Martini*, pp. 94–100; G. Previtali, in *Simone Martini*, pp. 29–32.
126 For the two paintings in the Louvre, see E. Mognetti and M. Lonjon, 'Le Panneau double-face du Maître des Anges Rebelles: recherches sur l'image et la forme' in *Hommage à Michele Laclotte. Étude sur la peinture du Moyen Age et de la Renaissance*, Rome 1994, pp. 35–49.
127 M. Laclotte, 'Le Maître des Anges Rebelles' in *Paragone*, 1969, 237, pp. 3–14.
128 See E. Mognetti and M. Lonjon, note 126 above.
129 J. Polzer, 'The "Master of the Rebel Angels" Reconsidered' in *The Art Bulletin*, 1981, LXIII, II, pp. 563–584.
130 F.M. Perkins, 'Some Sienese Paintings in American Collections' in *Art in America*, 1920, VIII, pp. 272–287.
131 D. Thiebaut, in *L'Art gotique siennois*, Florence 1983, p. 184.
132 On the artistic, historical and religious environment in Avignon and more generally in Provence in the fourteenth and fifteenth centuries, see

M. Laclotte and D. Thiebaut, *L'École d'Avignon*, Paris 1983.

133 E. Castelnuovo, 'Avignone rievocata' in *Paragone*, 1959, 119, pp. 28–51; idem, *Un Pittore italiano alla corte di Avignone. Matteo Giovannetti e la pittura in Provenza nel secolo XIV*, Turin 1962.

134 C. Volpe, 'Un'opera di Matteo Giovannetti' in *Paragone*, 1959, 119, pp. 63–66.

135 R. Longhi, 'Ancora del Maestro dei Santi Ermagora e Fortunato' in *Arte Veneta*, 1948, II, pp. 41–43.

136 L. Vertova, 'Testimonianze frammentarie di Matteo Giovanetti' in *Festschrift Ulrich Middeldorf*, Berlin 1968, pp. 45–51.

137 C. Volpe, *Pietro Lorenzetti*, p. 22.

138 J.A. Crowe and G.B. Cavalcaselle, *A New History of Painting in Italy*, London 1864, II, pp. 125ff.

139 C. Volpe, 'Proposte per il problema di Pietro Lorenzetti' in *Paragone*, 1951, 23, pp. 13–26; idem, *Pietro Lorenzetti*, p. 22.

140 L. Bellosi, *Pietro Lorenzetti ad Assisi*, Assisi 1982.

141 G. Chelazzi Dini, 'Un bassorilievo di Tino di Camaino a Galatina' in *Dialoghi di storia dell'arte*, 1995, 1, pp. 28–41.

142 O. Oertel, *Die Frühzeit der Italienischen Malerei*, Stuttgart 1953, p. 144.

143 M. Meiss, 'Nuovi dipinti e vecchi problemi' in *Rivista d'arte*, 1955, XXX, pp. 107–145.

144 For the disturbances in Assisi, see also M. Lucco, in C. Volpe, *Pietro Lorenzetti*, p. 16.

145 F. Bologna, *I pittori alla corte angioina di Napoli*, pp. 151, 175 and notes 40–43; C. Volpe, *Pietro Lorenzetti*, p. 37.

146 I. Hueck, 'Una Crocifissione su marmo del primo Trecento e alcuni smalti senesi' in *Antichità viva*, 1969, VIII, 1, pp. 22–34; idem, in *Il Gotico a Siena*, pp. 96–98.

147 E. Cioni, 'Alcune ipotesi per Guccio di Mannaia' in *Prospettiva*, 1979, 17, pp. 47–58; P. Toesca, *Il Trecento*, Turin 1951, p. 894.

148 M. Meiss, 'Ugolino Lorenzetti' in *The Art Bulletin*, 1931, XIII, pp. 376–397, especially pp. 380 and 393; idem, 'Nuovi dipinti e vecchi problemi', pp. 107–145.

149 For the identification of the Benedictine saint with St Leonard, see M. Seidel, in *Mostra di opere d'arte retaurate nelle province di Siena e Grosseto*, I, pp. 52–54.

150 M. Meiss, 'Nuovi dipinti e vecchi problemi', pp. 113–123.

151 H. Thode, 'Studien zur Geschichte der Italienischen Kunst im XIV Jahrhundert' in *Repertorium für Kunstwissenschaft*, 1888, XI, pp. 1–22.

152 C. Volpe, *Pietro Lorenzetti*, pp. 121–125.

153 Ibid., p. 58.

154 A.M. Maetzke, *Arte nell'aretino*, Florence 1979, pp. 26–36.

155 C. Brandi, *Pietro Lorenzetti*, Rome 1958.

156 C. Volpe, *Pietro Lorenzetti*.

157 J. Cannon, 'Pietro Lorenzetti and the History of the Carmelite Order' in *Journal of the Warburg and Courtauld Institutes*, 1987, L, pp. 18–28.

158 F. Zeri, 'Pietro Lorenzetti: quattro pannelli della Pala del 1329 al Carmine' in *Arte illustrata*, 1974, 58, pp. 146–156; H.B.J. Maginnis, 'Pietro Lorenzetti's Carmelite Madonna: a Reconstruction' in *Pantheon*, 1975, 33, pp. 10–16.

159 J. Cannon, 'Pietro Lorenzetti and the History of the Carmelite Order', pp. 18–28.

160 C. Volpe, *Pietro Lorenzetti*, p. 137.

161 R. Bartalini, 'Maso, la cronologia della cappella Bardi di Vernio e il giovane Orcagna' in *Prospettiva*, 1995, 77, pp. 16–35.

162 C. Volpe, *Pietro Lorenzetti*, p. 41.

163 L. Bellosi, *Pietro Lorenzetti ad Assisi*.

164 C. Volpe, *Pietro Lorenzetti*, p. 42.

165 E.T. Dewald, 'Pietro Lorenzetti' in *Art Studies*, 1929, VII, pp. 131–166; idem, *Pietro Lorenzetti*, Cambridge (Mass.) 1930.

166 F. Zeri, 'Reconstruction of a Two-sided Reliquary Panel by Pietro Lorenzetti' in *The Burlington Magazine*, 1953, XCV, p. 245.

167 H. van Os, *Sienese Altarpieces 1215–1460*, I, p. 82.

168 P. Bacci, 'Il pittore Mattia Preti a Siena' in *Bullettino senese di storia patria*, 1931, II, p. 2, note 1.

169 L. Ghiberti, *I Commentari*, p. 41.

170 Ibid.

171 G. Vasari, *The Lives of the Painters, Sculptors and Architects*, translated by A.B. Hinds, London and New York 1966, I, pp. 98–99.

172 G. Vasari, *The Lives of the Painters*, p. 123.

173 On Ghiberti's reliability, see L. Bellosi, *Buffalmacco e il trionfo della morte*, Turin 1974, pp. 113–119.

174 I. Ugurgieri Azzolini, *Le Pompe sanesi*, Pistoia 1649, II, pp. 336–338.

175 C. Volpe, *Pietro Lorenzetti*, p. 54.

176 D. Gallavotti Cavallero, *Lo Spedale di Santa Maria della Scala*, Pisa 1985, pp. 70–72; idem, 'Pietro, Ambrogio e Simone, 1335, e una questione di affreschi perduti' in *Prospettiva*, 1987, 48, pp. 69–74. On this subject and on the fourteenth- and fifteenth-century derivations from the frescoes, see H.B.J. Maginnis, 'The Lost Façade Frescos from Siena's Ospedale di S. Maria della Scala' in *Zeitschrift für Kunstgeschichte*, 1988, pp. 180–194;

P. Lorentz, 'De Sienne à Strasbourg: posterité d'une composition d'Ambrogio Lorenzetti, la "Nativité de la Vierge" de la façade de l'Hôpital Santa Maria della Scala à Sienne' in *Homage à Michel Laclotte*, pp. 118–131.

177 M. Eisenberg, 'The First Altarpiece for the "Cappella de' Signori" of the Palazzo Pubblico in Siena:… *tales figure sunt adeo pulcre*' in *The Burlington Magazine*, 1981, CXXIII, pp. 134–148.

178 F. Zeri, 'Un Dittico lorenzettiano' in *Diari di lavoro*, Bergamo 1971, pp. 17–19; idem, 'Ancora un dittico e un problema lorenzettiano', ibid., pp. 20–24.

179 C. Volpe, *Pietro Lorenzetti*, p. 52.

180 G. Richa, *Notizie istoriche delle chiese fiorentine*, Florence 1754, p. 398.

181 L. Bellosi, *Buffalmacco e il trionfo della morte*.

182 M. Boskovits, *Frühe Italienische Malerei, Gemäldegalerie Berlin*, Berlin 1988, pp. 84–91.

183 M. Carmichael, 'An Altarpiece of Saint Humility' in *The Ecclesiastical Review*, 1913, pp. 405ff.

184 L. Marcucci, 'La Data della Santa Umiltà di Pietro Lorenzetti' in *Arte antica e moderna*, 1961, 13–16, pp. 21–26; see *Acta Sanctorum*, Antwerp 1785, May, V, pp. 203–222.

185 *Acta Sanctorum*, August, V, pp. 843–853; M. Boskovits, *Frühe Italienische Malerei, Gemäldegalerie Berlin*, pp. 84–91.

186 C. Volpe, *Pietro Lorenzetti*, p. 177.

187 G. Chelazzi Dini, *Il Gotico a Siena*, pp. 229–232; idem, 'Alcune miniature di Pietro Lorenzetti' in *Antichità viva*, 1985, 1–3, pp. 17–20.

188 C. Volpe, *Pietro Lorenzetti*, p. 208; G. Chelazzi Dini, in *Il Gotico a Siena*,

pp. 162–163; idem, 'Alcune miniature di Pietro Lorenzetti', pp. 17–20.
189 L. Marcucci, *I Dipinti toscani del secolo XIV*, pp. 157–158.
190 C. Brandi, 'Affreschi inediti di Pietro Lorenzetti' in *L'Arte*, 1931, IV, pp. 332–347.
191 It is believed that Pietro Lorenzetti was the elder brother because his name preceded Ambrogio's on the inscription which was once under the frescoes on the façade of the Ospedale di Santa Maria della Scala showing scenes from the life of the Virgin. The frescoes have since been lost.
192 L. Ghiberti, *I Commentari*, p. 40.
193 G. Vasari, *The Lives of the Painters*, p. 124.
194 L. Ghiberti, *I Commentari*, pp. 40–41. The translation is taken from G. Rowley, *Ambrogio Lorenzetti*, Princeton 1958, I, p. 133.
195 M. Seidel, in *Mostra di opere*, 1979, I, pp. 58–60.
196 Ibid.; idem, 'Wiedergefundene Fragmente eines Hauptwerks von Ambrogio Lorenzetti. Ergebnisse der Restaurierungen im Kloster von San Francesco in Siena' in *Pantheon*, 1978, 36, pp. 119–127; idem, 'Gli affreschi di Ambrogio Lorenzetti nel Chiostro di San Francesco a Siena: ricostruzione e datazione' in *Prospettiva*, 1979, 18, pp. 10–20.
197 G. Rowley, *Ambrogio Lorenzetti*, I, p. 132.
198 G. De Nicola, 'Il Soggiorno fiorentino di Ambrogio Lorenzetti' in *Bollettino d'arte*, 1922, pp. 49–58.
199 G. Previtali, in G. Vasari, *Le Vite de' più eccellenti pittori, scultori e architettori* (Florence 1568), edited by P. Della Pergola, L. Grassi and G. Previtali, Novara 1967, I, p. 413.
200 M. Boskovits, 'Considerations on Pietro and Ambrogio Lorenzetti' in *Paragone*, 1986, 439, pp. 3–16.

201 A. Grunzweig, 'Una nuova prova del soggiorno di Ambrogio Lorenzetti in Firenze' in *Rivista d'arte*, 1933, XV, pp. 249–251; Florence, Archivio di Stato, *Mercanzia*, register 1033, fol. 69v.
202 G. Rowley, *Ambrogio Lorenzetti*, p. 129.
203 The information was clarified by I. Hueck, 'Le Matricole dei pittori fiorentini prima e dopo il 1320' in *Bollettino d'arte*, 1972, LVII, pp. 114–121, especially p. 116. It is usually agreed that Ambrogio matriculated in 1327.
204 F. Bocchi and G. Cinelli, *Le Bellezze della città di Firenze*, Florence 1677, pp. 38–39. For the complex history of the triptych, see L. Marcucci, *I dipinti toscani del secolo XIV*, pp. 159–161; *Gli Uffizi. Catalogo generale*, Florence 1979, p. 341.
205 L. Marcucci, *I Dipinti toscani del secolo XIV*, p. 160; G. Richa, *Notizie istoriche delle chiese fiorentine*, Florence 1754, I, pp. 239 and 242–243.
206 G. Rowley, *Ambrogio Lorenzetti*, pp. 49–51. Rowley's monograph on Ambrogio Lorenzetti, despite its mistakes in methodology, contains some interesting ideas. See also G. Previtali, 'L'Ambrogio Lorenzetti di George Rowley' in *Paragone*, 1960, 127, pp. 70–74; R. Offner, 'Reflections on Ambrogio Lorenzetti' in *Gazette des Beaux-Arts*, 1960, pp. 235–238; L. Cateni, 'Un polittico "too remote from Ambrogio" firmato da Ambrogio Lorenzetti' in *Prospettiva*, 1985, 40, pp. 62–67.
207 C. Volpe, 'Ambrogio Lorenzetti e le congiunture fiorentine-senesi nel quarto decennio del Trecento' in *Paragone*, 1951, 13, pp. 40–52; idem, *Nuove proposte sui Lorenzetti*, pp. 263–277; F. Zeri (*The Metropolitan Museum of Art. Italian*

Paintings, Sienese and Central Italian Schools, Vicenza 1980, pp. 29–30) believes that Giotto's influence has been eclipsed by that of Maso di Banco in this work and for this reason proposes a date of *c.* 1330. F. Brogi, *Inventario generale degli oggetti d'arte della Provincia di Siena* (compiled between 1862 and 1865), Siena 1897, p. 381.
208 G. Soulier, *Les Influences orientales dans la peinture toscane*, Paris 1924.
209 M. Boskovits ('Considerations on Pietro and Ambrogio Lorenzetti') proposes that the frescoes should be dated *c.* 1326 for stylistic reasons and because that year was important for the Franciscan Order in Siena.
210 C. Volpe, *Pietro Lorenzetti*, p. 41; A. Péter, 'Giotto and Ambrogio Lorenzetti' in *The Burlington Magazine*, 1940, LXXVI, pp. 3–8.
211 C. Volpe, *Nuove proposte sui Lorenzetti*, figs. 74a and 74b. M. Seidel believes that the frescoes in the chapter house in San Francesco were painted at the same time as those in the cloister, which he correctly dates 1336. See 'Wiedergefundene Fragmente eines Hauptwerks von Ambrogio Lorenzetti', pp. 119–127; idem, 'Gli affreschi di Ambrogio', pp. 10–20.
212 P. Torriti, *La Pinacoteca nazionale di Siena. I dipinti dal XII al XV secolo*, Genoa 1977, p. 109; C. Volpe, 'Ambrogio Lorenzetti e le congiunture', p. 42; idem, *Nuove proposte sui Lorenzetti*, p. 271.
213 *Gli Uffizi. Catalogo generale*, Florence 1979, pp. 340–341.
214 L. Marcucci, *I Dipinti toscani del secolo XIV*, pp. 161–163.
215 G. Vasari, *The Lives of the Painters*, pp. 123–124.
216 C. Volpe, *Nuove proposte sui Lorenzetti*, p. 275.

217 M. Laclotte, *De Giotto à Bellini. Les primitifs italiens dans les musées de France*, Paris 1956, p. 12.
218 C. Volpe, in *Il Gotico a Siena*, pp. 407–408.
219 For the problematic identification of the subject, see K. Christiansen, in *La Pittura senese del Rinascimento 1420–1500*, Siena 1989, pp. 109–111.
220 Oral communication from F. Zeri to C. Volpe. See C. Volpe, in *Il Gotico a Siena*, pp. 407–408.
221 A. Luchs, 'Ambrogio Lorenzetti at Montesiepi' in *The Burlington Magazine*, 1977, pp. 187–188.
222 E. Borsook, *Gli affreschi di Montesiepi*, Florence 1969; D. Norman, 'Montesiepi' in *Zeitschrift für Kunstgeschichte*, 1993, pp. 289–300.
223 For the first detailed description of the frescoes, see A. Libanori, *Vita del Glorioso S. Galgano*, Siena 1645.
224 See, for example, Goro di Biagio Ghezzi in Paganico.
225 For the iconographic innovation in the *sinopia* of the *Annunciation* at Montesiepi and for the probable sequence of events relating to the commission, see S. Settis, 'Iconografia dell'arte italiana, 1100–1500: una linea' in *Storia dell'arte italiana*, Turin 1979, III, pp. 173–270, especially pp. 260–262.
226 E. Carli, *La Pittura senese del Trecento*, Venice 1981, p. 213.
227 For an accurate description of the iconography of the *Maestà* in Montesiepi, see C. Frugoni, *Pietro e Ambrogio Lorenzetti*, Florence 1988, pp. 42–47.
228 F.M. Perkins, 'Affreschi poco conosciuti di Ambrogio Lorenzetti' in *La Diana*, 1929, IV, pp. 261–267.

229 M. Seidel, 'Die Fresken des Ambrogio Lorenzetti in S. Agostino' in *Mitteilungen des Kunsthistorischen Institutes in Florenz*, 1978, XXII, 2, pp. 185–252.

230 L. Ghiberti, *I Commentari*, p. 41. The translation is taken from G. Rowley, *Ambrogio Lorenzetti*, I, pp. 133–134.

231 R. Niccoli, 'Scoperta di un capolavoro' in *I Capolavori dell'arte senese*, Florence 1946, p. 8, pl. 3.

232 C. Volpe, 'Ambrogio e le congiunture', pp. 40–52. B. Santi, in *Mostra di opere d'arte restaurate nelle province di Siena e Grosseto*, Genoa 1979, I, pp. 60–66, provides important information on the history of the critical reception of the panel.

233 For an examination of the design of haloes and of their punchmarks that places them in the artistic context of Ambrogio Lorenzetti, see E. Skaug, 'Notes on the Chronology of Ambrogio Lorenzetti and a New Painting from his Shop' in *Mitteilungen des Kunsthistorischen Institutes in Florenz*, 1976, XX, pp. 301–332.

234 L. Ghiberti, *I Commentari*, p. 42.

235 G. Cagnola, 'Di un quadro poco noto del Lorenzetti' in *Rassegna d'arte*, 1902, II, p. 143.

236 S. Dale, 'Ambrogio Lorenzetti's Maestà at Massa Marittima' in *Source*, 1989, II, pp. 6–11.

237 R. van Marle, *The Italian Schools of Painting*, The Hague 1924, III, pp. 413–416; L. Gielly, *Les Primitifs siennois*, Paris 1926, pp. 91–92.

238 G. Vasari, *The Lives of the Painters*, p. 123.

239 E. Carli, *I Capolavori dell'arte senese*, pp. 36–37; idem, *La Pittura senese*, pp. 181–182.

240 Ibid., p. 178.

241 G. Vasari, *The Lives of the Painters*, p. 124.

242 E. Carli, *Dipinti senesi del contado e della Maremma*, Milan 1955, pp. 77–84; idem, *La Pittura senese*, pp. 178–179.

243 C. Volpe, *Ambrogio Lorenzetti*, p. 47.

244 G. Previtali, in G. Vasari, *Le Vite*, p. 413.

245 G. Rowley, *Ambrogio Lorenzetti*, p. 46.

246 E. Castelnuovo, in *Ambrogio Lorenzetti. Il Buon Governo*, Milan 1995, p. 9.

247 Maginnis has recently published some documents, among them are some that were already known but that had been wrongly interpreted. See H.B.J. Maginnis, 'Chiarimenti documentari: Simone Martini, i Memmi e Ambrogio Lorenzetti' in *Rivista d'arte*, 1989, XLI, pp. 3–23.

248 Ghiberti mentions the cycle of frescoes in the cloister of the convent of San Francesco in Siena of which some fragments have been found. He mentions the scenes of the *Credo*, the scenes from the life of St Catherine of Alexandria and a *Crucifixion* in the chapter house of the Augustinians in Siena; frescoes in the chapter house of the convent of Sant'Agostino in Florence; frescoes in a chapel of the church of San Procolo in Florence; and a chapel in Massa Marittima. However, he specifies neither the subject of the work nor the position of the Massa Marittima chapel. Vasari adds some other works: frescoes showing scenes from the life

of the Virgin on the façade of San Bernardino in Siena (cf. G. Previtali, in G. Vasari, *Le Vite*, p. 416, note 1); eight *verdeterra* scenes in the Palazzo Pubblico in Siena; and frescoes in the churches of Santa Margherita and San Francesco in Cortona.

249 L. Ghiberti, *I Commentari*, p. 41. Translation from G. Rowley, *Ambrogio Lorenzetti*, I, p. 134.

250 L. Lanzi, *Storia pittorica dell'Italia*, I, p. 319. See also E. Castelnuovo, in *Ambrogio Lorenzetti. Il Buon Governo*, Milan 1995, p. 9.

251 See M.M. Donato, in *Ambrogio Lorenzetti. Il Buon Governo*.

252 P. Toesca, *Il Trecento*, p. 578.

253 L. Bellosi (*Buffalmacco e il trionfo della morte*, pp. 53–54) has noticed that some figures in the fresco of *Good Government* were 'restored' in the second half of the fourteenth century by Andrea Vanni, probably because of popular disturbances that must have caused some damage to the walls of the Sala del Nove. Magnanimity, Temperance and Justice are among the figures repainted by Vanni.

254 M.M. Donato, in *Ambrogio Lorenzetti. Il Buon Governo*, p. 46.

255 F. Brugnolo, in *Ambrogio Lorenzetti. Il Buon Governo*, pp. 381–391.

256 P. Bacci, *Fonti e commenti*, p. 160.

257 H. van Os, *Sienese Altarpieces*, I, pp. 77–89.

258 G. Della Valle, *Lettere sanesi di un socio dell'Accademia di Fossano, sopra le belle arti*, Rome 1785, II, pp. 216–217 and 225–226.

259 L. Marcucci, *I Dipinti toscani del secolo XIV*, p. 164.

260 Ibid.

261 At the time of the recent restoration, L. Bellosi (in *Gli Uffizi, studi e ricerche. 7, La 'Presentazione al Tempio' di Ambrogio Lorenzetti*, Florence 1984, pp. 31–43) re-examined the work and sketched a brief but important profile of the artist.

262 P. Torriti, *La Pinacoteca nazionale di Siena. I dipinti dal XII al XV secolo*, p. 122; G. Rowley, *Ambrogio Lorenzetti*, p. 66.

263 R. Longhi, 'Due resti di un paliotto di Ambrogio Lorenzetti' in *Paragone*, 1951, 13, pp. 52–55. Also printed in *Opere complete di Roberto Longhi*, Florence 1974, VII, pp. 116–117.

264 G. Moran and C. Seymour Jr., 'The Jarves St. Martin and the Beggar' in *Yale University Art Gallery Bulletin*, 1967, 2, pp. 28–39.

265 P. Torriti, *La Pinacoteca nazionale di Siena. I dipinti dal XII al XV secolo*, p. 124.

266 N.E. Müller, 'Ambrogio Lorenzetti's Annunciation: a Re-examination' in *Mitteilungen des Kunsthistorischen Institutes in Florenz*, 1977, XXI, pp. 1–12.

267 E. Cioni Liserani, in *Il Gotico a Siena*, pp. 117–121.

268 C. Volpe, 'Proposte per il problema di Pietro Lorenzetti' in *Paragone*, 1951, 23, pp. 13–26; R. Longhi, 'Ancora per San Galgano' in *Paragone*, 1970, 241, pp. 6–8.

Painting after the Black Death (1348–1390)

The painters of the second half of the fourteenth century were greatly influenced by the art of Simone Martini and Pietro and Ambrogio Lorenzetti. They faithfully followed both the stylistic and iconographic solutions that these artists had adapted to an extent that is unusual in the history of Italian art.

According to documentary sources, Simone Martini died in Avignon in 1344, Ambrogio Lorenzetti was dead by the end of 1348 and it is probable that Pietro Lorenzetti also died in the same year. Some information regarding the will of Ambrogio Lorenzetti has recently been found among the *Memorie* and the *Entrate* of the Compagnia della Vergine Maria in Siena.[1] Dated 9 June 1348, these pieces of information prove that Ambrogio died during that year. They also show that his children died shortly after and that, according to his wish and since there were no heirs, all of Ambrogio's property went to the Compagnia della Vergine Maria for the remission of his and his wife Simona's sins.

No documentary information has survived regarding the fate of Pietro Lorenzetti but it seems reasonable to assume that he was a victim of the Black Death in 1348 as there is no record of his artistic activity after that year. The epidemic swept through Italy from the south to the north. It has been estimated that in some cities up to fifty per cent of the population died.

The greatest Sienese sculptor of the fourteenth century had already died before the onset of the Black Death. Tino di Camaino died in 1337 in Naples, where he had gone to work at the court of Robert of Anjou. He had probably resided in Naples continuously from 1323 to 1337 and he accrued a number of followers there. Influences of his style can be seen in Naples and in most of southern Italy until the end of the fourteenth century.[2]

One of the most important of the generation of Sienese artists born around 1330 and active by the end of the 1340s was the miniaturist and painter Niccolò di Ser Sozzo.[3] Other

p. 184
Niccolò di Ser Sozzo, *Virgin of the Assumption*, miniature from the *Caleffo Bianco*. Archivio di Stato, Siena.

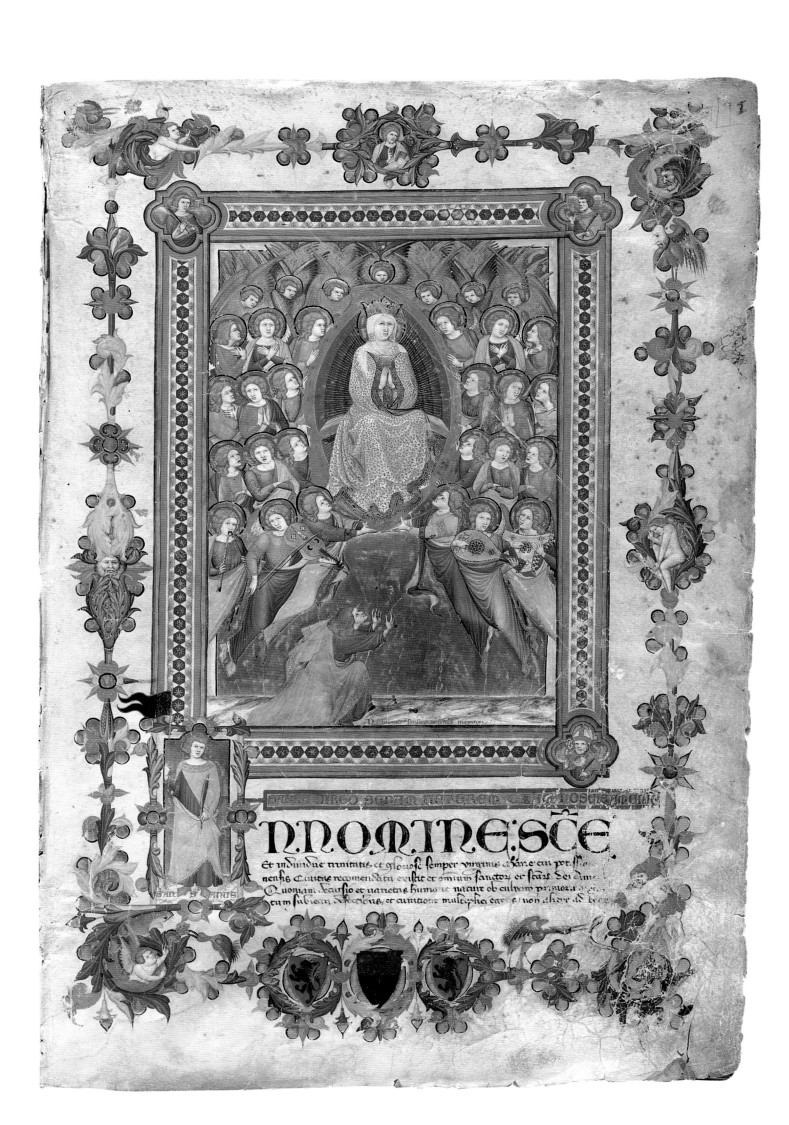

IN NOMINE SCE

et indiuidue trinitatis, et gloriose semper virginis marie cui potissi
nenhis ciuitate recomendata euistic et omium sanctoy et scax dei ama
Quoniam scursio et nauetne humane natuie ob culuim primora agi...
cum subicim defectibus, et amitione maleghei eare/ non alter db te...

SANCTVS

artists of a similar calibre include Luca di Tommè, Lippo Vanni, Bartolomeo Bulgarini, Jacopo di Mino del Pellicciaio and Francesco di Vannuccio.[4] Francesco di Vannuccio has a particularly memorable style, reminiscent of Simone Martini, that is characterized by a charming frown on the faces of his Madonnas and saints.

The accomplished miniaturist Niccolò di Ser Sozzo was greatly influenced by Simone Martini and Pietro Lorenzetti, particularly in the famous *Corale delle Solennità* in San Gimignano and above all in the marvellous *Virgin of the Assumption* in the *Caleffo Bianco* (Archivio di Stato, Siena). The latter draws upon the central pinnacle of Pietro Lorenzetti's *Arezzo Polyptych*. Although Niccolò di Ser Sozzo's miniatures are of a high quality, I believe that his paintings have generally been overrated, especially when compared to the compositions of his contemporaries. It is probable that Lippo Vanni had already anticipated some of Niccolò di Ser Sozzo's most successful ideas such as the St Thomas who, with a movement worthy of a skilful swordsman in mid-contest, waits to catch the Virgin's belt in the *Virgin of the Assumption* in the *Caleffo Bianco*.

Niccolò di Ser Sozzo was active in the 1360s and signed, together with Luca di Tommè, a polyptych dated 1362 (no. 51, Pinacoteca, Siena). The central panel of this polyptych represents the *Virgin and Child* while the side panels present *SS. John the Baptist, Thomas, Benedict* and *Stephen*. The joint execution of the painting raises the question of the respective roles of the two artists. Brandi believed that Niccolò completed the majority of the altarpiece and that Luca's contribution was limited to the simple execution of minor parts of the design.[5] However, this does not seem to be a satisfactory explanation as Luca di Tommè's signature implies a greater amount of participation in the work.

The predella of the polyptych contains four scenes from the life of St Thomas (National Gallery of Scotland, Edinburgh) that were originally placed under the four lateral saints. Beneath the central *Virgin and Child* was a *Crucifixion* (Pinacoteca Vaticana, Rome). These panels led Zeri to agree with Brandi's opinion that Niccolò di Ser Sozzo was the driving force in the partnership.[6]

Nevertheless, Luca di Tommè's early works demonstrate that he was an extremely competent artist, thoroughly able to

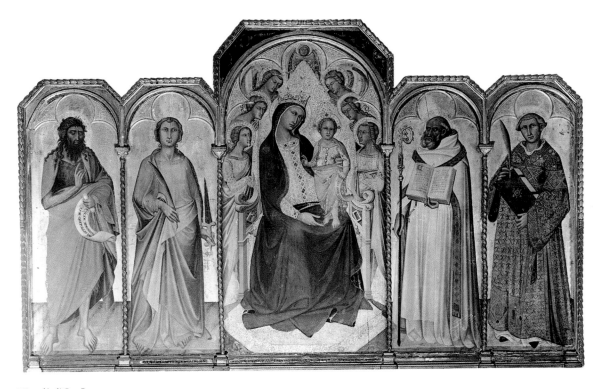

Niccolò di Ser Sozzo
and Luca di Tommè, *Virgin and Child
with SS. John the Baptist, Thomas,
Benedict and Stephen.* No. 51,
Pinacoteca, Siena.

express himself through a skilful painting technique. This can be seen in the triptych with the *Trinity* in the central panel flanked by scenes from the life of Christ and of the Virgin (Timken Art Gallery, San Diego). In the *Annunciation*, represented on the two pinnacles, Pietro Lorenzetti's influence is clear. The figures show a number of similarities to those in the upper register of the *Arezzo Polyptych* of 1320.

Luca di Tommè's double-sided *Processional Cross* (Fogg Art Museum, Cambridge, Massachusetts) demonstrates both his inspired invention and mastery of execution. The style of the cross shares a number of characteristics with the art of Francesco di Vannuccio, such as certain aspects of the frowns and the shadowy nature of the small faces.

It was long believed that Niccolò di Ser Sozzo belonged to the aristocratic Tegliacci family[7] but this theory has recently been disproved after a close examination of the relevant documents.[8] It now seems more likely that Niccolò was the son of a certain Ser Sozzo di Stefano, a miniaturist who is known only through documentary evidence.

Information previously believed to refer to the painter and miniaturist Niccolò di Ser Sozzo is therefore no longer

valid since it concerns the son of the notary Ser Sozzo di Francesco Tegliacci. However, we do know the date of Niccolò di Ser Sozzo's death – 15 June 1363 – the same year in which he first appears in the *Libro delle arti*. An earlier document of 1348 records a debt that the painter owed to the Comune of Siena but gives no further information.[9]

The artists just discussed belong to the generation active from around the middle of the fourteenth century until the 1380s and 1390s. They were long overshadowed by the great painters of the first half of the century and their artistic qualities have only recently been fully recognized. The second half of the fourteenth century has been viewed as a period of crisis in which the devastating effects of the Black Death prevented the further advance of the developments made by the great Sienese artists earlier in the century. This criticism of the period can no longer be sustained and the high quality of the works of Francesco di Vannuccio, Lippo Vanni, Bartolomeo Bulgarini and their contemporaries is now appreciated.

It was Meiss who reconstructed the catalogue of Luca di Tommè, enabling a reassessment of his art and distinctions to

Luca di Tommè,
St Thomas Offered a Banquet by the King of India. Private collection, on loan to the National Gallery of Scotland, Edinburgh.

be drawn between the different periods of his long career. The shadow of Niccolò di Ser Sozzo has been shed to expose Luca's artistic personality and a true appraisal of his paintings has now been made. Luca di Tommè is registered in the *Breve de' pittori senesi del MCCCLV*, generally believed to date from 1356, where he is enrolled after Lippo Vanni and Jacopo di Mino del Pelicciaio. Various archival documents record that Luca took part in public affairs a number of times[10] and they, together with his signed paintings, testify to his intense activity in producing panel paintings.[11]

Vasari, in his *Lives of the Painters*, praises Luca for a frescoed chapel and altarpiece in San Domenico in Arezzo and we know that he was given contracts to paint important works both in his own city and in other areas of Tuscany as well as in Umbria and the Marches.

Luca di Tommè's *Assumption of the Virgin* (Yale University Art Gallery, New Haven) probably came from the area around Arezzo.[12] Although an early work, it is one of the most successful of his entire artistic career. It has been admired for the delicate balance of the flight of the angels depicted within the precious Gothic frame.[13] One of Luca's

most moving works, because of the intense expressions and the dignified suffering of the mourners, is his 1366 *Crucifixion* (Museo Nazionale di San Matteo, Pisa). The painting, of unknown provenance, must have influenced contemporary Pisan painting, especially in the strong three-dimensionality of the heads.[14]

Other works by Luca di Tommè include three polyptychs: one that originally came from the parish church of Forsivo, near Norcia (Galleria Nazionale dell'Umbria, Perugia); another in the church of San Francesco a Mercatello sul Metauro (Pesaro); and finally a magnificent one from the convent of San Domenico in Rieti, signed and dated 1370 (Museo Civico, Rieti). I believe that to execute these large paintings with delicate frames the artist must have worked on site. This means that Luca di Tommè had an important role both in the city of his birth and in regions far from Tuscany.

A Gabella panel of 1357 showing the *Presentation in the Temple* (Archivio di Stato, Siena) is the earliest work attributed to Luca di Tommè.[15] Although greatly simplified, it is clear that Luca had studied Ambrogio Lorenzetti's version of the same subject painted for Siena Cathedral in 1342. The

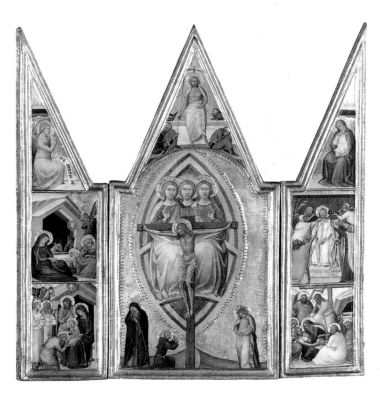

Luca di Tommè, *Trinity Triptych*. Timken Art Gallery, San Diego.

Luca di Tommè, *Virgin Annunciate*, detail of the *Trinity Triptych*. Timken Art Gallery, San Diego.

Luca di Tommè,
Crucifixion. Museo Nazionale
di San Matteo, Pisa.

attribution is supported by solid stylistic comparisons with other early works by Luca di Tommè, with a *Crucifixion* from Montepulciano and with the scenes representing the life of St Thomas in the predella of the polyptych signed with Niccolò di Ser Sozzo in 1362 (National Gallery of Scotland, Edinburgh).

Meiss believed that Luca di Tommè's style was representative of an artistic trend – characterized by religious and devotional emphasis – that was a reaction to the devastating effects of the Black Death of 1348. Meiss thought that the epidemic was the primary cause of a complete change of style in painting in Florence and Siena in the second half of the fourteenth century. This can be seen in the choice of subjects, in the attitude to God, in the conception of space, in the devotional intensity of the paintings and even in the tones of the colours.

Meiss's interesting and well-argued hypothesis cannot be accepted without reservations.[16] Some characteristics of the first half of the century that Meiss did not recognize in paintings after the disastrous events of 1348 do in fact often exist in works from both Florence and Siena.[17] It is certain however

that the devotional nature of the mature works of Luca di Tommè is typical of painting of the second half of the fourteenth century.

Lippo Vanni, a painter and miniaturist who also undertook work in fresco, was perhaps the most prolific of all the artists of his generation. Documents prove that he was already working independently in 1344 and 1345 and one of these records a payment for five miniatures executed in a gradual for the Ospedale di Santa Maria della Scala (cod. 98.4, Museo dell'Opera del Duomo, Siena).[18] The miniatures show *Christ in Heaven Blessing the Apostles*, the *Annunciation*, the *Birth of the Virgin*, the *Presentation in the Temple* and the *Assumption of the Virgin*. These small paintings are framed with great skill by the soft pastel tones of the illuminated initials.

In *Christ in Heaven Blessing the Apostles*, Lippo Vanni has shown the foreshortened faces of the apostles looking upwards in an effort to see the Saviour, while in the *Annunciation* the Virgin draws back timidly as Gabriel alights in a beautiful room with a cross-vaulted ceiling. The most spectacular of all the scenes is the *Birth of the Virgin*, which takes place in an extremely luxurious bedroom, possibly a

Luca di Tommè, *Presentation in the Temple*, Gabella panel, 1357. Archivio di Stato, Siena.

Luca di Tommè, *Presentation in the Temple*, detail of a Gabella panel, 1357. Archivio di Stato, Siena.

portrait of a room in a noble Sienese palace. The matron-like Anne lies on her bed with a fan to assuage the heat. In the foreground one handmaiden looks after the baby Mary and on the right two others hand her some cloth as they talk among themselves. In the *Presentation in the Temple* the architectural structure is influenced by the grandiose temple painted in 1342 by Ambrogio Lorenzetti for Siena Cathedral (Uffizi, Florence). In his depiction of the facial features, Lippo Vanni used Pietro Lorenzetti's broad faces and slightly square jawbones as a point of reference, thus confirming his training in the Lorenzetti brothers' workshop.

The accurate dating of the miniatures allows an evaluation of Lippo Vanni's artistic progress. The figure of St Thomas picking up Mary's belt in the *Assumption of the Virgin* precedes that of Niccolò di Ser Sozzo in the *Virgin of the Assumption* in the *Caleffo Bianco*. I believe that Meiss was right to date Niccolò di Ser Sozzo's *Virgin of the Assumption* on grounds of style between 1346 and 1348, rather than *c.* 1338, since the figure of St Thomas shows traces of Vanni's 1345 miniature.[19]

Lippo Vanni is mentioned in a number of archival documents that also record many works that have since been destroyed. He was enrolled in the *Breve de' pittori senesi del MCCCLV*.[20] The few signed and dated paintings and the miniatures securely attributed to him constitute the only solid points of reference for his career, on the basis of which other paintings can be attributed to him for stylistic reasons. The triptych with the *Madonna and Child with St Dominic and St Aurea of Ostia* in the central panel from the convent of Santi Domenico e Sisto in Rome is both signed and dated 1358. The lateral panels contain lively scenes from the life of St Aurea (Pontificio Ateneo Angelicum, Rome). The date of the painting is important because it allows many of Lippo Vanni's other works to be dated. The panels clearly show that the influence of Pietro and Ambrogio Lorenzetti has been combined with that of Simone Martini.

The style of the triptych of the *Madonna and Child with St Dominic and St Aurea of Ostia* and a fragmentary inscription have led to a tentative dating of between 1360 and 1370 for the fresco cycle in the Augustinian hermitage of San Leonardo al Lago near Siena.[21] The frescoes, which some consider to be Lippo Vanni's masterpiece, show scenes from the life of the Virgin. I believe them, however, to have been

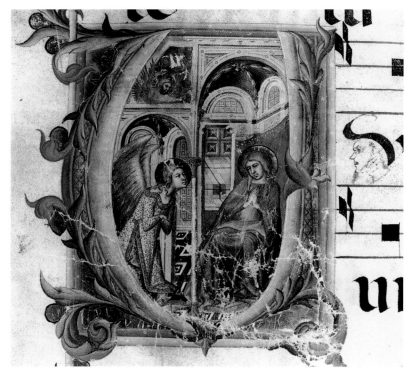

Lippo Vanni, *Annunciation,* miniature from *Gradual 98.4.* Museo dell'Opera del Duomo, Siena.

Lippo Vanni, *Birth of the Virgin,* miniature from *Gradual 98.4.* Museo dell'Opera del Duomo, Siena.

painted up to ten years earlier since they still show the influence of Pietro and Ambrogio Lorenzetti both in the arrangement of the compositions and in the facial features of the protagonists. They certainly contain some references to the scenes from the façade of the Ospedale di Santa Maria della Scala, painted in 1335.

This is further confirmation of Lippo Vanni's training in the Lorenzetti workshop and he may even have collaborated with Pietro Lorenzetti.[22] Volpe puts forward the hypothesis that a beautifully painted pinnacle by Lippo Vanni showing St Peter (private collection) once formed part of a polyptych by Pietro Lorenzetti, proposing that Lippo acted as Pietro's assistant in the execution of the work.

Lippo Vanni also painted a small reliquary triptych now in Baltimore showing the *Virgin and Child with SS. Aurea of Ostia and John the Baptist* in the central panel. The side panels contain *SS. Dominic and Ansanus* (?), *St Jerome* (?) and an unidentified *Apostle*, while the *Annunciation* is represented in the pinnacles. Volpe's observations, the high quality of the painting and the similarity of its style to that discussed above lead me to bring forward the date of this reliquary triptych. It

shows the same attention to detail and the same polish in the ornamentation that Volpe noted in the polyptych pinnacle. I believe therefore that the Baltimore painting forms part of Lippo Vanni's early work.[23] The gracefulness of the composition betrays the influence of Simone Martini at this point in Lippo's career.

Lippo Vanni also completed another precious reliquary triptych representing *St Dominic* in the central panel with *St Peter Martyr* and *St Thomas Aquinas* to either side (Pinacoteca Vaticana, Rome). It may have been completed later than the triptych in Baltimore since Simone Martini's influence is stronger and more decisive, as can be seen in the delicate colours used by Lippo Vanni. Lippo seems to be increasingly informed by Simone Martini's work after the early phase of his training under the Lorenzetti brothers. Lippo Vanni referred to the great Sienese artists of the first half of the century more than any of his contemporaries yet was still able to create a series of paintings than are uniquely his own.

One of his most successful works is the frescoed altarpiece, complete with pinnacles and a predella, in San Francesco in Siena. It shows the influence of Pietro and

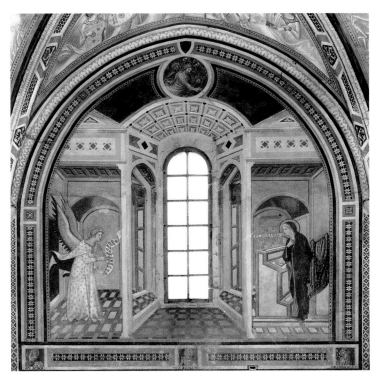

Lippo Vanni, *Annunciation*.
San Leonardo al Lago, Siena.

Ambrogio Lorenzetti as well as of Simone Martini. The commission must have required the work to appear like a polyptych but to be executed with less expensive means. The artist could probably have painted a polyptych more quickly in fresco than on panel and the cost of the carpentry needed to make the panels and the frame would have been avoided.

Meiss's research has led to the reconstruction of Bartolomeo Bulgarini's artistic personality and his identification with the Master of San Pietro d'Ovile.[24] The Master of San Pietro d'Ovile was also called Ugolino Lorenzetti by Berenson because the anonymous artist shared stylistic characteristics with Ugolino di Nerio and the Lorenzetti.[25] The earliest information we have about the painter, who came from the aristocratic Bulgarini family, relates to payment for a Biccherna panel in 1337. The information is referred to in old sources but can no longer be traced back to original documents. Payments for other Biccherna and Gabella panels are also cited in the documents.

It is only after the Black Death of 1348 that Bulgarini was commissioned to do more important works. In 1349 he painted a fresco, since destroyed, on the Porta Camollia in

Siena and was also given commissions outside Siena. In the same year he is cited in a document from the church of San Giovanni Fuorcivitas in Pistoia together with some Florentine artists (Taddeo Gaddi, the elusive Stefano Fiorentino and Andrea Orcagna) and the Sienese artist Jacopo di Mino del Pellicciaio, as one of the most skilful painters to have survived the Black Death and capable of painting the high altarpiece of the church in a fitting manner.[26] In 1350 Bartolomeo Bulgarini probably painted a panel destined for the St Sylvester Chapel in the prestigious Florentine church of Santa Croce.[27] In 1363 it appears that he was listed for the first time in the *Ruolo dei pittori senesi*. In 1370 he became a brother of the Ospedale di Santa Maria della Scala, to which he gave all his belongings. From then on he is recorded in documents as Frate Bartolomeo and the events of his life are tied to those of the hospital. Bulgarini died in 1378 leaving an incomplete panel painting that the hospital, the following year, commissioned another painter to finish.

A polyptych of the *Virgin and Child with Saints* (Museo di Santa Croce, Florence) can be identified as one of Bulgarini's

Lippo Vanni, *Polyptych with the Virgin and Child*, frescoed altarpiece. San Francesco, Siena.

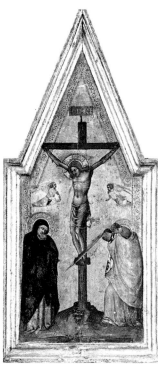

Bartolomeo Bulgarini, *Crucifixion*. Musée de Tessé, Le Mans.

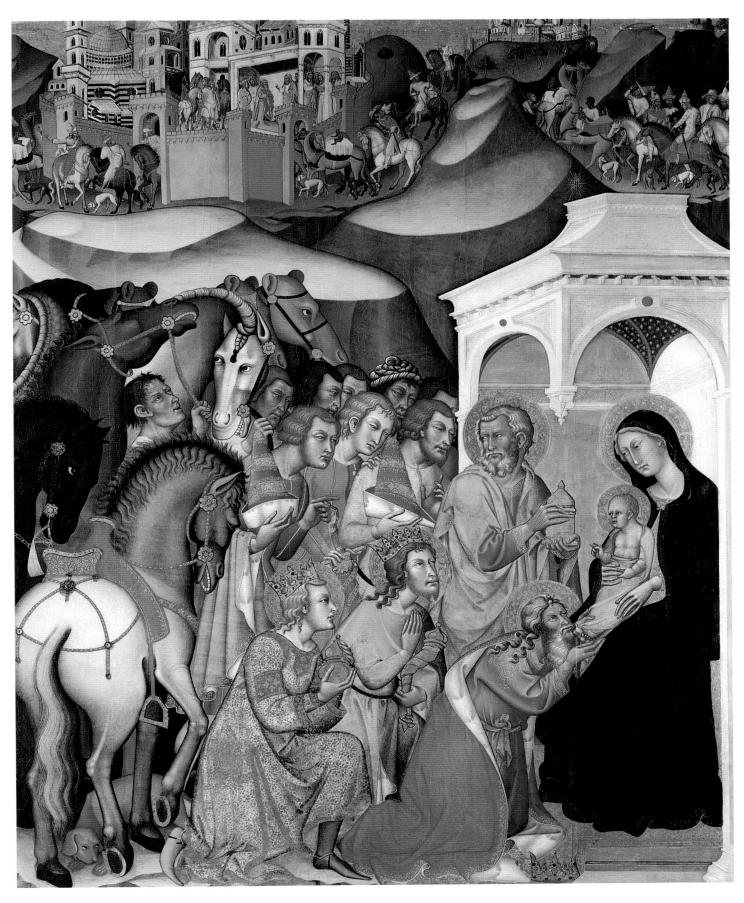

Bartolo di Fredi, *Adoration of the Magi*.
Pinacoteca, Siena.

early works as it is strongly influenced by Ugolino di Nerio and Duccio. At the height of his career Bulgarini painted three great altarpieces for the Ospedale di Santa Maria della Scala as well as others that are now in the Pinacoteca in Siena. One of the most successful paintings from this period is the *Nativity* (Fogg Art Museum, Cambridge, Massachusetts) which unfortunately has been cut away at the sides. The panel was executed for the altar of St Victor in Siena Cathedral.[28] Although its subject is Christ's birth it is Mary who is placed at the centre of the composition since Siena Cathedral is dedicated to the Virgin. The *Nativity* panel was probably flanked by representations that are now in Copenhagen of *St Victor* and *St Corona*, his companion in martyrdom. Unfortunately, the lateral panels have been considerably repainted, especially the clothes of the saints. It is possible to identify two predella panels from the altarpiece. These are a *Crucifixion* (Louvre, Paris) and a *Blinding of St Victor* (Städelsches Institut, Frankfurt), both of which demonstrate Pietro Lorenzetti's influence over Bartolomeo Bulgarini.

The number of works that have survived by Bartolo di Fredi, registered in the *Breve de' pittori senesi del MCCCLV*, is considerably fewer than those cited in the documents. In 1353 Bartolo di Fredi set up a workshop with Andrea Vanni. He held various public positions, as did the majority of artists of his generation who took part in the running of the Sienese Republic. In 1407 he made his will in favour of his only son, Andrea di Bartolo, who was an important miniaturist and painter. He died in 1410 and was buried in the cloister of San Domenico in Siena.

Bartolo di Fredi's first signed and dated work is a *Madonna della Misericordia* painted in 1364 (Museo Diocesano, Pienza), which was influenced by Lippo Memmi's *Madonna dei Raccomandati* in Orvieto. Other important influences on his art came from Niccolò di Ser Sozzo and Jacopo di Mino del Pellicciaio. His most famous frescoes were executed in 1367 in the Collegiata in San Gimignano on the north wall of the nave. The influence of the Lorenzetti brothers is evident and there are some direct quotations from their works, yet the frescoes still bear the imprint of Bartolo di Fredi's personal style. In the *Earthquake in the House of Job*, a total lack of depth results from an absence of three-dimensionality of form and from all the action taking place in the foreground.

Bartolo di Fredi,
Earthquake in the House of Job.
Collegiata, San Gimignano.

The frescoes showing scenes from the life of the Virgin and the Archangel Michael in the church of San Michele in Paganico were originally attributed to Bartolo di Fredi.[29] I believe, however, Freuler's recent identification of Biagio di Goro Ghezzi as the artist to be correct.[30] Ghezzi, who was previously known only through archival documents, was a pupil of Bartolo di Fredi. The frescoes demonstrate the influence of Lippo Vanni, particularly in the soft colouring and in the clear and simple placing of figures. Biagio di Goro Ghezzi emerges as a provincial version of Lippo Vanni, a gracious narrator of religious events which he relates in an ingenuous and popular manner. The stories unfold in a way that makes the religious figures seem approachable, which disproves Meiss's theory that the shock inflicted by the devastation of the Black Death made God and the saints seem distant and judgmental figures.

An examination of the extant information relating to the workshop, near the church of Santa Maria della Misericordia, shared by Bartolo di Fredi and Andrea Vanni from 1353 onwards provides a better understanding of how a *bottega* may have functioned in the fourteenth century. From the 'contract' between Bartolo di Fredi and Andrea Vanni one can deduce that artists with different trainings and different styles could agree to open a workshop together. It seems probable that their intention in doing so was to divide their expenses. Only a few works painted by Andrea Vanni have survived but they demonstrate that his style was very distinct to that of Bartolo di Fredi. Like Paolo di Giovanni Fei and Francesco di Vannuccio, Andrea Vanni was greatly influenced by Simone Martini. Both Andrea and Lippo Vanni are registered in the *Breve de' pittori senesi del MCCCLV* and Andrea is mentioned for the last time in a document of 6 September 1413.

Numerous documents inform us that Andrea Vanni was one of the artists of his generation to be most involved in public life and that he carried out a number of jobs for the Sienese state. He was also interested in the religious life of the city and belonged to a group of followers of Catherine Benincasa. He painted a 'portrait' of the future St Catherine of Siena in 1390 in the Chapel of the Vaults in San Domenico, Siena. Catherine is shown with a female worshipper kneeling to the right side of the fresco.

Andrea Vanni, *St Catherine of Siena and a Worshipper*. Chapel of the Vaults, San Domenico, Siena.

Andrea Vanni, *St Francis of Assisi*. Lindenau Museum, Altenburg.

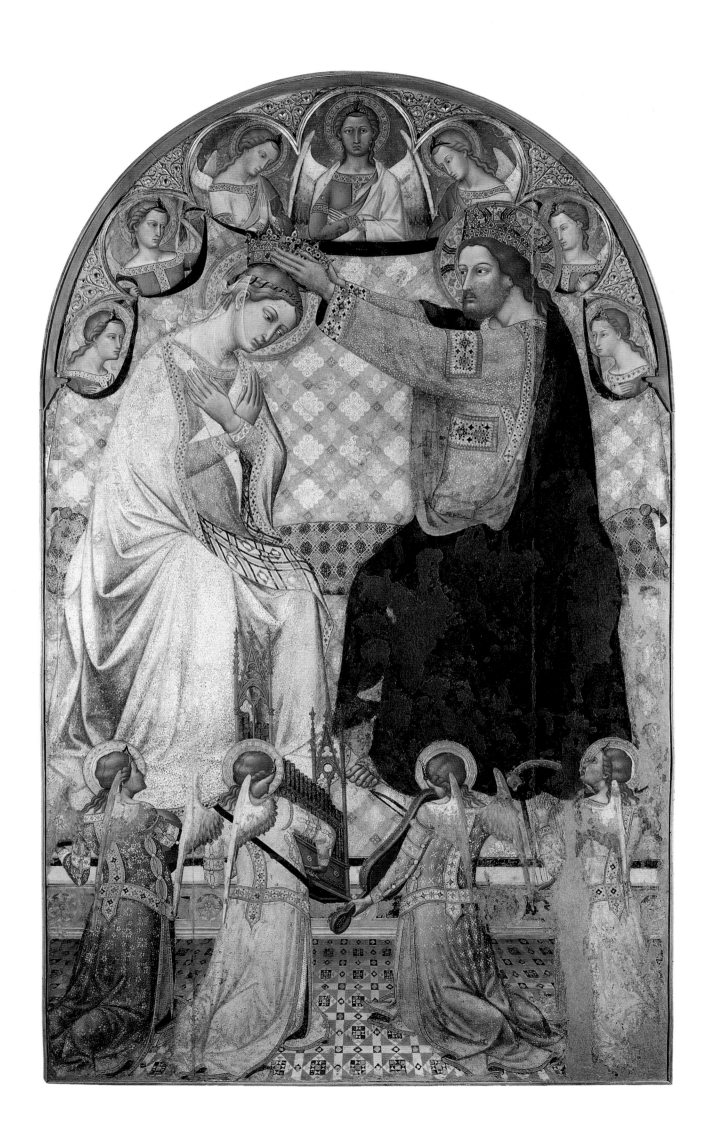

The polyptych commissioned by the queen of Naples, Joan I of Anjou, must be one of his most important, most prestigious and most successful works. The queen gave the painting to the castle of Casaluce in 1366. The only two panels to have survived – *St James the Greater* (Museo di Capodimonte, Naples) and *St Francis of Assisi* (Lindenau Museum, Altenburg) – demonstrate the amount that Andrea Vanni had learnt from Simone Martini's style and technique.

Together with Francesco di Vannuccio, Jacopo di Mino del Pellicciaio should be considered among the greatest Sienese painters of the second half of the fourteenth century. Unfortunately, few of his works have survived. There are only two that are both signed and dated – the *Madonna and Child* in the church of San Martino e Santa Vittoria in Sarteano, painted in 1342, and the *Mystic Marriage of St Catherine*, dated 1362, at one time in the church of Sant'Antonio in Fontebranda (Pinacoteca, Siena). The *Coronation of the Virgin* (Museo Civico, Montepulciano) was probably painted between 1342 and 1362.[31] In it Jacopo di Mino del Pellicciaio breathes new life into the style of Simone Martini, imbuing it with astonishing originality, refinement and mastery of

technique. The *Coronation of the Virgin* is a good example of Simone Martini's continuing influence in the second half of the fourteenth century, which was more extensive than that exercised in the 1360s by the paintings of the Lorenzetti.

It is likely that Jacopo di Mino del Pellicciaio also worked in Pisa and the frescoes representing the *Founders of the Religious Orders* in the church of San Francesco have been attributed to him. In addition, Jacopo carried out a considerable amount of work in Umbria. In the Oratory of St Bartholomew in Città della Pieve he frescoed a large *Crucifixion with Saints*. The work is full of pathos and clearly echoes the paintings of the Lorenzetti.[32]

As was the case with Jacopo di Mino del Pellicciaio, few paintings by Francesco di Vannuccio have survived. Francesco is documented in Siena between 1356 and 1403, after which date he disappears from the records. He is rarely mentioned in the archives and the paintings referred to have mostly been lost. Those that are extant demonstrate the sensitivity of his painting technique, which was influenced by both Taddeo di Bartolo and Paolo di Giovanni Fei.[33] In 1932 Offner wrote what has remained the definitive work on Francesco di

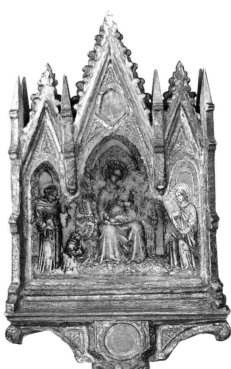

p. 196
Jacopo di Mino del Pellicciaio, *Coronation of the Virgin*. Museo Civico, Montepulciano.

Francesco di Vannuccio, *Crucifixion with the Virgin and SS. John the Evangelist and Augustine*. Gemäldegalerie, Staatliche Museen, Berlin.

Francesco di Vannuccio, *Virgin and Child with Saints and a Donor*. Gemäldegalerie, Staatliche Museen, Berlin.

Vannuccio in which he reconstructs his artistic personality.[34] Since then a number of works have been added to Francesco's catalogue on stylistic grounds but always in line with the profile traced by Offner and substantially confirming the characteristics that he first gathered together.

The fundamental problem in understanding Francesco di Vannuccio's art relates to the correct reading of the third number of the date on the unusual signed 'banner' depicting the *Crucifixion with the Virgin and SS. John the Evangelist and Augustine* (Staatliche Museen, Berlin). On the reverse of the painting a *graffito* represents the *Virgin and Child with Saints and a Donor*, also the work of Francesco di Vannuccio.

Depending on the interpretation of the date, the painting was executed in either the 1370s or the 1380s,[35] but I favour the earlier date. The Berlin *Crucifixion* is very close in style to a *Crucifixion* in the Johnson Collection in Philadelphia, meaning that this too can be dated to the 1370s. Among Francesco di Vannuccio's small-scale works, which form the majority of his surviving paintings, the *Madonna and Child with SS. Lawrence and Andrew* (no. 806, Rijksmuseum Meermanno-Westreenianum, The Hague) stands out. The

painting, teeming with gold and arabesques, originally formed the other half of a diptych with the Philadelphia *Crucifixion*. It is extremely ornate, almost the work of a goldsmith. The Virgin's sad expression, reflecting her thoughts about the unhappy fate of her son, contrasts with the liveliness of the baby Jesus, who clasps a little chirping bird tightly in his right hand. The bird, with wings raised, attempts to escape but the Christ Child's grip is firm. In his left hand Jesus holds out a long astylar cross to the ruffled St Andrew.

The large *Birth of the Virgin* by Paolo di Giovanni Fei (Pinacoteca, Siena) may be the painting that was once in the church of San Maurizio in Siena and that is recorded as having a date of either 1381 or 1391.[36] It is regarded by some as the most important Sienese painting from the end of the fourteenth century.[37] The composition echoes Pietro Lorenzetti's version of the same scene painted in 1342 for Siena Cathedral (Museo dell'Opera del Duomo, Siena), but the gracefulness of the figures and the skin tones recall the style of Simone Martini.

The *Presentation of the Virgin in the Temple* (National Gallery of Art, Washington, D.C.) probably formed the

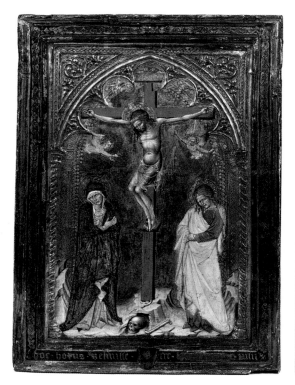

Francesco di Vannuccio, *Crucifixion with the Virgin, St John the Evangelist and Angels*. Johnson Collection, Philadelphia Museum of Art.

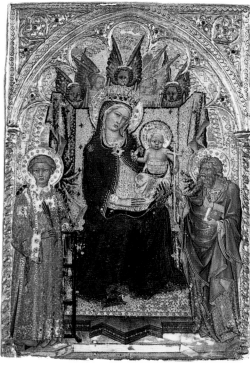

Francesco di Vannuccio, *Madonna and Child with SS. Lawrence and Andrew*. No. 806, Rijksmuseum Meermanno-Westreenianum, The Hague.

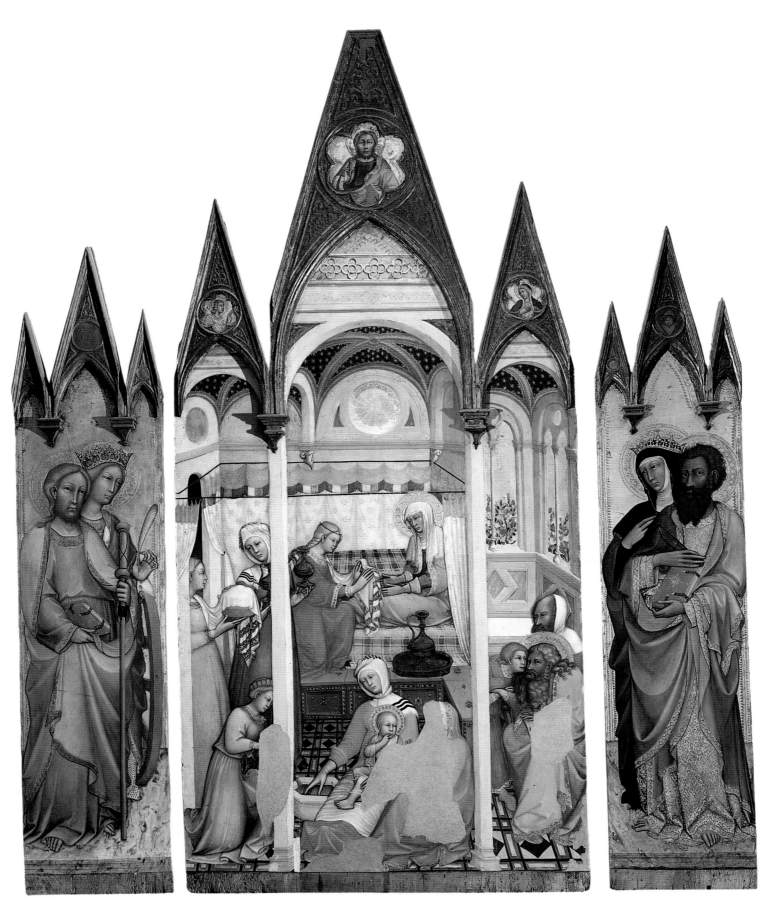

Paolo di Giovanni Fei,
Birth of the Virgin.
Pinacoteca, Siena.

central panel of a polyptych commissioned from Paolo di Giovanni Fei in 1398 for the St Peter Chapel in Siena Cathedral.[38] The architectural structure of the temple recalls that painted by Ambrogio Lorenzetti in his *Presentation in the Temple* of 1342 for the altar of St Crescentius in Siena Cathedral (Uffizi, Florence).

Andrea di Bartolo, the son of Bartolo di Fredi, worked in his father's workshop until Bartolo died in 1410. Stylistically his work remained similar to that of his father throughout his career. He adopted the narrative style that his father had used in small panel paintings and never imitated the abstract and inaccessible forms used by Bartolo di Fredi in his large-scale works such as the frescoes in San Gimignano.

The six small panels with scenes from the life of St Galganus (five in the Museo Nazionale di San Matteo, Pisa, and one in Dublin) are among the most beautiful of Andrea di Bartolo's works because of their rich ornamentation and the immediacy achieved in the narrative. They may once have formed part of a small altarpiece or the cover of a reliquary.[39] Andrea di Bartolo did a number of other works of this type. The most famous, executed at the beginning of the fifteenth century, are the four scenes from the life of the Virgin (three in the National Gallery of Art, Washington, D.C., and a fourth in Esztergom, Hungary).[40] The four small panels contain skilfully executed, graceful figures and may once have formed part of a larger work similar to the wings of the *Montalcino Polyptych*, painted by Bartolo di Fredi in 1388. Among Andrea di Bartolo's larger works, the *Virgin of the Assumption* (Richmond, Virginia), also known as the *Madonna della Cintola* because of the presence of St Thomas waiting to receive the Virgin's belt, should be noted for its clear pastel tones. It is one of the rare works signed by the artist. The small donor figures to either side of the Virgin's tomb are a certain Palamedes and his son Matteo di Urbino. That the donors came from Urbino confirms that Andrea di Bartolo's fame had spread to the heart of the Marches.

Andrea di Bartolo was also active as a miniaturist as evidence a number of illuminated manuscripts, now in the Biblioteca Comunale in Siena, which share characteristics with some of his panel paintings.[41]

Martino di Bartolomeo worked as both a miniaturist and a panel painter and was a contemporary of Andrea di Bartolo

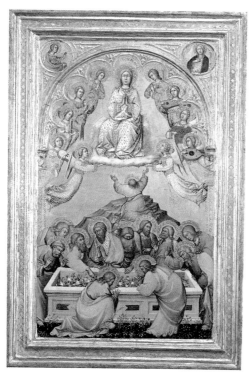

Paolo di Giovanni Fei,
Assumption of the Virgin. Samuel H.
Kress Collection, National Gallery
of Art, Washington, D.C.

Andrea di Bartolo,
*Christ Giving Communion to
the Saints*. MS. G.I.14, fol. 88v,
Biblioteca Comunale, Siena.

– both joined the *Breve de' pittori senesi* in 1389.[42] He expresses himself with greatest success and originality in his smaller works, such as the panels with scenes from the life of St Stephen (Städelsches Institut, Frankfurt). These have a grace in their execution that is not found in his larger paintings, such as the polyptych (no. 160) in the Pinacoteca in Siena. Here the motifs copied from Taddeo di Bartolo clearly demonstrate that Martino trained in Taddeo's workshop.

Notes

1 V. Wainwright, 'The Will of Ambrogio Lorenzetti' in *The Burlington Magazine*, 1975, CXVII, pp. 543–544.

2 On Tino di Camaino's activity in the south of Italy and on his workshop in Naples, see G. Chelazzi Dini, 'Un bassorilievo di Tino di Camaino a Galatina' in *Dialoghi di storia dell'arte*, 1995, pp. 28–41; idem, *Pacio e Giovanni Bertini da Firenze e la bottega napoletana di Tino di Camaino*, Florence 1996.

3 C. De Benedictis, *La Pittura senese 1330–1370*, Florence 1979.

4 G. Chelazzi Dini, in *Il Gotico a Siena*, exhibition catalogue, Florence 1982; idem, in *L'Art gotique siennois*, Florence 1983, *passim*; see also 'Luca di Tommè, Lippo Vanni, Niccolò di Buonaccorso and Niccolò di Ser Sozzo' in *Enciclopedia dell'arte medievale* (in press).

5 C. Brandi, 'Niccolò di Ser Sozzo Tegliacci' in *L'Arte*, 1932, XXXV, pp. 223–236.

6 F. Zeri, 'Sul problema di Niccolò Tegliacci e Lucca di Tommè' in *Paragone*, 1958, 105, pp. 3–16.

7 G. Moran and S. Fineschi, 'Niccolò di Ser Sozzi Tegliacci o di Stefano?' in *Paragone*, 1976, 321, pp. 58–63.

8 G. Bichi, *Risieduti nell'ordine del popolo*, 1713, MS., Archivio di Stato, Siena.

9 G. Milanesi, *Documenti per la storia dell'arte senese*, Siena 1854, I and II.

10 P. Bacci, 'Una tavola inedita e sconosciuta di Luca di Tommè con alcuni ignorati documenti della sua vita' in *Rassegna d'arte senese e del costume*, 1927, pp. 51–62.

11 G. Milanesi, *Documenti*, I, pp. 28–29 and 251–253; II, p. 36.

12 S.A. Fehm Jr., *Luca di Tommè. A Sienese Fourteenth-Century Painter*, Carbondale and Edwardsville 1986, p. 83.

13 P. Toesca, *Il Trecento*, Turin 1951, p. 595.

14 E. Carli, *Il Museo di Pisa*, Pisa 1974, pp. 55–76.

15 G. Chelazzi Dini, in *Il Gotico a Siena*, pp. 276–278.

16 Ibid., pp. 220–221 and *passim*.

17 C. Volpe, 'Il lungo percorso del "dipingere dolcissimo e tanto unito"' in *Storia dell'arte italiana*, Turin 1983, 5, pp. 229–304.

18 G. De Nicola, 'Studi sull'arte senese' in *Rassegna d'arte*, 1919, XIX, pp. 95–102.

19 M. Meiss, *Painting in Florence and Siena after the Black Death* (1951), Princeton 1978.

20 G. Milanesi, *Documenti*.

21 E. Carli, *Lippo Vanni e San Leonardo al Lago*, Florence 1969.

22 C. Volpe, 'Su Lippo Vanni da miniatore a pittore' in *Paragone*, 1976, 321, 1, pp. 53–57.

23 F. Zeri, *Italian Painters in the Walters Art Gallery*, Baltimore 1976, I, pp. 44–46.

24 M. Meiss, 'Ugolino Lorenzetti' in *The Art Bulletin*, 1931, XIII, pp. 376–397; idem, 'Bartolomeo Bulgarini altrimenti detto "Ugolino Lorenzetti"?' in *Rivista d'arte*, 1936, XVI–XVII, pp. 113–136.

25 B. Berenson, 'Ugolino Lorenzetti' in *Art in America*, 1917, pp. 259–275; 1918, pp. 25–52.

26 P. Toesca, *Il Trecento*, p. 608, note 129.

27 E. Romagnoli, *Biografia cronologica de' bellartisti senesi…*, MS. L.II.3, fol. 1835, BCS, Florence 1976, p. 508.

28 H. van Os, *Sienese Altarpieces, 1215–1460*, Groningen 1984, I, pp. 77–89.

29 B. Berenson, 'Tesori artistici in un villaggio dilapidato della provincia di Grosseto' in *Rassegna d'arte*, 1905, V, pp. 102–103.

30 G. Freuler, 'Die Fresken des Biagio di Goro Ghezzi in S. Michele in Paganico' in *Mitteilungen des Kunsthistorischen Institutes in Florenz*, 1981, XXV, pp. 31–58.

31 L. Bellosi, 'Jacopo di Mino del Pellicciaio' in *Bollettino d'arte*, 1972, LVII, 2, pp. 63–73.

32 P.P. Donati, 'Aggiunte al "Maestro degli Ordini"' in *Paragone*, 1968, 219, pp. 67–70.

33 C. Volpe, 'Francesco di Vannuccio' in *Petit Larousse de la peinture*, Paris 1979, p. 655.

34 R. Offner, 'The Works and Style of Francesco di Vannuccio' in *Art in America*, 1932, XX, pp. 89–114.

35 M. Boskovits, *Frühe Italienische Malerei, Gemäldegalerie Berlin*, Berlin 1988, pp. 35–37.

36 P. Torriti, *La Pinacoteca nazionale di Siena. I dipinti dal XII al XV secolo*, Genoa 1977, pp. 179–180.

37 L. Bellosi, in *Il Gotico a Siena*, p. 292.

38 F. Rusk Shapley, *Catalogue of the Italian Paintings of the National Gallery of Art*, Washington, D.C. 1979, I, pp. 175–177.

39 E. Carli, *Il Museo di Pisa*, pp. 61–62.

40 F. Rusk Shapley, *Catalogue of the Italian Paintings*, pp. 3–4.

41 G. Chelazzi Dini, in *Il Gotico a Siena*, pp. 315–326; idem, 'Andrea di Bartolo' in *Enciclopedia dell'arte medievale*, Rome 1991, I, pp. 594–595.

42 L. Bellosi, 'La mostra di Arezzo' in *Prospettiva*, 1975, 3, pp. 55–60.

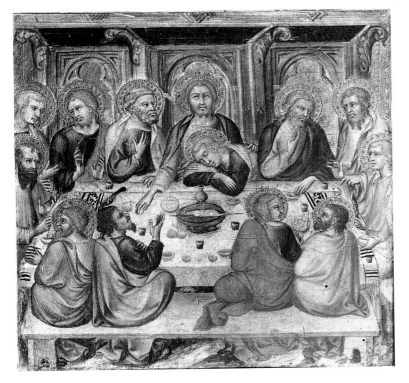

Andrea di Bartolo, *Last Supper*, from the predella of the *Madonna and Child with Saints*. Tuscania Cathedral.

Late Gothic Painting in Siena

From his death until *c.* 1520 the work of Simone Martini exercised the greatest influence over Sienese sculptors and painters. '*Maestro Simone nobilissimo pictore*'[1] was admired for the Gothic elegance and fluidity of line used in his balanced compositions and for the aristocratic and worldly nature of his paintings, even of those with religious subject matter. Lippo Vanni, Francesco di Vannuccio, Andrea Vanni, Paolo di Giovanni Fei, Martino di Bartolomeo and later Taddeo di Bartolo, Gregorio di Cecco, Benedetto di Bindo and Giovanni di Paolo were all strongly influenced by Simone Martini's style. Many of these artists were unable to express themselves in large compositions and produced their best works in a small format. The characteristics of their style include naturalistic passages, an elegant fluidity of line and rich decoration. Their narrative vivacity is underlined by an intense use of colours and, in some cases, by thick paint.

Although their style was still anchored in local tradition, the Sienese artists of the last part of the fourteenth century started to widen their horizons and to study painting outside the confines of Siena. They investigated developments in other Tuscan cities with renewed interest and a few of them were also influenced by painting in Northern Italy and thereby benefitted from the flowering of the International Gothic style.[2]

Even though important Sienese painters such as Sassetta, the Osservanza Master and Pietro di Giovanni d'Ambrogio learnt from the new Renaissance style, they could not entirely shed their nostalgia for the painting tradition of the first half of the fourteenth century. Simone Martini's art lived on through these painters and also through sculptors such as Jacopo della Quercia well into the sixteenth century.

The International Gothic style underwent its greatest development and most widespread expansion between 1380 and 1430. It penetrated the heart of the main European courts including those in England, Spain, France, Bohemia, Flanders and Italy. One of the most important International

Gothic painters, Gentile da Fabriano, arrived in Siena in 1425. An Italian exponent of this style, he was the most cosmopolitan and had the most refined mode of expression. In Siena, Gentile painted the *Madonna of the Notaries*,[3] which unfortunately has since been lost. However, it is recorded in the documents and would certainly have been admired by Sienese painters since it was easily visible in the corner of the Campo, the main square of Siena. Giovanni di Paolo must have studied the painting closely since its influence is obvious in his *Pecci Polyptych* of 1426.

Gentile da Fabriano's stay in Siena followed the shorter stays of Spinello Aretino, one of the main International Gothic painters working in Tuscany.[4] He was called to Siena in 1404 to execute some important work in the cathedral and in 1407 was asked by the Comune to execute the frescoes in the Sala di Balia in the Palazzo Pubblico. It was unprecedented for artists from outside Siena to be given prestigious commissions within the city. Like Florence, Siena had been effectively closed to foreign artists during the fourteenth century. Only painters from Orvieto such as Ugolino di Prete Ilario, Cola Petruccioli and Piero di Puccio, whose style was

partially based on Simone Martini's polyptychs in that city, had strong connections with Siena.

Among the painters working at the turn of the fifteenth century, Taddeo di Bartolo is the artist who was most successful in gaining commissions from outside Siena. He carried his version of Simone Martini's style to Liguria, Pisa and even to Sicily. Only one monograph has ever been published on Taddeo di Bartolo, that by Sibilla Symeonides in 1965.[5] Symeonides made an accurate assessment of Taddeo's style but excluded some valuable works that should be attributed to him. One of these paintings is the *Crucifixion* (no. 122, Pinacoteca, Siena) that once formed the central pinnacle of a large polyptych. The *Crucifixion* in the Musée du Petit Palais in Avignon (no. 227), a small panel painting packed with figures visibly disturbed by the dramatic event, is another painting that I believe should also be ascribed to Taddeo.

The earliest information that exists concerning Taddeo di Bartolo is the inclusion of his name in the documents of the Opera del Duomo in 1383, when he must have been about twenty years old.[6] It is noted that Taddeo painted various angels sculpted by Giacomo di Francesco del Tonghio for the

choir in Siena Cathedral. Three years later he is recorded as having painted a further twenty small statues for the choir. In 1389 Taddeo di Bartolo entered the *Ruolo dei pittori senesi* and in that same year he signed and dated the polyptych for the Oratory of San Paolo a Collegarli in the church of San Miniato al Tedesco in Pisa. The polyptych depicts the *Madonna and Child Flanked by SS. Sebastian, Paul, John the Baptist and Nicholas* and was the first of a number of Pisan commissions. Taddeo's work in Pisa was interrupted by a short but important stay in Liguria, where in 1393 he painted two altarpieces for the church of San Luca in Genoa commissioned by Cattaneo Spinola. On his return to Pisa Taddeo executed the polyptych for the high altar of San Paolo all'Orto (Musée des Beaux-Arts, Grenoble) commissioned by Gerardo Cassasi degli Assi in 1395. The polyptych is widely recognized as one of Taddeo di Bartolo's most successful works. The Virgin, in the central panel, is shown seated on a cloud of seraphim who are painted red and gilded. Taddeo used this device again in the Sienese triptych of *Santa Caterina della Notte* painted in 1400 and in the panel showing the *Crowned Madonna* of 1418 (Fogg Art Museum,

Cambridge, Massachusetts). In the *San Paolo all'Orto Polyptych* Jesus stands on the Virgin's knee and places his finger in the beak of a goldfinch. The Virgin's imposing height compared to the four saints to either side of her is made all the more conspicuous by the way in which Taddeo di Bartolo has painted her clothing. Her mantle is bathed in dense gold highlights alternating with deep shading that emphasizes the folds of her mantle. The whole work is of an extremely high quality with the exception of the hands and the feet – Taddeo di Bartolo's weak points.[7] The painting of the Virgin's cloak clearly shows that the artist had been influenced by Barnaba da Modena during his stay in Genoa. Barnaba had used a *sgraffito* technique to make the surfaces of his draperies appear more precious. An example of this can be seen in a *Madonna and Child* (Städelsches Institut, Frankfurt) which he signed and dated in Genoa in 1367.

Taddeo di Bartolo's stay in Pisa would have enabled him to study some of the most important Sienese and Florentine fourteenth-century paintings. These included Simone Martini's *Santa Caterina Polyptych* of 1320 as well as later works by the Florentine-trained artists Spinello Aretino and

p. 205
Taddeo di Bartolo,
Assumption of the Virgin.
Montepulciano Cathedral.

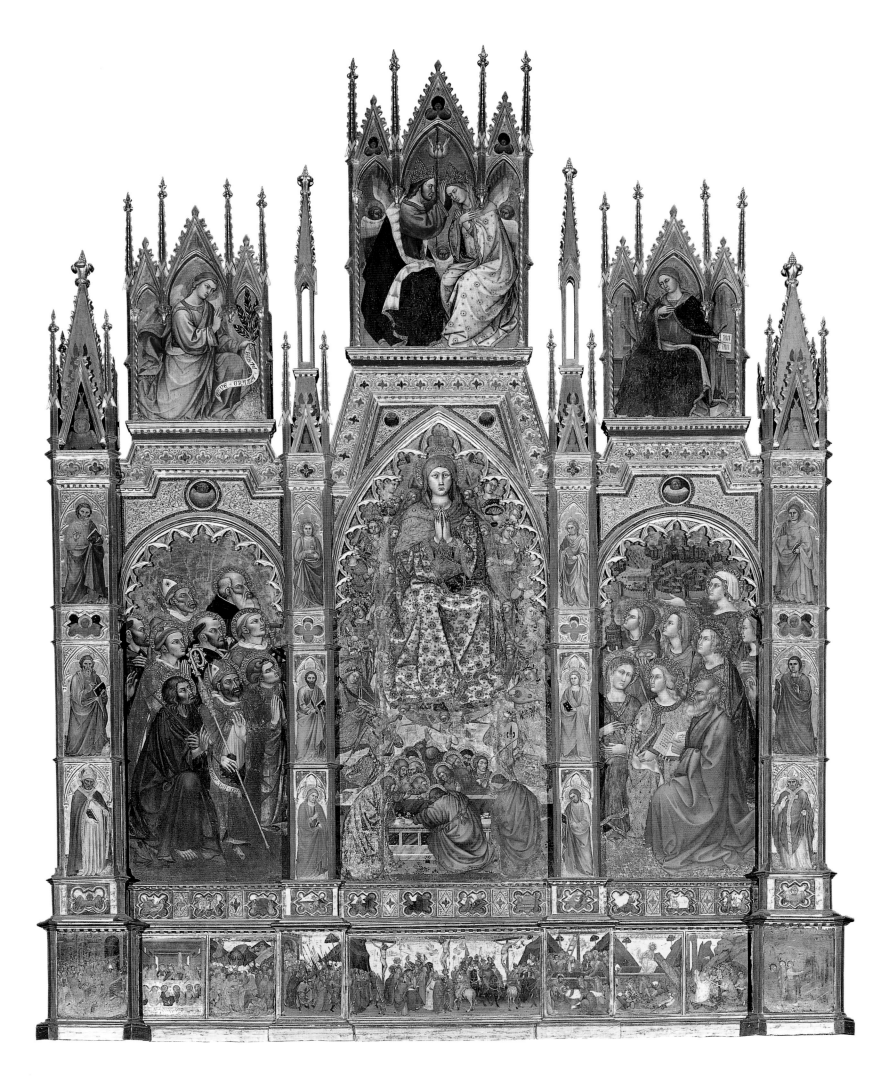

Niccolò di Pietro Gerini. Most importantly he would have seen the frescoes in the Campo Santo by Taddeo Gaddi, Piero di Puccio and Antonio Veneziano. Taddeo's time in Pisa was important for his stylistic development and while there he must also have encountered the *Crucifixion* painted in 1366 by Luca di Tommè. In the *Crucifixion* Luca had proved his ability to paint a work that was not only expressive but also full of dignity. In Taddeo's *San Paolo all'Orto Polyptych*, as in most of his work, it is the influence of Simone Martini that prevails. Simone's style is reflected above all in the figures of the Virgin and Child that faithfully follow those in the Palazzo Pubblico *Maestà*. The two depictions are similar both in their facial features, in their very human expressions and in the way the folds of the Virgin's mantle fall.

Before the *San Paolo all'Orto Polyptych* Taddeo di Bartolo painted the large *Last Judgment* fresco and the scenes of *Hell* and *Paradise* on the inside of the façade of the Collegiata in San Gimignano.[8] The fresco of *Hell* is a traditional representation, containing numerous small scenes and dominated by an enormous tentacled devil, that uses earth colours throughout. It is the *Last Judgment* and *Paradise*, however, that

provided greater opportunities for Taddeo to demonstrate his personal style in more wide-ranging works.

In 1397 Taddeo was once again in Pisa in order to finish various paintings in the church of San Francesco. Unfortunately, these have only partially survived. In the same year he was given a commission in Liguria where he painted the *Baptism of Christ* in the Collegiata in Triora, near to Imperia. The figure of Christ, immersed in water as high as his pelvis, is iconic while the haloes of the angels to either side are executed with raised gilded gesso in the shapes of letters. Taddeo repeated this type of halo a few years later in his vast polyptych of the *Assumption of the Virgin* for Montepulciano Cathedral. The motif derives from the practice, common in the early fourteenth century, of writing the names of the saints on their haloes. Pietro Lorenzetti had written St Lucy's name on her halo in the panel from the church of Santa Lucia de' Magnoli in Florence and also on the haloes of *SS. Bartholomew, Cecilia and John the Baptist,* panels of a polyptych dated 1332 (Pinacoteca, Siena). Ambrogio Lorenzetti used the device both in the *San Procolo Polyptych* of 1332 and in the *Annunciation* for the Sala del

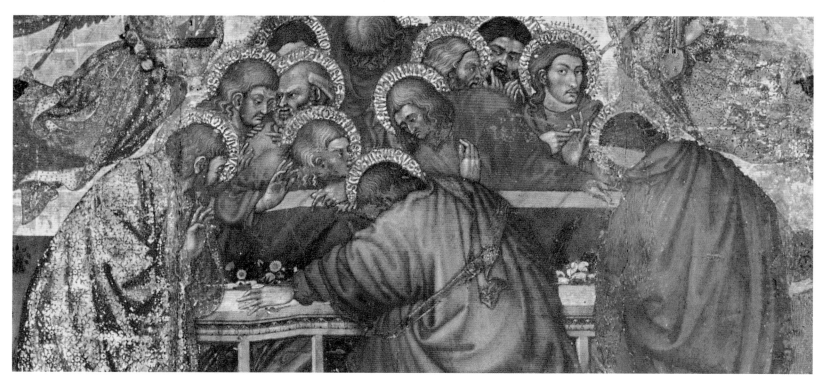

Taddeo di Bartolo,
Assumption of the Virgin, detail.
Montepulciano Cathedral.

Concistoro in the Palazzo Pubblico painted in 1344. Spinello Aretino also employed this type of halo decoration in the saints in the *Monteoliveto Polyptych* (Szépmuvészeti Muzeum, Budapest, and Fogg Art Museum, Cambridge, Massachusetts) and in the *Madonna and Child* that originally formed part of the *San Ponziano Polyptych* (private collection, London).

In 1401 Taddeo di Bartolo signed and dated the polyptych for Montepulciano Cathedral.[9] The central Virgin stands out from the composition both because of her large dimensions and because she projects beyond the small angels who surround her. She is clothed in a richly decorated mantle and her face is framed by a halo with an inscription in raised gilded gesso. These devices emphasize her part in the pyramidal composition formed with the group of apostles at the base. The apostles gaze down in amazement at the empty tomb, while in the centre of the group St Thomas guides our attention towards the figure of the Virgin by looking upwards. The panel above the *Assumption* depicts the *Coronation of the Virgin* and the side panels contain two groups of saints whose positioning and style echo that of the saints surrounding the Virgin in Simone Martini's *Maestà*. The technique with

which they are painted, however, is not so accomplished and they do not have Simone's breadth of vision. It is probable that the face of the apostle Thaddeus is a self-portrait of Taddeo di Bartolo, one of the earliest self-portraits to have survived.[10] Simone Martini's influence is evident in the thin facial features of the apostles and saints. Other artists, such as Francesco di Vannuccio, also used these facial features in their paintings, often with greater success. Among the group of saints to the right of the Virgin, St Antilla holds a model of the city of Montepulciano.[11] Taddeo di Bartolo reused this type of city model when he depicted the town of San Gimignano resting on the knees of its patron saint in the *St Geminianus Polyptych* (Museo Civico, San Gimignano). In this work the central figure of the saint is surrounded by six scenes from his life. Taddeo also painted a bird's-eye view of the city of Rome in a fresco in the Palazzo Pubblico in Siena dated 1414. The view is surprisingly similar to that painted between 1411 and 1416 by the Limbourg brothers in their miniatures for the *Très riches heures du Duc de Berry* (Musée Condé, Chantilly).

In 1403 Taddeo di Bartolo was engaged on another large work – a double-sided pentaptych for the church of San

Taddeo di Bartolo,
St Francis and the Crib at Greccio.
Landesgalerie, Hanover.

Francesco al Prato in Perugia. One side of the altarpiece has a central *Enthroned Virgin and Child* flanked by *SS. John the Baptist, Mary Magdalen, Catherine of Alexandria and John the Evangelist*. The central panel of the side facing towards the choir depicts *St Francis Crushing the Vices of Pride, Lust and Avarice under his Feet*. To either side of *St Francis* are *SS. Herculanus, Anthony of Padua, Louis of Toulouse and Constantine* while the panels at the outer edges, which join the front and rear of the altarpiece together, depict *St Peter* and *St Paul* (Galleria Nazionale dell'Umbria, Perugia).[12] The predella panels, which contain scenes from the life of St Francis, are now in the Landesgalerie in Hanover, with the exception of the *Appearance of St Francis at Arles* which belongs to the Van Heeck's Heerenberg Collection in Amsterdam. The *San Francesco Pentaptych* influenced other artists such as Giovanni di Paolo, as can be seen in his *Pecci Polyptych*.[13]

Between 1406 and 1408 Taddeo di Bartolo frescoed scenes from the *Last Days of the Virgin* on the vaults and walls of the second-floor chapel of the Palazzo Pubblico. The scenes were the *Annunciation*, the *Farewell to the Apostles*, the *Death of the Virgin*, the *Funeral of the Virgin* and the *Assumption*.

Taddeo has narrated the story in a solemn manner yet the scenes are richly decorated with brilliant colours and there is strong chiaroscuro in the draperies. Other details, such as the architecture which is so densely and unrealistically placed in the background of the *Funeral of the Virgin*, were clearly inspired by similar scenes in the work of the Northern artist Altichiero rather than by the more faithful views of Siena painted by the Lorenzetti.[14] Altichiero's influence in the frescoes confirms Vasari's information that Taddeo di Bartolo made a journey to Padua between 1389 and 1393, when the city was ruled by Francesco da Carrara the Younger.

Between October 1413 and 30 June 1414 Taddeo di Bartolo painted the series of *Uomini Illustri* (*Famous Roman Heroes*) in the anteroom of the chapel in the Palazzo Pubblico under the direction of two chosen Sienese citizens, Messer Pietro de Pecci and Messer Cristoforo di Andrea.[15] The cycle is the earliest example of this subject to have survived. Earlier versions painted in the palace of the Visconti in Milan and in the palace of Francesco da Carrara the Elder in Padua have been destroyed. The commissioning of the *Uomini Illustri* constitutes Siena's first sign of interest in the early fifteenth-

century humanist movement. However, with the exception of *Cicero*, who is somewhat hindered by his fifteenth-century clothes, most of the ancient Romans seem fierce and wild in a way that is not in keeping with their social status. In particular *M. Curius Dentatus* and *Judas Maccabeus*, dressed in fantastic armour and with helmets reaching down as far as their eyes, appear to be barbarians rather than heroes of the ancient Roman Republic. The cycle also represents the *Political Virtues* as tranquil matrons sitting languidly in their lunettes. The *Pagan Gods*, in the area under the arch, are wrapped in the dense shimmering folds of their clothes, which stand out against the gold ground.

On 26 August 1422 Taddeo di Bartolo named his wife Simona and his adopted son Gregorio di Cecco di Luca as his heirs in his will. He died soon after.[16] Gregorio di Cecco was also a painter and trained in his father's workshop.[17] We do not know when he was born but in 1389 his name appears in the *Ruolo dei pittori senesi*. He died a little before 1 July 1424.[18] It is possible that Gregorio was active as a painter in his own right from 1418 onwards.[19] The lack of references as well as the paucity of works that can convincingly be attributed to him mean that our knowledge of his style is fragmentary. In 1415 Gregorio was paid for painting some Biccherna panels. In 1420 he completed, with his father, a panel for the altar of the Marescotti family in the church of Sant'Agostino in Siena that has unfortunately been lost. The central part of the altarpiece in the Marescotti Chapel is a sculpted *Madonna del Magnificat*. The sculpting of the work has been attributed to Giovanni di Turino and the painting to Gregorio di Cecco.[20] The decoration of the Madonna's clothes is identical to that found in Gregorio di Cecco's 1423 *Assumption* for the Tolomei family altar in Siena Cathedral and the raised gesso along the embroidered edges was a technique sometimes used by Taddeo di Bartolo.

The *Tolomei Polyptych* (Museo dell'Opera del Duomo, Siena), for the altar of the Visitation, is Gregorio di Cecco's only signed and dated work. Although it has not survived in its entirety, it is still possible to discern the elegance of the composition and the detailed yet softly defined forms. These aspects of his art – for which Gregorio may have been indebted to Giovanni da Milano – in turn influenced the style of the Osservanza Master.[21]

Gregorio di Cecco di Luca,
Tolomei Polyptych. Museo dell'Opera
del Duomo, Siena.

In the central panel of the *Tolomei Polyptych* is the *Virgin of Humility with Christ and Six Angels* with *SS. Augustine, John the Baptist, Peter and Paul* in the lateral panels. The four evangelists are represented in the trefoils while in the pinnacles Gregorio has painted *St Blaise, St Ansanus* and the *Angel Gabriel Announcing the Birth of Christ to Mary* (private collection, Turin).[22] The central tabernacle contains the *Assumption of the Virgin*. The polyptych is the first Sienese altarpiece to feature the Virgin of Humility in the main central panel.[23] The definition of the figures and the naturalness of their gestures and expressions has a precedent in Ambrogio Lorenzetti's *Madonna del Latte* (Seminario Arcivescovile, Siena), in particular, in the position of the kicking Christ Child. For the facial features Gregorio di Cecco referred to Simone Martini, as his father Taddeo di Bartolo had done. Taddeo's influence is clear in the gold striations that emphasize the enamel-like preciousness of the painting. The central tabernacle has been attributed to the sculptor Domenico di Niccolò 'dei cori' because of the similarity between the framework and the carved wooden chandelier executed for the chapel of the Palazzo Pubblico in Siena, which is also attributed to

Domenico.[24] There is also a personal connection between Gregorio di Cecco and Domenico di Niccolò – in 1423 Gregorio married Domenico's daughter.

Three predella panels that are similar in style to the *Tolomei Polyptych* have been attributed to Gregorio and dated 1420. The central of the three was probably the *Crucifixion* (Museo dell'Opera del Duomo, Siena),[25] with the *Birth of the Virgin* (Pinacoteca Vaticana, Rome) and the *Marriage of the Virgin* (National Gallery, London) to either side. The panels have also been attributed to Gualtieri di Giovanni[26] and Benedetto di Bindo, possibly during the period when both Benedetto and Gregorio di Cecco were serving their apprenticeship in Taddeo di Bartolo's workshop. All three panels are strongly influenced by Taddeo di Bartolo both in the technique of painting the drapery with deep and regular folds as well as in the very detailed decoration.

Niccolò di Buonaccorso is documented between 1355 and 1388 and like other Sienese artists he took part in the public life of his city. Between 1372 and 1377 he was a member of the Council and in 1381 he was elected *gonfaloniere* (standard bearer) of the St Martin district.[27] For a

Niccolò di Buonaccorso,
Marriage of the Virgin.
National Gallery, London.

long time Niccolò was defined as a 'minor Sienese artist'[28] and it is only recently that, thanks to new and convincing attributions and to a more attentive examination of the works already ascribed to him, it has been possible to re-evaluate his importance.[29] The most frequent criticism of his work regards the uniform nature of his compositions. These are small devotional panels that are often similar in subject matter and apparently lacking in any notable stylistic aspects.

The attribution of works to Niccolò di Buonaccorso revolves around his only signed painting, the *Marriage of the Virgin* (National Gallery, London). This is one panel of a larger work which also contained the *Presentation of the Virgin* (Uffizi, Florence) and the *Coronation of the Virgin* (Lehman Collection, Metropolitan Museum of Art, New York).[30] The great merit of these small paintings lies in Niccolò di Buonaccorso's capacity to give an immediacy of expression to the events he narrates, in his construction of perspective in architectonic spaces and in his talent in positioning the decorative elements of the composition. These characteristics are also evident in Niccolò's other works, such as the small panel of the *Annunciation* (previously in the Sterbini Collection, Rome), a painting that can usefully be compared with Paolo di Giovanni Fei's *Annunciation* (previously in a private collection, Bergamo). Niccolò di Buonaccorso's experimentation with the representation of space was influenced by Ambrogio Lorenzetti, especially his *Presentation in the Temple* from the altar of St Crescentius in Siena Cathedral (Uffizi, Florence).[31]

Two panels from the church of Santa Margherita in Costalpino once formed part of an altarpiece, known as the *Montecchio Polyptych*, by Niccolò di Buonaccorso. One panel represents *St Lawrence with a Group of Worshippers at his Feet* (Sant'Andrea, Montecchio) and the other depicts the *Virgin and Child* (Kisters Collection, Kreuzlingen, Switzerland) and is signed and dated 1387. The altarpiece was mentioned by Milanesi in 1854 but the panels were believed lost until Boskovits identified the *Virgin and Child* and the figure of *St Lawrence* was found under a painting of St Margaret in the church of Sant'Andrea in Montecchio. The figures in both panels are characterized by severe facial features and they have deep shadows that are painted with a vigorous linear quality. Their matching measurements and raised gesso decoration confirm their provenance from the same polyptych.[32]

Niccolò probably completed the *Annunciation* from the Sterbini Collection, another in Hartford and a *Deposition* from the Lehman Collection at about the time of the *Montecchio Polyptych*.

Recently a number of works previously assigned to Niccolò di Buonaccorso, such as a Biccherna panel (Kunstgewerbemuseum, Staatliche Museen, Berlin), have been reattributed.[33] The diptych from the Museo Bandini in Fiesole has been given to Jacopo di Mino del Pellicciaio;[34] the *Virgin and Child with Saints* (previously in the Lehman Collection, Metropolitan Museum of Art, New York) is now considered an early work of Taddeo di Bartolo; and the two small panels with saints from the Pinacoteca Vaticana in Rome have been given to the Panzano Master. A *St Paul* (Metropolitan Museum of Art, New York) has been attributed to Niccolò di Buonaccorso[35] but I believe that the panel is more convincingly attributed to Francesco di Vannuccio.[36]

Although opinion on Niccolò's catalogue is by no means unanimous, there are a number of paintings on which his authorship has generally been agreed on grounds of style. These include the diptych with the *Mystic Marriage of St Catherine of Alexandria* and the *Crucifixion* (Museo Nazionale, L'Aquila) as well as the small triptych in the Indiana University Art Museum in Bloomington.[37] I believe that the *St Jerome in his Studio*, sitting remorsefully at his desk, which forms one panel of a diptych with the *Virgin of Humility* (Johnson Collection, Philadelphia Museum of Art) is rightly assigned to Niccolò di Buonaccorso, although Strehlke believed it to be by Benedetto di Bindo.[38]

Benedetto di Bindo, like Niccolò di Buonaccorso, is also known as one of the 'minor Sienese artists' despite the fact that he received some important commissions.[39] These included the frescoes in Siena Cathedral sacristy, the panel paintings that once formed part of the reliquary cupboard in the sacristy – the *Arliquiera* – and the fresco cycle in the St Catherine Chapel in San Domenico in Perugia. Benedetto di Bindo's date of birth is unknown but documents inform us that he died as a young man in Perugia on 19 September 1417, having moved to the city earlier in the year.

Benedetto completed the fresco cycle of the *Life of the Virgin* in the cathedral sacristy between 1411 and 1412.[40] In the central chapel he painted the *Birth of the Virgin*, the

Benedetto di Bindo,
Judas Presented to St Helen.
Museo dell'Opera del Duomo,
Siena.

Presentation in the Temple, the *Marriage of the Virgin* and *Mary's Return to her Parents' Home*. In the right chapel the four evangelists adorn the vaults, with the doctors of the church, including a representation of *St Augustine in Glory*, on the wall. The frescoes in the left chapel are the *Appearance of the Virgin to a Crowd in a City* and the *Appearance of the Archangel Michael on Castel Sant'Angelo*, accompanied by figures of *St Agnes*, *St Margaret* and an unidentified *Prophet*. The sacristy frescoes have suffered considerable damage and in many places the paint surface has been completely lost. Enough remains, however, to gain some understanding of Benedetto di Bindo's style.

Benedetto di Bindo was trained, together with Gregorio di Cecco di Luca, in the workshop of Taddeo di Bartolo and was influenced by Simone Martini, particularly in his choice of colours. He was also capable of great subtlety in his modelling and of a delicate chiaroscuro that accentuates the expressions of his pensive and sometimes frowning faces, which are close in style to those painted by Giovanni da Milano. These stylistic characteristics are evident in the scenes from the *Arliquiera* (Museo dell'Opera del Duomo, Siena)

that consists of eight panels painted on both sides. The panels are divided into thirty-two compartments; in each an angel carries a scroll on which is written the name of the relic. On the back of the panels are six scenes from the story of the *Finding of the True Cross* and two depicting the *Glorification of the Sacred Wood of the True Cross*. One of the scenes from the *Finding of the True Cross* portrays *Judas Presented to St Helen*. The action is set within a tall architectural structure supported on slender columns. The figures are placed to either side of the composition and converse through gesture. Benedetto di Bindo's skill is evident in the way he has painted the colours of the drapery and also in his drawing of the faces of Helen, the kneeling Judas and the crowd of onlookers. Yet the figures are rigidly placed in their poses and their movements are repetitive.

Benedetto's third commission for Siena Cathedral was finished before 10 May 1412. This was the painting of a series of panels, whose original function or position in the cathedral remains unknown, with the *Articles of the Faith*. That the panels are similar in style to those painted by Benedetto for the *Arliquiera* confirms his authorship.

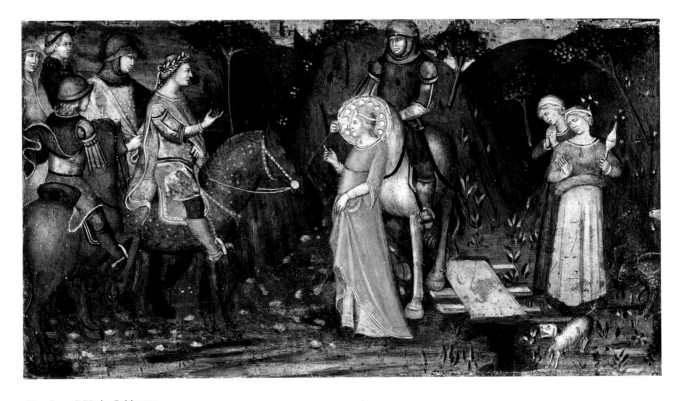

Benedetto di Bindo, *St Margaret Meeting the Prefect Olibrius*. Gemäldegalerie, Staatliche Museen, Berlin.

Before undertaking the commissions for the cathedral sacristy, Benedetto di Bindo had painted Francesco di Valdambrino's carved wooden statues of *St Savinus* and *St Victor* in 1409.[41] He also painted a fresco with a central *Assumption of the Virgin* in the Carmelite church. Unfortunately, this has been almost completely lost and the only figures that remain intact are those of the slender angels who fly and sing praises. It is possible that the *Virgin and Child with SS. Andrew and Honofrius* from the convent of Santa Marta (Pinacoteca, Siena) was also painted by Benedetto di Bindo,[42] although it has also been attributed to Gualtieri di Giovanni.[43] The precise drawing of the bodies, the brilliant colours and the use of chiaroscuro give the figures an intensity that is evident both in their faces and in the folds of their drapery. The face of the Virgin is similar to that of the *St Lucy* in the Institute of Arts in Minneapolis, but more tender and modelled in a more vibrant manner. It foreshadows the style of Benedetto di Bindo's subsequent paintings, which were mostly small predella panels, light-filled compositions containing gracious figures placed in natural and loosely assembled poses.[44]

The *Crucifixion* in Budapest is one such panel which together with *St Anthony Abbot*, *St Margaret* (location unknown) and *St Margaret Meeting the Prefect Olibrius* (Staatliche Museen, Berlin) formed part of a single work.[45] From a stylistic poin of view, they resemble paintings by Bartolomeo Bulgarini and Pietro Lorenzetti in the way the facial features are drawn, particularly the outline of the eyes and the long arch of the eyebrows reaching almost to the top of the nose.[46]

In the works that Benedetto painted at the height of his career the influence of the late Gothic style, as exemplified by Gentile da Fabriano, is apparent. Benedetto would have been able to study Gentile's paintings during his stay in Umbria. Some of the figures in the St Catherine Chapel in San Domenico in Perugia, such as the *St Dominic* in the vault, seem to bear early traces of Gentile da Fabriano's style. The saint has a dark and shadowy face and calligraphic decorations can be found on the borders of his thick woollen clothes.

Other works attributed to Benedetto di Bindo are the *Annunciation* in New York (Cathedral of St John the Divine),

which was probably intended for Siena Cathedral;[47] a *St John the Evangelist* and an unidentified *Apostle*, possibly St Peter (Rijksmuseum Het Catharijneconvent, Utrecht); and two panels with *St Dominic* and the *Blessed Giacomo da Bevagna* (Monte dei Paschi, Siena). The frame of these last two suggest they originally formed part of a triptych, the third part of

which has been identified as the *Virgin and Child with a Donor* (Samuel S. Fleischer Art Memorial, Philadelphia). The inclusion of the *Blessed Giacomo da Bevagna*, who came from Umbria, may indicate that the triptych was painted for a Dominican church in Umbria during the end of Benedetto di Bindo's stay there.[48]

Notes

1 L. Ghiberti, *I Commentari*, edited by J. von Schlosser, Berlin 1912, p. 42.

2 L. Bellosi, in *Il Gotico a Siena*, Florence 1982, p. 292.

3 For the *Madonna of the Notaries*, see A. De Marchi, *Gentile da Fabriano*, Milan 1992, pp. 193–194.

4 G. Damiani, in *Il Gotico a Siena*, pp. 301–303.

5 S. Symeonides, *Taddeo di Bartolo*, Siena 1965.

6 A. Lisini, 'Elenco dei pittori senesi vissuti nei secoli XIII e XIV' in *La Diana*, 1927, II, p. 305.

7 J. Mongellaz, in *Tableaux italiens. Catalogue raisonné de la collection de peinture italienne XIV–XIX siècles*, Grenoble 1988, p. 104.

8 E. Carli (*La Pittura senese del Trecento*, Venice 1981, p. 249) believes that the frescoes in San Gimignano were not painted at the beginning of Taddeo di Bartolo's career but at its height, *c.* 1413.

9 On the iconography of the *Assumption* and on the works of Taddeo di Bartolo, see H. van Os, 'The Assunta in Sienese Art' in *Studies in Early Tuscan Painting*, London 1992, pp. 130–143.

10 C. Wolters, 'Ein Selbstbildnis des Taddeo di Bartolo' in *Mitteilungen des Kunsthistorischen Institutes in Florenz*, 1953, pp. 70–72.

11 Bellosi believes that Taddeo di Bartolo was responsible for the castle of Montemassi on the left of Simone Martini's fresco of

Guidoriccio da Fogliano. See L. Bellosi, 'Ancora sul Guidoriccio' in *Prospettiva*, 1987, 50, pp. 49–55; idem, 'Il paesaggio nella pittura senese del Trecento' in *Uomo e natura nella letteratura e nell'arte italiana del Tre-Quattrocento*, interdisciplinary conference proceedings, Ospedaletto 1992, pp. 105–123.

12 For more information on this painting, see G.E. Solberg, 'A Reconstruction of Taddeo di Bartolo's Altarpiece for S. Francesco a Prato, Perugia' in *The Burlington Magazine*, 1992, 134, pp. 646–656.

13 G. Chelazzi Dini, in *Mostra di opere d'arte restaurate nelle province di Siena e Grosseto*, Genoa 1981, II, pp. 72–75.

14 C. Brandi, *Quattrocentisti senesi*, Milan 1949, p. 169.

15 C. Brandi (ed.), *Il Palazzo Pubblico di Siena. Vicende costruttive e decorazione*, Milan 1983, pp. 241 and 425. For the political significance of the cycle, see N. Rubinstein, 'The Political Significance of the Frescoes by Ambrogio Lorenzetti and Taddeo di Bartolo in the Palazzo Pubblico in Siena' in *Journal of the Warburg and Courtauld Institutes*, 1958, XXI, pp. 179–207.

16 G. Milanesi, *Documenti per la storia dell'arte senese*, Siena 1854, I, pp. 107–108. Other sources on the life and works of Taddeo di Bartolo can be found in J.A. Crowe and G.B. Cavalcaselle, *A New History of Painting in Italy*, London 1864, II; and L. Tanfani-Centofanti, *Notizie di artisti tratte dai documenti pisani*, Pisa 1897.

17 G. Corti, 'La Compagnia di Taddeo di Bartolo con Gregorio di Cecco, con altri documenti inediti' in *Mitteilungen des Kunsthistorischen Institutes in Florenz*, 1981, XXV, pp. 373–377.

18 Ibid.

19 G. Milanesi, *Documenti*, I, p. 47.

20 E. Neri Lusanna, 'Un episodio di collaborazione tra scultori e pittori nella Siena del primo Quattrocento: la "Madonna del Magnificat" di Sant'Agostino' in *Mitteilungen des Kunsthistorischen Institutes in Florenz*, 1981, pp. 325–340. Also L. Bellosi, in *Scultura dipinta. Maestri di legname e pittori a Siena. 1250–1450*, Florence 1987, p. 166.

21 R. Longhi, 'Postilla' in *Proporzioni*, 1948, II, p. 88.

22 For the Angel Gabriel, see R. Bartalini, in *Antichi maestri pittori. 18 opere dal 1350 al 1520*, Turin 1987, cat. 10.

23 H. van Os, *Studies in Early Tuscan Painting*, London 1992, p. 135.

24 Domenico di Niccolò (Siena, 1363–1453) was called 'dei cori' because he executed the wooden choir for the new chapel in the Palazzo Pubblico. It was commissioned on 26 August 1415. For the comparison between the carved wooden chandelier in the Palazzo Pubblico and the framework of the *Tolomei Polyptych*, see R. Bartalini, in *Antichi maestri pittori*, p. 198.

25 M. Laclotte and E. Mognetti observed similarities with Taddeo di Bartolo's *Crucifixion* in Avignon despite the loss of colour that has occurred. See M. Laclotte and E. Mognetti, *Avignon, Musée du Petit Palais. Peinture Italienne*, Paris 1987, p. 116.

26 For critical opinion on these panels, see B. Berenson, 'Quadri senza casa. Il Trecento senese' in *Dedalo*, 1930–1931, XI, pp. 329–362; B. Berenson, *Italian Pictures of the Renaissance. Central Italian and North Italian Schools*, London 1968, p. 201; C. Brandi, *Quattrocentisti senesi*, Milan 1949, p. 35, in which Brandi also attributes the *Virgin and Child* (Johnson Collection, Philadelphia Museum of Art) to Gualtieri di Giovanni. This hypothesis has been convincingly disputed by M. Boskovits, 'Su Niccolò di Buonaccorso, Benedetto di Bindo e la pittura senese del primo Quattrocento' in *Paragone*, 1980, 359–361, pp. 3–22; R. Longhi, 'Postilla', p. 88; M. Boskovits, 'Su Niccolò di Buonaccorso'; L. Bellosi, in *Il Gotico a Siena*, p. 348.

27 G. Milanesi, *Documenti*, Siena 1854, I, pp. 31–32 and note 2.

28 R. Longhi, 'Tracciato orvietano' in *Paragone*, 1962, 149, pp. 3–14.

29 M. Boskovits, 'Su Niccolò di Buonaccorso', pp. 3–22.

30 For the *Coronation of the Virgin*, see J. Pope-Hennessy, in *Italian Paintings in the Robert Lehman Collection*, New York 1987, pp. 33–35.

31 L. Marcucci, *I Dipinti del secolo XIV*, Rome 1965, p. 169.

32 M. Boskovits, 'Su Niccolò di Buonaccorso', pp. 5–6, proposes to identify, with some caution, two other predella panels from the *Santa Margherita Polyptych* in Costalpino. These are the *Crucifixion* (Szépmuvészeti Muzeum, Budapest) and the *Presentation of the Virgin in the Temple* (previously in the Kaulbach Collection, Munich).

33 For the most recent information on Niccolò di Buonaccorso, see G. Chelazzi Dini, 'Niccolò di Buonaccorso' in *Enciclopedia dell'arte medievale*, Rome (in press).

34 L. Bellosi, 'Jacopo di Mino del Pellicciaio' in *Bollettino d'arte*, 1972, LVII, p. 76.

35 M. Boskovits, 'Il Gotico senese rivisitato: proposte e commenti su una mostra' in *Arte Cristiana*, 1983, 698, p. 274, note 36.

36 F. Zeri and E.E. Gardner, *Italian Paintings. A Catalogue of the Collection of the Metropolitan Museum of Art. Sienese and Central Italian Schools*, New York 1980, pp. 13–14.

37 The triptych was attributed to Niccolò di Buonaccorso by B. Cole and A. Medicus-Gealt, 'A New Triptych by Niccolò di Buonaccorso and a Problem' in *The Burlington Magazine*, 1977, CXIX, pp. 184–187. The authors believe that the triptych came from the Ospedale di Santa Maria della Scala because of the stairs depicted in the painting. Niccolò di Buonaccorso also painted a *Virgin and Child with SS. Anthony Abbot and Catherine of Alexandria*, the so-called *Virgin of the Four Winds* (location unknown). See E. Carli, 'La Madonna dei Quattro Venti' in *Carta Canta*, Siena 1967, p. 32; A. Leoncini, *I Tabernacoli di Siena. Arte e devozione popolare*, Siena 1994, p. 148, pl. 154.

38 C. Brandi, *Giovanni di Paolo*, Florence 1947, p. 70, note 19; G. Chelazzi Dini, in *Il Gotico a Siena*, p. 362; C.B. Strehlke, 'Sienese Painting in the Johnson Collection' in *Paragone*, 1985, 427, pp. 3–15.

39 For information on Benedetto di Bindo, see P. Bacci, *Fonti e commenti per la storia dell'arte senese*, Siena 1944, pp. 195–229; C. Brandi, *Quattrocentisti senesi*, Milan 1949, pp. 29–32 and 175–180, notes 8–12;

C. Volpe, 'Deux panneaux de Benedetto di Bindo' in *La Revue des arts*, 1958, VIII, pp. 172–176. Volpe attributed an *Adoration of the Magi* to Benedetto di Bindo (private collection), as well as a fragment of a painting in the Musée de Dijon and painting no. 111 in the Pinacoteca in Siena. See also M. Boskovits, 'Su Niccolò di Buonaccorso', pp. 3–22.

40 On Benedetto di Bindo's frescoes in Siena Cathedral sacristy, see J. Mongellaz, 'Reconsidération de la distribution des rôles à l'intérieur du groupe des Maîtres de la Sacristie de la Cathédral de Sienne' in *Paragone*, 1985, 427, pp. 73–89.

41 R. Bartalini, in *Scultura dipinta. Maestri di legname e pittori a Siena. 1250–1450*, Florence 1987, p. 195.

42 C. Brandi, *Quattrocentisti senesi*, pl. 29.

43 P. Torriti, *La Pinacoteca nazionale di Siena. I dipinti dal XII al XV secolo*, Genoa 1977, pp. 214–215.

44 M. Boskovits, 'Su Niccolò di Buonaccorso', pp. 3–22.

45 M. Boskovits, *Frühe Italienische Malerei, Gemäldegalerie Berlin*, Berlin 1988, pp. 18–20.

46 C.B. Strehlke, 'Sienese Painting in the Johnson Collection' in *Paragone*, 1985, 427, pp. 3–15.

47 M. Boskovits, 'Il Gotico senese rivisitato: proposte e commenti su una mostra' in *Arte Cristiana*, 1983, 698, p. 267.

48 Boskovits's hypothesis of an Umbrian provenance has been accepted by R. Bartalini, in *La Sede storica del Monte dei Paschi di Siena. Vicende costruttive e opere d'arte*, Siena 1988, pp. 284–288. See M. Boskovits, 'Su Niccolò di Buonaccorso', p. 11–12.

The Fifteenth Century:
the Shadow of the Renaissance

Internecine fighting amongst the Sienese ruling class led the city in 1399 to turn to the duke of Milan, Gian Galeazzo Visconti, to impose peace. However, in 1402 Gian Galeazzo died and by 1404 Siena was once again a republic. The reinstated Sienese government clearly intended to maintain their devotion to the great artistic models of the early fourteenth century – a period when Siena was at the height of its political power. The conservative nature of Sienese painting, whether ecclesiastical or secular, prevailed mainly on iconographic questions and only secondarily on stylistic questions.

In 1450 the Franciscan friar Bernardino Albizzeschi was canonized as St Bernardino of Siena. He had preached in Siena citing the paintings in the Palazzo Pubblico in his sermons and advising his audience to go and see Ambrogio Lorenzetti's frescoes of *Good and Bad Government* and Simone Martini's *Maestà*. He used these works of art as educational instruments, which in effect broadened the role of the painter to encompass that of the teacher.

In addition to the government and the Church, the civic corporations were another important source of commissions within the city. These corporations were quite separate from the government, in which they took no part, unlike in Florence.[1] They commissioned many important works such as the *Arte della Lana [Wool Guild] Altarpiece* painted by Sassetta between 1423 and 1426.

At the beginning of the fifteenth century the first wave of humanism had not yet reached Siena but it did not take long to do so.[2] A little after 1420 it is probable that some Sienese painters – Sassetta, almost certainly Giovanni di Paolo, and soon afterwards Domenico di Bartolo – visited Florence to see the masterpieces of Renaissance art. Curiosity about the new style and the political necessity of maintaining good

relations with Florence favoured this temporary move. The Sienese artists gradually assimilated the new Renaissance art and in particular Brunelleschi's developments in the field of linear perspective. Some of these artists, such as Giovanni di Paolo, adopted the compositional schemes invented by the Florentines, rather than looking at the foundations of the new naturalistic style.

Although the Florentine developments did make some headway in Siena, conservatism usually prevailed. The main exception were the frescoes from the Ospedale di Santa Maria della Scala that looked to contemporary and 'realistic' art. Despite the continuing nostalgia for the past, Sienese painters of the early fifteenth century still achieved some extraordinary results.

The many restoration commissions given during the following century testify to the continuing respect for the great fourteenth-century paintings even though these 'restorations' were often a total repainting of the earlier work. For example, in 1445 Sano di Pietro undertook a radical retouching of the *Coronation of the Virgin* by Lippo Vanni in the Biccherna office in the Palazzo Pubblico.

The artistic situation in Siena in the 1430s can be summarized as moving towards contemporary Florentine art, but the Sienese artists borrowed only that which was compatible with their own traditions. This continued until Pius II, who became pope in 1457, gave a decisive push to the spread of humanism. The period up until the advent of Pius II has been characterized as the 'shadow of the Renaissance'. In other words, it was a time when the Gothic style still prospered but was overshadowed by the new Renaissance art that was already flourishing in Florence.[3]

In his training, Stefano di Giovanni, better known as Sassetta, was clearly influenced by fourteenth-century Sienese art and especially by the paintings of Pietro and Ambrogio Lorenzetti. However, Sassetta was also aware of the latest developments in Florentine art pioneered by artists such as Paolo Uccello and Fra Angelico from 1420 onwards and was particularly influenced by the art of Masaccio. Unfortunately, the fame which Sassetta won during his short life did not continue through the following centuries and he was almost completely forgotten until the early years of the twentieth century.[4]

The date of Sassetta's birth is still unknown but he was almost certainly born in Cortona since the name of the city appears after his signature in various documents.[5] He was the son of Giovanni di Consalvo (or Consolo) of Cortona. The family moved to Siena while Sassetta was still young but did not break their links with Cortona. In fact, one of Sassetta's most admired works was commissioned for the church of San Domenico in Cortona in the mid-1430s – the *Virgin and Child with St Nicholas, the Archangel Michael and SS. John the Baptist and Margaret*.

In 1423 Sassetta painted an altarpiece for the merchants of the *Arte della Lana* (Wool Guild), which is unfortunately no longer complete. Abbot Carli (*c.* 1750) and Angelo Maria Carapelli (1718) saw the triptych in the chapel of the church of San Pellegrino in Siena before it was divided in around 1777, the date the chapel was destroyed.[6] Views differ on the interpretation of the inscription recorded by Carli and Carapelli,[7] which reads: HINC OPUS OMNE. PATRES. STEPHANUS CONSTRUXIT AD ARAS SENENSIS JOHANNIS. AGENS CITRA LAPSUS ADULTOS (From here, o Fathers, the Sienese Stefano di Giovanni constructed

all the work at the altar, acting in opposition to the old errors [i.e., heresy]). It is more likely that the inscription refers to the Church Fathers who had gathered at the Council in Siena in 1423 rather than being a declaration of youthful arrogance on the part of the artist.[8]

One of the surviving parts of the altarpiece is a predella panel representing the *Burning of a Heretic* (National Gallery of Victoria, Melbourne).[9] Two landscape fragments from the Pinacoteca in Siena, previously believed to be by Ambrogio Lorenzetti, have also been attributed to Sassetta and these enable us to form a better understanding of the stylistic characteristics of his painting. The most important component of Sassetta's art derives from the local fourteenth-century figurative tradition and was partially due to his training in Benedetto di Bindo's workshop.[10] Sassetta's Sienese training is also evident in the architecture of his panels dedicated to St Thomas Aquinas. The *Vision of St Thomas Aquinas* (Pinacoteca Vaticana, Rome) is similar in its architectural conception to Pietro Lorenzetti's *Dream of Sobac* from the predella of the *Carmelite Altarpiece*,[11] with the interior spaces designed in the same way. Sassetta's perspective construction is rigorously

Sassetta, *Vision of St Thomas Aquinas*. Pinacoteca Vaticana, Rome.

worked out and the most consistent that can be found in Sienese painting at this time. The interiors are much more than an excuse for enriching the painting: their austerity reflects the religious and moral vigour of St Thomas Aquinas and his dedication to studying, reading and writing. In the other surviving predella panel, the *Miracle of the Sacrament* (Bowes Museum, Barnard Castle, Durham), Sassetta has represented the inside of a church where the central nave, the transept and the chapels, with their niches and altarpieces, have all been individuated. The figures, in particular those of the Carmelite friars and the surrounding kneeling women, have a monumental quality that is also found in the three-dimensional figures of the apostles in the *Last Supper* (Pinacoteca, Siena) that once formed part of the predella from the *Arte della Lana Altarpiece*. The composition of the *Last Supper* is divided into three by means of arches. The work is rigorously symmetrical and the gestures of the apostles have a measured eloquence, slightly undermined by the problems that Sassetta experienced in the perspective construction.

The *Burning of a Heretic* is a considerably more dramatic composition. The violence of the scene is reinforced by the dense and dark colours, which have an overall amber tone. The sense of drama is emphasized by the geometrical volumes of the silver horses and the yellow gold of the clothes of the various protagonists. Sassetta explores naturalistic effects in the panels and experiments with various new and original poses for the animals and men. He also tries out certain innovative formal solutions, such as the back view of the horses in sharp foreshortening, that anticipate those of Paolo Uccello in compositions like the *Battle of San Romano* (Uffizi, Florence). To either side of the heretic, who is already being consumed by the fire, the crowd is divided between the close-packed group who pray in front of an altar placed outside the city walls and the restless party of onlookers kept at bay by the guards.

In the *Temptation of St Anthony* (Pinacoteca, Siena), Sassetta has depicted the saint's strenuous resistance to the beating that the demons are inflicting on him. The most striking element of the panel, however, is the marvellously naive representation of nature, especially the great white streaks that constitute the sky – one of the first times that these appear in Italian painting.

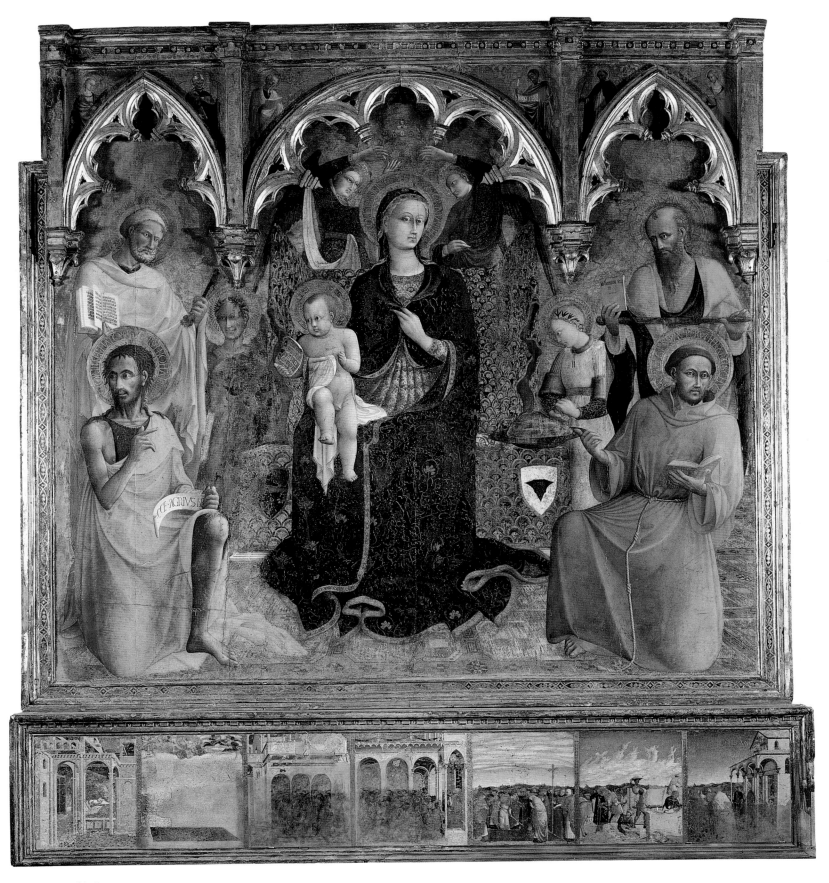

Sassetta, *Virgin of the Snow*.
Contini-Bonacossi Collection,
Palazzo Pitti, Florence.

Two miniatures which illustrate the *Missale Romanum* (cod. G.V.7, Biblioteca Comunale, Siena) may have been painted before the *Arte della Lana Altarpiece*. One shows a bust of the *Blessing Christ* and the other the *Crucifixion between St John the Evangelist and the Virgin* in which the Virgin and the evangelist have unusually switched positions.[12]

In the 1430s Sassetta's art continued on a parallel course with the revolutionary developments of the Florentines. The influence of Florentine art is evident in the *Virgin of the Snow* (Palazzo Pitti, Florence) painted for the St Boniface Chapel in Siena Cathedral. Sassetta received the commission in March 1430 and completed it in October 1432. The central Virgin supports the Christ Child with one hand; with the other she holds her mantle closed, although still revealing the richly ornate dress beneath. Arranged in a semicircle around her are a group of slim figures who express their nobility through their gestures and their comportment.

The foundations of linear perspective, as practised by the Florentines, were only partially understood by Sassetta. He may have had the opportunity to study perspective during a first visit to Florence in the 1420s and his paintings

demonstrate that he gradually built on this knowledge throughout his career. Sassetta's art is notable for the way in which the worldly and religious elements, as well as aspects of the Gothic and Renaissance styles, coexist throughout his entire career.[13]

The mixture of styles in Sassetta's paintings stems from a number of influences, which include both Giovanni da Milano and Masolino. The latter painted courtly narratives and elegant mannequins who were placed in silent pseudo-Renaissance architecture, such as the unending loggia in the frescoes in Castiglione Olona. It was probably the courtly aspect of Masolino's style that attracted Sassetta's eye.

It is clear from Sassetta's surviving works that he both knew and was influenced by Masaccio, who worked with Masolino on the frescoes in Santa Maria del Carmine in Florence. Towards the end of the 1420s Sassetta included citations from Masaccio's works in his own paintings, one of which is the famous nude figure in the panel representing *St Martin and the Beggar* (Monte dei Paschi, Siena). The panel, together with two mourners, was once part of the cross painted in 1433 for the church of San Martino in Siena.

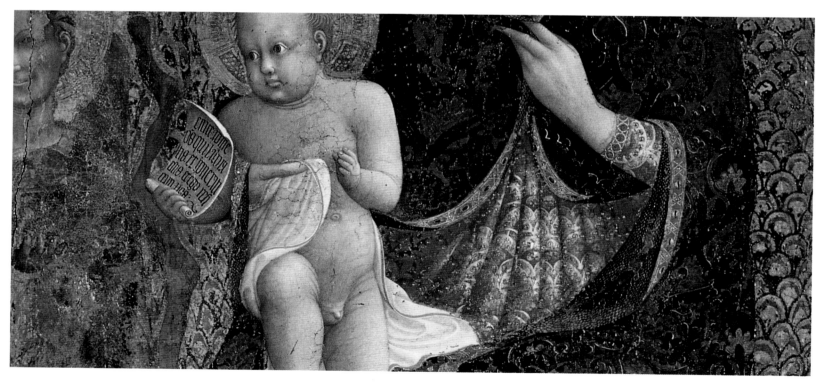

Sassetta, *Virgin of the Snow*,
detail. Contini-Bonacossi Collection,
Palazzo Pitti, Florence.

225

Unfortunately, at the end of the eighteenth century the work was sawn up in order to make doors. The nude and trembling man and the intensity of emotion transmitted by the two protagonists in Sassetta's *St Martin and the Beggar* bring to mind Masaccio's fresco of the *Baptism of the Neophytes* in Santa Maria del Carmine. Such examples show the extent of Sassetta's connections with Florence by the 1430s. The panel of *St Martin and the Beggar* has a number of stylistic similarities with the *Miracle of the Snow* and the *Construction of the Church of Santa Maria Maggiore*, panels from the predella of the *Virgin of the Snow* painted between 1430 and 1432.[14] These include the taut sinew beneath the shining coat of the small horse and the energetic outline of the saint, which recalls the thin figures crowded into the two predella panels.

Two panels of the *Journey of the Magi* (Metropolitan Museum of Art, New York) and the *Adoration of the Magi* (Monte dei Paschi, Siena) once formed part of a single work.[15] Sassetta probably painted them around 1435, a little before the *Borgo San Sepolcro Polyptych*.[16] The *Adoration of the Magi* was undoubtedly influenced by the *Strozzi Altarpiece* painted by Gentile da Fabriano in 1423, not so much in the composition, but more in the representation of the soft woollen materials and the fashionable clothes of the men. The two panels represent a turning point in Sassetta's art. From this time on, his style moved towards the refinement of Simone Martini's work as the spatial experiments of the Lorenzetti receded into second place.

In 1437 Sassetta received the commission to paint a double-sided altarpiece for the high altar of the church of San Francesco in Borgo San Sepolcro. He took seven years to complete this commission and was paid 519 florins – a very large sum for the time. It is unfortunate that the altarpiece was dismantled in the nineteenth century but all the panels still survive. The central panel of the side facing the choir was a *Virgin and Child with Six Angels* (Louvre, Paris). To the left were the *Blessed Ranieri Rasini* and *St John the Baptist* (Berenson Collection, Villa I Tatti, Settignano) and to the right *St Anthony of Padua* and *St John the Baptist* (Louvre, Paris). In the predella Sassetta depicted the miracles of the Blessed Ranieri. The central panel of the back of the altarpiece showed *St Francis in Ecstasy* (Berenson Collection, Villa I Tatti, Settignano) flanked by eight scenes from his life. Seven

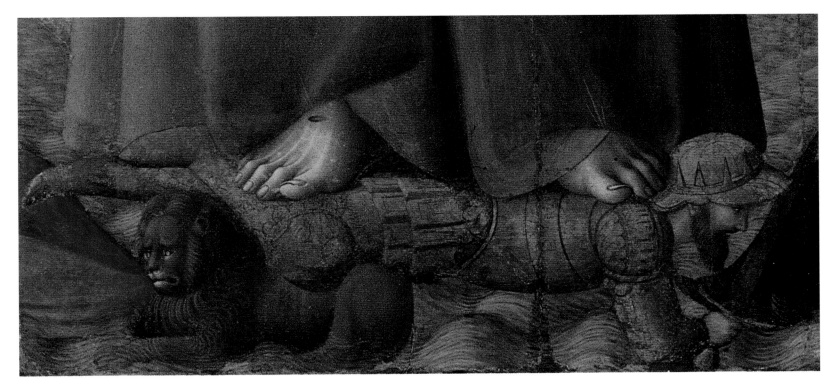

Sassetta, *St Francis in Ecstasy*, detail. Berenson Collection, Villa I Tatti, Harvard Center for Renaissance Studies, Settignano.

p. 226
Sassetta, *St Francis in Ecstasy*. Berenson Collection, Villa I Tatti, Harvard Center for Renaissance Studies, Settignano.

p. 227
Sassetta, *St Francis Giving his Mantle to a Poor Man and the Vision of the Heavenly City*. National Gallery, London.

of them are in London's National Gallery and the eighth, the *Mystical Marriage of St Francis with the Lady Poverty*, is in the Musée Condé in Chantilly.[17]

According to the surviving documents the commission was originally given to Antonio d'Anghiari, Piero della Francesca's first teacher, in 1430 but he had never carried out the work. The meticulous way in which Sassetta narrates the episodes and in which he constructs the setting is striking. The figures have a delicacy and subtlety indicative of the neo-Gothic trend in Sassetta's later works. They are both slender and monumental at the same time and wear clothes of pure saturated colours, which are illuminated by a clear light reminiscent of Domenico Veneziano's paintings. The *Borgo San Sepolcro Polyptych* was to greatly influence the art of Piero della Francesca.[18]

Sassetta also painted a group of seven panels representing the *Virgin of Humility with the Christ Child*. The panels are so similar in style that it is difficult to differentiate between them. The Virgin slightly turns away from the spectator to look at Christ who, in turn, looks back at his mother. The *Virgin of Humility* (Frick Art Museum, Pittsburgh), although

damaged, seems to have been executed at around the same time as the *Borgo San Sepolcro Polyptych* from which it takes the motif of the angels holding the foreshortened crown.

In 1447 Sassetta was commissioned by the *gonfaloniere* of the Terzo di San Martino (one of the three administrative areas of the city), following the orders of the Concistoro, to paint a fresco of the *Coronation of the Virgin* in the vault of the Porta Romana (a fragment of his fresco survives in the church of San Francesco). He died on 1 April 1450 before he could finish the work. Sano di Pietro took a number of attempts, between 1458 and 1466, to complete the fresco.[19]

The style of the anonymous Osservanza Master has a number of similarities with that of Sassetta but is more persistently Gothic. His name was taken from the triptych of the *Virgin and Child with SS. Ambrose and Jerome* in the church of the Osservanza in Siena, the predella of which is now in the Pinacoteca in Siena.[20] Because the Osservanza Master's style is so similar to that of Sassetta and Sano di Pietro, it has proved difficult to make any secure attributions to him. The hypothesis that the works attributed to the Osservanza Master are early paintings by Sano di Pietro has recently been proposed.[21]

Sassetta, *Virgin of Humility*.
Frick Art Museum,
Pittsburgh.

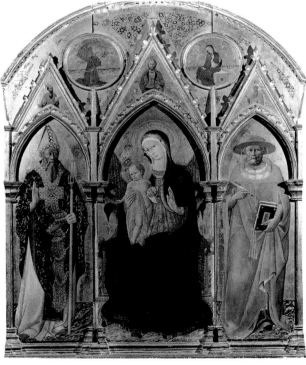

Osservanza Master, *Virgin and
Child with SS. Ambrose and Jerome*.
Church of the Osservanza, Siena.

p. 229
Osservanza Master, *Birth of the Virgin*.
Museo d'Arte Sacra, Asciano.

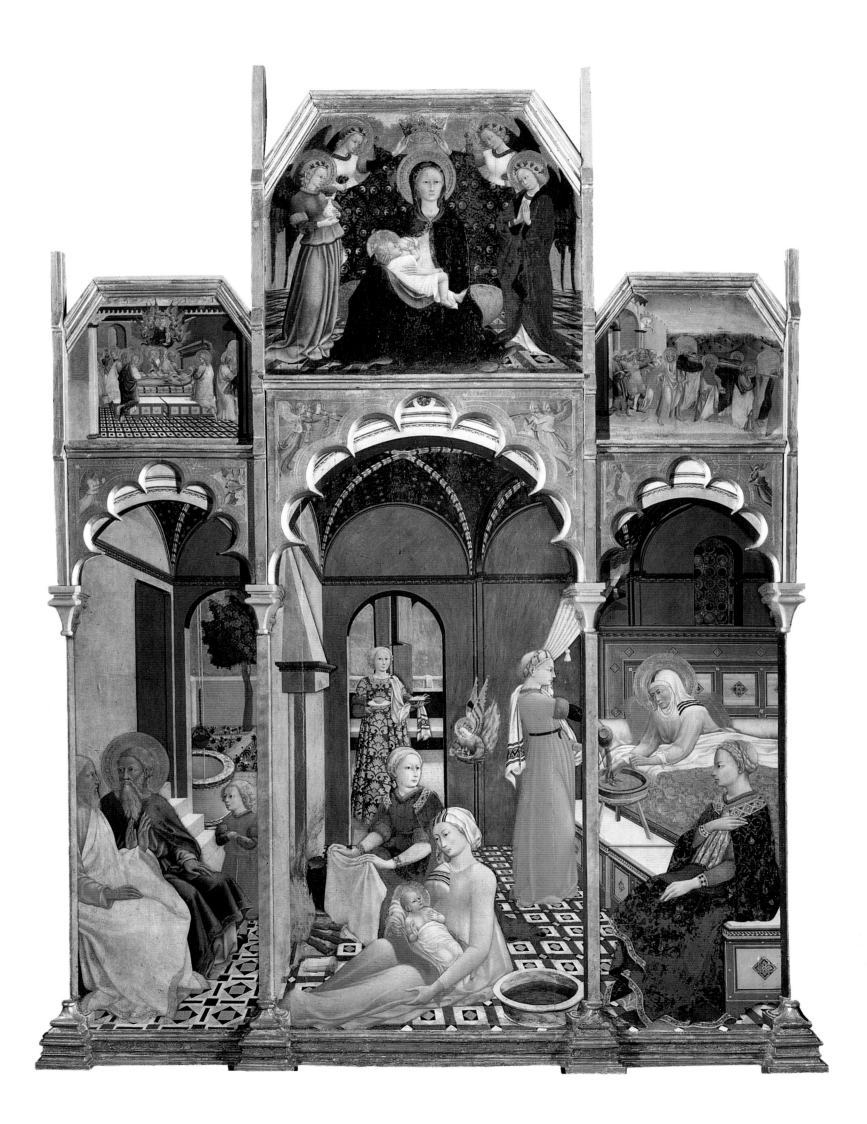

Other paintings ascribed to the Osservanza Master include a *Pietà with St Sebaldus and a Donor* (Monte dei Paschi, Siena); the *Birth of the Virgin* (Museo d'Arte Sacra, Asciano); two triptychs (Monte dei Paschi and no. 177, Pinacoteca, Siena); a series of scenes from the life of St Anthony; a predella showing the Passion of Christ; a predella panel with the *Martyrdom of St Bartholomew* (Pinacoteca, Siena) and *St George and the Dragon* (San Cristoforo, Siena); and a number of other small panel paintings housed in various collections.

The style of these paintings has led to the supposition that the Osservanza Master knew the work of Giovanni di Milano, an artist who had influenced both Masolino and Sassetta. The Osservanza Master has been described in relation to Sassetta as his more gothicizing alter-ego who is less interested in Masaccio's style and more conservative. This is shown in his love of decorative detail and in the profusion of gold and silver, which he used to emphasize the naturalistic elements of his scenes.

The Osservanza Master and Sassetta could not have been one and the same person since the stylistic incongruities between the former's *Virgin and Child with SS. Ambrose and Jerome* and the latter's *Virgin of the Snow* are too marked for paintings executed within six years of one another. The *Virgin and Child with SS. Ambrose and Jerome* has an inscription giving the date of 1436 while the *Virgin of the Snow* was painted between 1430 and 1432.

The *Birth of the Virgin* (Museo d'Arte Sacra, Asciano) and the *Pietà* (Monte dei Paschi, Siena) are both attributed to the Osservanza Master because of their similarities in style. There is a clear division between these works and the paintings known to have been executed by Sassetta, further confirming that the Osservanza Master cannot be identified as Sassetta. The Osservanza Master has been characterized as having a 'cold and measured soul' that is incompatible with Sassetta's 'sensual' mind, a mind that pushed him to experiment with his materials and led him to compare and combine his own potential and his own independent personality with the newly discovered laws of perspective. The Osservanza Master's intentions were quite different. He 'placed the vanishing point and drew in the orthogonals without any errors, he did not even forget to make the figures diminish in size,

Osservanza Master,
Birth of the Virgin, detail.
Museo d'Arte Sacra, Asciano.

but in the end he only discovered a practical expedient for arranging the architectural space'.[22]

In the *Birth of the Virgin* the Osservanza Master concentrates on the decorative qualities of the painting rather than on the profound religious significance of the event. The calm atmosphere of the scene and the natural movements of the protagonists demonstrate these qualities. The figures, with their small pointed facial features, pause in their movements as though they are elegant mannequins. The *Birth of the Virgin* was painted between 1430 and 1433 and its style recalls Gregorio di Cecco di Lucca. Gregorio, the adopted son of Taddeo di Bartolo, may have been the inspiration for the Osservanza Master's soft and modelled painting.

The figures in the *Virgin and Child with SS. Ambrose and Jerome* are delineated with a fluid line, but like the *Birth of the Virgin*, the religious message is not stressed. The figures of the central Virgin and Child and the lateral SS. Ambrose and Jerome are all placed frontally with dignified gestures that are similar to those in the *Virgin and Child Enthroned with Two Cherubim* (Lehman Collection, Metropolitan Museum of Art, New York), which is a faithful copy of the central group in the *Virgin and Child with SS. Ambrose and Jerome*. In these two paintings the Osservanza Master has changed the delicate lyricism of Sassetta into a 'a cold detachment, embodied by a Virgin who is a sacred idol more than an affectionate mother'.[23]

The *St George and the Dragon* (San Cristoforo, Siena) was painted for the Tolomei family chapel, founded in 1440, in the church of San Cristoforo. The style of this work has meant that it has been ascribed to a number of different artists. It has also been proposed that it was the result of a collaboration between two artists, Sano di Pietro – who from 1440 onwards had his own workshop – and the Osservanza Master. This hypothesis stemmed from the type of punches used in the *Birth of the Virgin* and the *Virgin and Child with SS. Ambrose and Jerome*, which are identical not only to those in the *St George and the Dragon* and the *Virgin and Child Enthroned with Two Cherubim*, both attributed to the Osservanza Master, but also to those in the *Gesuati Altarpiece*, dated 1444 and signed only by Sano di Pietro.

The Osservanza Master also painted a series of eight panels with scenes from the life of St Anthony Abbot and a

five-part predella with scenes from the Passion. These works show the Osservanza Master's creative ability in depicting internal and external settings against which the action takes place. The protagonists have more fluency in their movements and a greater sense of communication, both with each other and with the observer, than in other works by the Osservanza Master.

The *Resurrection* in Detroit is also attributed to the Osservanza Master. The complex arrangement of the colours, luminous and immersed in a timeless atmosphere, makes the background seem frozen as the miraculous event unfolds before a small group of soldiers, still dazed by sleep and night. A pale-green hill rises at the back of a night landscape surrounded by the reddish and grey-blue shades of the horizon. The marble sarcophagus is placed centrally among the soldiers who are woken by the blinding glare that radiates from the vast golden mandorla against which Christ is silhouetted. The resurrected Christ is almost completely covered by a light tunic and wears a solemn expression on his pallid face.

The works attributed to the Osservanza Master that have just been discussed were painted between approximately 1435, the date of the scenes from the life of St Anthony Abbot, and 1450, the date of the *St George and the Dragon*. On the basis of this, it has been suggested that the Osservanza Master can be identified with Vico di Luca, who was documented as working with Sassetta in Siena Cathedral in 1442.[24] Stylistic differences between many of the works attributed to the Osservanza Master and those known to have been painted by Sano di Pietro, who appeared in the *Ruolo dei pittori senesi* for the first time in 1428, rule out the latter's identification with the anonymous Osservanza Master.[25]

Sano di Pietro, who was born in 1405 and died in 1481, was a prolific painter during his long career. In 1444 Sano di Pietro painted the polyptych for San Girolamo dei Gesuati in Siena (Pinacoteca, Siena), his earliest signed and dated work to have survived, although at this time the artist was already nearly forty years old. It was probably painted at the same time as the Osservanza Master's Gabella panel of the *Archangel Michael* (no. 27, Archivio di Stato, Siena), which is a loose interpretation of Ambrogio Lorenzetti's version of the same subject in Asciano. The Gabella panel, one of the Osservanza Master's most subtle and elegant works,[26] cannot

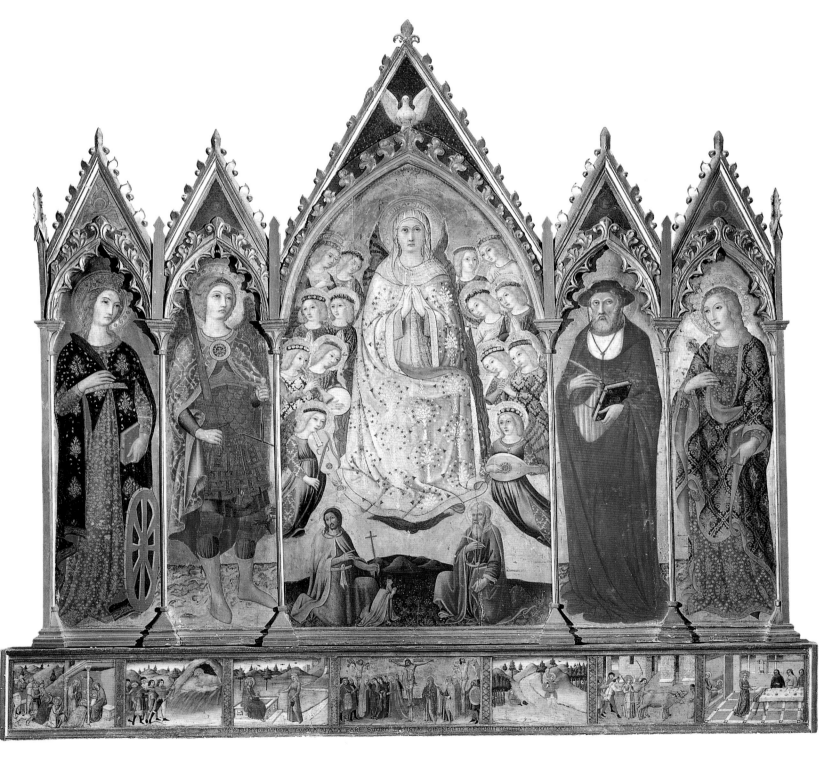

Sano di Pietro, *Assumption of the Virgin*. No. 227, Pinacoteca, Siena.

be reconciled with the uniformity of language and with the mannered execution that distinguish the artistic career of Sano di Pietro after 1450. The *Gesuati Altarpiece*, wanted for the consecration of the church, was commissioned by the Sienese Antonio Bettini who in 1440 had been given the task of founding a Gesuati community in San Giovanni e Paolo in Rome. One of the predella panels, in which Sano di Pietro has copied a number of motifs used by the Osservanza Master, shows *St Jerome in Prayer* at the entrance to his cave (Louvre, Paris).[27] Sano has emphasized the wretched nature of the cave by setting it against the luxurious vegetation that flourishes to either side.

In 1445 Sano di Pietro repainted the fresco of the *Coronation of the Virgin* originally executed by Lippo Vanni in the Sala di Biccherna in the Palazzo Pubblico. Sano di Pietro often worked with other artists in order to complete his numerous commissions within a short time and this painting was almost certainly undertaken in collaboration with Domenico di Bartolo.[28]

One of Sano di Pietro's most important works from before the *Gesuati Altarpiece* is the small *Assumption of the Virgin* (no. 227, Pinacoteca, Siena) which demonstrates his debt to Sassetta.[29] Sassetta's style can be recognized in the depiction of the childlike Virgin and in the arrangement of the angels who accompany the ascent to heaven with music and singing. The triptych from the Pinacoteca in Siena (no. 277) and that previously in the Chigi Saracini Collection in Siena (no. 92), both of which have been attributed to the Osservanza Master, demonstrate clear links with Sano di Pietro's *Assumption of the Virgin*. They pose the question of the relationship between the two artists, causing the problems surrounding the identification of the latter once again to resurface.

Sano di Pietro's triptych from the museum in Pienza was also painted before the *Gesuati Altarpiece* as were the two colourful and lively representations of the *Sermons of St Bernardino* (chapter room, Siena Cathedral). The last two are of documentary interest because one shows the fifteenth-century appearance of the Campo, the main square in Siena, and the other depicts the old façade of San Francesco. At the time, the lower half of the façade of the church was covered with black and white marble facing which was removed at

Sano di Pietro, *Breviarium fratrum minorum*. Cod. X.IV.2, fol. 512, Biblioteca Comunale, Siena.

the end of the nineteenth century. During the fourteenth and fifteenth centuries sermons were popular events and important because of their civic as well as their religious significance.[30] When he completed these paintings Sano di Pietro had already become the foremost painter of the Observant Franciscan friars and the representation of these sermons spread his fame further. The panels inspired a greater number of representations of St Bernardino, who had initiated the cult of Christ's monogram with which he is usually depicted.

From this time on commissions from the Comune of Siena became more and more frequent. Among them were the predella for the altarpiece in the Chapel of the Signori, a commemorative figure of Pope Calixtus III and an *Annunciation* painted in 1459. Sano di Pietro also did a considerable amount of work as a miniaturist, including the calendar of the *Breviarium fratrum minorum* (cod. X.IV.2, Biblioteca Comunale, Siena), which comes from the church of Santa Chiara. The freshness and inventiveness of the narrative that distinguish these miniatures lead me to date them to the 1430s or 1440s, to a time before Sano di Pietro began

wearily to repeat stereotyped models, as he did later in his career.[31]

Throughout his career Sano di Pietro adhered faithfully to the ideas of greater contemporary artists to such an extent that he has been identified with the Osservanza Master. After Sassetta's death the stimulus to discover new modes of expression waned and Sano di Pietro's art remained essentially the same until the end of his career. An overall judgment on his style, however, must take into account the high quality of some of his numerous works.

Unlike Sano di Pietro's career, that of Pietro di Giovanni d'Ambrogio (or Ambrosi) was relatively short;[32] he is first documented in 1410 and last heard of in 1449. Nevertheless, he was one of the most active and important painters in Siena in the first half of the fifteenth century. Pietro di Giovanni d'Ambrogio may have trained with Sassetta. Documents survive from 1440 recording payment for a completed commission in Città di Castello but unfortunately we do not known exactly what this was. In the same year Pietro di Giovanni is recorded as having painted two frescoes for the infirmary of the Ospedale di Santa Maria della Scala in Siena

Pietro di Giovanni d'Ambrogio,
Crucifixion from a processional standard.
Musée Jacquemart-André, Paris.

Pietro di Giovanni d'Ambrogio,
St Catherine of Alexandria in Glory
from a processional standard.
Musée Jacquemart-André, Paris.

Pietro di Giovanni d'Ambrogio,
Nativity. Museo d'Arte
Sacra, Asciano.

that have since been lost. In 1444, after the death of Bernardino of Siena, he painted one of the first representations of the future saint for the church of the Osservanza (Pinacoteca, Siena). In the same year Pietro di Giovanni signed and dated a splendid processional standard for a confraternity in Borgo San Sepolcro (Musée Jacquemart-André, Paris).[33] Painted on both sides, it was carried in a procession by the members of the flagellant group who can be seen on the standard kneeling before the majestic *Crucifixion*. Mourners flank the cross and angels hover above their heads in spectacular poses. On the back of the fragile cloth standard is an enormous representation of the patron saint of the confraternity, Catherine of Alexandria. The saint is majestically draped in a sumptuous dalmatic in red brocade gleaming with golden ornaments. She sits atop the instruments of her martyrdom, which are supported by pale blond female winged creatures whose heads are crowned with multi-coloured flowers. The smiling creatures effuse innocence and tenderness, increasing the splendour of the composition as a whole. The solemn figure of St Catherine has blond hair and bright black eyes, their gaze penetrating from her immobile

head. The delicate facial features, made up of tiny strokes, show traces of Sassetta's female figures and yet Pietro di Giovanni was able to adopt Sassetta's ideas in an unusual and fascinating manner. The way in which the saint's face is fixed, almost iconically, and the quasi-geometric forms of her body, emphasized by the clear and transparent colours, were to influence Piero della Francesca. On the other side of the standard, the mournful faces of the Virgin and St John the Evangelist express the dramatic nature of the event. The penetrating representation of distress and the long, soft folds in the drapery are typical of Pietro di Giovanni.

In 1446 Pietro di Giovanni painted a fresco of the *Crucifixion* in the Palazzo Pubblico and two years later he completed a *St Bernardino* in Lucignano. It is possible that he also took part in the decoration of the interior cloister of the Augustinian hermitage in Lecceto. Pietro also worked with Vecchietta on the reliquary cupboard – the *Arliquiera* – for Siena Cathedral (Pinacoteca, Siena).

Sassetta's influence can be found in many of Pietro di Giovanni's works, some of which were originally thought to be by Sassetta himself. This is the case, for example, with two

Pietro di Giovanni d'Ambrogio,
Nativity, detail. Museo d'Arte
Sacra, Asciano.

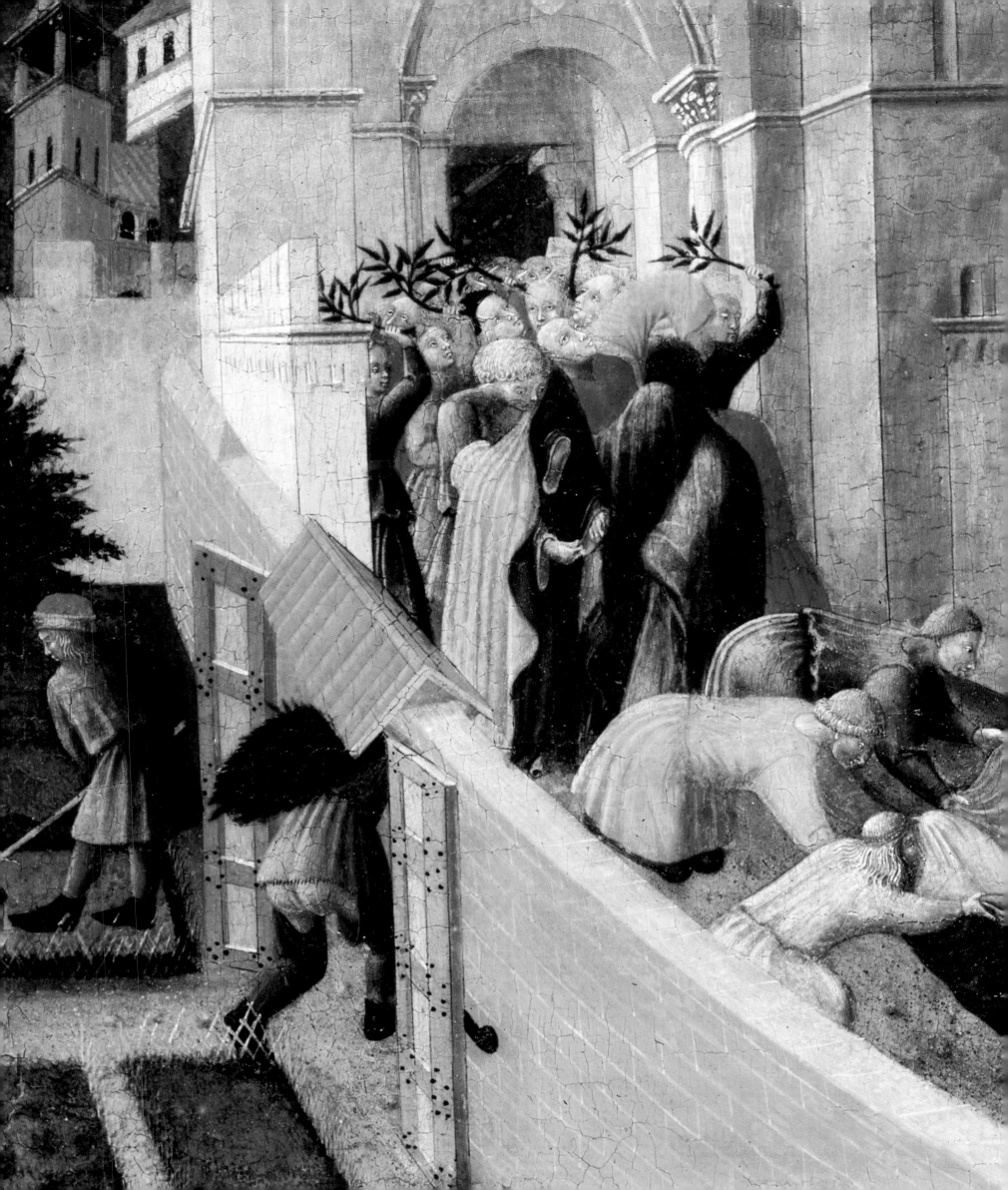

panels of *St Michael* and *St Nicholas of Bari* (Lehman Collection, Metropolitan Museum of Art, New York). Sadly both works are badly conserved and have lost so much of the paint surface that it is now possible to see parts of the wooden structure underneath the painting. Fortunately this does not affect the faces of the saints and Michael, in particular, is admirably executed.

Pietro di Giovanni also had some whimsical characteristics in his art as can be seen in the unusual construction which he adopted for his painting of the *Nativity* in the centre of a triptych (Museo d'Arte Sacra, Asciano) probably painted between 1430 and 1435. In the background he painted a view of a fantastic landscape. The composition was probably inspired by Ambrogio Lorenzetti's 1335 *Birth of the Virgin* for the façade of the Ospedale di Santa Maria della Scala. Luxuriant trees and a cityscape also form the background to the group of apostles who, with eccentric and affected facial features, follow Christ in the *Entry into Jerusalem* (Pinacoteca Giuseppe Stuard, Parma). The apostles confirm that Pietro di Giovanni had studied the works of Masaccio. The *Entry into Jerusalem* constituted part of an altarpiece together with a panel depicting a *Miracle of St Augustine* (?) (Gemäldegalerie, Staatliche Museen, Berlin),[34] a work which draws on Ambrogio Lorenzetti's coastal scene in the *St Nicholas of Bari Saving the City of Myra from Famine* (Uffizi, Florence).

The *Assumption of the Virgin with SS. Stephen and Sigismund* (Pinacoteca, Siena) is one of Pietro di Giovanni's later works.[35] It is strongly linked to the two full-length saints who are painted to either side of the Asciano *Nativity*, a work with which it also bears similarities in style. Finally, the *Madonna and Child with SS. Sebastian and Fabian* from the monastery of Ombrone has been attributed to Pietro di Giovanni.[36]

Giovanni di Paolo, the most 'Sienese' of the artists discussed, spent his career exploring the Gothic universe,[37] and his distinctive style earned him innumerable nicknames. Giovanni di Paolo di Grazia was involved in the execution of important narrative cycles for almost sixty years. These were stories of saints painted with old-fashioned faces and convulsive gestures, visibly consumed by their heavenly vocation and constantly shivering.

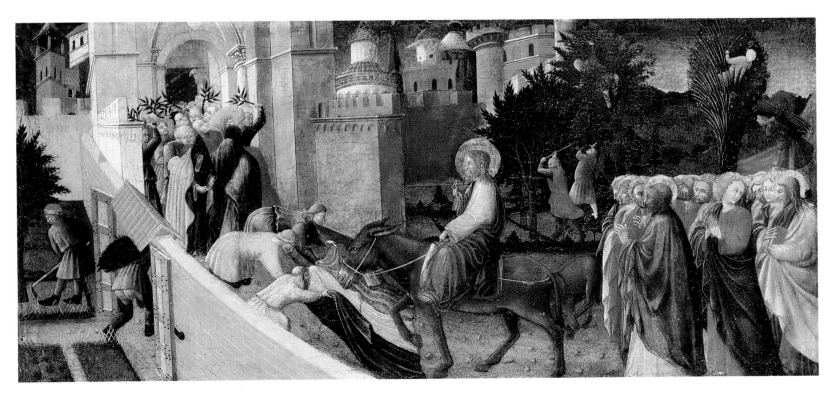

p. 238
Pietro di Giovanni d'Ambrogio,
Entry into Jerusalem, detail.
Pinacoteca Giuseppe
Stuard, Parma.

Pietro di Giovanni d'Ambrogio,
Entry into Jerusalem. Pinacoteca
Giuseppe Stuard, Parma.

Notwithstanding the originality and the intensity of his interpretations, he succeeded in persuading Pius II to hire him in 1462 as one of the honoured painters who were to decorate Pienza Cathedral. At that time Giovanni di Paolo, who worked as both a painter and a miniaturist, had already completed the most important works of his career. Even his early oeuvre evidences his knowledge of Lombard painting, which he had encountered through artists such as Gentile da Fabriano, Giovannino de' Grassi and Michelino da Besozzo. He was also familiar with the Franco-Flemish style that the Limbourg brothers had diffused when they visited Siena in *c.* 1413.

Two pairs of panels, one with *St Lawrence and a Deacon Saint* (Philadelphia Museum of Art) and the other representing *SS. Peter and Paul* (Lycett Green Collection, City of York Art Gallery), are identical in structure and decoration and were probably part of the same commission. The difference in style between the two panels, however, has led to the first two saints being attributed to Giovanni di Paolo and the second pair to Martino di Bartolomeo. In his early compositions Giovanni di Paolo was influenced by Taddeo di Bartolo and,

through the incisive and nervous drawing of Francesco di Vannuccio, some aspects of his art drew on the refined style of Simone Martini.

A few years before he enrolled in the *Ruolo dei pittori senesi* in 1428, Giovanni di Paolo was paid for painting the miniatures in the *Libro d'ore* belonging to the Castiglione family of Milan.[38] He subsequently painted a number of documented works for monastic communities that unfortunately have not survived.[39] In 1421 he decorated the top and sides of a box with the extremely elegant *Triumph of Venus* and a *Flight of Deer and Wild Boars* (Louvre, Paris). This, his earliest work, is one of the most beautiful examples of courtly Gothic taste in Sienese painting.[40] Giovanni di Paolo's authorship has been confirmed by a comparison with the unprecedented illustrations for *Paradiso* from Dante's *Divine Comedy*, which once belonged to Alfonso V of Aragon (Yates Thompson MS. 36, British Museum, London).[41]

The secular aspect of Giovanni di Paolo's painting depends largely on his early knowledge of Gentile da Fabriano's art and contrasts with his religious works such as the *Christ Suffering and Triumphant* (Pinacoteca, Siena).[42] In

p. 241
Giovanni di Paolo, *Virgin and Child with Music-making Angels*, panel from the *Pecci Polypych*. Santi Giusto e Clemente, Castelnuovo Berardenga, Siena.

this painting the trembling threadlike fingers, seeming like insects' antennae as they touch the cross, unveil Giovanni's poetic nature.[43]

The *Pecci Polyptych* for the church of San Domenico in Siena, signed and dated in 1426, is the first of a series of large works painted within a small space of time that demonstrate Giovanni di Paolo's fame and popularity in Siena. The central part of the *Pecci Polyptych* shows the *Virgin and Child with Music-making Angels* (Santi Giusto e Clemente, Castelnuovo Berardenga) and reveals some of the stylistic peculiarities of Giovanni di Paolo's early works.[44] In the panel Giovanni used some of Taddeo di Bartolo's compositional formulae but still managed to create a work that is both original and of the highest quality. The positioning of the Christ Child and the music-making angels derives from Taddeo di Bartolo's *Madonna and Child with Saints* painted for the Compagnia di Santa Caterina della Notte. The small facial features; the precious golden decorative elements; and the garlands of fleurs-de-lis, bellflowers and olive shoots interspersed with tufts of grass that embellish the mosaic at the base of the painting are all signs of the courtly Gothic style that Giovanni

used to decorate the box in the Louvre. The severe figures of *St John the Baptist* and *St Dominic* (nos. 193 and 197, Pinacoteca, Siena), the only other surviving panels from the main register of the *Pecci Polyptych*, provide a contrast to the serenity of the central panel. In the four predella scenes from the Passion of Christ (three in the Walters Art Gallery, Baltimore, and a fourth in the Lindenau Museum, Altenburg), Giovanni di Paolo has evoked a heightened sense of drama. The four small panels stylistically recall Simone Martini – in particular the *Way to Calvary* from the *Orsini Polyptych* (Louvre, Paris) – whose influence was still felt almost a century after he was active.

Gentile da Fabriano is documented in Siena in 1425. While in the city he painted the fresco of the *Madonna of the Notaries* in a tabernacle in the Campo, which unfortunately has since been destroyed. His influence on Giovanni di Paolo can be seen in the central panel of the 1427 *Branchini Polyptych*,[45] which depicts the *Madonna of Humility* (Norton Simon Art Foundation, Los Angeles), as well as in some later works. In these paintings Giovanni was clearly inspired by the magical creatures and beautiful landscapes full of naturalistic

Giovanni di Paolo, *Triumph of Death*, Biccherna panel, 1437. Kunstgewerbemuseum, Staatliche Museen, Berlin.

Giovanni di Paolo, *Triumph of Death*, detail of a Biccherna panel, 1437. Kunstgewerbemuseum, Staatliche Museen, Berlin.

passages that are typical of the International Gothic style and particularly of Gentile da Fabriano. Giovanni placed an inscription in the Virgin's halo in the *Branchini Polyptych* asking for her protection since he had painted her image. Such an inscription is rare and indicates Giovanni's pride in his work, while reminding us that the city of Siena was dedicated to the Virgin.

Giovanni di Paolo painted a Biccherna panel of the *Triumph of Death* in 1437 (Kunstgewerbemuseum, Staatliche Museen, Berlin).[46] Its shows a terrifying figure astride a fiery warhorse. Armed with a bow and with a long scythe attached to his waist, he breaks into a room where a group of ladies and gentlemen are absorbed in a game of dice. They do not appear to be aware of the danger but their destiny is clearly indicated by the arrows that have been driven into their bodies and by the victims lying on the ground at the entrance to the room. Giovanni di Paolo represented the subject again in the unusual miniatures which he painted to decorate the *Antiphonary* (cod. G.I.8, fol. 162, Biblioteca Comunale, Siena) from the Augustinian convent in Lecceto.[47] Painted at the same time as the *Paradiso* from the *Divine Comedy* (Yates Thompson MS. 36, British Museum, London), the *Antiphonary* was executed between 1438 and 1447. In the miniature of the *Triumph of Death*, the hairy winged figure that grips the deathly bow without pity is equally terrifying but this time the scene takes place next to a dense forest. Death furiously attacks a lone young man who, by now aware of his fate, clasps his hands together and bows in prayer, an arrow already driven into his neck. Despite the macabre subject, the miniature has a beautiful range of colours and tones that delicately melt into one another, as can be seen in the sky where intense azure blends with clear reddish shades.

As a miniaturist Giovanni di Paolo maximizes his talents as a narrator who pays attention to the smallest details.[48] The nervous quality of his drawing in larger paintings such as the *Deposition* (Pinacoteca Vaticana, Rome) is transformed into an elegant Gothic line. He maintains the intensity of expression in his figures, which are now dignified and move with measured yet eloquent gestures. A capacity for narrative synthesis is well represented in the numerous miniatures executed for the Yates Thompson *Paradiso*.[49] Of these *Folco Inveighing against the Corruption of the Florentines* contains a

Giovanni di Paolo, *Folco Inveighing against the Corruption of the Florentines*, miniature from the *Divine Comedy: Paradiso*. Yates Thompson MS. 36, British Library, London.

Giovanni di Paolo, *Annunciation*.
National Gallery of Art,
Washington, D.C.

Giovanni di Paolo, *St Clare Saving the Victims of a Shipwreck*. Gemäldegalerie, Staatliche Museen, Berlin.

simplified but precise representation of Florence, dominated by Brunelleschi's cupola for the cathedral of Santa Maria del Fiore. That the cupola is shown without the lantern and with the eastern exedra incomplete has securely dated the codex to shortly before the small panels showing the *Creation*, the *Expulsion from Paradise* (Lehman Collection, Metropolitan Museum of Art, New York) and *Paradise* (Metropolitan Museum of Art, New York). The paintings in New York were influenced in their iconography by the *Paradiso* miniatures as well as by the *Expulsion from Paradise* sculpted by Jacopo della Quercia for the Fonte Gaia (Palazzo Pubblico, Siena).[50]

Giovanni di Paolo painted six predella panels at some time between 1440 and 1445.[51] The subjects of these panels are the *Annunciation* and *Expulsion from Paradise* (both in the National Gallery of Art, Washington, D.C.), the *Nativity* (Pinacoteca Vaticana, Rome), the *Crucifixion* (Gemäldegalerie, Staatliche Museen, Berlin), the *Adoration of the Magi* (Cleveland Museum of Art, Massachusetts)[52] and the *Presentation of Jesus in the Temple* (Metropolitan Museum of Art, New York). The elegant *Annunciation* is dominated by an elaborate architectural structure in which the floor appears to slope steeply upwards. To the left, in the midst of luxuriant vegetation and pairs of jumping rabbits, Giovanni di Paolo has portrayed Adam and Eve. Their thin naked forms are expelled from Paradise by an angel covered only by a transparent cloth wound around his hips.[53] In the *Presentation of Jesus in the Temple* Giovanni di Paolo took Gentile da Fabriano's version of the same subject, which formed part of the predella for the 1423 *Strozzi Altarpiece* (Louvre, Paris, and Uffizi, Florence), and borrowed the composition, a method of working that he had adopted early in his career.

In 1453 Giovanni di Paolo painted the *St Nicholas of Bari Polyptych* (Pinacoteca, Siena). In the predella panel of the *Rescue of St Nicholas* the influence of Gentile da Fabriano's representation of the same subject from the predella of the *Quaratesi Altarpiece* is clear. Shortly after 1453 Giovanni di Paolo painted another polyptych (Pinacoteca, Siena) which represents the *Virgin and Child* in the central panel, with *St Peter Damian* and the *Apostle Thomas* to the left and *St Clare* and *St Ursula* to the right. The *Redeemer* inhabits the central pinnacle. *St Clare Saving the Victims of a Shipwreck* (Gemäldegalerie, Staatliche Museen, Berlin) once formed

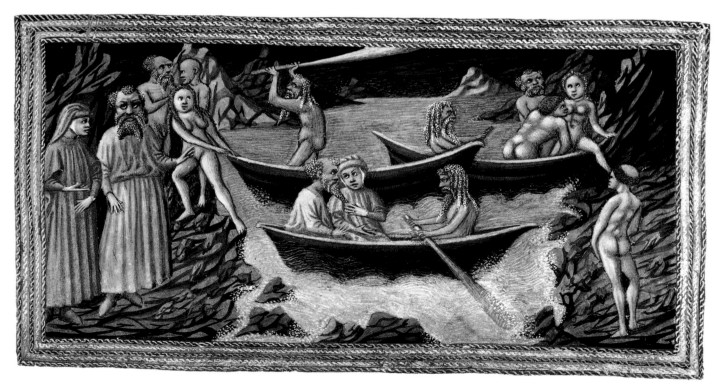

Nicola d'Ulisse, *Dante and Virgil on Charon's Boat*, miniature from the *Divine Comedy: Inferno*. Yates Thompson MS. 36, British Library, London.

part of the predella and is probably the most innovative of the panels because of the extraordinary representation of the stormy sea. The succession of well-ordered waves look more like sand dunes than a tempestuous sea.

During the fifteenth century the responsibility of organizing the celebrations for the festival of the Purification of the Virgin had been given to the Pizzicaiuoli, or candle-makers. In 1447 they commissioned Giovanni di Paolo to paint a great altarpiece that was to be placed on their altar in the church of the Ospedale di Santa Maria della Scala. The work was finished in 1449 but the Pizzicaiuoli did not like it and threatened to replace it on a number of occasions. The work has since been lost but a description informs us that the central panel contained the *Purification of the Virgin* accompanied by a series of scenes from the life of St Catherine of Siena.[54]

It was only from the mid-1440s that Giovanni di Paolo was influenced by Sassetta and began to use some of the Florentine pictorial devices that Sassetta had incorporated in the *Virgin of the Snow*. From this time onwards, the linear qualities of the drapery, which falls in elegant curves, reflect a close study of Sassetta's works. They show a new tendency towards an extremely decorative Gothic style, which he had already experimented with in the *Madonna della Misericordia* painted for Santa Maria dei Servi in 1431.[55]

In the small panels with scenes from the *Life of St Catherine*, Giovanni di Paolo created a close relationship between the narration of the story and the setting in which it takes place. The architecture, coloured with clear tones and sharply focused in the background, is drawn in such a way as to emphasize the sacred nature of the events. The walls of the rooms and the furniture, both of which are shown in sharp foreshortening, make the elegant figure of the saint stand out. Catherine of Siena's black and white habit completely hides her body, making it barely discernible except for the protruding knee or foot.

Among Giovanni di Paolo's most imposing narrative cycles is that depicting eleven scenes from the life of St John the Baptist. These panels can be appreciated for their delicate execution and their intense expressive qualities. They were probably painted before 1464, the year in which the reliquary of John the Baptist's arm arrived in Siena, and it has been

Nicola d'Ulisse, *Resurrection*.
Museo Castellina, Norcia.

suggested that they were intended to either form or decorate a piece of furniture containing the reliquary.[56]

The almost monochrome predella showing scenes from the life of St Galganus (no. 198, Pinacoteca, Siena) is the last known work by Giovanni di Paolo. The scenes have been described as 'desolate and decrepit, rising out of the abyss'.[57] In the final years of his career Giovanni di Paolo repeated motifs that were dear to him in an increasingly melancholy and introverted manner. He died in March 1482 and was buried in the Chapel of St John the Baptist in the Sienese church of Sant'Egidio, which has since been destroyed.

Nicola d'Ulisse was responsible for the miniatures of the *Inferno* and *Purgatorio* in the Yates Thompson *Divine Comedy* for which Giovanni di Paolo painted the *Paradiso* miniatures.[58] The settings of Nicola's miniatures – dominated by harsh mountains painted with cobalt blue, ochre and maroon, from which the blinding flashes of the flames burst forth – recall Domenico Veneziano's landscapes.[59] Dante wears brilliant blue clothing while Virgil is dressed in an intense pink. The two poets wander between the naked and skeletal forms of the damned. One of the most charming miniatures depicts the story of Count Ugolino, in which the drama of the episode is tempered by the graceful attitudes in which the figures are arranged. The miniatures show the milder character of Nicola's art when compared with that of Giovanni di Paolo.

Clouds and stars form the background to the illustrations of *Purgatorio*, envisaged against a mountainous landscape composed of browns and ochres. The drawing of the nude bodies that have prominent profiles and detailed anatomy has led to the miniatures being attributed to Nicola d'Ulisse on the basis of a comparison with his signed works. One of these is a *Resurrection* painted for the church of Santa Scolastica (Museo Castellina, Norcia). Although incomplete, the *Resurrection*'s inscription – H[OC] OPUS NICOLAI – has allowed the attribution to Nicola d'Ulisse. In 1470 Nicola was living in Norcia where he owned a house. Documentary sources tell us that he married a certain Angelella and adopted Bartolomeo di Giovanni Benedetti. In the Norcia *Resurrection* the thin figure of Christ, partially covered with a transparent veil, steps out in front of the sarcophagus on the top of which he rests his right foot. His lean face has, like the

faces of the damned from the Yates Thompson codex, a thin small mouth and wide-open eyes. The painting also contains other similarities to the miniatures such as the brilliant azure blue of the background against which Christ's flesh, the colour of burnt amber, stands out. Bruno Toscano believed that the Norcia *Resurrection* demonstrates Nicola d'Ulisse's dependence on the style of Bartolomeo di Tommaso of Foligno and in particular the influence of his frescoes in the church of San Francesco in Cascia.[60]

Until 1451–1452 Nicola d'Ulisse lived in Siena where he was known as Magistro. From this it can be deduced that by the time he left Siena he was already an established artist. He is known to have been given a prestigious commission for a now-lost *Assumption of the Virgin*, which was in the Palazzo Pubblico in Siena.[61] In 1457 Nicola was in Cascia where he painted a fresco for the church of Sant'Agostino that has been almost completely destroyed. This was followed by a cycle of frescoes showing the *Passion of Christ* painted in 1461 in the nuns' choir of Sant'Agostino. Unfortunately these were considerably altered in a subsequent restoration. Nevertheless, the quality of the frescoes is neither of the same high standard

as the painting of the Yates Thompson miniatures nor influenced by Florentine art to the same extent. Nicola d'Ulisse also painted a *Christ in Limbo* in the church of San Salvatore in Campi, near Norcia. This has also been badly damaged but it is still possible to discern that it too falls short of the standards that Nicola achieved in his miniatures.

Nicola's other miniatures include those in the *Missale Romanum* (MS. X.II.2, Biblioteca Comunale, Siena) commissioned by Cardinal Antonio Casini, whose coat of arms is recognizable at the bottom of some of the pages. The work was begun by the calligrapher Antonio di Angelo from Borgo San Sepolcro on 8 June 1427 and was completed by 29 March 1428. Many details, such as the richness of the historiated initials and of the almost two thousand decorated initials, testify to the magnificence of the codex.

The miniatures from the *Missale Romanum* have been attributed to Nicola d'Ulisse because of the convincing comparison between the whole-page *Crucifixion* (fol. 162v) and the *Crucifixion* from the abbey of Sant'Eutizio in Preci near Norcia.[62] The outline of the body and the articulation of the hands are similar in both works. A comparison with the

Norcia *Resurrection* also reveals parallels in the shading of the ribs, the kneecaps and the tibia.

Nicola d'Ulisse's influences include Jacopo della Quercia, whose stays in Ferrara and Bologna kept him in touch with the delicate and sinuous movements of the Gothic style in Lombardy. His work is recalled in the *Nativity* (fol. 16v) and the *Bathing of the Christ Child* (fol. 17r) in the *Missale Romanum*, both of which are also reminiscent of Michelino da Besozzo's unusual compositions. The early influence of Northern Italian art and the later influence of Domenico Veneziano's light-filled painting slowly receded during Nicola's long stay in Umbria.

Pellegrino di Mariano Rossini, another miniaturist, had only a minor role in the development of Sienese fifteenth-century painting. During his long career he never showed any outstanding qualities nor did he succeed in forming his own autonomous artistic personality. Both in his miniatures and in his works on panel it is often only too clear that he always referred to the work of Giovanni di Paolo. This did not, however, prevent him from receiving commissions as both a fresco and a panel painter and as a miniaturist. The

documents published by Milanesi in 1854 demonstrate his long association with the Ospedale di Santa Maria della Scala, although none of Pellegrino di Mariano's known works can be connected with the hospital. We have only one small signed and dated altarpiece with which to reconstruct Pellegrino's artistic career. This is the *Enthroned Virgin and Child with SS. John the Baptist and Bernardino of Siena* with the *Crucifixion* in the upper register (Brooks Memorial Art Gallery, Memphis), which was painted in 1450. The altarpiece, like the *Virgin and Child with Saints* (A.H. Couwenhoven Collection, Heelsum), shows exactly how influential Giovanni di Paolo was on Pellegrino's style. Pellegrino di Mariano worked alongside Giovanni di Paolo on the illustrations for a gradual (cod. H.I.2, Biblioteca Comunale, Siena) that almost certainly belonged to the Augustinian convent in Lecceto. The majority of the miniatures, which can be dated between between 1450 and 1455, were painted by Pellegrino di Mariano. He did not succeed in making the figures seem either elegant or refined in the small spaces assigned to them[63] and almost no landscapes have been included in these miniatures. The unaccomplished way

Priamo della Quercia, *St Ursula and the Archangel Michael*, panel of a triptych. Metropolitan Museum of Art, New York.

Priamo della Quercia, *Enthroned Madonna and Child*, panel of a triptych. Metropolitan Museum of Art, New York.

Priamo della Quercia, *SS. Agatha and Lucy*, panel of a triptych. Metropolitan Museum of Art, New York.

in which the faces have been drawn, without any significant features, undermines their emotional participation in the events depicted, an effect which Giovanni di Paolo valued highly.

The first surviving document recording Pellegrino di Mariano as an illuminator is dated 1469, the year he painted various miniatures, both with and without figures, for the Compagnia di Santa Marta in Siena. We know that he had already worked as a miniaturist in 1460 when he painted the choir books for Pienza Cathedral together with Sano di Pietro and a third artist whose name has not survived. Between 1465 and 1482 he painted miniatures both for Siena Cathedral and the Ospedale di Santa Maria della Scala whose compositions are pleasing because of their distinctive naive spontaneity.[64]

The *Crucifixion with Six Saints* (Walters Art Gallery, Baltimore) and the graceful *Coronation of the Virgin* (Ca' d'Oro, Venice) have been attributed to Pellegrino di Mariano on the basis of a comparison with the signed *Enthroned Virgin and Child with SS. John the Baptist and Bernardino of Siena*. A close study of these works demonstrates once again that Pellegrino was strongly indebted to Giovanni di Paolo. Other paintings attributed to Pellegrino di Mariano include representations of *St Galganus* and the *Blessed Peter of Siena* (Aartsbisschoppelijk Museum, Utrecht) as well as the *Blessed Andrea Gallerani* and the *Blessed Ambrogio Sansedoni* (Lehman Collection, Metropolitan Museum of Art, New York).[65]

Priamo della Quercia was the son of Pietro d'Angelo, who was documented in Lucca from 1394 to 1422, and the brother of the sculptor Jacopo della Quercia. He is recorded as a citizen of Lucca which has led to the hypothesis that he was born and received his first training there, drawing on the late Gothic art of his native city and of Pisa.[66] His activity as an artist is documented between 1426 and 1467. Priamo received a first commission in Lucca in 1428, but he left it unfinished to go to Siena.

Priamo's first surviving work is a triptych with an *Enthroned Madonna and Child* in the central panel, *St Ursula and the Archangel Michael* on the left and *SS. Agatha and Lucy* on the right (Metropolitan Museum of Art, New York).[67] It was attributed to Priamo in 1964 by Millard Meiss along with a three-niched wooden tabernacle (Museo di Villa Guinigi,

p. 252
Domenico di Bartolo,
Enthroned Madonna and Child between SS. Peter and Paul. National Gallery of Art, Washington, D.C.

p. 253
Domenico di Bartolo,
Virgin of Humility.
Pinacoteca, Siena.

Lucca) which originally contained sculptures.[68] The Archangel Michael's privileged position on the Virgin's right may indicate that the *Metropolitan Museum of Art Triptych* can be identified with the altarpiece commissioned in 1442 for the church of San Michele in Volterra,[69] although the documents that survive do not confirm this.[70]

The style of the *Metropolitan Museum of Art Triptych* gives an indication of how Priamo della Quercia's art was to develop during his time in Siena. The position of the Christ Child, who is seated with his legs apart and bent at the knee, intent on touching one of his feet, is a quotation from the work of Taddeo di Bartolo. Priamo's early style is pleasing, although for the most part lacking in innovatory features. While in Siena he continued to follow the formal courtly principles of the International Gothic style and was largely inspired by Taddeo di Bartolo. In the panel of *SS. Anthony Abbot and James* (Monte dei Paschi, Siena), which was executed at around the same time as the *Metropolitan Museum of Art Triptych*, Priamo della Quercia modelled the forms with a strong chiaroscuro and they appear heavy despite the sinuous line of their clothes. The exuberant and fantastic painting as

well as the bright tones used by the Portuguese artist Alvaro Pirez, who arrived in Siena some time before 1434,[71] influenced both Priamo della Quercia and Nicola d'Ulisse.

Priamo's first dated work is the fresco of the *Blessed Agostino Novello Giving the Habit to the Rector of the Ospedale della Scala* in the pilgrims' section of the Ospedale di Santa Maria della Scala, completed in 1442. In it he used a more natural style of representation, moving away from the Gothic inspiration of his earlier works. Priamo won the commission for the painting thanks to the good relations between the Ospedale and his brother Jacopo, who in 1434 had been proposed as rector but not elected.[72] A general view of the last bay of the fresco reveals his lack of inventive ability. The scene contains a chaotic succession of arcades and there is little diversity in the expressions on the faces of the people lined-up to attend the event. Priamo's paintings lack any personal input and his composition is clearly inspired by the frescoes that Vecchietta and Domenico di Bartolo had already painted in the pilgrims' section. His works often give the impression that they are a compilation of borrowed motifs and ideas and this is no exception. The tripartite spatial organization which

contains both old and elegantly dressed people is taken from Vecchietta, the more solid figures from Domenico di Bartolo and the flattened figures from Jacopo della Quercia.[73]

From 1440 to 1467 Priamo della Quercia was active in Volterra. In 1445 he painted a polyptych with a central figure of a seated *St Anthony Abbot Surrounded by Saints* for the Oratory of St Anthony. In 1450 he painted a *Virgin and Child with SS. James and Victor* and a panel of *St Bernardino of Siena* in the Palazzo dei Priori.[74] Recently a small triptych from a private collection showing the *Crucifixion with SS. Dominic and Peter Martyr* has been attributed to him, since the style is close to that of Priamo's early paintings.[75] However, the miniatures of *Hell* and *Purgatory* from the Yates Thompson *Divine Commedy* have been removed from Priamo's catalogue and given to Nicola d'Ulisse.[76]

At the end of his life of Taddeo di Bartolo, Vasari wrote a few words about Domenico di Bartolo: 'It is said that Domenico was modest and courteous, and that he was unusually kind and extremely generous'.[77] He was recounting the little he knew about the painter, who had been active in Siena. According to Vasari, Domenico was the nephew and pupil of Taddeo di Bartolo, but this seems unlikely given that in the 1428 *Ruolo dei pittori senesi* Domenico is registered as being from Asciano.[78] Vasari also lists Domenico di Bartolo's last works as a panel of the *Virgin Annunciate* in Santa Trinita in Florence and the high altarpiece from Santa Maria del Carmine. It is unlikely that these were Domenico's last works as the Florentine commissions have been dated between 1436 and 1438, which is almost a decade before his death.

Domenico di Bartolo's date of birth is unknown but in 1420, while still an apprentice, he was at work in Siena Cathedral. In 1434 he made a marble intarsia of tranquil symmetry and complex architectural structure for the floor of the cathedral. The intarsia was dedicated to Sigismund, the German king who had stayed in Siena between July 1432 and April 1433 waiting to be called to Rome to be crowned Holy Roman Emperor. A drawing of Sigismund that still survives was probably a study for the intarsia commission in which Domenico di Bartolo tested his capacities as a portraitist.

A small panel with the *Enthroned Madonna and Child between SS. Peter and Paul* (National Gallery of Art, Washington, D.C.), attributed to Domenico di Bartolo, was

executed at the same time as the cathedral intarsia.[79] The tight vertical format of the painting emphasizes the monumentality of the three adult figures, in particular that of the Virgin, who is seated inside a Renaissance niche – painted in clear and luminous tones – with a semicircular arch and polychromed marbles, surmounted by a pink shell. The position of the Virgin's arm recalls that of the *Virgin and Child with St Anne* (Uffizi, Florence) by Masaccio. However, the plasticity of Jesus' body and its vigorous modelling in the *Virgin and Child with St Anne* do not correspond to Domenico's arrangement of the figures, in which the Gothic style of his training still prevails. Masaccio's influence is also evident in the abstract elements which have been tentatively introduced into the composition. These components indicate Domenico's familiarity with the frescoes that Masaccio had executed in the Brancacci Chapel in Santa Maria del Carmine.

The *Virgin of Humility* (Pinacoteca, Siena) of 1433 is Domenico di Bartolo's first signed and dated work and its style demonstrates that he was aware of current Florentine innovations. Domenico's works have a greater affinity with Florentine art than with Sienese art. The influence of the early works of Filippo Lippi, the sun-drenched paintings of Domenico Veneziano and even the sculpture of Luca della Robbia can be found in his paintings.[80] Masaccio's influence is present in Domenico's iconographic choices, as well as in his composition and manner of expression. Domenico also took elements of his art from Donatello, such as the type of modelling which tends towards a cautious flattening of the forms. The clinging drapery and the alternation of the soft fall of the cloth with its harsh folds produces new light effects and give an unusual plastic robustness to the Virgin. It seems that Domenico di Bartolo made a conscious decision to use Florentine artists as models in an attempt to master the revolutionary Renaissance style that was developing.[81] Donatello was in Siena at the end of the 1430s working on Archbishop Pecci's funeral slab for the cathedral and also on the relief of the *Feast of Herod* for the baptistery font, thus making it easier for Domenico to absorb his style. For the iconography of the *Virgin of Humility*, Domenico di Bartolo probably looked to the ideas of St Bernardino of Siena, in particular his emphasis on the cult of the Virgin Mary.[82]

Domenico di Bartolo,
Distribution of Alms. Pilgrims'
quarters, Ospedale di Santa
Maria della Scala, Siena.

In 1435 Jacopo della Quercia had been named as cathedral *operaio* and it was through him that Domenico obtained the commission for the sacristy frescoes. They illustrated scenes from the lives of the four patron saints of Siena of which only a few fragments remain today. The work, interrupted by Jacopo della Quercia's death in 1438, was resumed the following year.

In 1437 Domenico di Bartolo painted a *Virgin and Child* (Johnson Collection, Philadelphia Museum of Art) depicted inside an arch-shaped rosebush. He may also have completed an altarpiece for the Augustinian friars in Asciano of which a fragment of a panel with the *Virgin and Child Enthroned* (Art Museum, Princeton University, New Jersey) has been identified as the only surviving part. However, it is also possible that the fragment is part of an altarpiece that Vasari recorded as having been commissioned for Santa Maria del Carmine in Florence. The Soderini family had patronage rights to the choir chapel and the altarpiece may well have been commissioned by Francesco Soderini, who was a generous patron of the Carmelite order and was married to the Sienese Lucrezia di Giovanni Tegliacci. The work of Masaccio was a strong influence on this painting as well as on the *Perugia Polyptych* (Galleria Nazionale dell'Umbria, Perugia), signed and dated 1438.

The *Perugia Polyptych*, commissioned by Abbess Antonia Buccoli, was painted for the convent of Santa Giuliana in Perugia. In the central panel there is an *Enthroned Virgin and Child*. The abbess kneels in prayer at the feet of the Virgin and is protected by her outstretched hand. The Christ Child holds a globe and a scroll bearing the words LUX MUNDI EGO SUM (I am the light of the world). He turns towards the abbess to bless her. A hilltop castle painted on the globe may represent Sant'Egidio al Colle, near to Perugia, whose temporal and spiritual rule had been given to the convent of Santa Giuliana and which assured the convent considerable income.[83]

St Juliana, the patron saint of the convent, is represented on the right lateral panel holding a devil on a leash. The various inconsistencies in the execution of the predella panels have led to the suggestion that Domenico painted them in collaboration with another artist, possibly Priamo della Quercia. This hypothesis is supported by a comparison with

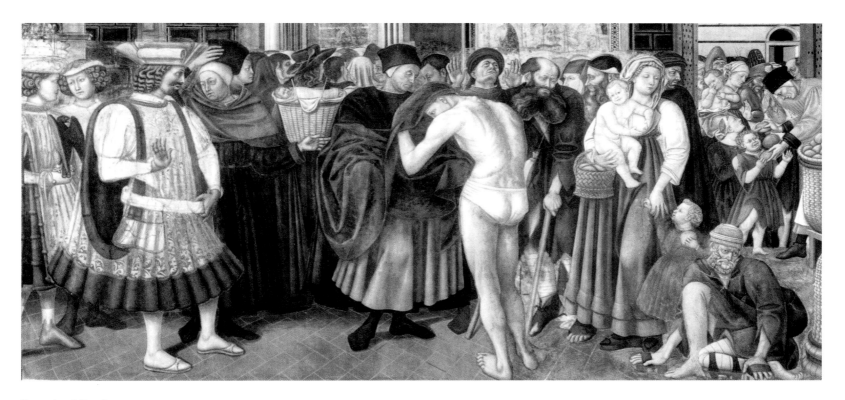

Domenico di Bartolo,
Distribution of Alms, detail.
Pilgrims' quarters, Ospedale di
Santa Maria della Scala, Siena.

the fresco from the pilgrims' quarters in the Ospedale di Santa Maria della Scala. In 1441, under the direct supervision of Domenico di Bartolo, Priamo painted a hesitant representation of the *Blessed Agostino Novello Giving the Habit to the Rector of the Ospedale della Scala*.

Between 1441 and 1444 Domenico di Bartolo painted a cycle of frescoes for the pilgrims' quarters in the Ospedale della Scala that illustrated the pious activities of the hospital. The idea for the frescoes had come from the rector, Giovanni di Francesco Buzzichelli. The walls to either side are divided into scenes showing historical, contemporary and allegorical scenes. Among those on the right-hand wall, one of the best known is that of the *Distribution of Alms*. In this work Domenico's talents as a brilliant narrator, a fine decorator and an accurate draughtsman of believable surroundings are shown to their best advantage. The frescoes show Domenico's reliance on contemporary Florentine art from which he later distanced himself to develop his own more Gothic style.

On 2 April 1444 Domenico was paid for a lunette fresco for the reliquary chapel in the Ospedale di Santa Maria della Scala. The fresco, of the *Madonna della Misericordia*, now exists only in a fragmentary form (Ospedale della Scala and Pinacoteca, Siena). The central part was removed from the wall in 1610 and transferred to the Chapel of the Holy Nail.[84] In 1445 Domenico di Bartolo began the 'restoration' of Lippo Vanni's *Coronation of the Virgin* in the Palazzo Pubblico but died shortly after. The work was completed by Sano di Pietro.

Between 1446 and 1449 Lorenzo di Pietro, known as Vecchietta, was at work in the Chapel of the Holy Nail. Vecchietta's talents in painting and sculpture attracted many Sienese artists to train in his workshop in the second half of the fifteenth century, among them Bartolomeo di Giovanni, Francesco di Giorgio Martini and Neroccio de' Landi.

We know from the document recording his baptism that Vecchietta was born in Siena in August 1410. In 1428 he was named in the *Ruolo dei pittori senesi*. His first documented commission dates to 1439, when, with Sano di Pietro, he sculpted and painted two statues, the *Virgin* and the *Angel Gabriel* for an *Annunciation*. These statues, which were intended for the high altar of Siena Cathedral, have since been lost.

Vecchietta, *Blessed Agostino Novello Giving the Habit to the Rector of the Ospedale della Scala*, scene from the *Arliquiera*. Pinacoteca, Siena.

Vecchietta, *Blessed Agostino Novello Giving the Habit to the Rector of the Ospedale della Scala*, detail of a scene from the *Arliquiera*. Pinacoteca, Siena.

Vecchietta's career between 1428 and 1439 is undocumented. However, some of the frescoes from the Collegiata in Castiglione Olona have been attributed to him on the basis of style.[84] The frescoes have also been ascribed to the Florentine Paolo Schiavo, whose paintings contain various references to Pesellino, Filippo Lippi, Masaccio and Andrea del Castagno. It seems certain that Vecchietta, working with Masolino and Paolo Schiavo, played an important role in the frescoes depicting the lives of SS. Stephen and Lawrence in the choir of the church. A comparison with Vecchietta's frescoes in the pilgrims' quarters of the Ospedale della Scala as well as his many references to Florentine art confirm the attribution. These influences also explain the stylistic similarities between Vecchietta and Sassetta, both of whom developed an essentially Gothic style to emphasize some of the most fascinating qualities of the early Florentine Renaissance.[85]

The commission for the frescoes in Castiglione Olona was given to Masolino by Cardinal Branda. Vecchietta's part in the commission demonstrates his distinctive personal style which is expressed most successfully in dramatic scenes of suffering such as the *Martyrdom of St Lawrence* and the *Burial of St Lawrence*. The perspective construction and the foreshortening emphasize the narrative tension in the frescoes.

Vecchietta collaborated with Masolino in the decoration of the baptistery in Castiglione Olona but may have worked independently on the frescoes in the Chapel of Cardinal Branda, painted between 1431 and 1435.[86] These works show that during his training Vecchietta was in direct contact with Florentine painters, perhaps owing to a stay in Florence and to a direct study of Masaccio's plastic forms. Vecchietta's liking for strongly characterized faces distinguishes his style from artists such as Sassetta. In his later paintings and sculptures there is a tendency to depict extremely sharp facial features. The new Renaissance ideas expressed in Donatello's bronze relief of the *Feast of Herod* from the baptismal font in Siena (as well as in his other works) had a great influence on Vecchietta's style.

Another important element in Vecchietta's artistic personality emerges very clearly from the frescoes painted in 1441 that have survived in the pilgrims' quarters of the Ospedale della Scala. The scenes demonstrate that Vecchietta had studied the sober Florentine architecture of Filippo Brunelleschi in depth. Brunelleschi's classical precepts guided Vecchietta in his construction of original surroundings in which the action of the frescoes takes place. The *Vision of the Blessed Sorore* contains the same figures as Vecchietta had painted in the frescoes in Castiglione Olona, characterized by their sharpened facial features and surly, almost grotesque, expressions.[87] The faces are shrouded in a dense and smoky chiaroscuro that tones down Vecchietta's favourite yellows, pale greens and pinks.[88]

Donatello's influence on Vecchietta's sculpture is clear in the polychromed *Pietà* in San Michele Arcangelo in Siena, executed *c.* 1445[89] and mentioned by Fabio Chigi in 1625–1626. Vecchietta painted the same subject in the *Mourning over the Dead Christ* (Museo del Seminario Arcivescovile, Monteriggioni) which at one time decorated the funeral chapel of the Martinozzi family in San Francesco in Siena. In the fresco the Virgin, helped by apostles and holy women, stretches forward – in the same way as in the San Michele Arcangelo *Pietà* – to support the body of Christ lying on her knees. The foreshortened heads and the tormented expressions confirm Masaccio's influence on Vecchietta and the delicate tones that model the faces recall the work of Masolino.

Vecchietta continued to work for the Ospedale di Santa Maria della Scala until the middle of the century. Between 1445 and 1449 he was commissioned, together with Pietro di Giovanni d'Ambrogio, to paint the *Arliquiera* (Pinacoteca, Siena) for the large sacristy in the Ospedale.[90] The cupboard consisted of two doors that closed an opening in the wall where the precious relics were kept. On the outside of these two panels Vecchietta and Pietro di Giovanni d'Ambrogio painted various city saints and blesseds, among whom is the *Blessed Agostino Novello Giving the Habit to the Rector of the Ospedale della Scala*, while on the interior of the panels are scenes from the Passion of Christ. The scene of *Agostino Novello Giving the Habit to the Rector of the Ospedale della Scala* as well as the other small thin figures on the outside panels

were undoubtedly painted by Vecchietta alone, who at this point was still working with the anxious freshness of his youthful style.

At the end of the first half of the fifteenth century Vecchietta ably completed the complicated cycle of sacristy frescoes dedicated to illustrating the *Articles of the Creed*.

Notes

1 C.B. Strehlke, in *La Pittura senese nel Rinascimento 1420–1500*, Siena 1989, p. 41.
2 R. Longhi, 'Ricerche su Giovanni di Francesco' in *Pinacotheca*, 1928, I, pp. 34–48, especially p. 35. Also printed in *Opere complete di Roberto Longhi*, Florence 1968, IV, pp. 21–36, especially p. 23.
3 Ibid., p. 24.
4 R. Langton Douglas, 'A Forgotten Painter' in *The Burlington Magazine*, 1903, pp. 306–318. Also B. Berenson, *A Sienese Painter of the Franciscan Legend*, London 1909; C. Brandi, *Quattrocentisti senesi*, Milan 1949, p. 37; G. De Nicola, 'Sassetta between 1423 and 1433' in *The Burlington Magazine*, 1913, XXI–XXII, I, pp. 208–215, II, pp. 276–283, III, pp. 322–336; F. Mason Perkins, 'Quattro tavole inedite del Sassetta' in *Rassegna d'arte*, 1907, pp. 45–46; J. Pope-Hennessy, *Sassetta*, London 1939; R. Longhi, 'Fatti di Masolino e Masaccio' in *La Critica d'arte*, 1940, XXV–XXVI, pp. 145–191, also published in *Opere complete di Roberto Longhi*, Florence 1975, VIII, 1, pp. 3–65; A. Graziani, 'Il Maestro dell'Osservanza (1942)' in *Proporzioni*, 1948, II, pp. 75–88.
5 G.A. Pecci (*Relazione delle cose più notabili della città di Siena*, Siena 1752, p. 93) was the first to give Stefano di Giovanni the name of Sassetta.
6 G. Carli, *Notizie di belle arti (secolo XVIII)*, MS. C.VII.20, fols. 81–82; A.M. Carapelli, *Notizie delle chiese e cose riguardevoli di Siena*, MS. B.VII.10, fol. 30v.
7 The correct interpretation of the inscription was given by P. Scapecchi, *Chiarimenti intorno alla pala dell'Arte della Lana*, Siena 1979.
8 C. Volpe, in *Il Gotico a Siena*, Florence 1982, p. 383; C. Brandi, *Quattrocentisti senesi*, p. 38.

9 G. De Nicola, 'Sassetta between 1423 and 1433'; F. Zeri, 'Ricerche sul Sassetta: La Pala dell'Arte della Lana (1423–6)' in *Quaderni di emblema*, 1973, II, pp. 22–34, also Turin 1991, pp. 189–198.
10 J. Pope-Hennessy, *Sassetta*, p. 17.
11 F. Zeri, 'Towards a Reconstruction of Sassetta's Arte della Lana Triptych' in *The Burlington Magazine*, 1956, XCVIII, p. 635. Also in *Giorno per giorno nella pittura*, Turin 1991, pp. 183–188, especially p. 187. See also F. Zeri, 'Ricerche sul Sassetta: La Pala dell'Arte della Lana (1423–6)'; K. Christiansen and L.B. Kanter, in *La pittura senese nel Rinascimento 1420–1500*, p. 83.
12 G. Schoenburg Waldenburg, 'Problemi proposti da un messale della Biblioteca di Siena' in *Commentari*, 1975, 3–4, pp. 267ff.; C. Volpe, 'Stefano di Giovanni' in *Il Gotico a Siena*, p. 385.
13 R. Longhi, 'Fatti di Masolino e Masaccio' in *La Critica d'arte*, 1940, XXV–XXVI, pp. 145–191, also published in *Opere complete di Roberto Longhi*, Florence 1975, VIII, 1, pp. 3–65, especially p. 10.
14 A. Angelini, in L. Bellosi and A. Angelini, *Sassetta e I pittori toscani tra XIII e XV secolo*, Siena 1986, p. 36.
15 J. Pope-Hennessy, *Sassetta*, pp. 77–88.
16 See A. De Marchi, *Gentile da Fabriano. Un viaggio nella pittura italiana alla fine del Gotico*, Milan 1992, pp. 194 and 210, note 7.
17 On the *San Sepolcro Polyptych*, see D. Gordon, 'The Reconstruction of Sassetta's Altarpiece for San Francesco, Borgo San Sepolcro, a Postscript' in *The Burlington Magazine*, 1993, 135, pp. 620–623.
18 R. Longhi, *Piero della Francesca*, Rome 1927. Also in *Opere complete di Roberto Longhi*, III, *Piero della Francesca*, Florence 1963, pp. 3–152, 171–185 and 207–217.

19 R. Longhi, 'Fatti di Masolino e Masaccio', pp. 145–191.
20 A. Graziani, 'Il Maestro dell'Osservanza', pp. 75–88.
21 C. Alessi, in *La Pittura in Italia. Il Quattrocento*, Milan 1987, pp. 750–752; A. De Marchi, in *La Sede storica del Monte dei Paschi. Vicende costruttive e opere d'arte*, Siena 1988, pp. 298–302.
22 A. Graziani, 'Il Maestro dell'Osservanza', p. 82.
23 K. Christiansen and L.B. Kanter, in *La Pittura senese nel Rinascimento 1420–1500*, p. 150.
24 A new hypothesis regarding the identity of the Osservanza Master has been proposed by C. Alessi and P. Scapecchi, 'Il Maestro dell'Osservanza: Sano di Pietro o Francesco di Bartolomeo?' in *Prospettiva*, 1985, 42, pp. 13–37. See also the arguments put forward by A. De Marchi, in *La Sede storica del Monte dei Paschi. Vicende costruttive e opere d'arte*, pp. 301–302, where she argues for the Osservanza Master being the young Sano di Pietro.
25 C. Brandi, *Quattrocentisti senesi*, pp. 75–87; J. Pope-Hennessy, 'Rethinking Sassetta' in *The Burlington Magazine*, 1956, 643, pp. 364–370; E. Carli, *Sassetta e il Maestro dell'Osservanza*, Milan 1957, p. 102; A. Angelini, in L. Bellosi and A. Angelini, *Sassetta e i pittori toscani tra XIII e XV secolo*, p. 46.
26 D. Benati, in *Il Gotico a Siena*, p. 396.
27 A. Graziani, 'Il Maestro dell'Osservanza', p. 86.
28 E. Carli, *Il Palazzo Pubblico di Siena*, Rome 1963, pp. 36–38.
29 P. Torriti, *La Pinacoteca nazionale di Siena. I dipinti dal XII al XV secolo*, Genoa 1977, pp. 258–259.

30 E. Carli, 'Luoghi ed opere d'arte senesi nelle prediche di Bernardino del 1427' in *Bernardino predicatore nella società del suo tempo*, conference proceedings from the Centro di Studi sulla Spiritualità Medievale, XVI, 9–12 October 1975, Todi 1976, pp. 153–182.
31 D. Benati, in *Il Gotico a Siena*, pp. 403–405.
32 C. Volpe, in *Il Gotico a Siena*, pp. 405–410.
33 *Le Musée Jacquemart-André*, Paris 1914, pp. 10–12. Also M. Seidel, 'Sozialgeschichte des Sieneser Renaissance-Bildes' in *Städel-Jahrbuch*, 1989, 12, pp. 71–139.
34 C. Volpe, in *Il Gotico a Siena*, pp. 407–408. To Pietro di Giovanni's small number of works Laclotte has recently added two panels from a predella showing *St Bartholomew Preaching* and the *Beheading of St Bartholomew*, which were given to the Louvre in 1984. See Laclotte, 'Une prédelle de Pietro di Giovanni d'Ambrogio' in *Paragone*, 1985, pp. 107–112.
35 A. Angelini, in *Mostra di opere d'arte restaurate nelle province di Siena e Grosseto*, Genoa 1983, III, pp. 114–115.
36 M. Ciatti, in *Mostra di opere d'arte restaurate nelle province di Siena e Grosseto*, Genoa 1981, II, pp. 81–82.
37 F. Zeri, 'Diari di lavoro 3. Giovanni di Paolo e Martino di Bartolomeo: una proposta' in *Paragone*, 1986, pp. 6–7.
38 V. Koudelka, 'Spigolature dal memoriale di Niccolò Galgani, O.P. (1424)' in *Archivium fratrum praedicatorum*, 1959, pp. 114, 133–134 and 137–138; C.B. Strehlke, in *La Pittura senese nel Rinascimento 1420–1500*, p. 182.
39 P. Bacci, 'Documenti e commenti per la storia dell'arte' in *Le Arti*, 1941, pp. 12–13.

40 M. Meiss, 'The Earliest Work of Giovanni di Paolo' in *Art in America*, 1936, pp. 137–143.

41 G. Chelazzi Dini, in *Il Gotico a Siena*, pp. 358–359.

42 A. De Marchi (*Gentile da Fabriano. Un viaggio nella pittura italiana alla fine del Gotico*, pp. 195 and 211, note 339) points out Giovanni di Paolo's debt to Gentile da Fabriano, not only to the *Strozzi Altarpiece* (1423) but also to the *Quaratesi Polyptych* (1425) and to other paintings. Giovanni di Paolo even tried to imitate Gentile da Fabriano's painting technique.

43 C. Brandi, *Quattrocentisti senesi*, pp. 91 and 258, pl. 119.

44 G. Chelazzi Dini, in *Mostra di opere d'arte restaurate nelle province di Siena e Grosseto*, 1981, II, pp. 72–75.

45 A third polyptych was painted for the Guelfi family chapel in San Domenico in Siena, but critics disagree over the identification of its parts. C.B. Strehlke, in *La Pittura senese nel Rinascimento 1420–1500*, p. 206, thought that the main altarpiece was the *Virgin and Child with SS. Dominic, Peter, Paul and Thomas Aquinas* (Uffizi, Florence). He also believed that the predella contained the *Crucifixion* and the *Expulsion from Paradise* (Lehman Collection, Metropolitan Museum of Art, New York) as well as the *Paradise* (Metropolitan Museum of Art, New York). The polyptych was painted in 1445.

46 This was painted after the commission received by Giovanni di Paolo in 1436 for an altarpiece for the Fondi family chapel in San Francesco in Siena. The history of this altarpiece and its separate panels has been the subject of differing interpretations. See, for example, C.B. Strehlke, in *La Pittura senese nel Rinascimento 1420–1500*, pp. 190–192.

47 Four miniatures from the *Lecceto Antiphonary* were not painted by Giovanni di Paolo. These are on fols. 149r, 156v, 160r and 161r. See G. Chelazzi Dini, in *Il Gotico a Siena*, pp. 367–368; C.B. Strehlke, in *La Pittura senese nel Rinascimento 1420–1500*, p. 202.

48 For Giovanni di Paolo's work as a miniaturist, see C.B. Strehlke, 'Three Notes on the Sienese Quattrocento' in *Gazette des Beaux-Arts*, 1989, 114, pp. 278–280.

49 The miniatures of the *Divine Comedy* are fully illustrated in P. Brieger, M. Meiss and C.S. Singleton, *Illuminated Manuscripts of the Divine Comedy*, 2 vols, Princeton 1969.

50 C.B. Strehlke, in *La Pittura senese nel Rinascimento 1420–1500*, pp. 207–214 and note 7.

51 Between the end of 1442 and the first months of 1443 Giovanni di Paolo completed the painting of the *Resurrected Christ* sculpted by Domenico di Niccolò dei Cori. See A. Bagnoli, in *Scultura dipinta. Maestri di legname e pittori di Siena. 1250–1450*, Florence 1987, p. 105.

52 There are other versions of the same subject, each of which shows strong similarities with the *Strozzi Altarpiece* painted in 1423 by Gentile da Fabriano for the church of Santa Trinita in Florence (Uffizi, Florence). See C.B. Strehlke, in *La Pittura senese nel Rinascimento 1420–1500*, pp. 223–224.

53 L.S. Dixon, 'Giovanni di Paolo's Cosmology' in *The Art Bulletin*, 1995, pp. 603–613, especially p. 612.

54 See C. Brandi, 'Giovanni di Paolo' in *Le Arti*, 1941, pp. 320–321.

55 C.B. Strehlke, in *La Pittura senese nel Rinascimento 1420–1500*, p. 192.

56 Ibid., pp. 229–232.

57 C. Brandi, *Quattrocentisti senesi*, p. 103.

58 G. Chelazzi Dini, 'Lorenzo Vecchietta, Priamo della Quercia, Nicola da Siena: nuove osservazioni sulla Divina Commedia Yates Thompson 36' in *Jacopo della Quercia fra Gotico e Rinascimento*, Florence 1977, pp. 203–227.

59 J. Pope-Hennessy, *Lorenzo Vecchietta and Giovanni di Paolo. A Sienese Codex of the Divine Comedy*, London 1947.

60 B. Toscano, 'Bartolomeo di Tommaso e Nicola da Siena' in *Commentari*, 1964, pp. 37–51. The manuscripts of G. Sordini are in the Archivio di Stato in Spoleto (Archivio Sordini P.14.162).

61 S. Borghesi and L. Bianchi, *Nuovi documenti per la storia dell'arte senese*, Siena 1898, pp. 170–171.

62 F. Santi, *III Mostra di opere restaurate*, Perugia 1956, pp. 19–20.

63 E. Carli, in *Il Gotico a Siena*, p. 352.

64 J. Pope-Hennessy, 'Panel Paintings of Pellegrino da Mariano' in *The Burlington Magazine*, 1939, pp. 213–218; C. Brandi,

'Giovanni di Paolo', Florence 1947, p. 86, for some accurate observations on the style and the dating of the Lecceto graduals; C.B. Strehlke, in *La Pittura senese nel Rinascimento 1420–1500*, pp. 257–262.

65 Various authors, *The Early Sienese Paintings in Holland*, Florence 1989, pp. 112–114.

66 M. Paoli, 'Documento per Priamo della Quercia' in *Critica d'arte*, 1985, p. 101.

67 E. Avanzati, in *La Sede storica del Monte dei Paschi. Vicende costruttive e opere d'arte*, Siena 1988, p. 291.

68 M. Meiss, 'The Yates Thompson Dante and Priamo della Quercia' in *The Burlington Magazine*, 1964, p. 407.

69 F. Zeri and E.F. Gardner, *Sienese and Central Italian Schools. A Catalogue of the Collection of the Metropolitan Museum of Art*, Vicenza 1980, pp. 70–71.

70 G. Targioni Tozzetti, *Relazioni d'alcuni viaggi*, Florence 1769, III, p. 81.

71 G. Chelazzi Dini, 'Lorenzo Vecchietta, Priamo della Quercia, Nicola da Siena: nuove osservazioni sulla Divina Commedia Yates Thompson 36', pp. 203–228.

72 D. Gallavotti Cavallero, 'Gli affreschi quattrocenteschi della Sala del Pellegrinaio nello Spedale di Santa Maria della Scala in Siena' in *Storia dell'arte*, 1972, p. 28; idem, *Lo Spedale di Santa Maria della Scala in Siena: Vicenda di una committenza artistica*, Pisa 1985, p. 161.

73 D. Gallavotti Cavallero, *Lo Spedale di Santa Maria della Scala in Siena*, p. 161–162.

74 G. De Nicola, 'Studi sull'arte senese, I – Priamo della Quercia' in *Rassegna d'arte*, 1928, pp. 69–74; idem, 'Priamo della Quercia. Appendice' in *Rassegna d'arte*, 1928, pp. 153–154.

75 G. Chelazzi Dini, 'Lorenzo Vecchietta, Priamo della Quercia, Nicola da Siena: nuove osservazioni sulla Divina Commedia Yates Thompson 36', p. 204.

76 Ibid., pp. 203–209.

77 G. Vasari, *Le Vite de' più eccellenti pittori, scultori e architettori* (Florence 1568), edited by P. Della Pergola, L. Grassi and G. Previtali, Novara 1967, II, pp. 53–61.

78 G. Milanesi, *Documenti per la storia dell'arte senese*, Siena 1854, I, p. 49; II, pp. 161–162 and 171–173.

79 For the various opinions on the attribution of this painting, see Ragghianti,

'Notizie e letture' in *La Critica d'arte*, 1938, pp. 22–23; G. Pudelko, 'The Early Works of Fra' Filippo Lippi' in *The Art Bulletin*, 1936, pp. 104–112; R. Longhi, 'Fatti di Masolino e Masaccio', pp. 145–191; C. Brandi, *Quattrocentisti senesi*, pp. 107–109; J. Pope-Hennessy, 'The Development of Realistic Painting in Siena' in *The Burlington Magazine*, 1944, pp. 110–119 and 139–145.

80 L. Bellosi, 'Per Luca della Robbia' in *Prospettiva*, 1981, pp. 62–72.

81 G. Damiani, in L. Bellosi (ed.), *Una Scuola per Piero. Luce, colore e prospettiva nella formazione fiorentina di Piero della Francesca*, Florence 1992, pp. 59–63.

82 C.B. Strehlke, 'La Madonna dell'Umiltà di Domenico di Bartolo e San Bernardino' in *Arte Cristiana*, 1984, LXXII, pp. 381–390.

83 C.B. Strehlke, 'Three Notes on the Sienese Quattrocento', pp. 271–275.

84 C.B. Strehlke, in *La Pittura senese nel Rinascimento 1420–1500*, Siena 1989, pp. 268–271.

85 R. Longhi, 'Ricerche su Giovanni di Francesco' in *Pinacotheca*, 1928, I, p. 37, also printed in *Opere complete di Roberto Longhi*, Florence 1968, IV, p. 24.

86 C. Bertelli, 'Masolino e il Vecchietta a Castiglione Olona' in *Paragone*, 1987, pp. 26–47.

87 On the cycle of frescoes in the pilgrims' quarters, see D. Gallavotti Cavallero, 'Gli affreschi quattrocenteschi della Sala del Pellegrinaio nello Spedale di Santa Maria della Scala in Siena', pp. 1–37; idem, *Lo Spedale di Santa Maria della Scala in Siena*.

88 L. Bellosi, *Francesco di Giorgio e il Rinascimento a Siena. 1450–1500*, Milan 1993, p. 523.

89 The earliest known sculpture by Vecchietta, however, is the *St James the Less* from the De Carlo Collection. See G. Previtali, 'Un "San Giacomo Minore" del Vecchietta' in *Paragone*, 1964, pp. 43–45; A. Bagnoli, in *Scultura dipinta. Maestri di legname e pittori di Siena. 1250–1450*, Florence 1987, pp. 177–180.

90 The documents are published in G. Milanesi, *Documenti per la storia dell'arte senese*, Siena 1854, II, p. 388. See also P. Bacci, *Fonti e commenti per la storia dell'arte*, Siena 1944, p. 105.

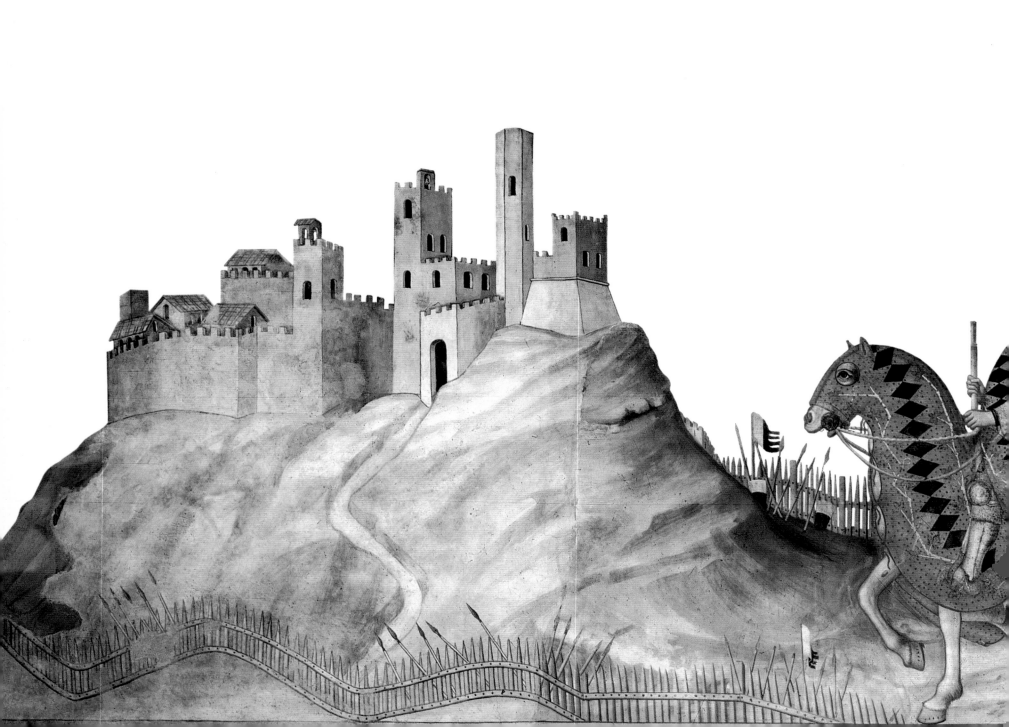

ALESSANDRO ANGELINI

The Second Half of the Fifteenth Century

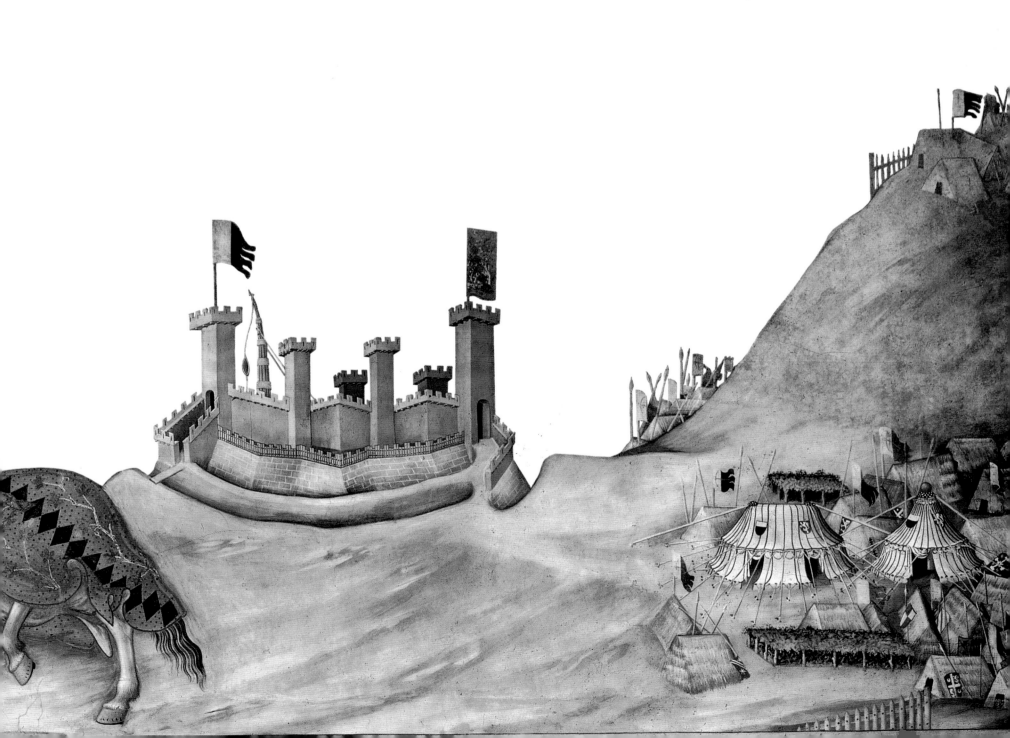

Painters and Workshops in the Second Half of the Fifteenth Century

Siena Cathedral Baptistery

On 24 May of the Holy Year of 1450 Pope Nicholas V celebrated the canonization of Bernardino of Siena in St Peter's, Rome.[1] The news, which had been long awaited, was welcomed with celebrations in all the communities in which Bernardino had preached. In Siena the festivities carried on for some days, especially in the Campo.[2] Altars were constructed in Siena's *contrade* (districts) where mass was said in front of the whole population. The bishop and many members of the religious orders congregated to sing vespers on a stage erected at the foot of the Palazzo Pubblico. In front of the Palazzo del Podestà a wooden construction containing a hidden mechanism, illuminated by a wheel of lights, represented St Bernardino ascending to Paradise.[3]

The ephemeral celebrations and decorations were followed by more lasting signs of the cult of the Franciscan St Bernardino, who had been suspected of heresy during his lifetime but had now attained canonization.[4] In 1457 there was a project to construct an altar dedicated to the saint in Siena Cathedral and in 1458 the *operaio* of the cathedral, Mariano Bargagli, commissioned Donatello to execute a statue of St Bernardino. Unfortunately the commission was never carried out. The sculpture was to have been placed among those in the loggia of St Paul and would have significantly changed the iconography of the existing cycle.[5]

On 7 February 1450 the Opera del Duomo commissioned Vecchietta to paint the last of the great mid-century

Vecchietta, *Articles of the Creed*,
detail of the vault.
Baptistery, Siena.

p. 265
Vecchietta, *Bust of a Young Girl*,
detail of the frame
of the vault frescoes.
Baptistery, Siena.

fresco cycles in Siena on the vaults and walls of the baptistery of San Giovanni.[6] The cycle consisted of various religious motifs that St Bernardino had used in his preaching. They included the glorification of the Creed, the veneration of the Virgin Mary, the contemplation of Christ's passion and the encouragement of pious works. There were also elements of the cycle dedicated to the value of civic virtues, such as Peace and Harmony (*Pax* and *Concordia*), which are rare in religious iconography although they had been represented in Ambrogio Lorenzetti's frescoes in the Sala dei Nove.[7] St Bernardino is depicted a number of times in the frescoes. Interestingly, in the *Last Judgment* he appears in the background as the most recent arrival among the lines of the blessed, welcomed by the embrace of an angel.

Vecchietta's contract for the baptistery frescoes employed him, together with a *lavorante* (helper), to complete a large and important cycle. With this commission, work on the baptistery, which until this point had consisted of the sporadic contributions of the Bolognese artists Michele di Matteo and Agostino di Marsilio, gained momentum. Vecchietta, the last surviving Sienese artist to belong to the 'heroic' generation of

Sassetta and Domenico di Bartolo, painted a cycle containing a number of Renaissance stylistic elements and in which the influences of Masolino, with whom he had worked, Donatello and Masaccio are evident. Vecchietta moved away from the late Gothic linearism of Michele di Matteo and improved on the old-fashioned fourteenth-century style of Agostino di Marsilio, an artist who had played a minor part in the frescoes in the pilgrims' quarters in the Ospedale di Santa Maria della Scala.[8]

Agostino di Marsilio had already decorated the ribs and the mouldings in the left vault of the baptistery in his outdated Gothic style. The decoration consisted of abstract vegetal motifs, like the *drôleries* of Gothic miniatures, and little polylobular mouldings containing heads seen either frontally or in profile. In the four vaults Vecchietta inserted frescoes representing the first *Articles of the Creed*, an unusual iconographic theme that had enjoyed a certain amount of success in Siena from the fourteenth century onwards. Vecchietta had already depicted the subject in the sacristy of the Ospedale di Santa Maria della Scala and Ambrogio Lorenzetti had painted it in the fourteenth century in Sant'Agostino.[9] Vecchietta

Vecchietta, *Descent into Limbo*,
detail of the vault.
Baptistery, Siena.

introduced the narrative expedient of a kneeling worshipper who, from the corner of the composition, contemplates the allegories or mystical scenes which open out in front of him. The worshipper speaks the word 'credo', which is written on each of the vaults. The overall effect of the allegorical cycle is purposely abstract and it is painted in a deliberately archaic manner. The scenes stand out against a starry night sky as though they are taking place in a timeless atmosphere. However, Vecchietta does not employ an abstract composition throughout the cycle, as can be seen in the *Annunciation* which is set in a Brunelleschian classical temple. The building's two pilasters and column give an effect of recession that is not entirely successful because the arched structure of the vault is slightly askew. A similar solution appears in the fourth vault, where Vecchietta has combined the various phases of the *Passion*, the *Crucifixion* and the *Burial of Christ* into an accomplished, unified composition.

In the central vault of the baptistery, Vecchietta painted fictive architectural niches on the mouldings. The niches contain acanthus volutes and *oculi* in difficult foreshortening. Inside the *oculi* are busts of young and richly clothed men and women, who seem to bear little relevance to the iconography of the Creed but are certainly some of the freshest and most lively innovations of the whole cycle. The inspiration for the *oculi*, as well as the grotesque heads used by Paolo Uccello in the festoons for the Chapel of the Assumption in Prato Cathedral, probably came from Masolino, who had employed a similar solution in the window of the Brancacci Chapel. However, in comparison to Masolino, Vecchietta is more interested in the architectural structure of the tondi, which are very different in style to Agostino di Marsilio's polylobular mouldings. The little angels inside the niches who hold festoons or play instruments seem to be pictorial versions of those that Donatello had sculpted twenty years previously on the baptismal font. They are often shown in strange poses, articulated by shading that clearly derives from Masaccio. They look like children whose chest muscles have been developed by fighting in the grass.

The decoration of the central vault includes some visually fascinating scenes, such as that of the *Eucharist*. The altar on which the Holy Spirit descends stands in suspended space at the centre of a large polychromed marble intarsia pavement,

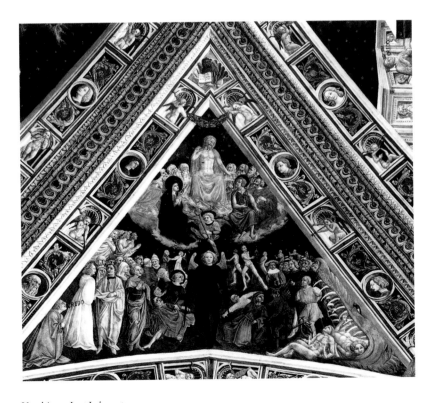

Vecchietta, *Last Judgment*,
detail of the vault.
Baptistery, Siena.

which is enclosed at the back by a grey and watery-green transenna, decorated with antique relief busts. The *Ascension* takes place in a vast landscape seen from a bird's-eye view. The composition contains rural details, such as the stream of water running between the bleak hills in the distance, that recall the magical, shade-filled paintings of Masolino in Castiglione Olona. In the *Last Judgment*, the firm anatomy of the body of the Judging Christ, accentuated by shading, bears traces of Masaccio. Vecchietta has also inserted elegant abstract motifs, such as the giant alligator mouth of a demon in the corner of the vault. The long fangs of the demon impale the naked bodies of the damned. In the three preceding bays the twelve apostles are represented, four in each vault. The apostles stand out against the night blue of the vault and each is identified by an inscription.

Agostino di Marsilio, who worked on the project as Vecchietta's assistant, painted the frescoes in the left and right vaults. In the one on the right, in the niches that open behind the shoulders of *SS. Blaise, Lucy and Sebastian*, Agostino struggled to bring himself up to date with Vecchietta's 'modern' vocabulary. In the central bay Vecchietta painted four *oculi* in

sharp foreshortening that contain mocking musicians who seem to flaunt their nudity. Vecchietta often included figures that had no relevance to the iconographical programme – perhaps believing that figures painted high on the vaults could not be seen from below.[10]

On the back right vault Vecchietta returned to the simpler decoration of the first bay. The heads that he painted here are among his most fascinating inventions. Job is one of the most memorable of the stern old prophets, shown with a long flowing beard that runs beyond the limits of the moulding. He sits in a most unruly pose, with one leg hanging down and projecting a shadow on to the wall. Vecchietta also painted some monochrome Virtues clearly inspired by Ambrogio Lorenzetti's frescoes in the Sala dei Nove. These include Harmony, holding a plane, and Peace, with a branch of olives, standing over her weapons.

The last scenes of the *Articles of the Creed* are dedicated to the glorification of the Church. They include representations of *Baptism* and *Ordination* and conclude with the *Resurrection of the Dead* and *Paradise*. The last scene takes place in a *hortus conclusus* (enclosed garden) covered with flowers. It provides,

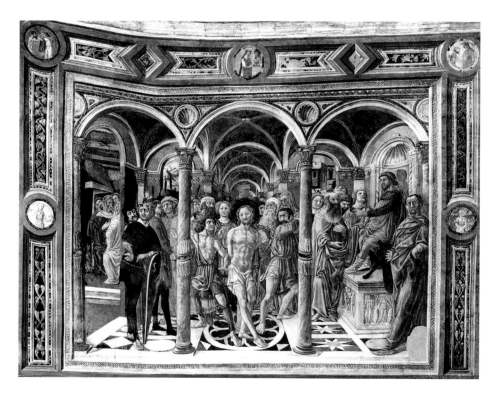

Vecchietta, *Flagellation*.
Baptistery, Siena.

at least in part, the key to reading the entire cycle. The patron saints of Siena are emphasized in the foreground and St Bernardino is centrally positioned as the saint whose preaching inspired the theme of the cycle. The frequent use of gold, which is characteristic of the baptistery's decoration, assumes greater prominence in the light-filled *Paradise*, where rays emanate from bodies and disperse over the entire scene like rain.

Having finished the work on the vaults, the decoration of the baptistery continued with the arch leading to the apse. Here Vecchietta painted the *Assumption of the Virgin*, complete with a festive retinue of blond, rosy-faced angels. This is the last homage Vecchietta paid to his first master, Sassetta, whose sudden death in 1450 left the great fresco inside the Porta Romana unfinished. The chorus of fragile, adolescent angels, placed in groups to either side of the Virgin over the entire surface of the arch, is reminiscent of Sassetta's last work. 'As the earth is surrounded with flowers and sweet-smelling things in the springtime… Mary is always surrounded by angels… they are all around her, giving her extremely sweet and gentle songs and perfumes… [they are] rejoicing,

singing, dancing, making a circle around her.' These words were dedicated by St Bernardino to the Virgin of the Assumption[11] and are evoked with rare elegance in the golden surfaces of the fresco.

Underneath the arch and above the moulding are more saints and blessed figures from Siena, including *Ansanus, Victor, Savinus, Crescentius, Ambrogio Sansedoni* and *Catherine of Siena. St Bernardino* is given a dominant position at the centre of the arch. His open arms hold up small panels bearing the name of Jesus. On the apse walls are small paintings showing the *Works of Mercy* and the *Theological Virtues* painted on a gold background as though they were scenes from a predella. Vecchietta also executed the *Annunciation* in the apse, a recent restoration of which has revived the original luminosity of the work. The two large frescoes showing the *Flagellation* and the *Way to Calvary* are those most reminiscent of Masaccio's style, but Vecchietta added aspects that seem almost grotesque. The two scenes have an unfortunate tendency to over-dramatize the action, which makes Christ's executioners seem both too large and too frightening. He over-accentuated the shadows and exaggerated the foreshortening

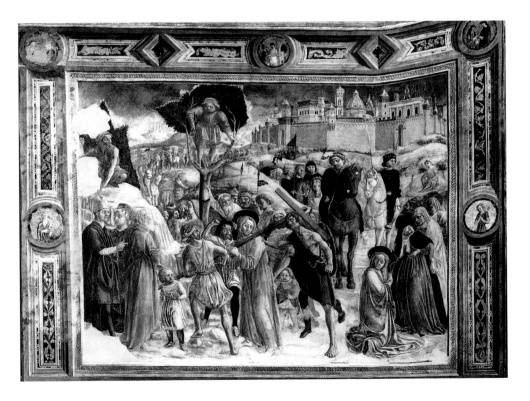

Vecchietta, *Way to Calvary*.
Baptistery, Siena.

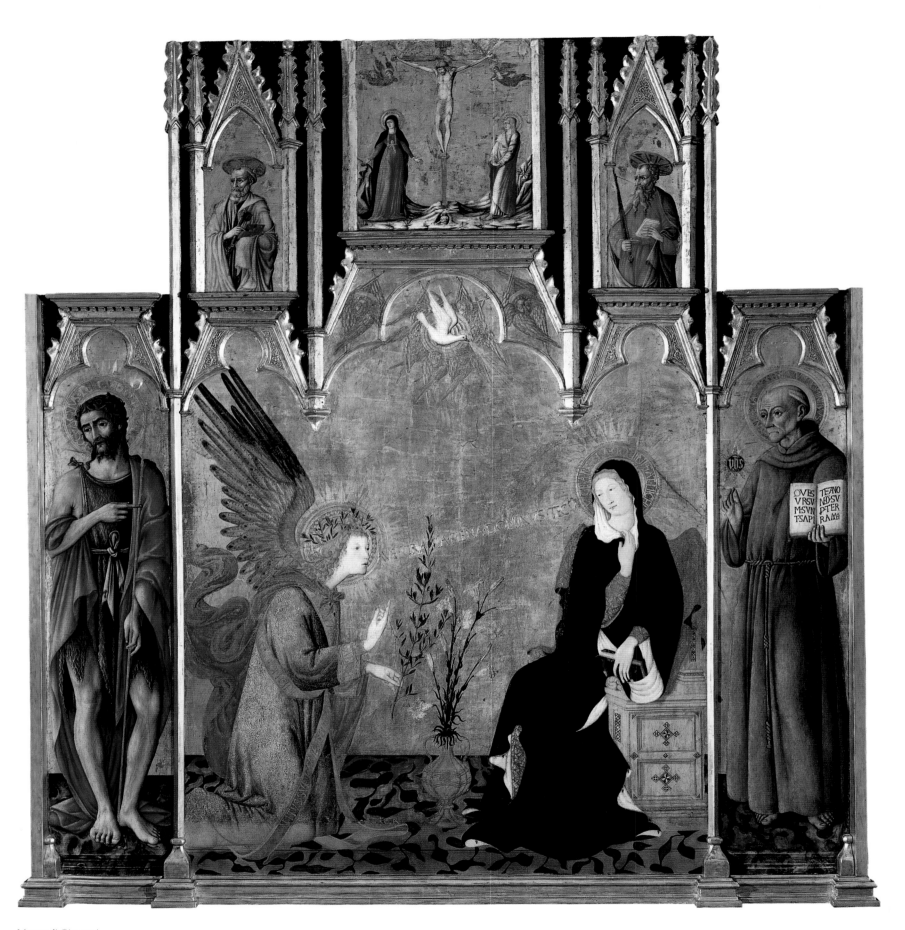

Matteo di Giovanni,
Annunciation, detail from
the *San Pietro a Ovile Polyptych*.
Pinacoteca, Siena.

with effects that verge on caricature. Furthermore, a sort of antiquarian frenzy seems to have taken over. The *Flagellation* consists of a series of different types of marbles, reliefs, niches and fluted columns that somehow contract the space represented within the composition. The *Way to Calvary* was influenced by the frescoes that Masolino and Masaccio executed in Rome. This is particularly true of the central group of horsemen, of the menacing expressions of the executioners and of the masks of devastating pain on the faces of the three Marys. The city in the distance is not convincingly placed in the composition and lacks spatial coherence.

In the baptistery frescoes Vecchietta used a composite technique of painting combining true fresco, tempera and oil. He also used metal leaf in a sophisticated way that must originally have given the magical effect of moving and vibrant light.[12] In spite of the complexity of the techniques used, the scenes were painted freely and with rapid brushstrokes which became almost liquid in the case of the hair and beards. It is as if Vecchietta worked from abbreviated signs that indicated the composition rather than faithfully following a drawing.

Matteo di Giovanni originally came from Borgo San Sepolcro but is documented uninterruptedly from 1453 in Siena, where he had a long career and received many commissions.[13] One of his first surviving works in Siena is the polyptych originally from the church of San Pietro a Ovile containing a representation of *St Bernardino* in the right lateral panel (Pinacoteca, Siena). The painting is one of the most intriguing and discussed panel paintings executed in Siena at the beginning of the second half of the fifteenth century. The central *Annunciation*, within an elaborate and flowery Gothic framework, has modelled its composition on Simone Martini's altarpiece for Siena Cathedral of 1333. The left lateral panel depicts *St John the Baptist* and the pinnacles contain the *Crucifixion* flanked by *SS. Peter and Paul*. The predella shows scenes from the life of the Virgin (Louvre, Paris, and Johnson Collection, Philadelphia Museum of Art). Unfortunately, the *Annunciation* is much deteriorated and it is now almost impossible to judge the original appearance of the flesh colours. It is in the side panels and the predella that Matteo di Giovanni's style can best be appreciated. These panels still show the influence of Domenico di Bartolo and of

Matteo di Giovanni,
San Sepolcro Triptych.
Museo Civico, Sansepolcro.

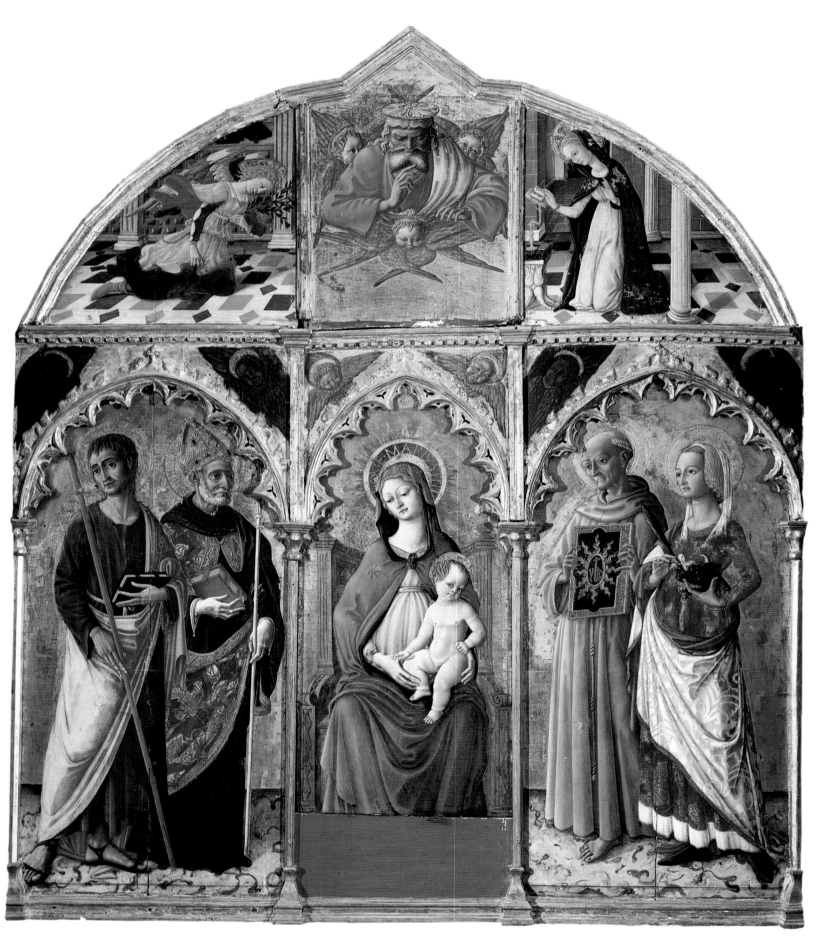

Matteo di Giovanni, *Virgin
and Child with SS. James,
Augustine, Bernardino and Margaret*.
Museo della Collegiata di Sant'Agata,
Asciano (originally in Sant'Agostino).

Pietro di Giovanni d'Ambrogio.[14] In the predella panels in the Johnson Collection, Matteo di Giovanni has painted floors of brilliantly coloured polychromed intarsia and interiors with shining reflective marble. These compositions constitute the immediate precedent for the scenes from the life of St John the Baptist in the predella of the *San Sepolcro Triptych*.

Matteo di Giovanni painted the *San Sepolcro Triptych* in *c.* 1455. At this time he was employed by the Opera di San Giovanni Battista in Val d'Afra to execute the panels surrounding Pietro della Francesca's *Baptism of Christ* (National Gallery, London) that had been completed in the mid-1430s.[15] He painted the solid figures of *SS. Peter and Paul* standing on dark marble slabs to either side of Piero's composition. They have polished heads and their beards and hair are painted as though they are made of the same metal alloy that is found in the saints in the *San Pietro a Ovile Polyptych*. The intense facial features of the figures in the lateral panels are defined by clean and decisive lines. Clear bright colours are used in the predella scenes where the architecture resembles that of the predella panels in the Johnson Collection.

A few years after these commissions Matteo di Giovanni painted a polyptych with a central *Virgin and Child* for the church of Sant'Agostino in Asciano. The lateral panels contain the figures of *SS. James, Augustine, Bernardino and Margaret*. The polyptych was commissioned by Jacopo Scotti who worshipped in the church of Sant'Agostino and was later buried there. It reflects Domenico di Bartolo's style, especially in the figures of the *Virgin and Child*, while the persistent sense of volume recalls Piero della Francesca. The foreshortened God the Father, who is represented as he blesses the figures from on high, must be similar to the lost figure that Matteo di Giovanni painted in a tondo for the *San Sepolcro Polyptych* and which was placed above Piero della Francesca's *Baptism of Christ*. The predella from the Asciano altarpiece contains scenes from the life of St Catherine. It closely follows in style the predellas of Matteo di Giovanni's earlier polyptychs in the lively colour of the architecture, in the intense facial features and in the light-filled cobalt-blue sky.

In the 1450s the Signori del Biado commissioned a panel in honour of Pope Calixtus III to be placed in the Palazzo

Benvenuto di Giovanni,
Miracle of the Miser's Heart.
Baptistery, Siena.

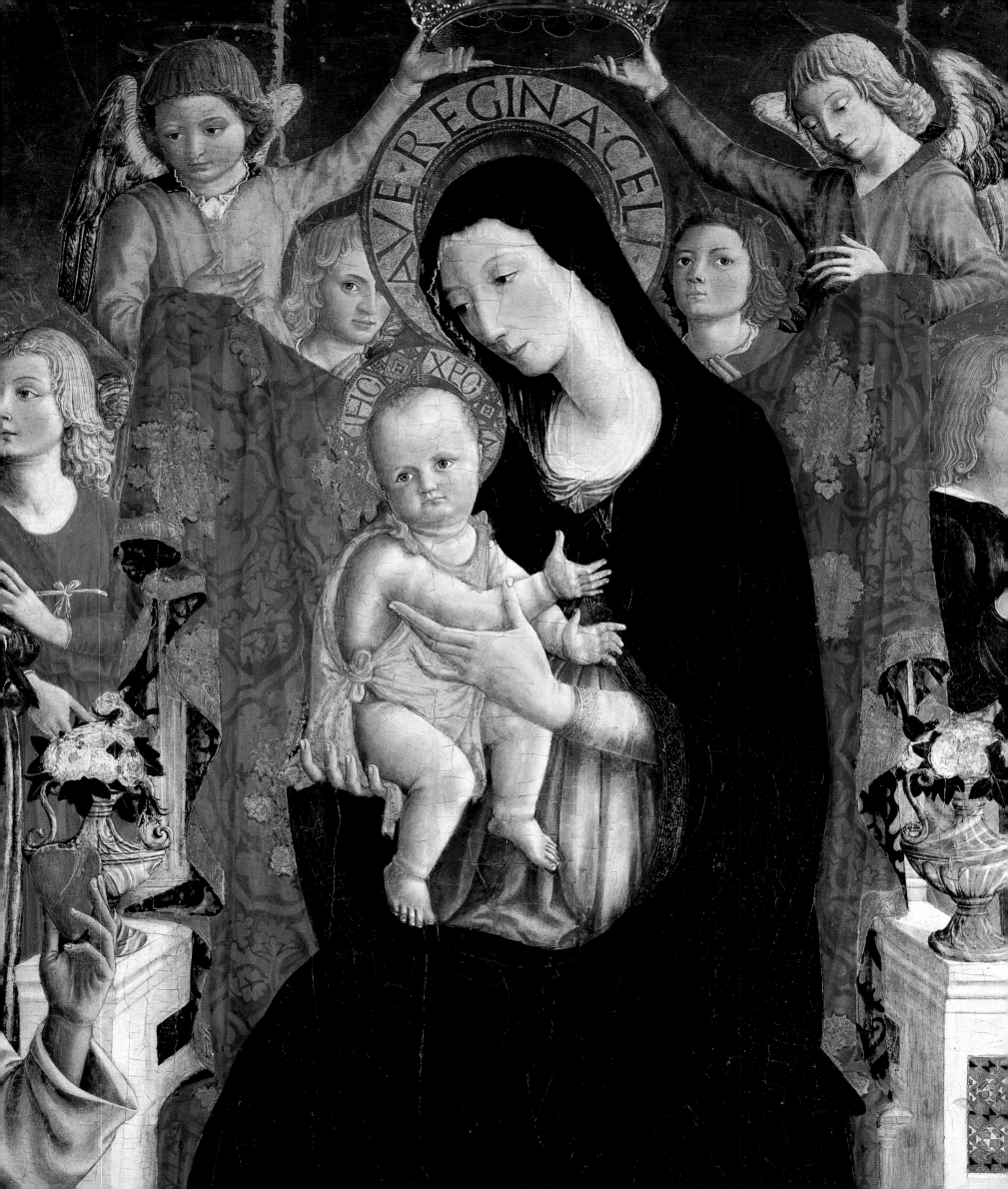

Pubblico (Pinacoteca, Siena). The composition commemorates the protection that the first Borgia pope gave to Siena in the critical years of famine and during the attacks of the mercenary leader Jacopo Piccinino. The panel depicts a dialogue between the Virgin and Calixtus III with a foreshortened view of the city in the background. In 1456 Vecchietta painted a lunette fresco of the *Madonna della Misericordia* for the offices of the Signori del Biado. In the arch above this lunette he painted busts of saints and of the city's protectors, using a similar solution to that which he had already employed in the baptistery. The following year he was commissioned by Giacomo d'Andruccio, a silk merchant, to paint an altarpiece now in the Uffizi in Florence. At around the same time he executed a triptych showing the *Virgin and Child with SS. John the Baptist and Jerome* (Musée du Petit Palais, Avignon) which is clearly influenced by Donatello.[16]

During the 1450s Vecchietta received a number of commissions and also formed a successful workshop in which the great artists of the next generation were trained. The decade ended with a new series of paintings in the baptistery, initiated by the banker Antonio di Carlo Nicoluccio who commissioned the decoration of the St Anthony of Padua Chapel. Matteo di Giovanni worked on the altarpiece (Museo dell'Opera del Duomo, Siena) and Benvenuto di Giovanni executed the fresco in the lunette with scenes from the life of St Anthony. Matteo di Giovanni's large scalloped altarpiece, signed and dated 1460, was put in position after the frescoes had been completed and is his most successful early work. It consists of a central *Virgin and Child* flanked by *St Anthony of Padua* and *St Bernardino*, who was probably included because of his importance in the iconography of the other parts of the decoration of the baptistery. The most original feature of this imposing composition is the eight angels surrounding the marble altar. They are seen from below in slight foreshortening and their movements recall the angels that Piero della Francesca had included in his *Baptism of Christ*. The panel has also been profoundly influenced by Piero della Francesca and Domenico Veneziano in other ways, although it is difficult to individuate precise sources. The brilliant liveliness of colour, added to a new depth of space, makes this painting a rare example of a Sienese 'painting of light'.[17]

Benvenuto di Giovanni was already working in the baptistery in 1453, the year in which he is recorded in a document as '*nostro dipintore in San Giovanni*' (our painter in San Giovanni).[18] At the time he was working under the guidance of Vecchietta, with whom he is recorded in a second document of 1460 as being in debt to the Opera del Duomo together with the young Francesco di Giorgio.[19] The few works by Benvenuto di Giovanni that can be dated before 1460 rely strongly on the work of Vecchietta.[20] The miniatures in *Codex 97.3* (Museo dell'Opera del Duomo, Siena) and the front panel of the *cassone* with the *Triumph of David* (Pinacoteca, Siena) demonstrate the strength of Vecchietta's influence, which was only diluted in later works. The three scenes from the life of St Anthony of Padua in the baptistery in Siena are set in architectural structures containing buildings that recall Vecchietta's exuberant multicoloured antiquarian taste. The innovatory and poetical qualities of Benvenuto di Giovanni come to the fore in the walls of the towers that stand out against the pale-blue sky in the *Miracle of the Newly Born Child* and in the group of nuns walking across a paved sunlit piazza in the *Miracle of the Miser's Heart*.

Work on the the Chapel of St Anthony of Padua had already finished when the painted decoration of the baptistery, which was then almost complete, was interrupted. When Pius II visited the baptistery on his way through Siena in 1460, he must have admired those painters, such as Vecchietta and Matteo di Giovanni, to whom he later offered prestigious commissions for the new cathedral in Pienza.

Notes

1 A. Allegretti, 'Diarj scritti da Allegretto Allegretti delle cose sanesi del suo tempo' in L.A. Muratori, *Rerum italicarum scriptores*, Milan 1733, XXIII, p. 767.
2 'Cronaca senese di Tommaso Fecini (1431–1479)' in *Raccolta di storici italiani dal Cinquecento al Millecinquecento…*, Bologna 1939, XV, VI, p. 861.
3 Ibid.
4 See C.B. Strehlke in *La Pittura senese nel Rinascimento 1420–1500*, Siena 1989, pp. 47–49.
5 S. Hansen, *La Loggia della Mercanzia in Siena*, Siena 1992, p. 48.
6 G. Milanesi, *Documenti per l'arte senese*, Siena 1854, II, p. 369; G. Vigni, *Lorenzo di Pietro detto il Vecchietta*, Florence 1937, p. 76; C. Alessi, 'Le Pitture murali della zona presbiteriale del Battistero di Siena: storia, studi e restauri' in *OPD*, 1992, 4, p. 9.
7 For a general discussion of the sermons of St Bernardino on Sienese art, see C.B. Strehlke, 'La Madonna dell'Umiltà di Domenico di Bartolo e San Bernardino' in *Arte Cristiana*, 1984, 705, pp. 381–390.
8 On Agostino di Marsilio, see A. Angelini, review of D. Gallavotti Cavallero, *Lo Spedale*

di Santa Maria della Scala. Vicenda di una committenza artistica, Pisa 1985, in *Bullettino senese di storia patria*, 1987, pp. 459–460.
9 H.W. van Os, *Vecchietta and the Sacristy of the Siena Hospital Church, a Study in Renaissance Religious Symbolism*, New York 1974, pp. 62ff. Vasari recounts that Ambrogio Lorenzetti painted the *Articles of the Faith* in the chapter house of Sant'Agostino and the frescoes are also referred to by St Bernardino. See his *Prediche volgari*, edited by P. Bargellini, Milan and Rome 1936, pp. 68–69. It is probable that the baptistery cycle deliberately mirrored the iconography of the frescoes in Sant'Agostino.
10 A devil-like nude figure, absolutely invisible from the ground, is frescoed in the passage which connects the baptistery to the cathedral and is reproduced in *Francesco di Giorgio e il Rinascimento a Siena*, Milan 1993, p. 489.
11 St Bernardino, *Prediche volgari*, p. 48. In this sermon St Bernardino refers to Simone Martini's fresco of the *Assumption of the Virgin* on the Porta Camollia.

12 C. Alessi, 'Le Pitture murali della zona presbiteriale del Battistero di Siena: storia, studi e restauri', pp. 18ff.
13 For the career of Matteo di Giovanni, see A. Angelini, in *La Pittura in Italia. Il Quattrocento*, edited by F. Zeri, Milan 1987, II, pp. 706–707; L. Kanter, in *La Pittura senese nel Rinascimento 1420–1500*, pp. 284–296.
14 Some art historians (following J. Pope-Hennessy, 'The Development of Realistic Painting in Siena' in *The Burlington Magazine*, 1944, pp. 140–144) have identified Giovanni di Pietro, the brother of Vecchietta, as the painter of at least part of the polyptych. Giovanni di Pietro is documented as a collaborator of Matteo di Giovanni from 1453 to 1457 but his style has never been properly investigated. For an overview of the question see C.B. Strehlke, in *La Pittura senese nel Rinascimento 1420–1500*, pp. 278–283; G. Freuler, in *Manifestatori delle cose miracolose*, Lugano 1991, pp. 98–100; C. Alessi, in *Panis vivus. Arredi e testimonianze figurative del culto eucaristico dal VI al XIX secolo*, Siena 1994, pp. 52–54; L. Bellosi, in

Francesco di Giorgio e il Rinascimento a Siena, Milan 1993, p. 87, note 44; and A. Angelini, ibid., p. 130.
15 The original arrangement of Matteo di Giovanni's polyptych containing Piero della Francesca's *Baptism of Christ* as a central panel, in the church of San Giovanni Battista in Val d'Afra, has recently been clarified by C. Pizzorusso, 'Sul "Battesimo" di Piero della Francesca' in *Artista*, 1991, pp. 130–132.
16 A. De Marchi, in *La Pittura in Italia. Il Quattrocento*, II, pp. 764–765.
17 See L. Bellosi, in *Pittura di luce, Giovanni di Francesco e l'arte fiorentina di metà Quattrocento*, pp. 11–45; idem, in *Francesco di Giorgio e il Rinascimento a Siena*, p. 87, notes 42–43.
18 V. Lusini, *Il San Giovanni di Siena e i suoi restauri*, Florence 1901, p. 59, note 1.
19 C. Alessi, 'Le Pitture murali della zona presbiteriale del Battistero di Siena: storia, studi e restauri', p. 15.
20 For Benvenuto di Giovanni's career during the 1450s, see R. Bartalini, in *Francesco di Giorgio e il Rinascimento a Siena*, pp. 95–97.

Pius II, Siena and Pienza

In the early 1460s Pius II, whose family – the Piccolomini – had close connections with Siena, began work on the small medieval village of Pienza, aiming to transform it into an ideal urban centre, composed of measured and clear forms in tune with the humanistic ideas of Alberti. The Palazzo Piccolomini, designed by Bernardo Rossellino, imitated the architectural idioms of the Palazzo Rucellai in Florence, a supreme example of private civic building. Pienza Cathedral, 'with the white clarity of its walls and columns', had a façade that recalled an antique temple and echoed the Roman forms of the Tempio Malatestiano in Rimini designed by Alberti. Shortly after its completion, Pius II described Pienza Cathedral in his *Commentarii*. He observed with pleasure how the Florentine architect had followed his strict and precise orders with intelligence and skill.[1] The overall effect of the cathedral was classical, yet the insertion of vast glass windows, like those in French Gothic cathedrals, gave the sensation that the walls themselves were made of glass and not stone.[2]

Under the direction of Pius II the central piazza of Pienza was completely reconstructed in a modern style – that is, a style which drew its inspiration from classical antiquity. At the same time the city of Siena also underwent considerable visual changes. The presence of politicians, humanists, and commissioners connected in some way to the papal court must have contributed to this antique fever. Such people supported the Piccolomini family's desire to give the city a Roman appearance. Pius II's stay in Siena at the beginning of 1460 reawakened a new building fervour on the part of local patrons and fuelled various building projects that evoked the antique past.[3] On 18 May 1462 the first marble column was erected in the loggia which the pope had ordered to be built in the Palazzo Piccolomini. In 1468 the roof was taken off the chapel in the Campo in order to make the vaults over the piers. On 12 September 1469 the walls of Messer Nanni Todeschini's palace were begun. Todeschini was Pius II's brother-in-law and the father of the cardinal of Siena. In

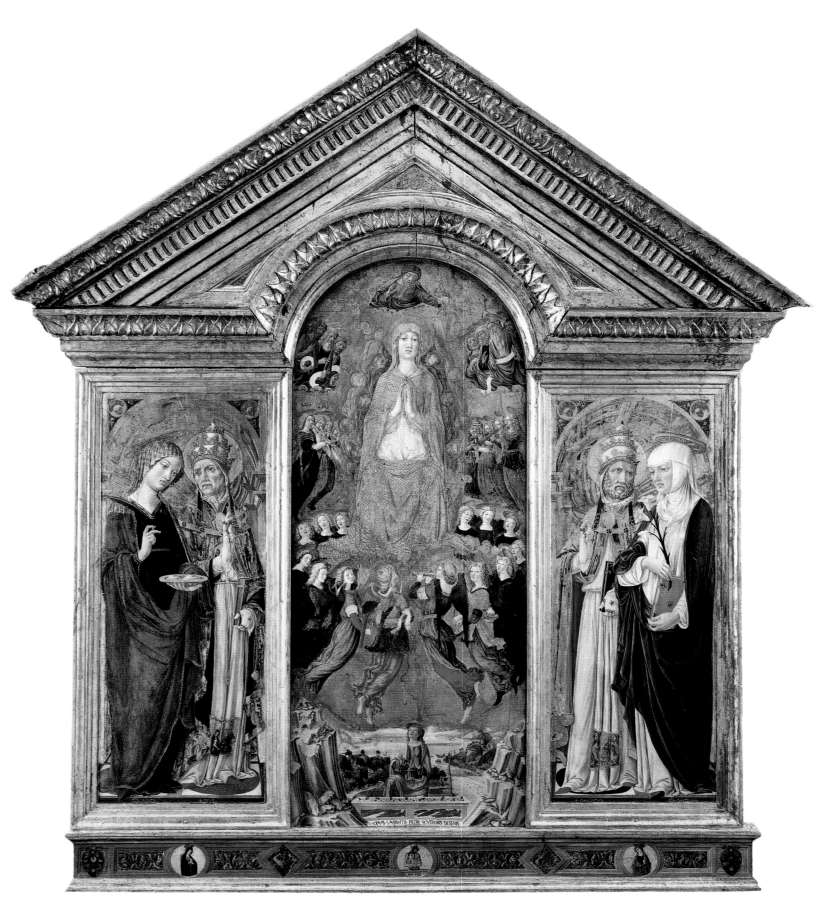

Vecchietta, *Assumption of
the Virgin and SS. Agatha, Pius I,
Calixtus and Catherine of Siena.*
Pienza Cathedral.

April 1471 Giovanni Cinughi, bishop of Pienza, started to build a church dedicated to Santa Maria della Nieve next to the Porta de' Malavolti.[4]

To return to Pienza Cathedral, Pius II issued precise orders regarding the interior decoration, which was to remain unchanged in the future. The only ornamentation allowed was that on the five altars commissioned by Pius II and consecrated in 1463.[5] The five altarpieces all have a square main panel, a cornice and architrave, and a pediment topped by a tympanum or by a lunette that resembles the travertine tabernacle of the eucharist constructed by Bernardo Rossellino.[6] The frames of the altarpieces consist of large gold pilasters with volutes or palmettes decorated in the manner of ancient architecture. They constitute the first fifteenth-century Sienese panel paintings that completely and deliberately abandon flowery Gothic frames and slender ogival spires, whose popularity continued even in the second half of the fifteenth century. Having established the classical form of the panels, Pius II seemed less fixed in selecting artists to paint the altarpieces. Painters from two different generations were chosen – Vecchietta and Matteo di Giovanni, who used the new language of the Renaissance, as well as the older Giovanni di Paolo and Sano di Pietro, who had been trained in the late Gothic style and repeated, for the most part, tired and already dated schemes. However, Giovanni di Paolo was still able to execute an intense passage of painting in the lunette of the *Pietà*. Here he depicted Christ after he had been taken down from the cross and the nails had been removed from his body. The corpse, which is rigidly twisted, demonstrates Giovanni's artistic ability.

The most important painting of the group was that by Vecchietta. The main panel represented the *Assumption of the Virgin*, to which the cathedral was dedicated. Two Albertian niches to either side contain *SS. Agatha, Pius I, Calixtus and Catherine of Siena*, who were all particularly dear to Pius II. The coffered vaults of the niches are scratched into the gold background, creating a charming effect of foreshortening when seen from below.[7] The angels around the Virgin already seem to prefigure the tender, pale, blond creatures that Neroccio de' Landi liked to paint.

At the same time as his work for Pienza Cathedral, Vecchietta also painted the altarpiece for San Niccolò in Spedaletto.

Vecchietta, predella of the *Spedaletto Altarpiece*. Museo della Cattedrale, Pienza.

This church was near to Pienza and had been consecrated by Pius II on 4 September 1462. In the panel Vecchietta shows the increasing influence of the light-filled art of Domenico Veneziano. The altarpiece has a modern classical form similar to those in Pienza Cathedral, is filled with vibrant and brilliant colours and is in complete harmony with the development of Florentine painting during this period.[8] To one side of the enthroned Virgin Mary is *St John the Baptist*, whose figure derives from Donatello's bronze sculpture for Siena Cathedral. This can be seen in his severe and dramatic expression as well as in his wild appearance. In the lunette containing the *Annunciation* and in the scenes from the predella, the influence of Domenico Veneziano can be discerned in the milk white of the columns that contrasts with the lively colours of the marble mosaic work shown in perspective on the floor. Massacio's shading has been abandoned and the work is instead strongly influenced by Alberti's architecture, with bright areas of colour bathed in a hot expanse of midday sun.

For the nearby monastery of Sant'Anna in Camprena Vecchietta painted the *Death and Resurrection of the Monk*, which originally formed part of the predella of an altarpiece that has since been dismantled. The two monks on the right, standing on scaffolding and constructing the walls of the monastery, have close links with contemporary paintings by Francesco di Giorgio.[9]

The two altarpieces painted by Matteo di Giovanni for Pienza Cathedral were completed within a short time of one another. They are dedicated to St Matthew, the patron saint of Pienza, and to St Jerome. The lunette of the *Flagellation of Christ* shows the influence of Antonio Pollaiuolo in the energetic and rigid use of line that defines the contracted limbs of the executioners. Seen from below, the statuesque figure of Christ at the column, calm, impassive and almost above pain, is reminiscent of Piero della Francesca's painting. In the altarpiece dedicated to St Jerome, Matteo di Giovanni seems to have been infected by the passion for the antique that was maturing in Siena during the papacy of Pius II and whose main exponent was Antonio Federighi.[10] The cameos of female busts on the back of the throne seem to anticipate certain motifs used by Liberale da Verona in their antique inventiveness.

Vecchietta, *Death and Resurrection of the Monk*. Museo della Cattedrale, Pienza (originally in Sant'Anna in Camprena).

Around 1460 Vecchietta painted an important altarpiece with the collaboration of his pupils that was probably intended for the church of San Francesco in Siena.[11] San Francesco had become the mausoleum of both the Piccolomini family and the families who supported them. Sources tell us that there was an altarpiece by Vecchietta in the St Bernardino Chapel. It was probably largely destroyed in the fire that swept through the church in 1655. The small panels recently identified as coming from the altarpiece all have a strongly Franciscan iconography and originally formed part of a single predella.[12] The panels depict *St Bernardino Preaching* (Walker Art Gallery, Liverpool), the *Miracle of St Anthony of Padua* (Alte Pinakothek, Munich) and the *Miracle of St Louis of Toulouse* (Pinacoteca Vaticana, Rome). The three compositions have been attributed to the young Francesco di Giorgio, to Benvenuto di Giovanni and to Vecchietta respectively. Four smaller panels were placed between the narrative panels, two of which represented pairs of flagellants and two *Franciscan Allegories*. The smaller paintings, which formed end-stops to the three scenes, were painted by Francesco di Giorgio. His *St Bernardino Preaching* is the masterpiece of the

group and was one of Francesco's first independent paintings executed while he was still working in Vecchietta's workshop.

Francesco di Giorgio was influenced by Vecchietta's paintings of the early 1460s, a time when the master was particularly affected by Domenico Veneziano's light-filled painting. When compared with Vecchietta's work, Francesco di Giorgio's *St Bernardino Preaching* emphasizes the clear perspective construction of the composition. The scene is crowded with figures arranged on the pavement of a city piazza, enclosed by brightly coloured buildings that have been inspired by ancient edifices. The buildings anticipate the many architectural designs that Francesco di Giorgio used to illustrate his famous treatises. The realistic figures with intense expressions painted in the *St Bernardino Preaching* reappear, although in larger dimensions, in the *Franciscan Allegories* (Alte Pinakothek, Munich).[13]

Another early work by Francesco di Giorgio, painted around 1460, is the front panel of a *cassone* showing the *Abduction of Helen* (Berenson Collection, Villa I Tatti, Settignano, and Museo Stibbert, Florence).[14] The temple at the left of the composition, with its multicoloured trabeation, its *oculi* in

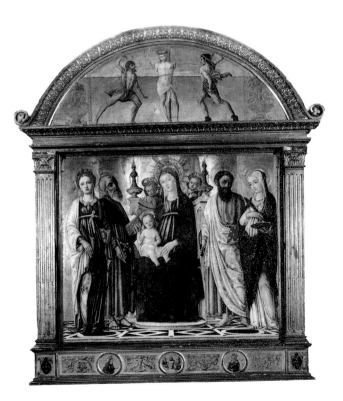

Matteo di Giovanni, *Madonna and Child with SS. Catherine of Alexandria, Matthew, Bartholomew and Lucy.* Pienza Cathedral.

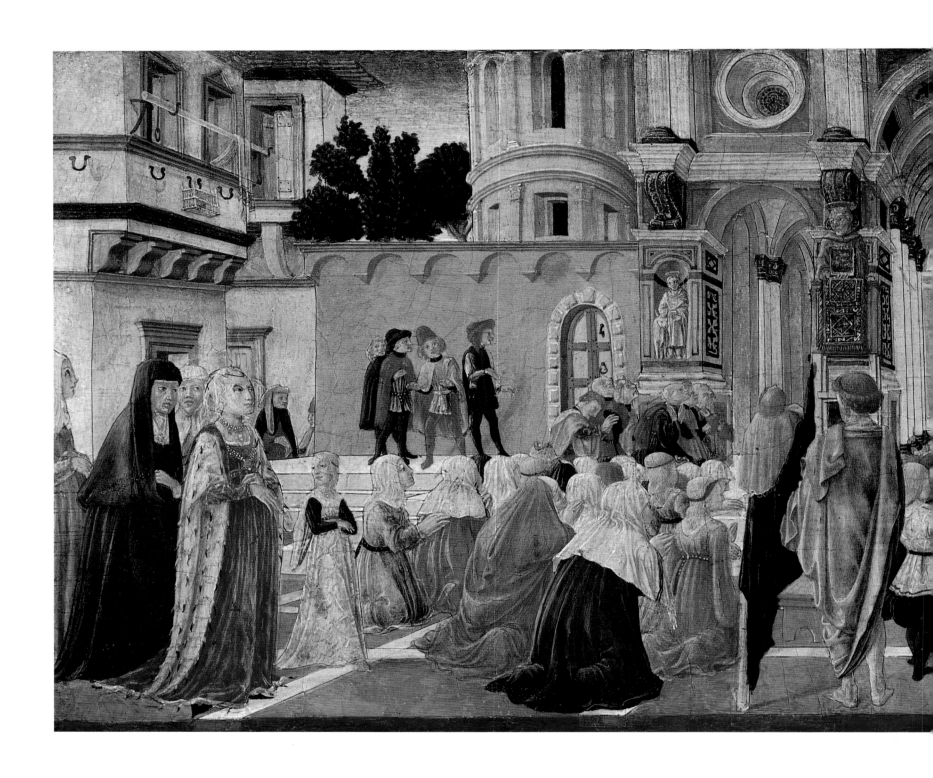

Francesco di Giorgio Martini,
St Bernardino Preaching.
Walker Art Gallery, Liverpool.

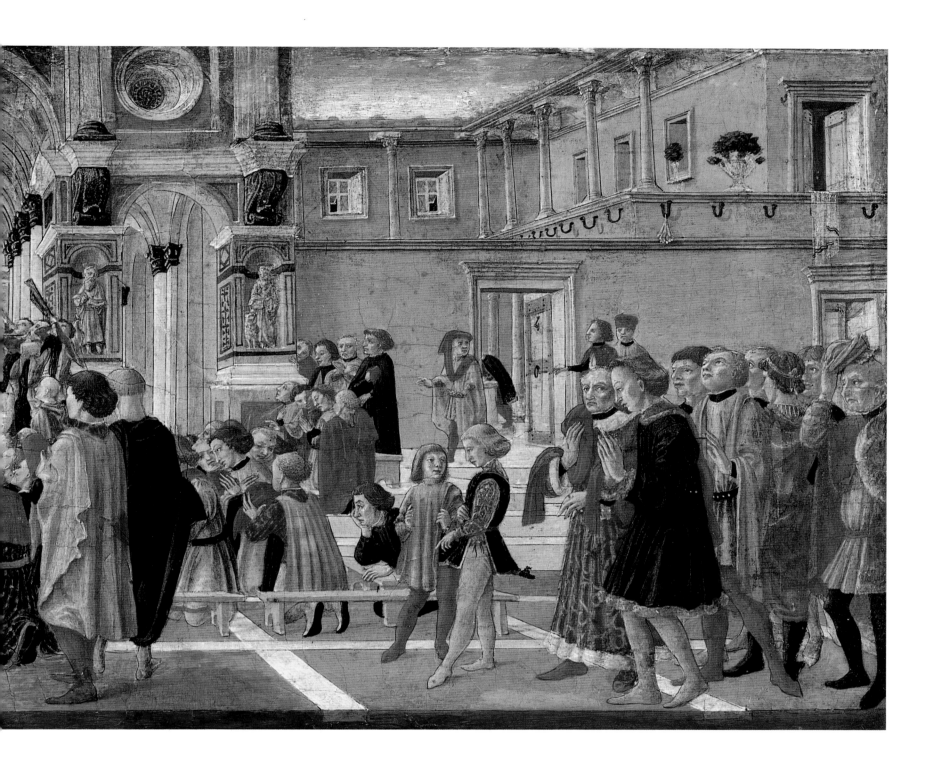

foreshortening and its colonnade in perspective, is rendered with the same architectural and archaeological sensitivity as the buildings in the background of *St Bernardino Preaching*. In 1460 Francesco di Giorgio painted a Gabella panel representing *Pius II Consecrating his Nephew Francesco Piccolomini Todeschini as Cardinal*.[15] The room shown in the panel shares stylistic characteristics with the works just discussed and confirms that they were all painted within a few years of one another. The ornate pink pilasters with mock antique stucco reliefs used in the background demonstrate Francesco di Giorgio's refined classical taste.

Francesco di Giorgio was born in 1439 and the first documents refer to him as a '*dipintore*' (decorator), even though his abilities and versatility soon induced him to devote himself to more difficult and possibly better-paid commissions.[16] In 1463 Alessandro da Sermoneta – a famous doctor and a teacher at the Studio in Siena – commissioned him to paint a frontispiece for Albertus Magnus's *De animalibus* (Museo Castelli, Siena). The miniature demonstrates his many influences and is the first fully Renaissance-style representation of its type in Sienese art.[17] The ornamentation of the page,

which until then had usually been treated as a late Gothic *drôlerie*, consists of a frieze with three antique roundels. Inside these are episodes that were probably inspired by Antonio Pollaiuolo's *Labours of Hercules* in the Palazzo Medici in Florence, which had been executed in 1460. Bodies twisting and shaking with a quivering bestial energy; a heroic ideal expressed through the muscular mass of the bodies; and a dynamism underlined by incisive drawing are all characteristics that Francesco di Giorgio and Antonio Federighi inherited from Antonio Pollaiuolo. Antonio Federighi sculpted some marble reliefs with the *Labours of Hercules* and *Scenes from Genesis* on the moulding of the Holy Saturday Chamber in Siena Cathedral. These had refined friezes containing putti and sea nymphs that seem in complete harmony with the Florentine *nielli* sculpted by Maso Finiguerra and Antonio Pollaiuolo.

At the end of the 1460s Donatello was in Siena for an extended period of time and even considered moving there permanently. His stay in Siena provoked lasting changes in Sienese art.[18] In 1457 the rector of the Opera del Duomo, Cristoforo Felici, commissioned Donatello to execute the

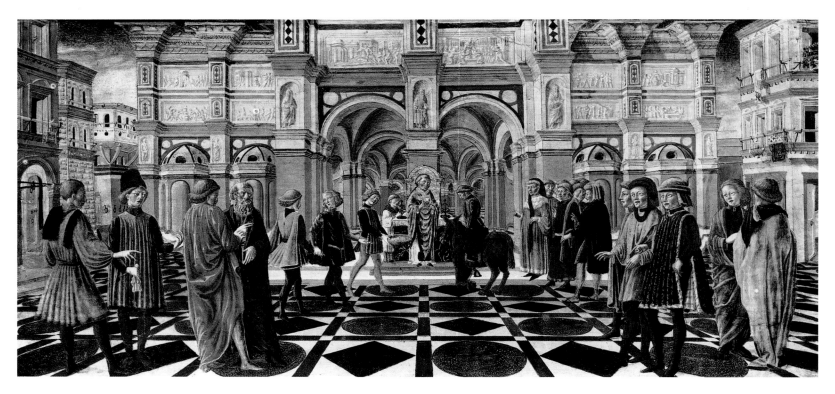

Benvenuto di Giovanni, *Miracle of St Anthony of Padua (Miracle of the Mule)*. Alte Pinakothek, Munich.

bronze reliefs for the doors of the cathedral. Although Donatello did not finish this work he modelled at least two wax reliefs for the doors (which have since been lost). These models were kept in the cathedral workshop and must have been of particular interest to local artists. There is no doubt that the Sienese artists who saw the models later referred to them in their own works and it is probable that Donatello's models created delightful effects by flattening the forms. From the 1460s onwards the sculpture of Francesco di Giorgio and Vecchietta resounds with Donatello's lively and dramatic treatment of bronze. The execution of the works at times makes them seem like preparatory models tending to suggest the forms rather than to define them completely. A little later, local painters like Matteo di Giovanni, basing themselves on Donatello's works in Siena such as the *Madonna del Perdono*, represented the Virgin and Child seated on a faldstool surrounded by heads of cherubim, looking as though they were made of bronze and lit by a gold light. In Siena, Donatello's influence is often translated into refined and elegant forms with a more polished finish. Those elements of wild brutality and crude realism that we see, for

example, in the *St John the Baptist* executed for the cathedral, have almost completely disappeared. When Francesco di Giorgio sculpted a *St John the Baptist* in 1464 – for the Compagnia di San Giovanni della Morte – he envisaged his saint carved in elegantly painted wood and looking like a classical Hercules. He gave him dignity by covering his shoulders with a great red cloak, almost as though he was an antique draped figure.[19]

It would be impossible to separate the paintings of these Sienese artists from their activity as sculptors. This is most clearly exemplified by the case of Vecchietta, who in the same brief space of time sculpted *St Peter* and *St Paul* in marble for the Loggia della Mercanzia and painted a fresco of *St Catherine of Siena* for the Sala del Mappamondo in the Palazzo Pubblico. All of the figures have nervous and refined qualities with drapery that falls in thin vertical tubes and cloaks that are chiselled with an energy that creates ample folds. But the *St Catherine of Siena* has perhaps the more Renaissance appearance. She is placed in the rigorously semicircular space of a grey and pink classical niche decorated with festoons and ox skulls.

Francesco di Giorgio Martini,
Imposition of the Yoke of Obedience.
Alte Pinakothek, Munich.

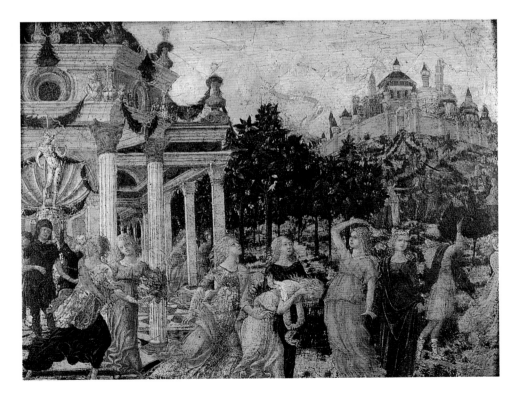

Francesco di Giorgio Martini,
Abduction of Helen. Berenson
Collection, Villa I Tatti, Harvard
Center for Renaissance Studies,
Settignano.

p. 286
Francesco di Giorgio Martini,
De animalibus, frontispiece.
Museo Castelli, church of
the Osservanza, Siena.

Notes

1 Enea Silvio Piccolomini, *Commentarii*, edited by L. Totaro, Milan 1984, IX, pp. 1760–1765. The most important study of Pius II as a patron remains that of R. Rubinstein, *Pius II as Patron of Art, with a Special Reference to the History of the Vatican*, higher degree thesis, Courtauld Institute of Art, London University 1957, *passim*. See also R. Bartalini, in *Francesco di Giorgio il Rinascimento a Siena*, Milan 1993, pp. 92–105.

2 On the architecture of the cathedral, see E. Carli, *Pienza, città di Pio II*, Rome 1966, pp. 28–46. Also H.W. van Os, 'Painting in a House of Glass: the Altarpiece of Pienza' in *Simiolus*, 1987, 17, pp. 23–40; A. Tonnenesmann, *Pienza Städtebau und Humanismus*, Munich 1990, pp. 35–54; P. Palladino, '"Pittura in una casa di vetro": un riesame e una proposta sul programma decorativo di Pio II per la cattedrale di Pienza' in *Prospettiva*, 1994, 75–76, pp. 100–108.

3 A. Angelini, 'Siena 1460: episodi artistici al tempo di Pio II' in *Umanesimo a Siena.*

Letteratura, arti figurative, musica, conference proceedings edited by E. Cioni and D. Fausti, Siena 1994, pp. 263–284; idem, 'Giovanni di Stefano e le lupe marmoree di Porta Romana a Siena' in *Prospettiva*, 1992, 65, pp. 50–55.

4 'Ephemerides senenses ab Allegretto de Allegrettis' in L.A. Muratori, *Rerum italicarum scriptores*, Milan 1733, XXIII, pp. 769 and 773.

5 On the positioning of the altars, see P. Palladino, '"Pittura in una casa di vetro"', pp. 103–108.

6 R. Bartalini, in *Francesco di Giorgio e il Rinascimento a Siena*, p. 92.

7 L. Cavazzini, in *Francesco di Giorgio e il Rinascimento a Siena*, pp. 136–139.

8 For the Spedaletto panel, see B. Sani, in *Mostra di opere d'arte restaurate nelle province di Siena e Grosseto*, Genoa 1981, II, pp. 96–98; L. Martini, in *Pienza e la Val d'Orcia, opere d'arte restaurate dal XIV al XVII secolo*, Genoa 1984, pp. 44–48. On the relationship between Vecchietta and Domenico Veneziano, see R. Longhi, 'Il

Maestro di Pratovecchio' in *Paragone*, 1952, 35, pp. 10–37, now published in 'Fatti di Masolino e Masaccio ed altri studi sul Quattrocento' in *Opere complete di Roberto Longhi*, Florence 1975, VIII, pp. 99–122; C. Brandi, *Quattrocentisti senesi*, Milan 1949, pp. 130–131.

9 B. Sani, in *Mostra di opere d'arte restaurate nelle province di Siena e Grosseto*, II, pp. 94–95; L. Martini, in *Pienza e la Val d'Orcia, opere d'arte restaurate dal XIV al XVII secolo*, pp. 49–50.

10 A. Angelini, 'Giovanni di Stefano e le lupe marmoree di Porta Romana a Siena', pp. 50–51.

11 A. Toti, 'La Chiesa di San Francesco in Siena ed i Piccolomini' in *Bullettino senese di storia patria*, 1894, p. 86.

12 L. Bellosi, in *Francesco di Giorgio e il Rinascimento a Siena*, pp. 39–57. For a different opinion on the original position of the panels see C.B. Strehlke, 'Exhibition Reviews' in *The Burlington Magazine*, 1993, pp. 501–502.

13 See L. Bellosi, in *Francesco di Giorgio e il Rinascimento a Siena*, pp. 106–113.

14 F. Bisogni, 'Risarcimento del "Ratto di Elena" di Francesco di Giorgio' in *Prospettiva*, 1976, 7, pp. 390–391.

15 A. Angelini, 'Francesco di Giorgio pittore e la sua bottega. Alcune osservazioni su una recente monografia' in *Prospettiva*, 1988, 52, pp. 15–16; idem, in *Umanesimo a Siena. Letteratura, arti figurative, musica*, pp. 264–265.

16 The most comprehensive study of Francesco di Giorgio remains A.S. Weller, *Francesco di Giorgio, 1439–1501*, Chicago 1939.

17 This has recently been shown in the Sienese exhibition on Francesco di Giorgio. See A. Angelini, in *Francesco di Giorgio e il Rinascimento a Siena*, pp. 142–145.

18 On Donatello's stay in Siena, see A. Bagnoli, in *Francesco di Giorgio e il Rinascimento a Siena*, pp. 162–169; G. Gentilini, ibid., pp. 170–187.

19 A. Bagnoli, in *Francesco di Giorgio e il Rinascimento a Siena*, pp. 192–195.

Liberale da Verona, *Christ Washing the Feet of the Apostles*, miniature from *Codex Y*. Museo della Cattedrale, Chiusi.

Liberale da Verona and Girolamo da Cremona in Siena

The arrival of Liberale da Verona in Siena in 1466 was due to the good offices of the Olivetan Order. The young miniaturist had ties with the Benedictine monastery of Santa Maria in Organo in Verona where he is documented in 1465. From there he went to Tuscany to work for the main hermitage of the order – Monte Oliveto Maggiore.[1] We know nothing about Liberale's training but the hypothesis that he spent some time in the Ferrara of Duke Borso d'Este is borne out by the style of the works he executed in Siena.[2] In particular, the painter Michele Pannonio, to whom some miniatures of the Bible of Borso d'Este are attributed, must have had a strong influence on Liberale. This can be seen above all in the *Crucifixion* (private collection) attributed to Liberale by Longhi.[3] The painting has an expressionistic energy and the emotions of the figures are accentuated to the point where they bend with the suppleness of rushes. This is an approach that is completely foreign to Renaissance organic unity and to the proportional and measured study of human anatomy.

The influences that he found in Ferrara allowed Liberale to formulate an expressive style, which seems deliberately to disturb the tranquil waters of contemporary Sienese painting.[4] Shortly after his arrival in Tuscany, Liberale also drew inspiration from Sano di Pietro, one of the most old-fashioned of the Sienese painters.

Liberale da Verona's first miniatures, executed for the new choir of Monte Oliveto Maggiore (Museo della Cattedrale, Chiusi), still have controlled marginal decorations that do not give any indication of the inventive explosion about to happen. But in the historiated scenes of *Codex Q*, which includes a depiction of the *Resurrection* (or the *Ascension*), Liberale da Verona is already bending his compositions, crammed with figures, to fit the rhythm of the initial. The masterpiece of Liberale da Verona's early work is the *Christ Washing the Feet of the Apostles* from *Codex Y*. In it the figures, which have rounded forms and slightly drowsy expressions similar to those painted by Sano di Pietro, seem also to be imbued by a

Liberale da Verona, *False Prophets*,
miniature from *Gradual 9*, fol. 33.
Piccolomini Library,
Siena Cathedral.

p. 289
Liberale da Verona,
Allegory of the Wind,
miniature from *Gradual 12*, fol. 101.
Piccolomini Library, Siena Cathedral.

new and electrifying vitality. Inside an initial O, Liberale has represented *Death*, who rises from a hideous grave full of scaly serpents. The composition is reminiscent of a macabre Burgundian *memento mori*.[5]

At about the same time as he painted these miniatures, Liberale da Verona also painted a panel of the *Virgin and Child with SS. Anthony of Padua, Jerome and Four Angels* (private collection, Florence). It is similar in style to Sano di Pietro's paintings although the figures appear more tender, elegant and alive.[6] In January 1467 Liberale was in contact with the administrators of the Opera del Duomo in Siena who commissioned him to paint a miniature within the letter C, which has been identified as the one now in the Barber Institute in Birmingham that shows *Christ in Glory amongst the Angels*.[7] The style of the miniatures still shows close ties to the decoration of the codices for the monastery of Monte Oliveto Maggiore, but at the same time it foreshadows the monumentality of the miniatures that Liberale was later to paint for Siena Cathedral. The test piece of the initial C must have satisfied the patrons because on 13 February they commissioned Liberale to paint sixteen historiated initials in *Choir Book 24.9*.

These illustrate various parables from the gospels. The stories from the New Testament are related in a lively, amusing and fairy-tale manner and are portrayed inside coloured cornices, which are sometimes represented as serpents coiled in the form of a letter. The figures are wrapped in exuberantly moving draperies painted in bright and precious colours. They are often depicted in strange and improbable poses, in unbelievable foreshortening and with bold receding profiles. There are marked by an extraordinary expressive liberty, by a glowing colour scheme and by a freedom in the drawing and in the definition of anatomy and proportion. In the brightly coloured landscapes in the background of the miniatures, which look as though they come from fairy tales, the influence of Ferrarese miniaturists working at the court of Borso d'Este is evident. However, Liberale gave free rein to his imagination, breaking away from the staid and painstaking method of laying out figures that the Ferrarese miniaturists has used. Liberale's fertile imagination is evident in the multicoloured sky crossed with lines of light in the *Good Samaritan* or in the calm glazed sky that rises above a vast lake filled with reflections in the *Healing of the Deaf and Dumb Man*. Christ's

Girolamo da Cremona, *Birth of the Virgin*, miniature from *Gradual 28.12*, fol. 64v. Piccolomini Library, Siena Cathedral.

Girolamo da Cremona, *Virgin of the Assumption*, detail of a miniature from *Gradual 28.12*, fol. 49r. Piccolomini Library, Siena Cathedral.

tall and restless figure in the *Prophecy about Jerusalem* (*Gradual 9*, fol. 43) is reminiscent of that in the miniature of the *False Prophets* (*Gradual 9*, fol. 33), in which his body twists to face the apostles. This almost completely obscures the outline of Christ's profile, presenting instead his rayed halo to the spectator. In the same miniature the severe austerity of the bearded figures of the false prophets, who at first appear to be dignified oriental sages, is shattered by one of nature's unexpected jokes – Liberale has painted wolves' claws emerging beneath their clothes.

Liberale da Verona completed the first choir book on 16 November 1468. Other works executed during his early years in Siena include the miniatures from *Gradual 20.5*, such as *Christ and Satan* and the *Transfiguration*. One of Liberale's early masterpieces is the *Allegory of the Wind* from *Gradual 12* (fol. 101), which has an unusually daring colour scheme. The deep-blue figure of the Wind, whose hair fans out like the tail of a peacock, is intent on guiding the prow of a ghostly ship with his foot. The clear blue of his body contrasts with the dense sky of leaden clouds which decrease in intensity towards the golden horizon.

During this period Liberale da Verona was increasingly influenced by Francesco di Giorgio.[8] This can be seen above all in his panel paintings, in which he incorporated sumptuous buildings constructed in a bizarre antique style. Two compartments from a predella with *Scenes from the Life of St Peter* (Fitzwilliam Museum, Cambridge, and Staatliche Museen, Berlin) demonstrate this new architectural language. The buildings include amphitheatres, palaces and *aediculae* painted in colours similar to those used by Francesco di Giorgio. However, Liberale da Verona's more wide-ranging imagination permeates every part of the compositions. For example, the sculptures in the niches that appear in the Berlin panel have an exuberance and a vivacity that is completely original and unprecedented in Sienese art at the time. The architecture has extremely sharp outlines as though it has been carved from hard stone. This is a stylistic feature that would later appear in the drapery and faces of the figures and become increasingly common in Liberale's work following the influence of Girolamo da Cremona. Consequently the *Scenes from the Life of St Peter*, the *Abduction of Helen* (Musée du Petit Palais, Avignon) and the *St Jerome and the Lion* (Musée

Girolamo da Cremona, *Resurrection of Christ*, miniature from *Gradual 23.8*, fol. 2r. Piccolomini Library, Siena Cathedral.

Liberale da Verona, *Adoration of the Magi*, miniature from *Gradual 19.4*, fol. 7v. Piccolomini Library, Siena Cathedral.

Fesch, Ajaccio) can be dated around 1470, before Girolamo da Cremona's influence became so perceptible.[9]

Girolamo da Cremona, a pupil of Andrea Mantegna, came to Siena in 1470 and stayed there for two years. His presence in the city had repercussions on Sienese art that are most clearly expressed by Liberale da Verona. Girolamo's most successful miniatures, such as the *Birth of the Virgin* or the *Virgin of the Assumption* from *Gradual 28.12*, demonstrate a stylistic orientation that differs considerably from that of Liberale.[10] The forms used by Girolamo have a greater solidity when compared to the fluid and overflowing outlines of Liberale. His works seem to be illuminated by a penetrating crystal light that explores every object relentlessly, subjecting it to close and accurate observation. A group of angels carries the *Virgin of the Assumption* to heaven. She is ascetically thin as though consumed by passion and wrapped in a mantle whose folds appear to be made of thin sheets of metal, an effect that brings to mind the many-faceted exterior of a precious crystal. At her feet a sharply focused, hilly landscape stretches into the distance, covered by a green blanket of grass and immersed in the mildness of a spring morning. The clarity of

the view is rare in contemporary painting and must have been inspired by the clay-like landscape of the hills around Siena. The close examination of reality, which includes the concrete and tangible rendering of objects, and the attention to the surfaces of the figures and to the consistency of the objects represented clearly distinguishes the work of Girolamo da Cremona from that of Liberale da Verona. Girolamo's acute observation can best be seen in the decorative margins of his miniatures, which with their bizarre and fantastic inspiration are undoubtedly more Renaissance than those painted by Liberale da Verona to this point. Around the *Resurrection of Christ* (*Gradual 23.8*) Girolamo has placed a dense but ordered tangle of dried clusters of grapes from the stems of which hang gleaming pearls, rubies and emeralds. Within the border, classical roundels composed of wreaths of leaves are arranged in a rigorously symmetrical manner. The roundels contain stories from the gospels, drawn with a lucidity that is reminiscent of Mantegna.

Many of Girolamo da Cremona's works have a clarity that gives them the appearance of carved crystal. This effect influenced Liberale da Verona, who had a capacity for both

Benvenuto di Giovanni, predella
with scenes from the life of the
Virgin from the *Annunciation with
S.S. Michael and Catherine*,
Museo Civico, Volterra.

assimilating the contributions of other artists and adding to them. In 1472 Liberale painted a miniature for an initial depicting the *Liberation of the Possessed*. The stylistic change in this work is due in part to the influence of Girolamo da Cremona. The figures, which are more monumental and placed more convincingly in space, are wrapped in draperies that have a mineral consistency. The garments are bathed in light, giving the effect of shot colour or colour veiled with gold. The mantles, which for the first time in Liberale's work appear to fall over solid three-dimensional bodies, are ruffled by the wind and vibrate in the crystalline air. Girolamo da Cremona's influence can be seen in the arrangement of the decoration, which is more regular and classical in its distribution of motifs, but still inhabited by whimsical and elegant creatures.

Around 1472 Liberale painted two masterpieces on panel – the *Redeemer and Saints* from Viterbo Cathedral and the *Virgin and Child with SS. Benedict and Frances of Rome* from Santa Maria Nuova in Rome. In the Viterbo panel the Redeemer's mantle seems to be composed of moving spirals of material that untangle before our eyes. Liberale depicted

this type of Christ many times in his last miniatures painted in Siena, such as those in *Gradual 21.6*. The most charming of these representations is perhaps that of the *Expulsion of the Moneychangers from the Temple*. In this scene, Christ, who flies violently across the painting, almost disappearing beyond the frame, leaves space for the voluminous azure cloak that spirals out behind him. The same mineral consistency in the drapery, vigorously blown by the wind, is found in the *Archangel Michael Expelling the Demon* (*Gradual 28.12*, fol. 8) and in the *Angels who Play the Trumpet* (*Antiphonary 1.A*, fol. 133v). Possibly the most complex and whimsical decoration executed by Liberale in Siena is that of the initial of the verso of folio 7 of *Gradual 19.4*, representing the *Adoration of the Magi*. The motif of the dolphins, which Liberale took from Antonio Federighi's classical repertory, is interpreted in a completely original way as two grotesques who are entwined in the leafy volutes.

After 1476 Liberale returned to Verona, where he continued to receive numerous commissions, mainly as a painter. The style of both Liberale and Girolamo da Cremona inspired local Sienese painters for the following twenty years.

Benvenuto di Giovanni,
Borghesi Altarpiece.
San Domenico, Siena.

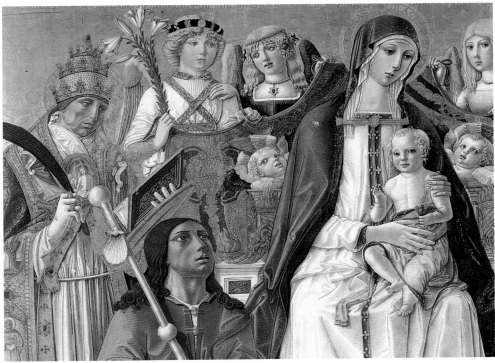

Benvenuto di Giovanni,
Borghesi Altarpiece, detail.
San Domenico, Siena.

Benvenuto di Giovanni, who had been trained in Vecchietta's workshop, is the artist whose work was most affected by these two miniaturists and who changed his style accordingly.[11] In his 1466 *Annunciation with SS. Michael and Catherine* painted for the church of San Girolamo in Volterra, strong traces of Vecchietta are still apparent. The predella from the altarpiece contains four scenes from the life of the Virgin (Museo Civico, Volterra). The thin, almost gaunt figures stand out against the gold background, recalling the work of Simone Martini. Vecchietta's influence can be seen in the light-filled scenes of the predella, where the lively colours are reminiscent of the type of painting that developed in Tuscany in the wake of Domenico Veneziano.

The small Gabella panel of 1468 showing the *Finances of the Comune of Siena in Times of Peace* (Archivio di Stato, Siena) belongs to the same phase of Benvenuto di Giovanni's development.[12] On the left, silhouetted against a black background, are the thin figures of the Sienese magnates drawing their profits. They are dressed elegantly with crimson *cioppe* (long tunics) and black and scarlet berets. The square desks of the office of the Gabella reflect the light

sharply, while the pointed feet of the bystanders project shadows on to the pavement. Benvenuto di Giovanni's delicate sensitivity to the effects of light drew on his knowledge of the miniatures painted by Girolamo da Cremona in *c.* 1470. This was the year in which Benvenuto di Giovanni signed his *Annunciation* for the church of San Bernardino in Sinalunga. Gabriel wears a silk garment with tubular folds that seem to have the hard consistency of cut minerals. The Virgin's room opens out on to the large multicoloured chessboard of the paved piazza, the plastered walls of which bear similarities to the architecture of Simone Martini. Beyond the steps in the background are a courtyard and two cypresses whose ordered lucidity recalls that of a monastic cloister. The whole scene seems to be in a state of suspended animation. God the Father's bright coral-red mandorla stands out against the night sky, as though this were a miniature by Liberale da Verona.

The *Nativity* (Pinacoteca Comunale, Volterra), painted in 1470, is set in a landscape illuminated by the moon. Sharp shadows project over the objects at the rear of the composition, creating an almost tangible three-dimensionality. Similar

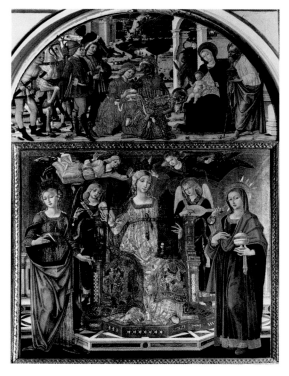

Matteo di Giovanni, *Enthroned
St Barbara between SS. Mary Magdalen
and Catherine of Alexandria.*
San Domenico, Siena.

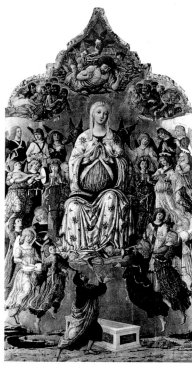

Matteo di Giovanni,
Assumption of the Virgin.
National Gallery, London.

Matteo di Giovanni,
Assumption of the Virgin, detail.
National Gallery, London.

effects can be seen in the two frescoes from the church of Sant'Eugenio in Monastero, which depict the *Crucifixion* and the *Resurrection of Christ*. Both have vast landscapes that extend into the distance and are portrayed with a crystalline clarity of form. The shining skin of the figures in these compositions relates directly to the work of Girolamo da Cremona. In 1479 Benvenuto di Giovanni painted the triptych of the *Virgin and Child with SS. Peter and Nicholas of Bari* (National Gallery, London). The metallic way in which the forms have been frozen in this triptych anticipates the stylistic features of the *Borghesi Altarpiece* (San Domenico, Siena). The altarpiece, which is framed *all'antica*, was commissioned for the church of San Domenico by the Borghesi, a rich Sienese banking family. It demonstrates that, some years after his departure, Girolamo da Cremona's style was still influential in Siena and capable of inspiring a rich vein of artistic activity. The two pairs of young angels who carefully hold the tapestry behind the Virgin's throne are among the most memorable creatures to be painted during the fifteenth century in Siena. And in the lunette the rigid body of Christ, which is supported by four mourning angels, is placed

against the marble slab of the sepulchre. The agonizing weight of the figure is reminiscent of those painted by Carlo Crivelli.

Soon after the triptych of the *Virgin and Child with SS. Peter and Nicholas of Bari*, Matteo di Giovanni also painted an impressive panel for San Domenico. This is the panel with the *Enthroned St Barbara between SS. Mary Magdalen and Catherine of Alexandria* commissioned for the St Barbara Chapel in 1478.[13] The three female saints, who are portrayed as women of exceptional elegance, are placed against a dazzling gold ground. Their clothes contain complex pomegranate designs that give an almost arabesque effect. In this panel Matteo di Giovanni seems to have forgotten his early interest in perspective and to have discovered, in a more traditional compositional formula, the fascination of sinuous linear rhythms. In the *Adoration of the Magi* painted in the lunette, Matteo di Giovanni has created a landscape that adopts Girolamo da Cremona's adamantine sharpness, although the painting seems to have lost some of the metallic effect that always characterizes the colour of Girolamo's miniatures. The influences of Girolamo and Liberale da Verona are more

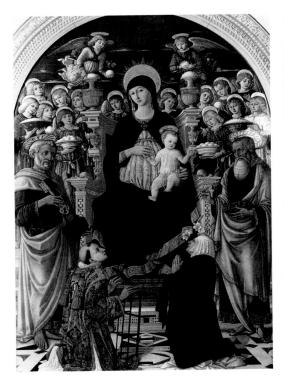

Matteo di Giovanni,
Madonna della Neve.
Pinacoteca, Siena.

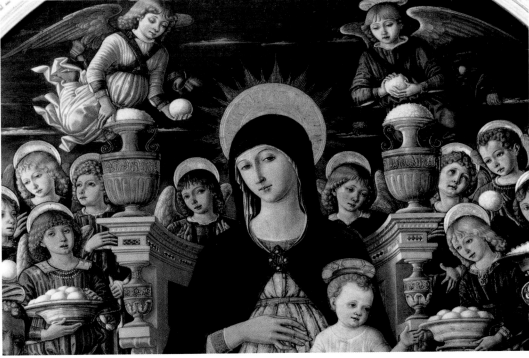

Matteo di Giovanni,
Madonna della Neve, detail.
Pinacoteca, Siena.

apparent in the *Assumption of the Virgin* (National Gallery, London) painted by Matteo di Giovanni in 1474 for the church of Sant'Agostino in Asciano.[14] The sharp and dynamic drawing defining the profile of St Thomas, who is waiting to receive the Virgin's belt; the nervous articulation of the folds and draperies; the mandorla of cherubim surrounding Christ at the top of the composition; and the landscape stretching out barrenly against the background all have a precedent in Girolamo da Cremona's crystalline and petrified depictions of nature.

Between 1473 and 1477, that is, between the execution of the altarpiece for Sant'Agostino in Asciano and the one for the St Barbara Chapel, Matteo di Giovanni completed the *Madonna della Neve* (Virgin of the Snow), commissioned by the heirs of the first bishop of Pienza, Giovanni Cinughi (1462–1470).[15] The arched panel was placed in the small church of the Madonna della Neve in Siena, which had been built in accordance with the bishop's wishes, possibly to a design by Francesco di Giorgio. The completely Renaissance forms of the church's façade seem to be reflected in the wide pilasters of the panel's frame. Little angels who hand out

snowballs crowd around the Virgin's imposing throne. They keep the snow in bowls and amphorae and press it into frozen balls with their hands.

The early works of the Stratonice Master, who can probably be identified as the Lucchese painter Michele Ciampanti, present some of the strangest examples of the effects of Girolamo da Cremona and Liberale da Verona's influence.[16] This miniaturist, whose art was informed by a number of complex and diverse artistic styles, worked continuously in Lucca from 1482 onwards but must have been trained in Siena in the 1470s. His Sienese training is evident in the sophisticated and sharp style of his *Crucifixion* (private collection, Turin) and his *Adoration of the Magi* (Lindenau Museum, Altenburg), both of which were executed in the shadow of Matteo di Giovanni and Liberale da Verona. Before going to Florence in *c.* 1480, where he discovered profound similarities with artists of the calibre of Sandro Botticelli and the young Filippino Lippi, the Stratonice Master worked closely with Francesco di Giorgio, for whom he drew certain architectural machines that appear in the *Palatine Codex 767* (Biblioteca Nazionale, Florence). In the illustrations for the manuscript Francesco di

Francesco di Giorgio Martini and Fiduciario, *Coronation of the Virgin*. Pinacoteca, Siena.

Francesco di Giorgio Martini and Fiduciario, *Coronation of the Virgin*, detail. Pinacoteca, Siena.

Giorgio's machines are operated by human figures who are drawn with a pen. The style of the figures demonstrates that Michele Ciampanti had worked with Francesco di Giorgio on the project.[17]

Michele Ciampanti's masterpieces are the *Stratonice Scenes*, some of which are in the Huntington Library in San Marino, California. The thin and elegant protagonists are stylistically consistent with the ethereal blond figures painted by Matteo di Giovanni. The buildings, decorated with cornices, pilasters, tympana and volutes, are modelled on Liberale da Verona's architectural representations. Splintered and crumbly, the rocky walls on which tufts of thin vegetation grow, also recall Liberale's style, as does the mythological menagerie that populates the *Abduction of Proserpine*.[18]

Notes

1 Liberale da Verona's activity as a miniaturist has been analyzed through a complete re-examination of the documents by H.J. Eberhardt, *Die Miniaturen von Liberale da Verona, Girolamo da Cremona und Venturino da Milano in der Chorbüchern des Doms von Siena. Dokumentation, Attribution, Chronologie*, dissertation, Berlin 1972, Munich 1983; idem, 'Sull'attività senese di Liberale da Verona, Girolamo da Cremona, Venturino da Milano, Giovanni da Udine, Prete Carlo da Venezia' in E. Testi (ed.), *La miniatura italiana tra Gotico e Rinascimento I, Atti del II Congresso di Storia della miniatura italiana*, Florence 1985, pp. 415–434. For the Northern miniaturists in general, see A. De Marchi, in *Francesco di Giorgio e il Rinascimento a Siena 1450–1500*, Milan 1993, pp. 228–237. For a complete overview of illuminated manuscripts in Siena by Liberale da Verona and Girolamo da Cremona, see M.G. Ciardi Dupré, *I Corali del Duomo di Siena*, Milan 1972. Other works dealing with Liberale da Verona are C. Del Bravo, *Liberale da Verona*, Florence 1967, and F. Bisogni, 'Liberale o Girolamo?' in *Arte illustrata*, 1973, pp. 400–408.
2 On this important hypothesis, see M. Boskovits, 'Ferrarese Painting about 1450: some New Arguments' in *The Burlington Magazine*, 1978, CXX, pp. 370–385 and M. Natale, 'Lo Studiolo di Belfiore: un cantiere ancora aperto' in *Le muse e il principe, arte di corte nel Rinascimento padano*, edited by A. Mottola Molfino and M. Natale, Milan 1991, pp. 17–44.
3 R. Longhi, 'Un apice espressionistico di Liberale da Verona' in *Paragone*, 1955, 65, pp. 3–7, also printed in *Ricerche sulla pittura veneta, opere complete di Roberto Longhi*, Florence 1978, X, pp. 135–141; M. Boskovits, 'Ferrarese Painting about 1450: some New Arguments', pp. 370–385; A. De Marchi, in *Francesco di Giorgio e il Rinascimento a Siena 1450–1500*, p. 228.
4 A. De Marchi, in *Francesco di Giorgio e il Rinascimento a Siena 1450–1500*, p. 240.
5 See G. Chesne Dauphine Griffo, in *Codici liturgici miniati dei benedettini in Toscana, I corali del Duomo di Chiusi*, edited by M.G. Ciardi Dupré Dal Poggetto, Florence 1983, pp. 503–512; A. De Marchi,

in *Francesco di Giorgio e il Rinascimento a Siena 1450–1500*, pp. 238–240.
6 F. Zeri, 'The Beginnings of Liberale da Verona' in *The Burlington Magazine*, 1951, XCII, also published in *Giorno per giorno nella pittura, scritti sull'arte dell'Italia settentrionale dal Trecento al primo Cinquecento*, Turin 1988, pp. 61–63.
7 H.J. Eberhardt, 'Sull'attività senese di Liberale da Verona, Girolamo da Cremona, Venturino da Milano, Giovanni da Udine, Prete Carlo da Venezia', pp. 415–426.
8 On the relationship between Liberale, Francesco di Giorgio and Neroccio de' Landi, see C. Del Bravo, 'Liberale a Siena' in *Paragone*, 1960, 129, pp. 16–38.
9 On the painting of *St Jerome and the Lion* in the Fesch Collection, see D. Thiébaut, *Ajaccio, Musée Fesch. Les primitifs italiens*, Paris 1987, pp. 86–87.
10 P. Toesca, 'Un dipinto di Girolamo da Cremona' in *Rassegna d'arte*, 1918, XVIII, pp. 141–143; M. Salmi, 'Girolamo da Cremona miniatore e pittore' in *Bollettino d'arte*, 1922–1923, II, pp. 385–404 and 461–478; F. Zeri, 'Una pala d'altare di Gerolamo da Cremona' in *Bollettino d'arte*, 1950, XXXV, pp. 35–42; M. Levi D'Ancona, 'Postille a Girolamo da Cremona' in *Studi in onore di Tammaro De Marinis*, Rome 1964, III, pp. 45–104; M. Righetti, 'Indagine su Girolamo da Cremona miniatore' in *Arte Lombarda*, 1974, 41, pp. 32–42; H.J. Eberhardt, *Die Miniaturen von Liberale da Verona, Girolamo da Cremona und Venturino da Milano in der Chorbüchern des Doms von Siena, passim*; A. De Marchi, in *Francesco di Giorgio e il Rinascimento a Siena 1450–1500*, pp. 228–237.
11 C. Brandi, *Quattrocentisti senesi*, Milan 1949, pp. 148–152. See also F. Bologna, 'Miniature di Benvenuto di Giovanni' in *Paragone*, 1954, 51, pp. 15–19; M.C. Bandera, 'Qualche osservazione su Benvenuto di Giovanni' in *Antichità viva*, 1974, 1, pp. 3–17; A. Angelini, 'Benvenuto di Giovanni' in *La Pittura in Italia. Il Quattrocento*, Milan 1987, II, p. 582; L. Kanter, in *La Pittura senese del Rinascimento 1420–1500*, Siena 1989, pp. 317–329; M. Seidel, 'Sozialgeschichte des Sieneser Renaissance Bildes. Studien zu Francesco di Giorgio, Neroccio de'

Landi, Benvenuto di Giovanni, Matteo di Giovanni und Bernardino Fungai' in *Städel Jahrbuch*, 1989, new series, XII, *passim*; R. Bartalini, in *Francesco di Giorgio e il Rinascimento a Siena 1450–1500*, pp. 95–97; C. Alessi, ibid., pp. 266–273.
12 E. Carli, in *Le Biccherne. Tavole dipinte delle magistrature senesi (secolo XIII–XVII)*, Rome 1984, pp. 26 and 172; C. Alessi, in *Francesco di Giorgio e il Rinascimento a Siena 1450–1500*, pp. 266–267.
13 On the commissions for the fifteenth-century altarpieces for the church of San Domenico, see M. Seidel, 'Sozialgeschichte des Sieneser Renaissance Bildes. Studien zu Francesco di Giorgio, Neroccio de' Landi, Benvenuto di Giovanni, Matteo di Giovanni und Bernardino Fungai'.
14 On Matteo di Giovanni's Asciano polyptych, see J. Pope-Hennessy, 'Matteo di Giovanni's Assumption Altarpiece' in *Proporzioni*, 1950, III, pp. 81–85.
15 B. Santi, in *Mostra di opere d'arte restaurate nelle province di Siena e Grosseto*, 1983, III, pp. 130–135.
16 B.B. Fredericksen, 'The Earliest Painting by the Stratonice Master' in *Paragone*, 1966, pp. 53–55; M. Tazartes, 'Anagrafe lucchese. II. Michele Ciampanti: il Maestro di Stratonice?' in *Ricerche di storia dell'arte*, 1985, pp. 18–27; A. Galli, in *Francesco di Giorgio e il Rinascimento a Siena 1450–1500*, pp. 274–283 and 524–525.
17 See A. Galli, in *Francesco di Giorgio e il Rinascimento a Siena 1450–1500*, p. 276.
18 Ibid., pp. 280–283.

Francesco di Giorgio Martini, *Nativity*. Pinacoteca, Siena.

Francesco di Giorgio Martini's Workshop

According to Leon Battista Alberti, the ideal modern architect was a universal man. He had to be not only knowledgeable in various fields of expertise but also capable of applying that knowledge to the science of architecture. The best example of such a man in Siena was Francesco di Giorgio Martini (1439–1501), who started his career working mainly as a painter but this soon became complementary, if not secondary, to his architectural work. From the 1460s he was employed as a hydraulic engineer and dedicated much of his time to Siena's water supply. Like his famous fellow citizen Mariano di Jacopo, known as il Taccola (the Jackdaw), Francesco di Giorgio undertook architectural commissions,[1] the results of which are no longer completely extant. Documents exist, however, that demonstrate the extent of Francesco di Giorgio's work, for example in the prestigious church of the Annunziata next to the Ospedale della Scala.[2]

Francesco di Giorgio's work as an engineer, an architect and a designer (in the modern sense of the word, that is, one who plans) is given more importance than his activity as a painter. However, he continued to paint according to the medieval practices of the workshop tradition and the commissions he received in this field did not decline with his increasing success as an architect. This meant that it was necessary to run a tightly organized workshop and to delegate trusted assistants to execute the paintings that he composed.[3] This workshop procedure explains the mention of an assistant and apprentices with Francesco di Giorgio in the documents, which evidence the sheer number of commissions that Francesco di Giorgio received. Lotto di Domenico, Antonio di Capitolo and Giacomo Cozzarelli are among his assistants recorded in the 1470s and 1480s. Some of them were employed to work on the great fresco of the *Coronation of the Virgin* for the apse of the church of the Annunziata. The work has unfortunately been destroyed but it must have been one of the most important commissions undertaken by the workshop.

p. 298
Francesco di Giorgio Martini,
Nativity, detail.
Pinacoteca, Siena.

Neroccio di Bartolomeo
de' Landi, *Virgin and Child*.
Accademia Carrara, Bergamo.

Francesco di Giorgio's surviving paintings from the 1470s and 1480s show a significant change in style when compared to the works from the early part of his career. As we have seen, his early works were notable for their vigorous, energetic and light-filled compositions. Panels such as the *Annunciation*, the *Virgin and Child with an Angel*, and the *Coronation of the Virgin* (Pinacoteca, Siena) show a certain tenderness in their compositional elements. The thin and delicate forms in these paintings contrast with the concentration on geometry and perspective that is present in the artist's earlier works. The figures conform to a model of humanity that is blond, with a fragile bodily structure, a gentle nature and almost infantile characteristics. The recent technical analysis of these paintings, in particular the reflectographs, has demonstrated that Francesco di Giorgio employed a developed sense of three-dimensionality in his drawing and a capacity for rigorous perspective and shading that was always combined with a sure sense of volume. This is true of the drawing underneath the *Virgin and Child* in the Musée du Petit Palais in Avignon.[4] It is clear that while Francesco di Giorgio designed and drew these paintings himself, the colour was applied by a less expert hand, making the overall effect more vague than in the drawing.[5] The majority of the paintings executed in Francesco di Giorgio's workshop in the 1480s show the style of an assistant who is traditionally given the name of Fiduciario (trusted assistant). The *Coronation of the Virgin*, painted for the SS. Sebastian and Catherine Chapel in the church of Monte Oliveto Maggiore (Pinacoteca, Siena), is one result of the collaboration between Francesco di Giorgio and Fiduciario. The painting demonstrates that Francesco di Giorgio used this alter ego even for his most prestigious commissions. A forceful drawing style characterized by the use of vigorous lines defines the central group of Christ crowning the Virgin. The group is supported by a complex construction of angels, cherubim and clouds, in a composition that resembles a sophisticated figurative tray.[6] Francesco di Giorgio succeeds in harmonizing ideas taken from Northern miniaturists with a composition inspired by a *niello* by Maso Finiguerra. The excellent planning of the composition is slightly undermined in places by the input of Fiduciario, who fails to maintain the quality of the original composition. The drawing for the painting is incredibly clear and energetic, like

other compositions that came from Francesco di Giorgio's workshop. It is closely related to bronze reliefs cast by Francesco di Giorgio in the early 1470s in its vibrant and almost tangible surfaces.[7]

The only important work from this period that shows Francesco di Giorgio's painting technique is the *Nativity* (Pinacoteca, Siena). It was commissioned in 1475 by the Olivetan monks of the destroyed monastery of San Benedetto outside Porta Tufi. In the commissioning document the monks specifically asked that the panel be executed well and stipulated that Francesco di Giorgio should be fully involved. The panel demonstrates Francesco's extremely sophisticated painterly qualities. The group of the Holy Family in the centre of the composition, the two angels and SS. Bernard and Thomas Aquinas are robust and energetic figures, a far cry from the ethereal, frail figures painted by Fiduciario. Francesco di Giorgio used thick paint to construct the solid and imposing forms. The surfaces of the bodies shine – from the flowing hair to the pearls of the angels and to the haloes, which are full of reflections. The brushstrokes follow the smooth drawing and the movement of the drapery folds.[8] The *Nativity* demonstrates that Francesco di Giorgio had kept abreast with the developments in contemporary Florentine painting, channelling his interests towards the nervous three-dimensionality of Antonio Pollaiuolo and of Verrocchio. The background of the painting is not so successful; it contains little perspective and its awkward painting style indicates that it was completed by Fiduciario.

In 1475 the *Societas in arte pictoria* (Society of Pictorial Art) was dissolved. It had been formed a little earlier by Francesco di Giorgio and Neroccio di Bartolomeo de' Landi, but we do not know how the collaboration between the two artists began.[9] It seems probable that they met when working in Vecchietta's workshop, although Neroccio was younger than Francesco di Giorgio and in some ways dependent on his older colleague, who had such a spirit of initiative. Neroccio de' Landi was born in 1447 and must still have been a teenager when he entered Vecchietta's workshop and his first works show clear echoes of his master's style.[10] Like Vecchietta and Francesco di Giorgio, Neroccio de' Landi was skilled in producing both paintings and sculptures. His sculpture of

St Catherine of Siena for the Oratory of St Catherine in Fontebranda – for which the last payment was made in May 1474 – strongly reflects Vecchietta's work in style. It is an extremely elegant sculpture, carved in wood and then painted, with clear parallels to Vecchietta's *St Bernardino* for the town of Narni (Bargello, Florence). Vecchietta's influence is evident in the circular base with the wreath of cherubim heads. The face of the saint, which has the graceful lines of an adolescent and an expression that is reserved and almost severe, contains similarities to some of the sculptures being produced by Francesco di Giorgio's workshop at the time.[11]

Neroccio's first small paintings demonstrate that he executed his earliest independent works under the influence of Vecchietta and Francesco di Giorgio. The paintings include the *Four Saints* (Johnson Collection, Philadelphia Museum of Art), the predella containing scenes from the *Life of St Sebastian* (Museo della Cattedrale, Pienza) and the two scenes from the *Life of St Catherine* (Berenson Collection, Villa I Tatti, Settignano, and previously Weddington Collection, London). Compared to Francesco di Giorgio, Neroccio de' Landi's work has less clarity and is more backward-looking. Despite his more refined elegance and his taste for decoration, which even involves punches on the gold ground, his style is closer to that of Francesco di Giorgio's assistant Fiduciario. The two scenes from the *Life of St Bernardino* (Museo Civico, Siena) clearly show Neroccio de' Landi's translation of Francesco di Giorgio's compositional ideas into more delicate and tender forms. In particular, the *St Bernardino Preaching in the Piazza del Campo* has links with the same subject by Francesco di Giorgio (Walker Art Gallery, Liverpool). However, Neroccio concentrated more on the lively colours of the palaces that surround the piazza and on the arrangement of the heads of the faithful that radiate out from the centre, than on the perspectival definition of space or the geometrical construction of the bodies.

Neroccio de' Landi's attained his most personal style in works completed after 1470, as in the refined formal perfection of the *Virgin and Child* (Accademia Carrara, Bergamo) and the *Annunciation* (Yale University Art Gallery, New Haven). The *Annunciation*, which has the form of a lunette,

contains elegant elongated figures. The details of the painting have an unusual clarity and almost seem to recall Simone Martini's Gothic charm. However, the bas-reliefs of the transenna that closes the back of the scene show a certain affectation in their use of mock-antique motifs. The figures on the transenna have a nervous, intense vivacity and twisted gestures.

The *Virgin and Child with SS. Jerome and Bernardino* (Pinacoteca, Siena) may have been painted a little before the Yale *Annunciation*. Neroccio's Mary assumes her usual aristocratic pose. Her detachment is emphasized by the distance separating her face, small and with tiny features, from the blessing Christ Child who clings to the armrests of the bronze faldstool. As in the triptych of the *Virgin and Child with the Archangel Michael and St Bernardino* (Pinacoteca, Siena) dated 1476, the figures stand out against the gold ground. It seems as though Neroccio de' Landi was trying to evoke the shining splendour of medieval Sienese painting. The margins of the panels and the haloes of the holy figures are decorated with vegetal motifs just like on Gothic panels, such as those painted by Simone Martini. In the *Virgin and Child with the Archangel Michael and St Bernardino*, Neroccio used precious materials in the exuberant reliefs on the archangel's golden armour, which contains embossed festoons, niches, and heads of cherubim. The pallid ivory complexions of the Virgin and Child, with their pearl-coloured reflections, contrast with the velvet red of the clothing. The tapering hand of the Virgin is silhouetted against the night-blue of her mantle. Neroccio de' Landi's aristocratic figures are undeniably fascinating. They recall, as though in a dream, Simone Martini's elegant art. This led early twentieth-century art historians, including Berenson, to believe that they had found the very essence of fifteenth-century Sienese art in the backward-looking style of Neroccio de' Landi.[12]

Vecchietta's last works are very different in style from those of his pupil Neroccio de' Landi. A few years before his death in 1480 he asked the Ospedale di Santa Maria della Scala, for which he had worked for many years, for the patronage rights to a chapel in the church of the Annunziata. The chapel was dedicated to the Saviour and Vecchietta

intended it as his final resting place. He executed two monumental works for the chapel – the bronze *Resurrected Christ*, which was later transferred to the high altar of the church, and a panel of the *Virgin and Child with SS. Peter, Paul, Lawrence and Francis* (no. 210, Pinacoteca, Siena).[13] In this great painting Vecchietta demonstrated his now-complete adherence to the antique language of Alberti and finally renounced the influence of Masolino. The *sacra conversazione* is set within a great niche which defines the space of the painting and is covered with multicoloured marbles. The richly coffered vault recalls the architecture of imperial Rome. The semicircle of the niche echoes the frame of the painting, while the figures themselves move solemnly within a space that is at last completely habitable.

Notes

1 On Francesco di Giorgio's activity as an engineer, see P. Galluzzi (ed.), *Prima di Leonardo. Cultura delle macchine a Siena nel Rinascimento*, Milan 1991, *passim*. On Mariano di Jacopo, see L.G. Boccia, ibid., p. 56. On Francesco di Giorgio as an architect, see Francesco Paolo Fiore and Manfredo Tafuri (eds), *Francesco di Giorgio architetto*, Milan 1993, *passim*.

2 For the documents relating to Francesco di Giorgio, see C. Zarrilli, in *Francesco di Giorgio e il Rinascimento a Siena 1450–1500*, Milan 1993, pp. 530ff.

3 A.S. Weller, *Francesco di Giorgio 1439–1501*, Chicago 1943, p. 82; A. Angelini, 'Francesco di Giorgio pittore e la sua bottega. Osservazioni su una recente monografia' in *Prospettiva*, 1988, 52, pp. 10–24. This is a review of R. Toledano, *Francesco di Giorgio Martini pittore e scultore*, Milan 1987. See also A.F. Iorio, *The Paintings of Francesco di Giorgio: A Reassessment*, Ph.D. thesis, University of Virginia 1993. Iorio believes that most of the paintings attributed to Francesco di Giorgio were executed by members of his workshop.

4 A. Angelini, in *Sienne e Avignon*, edited by E. Moench-Scherer, Avignon 1992, pp. 72–75.

5 See L. Bellosi, in *Francesco di Giorgio e il Rinascimento a Siena 1450–1500*, pp. 29–39.

6 On the *Coronation of the Virgin*, see A. De Marchi, in *Francesco di Giorgio e il Rinascimento a Siena 1450–1500*, pp. 300–305.

7 On Francesco di Giorgio's activity as a sculptor, see A.S. Weller, *Francesco di Giorgio 1439–1501*, *passim*; C. Del Bravo, *Scultura senese del Quattrocento*, Florence 1970, pp. 101–107; E. Carli, *Gli scultori senesi*, Milan 1980, pp. 45–46; A. Bagnoli, 'Donatello e Siena: alcune considerazioni sul Vecchietta e su Francesco di Giorgio' in *Donatello Studien*, Munich 1989, pp. 278–291; G. Gentilini, in *La Scultura bozzetti in terracotta, piccoli marmi e altre sculture dal XIV al XX secolo, Siena, Palazzo Chigi Saracini*, Florence 1989, pp. 99–110; L. Bellosi, in *Francesco di Giorgio e il Rinascimento a Siena 1450–1500*, pp. 20ff. and 198–199; A. Bagnoli, ibid., pp. 382–389 and *passim*.

8 On the Monte Oliveto Maggiore Nativity, see L. Bellosi and A. Angelini, in *Francesco di Giorgio e il Rinascimento a Siena 1450–1500*, pp. 29 and 314–317.

9 On the company formed by Neroccio de' Landi and Francesco di Giorgio, see L. Dami, 'Neroccio di Bartolomeo Landi' in *Rassegna d'arte*, 1913, XIII, pp. 138–139; A.S. Weller, *Francesco di Giorgio 1439–1501*, pp. 6–7; M. Seidel, 'Sozialgeschichte des Sieneser Renaissance Bildes. Studien zu Francesco di Giorgio, Neroccio de' Landi, Benvenuto di Giovanni, Matteo di Giovanni und Bernardino Fungai' in *Städel Jahrbuch*, 1989, new series, XII, pp. 116–123.

10 G. Coor, *Neroccio de' Landi 1447–1500*, Princeton 1961. See also L. Kantner, in *La Pittura senese nel Rinascimento 1420–1500*, Siena 1989, pp. 342–347; M. Maccherini, in *Francesco di Giorgio e il Rinascimento a Siena 1450–1500*, pp. 318–330 and 526–527.

11 A. Bagnoli, in *Francesco di Giorgio e il Rinascimento a Siena 1450–1500*, pp. 218–221.

12 See G. Agosti, in *Francesco di Giorgio e il Rinascimento a Siena 1450–1500*, pp. 499–502.

13 For the bronze *Resurrected Christ*, see A. Bagnoli, in *Francesco di Giorgio e il Rinascimento a Siena 1450–1500*, pp. 212–215. On the panel for the Saviour Chapel, see L. Cavazzini, ibid., pp. 216–217.

Sienese Art at the End of the Fifteenth Century

In November 1477 Francesco di Giorgio declared himself resident in Urbino, where he was working at the court of Federico da Montefeltro. He remained there for around ten years and during his stay his most pressing commissions were architectural. His work included the construction of defensive fortresses and ramparts throughout the dukedom and being in charge of the building works for the palaces of Gubbio and Urbino.[1] Francesco di Giorgio's workshop employed artists from a number of different places, among them were some from Siena, such as Giacomo Cozzarelli and Giovanni di Stefano who were faithful followers. Documents indicate that Giacomo Cozzarelli also worked for Federico da Montefeltro as a painter but unfortunately his work has not survived. However, it is possible to individuate the hands of these Sienese artists in the making of the figured capitals that decorate the grand staircase of the palace in Urbino.[2]

Francesco di Giorgio's stay in Urbino was frequently interrupted by journeys to Siena, since the government there often required his valuable contributions as an architect and as an engineer. The journeys between Urbino and Siena must have created close ties between the cities, benefitting Siena by opening her gates to wider influences. The presence of Sienese artists in Urbino was only to affect art in Siena at the end of the century. From 1480 to 1500 the workshops of Matteo di Giovanni and Benvenuto di Giovanni continued to enjoy considerable success. Benvenuto di Giovanni trained his son Girolamo di Benvenuto, and probably also Pietro di Domenico, in his workshop. In the 1480s Matteo di Giovanni and Benvenuto di Giovanni were at the height of their respective careers and their works reflect a continuing pride in the local figurative tradition.

In 1491 Benvenuto di Giovanni painted and signed his last great work, the large *Ascension of Christ* for the monastery of Sant'Eugenio (Pinacoteca, Siena). In his late works Benvenuto di Giovanni received considerable help from his son. The figures of the apostles, at the base of the painting, have

Girolamo di Benvenuto,
Adoration of the Shepherds.
Museo Civico, Montepulciano.

Guidoccio Cozzarelli,
Baptism of Christ. San Bernardino,
Sinalunga, Siena.

dramatically expressive faces and are clothed in drapery that is segmented into metallic folds. They demonstrate that Benvenuto di Giovanni was capable of creating great intensity in his painting. The mineral quality of the colours recalls the work of Girolamo da Cremona. The whole has been animated by a strange but subtle inventiveness, which in part reflects the miniature effects of Flemish painting. The landscape in the background contains a lake, which can be seen through the hills, and is punctuated by Northern bell towers, a feature that appeared throughout central Italian painting towards the end of the century. Benvenuto di Giovanni's personal and unconventional assimilation of pictorial models from across the Alps stands in direct opposition to the gentle, sweeping arrangement of the landscape, which ultimately derives from Flemish painting, but was already prevalent in the Umbrian and Tuscan landscape paintings inspired by the work of Perugino.

Another large panel painting of the *Assumption of the Virgin* (Metropolitan Museum of Art, New York) is signed by Benvenuto di Giovanni and dated 1498. This impressive work is composed in a similar way to the *Ascension* in Siena but one senses Girolamo's intervention on the pictorial surface. From this time onwards Benvenuto di Giovanni's signature guarantees the panel's provenance from his workshop rather than the artist's personal contribution to the painting. Girolamo di Benvenuto gradually took over the commissions assigned to his father. It is not by chance that the *Assumption of the Virgin with SS. Thomas, Francis and Anthony* by Girolamo di Benvenuto (Museo Diocesano, Montalcino) is modelled on the composition of his father's painting of the same subject in New York. Girolamo's work was painted at the beginning of the sixteenth century,[3] a few years after he had executed his best works. These include the *St Jerome in the Desert* (Musée du Petit Palais, Avignon), with its clear and angular forms; the *Adoration of the Shepherds* (Museo Civico, Montepulciano), with its mannered and even somewhat grotesque passages; and the *St Catherine Convincing the Pope to Return to Rome from Avignon* (Museo delle Pie Disposizioni, Siena). It is possible

that the predella with scenes from the *Life of St Catherine of Siena* (various collections), the frame of which was considerably altered in the nineteenth century, may have originally formed part of this painting. *St Catherine Convincing the Pope to Return to Rome from Avignon* is Girolamo di Benvenuto's most successful work from the period when his attachment to the miniaturist effects of western Italian art was most noticeable.[4]

From 1475 onwards Matteo di Giovanni was assisted by an able collaborator, Guidoccio Cozzarelli, who later became a sort of alter ego of his master. Cozzarelli's works that are closest to the style of Matteo di Giovanni include a series of miniatures illustrating a manuscript belonging to Siena Cathedral (26.R, *c.* 1482); the *Virgin and Child Enthroned between St Jerome and the Blessed Giovanni Colombini* painted in 1482 (Pinacoteca, Siena); and, above all, the *Virgin and Child with Angels* painted in 1484 (Museo Civico, Siena). It was around this time that Cozzarelli painted his most important work, the *Baptism of Christ*, for the church of San Bernardino in Sinalunga to which he later added the lunette of the *Virgin and Child with SS. Francis and Bernardino and Two Angels*.[5] The stylistic proximity of this particularly busy altarpiece to Matteo di Giovanni's work as well as the way in which the composition explicitly recalls Piero della Francesca's famous *Baptism of Christ* for Borgo San Sepolcro, must stem from the requirements of the commission. The panel was painted for the Sienese Orlandini family and so the altarpiece ought logically to have followed illustrious Sienese precedents such as the *Borghesi Altarpiece* or the *St Barbara Altarpiece* painted by Matteo di Giovanni. Cozzarelli reused the scalloped structure of the painting of the *Virgin and Child with the Apostles Simon and Thaddeus* dated 1486 and commissioned by the Pannilini brothers for San Bernardino in Sinalunga.

Pietro di Francesco Orioli was only slightly younger that Guidoccio Cozzarelli. His first works, such as the *Virgin and Child with Saints* from the Pieve of San Pietro e San Paolo in Buonconvento and the *Nativity* from the church of Sant'-Agostino in Massa Marittima, indicate that he was trained in

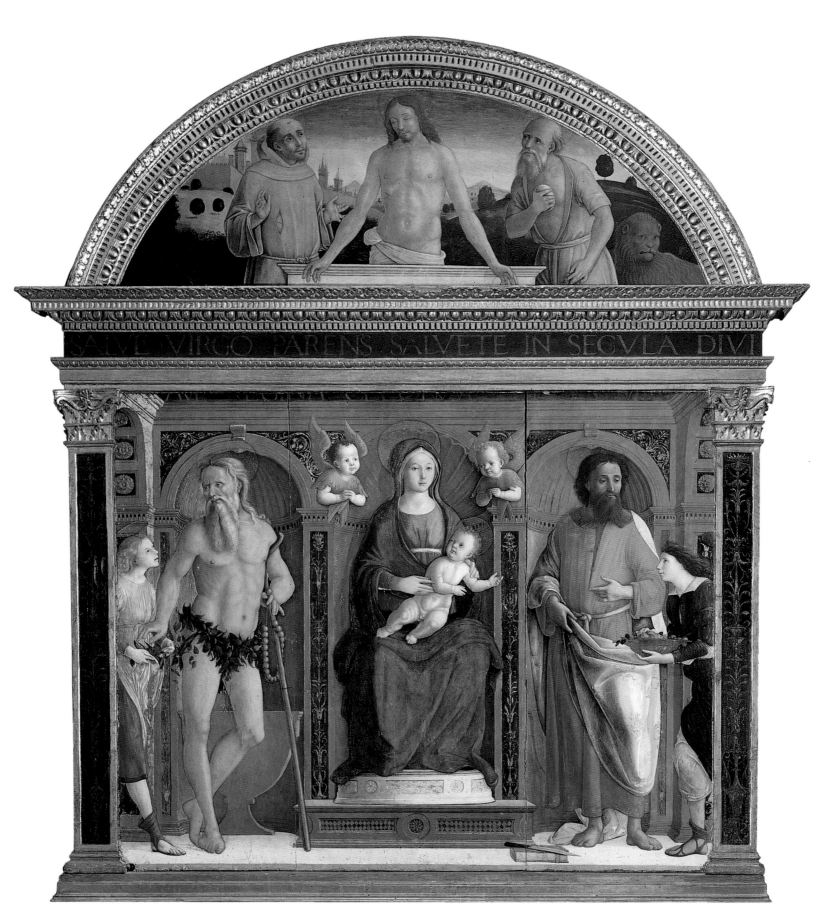

Pietro di Francesco Orioli,
*Virgin and Child with SS. Honofrius
and Bartholomew and Two Angels.*
Pinacoteca, Siena.

Matteo di Giovanni's workshop.[6] However, Orioli did not tow the workshop line. He was gifted with a distinct artistic personality and his early works show an interest in space and a search for solidity in his compositions that was completely alien, at this time, to the work of Matteo di Giovanni. The *Virgin and Child with SS. Honofrius and Bartholomew and Two Angels* and its lunette of the *Pietà with SS. Francis and Jerome* (Pinacoteca, Siena) were painted by Orioli early in his career. The painting shows artistic influences that cannot be explained by Orioli's Sienese training but which reflect instead the work of Florentine painters such as Domenico Ghirlandaio. The impressive frame, consisting of two pilasters surmounted by a classical architrave, surpasses the models that were then available in Siena. Orioli used an illusionistic solution of well-balanced space in the painting, which is framed by the two engraved pilasters. These form part of the composition, their attached concave arches receding into the space of the painting. The two saints flanking the Virgin's throne display obvious similarities to certain figures painted in 1475 by Ghirlandaio in the frescoes in the St Fina Chapel in the Collegiata in San Gimignano and to figures in his various fresco cycles in Florence painted in the 1480s. Ghirlandaio's influence may have reached Siena through the work of the Florentine painter Fra Giuliano, who was a member of the Order of the Gesuati. According to the historian Sigismondo Tizio writing in the early sixteenth century, Fra Giuliano died in Siena in 1487. He painted a now-fragmentary fresco of the *Virgin and Child with St Jerome, the Blessed Giovanni Colombini and Two Angels* (San Girolamo) that shows him to be a faithful follower of Ghirlandaio. The elegant figures of the angels bear similarities to Orioli's *Virgin and Child with SS. Honofrius and Bartholomew and Two Angels*.[7]

The arrival of artistic influences from outside Siena was a sign of the changing political situation in Italy. During the last two decades of the fifteenth century Siena was involved in a series of alliances and agreements with the aim of securing power over central Italy. Around 1480 Siena found powerful allies against its traditional enemy, Florence, in the Papal States governed by Sixtus IV, in Aragonese Naples and in the duchy of Urbino. During the fighting that followed the alliance succeeded in capturing from Florence some important strongholds on the borders of Sienese territory. These

Design by Matteo di Giovanni (?),
Massacre of the Innocents, marble
pavement intarsia, detail.
Left transept, Siena Cathedral.

included Poggio Imperiale and Colle di Val d'Elsa.[8] Some of these episodes as well as the interior troubles due to the state of tension among citizens, political factions and alliances between the magnates are represented in the small panels from the office of the Gabella. The panels illustrate crucial political events such as the *Surrender of Colle di Val d'Elsa* (1480) and the *Agreement between the Classes and the Offer of the Keys of the City to the Virgin of Mercy*, painted by Orioli in 1483. They also present allegorical scenes linked to a religious iconography that emphasizes the Virgin Mary.[9] Among the most interesting of the panels is Orioli's *Agreement between the Classes and the Offer of the Keys of the City to the Virgin of Mercy*. It contains a spatially sophisticated view of the interior of Siena Cathedral, within which a line of citizens worship the Madonna of Mercy.

Neroccio de' Landi also painted a Gabella panel in 1480. The work has a complex allegorical significance and shows the *Virgin Recommending the City of Siena to Christ*. The city walls are surrounded with a cord as a symbol of harmony, following the famous precedent set by Ambrogio Lorenzetti in the Sala dei Nove in the Palazzo Pubblico. It is less easy to understand the significance of the three columns, each a different colour, which support the city.[10]

Of the painters just discussed it is Matteo di Giovanni who painted the most Gabella panels. Between 1487 and 1489 he completed four, alternating political and religious subjects.[11] Matteo di Giovanni was probably also responsible for the marble inlay on the pavement of the left transept in Siena Cathedral depicting the *Massacre of the Innocents*. The choice of subject is directly related to an event that reverberated throughout the whole of Italy – the siege of the city of Otranto in Puglia by the Turks.[12] The raid sowed dismay in the entire peninsula. In 1480 the duke of Calabria, the son of Alfonso of Aragon the king of Naples, was sent with his troops to Sienese territory to support the alliance against Florence. However, he was forced to head south because of the unexpected danger posed by the Turks. The connection between the dramatic scene represented on the floor of the cathedral and the events in Otranto is significant. The depiction of the horror of the *Massacre of the Innocents* as perpetrated by a bloodthirsty Herod wearing exotic clothing appears to refer to contemporary events. The allusion is

Matteo di Giovanni,
Massacre of the Innocents.
Museo di Capodimonte,
Naples.

Design by Francesco di Giorgio
Martini (?), *Story of Jepthah*,
marble pavement intarsia, detail.
Left transept, Siena Cathedral.

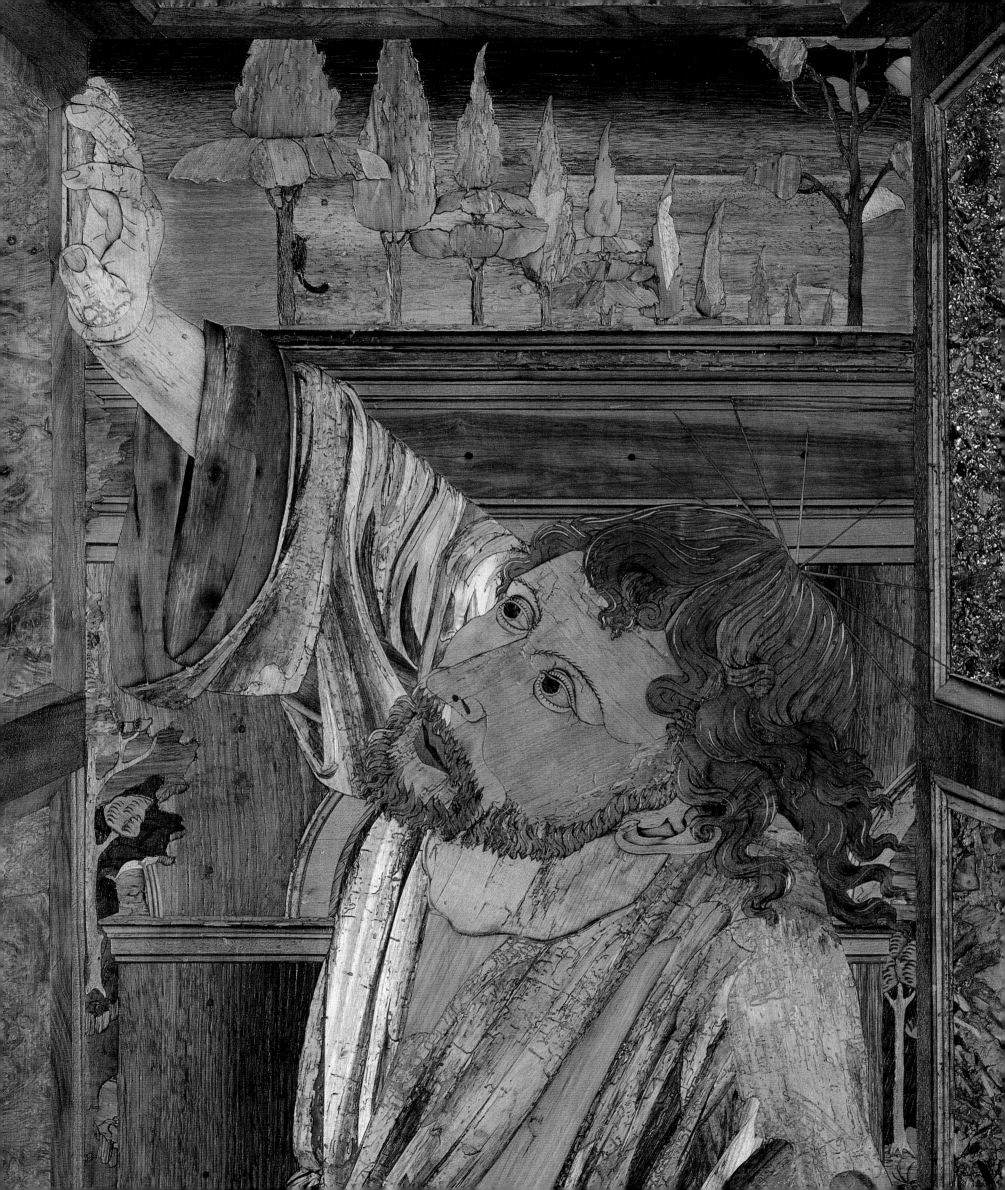

supported by the fact that Alberto Aringhieri, the commissioner of the scene, was a knight of Rhodes and therefore a defender of the Christian faith against the Turkish threat. Aringhieri commissioned the work in his capacity as cathedral rector but is identified on the intarsia as a *cavaliere di Rodi*.[13]

The intarsia uses marble of different tones to obtain the most delicate effects. The attribution to Matteo di Giovanni is based on a comparison with his three other versions of the same subject, executed between the end of the 1480s and the beginning of the 1490s.[14] The panels come from the two Sienese churches of Sant'Agostino and Santa Maria dei Servi and from the Neapolitan church of Santa Caterina in Formiello (Museo di Capodimonte, Naples). They show the same bloody biblical scene and contain even more exotic references and Turkish costumes, thus linking their inspiration to the events at Otranto.[15] It is interesting to observe that the two cities in which these four representations survive are Siena and Naples, political allies at the time of the siege.[16]

Alberto Aringhieri's long tenure as rector of Siena Cathedral is characterized by constant work on the pavement intarsias. The complex decorative scheme was started in the fourteenth century and in the first half of the fifteenth century some large scenes from the Old Testament were executed in the transept. However, it was only under Aringhieri that work continued systematically, following a well-defined programme that included biblical scenes in the transept and a series of *Sibyls* in the side aisles.[17] All the most important Sienese painters worked on this great undertaking, preparing the cartoons that the stonemasons then translated into coloured marble. The predominant black and white marble of the cathedral structure was repeated in the pavement, above all in the series of *Sibyls*, which naturally included *Hermes Trismegistos*. In the biblical stories in the transept, the colouring of the marbles is even richer. The very beautiful composition of the *Story of Jepthah* (1485) boasts the red of the city walls and the battle ground, the yellow that stains the tufa hills and the black of a horse's coat and a Moorish soldier's complexion. Following a comparison between the soldiers scuffling in the fray and the many similar figures in his surviving drawings, it is possible to deduce that the scene was designed by Francesco di Giorgio.[18]

p. 309
Antonio Barili, *Apostle*, detail.
Collegiata, San Quirico d'Orcia
(originally in Siena Cathedral).

Antonio Barili, *St Catherine
of Alexandria Disputing with the Sultan*.
Collegiata, San Quirico d'Orcia
(originally in Siena Cathedral).

Another important decorative cycle was planned during Aringhieri's office as cathedral rector. These were the nineteen marquetry panels in the choir stalls in the St John Chapel designed by Antonio Barili.[19] Some of the backs of the choir stalls with their intarsia 'windows' were transferred to the Collegiata of San Quirico d'Orcia in 1749 and the remaining compartments have been lost.[20] Antonio Barili, head of one of the most successful intarsia workshops in Italy, had returned to Siena from the Marches in 1488, where he had worked as a follower of Francesco di Giorgio. One of his commissions executed during this period is the series of delicate intarsias for the choir of Santa Maria Nuova in Fano. The 'windows' display various objects in precisely defined perspective,[21] with a clarity that is also found in the intarsias from Siena Cathedral. There are extraordinary passages depicting books, ink stands, rounded lutes and carpentry tools. The cathedral cycle, when compared with that in Fano, is further enriched by the frequent inclusion of human figures portrayed in complex positions and placed within the perspective structure. The *Disciple of St John the Baptist* seen from the back in foreshortening and the *Apostle* bending forwards to lean out of the open window remain among the most memorable figures in the history of perspective intarsia in Italy. The intarsias are rich with delicate chromatic variations and virtuoso light effects. The question of the identity of the painter who provided the cartoons with which Barili worked remains unanswered.[22] The most monumental composition of the cycle, that of *St Catherine of Alexandria Disputing with the Sultan*, has the majestic structure and suspended atmosphere of one of Piero della Francesca's paintings. From the book displayed on the window-sill to the oval head of the saint, from the bent, foreshortened fingers of the sultan to the clothes stained with shadows, every element of the window recalls the solid forms of the magical and abstract world of Piero della Francesca.[23] The time that Barili spent in the Marches may largely explain this influence in the Siena Cathedral choir stalls. The friezes above the intarsias, carved with motifs of acanthus volutes, coupled dolphins and flowing vegetal wreaths, recall the travertine ones that ornament the fireplaces and pilasters of Federico da Montefeltro's ducal palace that Barili would have seen during his time in the Marches.

Pietro di Francesco Orioli,
*Christ Washing the Feet of
the Apostles*, detail.
Baptistery, Siena.

Pietro di Francesco Orioli,
Coronation of the Virgin.
Collegiata of San Leonardo,
San Casciano dei Bagni.

Antonio Barili's masterpiece fits perfectly within the stream of cultural stimuli that flowed from the Marches towards Siena at the end of the 1480s, when the small colony of Sienese artists who had been working at the court of Urbino finally returned to their native city. We know that Francesco di Giorgio, Giacomo Cozzarelli, Giovanni di Stefano and Antonio Barili all worked in Urbino and probably Pietro di Francesco Orioli too. In the paintings that he completed around 1490 Orioli demonstrates a new and accentuated use of geometrical forms as well as an intensified search for perspective solutions that seem to have a precedent in the great models painted by Piero della Francesca in Urbino. In 1489 Orioli was paid for a fresco in the Sienese baptistery that depicted *Christ Washing the Feet of the Apostles*.[24] Such determined use of perspective is unprecedented in Sienese art. Orioli created what could be termed a manifesto of spatial solutions, that are inspired by the work of Piero della Francesca and stem from rigorous mathematical principles. The apostles are imposing figures with solemn gestures, who are positioned under the classical pilasters supporting the large central arch. The painted architecture, set against the background view of a port, seems to be an illusionistic translation of the real architecture of some of the buildings designed by Francesco di Giorgio. The port, a lively scene containing small moving figures, is strikingly similar to that which appears in the *Architectural View* (Staatliche Museen, Berlin) executed for the court of Urbino.

In 1492 Orioli was paid for a fresco in the Sala della Pace in the Palazzo Pubblico. The painting demonstrates the extent to which he was influenced by Francesco di Giorgio's architectural models. It depicts a series of small arches seen in perspective and separated by classical pilaster strips.[25] Around 1490 Orioli painted the altarpiece of the *Coronation of the Virgin* for the Collegiata of San Leonardo in San Casciano dei Bagni, which once again demonstrates his attention to the science of perspective and once again refers to the work of Piero della Francesca.[26]

The Biccherna panel of 1488, painted by Matteo di Giovanni, visually documents the furtive return of the exiles belonging to the Monte dei Nove,[27] an important episode in Sienese history. The assertion of authority by those associated with the Monte dei Nove had the effect of reinforcing the

Luca Signorelli, *Bichi Altarpiece*, detail of *SS. Jerome, Catherine of Siena and Mary Magdalen*. Gemäldegalerie, Staatliche Museen, Berlin.

Luca Signorelli, *Bichi Altarpiece*, detail of *SS. Francis, Augustine and Catherine of Alexandria*. Gemäldegalerie, Staatliche Museen, Berlin.

Master of the Bizarre Putti,
Annunciation.
Museo Diocesano, Volterra.

personal power of one of the greatest representatives of this strong political faction, Pandolfo Petrucci, who succeeded in constructing his own small local dominion.[28]

One of the nobles belonging to the Monte dei Nove, who was able to return to Siena at this time, was Antonio Bichi. Soon after he entered the city he decided to oversee the decoration of the family chapel located in the right transept of the church of Sant'Agostino. The commission, which included a maiolica pavement, monochrome frescoes on the side walls and in the vault and the polyptych on the altar, was given to various artists under the supervision of Francesco di Giorgio and Luca Signorelli.[29] The documentation relating to the chapel proves the entire decoration was complete by 1494, a date which also appears on the original gate to the chapel. The *Erythraean Sibyl* and the *Tiburtine Sibyl* were painted following Signorelli's design. They are placed in two *oculi* shown in foreshortening from below. The side walls of the chapel were completed by Francesco di Giorgio and his entourage, who painted frescoes showing the *Birth of the Virgin* and the *Nativity*. It is clear that although the cartoons for the two compositions were largely by Francesco di Giorgio, the execution of the frescoes was mostly delegated to his collaborators. The paintings can be divided, on the base of a stylistic analysis, between Fiduciario, who painted most of the large figures, and Pietro di Francesco Orioli.[30] Orioli was particularly concerned with the architecture of St Anne's room in the *Birth of the Virgin* and of the stable in the *Nativity* as well as with the entire landscape background of this second fresco, which extends into the distance. The altar polyptych is the fruit of a more organic collaboration between the two workshops. It is composed of painted panels with a wooden statue of *St Christopher* (Louvre, Paris) carved by Francesco di Giorgio in the centre. The subject was chosen in memory of Cristoforo Bellandi, the deceased son-in-law of Antonio Bichi.[31] To either side of the central statue and in the predella were panels painted by Luca Signorelli. The two largest and most impressive panels were those to the left and right of *St Christopher*. These were, respectively, *SS. Jerome, Catherine of Siena and Mary Magdalen* and *SS. Francis, Augustine and Catherine of Alexandria*.[32] The *Bichi Polyptych* shows Luca Signorelli at his very best. The saints are rendered with nervous and contracted gestures, defined with an incisive line and with a

p. 315
Griselda Master,
Tiberius Graccus. Szépmuvészeti
Muzeum, Budapest.

p. 316
Griselda Master,
Scenes from the Story of Griselda:
The Wedding of Griselda and Gualtieri,
Griselda Leaves Gualtieri's House
and *The Feast of Gualtieri and Griselda.*
National Gallery, London.

p. 317
Griselda Master,
Artemisia.
Museo Poldi Pezzoli, Milan.

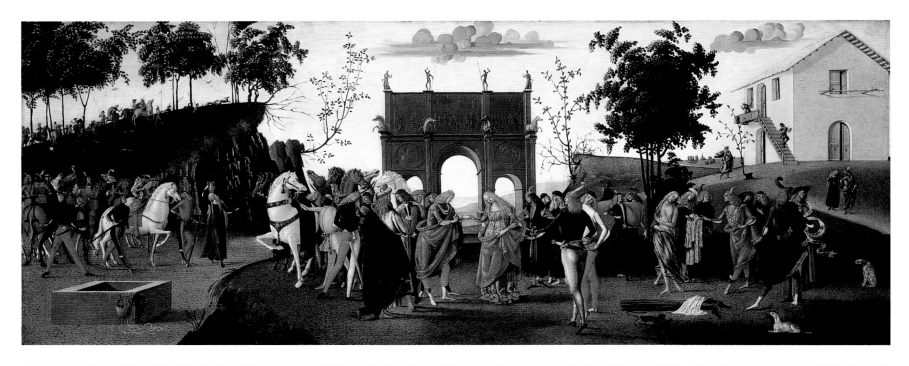

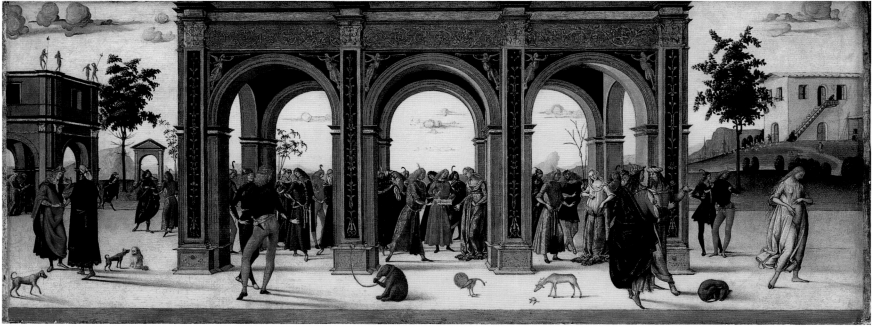

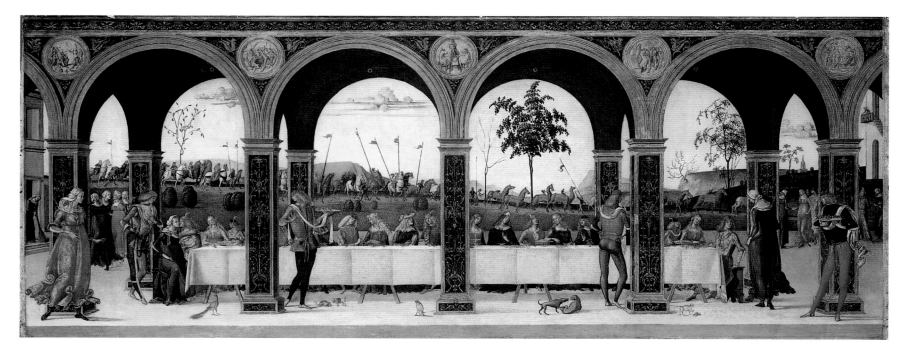

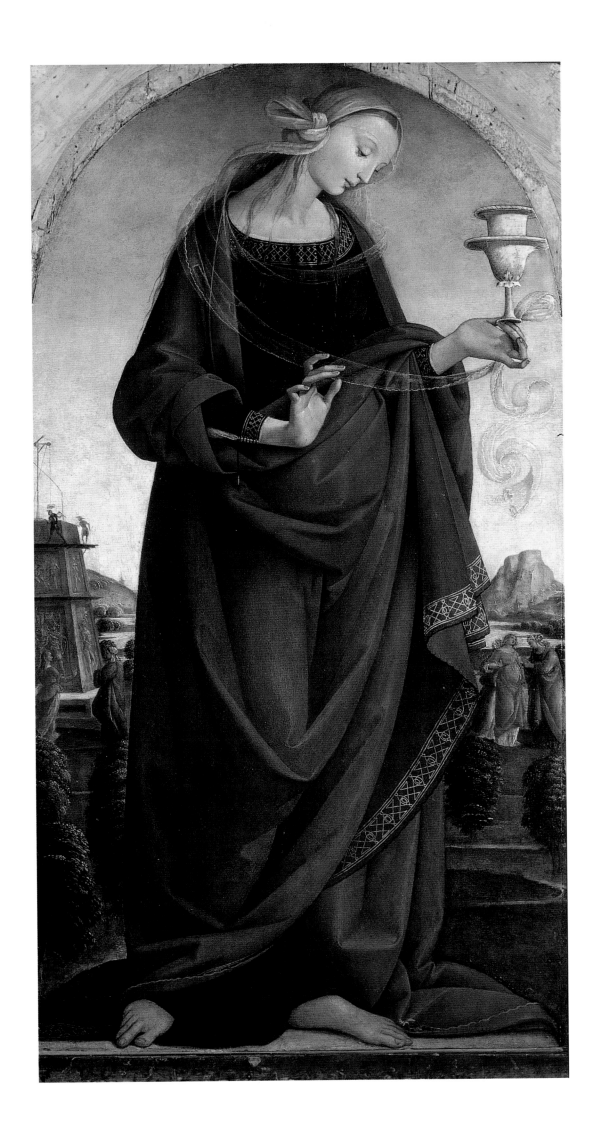

minute attention to surface texture. From the long twisting hair of *St Mary Magdalen* to her gleaming glass urn, from the precious drapery of *St Augustine* to his crystal crosier, the artist demonstrates a sensitivity to Flemish art. The pilaster strips under the entrance arch of the Bichi Chapel can be attributed to a follower of Signorelli. They are decorated with lively and bizarre grotesques painted with clear brushstrokes. It is possible that the pilaster strips were executed by the same artist who painted the delightful small altarpiece in the Pinacoteca in Siena (no. 571) and the small partially dismembered tabernacle, the main part of which is in the Museo Diocesano in Volterra.[33] At the beginning of his career this painter was influenced by Bartolomeo della Gatta and Luca Signorelli, in particular by their sophisticated and eccentric painting, rich with subtle gradations of light. The painter has been given the name of the Master of the Bizarre Putti and has a greater artistic range than Girolamo di Domenico, the painter of the frescoes in San Rocco in Seggiano.[34] Girolamo di Domenico is documented as having contributed to the decoration of the Bichi Chapel and was clearly influenced by Signorelli's methods. Mariotto d'Andrea da Volterra, who worked in Siena as well as in his native city, has a style that is very close to that of the Master of the Bizarre Putti.[35]

The most distinguished of the painters associated with Signorelli is undoubtedly the Griselda Master, who introduced a refined and richly eccentric style of painting into Siena at the turn of the century.[36] This great anonymous painter must have done some of his training on the scaffolding of the Sistine Chapel beside Bartolomeo della Gatta and Perugino (1480–1482). He took part in executing some panels commissioned on the occasion of a Piccolomini family wedding, probably that of Silvio dei Piccolomini di Sticciano, which took place in 1492.[37] The panels form a series showing ancient heroes and heroines chosen to celebrate the conjugal virtues of faithfulness and continence. Francesco di Giorgio, Pietro di Francesco Orioli, Neroccio de' Landi and probably Matteo di Giovanni contributed to them and painted, respectively, the figures of *Scipio Africanus* (Bargello, Florence), *Sulpicia* (Walters Art Gallery, Baltimore), *Claudia Quinta* (National Gallery of Art, Washington, D.C.) and the fragmentary *Judith* (location unknown). The most delicate and intense figure is Orioli's *Sulpicia*. She is elegantly

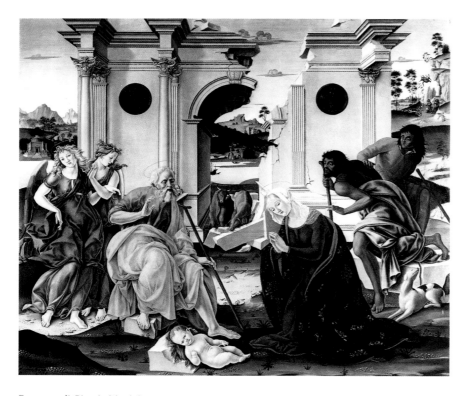

Francesco di Giorgio Martini,
assistant and Bernardino Fungai,
Nativity. San Domenico, Siena.

balanced, immersed in the azure light of a gentle rural landscape. In the palm of her hand she supports a small centrally planned temple whose architecture is reminiscent of Francesco di Giorgio Martini's style.[38] The heroes painted by the Griselda Master are more subtle and original. They include *Alexander the Great* (Barber Institute, Birmingham), *Tiberius Graccus* (Szépmuvészeti Muzeum, Budapest), *Eunostos of Tanagra* (National Gallery of Art, Washington, D.C.) and *Artemisia* (Museo Poldi Pezzoli, Milan). The sophisticated movements of the figures, the thick curly hair that catches the light and the elegant and rich clothes all contribute to making the Piccolomini cycle, with its complex references to classical culture, one of the most distinguished and admirable examples of Tuscan figurative art from this period.

Francesco di Giorgio received commissions as a painter until late in his career, notwithstanding his numerous architectural commitments. At the end of the century he inherited the important commission to paint the *Nativity* for the Tancredi Chapel in the church of San Domenico. It had originally been given to Matteo di Giovanni but remained unfinished due to his death in 1497. The painter Ludovico Scotti is also documented as taking part in the commission and may have worked in collaboration with Francesco di Giorgio.[39] However, it was Francesco di Giorgio himself who executed the cartoons for the bystanders adoring the Christ Child. The figures are sweetly and elegantly sentimental in a way that is reminiscent of the work of Botticelli. The great triumphal arch, which closes off the background of the painting like an enormous piece of archaeological stage scenery, is a predictable indication of Francesco di Giorgio's architectural concerns. The angels on the left, who move in a strangely agitated manner, are a translation into pictorial form of those which Francesco di Giorgio was founding in bronze for the high altar of Siena Cathedral.[40] Bernardino Fungai, one of the lesser masters who were trained in Siena in the 1480s, worked beside or under the supervision of Francesco di Giorgio in the Tancredi Chapel. He was responsible for the two shepherds on the right and for some passages of the landscape in the background.[41] After Ludovico Scotti's death in the early years of the sixteenth century, Fungai finished the panel and painted the predella. Pietro di Francesco Orioli and the Griselda Master were particularly influential at

Luca Signorelli, *St Benedict Greeting Totila*. Monte Oliveto Maggiore, Asciano.

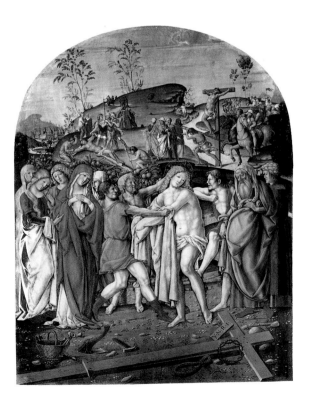

Fiduciario, *Christ Stripped of his Garments*. No. 428, Pinacoteca, Siena.

the time,[42] but Fungai was no stranger to the work of Florentine artists such as Domenico Ghirlandaio and Cosimo Rosselli. His fresco of the *Last Supper* from the refectory of Santa Margherita in Castelvecchio clearly shows Rosselli's influence. The composition was inspired by Rosselli's version of the same subject in the Sistine Chapel (1482). Fungai had, together with Perugino and Antoniazzo Romano, painted the decorative display for the election of Innocent VIII in the Vatican apartments in 1484.

Pietro di Domenico is another painter who was almost contemporary with Fungai but whose artistic career ended at the beginning of the sixteenth century.[43] Influenced by a rustic and almost gypsylike vivacity, his inventive style finds its greatest expression in the *Assumption of the Virgin* and the *Nativity* from the Collegiata in Radicondoli. This intelligent and imaginative painting contains reminiscences of the work of Pietro di Francesco Orioli and Francesco di Giorgio, mixed with lively and accurate quotations from Signorelli's *Bichi Altarpiece*. The intensity of Pietro di Domenico's paintings and their almost dreamlike effect can be better appreciated in the two versions of the *Nativity* in the Pinacoteca in Siena (nos. 279 and 390). The backgrounds echo the style of the Griselda Master, but Signorelli's influence is still strong. Between 1497 and 1498 Signorelli painted a series of frescoes in the choir of Monte Oliveto Maggiore showing scenes from the *Life of St Benedict*.[44] His irritating formalism and his tortuous way of displaying the anatomy by means of forced gestures was shortly to explode in the famous cycle in the San Brizio Chapel in Orvieto Cathedral. In the scene of *St Benedict Greeting Totila* from Monte Oliveto Maggiore one can already see Signorelli's tendency to draw mannequins instead of people made of flesh and blood, particularly in the

group of soldiers at the right. Signorelli's mature works are marked by this stylistic propensity. In the Monte Oliveto Maggiore frescoes Signorelli still pays, at least in part, attention to the 'values' which we have seen in the *Bichi Altarpiece*. The light-filled habits of the monks contrast with the dark complexions of their faces, which have been exposed to the sun during hours in the fields. The limpid azure atmosphere in which the figures are bathed gives them a freshness and lively naturalness, elements that Signorelli lost in his later paintings.

Some of the personalities who had dominated Sienese art for decades died at the beginning of the sixteenth century. These include Neroccio de' Landi (1500) and Francesco di Giorgio (1501). Matteo di Giovanni had died before the turn of the century in 1497 and Pietro di Francesco Orioli the year before that, 1496. Other painters such as Benvenuto di Giovanni continued working into the new century, even if they often seemed to have been overtaken by the times. The painting which most suitably closes the fifteenth century in Siena is the *Christ Stripped of his Garments* painted for the church of San Bernardino all'Osservanza near Siena (no. 428, Pinacoteca, Siena).[45] The painting came from Francesco di Giorgio's workshop and testifies once again to the intervention of the anonymous Fiduciario. Here he demonstrates a sweeter and more tender style than was apparent in his previous works. The composition contains classical elements that presuppose a knowledge of Perugino's works. The background, which is populated by small rounded figures, shares similarities with the frescoes in Sant'Anna in Camprena by the young Sodoma. The sweet style of painting that characterizes Pandolfo Petrucci's brief period of power is evident here and it is clear that in this panel Fiduciario has striven to update his work.

Notes

1 A.S. Weller, *Francesco di Giorgio 1439–1501*, Chicago 1939, pp. 134–210. On the architect's activity in Gubbio, see the recently discovered documents published in G. Martines, 'Francesco di Giorgio a Gubbio in tre documenti d'archivio rinvenuti e trascritti da Pier Luigi Menichetti' in *Ricerche di storia dell'arte*, 1980, II, pp. 67–68.

2 P. Rotondi, *Il Palazzo ducale di Urbino*, Urbino 1950, *passim*; A. Angelini, in *Francesco di Giorgio e il Rinascimento a Siena 1450–1500*, Milan 1993, pp. 332–345.

3 On Girolamo di Benvenuto, see B.B. Fredericksen and D.D. Davisson, *Benvenuto di Giovanni, Girolamo di Benvenuto. Their Altarpieces in the J. Paul Getty Museum*, Malibu 1966; F. Zeri, 'Girolamo di Benvenuto: il completamento della "Madonna delle Nevi" in *Antologia di belle arti*, 1979, III, 9–12, pp. 48–54; A. Angelini, in *La Pittura in Italia. Il Quattrocento*, Milan 1987, II, pp. 649–650.

4 For the most recent work on the predella with the scenes from the *Life of St Catherine of Siena*, see E. Moench Scherer, in *Catherine de Sienne*, exhibition catalogue, Avignon 1992, pp. 254–255.

5 On Guidoccio Cozzarelli and the two commissions for the church of San Bernardino in Sinalunga, see L. Pardekooper, 'Due famiglie rivali e due pale di Guidoccio Cozzarelli per Sinalunga' in *Prospettiva*, 1993, 72, pp. 51–65.

6 A. Angelini, 'Da Giacomo Pacchiarotti a Pietro Orioli' in *Prospettiva*, 1982, 29, pp. 72–78; idem, 'Pietro Orioli e il momento "urbinate" della pittura senese del Quattrocento' in *Prospettiva*, 1982, 30, pp. 30–43; K. Christiansen, in *La Pittura senese nel Rinascimento 1420–1500*, Siena 1989, pp. 29–30; L. Kanter, ibid., pp. 349–353; P. Santucci, 'La Pittura del Quattrocento' in *Storia dell'arte in Italia*, Turin 1992, pp. 235–236.

7 A. Angelini, in *Francesco di Giorgio*, pp. 368–371.

8 Among the Sienese sources that mention the events described by Niccolò Machiavelli as the 'Tuscan war', see T. Fecini, *Cronaca senese* (post 1479), B.C.S.A. VII. 9, edited by A. Lisini and F. Jacometti, in *Rerum italicarum scriptores*, Bologna 1931–1939, XV, part VI, p. 874; A. Allegretti, 'Diarj scritti da Allegretto Allegretti delle cose sanesi del suo tempo' (before 1497), in L.A. Muratori, *Rerum italicarum scriptores*, Milan 1733, XXIII, p. 794.

9 For the two Gabella panels, see A. Angelini, in *Francesco di Giorgio*, pp. 362–363 and 366–367. The first reference to the *Agreement between the Classes and the Offer of the Keys of the City to the Virgin of Mercy* can be found in L. Kanter, in *La Pittura senese nel Rinascimento*, p. 335, note 1.

10 M. Maccherini, in *Francesco di Giorgio*, pp. 326–327.

11 C. Zarrilli and P. Sinibaldi in *Le Biccherne, tavole dipinte delle magistrature senesi (secoli XIII–XVIII)*, Rome 1984, pp. 190–191 and 192–195. The three panels, from the years 1487, 1488 and 1489, are usually attributed to Guidoccio Cozzarelli. However, E. Trimpi (*Matteo di Giovanni. Documents and a Critical Catalogue of his Panel Paintings*, Ph.D. thesis, University of Michigan, Ann Arbor 1987, pp. 150–153, 224–226 and 227–229) has recently definitively changed the attribution to Matteo di Giovanni in the light of a previously unpublished document recording payment (ibid., pp. 73–74). Guidoccio Cozzarelli is still given the Gabella panels of 1484 with the *Presentation in the Temple* (P. Sinibaldi, *Le Biccherne*, pp. 186–187) and the example at one time belonging to the Vigdor Collection, Vienna. See M.A. Ceppari, 'Tra legislazione annonaria e tecnologia: alla ricerca di una biccherna perduta' in A. Ascheri (ed.), *Antica legislazione della Repubblica senese*, Siena 1993, pp. 200–208.

12 Vespasiano da Bisticci, 'Lamento d'Italia per la presa di Otranto fatta dai Turchi nel 1480' in *Archivio storico italiano*, 1843, IV, pp. 461–462; P. Schubring, 'Das Blutbad von Otranto in der Malerei des Quattrocento' in *Monatshefte für Kunstwissenschaft*, 1908, II, pp. 593–601.

13 R.H. Hobart Cust, *The Pavement Masters of Siena (1369–1562)*, London 1901, pp. 22–23; G.S. Aronow, *A Documentary History of the Pavement Decoration in Siena Cathedral, 1362 through 1506*, Ph.D. thesis, Columbia University, New York 1985, Ann Arbor 1989, pp. 211–235.

14 For a different opinion see J. Pope-Hennessy, 'A Shocking Scena' in *Apollo*, 1982, 241, pp. 150–157.

15 E. Trimpi, *Matteo di Giovanni*, pp. 160–162 and 206–208. For F. Bologna (*Napoli e le rotte mediterranee della pittura. Da Alfonso il Magnanimo a Ferdinando il Cattolico*, Naples 1977, p. 155ff.), the Naples panel could be dated 1478 and, therefore, would have no relationship with the siege of Otranto.

16 F. Bologna, *Napoli e le rotte mediterranee*, pp. 155ff.; P. Santucci, *La Pittura nel Quattrocento*, p. 236.

17 Among the most recent publications on the pavement of the cathedral is B. Santi, *Il Pavimento del Duomo di Siena*, Florence 1982. See also G.S. Aronow, *A Documentary History of the Pavement*; A. Landi, 'Racconto' del *Duomo di Siena* (1655), Florence 1992, pp. 58ff., with extremely useful notes by the editor E. Carli. For the iconographic sources relating to the cycle of the *Sibyls*, see R. Guerrini, 'Le Divinae Institutiones di Lattanzio nelle epigrafi del Rinascimento.

Il Collegio di Cambio in Perugia ed il pavimento del Duomo di Siena (Ermete Trismegisto e Sibille)' in *Annuario dell'Istituto Storico Diocesano di Siena*, 1992–1993, I, pp. 5–38; A.M. Romaldo, 'Corpus Titulorum Senensium, le Divinae Institutiones e il pavimento del Duomo di Siena', ibid., pp. 51–79.

18 The proposal has been put forward by Andrea De Marchi, in *Francesco di Giorgio*, p. 448.

19 A. Landi, 'Racconto', pp. 32–37.

20 C. Sisi, 'Le tarsie per il coro della cappella di San Giovanni: Antonio Barili e gli interventi senesi di Luca Signorelli' in *Antichità viva*, 1978, XVII, 2, pp. 33–42.

21 M. Trionfi Honorati, 'Antonio e Andrea Barili a Fano' in *Antichità viva*, 1975, XIV, 6, pp. 35–42.

22 The most up-to-date consideration of this complex critical problem can be found in S. Fraschetti, in *Francesco di Giorgio*, pp. 374–381.

23 A. Angelini, 'Resti di un "cenacolo" di Pietro Orioli a Monte Oliveto' in *Prospettiva*, 1988–1989 (1990), 53–56 (*Scritti in ricordo di Giovanni Previtali*), pp. 291–298.

24 G. Milanesi, *Documenti per la storia dell'arte senese*, Siena 1856, II, pp. 391–392.

25 Ibid., p. 391; A.S. Weller, *Francesco di Giorgio 1439–1501*, pp. 372–373.

26 A. Angelini, in *Francesco di Giorgio*, pp. 372–373.

27 The panel is now in the British Library, London. See C. Zarrilli, in *Le Biccherne*, pp. 192–193. The attribution to Matteo di Giovanni has recently been confirmed by E. Trimpi, *Matteo di Giovanni*, pp. 150–153, note 11.

28 G.A. Pecci, *Memorie storico-critiche della città di Siena che servono alla vita civile di Pandolfo Petrucci dal MCCCCLXXX al MDXII* (1755), Siena 1988, I, pp. 46ff.

29 See M. Seidel, 'Die Fresken des Francesco di Giorgio' in *Mitteilungen des Kunsthistorischen Institutes in Florenz*, 1979, XXIII, pp. 1–108; F. Sricchia Santoro, in *Francesco di Giorgio*, pp. 420–423 and 444–447.

30 A. Angelini, *Da Giacomo Pacchiarotti a Pietro Orioli*, p. 77; idem, *Francesco di Giorgio pittore*, pp. 20–21.

31 A. Bagnoli, in *Francesco di Giorgio*, pp. 440–443.

32 M. Seidel, 'Signorelli um 1490' in *Jahrbuch der Berliner Museen*, 1984, XXVI, pp. 181–256.

33 On this painter, see the bibliography in A. Angelini, *Francesco di Giorgio*, pp. 424–427.

34 A. da Seggiano, *Seggiano. Castello del Montamiata*, Florence 1913, pp. 116–120; A. Conti, 'Gli affreschi di San Rocco a Seggiano hanno un padre' in *Nuovo Amiata*, February 1985, p. 3; A. Angelini, in *Francesco di Giorgio*, p. 424.

35 M. Parisi, in *Francesco di Giorgio*, pp. 434–437 and 525.

36 For the most recent bibliography on the Griselda Master, see V. Tàtrai, 'Il Maestro della storia di Griselda e una famiglia di mecenati dimenticata' in *Acta historiae artium academiae scientiarum fungaicae*, 1979, XXV, pp. 27–66; A. Angelini, 'Intorno al "Maestro di Griselda"' in *Annali della fondazione di studi di storia dell'arte Roberto Longhi*, 1989, II, pp. 5–15; L. Cavazzini, in *Francesco di Giorgio*, pp. 524–525.

37 On the series of heroes, which has been linked to the Piccolomini family, see R. Bartalini, in *Francesco di Giorgio*, pp. 462–469.

38 F. Zeri, *Italian Paintings in the Walters Art Gallery*, Baltimore 1976, I, pp. 134–138.

39 For the most recent work on this painting, see M. Seidel, 'Francesco di Giorgio o Ludovico Scotti? Storia della "Pala Tancredi" in San Domenico a Siena' in *OPD*, 1989, 1, pp. 31–36; idem, 'Sozialgeschichte', pp. 91–116; idem, in *Die Kirchen von Siena*, Munich 1992, II, pp. 593–599 and 909–911, docs. 149 and 152–153. Also A. Angelini, in *Francesco di Giorgio*, pp. 476–480.

40 C. Maltese, 'Il protomanierismo di Francesco di Giorgio Martini' in *Storia dell'arte*, 1969, 4, pp. 440–446; F. Fumi, 'Nuovi documenti per gli angeli dell'altar maggiore del Duomo di Siena' in *Prospettiva*, 1981, 26, pp. 9–25.

41 K. Christiansen, in *La Pittura senese*, p. 36, note 37; M. Seidel, 'Sozialgeschichte', pp. 91–105; M. Parisi, in *Francesco di Giorgio*, pp. 482–483.

42 For a more up-to-date critical profile of Bernardino Fungai, see M. Parisi, in *Francesco di Giorgio e il Rinascimento*, pp. 521–522.

43 For a new chronological order of these painters and a concise profile, see A. De Marchi, in *La Sede storica del Monte dei Paschi di Siena. Vicende costruttive e opere d'arte*, edited by F. Gurrieri, L. Bellosi, G. Briganti and P. Torriti, Florence 1988, p. 320; M. Folchi, in *Francesco di Giorgio*, pp. 470–473 and 527.

44 E. Carli, *Le Storie di San Benedetto a Monteoliveto Maggiore*, Milan 1980, pp. 7–11. For a different internal dating of Signorelli's frescoes in Monte Oliveto Maggiore, see L. Kanter, *The Late Works of Luca Signorelli and his Followers, 1498–1559*, Ph.D. thesis, New York University 1989, pp. 72–92. On the present state of the conservation of the cycle, see C. Alessi and D. Rossi, in *Restauri e recuperi in terra di Siena*, Siena 1995, pp. 13–16.

45 F. Sricchia Santoro, in *Francesco di Giorgio*, pp. 486–487.

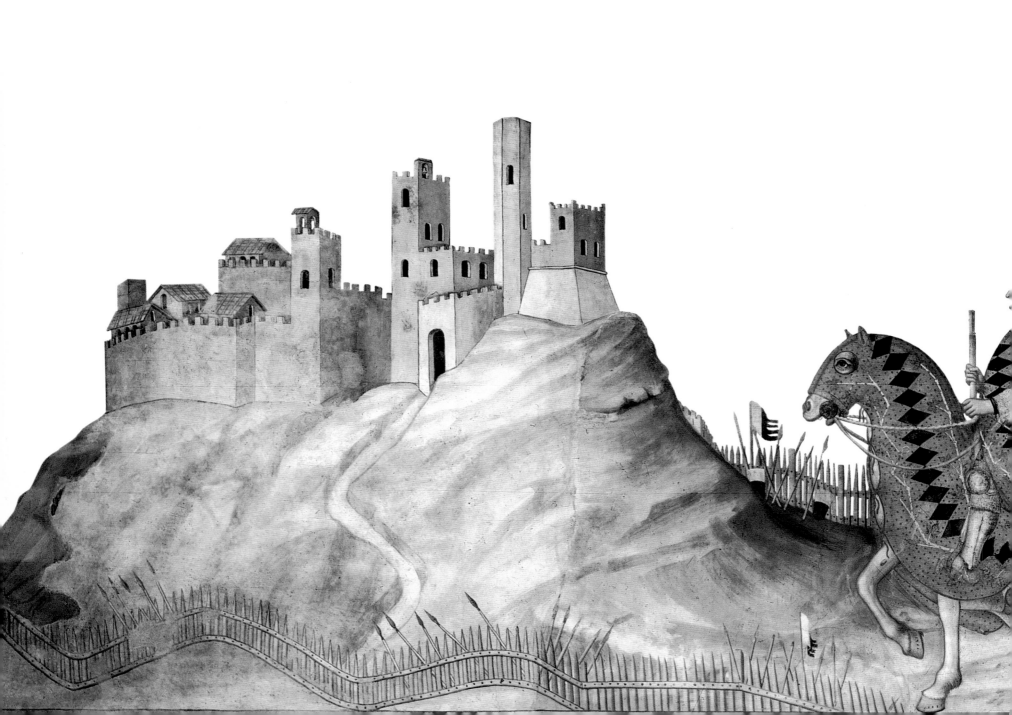

Bernardina Sani

The Sixteenth and Seventeenth Centuries

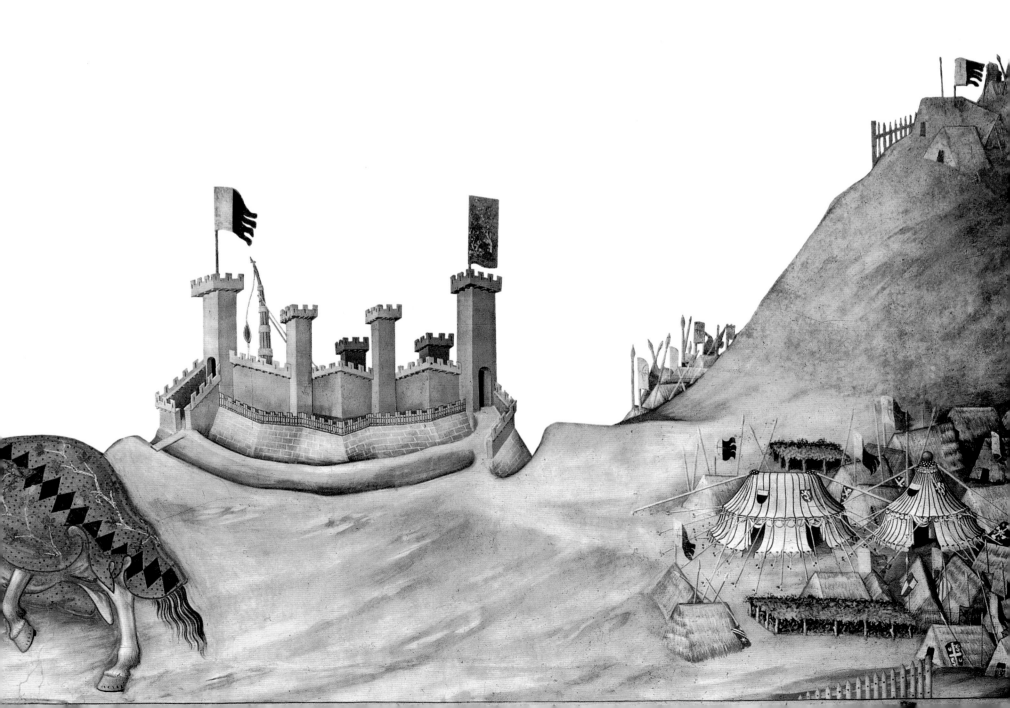

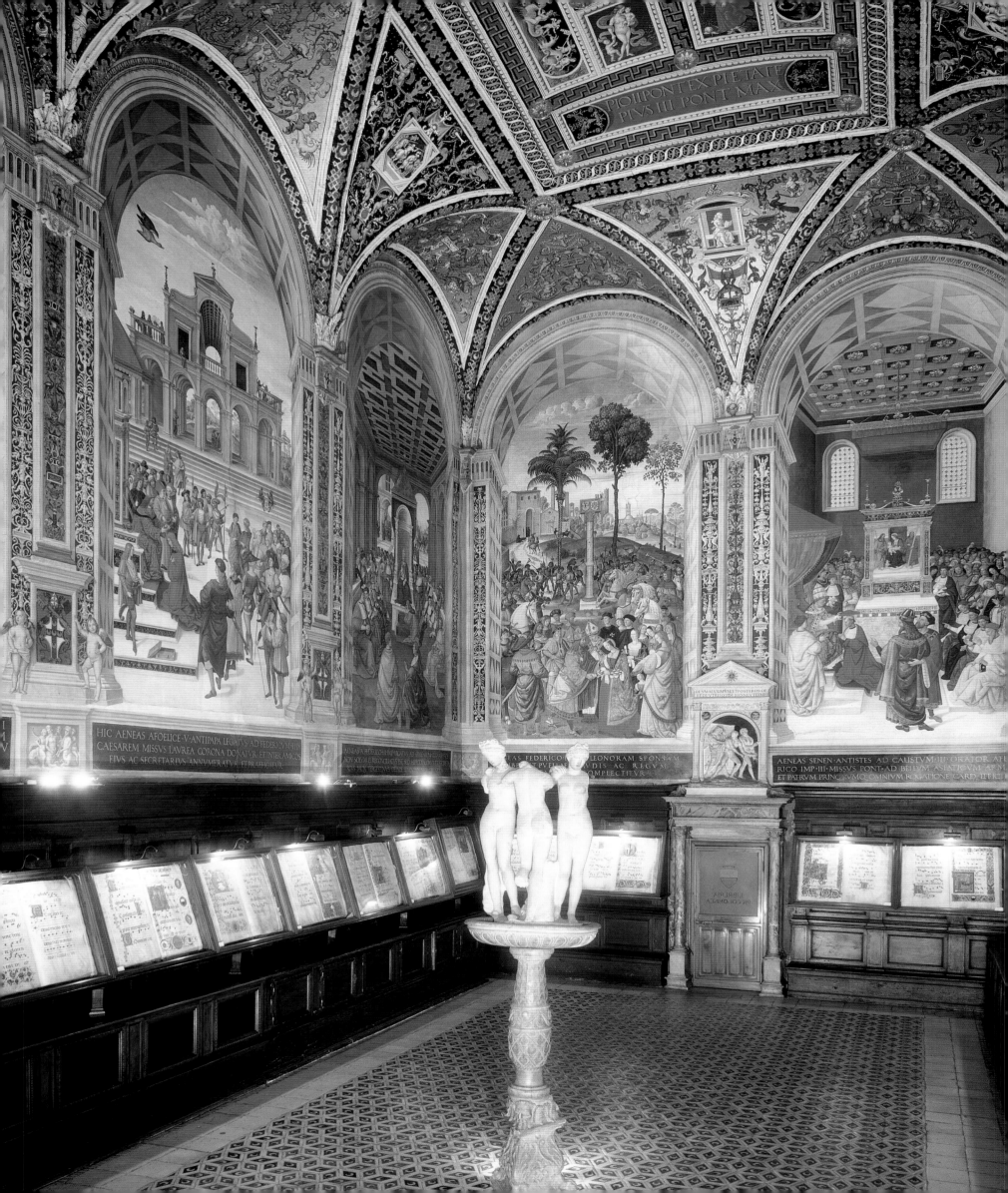

From Classicism to the *Maniera Moderna*

The Piccolomini Library: a Camera Picta *for a Humanist Pope*

The return of the exiles associated with the Monte dei Nove was instrumental in Pandolfo Petrucci's rise to power at the beginning of the sixteenth century. This contributed to the transformation of the city. The progress of humanism and its associated studies, indicated by the presence of Filelfo and by connections with the fifteenth-century Florentine humanists Bruni and Bracciolini,[1] left a deep impression on the arts. The first field to be affected was that of town planning. The magistracy in charge of coordinating building within Siena set out to glorify the city,[2] altering the appearance of Siena and transforming the lifestyle of the patrician families. Decorum and magnificence were key words for supporters of the Nove and for the powerful merchants who converted their own houses, endowed chapels and influenced the decorations in the cathedral and in the Ospedale di Santa Maria della Scala.

In the space of a few years, the outdated pictorial syntax of Benvenuto di Giovanni and Girolamo di Benvenuto was relegated to a past that could not be revisited, following the spread of Perugino's extremely successful style. However, in Siena this style was not adopted in a uniform manner. Intent on increasing their importance, families such as the Piccolomini brought Roman influences to Siena. The Petrucci family, with their aspirations to aristocratic magnificence, emulated the Piccolomini, as did the Chigi and the Spannocchi, powerful banking and merchant families. These families, with their knowledge of Rome, Urbino and Milan, presided over the transformation of the pictorial decoration of the palaces, churches and monasteries of Siena. Their input added a number of other influences to the sweet classicism of Perugino, preparing the way for the *maniera moderna*.

p. 324
Piccolomini Library, Siena Cathedral.

The Piccolomini Library, together with the cathedral pavement and the St Catherine Chapel in San Domenico, has always had great popular appeal. An understanding of the works should consider the enduring fame of the frescoes and ignore the often excessive enthusiasm or condemnation of past authors. The *Swoon of St Catherine of Siena* inspired Ingres and the Purists, who interpreted Sodoma's images of piety and mysticism with sentimental sobriety. The scenes from the *Life of Pius II* by Pinturicchio became a prototype of history painting for the Pre-Raphaelites and the Decadents. After the devastating fire of 1834 it was proposed that the decoration of the newly rebuilt Houses of Parliament in London should be modelled on the Piccolomini Library frescoes. William Dyce was sent from the Royal Academy to study and to gather inspiration in the library.[3] The decline of the Decadent movement led to a drop in art-historical appreciation of the Piccolomini frescoes, Berenson being a particular case in point. The public, however, who were greatly attached to the illustrative and celebratory character of the fresco cycle, continued to admire Pinturicchio's magnificent example of history painting.

The scenes were painted in the crucial early years of the sixteenth century. During this time the sweet classicism of the Umbrian school conquered Sienese painting. When Pinturicchio undertook the library commission he was nearing the end of his career and his style was under threat from the imminent emergence of artists such as Raphael. Pinturicchio illustrated the powerful Piccolomini family's desire for a nostalgic evocation of their glories. The work was completed while Pandolfo Petrucci was consolidating his power over Siena at a time when the favoured artists in Siena were Signorelli, Perugino and Pinturicchio.

In 1492 Cardinal Francesco Todeschini Piccolomini, archbishop of Siena, began constructing a hall, made out of the old cathedral canonry, to house the Greek, Latin and Hebrew codices of his maternal uncle, the great humanist pope, Pius II. Francesco's intention was to decorate the room on the model of the classically inspired Vatican Library commissioned by Sixtus IV, his knowledge of which stemmed from his long stays in Rome when he studied there assiduously. Francesco was interested in both literature and art and witnesses from within the humanist world wrote about his collection. 'He had the graces in niches', wrote Poliziano. He was referring not only to the celebrated marble group that had been seen by Albertini[4] and was later transferred to the Piccolomini Library, but also to Cardinal Piccolomini's collection of manuscripts. The original holding had been formed by Pius II but was added to by Francesco. Cardinal Piccolomini wanted to house the collection in his native city, the place where Pius II had studied during his youth. The Piccolomini family had already played a decisive role in the urban development of Siena by constructing two palaces designed by Rossellino and situated in via di Città and in Banchi di Sotto. The geometric façades of the Piccolomini palaces stood in contrast to the crooked medieval streets. The magistracy in charge of coordinating building within Siena described them as 'marvellous work' and a 'very dignified ornamentation' of the city. Now Francesco wanted to add a library to these palaces, which were public only in so far as their imposing façades looked out on to the street. The proposed library was intended to celebrate the Piccolomini family.

Francesco did not turn to Sienese masters, limiting their contribution to the carpenter Antonio Barili who, between 1495 and 1496, produced the furniture in which to keep the manuscripts.[5] At around this time plans were made for the vault, which was to be decorated with leaf patterns. However, this remained a provisional solution because on 29 June 1502 the '*Cardinale di Siena*' signed a contract with '*Bernardino detto el Penturicchio pictore Perusino*' (Bernardino, called Pinturicchio, a painter from Perugia) for the fresco decoration of the room. Piccolomini chose one of Perugino's pupils who had already been employed in the greatest houses in Italy. Pinturicchio had painted a chapel 'barely touched by the new fashion for grotesque decorations' in Santa Maria in Aracoeli in Rome for the Bufalini in *c.* 1485. He had also worked in the Borgia apartments in the Vatican between 1492 and 1494, which contained decorations overflowing with classical

motifs, and had undertaken commissions for the Baglioni and the Della Rovere families. He therefore appeared to be the only fresco painter capable of completing a *camera picta* to celebrate humanism, diplomacy and Pius II. The artist was employed to paint, apart from the vault in fresco, ten stories recording the life of Pius II, 'with the appropriate figures, gestures and clothes that are necessary and suitable in order to express them [the episodes] well'. In Albertian terms, the cardinal wanted the pictures to convey the idea of decorum as defined in humanist tracts. As Pius II had affirmed in a letter of 1451, 'while eloquence thrives, painting thrives'.[6] Cardinal Piccolomini tried to bind Pinturicchio with a detailed contract, fearing that the master would not draw all of the scenes with his own hand, either in the preparatory cartoons or on the walls. The contract, therefore, specifies that Pinturicchio had to paint all the heads in fresco with his own hand, complete all the retouching *a secco*, and make sure that everything was finished according to his own best style. He was to be paid as each scene was completed.

Destiny intervened to obstruct the completion of the programme. On 21 September 1503 Francesco Todeschini Piccolomini became pope and took the name of Pius III. His good fortune did not last long because on 18 October 1503 he died and Pinturicchio was left to continue the frescoes without the advice of their instigator. Francesco had made a will in April 1503 in which the duty of continuing the work on the library in the event that he should die before it was complete fell to his heirs. From the text of the will it seems that the painting was not at a very advanced stage and it is probable that there was still work to be done on the vault, at the centre of which is the Piccolomini coat of arms with the cardinal's hat above it. The coat of arms also figures on the corbels at the top of the pilasters that divide the large arches. However it does not necessarily follow that the work had advanced this far by the end of 1503. It is difficult to establish the order in which the various parts of the library were decorated and if the ornamentation was given precedence over the figures. However, on the basis of the iconography, the easiest and most obvious theory would be that the vault and the corbels were completed before Francesco was elected Pope Pius III.

Between the death of Pius III and February 1508, when Agnese, the wife of Andrea Piccolomini, gave Pinturicchio the remaining part of his payment on behalf of her sons, the history of the decoration is shrouded in uncertainty. Until recently it was believed that work resumed in 1504 with the fresco of the *Coronation of Pius III as Pope* on the external wall of the library. The execution of the fresco would have interrupted the completion of the scenes dedicated to Pius II. However, in 1985 Beck discovered that the payment to the workmen who dismantled the scaffolding erected for the *Coronation* fresco was dated 1508 and that the scene was therefore a weak conclusion to the ambitious cycle planned for the interior of the library.[7]

From the document recording the final payment for the decoration of the library, it appears that Andrea Piccolomini supervised the execution of the frescoes after the death of Pius III. Andrea was one of Pius III's two brothers. The other brother, Giacomo, appears to have taken no part in the project. Andrea and Giacomo continued the humanist traditions of the family, lavishing great attention on the education of their children, whom they even enrolled in a literary club, the members of which were given Arcadian names. The two brothers continued to take an active interest in the appearance of the architectural and pictorial undertakings of the family.[8] Notwithstanding the clauses of the Piccolomini Library contract, which forbade him to undertake any other work, Pinturicchio still accepted other commissions. Andrea and Giacomo Piccolomini did not seem able to prevent this. In fact, Andrea himself commissioned Pinturicchio to paint an altarpiece for San Francesco.

Sienese art at the time of the decoration of the Piccolomini Library was dominated by Pinturicchio's workshop, which originally came from Umbria but had also operated in the centre of Italy and undertaken prestigious commissions in Rome. Vasari testifies that there were 'many boys and workmen from Pietro's school' in this workshop.[9] This proves that pupils of Pietro Vannucci, otherwise known as Perugino

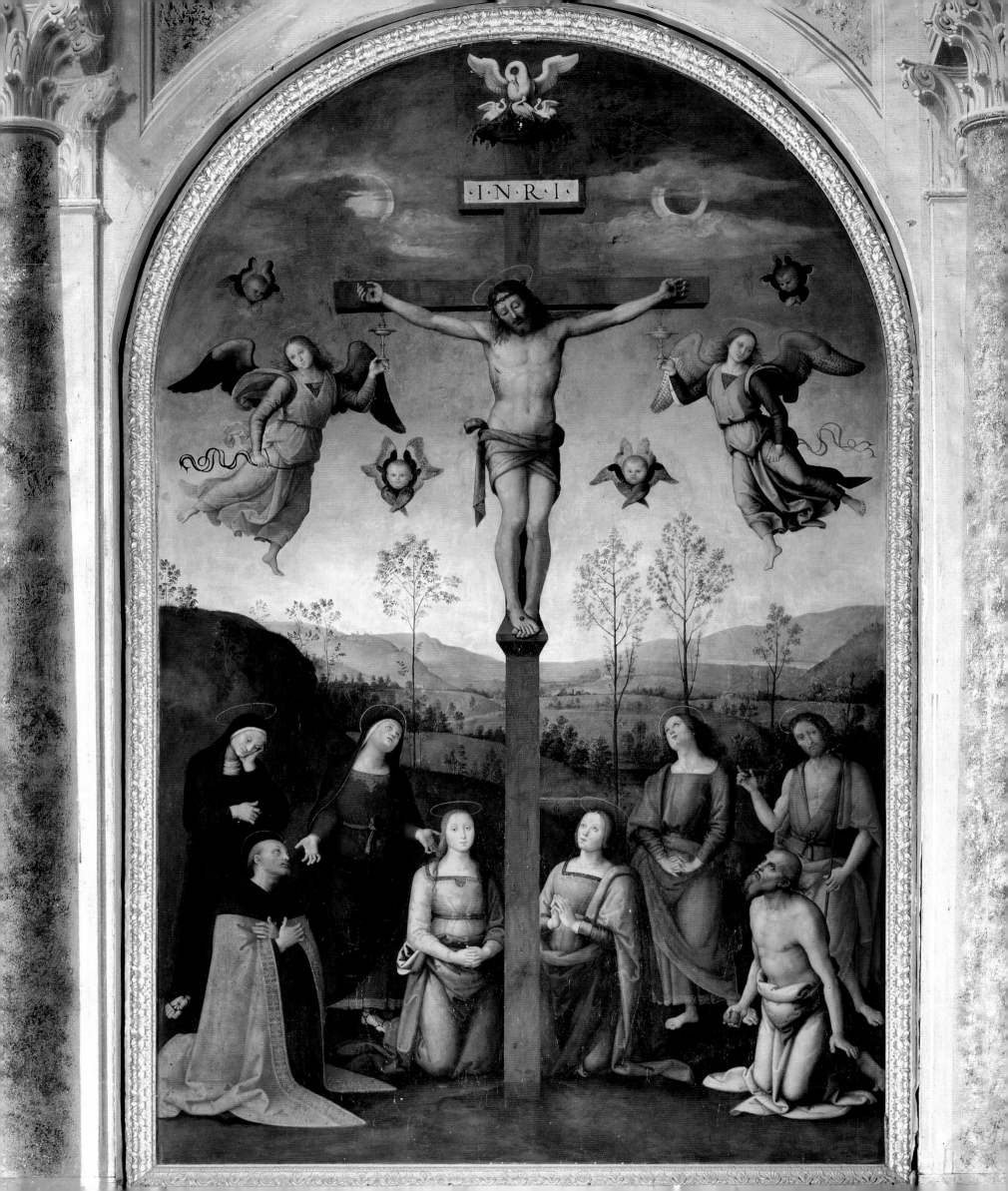

whose 'sweet style' was the freshest manifestation of the *maniera moderna*, transferred to Pinturicchio's workshop.[10] The esteem in which Perugino was held in Siena is shown by Agostino Chigi's description in his letter of 7 November 1500 to his father Mariano. He relates his intention to commission Perugino to paint the altarpiece for the family chapel in Sant'Agostino: 'if he [Perugino] paints it with his own hand he is the best master in Italy. The painter called Pinturicchio has been his pupil. At present he is not here. There are no other masters who are of any value'.[11]

The Chigi competed among themselves in their commissions to Umbrian painters, or, more accurately, to the interpreters of the sweet classical style. In 1502 they signed a contract with Perugino for a *Crucifixion* to be placed on their altar in Sant'Agostino. The work, which is the greatest example of sweet classicism in Siena, was finished in 1506. Perugino, as the subtle interpreter of the languor and the affected airs of the saints who seem only mildly moved by Christ's Passion, which is set against a twilight landscape, had already earnt from Michelangelo the name of Goffo, meaning awkward or clumsy.[12]

According to Vasari, Perugino's pupils, among them Raphael, worked in the Piccolomini Library. It is difficult to ascertain whether Raphael was responsible for the original ideas behind the composition of the scenes, even if the presence of various works by Perugino and his workshop in Siena indicate that this is possible. In his life of Pinturicchio, Vasari relates: 'It is indeed true that the sketches and the cartoons for all the scenes there were by Raphael of Urbino, then a youth, who had been his [Pinturicchio's] companion and fellow-pupil under Pietro [Perugino], whose style Raphael had thoroughly mastered'.[13] However, in his life of Raphael, Vasari changes the extent of Raphael's intervention in the cycle and limits it to some drawings and cartoons. At the same time he is more precise about the dates, which allows us to place the compositions more securely within Raphael's career. Again according to Vasari, while working in Siena the young Raphael received news of the cartoons for Leonardo da Vinci's *Battle of Anghiari* and for Michelangelo's *Battle of Cascina*, which precipitated his move to Florence.[14] Michelangelo and Leonardo were the names that attracted the new generation of painters, causing ruptures in the style

p. 328
Perugino, *Crucifixion*.
Sant'Agostino, Siena.

of the young Sienese artists. One only has to look, besides Sodoma, at the early and little known training of Beccafumi.

Vasari's testimony has undoubtedly contributed to the success of the frescoes.[15] However, not all art historians are willing to accept Raphael's contribution to the cycle and there are a number of attributional problems relating to the few surviving drawings and cartoons. Opinion is divided as to whether they can be ascribed solely to Pinturicchio or whether Raphael was responsible for some of them. All the extant drawings show, in the design stage, the intervention of a strong personality, capable of remaining faithful to the spirit of Pius II's *Commentarii* text in a way that makes the ideas in the cartoons richer than those in the final painting.[16]

A comparison between the fresco of the *Departure of Aeneas Silvius Piccolomini for the Council of Basel* and the corresponding cartoon (Uffizi, Florence) demonstrates that in transferring the work on to the wall certain narrative qualities were lost. The cartoon, which is probably by the young Raphael, depicts the young Aeneas Silvius Piccolomini before his election to the papacy. The future pope wears hose and a small jacket. The scene is bathed in an atmospheric light

reminiscent of Leonardo da Vinci, while the figures dart here and there, created by lively movements of the pen. Raphael has captured the spirit of the narrative related by Pius II, which recalls all the aspects of his youth, even the political concepts that were then favoured by the Council, so different from those of his later years. Although the references to Florentine painting are evident, they do not allow a precise dating for Raphael's drawing.[17] It is only conjecture that it can be dated after the death of Pius II. In the fresco, where it is difficult to discern Raphael's direct intervention,[18] the protagonists and the scene become both more solemn and more commonplace. The young Aeneas Silvius Piccolomini, who is to accompany Cardinal Capranica to the Council of Basel, sits on a white horse as he turns to look at the spectator. He wears an ample cloak and a rather cumbersome hat with an upturned brim. The voyage to Basel was difficult. Pius II described how the tyrant Jacopo Appiano tried to stop them boarding the ship and also how a tempest meant that 'they were buffeted by violent gales and driven off their course to within sight of Africa'. However, the painting is only faithful to Pius II's lively description in iconography and not in spirit.

Pinturicchio, *Departure of Aeneas Silvius Piccolomini for the Council of Basel*. Piccolomini Library, Siena Cathedral.

Pinturicchio, *Departure of Aeneas Silvius Piccolomini for the Council of Basel*, detail. Piccolomini Library, Siena Cathedral.

Among Raphael's drawings relating to the frescoes in the Piccolomini Library, the cartoon of the *Meeting of Frederick III with Eleanor of Aragon* (Pierpont Morgan Library, New York) is similar to the fresco in its failure to follow the spirit of Pius II's narrative.

There are other drawings attributed to Raphael connected with the Piccolomini Library, such as one in the Ashmolean Museum in Oxford with warriors and putti holding shields, and two in the Louvre, a study of a putto and a first sketch of the framing arches. The drawings refer to the imposing scenographic elements that frame the episodes. The work in the Louvre shows Raphael's early thoughts about the arches, but does not contain the impressive perspective that can be seen in the frescoes and was stipulated in the contract.

Large arches in deep perspective form a loggia through which one sees ten of the most important events in the life of Pius II. They are the *Departure of Aeneas Silvius Piccolomini for the Council of Basel, Aeneas Silvius Piccolomini as Ambassador to the King of Scotland, Aeneas Silvius Piccolomini Crowned Poet by the Emperor Frederick III, Aeneas Silvius Piccolomini Makes an Act of Submission to Pope Eugene IV*, the *Meeting of Frederick III with Eleanor of Aragon, Aeneas Silvius Piccolomini Appointed Cardinal*, the *Coronation of Aeneas Silvius Piccolomini as Pius II, Pius II Holds an Assembly at Mantua to Organize a Crusade against the Turks*, the *Canonization of St Catherine of Siena* and *Pius II Goes to Ancona in order to Encourage the Crusade*. The pope's life is narrated in a uniformly celebratory tone. The pictorial language recalls the sweetness and quiet elegance of Umbrian painting, particularly in *Aeneas Silvius Piccolomini as Ambassador to the King of Scotland*. At the centre of the landscape background, a great lake opens out behind the mixed marble columns supporting an ornate arcade with medallions, which in turn contain busts of classical warriors.

The fresco of *Aeneas Silvius Piccolomini Crowned Poet by the Emperor Frederick III* is extremely clearly lit. Its complex perspective construction recalls similar perspective games with which Pinturicchio had already experimented in the frescoes of the *Life of St Bernardino* in Santa Maria in Aracoeli in Rome. The Roman scenes contain architecture that is reminiscent of Perugino's works in the Sistine Chapel and it appears that an attempt has been made to arrange the scenes organically.

Raphael, *Departure of Aeneas Silvius Piccolomini for the Council of Basel*. Uffizi, Florence.

Raphael, *Departure of Aeneas Silvius Piccolomini for the Council of Basel*, detail. Uffizi, Florence.

The ceiling of the Piccolomini Library merits a separate discussion. The contract of 1502 engaged Pinturicchio to furnish a decoration 'with those fantasies, colours and compartments which he [Pinturicchio] will judge most imaginative, most beautiful and most decorative'. It went on to require that the decorations should be those 'that are today called grotesques… as will be considered most beautiful and most imaginative'. This was a reference to the fashion for the fantastic decorative elements inspired by classical art that had become known in Rome through the discovery of Nero's Domus Aurea (Golden House). The ceiling decoration did not follow a precise programme, nor did it presuppose a correct interpretation of the classical motifs. The depiction of the *Rape of Proserpine* on the ceiling is a direct quotation from an antique sarcophagus. The other antique motifs, however, are not faithful to their sources. They are placed on backgrounds of contrasting colour or of fake mosaic, a solution already employed by Pinturicchio in Rome.[19] Furthermore, the motifs are sometimes inspired by fifteenth-century candelabra.[20] With regard to the quality of the painting, the ceiling is not considered one of Pinturicchio's greatest achievements and was probably painted mainly by his assistants. This has recently led some art historians to suggest links with Perugino's famous precedent in the vault of the Sala dell' Udienza in the Collegio del Cambio in Perugia and with Signorelli's vault frescoes in the San Brizio Chapel in Orvieto Cathedral.

The vault provides explicit confirmation that Sienese art was suspended between an acceptance of the new classical influences and the artistic hegemony of masters who belonged to the old order but were still influential. Not all artists working in the library kept abreast with the artistic developments of the day and it is perhaps relevant to look at the example of Pacchiarotto and Pacchia, who together painted the grotesques.[21] Although only partially, Pacchiarotto did absorb some of Perugino's ideas. On the other hand, thanks to his stay in Rome (documented in the inventory of Neroccio de' Landi's goods in 1500), Girolamo del Pacchia painted in the new sweet style using soft chiaroscuro, even though he was a local artist. His adopting the latest style foreshadows his more mature painting phase. It is not surprising, therefore, that figures like the *Charity* on the ceiling of

p. 332
Pinturicchio, *Aeneas Silvius Piccolomini as Ambassador to the King of Scotland*. Piccolomini Library, Siena Cathedral.

the library find similarities in the three scenes from a predella in Manchester, also attributed to Pacchiarotto and Pacchia, which demonstrate the diffusion of certain classicizing decorative ideas. For example, the monochrome motifs of sea monsters at the bottom of the candelabra that separate the scenes in the Piccolomini Library also ornament the architecture of the Manchester predella.

The sweet chiaroscuro of Perugino and Pinturicchio appeared the most suitable means to convey the decorum which had been Francesco Piccolomini's main aim when glorifying his uncle. Francesco, however, also appreciated a very different style of art. In 1501 he commissioned Michelangelo to sculpt fifteen statues for the family altar in Siena Cathedral but, despite the added financial backing of Andrea and Giacomo Piccolomini, the commission was never fulfilled.

In the first decade of the fifteenth century Michelangelo and Raphael, artists who ventured beyond the limits of graceful classicism, appeared in Siena like fleeting shadows, leaving hardly any trace. The younger generation of artists were then forced to look for inspiration elsewhere and to travel down less direct paths in search of Michelangelo and Raphael's art. It was only in this way that they were able to master the new style of painting. It was a complicated period because of the growth of classical influences, in both literature and archaeology. The sense of humanist commitment to which the Piccolomini had dedicated so much energy during the course of the previous century was to change as a result.

Sodoma, scene from the
Miracle of the Loaves and Fishes.
Sant'Anna in Camprena, Pienza.

Light and Emotion in Sodoma's Painting

Leonardo da Vinci was in Siena in 1502 but left no paintings in the city as far as we know. He was concentrating on his engineering studies, which he wanted to develop in conjunction with Paolo di Vannoccio Biringucci. His studies brought him into contact with the circle of Francesco di Giorgio Martini, his pupil Giacomo Cozzarelli and those who gathered around Pandolfo Petrucci. Leonardo's ideas on the depiction of light and emotion had a strong influence on Sienese art thanks to a painter from Lombardy, Giovanni Antonio Bazzi, known as Sodoma (1477–1549). Sodoma spent most of his career in Siena and was one of the protagonists of the style that developed in the city in the wake of Leonardo and Michelangelo. Vasari informs us that the painter, who came from Vercelli, was brought to Siena by 'some merchants, agents of the Spannocchi family', but he does not say that Sodoma's first paintings in Siena were Spannocchi commissions. It is possible that Sodoma's artistic career began before the powerful Spannocchi banking family,

who had branches in Rome and throughout Italy, precipitated his arrival in Siena. Many Lombard artists left Milan after the fall of Ludovico il Moro and travelled as far as central Italy and Rome. Sodoma's participation in this trend is supported by a document, dated in Siena on 13 March 1499, in which a certain '*Bartholomeus olim Ghulielmi de Bazio de Quirino*' received his brother Niccoluccio's legacy from Giulio and Antonio Spannocchi. Niccoluccio was a servant in the Spannocchi household and had been killed in Rome. If the Bartholomeus of the document can be identified as Sodoma, it indicates not only that Sodoma was linked with the Spannocchi family but also confirms his presence in Rome.[22] It is also possible that, since we know of no works executed by Sodoma under Spannocchi patronage, the artist was unable to work for them because of the family's insolvency that followed the death of Pius III. Their bankruptcy forced them to cede their palace to Pandolfo Petrucci, although perhaps only temporarily.[23]

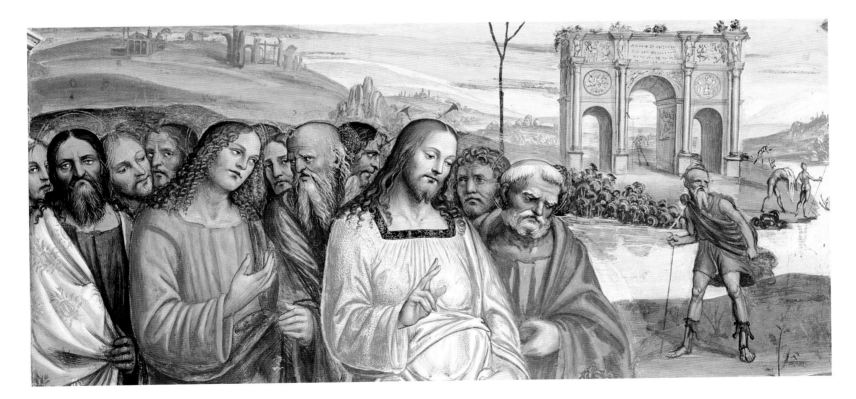

Sodoma, scene from the
Miracle of the Loaves and Fishes, detail.
Sant'Anna in Camprena, Pienza.

Sodoma's first work on Sienese territory is the fresco decoration of the refectory in the Olivetan monastery of Sant'Anna in Camprena. According to a contract made with the cellarer, Fra Andrea Cossa, it was started in 1503 and finished in June 1504.[24] The contract contained minute instructions about the iconographic programme and the positioning of the separate scenes. Sodoma had to portray some of the monks '*del proprio*', that is, from life and also to give the scenes 'beautiful and praiseworthy landscapes and scenes suitable to each of the stories'. On the wall opposite the entrance Sodoma painted the *Miracle of the Loaves and Fishes*. The composition is divided into three arched areas that are moulded to fit the ceiling vaults. Opposite this fresco and above the door is the *Pietà*. To the left of this is *St Benedict with some Monks* and to the right is *St Anne and the Virgin with Two Olivetan Monks*. On the other walls are monochrome frescoes with scenes from the *Life of St Anne* and a frieze of grotesques with *oculi* that frame figures of various saints. The regular arrangement of the elements in the scenes, above all in the *Miracle of the Loaves and Fishes* in which the landscape at the back forms an element of continuity spreading across all three

segments of the scene, cannot be understood without reference to Perugino's art. It is as though Sodoma had used Perugino's *Crucifixion* in Santa Maria Maddalena dei Pazzi in Florence as a model. However, the fresco cycle contains something substantially different from and almost contradictory to Perugino's artistic language. This can be seen in the areas of daring perspective in the *Pietà*, for example, where the Madonna stretches out her legs into the foreground, showing the spectator the soles of her shoes. The architecture in the frescoes as well as the compact and tersely expressed forms of the figures, in particular the heads of the Benedictine monks, give some clues about Sodoma's pre-Siena career. The virtuoso way in which Sodoma dealt with the perspective presupposes that he had spent some time in Milan and had come into contact with the daring perspective of Bramante and Bramantino. The delicate experiments with light – evidenced throughout the scenes – and those with expression – concentrated above all on the *Pietà* – indicate that Sodoma was aware of Leonardo's interest in movement, gesture and physiognomy. According to Leonardo, 'that figure is most praiseworthy that with his gestures best

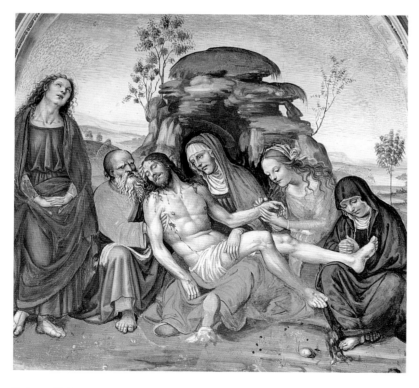

Sodoma, *Pietà*.
Sant'Anna in Camprena,
Pienza.

expresses the passion of his soul'. Sodoma's frescoes express the feelings of the protagonists, since without emotion the painting is 'two times dead'. In the *Pietà* this can be seen in the tearful face of the Virgin and the gloomy figure of the old man (perhaps Joseph of Arimathea or Nicodemus) who cleans the blood flowing from the wound in Christ's side.

The frescoes demonstrate Sodoma's desire to represent both realistic space and convincing psychology. In addition they show his familiarity with both Roman topography and the latest developments in painting in Rome, which can be seen in the grotesques, where Sodoma demonstrates a seemingly unending repertory of bizarre forms. His antiquarian citations reach their climax in the background of the fresco depicting the *Miracle of the Loaves and Fishes*,[25] which is littered with classical ruins. An amphitheatre recalls the Colosseum and a triumphal arch refers to the Arch of Constantine. There are also clear citations from classical statues such as the woman, with her back to us, carrying a baby and the boy grinding grain on a stone. The latter is reminiscent of the *Knife Grinder* (Uffizi, Florence) which during the early sixteenth century was in the Villa Farnesina in Rome, according to Agostino Chigi's inventory.[26] Its inclusion in the fresco is further confirmation that Sodoma must have spent some time in Rome even though we no longer have any written proof of this.

Once the frescoes in Sant'Anna in Camprena were finished, Sodoma undertook the commission of completing the frescoes in Monte Oliveto Maggiore which had been left unfinished by Signorelli. He worked there from August 1505 until 1508. During the time that Sodoma was in the monastery, Airoldi was master general of the order (1505–1507) and the abbot was Francesco II Ringhieri.[27] The cycle shows scenes from the *Life of St Benedict* that form an ambitious programme based on the *Dialogues of St Gregory*.[28] In the scenes, Sodoma's narrative ability which he had tested in his work in Sant'Anna in Camprena appears almost limitless. The spectator's eye can either glide over the grandeur of classical architecture before being plunged into tranquil and distant landscapes or study the extremely well individuated characters of the figures. Sodoma continued to employ a harsh approach in the early frescoes, which are still tied to the virtuoso use of perspective and the sentimentalism

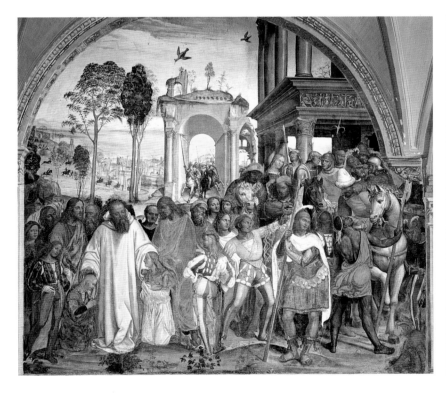

Sodoma, *St Benedict Receiving the Two Young Romans Maurus and Placidus* from *Scenes from the Life of St Benedict*. Main cloister, Monte Oliveto Maggiore, Asciano.

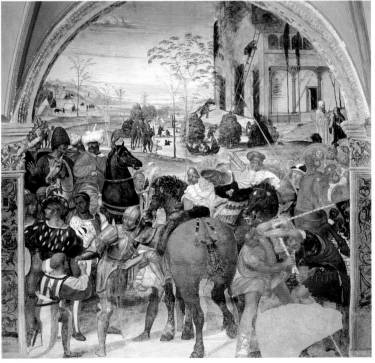

Sodoma, *St Benedict Foretelling the Destruction of Montecassino* from *Scenes from the Life of St Benedict*. Main cloister, Monte Oliveto Maggiore, Asciano.

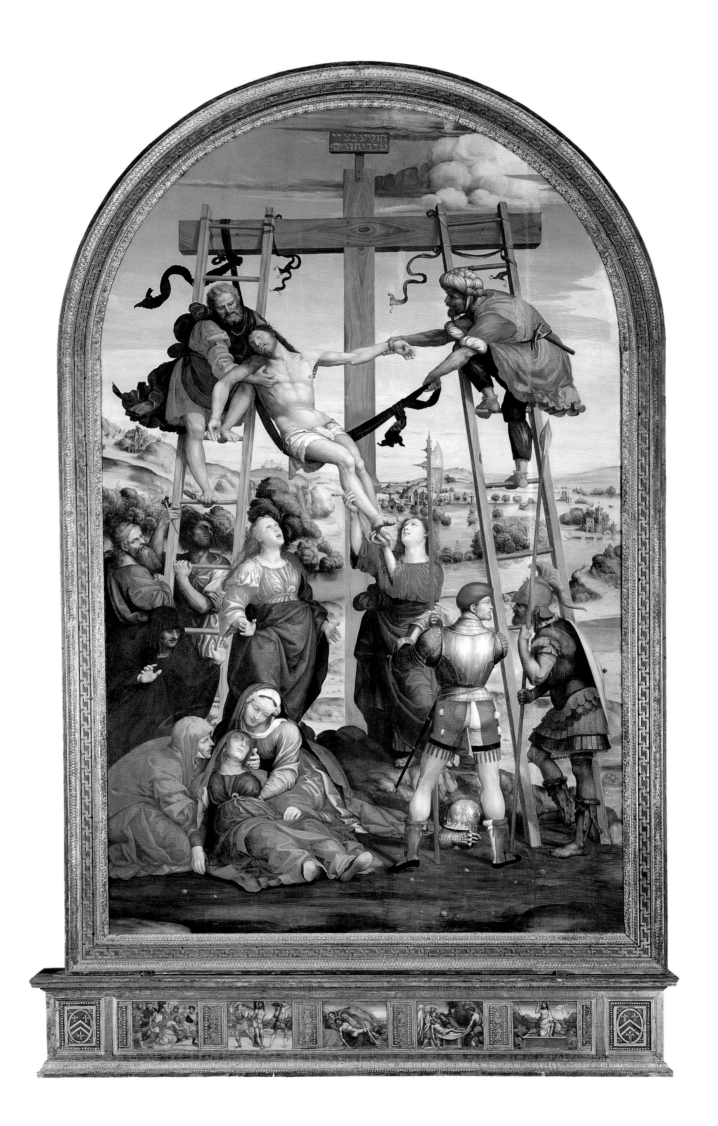

of his first Milanese works. They also relate to paintings like the *Pietà* in Santa Maria dell'Orto in Rome and the *Pietà* (private collection) published by Bagnoli, as well as to the frescoes in Subiaco. However, this harshness soon melts into a type of painting that is more reliant on a detailed study of the natural world. Sodoma's narrative skill enriches his compositions to a degree that almost rivals literature.

The work in the choir of Monte Oliveto must have resumed with the *Miraculous Conversion of the Wine into a Snake*. During restoration a parchment dated 1505 was found behind this fresco, the same year in which the frescoes in Sant'-Anna in Camprena were finished. The date of the document means that important differences between the cycles in Sant'-Anna in Camprena and in Monte Oliveto Maggiore cannot be attributed to Sodoma's supposed return to Lombardy. It is more likely that influences encountered in Tuscany account for the differences. We know that Sodoma had already looked towards Florence. Leonardo's cartoon of the *Battle of Anghiari* fascinated him and became a source of inspiration for his exaggerated compositions in which crowds of men and horses are depicted among the ruins of classical architectural complexes. Examples of such an influence are found in the frescoes of *St Benedict Receiving the Two Young Romans Maurus and Placidus* and *St Benedict Foretelling the Destruction of Monte-cassino*, the latter full of soldiers with caricatured facial features. These characteristics – already composed under the influence of Raphael – reappear in the *Deposition* (Pinacoteca, Siena) from the Cinuzzi family altar in San Francesco in Siena. Sigismondo Tizio recorded the painting in his *Historiae senenses* written in 1513, thereby providing a *terminus ante quem* for its completion. The style of the altar panel is very different from that of the frescoes in either Sant'Anna in Camprena or in Monte Oliveto Maggiore. The majestic and extensive setting of the *Deposition* makes it probable that it was painted some time after work at Monte Oliveto Maggiore had been completed.[29] The commission therefore cannot be directly related to the document of 1502 in which the heirs of Gherardo Cinuzzi declare their intention to execute his expressed wishes for the construction of an altar.

At the same time as the works for Monte Oliveto Maggiore, Sodoma must have painted the mythological and historical subjects for the palace that Sigismondo Chigi was

reconstructing in Casato, an assumption confirmed by Fabio Chigi's description in the *Commentari*. Chigi describes a room with a coffered ceiling, to which canvases containing subjects taken from Ovid's *Metamorphoses* were attached, and a room containing scenes from the *Life of Julius Caesar*. He attributes both of these to Sodoma. The classicizing style of the surviving small canvases from the *Metamorphoses* recalls the monochrome paintings of Sant'Anna in Camprena and, in particular, the scene of the *Expulsion of Joachim from the Temple*.[30] This implies a date close to the documented reconstruction of the palace and distant from the event that sparked the decoration – the marriage of Sigismondo Chigi to Sulpicia Petrucci in 1507. The model that the rising merchant Chigi probably wanted to emulate was Isabella d'Este's *studiolo*. It was one of the most ambitious decorative schemes to be planned in an Italian court and contained a complex allegorical programme derived from ancient fables. The artists who worked on the project included Mantegna, Costa and, between 1503 and 1505, Perugino. Perugino's *Fight between Love and Chastity* is the painting most closely linked to the art of Sodoma, but it left Isabella d'Este cold as she wanted a completely different type of charm for her rooms. However, it is possible that Perugino's work was well known among the Chigi, who were at that time admirers of Perugino.

Had the rise of humanism led to the widespread desire to live in a classical manner, *all'antica*? The Villa Chigi alle Volte seems to provide an answer. It was planned while Mariano Chigi was still alive and was completed by his son Sigismondo, perhaps by the hand of the young Baldassarre Peruzzi (1481–1536). Overall, the construction corresponds to the typology of the '*chasa sichondo el modo greco*' (house according to the Greek style) in the *Trattati di Francesco di Giorgio Martini*. It constitutes the ideal precedent for the suburban house commissioned from Baldassarre Peruzzi by Agostino Chigi in Rome. The Chigi, both in Siena and Rome, concentrated their attentions and their commissions on new artists – either those who were young or those who painted in a more 'modern' style.

The Munificence of Pandolfo Petrucci

Pandolfo Petrucci's role as a commissioner of art is different and more complex than that of the other heads of powerful Sienese families. At first glance it seems that he relied on established artists such as Pinturicchio and Signorelli for the decoration of his palace when, in reality, a hotbed of artists grew up around him. Unfortunately, these artists are no longer identifiable because their works have been ruined and there is little documentation. Pandolfo was a member of one of the old Sienese aristocratic families and a protagonist of the first wave of humanism. He had grown up in exile after the Petrucci, suspected of plotting to hand Siena over to Alfonso of Aragon, were forced to leave Siena while he was still a boy. After his return to the city, Pandolfo managed to seize the reins of power and succeeded in imposing an aristocratic government on Siena. He maintained his authority despite participating in the failed Magione plot which forced him into a brief exile.

When he returned to Siena, Pandolfo dedicated himself to constructing his palace, near to the cathedral, with the aim of honouring himself, his family, his descendants, and also his city.[31] A close consideration of this intention helps to explain Petrucci's iconographic and stylistic choices for the palace. It cannot have been by chance that in 1504 Pandolfo bought from the Accarigi a palace near the baptistery even though the Petrucci already owned a house in that area, probably adjacent to the new acquisition. Pandolfo's policy was one of self-aggrandizement, which he realized by building an aristocratic palace in the religious centre of Siena. He reasserted the power of the family by giving them a home in the centre of their native city, as they had had before the period of exile.[32]

The work of reorganizing the buildings was probably given to Giacomo Cozzarelli. The Palazzo Petrucci assumed the character of a small court, inspired by the Milanese court of Ludovico il Moro, of whom Pandolfo was a protégé.[33] The

façade of the Palazzo Petrucci did not have the scenographic characteristics of the 'Florentine' palaces of the Piccolomini and the Spannocchi, designed by Bernardo Rossellino and Giuliano da Maiano respectively. Its exterior was less grandiose and was decorated almost solely by large wrought-iron rings and by torch-holders cast in bronze by Cozzarelli. In the first half of the sixteenth century, even after the death of Pandolfo, the rooms of the palace were used to host princes and cardinals such as Bernardino Carvajal, Francesco Alidosi and Ascanio Sforza. By the second half of the sixteenth century, after the fall of the Republic, the palace had already been divided into four apartments. These were inhabited by members of the family and, as a result of weddings, by extended families. A quarter of the palace belonged to Camillo Venturi and Gerolama Petrucci, a half to Borghese Borghesi, Giulia Petrucci and Anton Maria Petrucci,[34] and the last quarter to Marcello Bandinelli, as has been confirmed by a recently discovered document. Very few paintings decorate the rooms of the Bandinelli apartment but some of them probably constitute the remains of Pandolfo Petrucci's original rich decoration. There are a highly respected portrait of a

woman by Raphael of Urbino ('*un Ritratto d'una Donna stimato di Raffaello da Urbino*'); a tondo of Our Lady, the work of Luca Signorelli ('*un tondo con una nostra donna opera di Luca Signorelli*'); and a Venus by Mecarino (Beccafumi) made out of a headboard ('*una Venere di Mecarino cavata da una lettiera*'). Venus also featured in the room painted by Beccafumi for Francesco di Camillo Petrucci at the end of the second decade of the sixteenth century. A headboard made into a painting, believed to be by Pacchiarotto, showed the story of Ariadne and Theseus which the inventory wrongly describes as the story of Ariadne and Perseus (*una testiera ridotta in un quadro che mostra l'istoria di Arianna con Perseo opera del pachiarotto*).[35] Since the works of Pacchia and Pacchiarotto were often mistaken for one another, it is possible that the inventory refers to the *Abandoned Ariadne* in the Chigi Saracini Collection. The dispersal of the collection, testified to by Guglielmo Della Valle and by Giovan Girolamo Carli, was complete by the end of the nineteenth century.

Two aspects of Pandolfo's patronage are particularly important. On one hand there was his interest in the practical problems of engineering, metallurgy and architecture, while

Early sixteenth-century
Sienese painter, *Justice*.
Sala delle Deità e Virtù,
Palazzo Petrucci, Siena.

on the other was his real passion for allegories and ancient stories, translated into painting by artists from both the old and new generations. Pandolfo's own responsibilities, such as being *operaio* of the Opera del Duomo, allowed him to participate in activities that, besides economic and property functions, included the supervision of architecture and decorative displays. One aspect that stands out is his industrial initiatives, such as the creation in 1488 of a company that utilized Siena's water resources. Francesco di Giorgio, Paolo Salvetti and Paolo Vannocci were also involved in this venture. They were later joined by others including Giacomo Cozzarelli, Pandolfo's favourite architect and sculptor.[36] His ownership of numerous mines and his responsibility for public weapons enabled Pandolfo to consolidate his business relationships with both architects and founders. His involvement with arms provided particularly close links to Vannoccio, son of Paolo Biringucci, an expert founder and the author of a treatise entitled *De la pyrotecnia*.

Business enterprises did not detract from the importance of Pandolfo's relationships with artists. He was closely involved with a number of painters in his projects for the restructuring of the convent of the Osservanza, where he prepared the family mausoleum. The same is true for the work on the church of Santo Spirito and for the construction of the convent of the Maddalena outside Porta Tufi. Pandolfo's plans for his palace are closely linked to those for his brother Giacoppo's palace in Piazza del Duomo. After Giacoppo's death and the struggle between the two branches of the Petrucci family, Giacoppo's house was incorporated into the Medici governor's palace in the course of the sixteenth century. The palace would have enjoyed the magnificence appropriate to a family seat and therefore its decoration gave prominence to the heraldry associated with Pandolfo's marriage politics. In 1507 his daughter Sulpicia married Sigismondo Chigi and in 1509 his son Borghese married Vittoria Piccolomini.

According to Vasari's testimony in his life of Girolamo Genga, there were various rooms containing pictorial decoration in the palace. Unfortunately, there are now only two rooms with any decoration remaining,[37] which are the only two mentioned by Carli and Della Valle in the mid-eighteenth century.[38] One of the rooms contained a frieze of

Master of the Saracini Heroines, *Cleopatra*. Chigi Saracini Collection, Siena.

Master of the Saracini Heroines, *Cleopatra*, detail. Chigi Saracini Collection, Siena.

twelve compartments with half figures of women representing goddesses and virtues. These are known through three fragments (two in the Art Museum, Princeton University, New Jersey, and one still *in loco*) depicting *Minerva*, *Prudence* and *Justice*.[39]

The figures are separated by grotesques, in which strange winged figures are entwined. Some of these beings have horn-like ears and protuberances on their foreheads that look like noses. They are quite different from ancient Roman models.[40] These comic diversions can be seen, in a more simplified form, not only in the grotesques below the scenes in the San Brizio Chapel in Orvieto Cathedral by Luca Signorelli, but also in the motifs carved by Antonio Barili in the pilaster strips of the Palazzo Petrucci (Soprintendenza ai Beni Artistici e Storici, Siena).

The goddesses and virtues in the Palazzo Petrucci must have been completed between 1504, the date when the palace was bought from the Aringhieri, and 1507. They are mentioned in three epigrams by Evangelista Maddaleni Capodiferro composed no later than the latter date. The epigrams record a Venus '*picta ad focum Pandulphi Petrucci*' (painted

for Pandolfo Petrucci's home) and also '*Juno depicta et cypride Pallas*' (a painted Juno and Cypriot Pallas). They are, therefore, contemporary with the decoration of the Piccolomini Library and with the antique fables in the Palazzo Chigi in Casato, and yet they are completely different, mainly because of the clear political significance of at least two of the virtues – *Prudence* and *Justice*. These virtues, together with the goddesses *Pallas*, *Venus* and *Juno*, refer to the duties of a leader at the height of his success. Pandolfo had dealt prudently with threats from Florence and had been just in his dealings with the citizens of Siena. Moreover, the figures form part of a hortatory tradition that had been consolidated in Siena. It included not only the famous men destined for public decorative programmes, such as Taddeo di Bartolo's *Uomini Illustri* in the Palazzo Pubblico, but also series of heroic figures, mainly female, destined for private decorative programmes, such as that in the Palazzo Piccolomini. There are stylistic differences among the figures that enable us to surmise the intervention of more than one painter. *Prudence* and the female figure in Princeton can be linked to examples that are stylistically close to the work of Francesco di Giorgio Martini

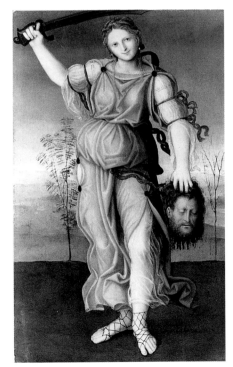

Master of the Saracini Heroines, *Judith*. Chigi Saracini Collection, Siena.

Master of the Saracini Heroines, *Judith*, detail. Chigi Saracini Collection, Siena.

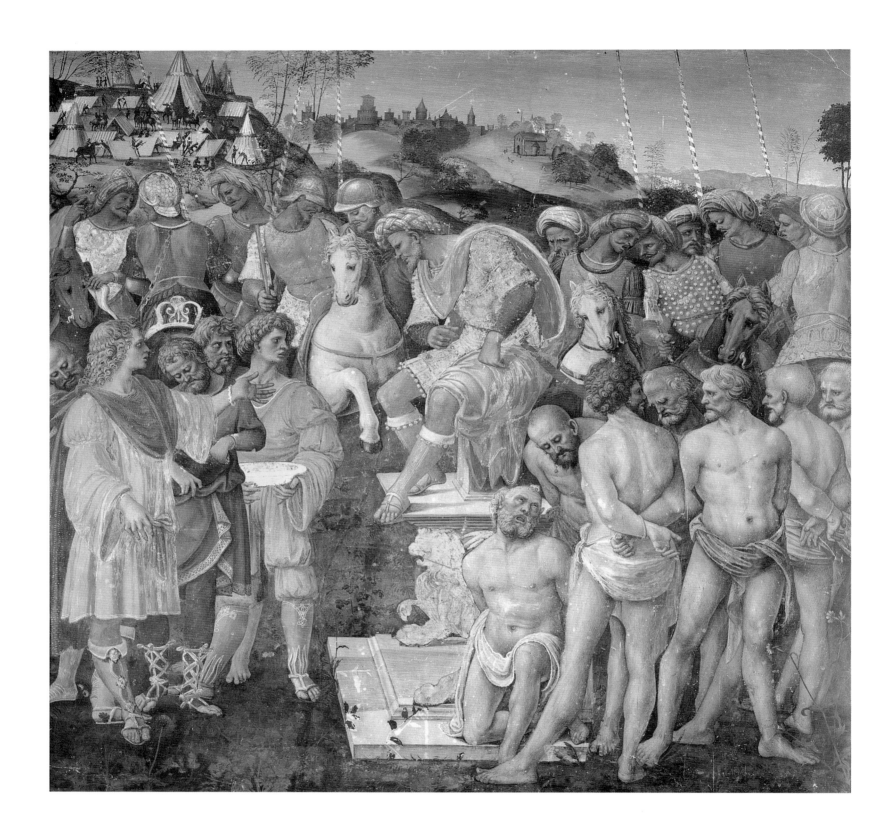

Girolamo Genga, *The Son of
Fabius Maximus Ransoms the
Roman Prisoners from Hannibal.*
Pinacoteca, Siena.

and could be directly influenced by advice from the palace architect, Giacomo Cozzarelli. However, the figures of *Minerva* and *Justice* emphasize synthesis, architectonic construction and expression. They are the fruit of the new style, which evolved parallel to Cozzarelli's sculpture.

Girolamo Genga (*c.* 1476–1551) came from Urbino and the two pieces of decoration from the Palazzo Petrucci now in Princeton have been attributed to him. This assumption derives from Vasari's life of the artist but is not supported by a comparison between Genga's previous works and those from the palace. Genga's earlier works include the *Scenes from the Passion* (Lindenau Museum, Altenburg), which are strongly influenced by the work of Signorelli.[41] The figures of *Minerva* and *Justice* have stylistic similarities with an *Archangel Michael* (Pinacoteca, Siena), in which the harmony of the forms is cast in delicate shadows and accompanied by attempts at firm expression that permeate even the large masks on Michael's armour. The panel was painted by the same artist responsible for *Cleopatra*, *Sophonisba* and *Judith* (Chigi Saracini Collection, Siena) who has been given the name of Master of the Saracini Heroines.[42] The *Archangel Michael* therefore connects

the frescoes in the first room of the Palazzo Petrucci to a group of artists who cannot be individuated with certainty. However, some elements clearly relate to the work of Beccafumi and Genga – the latter by this time had moved away from Signorelli's influence. The first room in the Palazzo Petrucci therefore provides initial signs of the break-up of the language of sweet classicism.

The second room moves away from purely allegorical concepts. It shows a series of narrative events taken from classical and Italian literature, with multiple interrelating themes. Pandolfo Petrucci commissioned established artists to complete the paintings. On 24 April 1508 Pandolfo invited Pinturicchio to return to Siena in a letter reproduced on the *Sant'Andrea Altarpiece* in Spello. The invitation can only be understood in relation to the commission then being executed in the palace in preparation for the marriage of Pandolfo's son Borghese with Vittoria Piccolomini.[43] Pinturicchio's contribution is most striking in the ceiling decoration (Metropolitan Museum of Art, New York), the centre of which is dominated by the Petrucci arms surrounded by a stucco festoon. Around this central element are

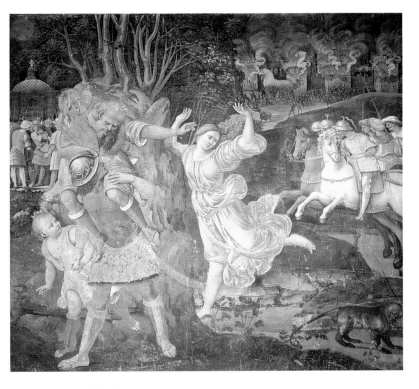

Girolamo Genga, *Flight of Aeneas and the Disappearance of his Wife Creusa*. Pinacoteca, Siena.

paintings, executed within round- or mandorla-shaped frames, that are linked to the walls by means of pendentives. These are decorated with stucco frames containing paintings of the muses. Fragments of the decoration are still visible *in situ* but an overall idea of the complex can only be obtained from Gaetano Marinelli's drawing, which was published by Franchi in the nineteenth century.[44] Along the walls of the room was a pontoon of wood on which pilaster strips (Soprintendenza di Beni Artistici e Storici, Siena) rested on bases containing the quartered arms of the Petrucci and the Piccolomini. Engravings on the pilaster strips intertwine light leafy decorations with elegant little putti, chimeras, Christian virtues, flowers and birds, all executed by Antonio Barili in a natural manner. The floor was planned as part of the overall decoration. Made of glazed terracotta paving tiles decorated with coats of arms and candelabra, it is one of the first attempts to recreate a classical caustic pavement.[45] Some of the floor tiles also contain the quartered coats of arms of the Petrucci and the Piccolomini while others record the date – 1509 (Victoria and Albert Museum, London; Louvre, Paris; and Berlin).

The walls were mainly decorated by Signorelli's workshop, although the lack of documentation means that attributions can only be tentative. The surviving sources relating to the frescoes are relatively late. The most consistent of these, by Giovan Girolamo Carli and Guglielmo Della Valle, record that the walls were decorated by eight fresco paintings. Only five have survived: *The Son of Fabius Maximus Ransoms the Roman Prisoners from Hannibal*, the *Flight of Aeneas and the Disappearance of his Wife Creusa* (Pinacoteca, Siena), the *Triumph of Chastity, Coriolanus Persuaded by his Family to Save Rome* and *Penelope Weaving* (National Gallery, London). The three missing paintings were the *Continence of Scipio*, the *Calumny of Apelles* and a *Bachanal* described by Della Valle. The only trace of these is a Signorelli-style drawing in the British Museum.

The cycle was thematically very complex; it joins together stories from Greek, Latin and Italian sources, drawing on works by Homer, Theocritus, Plutarch, Virgil, Valerius Maximus and Petrarch. The themes selected praise *pietas* (Aeneas), *fides* (Penelope) and *castitas*[46] in a programme referring to the virtues of the family, the *familiaris concordia*. To these are linked the themes of exile and political flattery.[47]

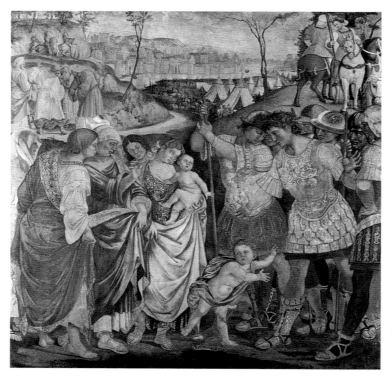

Luca Signorelli, *Coriolanus Persuaded by his Family to Save Rome*. National Gallery, London.

Luca Signorelli, *Triumph of Chastity*. National Gallery, London.

The subjects therefore relate to the marriage alliance between the Petrucci and the Piccolomini families and also give weight to the relationship between parent and child. For example, Telemachus does not conceal the return of Ulysses from his mother Penelope.[48] Portrayed in the background of the painting, Ulysses himself appears after his adventures with Circe and the sirens, dressed as a beggar at the door of the room.[49] Emphasis is also given to the episodes in which Aeneas saves Anchises from the fire that will destroy Troy and in which the son of Fabius Maximus makes a contract with Hannibal for the ransom of the Roman prisoners. The allusion to Petrucci family history is more than evident in these scenes — to the exile of Bartolomeo and his son Pandolfo, while the latter was still a child, and also to the more recent exile of Pandolfo, after which the fortunes of the family were reborn. Moreover the programme is built on literary foundations that allude not so much to the personal tastes or education of the programme's composer as to the collective patrimony of the humanistic education of the Petrucci family.[50] Before their exile, the Petrucci's family circle included people such as Andreoccio Petrucci, who was involved in the first wave of humanism in Siena. The decoration of the two rooms, therefore, assumes a much greater significance than the celebration of a political wedding.

The decoration was modelled on Isabella Gonzaga's *studiolo* with its union of allegories and fables. The use of classical sources enriched the cycle to such an extent that we can recognize in the separate elements of the ceiling decoration similarities to the golden vault of the Domus Aurea. The Palazzo Petrucci ceiling contains a mixture of fables: *Galatea*, the *Caledonian Boar, Amphitrite* and the *Judgment of Paris*. They are not connected by a precise programme and their simplified forms are reminiscent of Pinturicchio's workshop.[51]

From a stylistic point of view, the scenes on the walls should be divided between Pinturicchio, Signorelli and Genga. Vasari provides information about Genga's stay with Pandolfo Petrucci that is helpful in reconstructing activity that was later denied by seventeenth-century historians, such as Mancini. Mancini was the first to read an inscription in Greek letters bearing the name of Luca da Cortona, better known as Signorelli, in one of the frescoes. Fabio Chigi also mentions that Signorelli painted rooms in the Palazzo Chigi. The inscription – *Lucas Coritius* – is now barely legible in two scrolls that are inserted in the *Triumph of Chastity* and in the *Coriolanus Persuaded by his Family to Save Rome* (National Gallery, London).[52] The two works have therefore been attributed to Signorelli's workshop, while the frescoes of *Fabius Maximus* and the *Flight of Aeneas* have been ascribed to Genga. Information given to us by Vasari supports the hypothesis that Genga also contributed substantially to the *Triumph of Chastity* and the *Coriolanus*. Apart from mentioning that Genga painted many rooms in the Palazzo Petrucci, Vasari also records that he had worked both in Signorelli's and in Pinturicchio's workshop. Governed by famous artists at the end of their careers who were not competing against one another, both of the workshops were involved in the decoration of the second room in the Palazzo Petrucci. Pinturicchio and Signorelli therefore both found themselves working with the young Girolamo Genga, which provoked a deep change in the artistic language of their two workshops. Genga was not yet at his most original in these works but nevertheless his separate artistic personality emerges clearly.

Girolamo Genga in Siena

If we believe Vasari's information, Girolamo Genga trained under two of the most esteemed artists of the late fifteenth and early sixteenth centuries. He worked first with Signorelli and then, for about three years, with Perugino, in whose workshop he would have had some contact with Raphael. According to Vasari, Genga spent some time in Florence, an important period in his artistic development. He then went to Siena where he stayed until the death of Pandolfo Petrucci in 1512. The four scenes in the Palazzo Petrucci raise the question of the nature of Genga's relationship with Signorelli's workshop. Around 1507 the workshop designed a *Judgment of Solomon* to be executed in marble for Siena

Cathedral's pavement. The commission moved away from the homogeneity required by the workshop system.[53] With his competence in architecture, perspective and military engineering (which he developed later) and with his experience as a decorator and as a costume designer, which is already evident in the frescoes from the Palazzo Petrucci (Pinacoteca, Siena), Genga was able to realize the aspirations of Pandolfo Petrucci.

There is no documentation about Girolamo Genga's stay in Siena until 1510, the year in which he painted the *Transfiguration* on the organ cover in the cathedral. The style of the work differs greatly from that found in the Palazzo Petrucci frescoes. In the *Transfiguration* Genga's arrangement of the elements of the composition in a solemn and well-ordered manner is reminiscent of Raphael. The Palazzo Petrucci frescoes, on the other hand, are composed of seemingly unordered motifs. There are frequent archaeological citations, such as the gesture of the son of Fabius Maximus that seems to be taken from the *Apollo Belvedere*. There are also echoes of the Roman commissions undertaken by the

Bolognese Jacopo Ripanda and the Sienese Baldassarre Peruzzi. Genga shows himself here to be an unsettled painter who, instead of emphasizing the forms suggested by the antique marbles, concentrated on linear elements and small gold punches. It is as though he harked back to the most old-fashioned forms of the previous century. In the Petrucci frescoes unusual passages stand out, such as the fire of Troy and the golden moon among the woods in the *Flight of Aeneas*. There are also elements, however, such as the flowers, grass and animals, that prefigure the imaginative use of natural motifs in the *Madonna and Child with SS. John and Anthony of Padua* (Pinacoteca, Siena). These elements also provide an insight into the eccentric artist that Genga was to become when he painted the *Cesena Altarpiece*.[54]

The style of the Palazzo Petrucci decoration, which at first may appear to be dominated by two well-established workshops, marks a change from the sweet classicism normally practised by Pinturicchio. These events also had an effect on Domenico Beccafumi (1484–1551), an artist whom I will discuss later.

Baldassarre Peruzzi's First Commissions

Vasari believed Baldassarre Peruzzi to be one of the most important artists of the sixteenth century. However, it is not easy to verify Vasari's opinion, at least in the field of painting. During his career Peruzzi showed inventive inspiration in numerous drawings but it was often his assistants who transformed them into paintings. Peruzzi concentrated mainly on his theoretical and architectural commitments and little is therefore known about his Sienese training. Vasari records that he worked with designers and goldsmiths and that he must have developed under the influence of Francesco di Giorgio Martini. On the evidence of payments dated 1501 and 1502 for works in the St John Chapel in Siena Cathedral that have now been lost,[55] it is believed that his painting was influenced by Pinturicchio. This is difficult to prove although the frescoes in Sant'Onofrio in Rome, which have been attributed to Peruzzi, also show elements of Pinturicchio's style. It is possible that Peruzzi worked with Pinturicchio in

the fresco of the *Coronation of Pius III* on the exterior of the Piccolomini Library.[56] However, a rereading of the relevant document, which testifies that the fresco was completed in 1508,[57] means that it would have been difficult for Peruzzi to have played a part in the work because in 1508 he was already living in Rome. At that time Peruzzi's ties with Siena were through the Chigi family. He had probably worked for Sigismondo Chigi on the completion of the Villa Chigi alle Volte in Cerreto Selva, a few miles from Siena. Peruzzi then moved to Rome where he was employed on the project for the suburban villa of the rich and powerful Agostino Chigi, Sigismondo's brother. It seems clear that Peruzzi relied on Chigi patronage to develop his career even though Vasari provides a completely different version of events. According to Vasari, Peruzzi went to Rome following a painter from Volterra, by the name of Pietro, who worked for Pope Alexander VI. Vasari also says that Peruzzi was given the

commission for the frescoes in the apse of Sant'Onofrio. However, it seems likely that this work was carried out by more than one artist and that Peruzzi's contribution, if indeed we still want to believe Vasari's account of the events, was fairly small.[58]

Agostino Chigi's commissioning of the Villa Farnesina clearly demonstrates his desire to ennoble his family and place them among the elite of the period. The villa is classically planned and has obvious links with Vitruvian theory. The interior decoration includes a small room with a frieze, in which the painter narrates the deeds of Hercules and Meleager, followed by a loggia opening towards the River Tiber. This part of the Villa Farnesina was completed before 1511. It quickly became famous and was often mentioned in literature. In the loggia Peruzzi's painting is next to that of Raphael, who was responsible for the very beautiful Galatea escaping from Polyphemus. In complete contrast with Raphael's interpretation of classical myth, which is marked by its soft and tender elegance, Peruzzi's painting resembles fine cameos and large relief sculptures, patched together into a whole.[59] His reading of antiquity is precise, shrewd and captious. The subjects, which are depicted in octagons at the centre of the vault, include the *Rape of Europa*, the *Birth of*

Venus, *Saturn and Venus*, *Perseus Killing Medusa* and *Elice (the Great Bear) on a Carriage Pulled by Oxen*. They also have an astrological significance since they represent the planets at the moment of Agostino Chigi's birth.[60] The scheme is connected with the humanist astrological tradition, as represented by Marsilio Ficino, that spread to both Ferrara and Florence, while the style imitates classical sculptural models.

When in Rome, Peruzzi's inspiration for his paintings was not limited to just ancient sculpture. It is also possible to distinguish his intervention, at the design stage, in works completed by other artists. Shortly after 1510, he designed a monochrome decoration with episodes from the life of Trajan, taken from Trajan's Column, for the Salone Riario of the bishop's residence in Ostia. Vasari mentions the work, making an erroneous reference to Julius II. Peruzzi worked on this project in association with Jacopo Ripanda but seems only to have directed the group of artists employed on the commission, some of whom came from Lombardy and Bologna.[61] The work at Ostia is typical of the art inspired by classical sources that was being executed in Rome at a time when major changes were occurring in Raphael's workshop.

Notes

1 G. Fioravanti, 'Maestri di grammatica a Siena nella seconda metà del Quattrocento' in *Umanesimo a Siena. Letteratura, arti figurative, musica*, conference proceedings edited by E. Cioni and D. Fausti, Siena 1994, pp. 11–27.
2 P. Pertici, *La Città magnificata. Interventi edilizi a Siena nel Rinascimento*, Siena 1995.
3 B. Sani, 'Artisti, critici, restauratori, mercanti a Siena dallo storicismo al decadentismo' in *Siena tra Purismo e Liberty*, Rome 1988, pp. 18–19.
4 F. Albertini, *Opusculum de mirabilibus novae et veteris urbis Romae*, Rome 1510, p. 240: 'Domus reve. Francisci Piccolomini car. senensis non longe est a predicta in qua erant statuae gratiarum positae' (The house of the reverend Francesco Piccolomini, the cardinal of Siena, is not far from that in which the statues of the graces used to be.)

5 S. Fraschetti, 'Antonio di Neri Barili' in *Domenico Beccafumi e il suo tempo*, Milan 1990, p. 548.
6 A. Chastel, *I Centri del Rinascimento. Arte italiana. 1460–1500*, Milan 1979, p. 38.
7 J. Beck, 'A New Date for Pinturicchio's Piccolomini Library' in *Paragone*, 1985, 419, 421 and 423, pp. 140–143.
8 R. Bianchi, 'Cultura umanistica intorno ai Piccolomini fra Quattro e Cinquecento: Antonio da San Severino ed altri' in *Umanesimo a Siena*, pp. 140–143.
9 G. Vasari, *Le Vite de' più eccellenti pittori, scultori e architetti*, edited by P. della Pergola, L. Grassi and G. Previtali, Novara 1967, III, p. 274.
10 A. Chastel, *La Grande officina. Arte italiana 1440–1500*, Milan 1979, p. 297.
11 I am following here the text as reconstructed by Rowland and not the eighteenth-century transcription cited by Cugnoni (*Agostino Chigi e il Magnifico*,

Rome 1878). See J.D. Rowland, '"Render unto Caesar the Things Which are Caesar's": Humanism and the Arts in the Patronage of Agostino Chigi' in *Renaissance Quarterly*, 1986, XXXIX, 4, p. 679.
12 A. Chastel, *La Grande officina*, pp. 295–300.
13 G. Vasari, *Le Vite*, III, pp. 273–274.
14 G. Vasari, *Le Vite*, IV, p. 63.
15 P. Scarpellini, *Pinturicchio alla Libreria Piccolomini*, Milan 1965.
16 E.S. Piccolomini, *Commentarii*, edited by L. Totaro, Milan 1984. For an English translation, see *The Commentaries of Pius II*, translated by F.A. Gragg and with an introduction and note by L.C. Gabel, Northampton (Mass.) 1937, Books I–V; 1951, Books VI–IX.
17 K. Oberhuber, 'The Colonna Altarpiece in the Metropolitan Museum and Problems of the Early Style of Raphael' in *Metropolitan Museum Journal*, 1978, XII, pp. 55–90.

18 E. Carli, *Il Pinturicchio*, Milan 1960, pp. 72–73.
19 N. Dacos, 'De Pinturicchio à Michelangelo di Pietro da Lucca. Les premiers grotesques à Sienne' in *Umanesimo a Siena*, pp. 311–324.
20 C. Acidini Luchinat, 'La grottesca' in *Storia dell'arte italiana*, Turin 1982, 11, pp. 168–169.
21 F. Sricchia Santoro, '"Ricerche senesi". 1 Pacchiarotto e Pacchia' in *Prospettiva*, 1982, 29, pp. 14–23.
22 I would like to thank Ubaldo Morandi for informing me about the existence of this document. ASS. Notarile Antecosimiano, 994, no. 668: '*Quietantia pro heredibus Ambroxii de Spannochiis de bonis Niccoluccii eorum famuli. In Dei nomine amen. Anno Domini MᶜCCCCLXXXXVIII, inditione 2.a, die vero XIII martii et cetera. Notum sit omnibus qualiter quidam vocatus prout asseruit Bartholomeus olim Ghulielmi*

de Bazio de Quirino partibus Lombardie et habitator Crepaconi nomine suo proprio ac etiam ut procurator et procuratorio nomine Martini et Antonii suorum fratrum specialiter ad infrascripta faciendum, prout de dicto mandato et procura constat manu ser Johannis Zinelli de Meserano notarii publici cum literis testimonialibus et fide notariatu, et dictis nominibus et quolibet vel altero ipsorum pro se et eius libera et mera voluntate et ex certa scientia et non vi, dolo, metu et cetera fuit confessus et recognovit spectabili viro Julio olim Ambroxii de Spannochiis de Piccolominibus de Senis presenti, recipienti pro se et Antonio eius fratre et eorum heredibus et cetera, se habuisse et recepisse usque in presentem diem partim Rome a dicto Antonio et partim Senis a dicto Julio omnia bona et res, pannamenta et denarios que, quos et quas dicti Antonius et Julius habuissent et haberent penes eos vel in domibus eorum et in eorum potestate de bonis, rebus, pannis et denariis Niccoluccii eorum fratris premortui, qui fuit interfectus, de quo Niccoluccio dicti Bartolomeus et fratres supra nominati fuerunt et sunt prout asseruit successores et heredes, de quibus et ipsum Julium presentem et ut supra recipientum quietavit [...] Actum Senis in bancho heredum Ambroxii de Spanocchiis de Piccolominibus coram et presentibus Alexandro Galgani de Bonagiontis et Johanne Placiti de Placitis. Ego Petrus Francisci notarius rogatus subscripsi.' (Receipt in favour of the heirs of Ambrogio Spannocchi regarding the goods of Niccoluccio their servant. In the name of God, Amen. The year of our Lord 1498, second indiction, the thirteenth day of March, etc. Let it be known to all that, as he himself affirms, a certain Guglielmo di Bazio of Quirino, from Lombardy and resident in Crepacone, on his own behalf and also as procurator and on behalf of his brothers Martino and Antonio, with the special intention of doing those things which are set out below, according to that which is known from the aforementioned mandate and mandatory power of Ser Giovanni Zinelli of Meserano, public notary, with testimonial letters and letters of good faith from the office of the public notary to the said people or to one of the same, confessed by himself and of his own free will and accord with a full knowledge and not through force, deceit, fear etc. and acknowledged to Messer Giulio [son] of the late Ambrogio degli Spannochi dei Piccolomini of Siena being present and of having had and received up until the present day a portion in Rome, from the aforementioned Antonio, and a portion in Siena, from the aforementioned Giulio, of all the goods and belongings and cloth and money that they had had from the said Niccoluccio, their dead brother, who was killed, of which Niccoluccio, the said Bartolomeo and the aforementioned brothers were and are according to their testimony, his successors and heirs, on behalf of whom he [Guglielmo] issues the receipt to the same Giulio present and receiving as above.... Drawn up in Siena in the office of the heirs of Ambrogio Spannocchi dei Piccolomini in the presence of Alessandro di Galgano dei Bonaggiunti and Giovanni di Placito dei Placiti. I, the notary Pietro di Francesco, drew up the document.)

23 J.D. Rowland, '"Render unto Caesar"', p. 679.

24 P. Lugano, 'Il "Sodoma" e i suoi affreschi a Camprena' in *Bullettino senese di storia patria*, 1902, IX, pp. 239–249; E. Carli, *Il Sodoma a Sant'Anna a Camprena*, Florence 1974; F. Sricchia Santoro, '"Ricerche senesi". 4. Il giovane Sodoma' in *Prospettiva*, 1982, 30, pp. 43–58.

25 W. Loseries, 'Sodoma e la scultura antica' in *Umanesimo a Siena*, pp. 345–381.

26 R. Bartalini, *Le occasioni del Sodoma. Dalla Milano di Leonardo alla Roma di Raffaello*, Rome 1996, pp. 135–136.

27 A. Bagnoli, 'Un "Compianto sul Cristo" e alcune osservazioni per il Sodoma di Monteoliveto' in *Prospettiva*, 1988, 52, pp. 68–74.

28 E. Carli, *Le Storie di San Benedetto a Monteoliveto Maggiore*, Milan 1980.

29 F. Sricchia Santoro, '"Ricerche senesi". 4. Il giovane Sodoma', pp. 43–45; R. Bartalini, 'Giovanni Antonio Bazzi detto il Sodoma' in *Domenico Beccafumi*, p. 246.

30 See M. Davis, in *European Paintings in the Collection of the Worcester Art Museum*, Worcester 1974, pp. 459–462. Also P. Zambrano, 'A New Scene by Sodoma from the Ceiling of the Palazzo Chigi at Casato di Sotto, Siena' in *The Burlington Magazine*, 1994, CXXXVI, pp. 609–612; R. Bartalini, *Le occasioni*, pp. 110–112.

31 The idea, referring to Nicholas V, is taken from the dedication of Leon Battista Alberti's *De re aedificatoria*. See C.H. Clough, 'Pandolfo Petrucci e il concetto di "Magnificenza"' in *Arte, committenza ed economia a Roma e nelle corti del Rinascimento, 1420–1530*, edited by A. Esch and C. Liutpold Frommel, Turin 1995, p. 384.

32 P. Pertici, *La Città magnificata*, pp. 82–83.

33 G. Agosti and V. Farinella, 'Interni senesi "all'antica"' in *Domenico Beccafumi*, pp. 590–592.

34 A. Ferrari, R. Valentini and M. Viti, 'Il Palazzo del Magnifico a Siena' in *Bullettino senese di storia patria*, 1985, XCII, pp. 113–114.

35 ASS, Curia del Placito, 275, fol. 11: '*primo maggio 1603 / Inventario di tutti li stabili mobili e semoventi che si trovano al presente de beni propri di Ms Marcello Bandinelli rimasti per la sua morte a Pandolfo e Marcellino suoi figli. Riscontro di mobili* [of the '*casa che abitano in Siena nel Palazzo del Magnifico*'] / *Due camare adornate con casse di stampe e disegni di più sorti grandi e piccoli che per fuggir la troppa lunghezza e per esser in... numero si lassa di notar partitamente. / Un quadro d'una Madonna con alchune figure di m.ro Riccio Sanese / Un Ritratto d'una Donna stimato di*

Raffaello da Urbino/ Un tondo con una nostra donna opera di Luca Signorelli/ Una altro tondo opera…, una Venere di Mecarino cavata da una lettiera/ Un quadro dentrovi figurato Adamo ed Eva, Abele e Caino figli opera… del Brescianino/ Due quadri uno rappresentante la patienza l'altro la giustizia opera…, una testiera ridotta in un quadro che mostra l'istoria di Arianna con Perseo opera del pacchiarotto/ Quadretto d'una nostra donna con alchune altre figurette et ornamento dorato all'anticha opera.' (1 May 1603. Inventory of all the fixed and semi-fixed goods that can now be found of Ms Marcello Bandinelli's own property, left at his death to Pandolfo and Marcellino, his sons. A check-list of the goods [from the 'house in which they live in Siena in the palace of il Magnifico (Pandolfo Petrucci)'].Ⅴ Two rooms containing chests of engravings and drawings of various sorts, both large and small, and because there are… number of them they will be noted separately./ A painting of the Virgin with some other figures by the Sienese painter Riccio/ A highly respected portrait of a woman by Raphael of Urbino/ A tondo of Our Lady, the work of Luca Signorelli/ Another tondo, the work of…, a Venus by Mecarino [Beccafumi] made out of a headboard/ A painting in which Adam and Eve are depicted, [and] Cain and Abel their sons, the work of… Brescianino/ Two paintings, one of which represents Patience and the other Justice, the work of…, a

headboard that has been made into a painting showing the story of Ariadne and Perseus, the work of Pacchiarotto [Girolamo del Pacchia]/ A small painting of Our Lady with various other small figures and ornamented with gold in the style of old paintings.)

36 G. Chironi, 'Politici e ingegneri. I Provveditori della Camera del Comune di Siena negli anni '90 del Quattrocento' in Ricerche storiche, 1993, 2, pp. 375 and 395.
37 G. Agosti, 'Precisioni su un "Baccanale" perduto del Signorelli' in Prospettiva, 1982, 30, pp. 70–77.
38 G.G. Carli, Notizie di belle arti, in BCS, C.VII.20, fols. 16 and 74–75.
39 F. Sricchia Santoro, '"Ricerche Senesi". 2. Il Palazzo del Magnifico Pandolfo Petrucci' in Prospettiva, 1982, 29, pp. 24–31.
40 N. Dacos, 'De Pinturicchio à Michelangelo de Pietro da Lucca', pp. 311–343.
41 A. Petrioli Tofani, 'Per Girolamo Genga' in Paragone, 1969, 229, p. 22.
42 A. De Marchi, '"Maestro delle Eroine Saracini"' in Da Sodoma a Marco Pino, Siena 1988, pp. 83–90.
43 A. Petrioli Tofani, 'Per Girolamo Genga', p. 27.
44 A. Franchi, 'Le Palais du Magnifico à Sienne' in L'Art, 1882, pp. 147–152 and 181–185.
45 M. Collareta, 'Encaustum vulgo smaltum' in Annali della Scuola Normale di Pisa, 1984, XIV, 2, pp. 757–769.

46 G. Agosti, 'Precisioni', pp. 70–77.
47 V. Tàtrai, 'Gli affreschi di Palazzo Petrucci a Siena. Una precisazione iconografica e un'ipotesi sul programma' in Acta historiae artium, 1978, pp. 177–183.
48 On the meaning of this fresco, see M. Baxandall, Painting and Experience in Fifteenth-Century Italy, Oxford 1972, p. 60. Baxandall considers whether the elegantly dressed young man is Telemachus or one of the suitors. Is he telling Penelope what has happened to Ulysses or is he asking for her hand? Does the painting depict Telemachus relating the story of his voyage in search of Ulysses or one of the suitors discovering Penelope's trick?
49 C.H. Clough (Arte, committenza, fig. 112) believes that the painting relates to the return of Ulysses.
50 A. Pinelli, 'Messaggi in chiaro e messaggi in codice. Arte, umanesimo e politica nei cicli profani del Beccafumi' in Umanesimo a Siena, pp. 383–452. Pinelli puts forward the hypothesis that the programme was formulated by Sigismondo Tizio. However Tizio was not a major supporter of the Petrucci. Della Valle attributed the formulation of the programme to Antonio da Venafro.
51 F. Sricchia Santoro, '"Ricerche Senesi". 2. Il Palazzo', pp. 24–31, attributes the work to Genga. Agosti and Dacos propose an attribution to Pinturicchio and his workshop.

52 M. Davies, National Gallery Catalogues. The Earlier Italian Schools, pp. 472–479.
53 F. Sricchia Santoro, Domenico Beccafumi, p. 262; A. Colombi Ferretti, Girolamo Genga e l'altare di S. Agostino a Cesena, Bologna 1985, pp. 19–23.
54 A. Colombi Ferretti, Girolamo Genga, pp. 7–18 and 77–100.
55 F. Sricchia Santoro, 'Baldassarre Peruzzi' in Domenico Beccafumi, p. 22.
56 R. Cannatà, 'Problemi stilistici e attributivi del ciclo di Civita Castellana' in Il Quattrocento a Viterbo, Rome 1983.
57 See note 5.
58 M. Faietti and K. Oberhuber, 'Jacopo Ripanda e il suo collaboratore (il Maestro di Oxford) in alcuni cantieri romani del primo cinquecento' in Ricerche di storia dell'arte, 1988, 34, pp. 58–64.
59 C.L. Frommel, Baldassarre Peruzzi als Maler und Zeichner, Vienna 1967–1968, pp. 61–68.
60 F. Saxl, La fede astrologica di Agostino Chigi. Interpretazione dei dipinti di Baldassarre Peruzzi nella sala di Galatea della Farnesina, Rome 1934.
61 G. Borghini, 'Il Salone Riario nell'Episcopio di Ostia' in Il Borgo di Ostia da Sisto IV al Giulio II, edited by S. Danesi Squarzina and G. Borghini, Rome 1981, pp. 91–103; V. Farinella, Archeologia e pittura a Roma tra Quattrocento e Cinquecento, Turin 1992, pp. 132–159.

Siena and the *Maniera Moderna*

The Influence of Raphael

A number of different influences could be sensed in Siena from the second decade of the sixteenth century onwards. In 1512 Raphael painted the *Triumph of Galatea* in Agostino Chigi's Villa Farnesina in Rome, expressing in it his ideal of harmony in painting. The decoration of the Villa Farnesina included frescoes based on Ovid, some of which were painted by Sebastiano del Piombo who used colours specially delivered from his home city of Venice. In Siena the period influenced by the sweet classicism of Umbrian painters such as Perugino and Pinturicchio was drawing to a close due to Sodoma's increasing popularity which stemmed from his use of deep perspective, something which he had learnt from Lombard painting. Another element that contributed to the decline of sweet classicism was the elusive influence of Leonardo, Michelangelo and Raphael. Within Siena the

interest in antiquity had already stimulated attempts at a fantastic recreation of the classical past. Francesco di Giorgio's experimentation in the fields of engineering, metallurgy and founding gave rise to an increase in woodcuts, figurative maiolica and marble mosaic work – arts related to those of painting and drawing.

Pandolfo Petrucci died in 1512 and his successors, supported from within Siena by the Nove and externally by the Medici and by France, slipped into ruin. From the second decade of the sixteenth century onwards, fights between the various factions and attacks from the Holy League rocked the stability of the city. The leaders of Siena were increasingly threatened both by the papacy and the Holy Roman Empire. The wars in Italy did not interrupt artistic activity but they did make an impression on style. An increasing sense of

P. 353
Andrea del Brescianino, *Venus*.
Galleria Borghese, Rome.

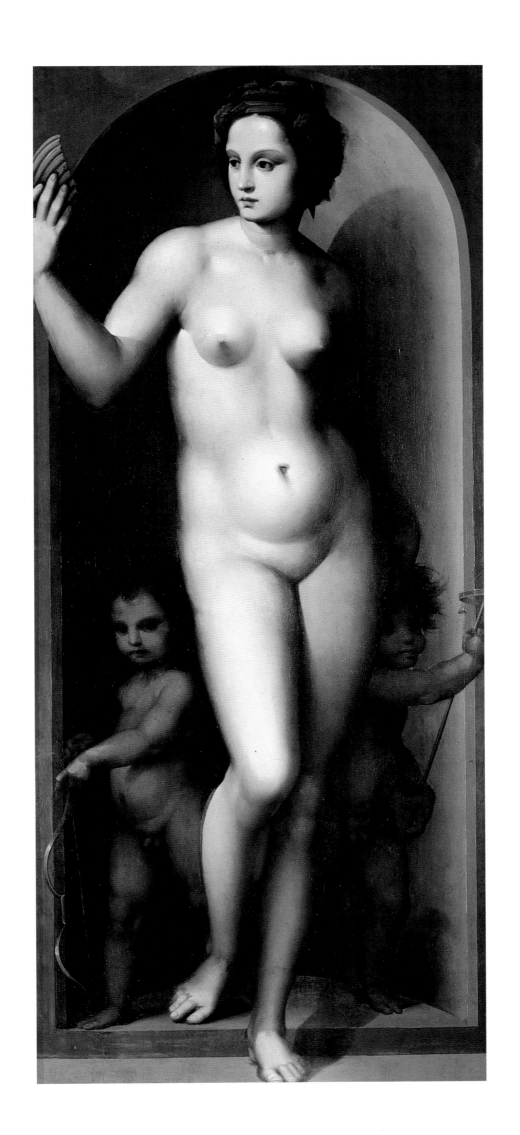

uneasiness affected the stylistic harmony of the beginning of the century.[1]

By the end of 1510 Sodoma had returned to Siena from Rome, at a time when Sienese artists, Sodoma included, were greatly influenced by Raphael. Immediately after his return Sodoma painted the large *Deposition* for the Cinuzzi Chapel in San Francesco. The painting demonstrates that he was well aware of recent developments in Florentine painting, especially the works of Leonardo da Vinci and Filippino Lippi, as well as Raphael's frescoes in the Stanza della Segnatura in the Vatican. The *Deposition* is set in a broad expanse of landscape of rivers and hills and bathed in a calm midday light that ennobles the majestic sacred scene. The sweet harmony of the figures in the *Deposition* demonstrates Raphael's influence, while the intense expressions derive from the works of Leonardo da Vinci.

Girolamo del Pacchia must also have studied the works of Raphael closely and between 1513 and 1514 Pacchia painted a *Coronation of the Virgin* for the church of Santo Spirito. It can be dated from a document in which the Dominican friars of Santo Spirito gave a chapel to the Balisteri family, who undertook to decorate it with an altarpiece. This is probably the *Coronation of the Virgin* seen by Bossio in 1575. Pacchia modelled his composition on Raphael's last paintings in Florence and his first in Rome. In the upper part of the painting, in which the coronation is depicted, the well-delineated and lively forms recall Raphael's *Madonna of the Baldachin* (Palazzo Pitti, Florence). However, the main inspiration for the lower part comes from the ample and powerful forms of the saints in the Stanza della Segnatura. Even the little angels who move restlessly among the soft grey clouds display a familiarity with Raphael's work. This influence seems to have been mediated through Girolamo Genga's *Transfiguration* painted in 1510 for the organ cover in Siena Cathedral.[2] Towards the end of the first decade of the sixteenth century, painters in Siena became both aware of the developments in Florentine painting and sensitive to the new elements in Raphael's works. Raphael was the most important influence on Sienese painting but a knowledge of his work did not have the same effect on all Sienese artists.

The style of Andrea Picinelli, known as Andrea del Brescianino (active in Siena from 1506/1507 to 1524 and in

Florence from 1525 onwards), was very much influenced by both Fra Bartolomeo and Raphael as well as by Leonardo da Vinci's use of chiaroscuro. Soon after his return to Siena in 1506 or 1507 he painted a *Madonna and Child with St John the Baptist* (Museo d'Arte Sacra, Buonconvento). The work is closely related to Raphael's very early style. It includes soft chiaroscuro passages that still retain a certain degree of rigidity, a feature which disappears in the *Annunciation* (Lindenau Museum, Altenburg) and in the later paintings of *Faith* (*Lucrezia*), *Hope* and *Charity* (Pinacoteca, Siena). The later works show the influence of Andrea del Sarto,[3] as does the delicately painted *Venus* (Galleria Borghese, Rome).[4] Brescianino looked only to Raphael's Florentine style and concentrated on the formal aspects that were closest to the sweet classical style. However, other painters in Siena had already had contact with the more powerful and dramatic aspects that are characteristic of Raphael's later Roman paintings.

Domenico Beccafumi's Early Career

In an entirely different manner to the artists discussed above, Girolamo Genga did not passively adapt Raphael's style to the literary and mythological culture of the Palazzo Petrucci decorations but formulated an eccentric artistic language that became a catalyst for younger painters. Domenico Beccafumi (1484?–1551) may have participated in the decoration of the Palazzo Petrucci. An act of sale shows that Beccafumi in 1507 was already of age and practising as a painter.[5] Comparisons between paintings executed by Genga[6] in Siena and those attributed to Beccafumi, such as the tondo of the *Madonna and Child with St John the Baptist* in Berlin[7] or the bier now in the Pinacoteca in Siena, support the hypothesis that Beccafumi worked with Genga or was at least strongly influenced by him. This adds to our knowledge of the early work of Beccafumi, who was to become the dominant Sienese artist in the first half of the sixteenth century.

Vasari constructed an exemplary career for Beccafumi, in which he compares the start of Beccafumi's activity to that of

Giotto. Like the young Giotto, Beccafumi was discovered by his master drawing in the sand and his career took off from there. The reconstruction put forward by Vasari is too perfect to be believed in all its detail. Important facts such as his journey to Rome are seen as a direct consequence of his desire to see Michelangelo's completed Sistine Chapel ceiling and Raphael's various works in the city. This means that little is mentioned about Beccafumi's other influences. However, Vasari explains Beccafumi's use of soft colours by suggesting that he had come under the sway of other painters during his training. Beccafumi would have encountered Perugino's work in Siena, while in Rome he concentrated on the study of antique statues and ruins under the guidance of an unknown master.

Beccafumi's first works contain classical subject matters. They are connected with the admonitory tradition, which flowered in Siena in the form of various series of paintings dedicated to ancient heroines. The *Lucrezia* (Oberlin College, Ohio) and the *Penelope* (Seminario Patariarcale, Venice) should be considered among Beccafumi's earliest paintings. Their style is very different from that of the Master of the Saracini Heroines but still shows the influence of Girolamo Genga, above all in the *Penelope*, which has parallels with Genga's *Cesena Altarpiece*. The *Annunciation* in the *Cesena Altarpiece* is constructed with a very delicate painting technique that nevertheless uses saturated colours, which appear slightly heavy when compared to the gentle colouring of Beccafumi. Vasari defines the painter of Beccafumi's first works as 'a bold draughtsman of prolific inventions and a beautiful colourist'. According to Vasari, in 1512 Beccafumi frescoed the façade of a house belonging to the Borghesi family near the Postierla column. This turned into a competition with Sodoma, who was working on the façade of Agostino Bardi's house. The documents relating to Sodoma suggest that Beccafumi's work was actually carried out in 1513. Unfortunately, neither of these works has survived, but a pen drawing by Beccafumi gives some idea of the design. It shows trophies, classical battles and historical figures, one of whom, identified by an inscription, is Virgil's Marcellus. The drawing confirms Beccafumi's connection with Rome and

with the artists and scholars associated with Baldassarre Peruzzi. It is also a surprising example of a watercolour study, containing colours ranging from grey-brown to sepia and pink.[8]

At the start of 1513 Beccafumi took part in the work to renovate the Chapel of the Mantle in the Ospedale di Santa Maria della Scala. Pandolfo Petrucci may have commissioned the restoration shortly before his death. On 6 May 1513 Beccafumi received the outstanding payment for a panel of a *Trinity* (Pinacoteca, Siena) from Battista Antonio da Ceva. The frame of the triptych is austere, laden with grotesques at the base and with a large crowning element gilded with dentils and pendants. Different proportional systems are enforced in the various parts of the composition. The central panel, separated from the lateral panels by pilaster strips, depicts an iconic *Trinity*. The side panels contain *SS. Cosmas, John the Baptist, John the Evangelist* and *Damian*. Their dimensions appear a little smaller than life-size which creates the impression of real people adoring a sacred image. Both the iconography and the style are strongly influenced by Florentine art, such as the *Trinity* painted by Mariotto Albertinelli for the nuns of San Paolino in via Faenza around 1510. Beccafumi clearly referred to the figure of Christ placed between his father's knees in Albertinelli's work and to the angel at the feet of the Virgin in the *Carondelet Madonna* by Fra Bartolomeo.[9] However, the intensity of the chiaroscuro surpasses the earlier paintings and demonstrates Beccafumi's familiarity with the work of Leonardo.

Beccafumi's interest in light is evident in almost all of his works, even in his most classicizing compositions. Between 1514 and 1515 Beccafumi painted the altarpiece of the *Stigmatization of St Catherine of Siena* for the now-destroyed monastery of San Benedetto (Pinacoteca, Siena). It was executed when the influence of Fra Bartolomeo's *God the Father between SS. Mary Magdalen and Catherine of Siena* was at its strongest. Beccafumi imitates Fra Bartolomeo's majestic composition of the figures and their slow gestures. He was also strongly attracted by the way in which the light revealed the forms in the landscape. Fra Bartolomeo's light penetrates into the depths of the painting, an effect achieved by the use

of chalk drawings on prepared grey paper – a Florentine innovation – on which Fra Bartolomeo had sketched the fall of the light.[10] Fra Bartolomeo's *Carondelet Madonna* breaks away from the peaceful harmony of earlier Florentine painting in the iron-grey clouds that support the Virgin and in the bare little trees with gaunt and withered branches, which translate into arabesques that stand out against the clarity of the sky.

Shortly afterwards Beccafumi added ochre and saffron to his colour range, as seen in the fresco of the *Meeting at the Golden Gate* in the Chapel of the Mantle, which was probably painted around 1518 after the *Stigmatization of St Catherine*.[11] Here, Beccafumi looked to Rosso Fiorentino, in particular to his paintings in the Chiostro dei Voti in the church of the Santissima Annunziata in Florence. Beccafumi achieved the dense colour and the abnormally elongated figures after repeated attempts, traces of which survive in two drawings in the Uffizi. The lines of the pen delineate diaphanous figures who inhabit an almost invisible setting. Ripples of ink mark out zones of shade from which the figures emerge. The artist's drawing technique transferred itself into the details of the

fresco without weakening the deep chiaroscuro. What remains of the Chapel of the Mantle gives only a shadowy idea of the decorative scheme.

Beccafumi was helped in the commission by Bartolomeo di David (1482–1545/1546), who polychromed the sculptures of a *Crib* and the *Blessed Sorore* and also painted a landscape background.[12] In the first decade of the sixteenth century Bartolomeo di David had worked in the charterhouse in Pontignano and at the end of the decade he signed a contract with the Compagnia del Corpus Domini in Capalbio for a processional standard. None of these works has survived, so it is impossible to compare Bartolomeo di David's early work with that of his contemporary Beccafumi. Later in his career Bartolomeo was deeply influenced by Beccafumi's style, which he gradually added to the classical elements with which he had experimented in Rome. The existence in Siena of painters such as Bartolomeo di David – an artist whose works have still not been clearly defined from the point of view of either chronology or attribution – is the clearest sign that the city's artistic community was thriving, revolving around central figures such as Domenico Beccafumi.

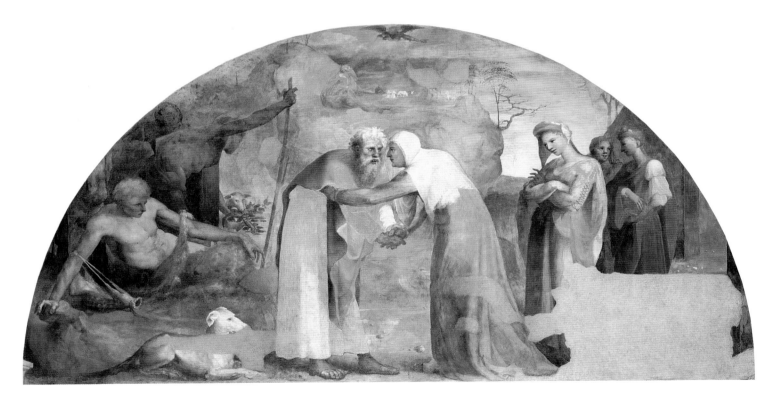

Domenico Beccafumi,
Meeting at the Golden Gate.
Chapel of the Mantle, Ospedale
di Santa Maria della Scala, Siena.

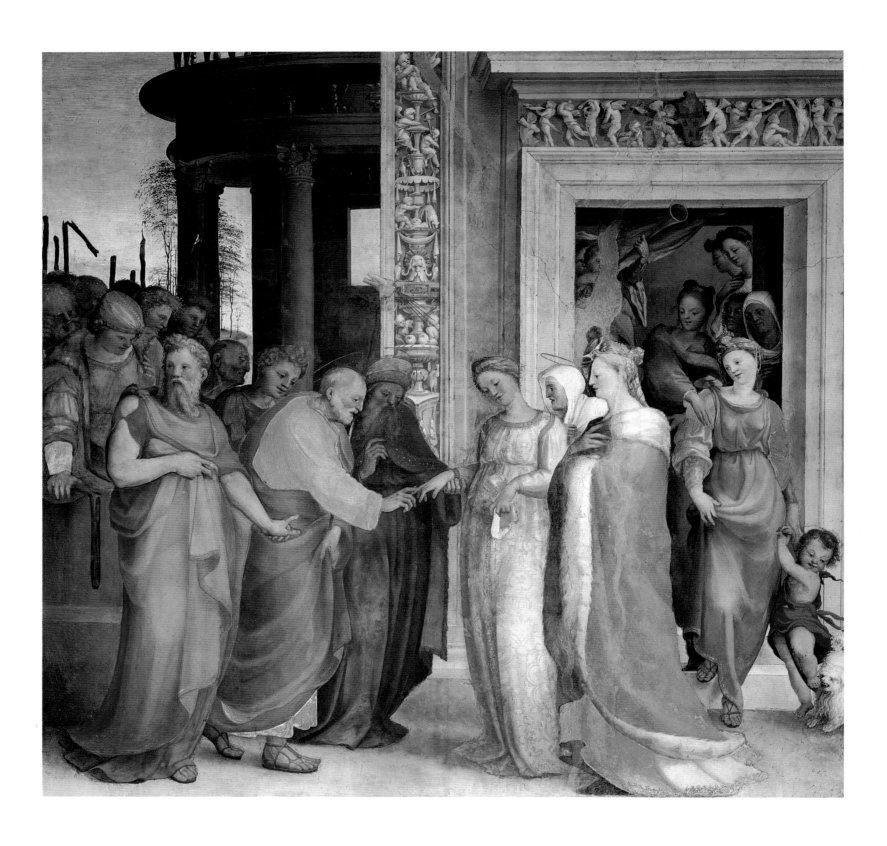

Domenico Beccafumi,
Marriage of the Virgin. Oratory
of St Bernardino, Siena.

The Oratory of St Bernardino

During the second decade of the sixteenth century, Becca-fumi took over the position of pre-eminence that Sodoma had held for nearly twenty years. The place where their styles can best be compared is the Oratory of St Bernardino, where Sodoma, Beccafumi and Girolamo del Pacchia painted the decorative scheme. The oratory was the seat of the Compagnia di Santa Maria degli Angeli della Veste Nera. After St Bernardino's canonization in 1450 the confraternity joined his name to the list of saints whom they specially venerated. At that time they made plans to decorate the oratory in honour of St Bernardino but financial considerations slowed down progress. The work on the decorative framework for the oratory is documented but information relating to the narrative paintings is scarce. The main document to survive is a 1518 agreement with Pacchia, Sodoma and Beccafumi. It shows that the Compagnia owed money to Pacchia for the *Annunciation*, the *Birth of the Virgin*, and the *St Bernardino*; to Beccafumi for the *Marriage of the Virgin* and the *Death of the*

Virgin; and to Sodoma for the *Presentation in the Temple*, the *Coronation of the Virgin*, *St Francis*, *St Louis*, and *St Anthony*. From the document we can assume that the above paintings had already been completed. Sodoma's contributions were the most substantial and imposing in the scheme, while Pacchia stuck to a register of delicate interpretation influenced by non-Sienese art. Beccafumi stretched the limits of classical composition in order to achieve 'grace' in his compositions or, as Vasari put it, 'he used a licence in following the rules, which although it was not following the rules… was regulated by the rules'.

As previously mentioned, the frescoes in the Oratory of St Bernardino must have been painted before 1518. It is more difficult, however, to establish their internal chronology and it is only a hypothesis that the cycle began with Pacchia's *Annunciation* and *Birth of the Virgin*. Pacchia's style is very different here from that in his *Coronation of the Virgin* in Santo Spirito, when he was dominated by the influence of

Sodoma, *Presentation in the Temple*.
Oratory of St Bernardino, Siena.

Raphael's *Dispute over the Holy Sacrament* in the Stanza della Segnatura. In the oratory he turns decisively to Florentine artists for inspiration, including those of the previous generation. Certain aspects of his frescoes in the oratory recall Filippino Lippi's *Annunciation* in the Carafa Chapel in Santa Maria sopra Minerva in Rome, which was painted in 1488. Pacchia's Archangel Gabriel flies across a rich setting, articulated with pilaster strips adorned by candelabra and with arches divided into coffers bearing golden floral motifs. The architecture comprises a forceful combination of the motifs used by Lippi in Santa Maria sopra Minerva. To Lippi's complex perspective structure Pacchia added an elegant fullness of form and a parade of colours bathed in a clear light which merges the marble of the step to the sky. Such a wealth of ideas is not repeated in the *Birth of the Virgin*, which was influenced by Andrea del Sarto's version of the same subject painted in the Santissima Annunziata in Florence between 1513 and 1514. Girolamo del Pacchia followed Andrea del Sarto's quiet and solemn arrangement of the scene, although he blunted every perspective accentuation. He painted the figures in a clear light that emphasizes the yellow and gold

clothes and the ivory skin of the women who assist at the birth and wash the Virgin.

In the Oratory of St Bernardino, Domenico Beccafumi was working alongside two of the most capable artists then active in Siena. In his *Marriage of the Virgin* he altered every element of the traditional compositional structure. The setting contains classical architecture – a marble door with an architrave in which a fake frieze figuring dancing putti stands out against a façade bordered with candelabra containing the same tumult of putti. This calls to mind the antique Roman references employed by Peruzzi, Ripanda and Aspertini. Beccafumi contrasted the marble façade with a circular temple whose columns and architrave are enveloped in shadow. The temple closely resembles the tempietto of San Pietro in Montorio in Rome, designed by Bramante, although Beccafumi's painting lacks the geometrical precision of Bramante's building. Furthermore, the fresco conveys a sense of restlessness and agitation that is reinforced by the slender trees on the horizon, some of whose trunks have been broken by flashes of lightning. The elongated Gothic curves of the figures in the foreground do little to calm the sense of unrest.

Girolamo del Pacchia, *Annunciation*, with Domenico Beccafumi, *Virgin and Child with Saints* in the centre. Oratory of St Bernardino, Siena.

Beccafumi's painting is unique in Italian art during this period. The artists who come nearest to his work are the most eccentric Italian painters of the period – Piero di Cosimo, Lorenzo Lotto and Amico Aspertini. But even they do not provide a direct precedent for Domenico's flights of fancy in the Oratory of St Bernardino. The oratory frescoes must have been painted at the same time as the exceptionally bold *St Paul Enthroned* for the St Paul Chapel in the Mercanzia (Museo dell'Opera del Duomo, Siena). Like the *Marriage of the Virgin* and the *St Paul Enthroned*, the *Death of the Virgin* in the Oratory of St Bernardino also breaks the rules of correct composition. Beccafumi's scene can be compared with the work of Rosso Fiorentino, even with the *Assumption* in the Chiostro dei Voti of the Santissima Annunziata in Florence. The painting stands out because of its colours, which include the use of dazzling flame-like reflections. The painting demonstrates the stylistic changes that Italian painting had undergone since the first signs of anti-classicism, as exemplified in the work of Aspertini. Looking at Christ gliding out of the celestial fire to grasp Mary's soul, art appears to be the antithesis of reality.[13]

Sodoma's frescoes in the interior of the Chapel of the Mantle dominate the decorative scheme, but only quantitatively. At this time Sodoma was at the height of his success, but when placed in a historical perspective he cannot be regarded as the most important painter working in Siena. As can be seen in the adjoining frescoes, his standing had already been undermined by Beccafumi. Sodoma must have painted the frescoes for the Compagnia di San Bernardino at the same time as he was employed by Agostino Chigi in the Villa Farnesina in Rome. The *Presentation of Mary in the Temple* and the *Coronation of the Virgin* are similar in style to the *Marriage of Alexander and Roxana* and the *Family of Darius in front of the Victorious Alexander* painted for the Villa Farnesina. The latter two were painted between 1516 and 1518, the period leading up to Agostino's wedding with the Venetian Francesca Ordeaschi.

In the scene of the *Marriage of Alexander and Roxana*, Sodoma was asked to reconstruct a celebrated classical painting by the Greek artist Aëtion that had been lost. Agostino Chigi's first choice for the commission was Raphael as some drawings, which testify to the complex iconographical

Domenico Beccafumi, *Virgin and Child with Saints*, detail. Oratory of St Bernardino, Siena.

project, demonstrate. One of them, thought to be by Raphael himself, is in the Albertina in Vienna. Sodoma was chosen because of his connections with Sigismondo Chigi and was given precise instructions on the contents of the paintings. With a text by Lucian, the *History* of Herodotus[14] and the drawings provided by Raphael[15] as his sources, he was committed to a rhetorical form of painting. In addition, Raphael's drawing provided Sodoma with an almost academic study of bodies and their gestures, together with a measured representation of the scene. Sodoma's paintings remain faithful to their sources and his experience in Rome is also reflected in the scenes in the Oratory of St Bernardino. However, there are certain differences between the Roman and the Sienese compositions. In the two Roman scenes Sodoma either uses a number of buildings in sharp foreshortening or does not give the narrative a clear central point, whereas in the Sienese scenes he chooses to adopt a more rigid symmetry. The imposing effect of the frescoes is reinforced in the *Presentation of Mary in the Temple* by the solemn colonnade of mixed marble columns in which the onlookers stand. This recalls Roman precedents such as the columns which Baldassarre Peruzzi and his helpers had painted in the Sala delle Prospettive in the Villa Farnesina.

Sodoma's part in the Oratory of St Bernardino was not limited to the scenes that have already been discussed. The *Visitation* and the *Assumption*, neither of which are mentioned in the document of 1518, were probably painted between 1525 and 1529.[16] They are thoughtless repetitions of the eloquent ideas expressed by Sodoma in the first scenes. Domenico Beccafumi also resumed work on the oratory some time after the *Presentation of Mary in the Temple* and the *Birth of the Virgin*. He painted, to substitute an older version, the confraternity's altarpiece, which was dedicated to the Virgin and saints. It is only in 1533 that documents relating to the decoration of the oratory begin to mention the altarpiece which was completed between 1535 and 1537. By this time Beccafumi was no longer the artist who had made such fertile experiments in the first paintings in the oratory. The altarpiece shows how he now liked to define clear, measured and balanced forms.

Domenico Beccafumi's Mature Style

Beccafumi's art changed considerably during the first part of his career. Not only had his style developed, it had also changed direction and had been subjected to much rethinking, making it one of the richest in Italy at the time. His art matured in his home city of Siena, which he found hard to leave even when his career demanded it. Nevertheless, it is important to hypothesize a second journey to Rome around 1519 in order to explain the development of his artistic language.[17] An examination of Beccafumi's paintings during this period reveals reflections of the most important developments in contemporary Roman art. Beccafumi had clearly understood the 'studied carelessness' of Raphael's most recent paintings, such as the Stanza of Heliodorus, the Stanza of the Fire in the Borgo, the cartoons for the Sistine Chapel tapestries, the Vatican Loggias and the Loggia of Psyche which was unveiled on 1 January 1519 in the Villa Farnesina.[18]

The Roman influence can be detected in Beccafumi's decoration for the room of Francesco di Camillo Petrucci in the Palazzo Petrucci. Pandolfo Petrucci's nephew Francesco succeeded in taking over the government of Siena in 1521 but was then exiled in 1523. Beccafumi encountered difficulties in being paid for the work, which must have been completed in 1519. In a request for payment made to the Comune of Siena on 4 September 1527, he declared that he had painted the work eight years before. At that time the palace housing the paintings belonged to Scipione di Girolamo Petrucci, who had bought it from Francesco. The ensemble of paintings has been dismantled, but it is possible to attempt a reconstruction of the whole.[19] Two panels in the Martelli Collection in Florence showing the *Cult of Vesta* and the *Lupercalia* must once have formed part of the work. The panels of *Marcia* and *Tanaquil* (National Gallery, London) are close in style to the Martelli Collection panels. They contain Latin couplets in gold capital letters that are directly comparable to those in the *Lupercalia*; they too probably formed part of the same decoration. The *Penelope* (Seminario Patriarcale,

Girolamo del Pacchia,
Abandoned Ariadne. Chigi
Saracini Collection, Siena.

pp. 364–365
Domenico Beccafumi,
ceiling decoration.
Palazzo Venturi, Siena.

Venice), however, is more old-fashioned. The presence of a *Venus*, which could be that in the Barber Institute in Birmingham which once formed part of a bedstead, is less certain.[20] The possibility of its constituting part of Francesco di Camillo Petrucci's decoration is reinforced by the inventory of Marcello Bandinelli's moveable and non-moveable goods at the time when he was living in Pandolfo Petrucci's palace. Bandinelli, who was related to the Petrucci family, owned a quarter of the palace which he included in the inventory made for his younger sons Pandolfo and Marcellino at his death in 1603. Among the furniture listed in the rooms appears 'a Venus by Mecarino [Beccafumi] made out of a headboard',[21] which could have been part of the decoration made for Francesco di Camillo Petrucci.

Beccafumi's decoration for Francesco di Camillo continued the Petrucci family's tradition of commissioning cycles of paintings with a humanistic character, in which the virtues of the family were celebrated. This was done through the idealization of classical female figures, famous for their virtues as wives and mothers. Such a visualization of history and myth served private purposes, as often happened at that time, particularly in Siena where classical heroines were used hortatorily in the decorative context of wedding chambers. With this in mind, it seems strange that Beccafumi's decoration was not commissioned on the occasion of Francesco Petrucci's marriage in 1512.

The humanistic theme prevented Beccafumi from yielding to his most unbridled fantasies. He constructed the scenes by concentrating on his use of colour, in particularly mother of pearl. In the *Temple of Vesta* and the *Lupercalia* he paints shadows to contrast with the forms of the protagonists, who are animated transfigurations of classical sculptures.

Around the end of the decade, influences from contemporary Roman art can be seen in the works of painters practising in Siena. Girolamo del Pacchia, for example, was aware of Raphael's work in the Vatican Loggias. Like Beccafumi, Pacchia also painted a wedding decoration of which a small rectangular panel, probably taken from a bedstead, remains. It depicts the story of *Abandoned Ariadne* (Chigi

Saracini Collection, Siena). The provenance of this painting is unknown and its attribution to Sodoma seems unlikely.[22] The Raphael-inspired panel has a style that is much more in line with the work of Pacchia, to whom a *Female Figure in a Landscape* and an *Allegorical Figure* in Budapest, painted in *c.*1518, have also been attributed.[23] Pacchia's painting is characterized by its softness, an effect probably intended to imitate the concise painting technique that Pliny described.[24] Although indirectly, the inventory of Marcello Bandinelli's goods supports the attribution to Pacchia. It lists a 'headboard that has been made into a painting, showing the story of Ariadne with Perseus, [it is] the work of Pacchiarotto'. For seventeenth-century authors, including Mancini, the dividing line between the works of Pacchia and Pacchiarotto was continually being redrawn. It is therefore possible that Pacchia did paint an *Ariadne* for a wedding chamber and that this can be identified with the work in the Chigi Saracini Collection.

At the end of the second decade of the sixteenth century Beccafumi consolidated his relationship with the families who supported the Nove. His main commissioners were the Petrucci, Marsili, Venturi and Borghesi families. They were some of the richest families in the city and were all related to one another through marriage although they often supported opposing factions. After Pandolfo Petrucci's death, his descendants succeeded in governing the city, but power struggles within the family left it politically weaker and finally led to its downfall. The tense political situation, however, did not hamper commissions for decorations in private palaces in the city, which continued with their humanist subject matters but stylistically veered towards those Agostino Chigi had commissioned in the Villa Farnesina.

One such decorative commission was for a ceiling in the Palazzo Venturi. It was painted by Domenico Beccafumi and contains stories taken from classical literature. Painted in a small room, the cycle is the most complex manifestation of humanist painting taken from classical literature prior to the concept being developed in a public place, such as on the ceiling of the Sala del Concistoro in the Palazzo Pubblico.

The subtlety of these frescoes induced Lanzi to say that Beccafumi's style is 'like a liqueur that keeps its taste while closed in a small bottle, but when placed in a larger receptacle evaporates and loses [its taste]'.[25] The Venturi family coat of arms is placed in the centre of the ceiling. The Venturi were connected with the Petrucci through marriage but supported the losing faction in the struggle for power. At the death of Cardinal Raffaello Petrucci two members of the family, Francesco di Camillo and Fabio di Pandolfo, came to blows. Francesco's faction, to which the Venturi were linked, was expelled from the city[26] and this must have been when the Agostini gained control of the palace. The Agostini were a family of obscure origins from Monte del Popolo, who probably owed the beginning of their fortunes to a certain Paolo who was the notary of the Balia in 1525. Vasari's testimony has led art historians to believe that the Agostini commissioned the Palazzo Venturi project from Beccafumi and to give the frescoes a late date that is discordant with their style. In the second edition of his *Lives of the Painters* Vasari speaks of the vault painted by Beccafumi being in a room belonging to Marcello Agostini. Marcello was born in 1514 and could therefore only have been a patron of Beccafumi in the 1530s and later.[27] His social success is apparent from his marriage to Sulpitia Piccolomini and from his first public office in the city magistracy in 1546. In the same year he bought a piece of land outside Porta Laterina, called La Rosa, from the heirs of Filippo Decio.[28] The weight of evidence, therefore, supports the hypothesis that the palace in via dei Pellegrini only came into Agostini possession after Beccafumi had completed the decorative cycle.

The frescoes have a central thematic nucleus of family and civic virtues. They were probably planned to celebrate a wedding, possibly that of Alessandro Venturi, son of Jacopo, and Bartolomea Luti in 1509. The iconography of the frescoes also suggests a political context. The reappearance of the themes of family and state, which had already been treated together in the decoration of the Palazzo Petrucci about ten years previously,[29] may have followed the attempts at political domination on the part of the various factions connected to the Petrucci, including the Venturi. In the Palazzo Petrucci the approach to the classical texts serves to remind us of events in the family's history: the exile, the return, the relationship between father and sons and the allusion to the humanistic traditions of the family. In the Palazzo Venturi the iconography seems to refer to the future of the family and their aspirations to the political domination of Siena, which were soon to be quashed by reality.

The connection between the Venturi and Beccafumi's ceiling is important in terms of the chronology of the cycle. The frescoes were probably executed around 1519, a date that explains the strong similarities with contemporary frescoes in Rome.

The Venturi ceiling was the most complex iconographic cycle painted in Siena during this period. Its principal source is the *Factorum et dictorum memorabilium libri* by Valerius Maximus.[30] The painting follows the narrative structure of Valerius Maximus's book, taking the main examples of virtues used in the cycle from it. Some episodes are also taken from Livy, Cicero, Florus and Pliny. The two principal examples are depicted at the centre of the ceiling between two fictive tapestries, an idea that must have come from the Loggia of Psyche in the Villa Farnesina. The frescoes are the *Continence of Scipio* and *Zeuxis Painting the Portrait of Helen*. In addition, there are another six octagonal paintings as well as mythological stories taken from Ovid's *Metamorphoses* and from Hesiod. The stories are shown in medallions supported by small genii, cherubs, nymphs and caryatids in the four corners of the room. The meaning of the iconography is still not completely clear but its style is nevertheless impressive.

Beccafumi used complex perspectives that cut across one another in a disturbing manner. He reconstructs fantastic architectural elements on antique ruins. His figures are mostly formed from pastel tones. A previously unpublished drawing from the Biblioteca Comunale in Siena shows the creative process through which the frescoes in the Palazzo Venturi were composed. Coloured with tempera, the drawing shows the *Head of an Old Man* and must have been a preparatory study for the head of Prometheus in the

medallion depicting *Prometheus Fashions Man from Clay*.[31] The connection with the fresco can be proved by the identical profile of the two figures, while the slight variations in their eyes and in their hair can be attributed to their different expressions, although that in the drawing is much more intense. I have already mentioned the possible relationship between Beccafumi's drawings and Fra Bartolomeo's masterful use of delicate and soft shading. Beccafumi's other known sketches are in tempera or coloured oils and can mostly be related to the frescoes in the Sala del Concistoro. The *Head of an Old Man* provides an insight into Beccafumi's way of articulating artistic thoughts through coloured drawing. It also gives us a better knowledge of Beccafumi's constant research on chiaroscuro and, thereby, of one of the key problems addressed by sixteenth-century artistic theory.

In the Venturi frescoes the continuous softening of the colours, which are enriched with tones of mother of pearl or with reddish gleams, stems from Raphael's works in Rome. There are echoes of the Stanza of Heliodorus, of the Stanza of the Fire in the Borgo and also of the Loggia of Psyche and the Vatican Loggias. Even the architecture, which is reminiscent of Peruzzi's classicism, and the settings assume an unreal quality,[32] a sort of ideal dimension of virtue, society and power that belongs to a world that is quite different from that of daily life.

During his career, Beccafumi received many religious commissions. The *Nativity* from the church of San Martino in Siena was painted shortly after the Venturi frescoes and has been much studied. Vasari treated it as a turning point in Beccafumi's work. It was planned in relationship to the marble altar sculpted by Lorenzo di Mariano in 1522 for Anastasia Marsili, the widow of Ugolino Ugolini, and can therefore be dated around that year.

In the *Nativity* Beccafumi staged a grandiose sacred scene in which the protagonists are arranged symmetrically in the foreground, illuminated by a diagonal light, while the less important figures emerge in the middle ground. The bent pilgrims, weighed down by their rags and by their anxieties, slowly present themselves at the arch, astonished and reverent when faced with the birth of the Saviour. A ruined triumphal arch, with broken columns that have been replaced by ivy-ridden tree trunks, is obscured by an illogical system of

Domenico Beccafumi,
Head of an Old Man. S.III.2, fol. 29r,
Biblioteca Comunale, Siena.

p. 369
Domenico Beccafumi,
Nativity. San Martino, Siena.

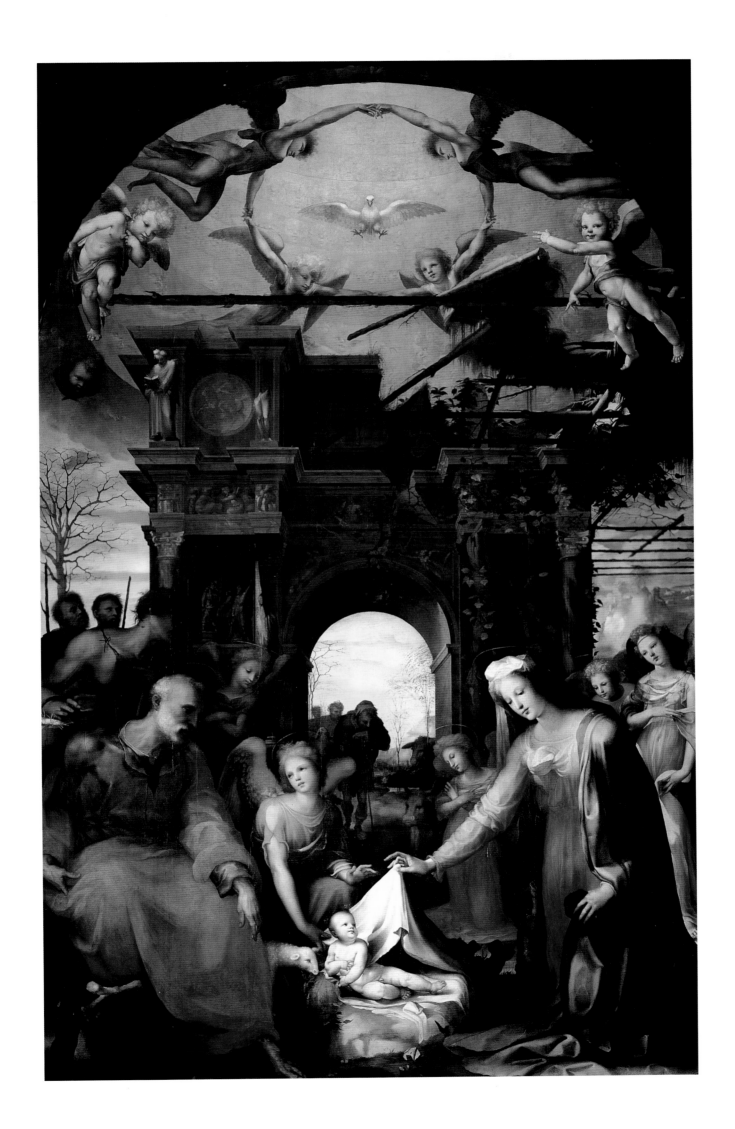

wooden beams symbolizing the fall of the pagan world. At the top of the composition, against a red sunset, there is a circle of dancing angels. This sky marks a step in Beccafumi's move towards the use of skies that are lit up by flashes of fire. He had already painted such a sky in the *Death of the Virgin* in the Oratory of St Bernardino. The composition of the *Death of the Virgin*, however, contained a number of fantastic elements which do not appear in the *Nativity*, where the colour is applied in large, calm areas. The almost Venetian rhythms of the mature Raphael appear to be grafted on to the painting.[33]

The problem of the using chiaroscuro, which Beccafumi explored throughout his career, can be seen in the marble intarsia work commissioned for the pavement of Siena Cathedral. Beccafumi's involvement in this project revolutionized the art of intarsia. In the first edition of his *Lives of the Painters*, Vasari recorded that modern artists had invented 'another type of mosaic inlay, [with] which they mimic scenes painted in chiaroscuro'. On 11 March 1519 Beccafumi received a payment for the cartoon, which must have been a general plan of the scenes that were to be placed under the cupola of the cathedral. In September 1521, as an *operaio*,

Guido Palmieri was paid thirty-two scudi for having drawn and painted the stories of Elijah and Ahab in three compartments. These were the *Sacrifice of the Priests of Baal*, the *Sacrifice of Elijah* and the *Killing of the Priests of Baal*. Finally, a document of 1524 records the payment for the central hexagon depicting the *Agreement between Elijah and Ahab* and two lozenges representing *Elijah and Abdia* and *Abdia and Ahab*.

The pavement intarsias are the first representation of this biblical story in Italian art. Beccafumi faithfully follows the text from the Book of Kings, which recounts the story of a drought that devastated the pastureland. Elijah and Ahab made a pact to obtain rain with a sacrifice that would please the true God. Elijah made a pure sacrifice and when invoked, the true God produced fire that consumed the sacrificial victim. The priests of Baal's attempt failed and so it was the true God, that of Israel, who caused the rain to fall. The choice of these biblical scenes is probably connected with the function of the area of the cathedral in which they are placed, which is dedicated to preaching. According to Niccolò da Lira, a celebrated fourteenth-century commentator on the Bible, the contrast between Elijah and the priests of Baal

Domenico Beccafumi, *Nativity*,
detail. San Martino, Siena.

represents the fight between the preachers of the truth and those who preach false doctrines.[34]

The intarsia programme under the cupola functions as an intermediary element between the nave and the altar, because of both its style and its iconographic significance. Some of the programme was altered in the nineteenth century when the fourteenth- and fifteenth-century lozenges and those designed in 1562 by Giovan Battista Sozzini were changed. The intarsias in the nave area included *Hermes Trismegistos* who gave the laws to the Egyptians, thereby providing them with human wisdom. Beccafumi designed *Moses Receiving the Tables of the Law* for the area in front of the altar. The commandments given to Moses represent divine wisdom.[35]

In this first section the problem of chiaroscuro in the intarsia is dealt with in a timid fashion. The difference in style from the *Allegory of Wisdom* designed by Pinturicchio in 1505 is not immediately evident. Given the almost total absence of preparatory drawings, for information about the execution of the intarsias we must rely on a document of 1521 from which we learn that Beccafumi's cartoons were first traced with charcoal and then colours were laid down with a brush. This is true of the only remaining fragment of the cartoons for the scenes that were completed in 1521, which shows a child drawn in charcoal with his yellow clothes coloured by a brush.[36] The groups of figures in the scenes are expertly arranged and there is a progressive softening at their edges, which reaches its height in the later intarsias such as *Elijah and Abdia*. The head of Elijah closely resembles the drawing that I linked with the representation of *Prometheus* in the frescoes in the Palazzo Venturi.

Beccafumi's participation in a cycle of such great religious significance as the decoration of the floor of Siena Cathedral must have exerted an influence on his religious painting. He was employed on important religious commissions at the same time as Bernardino Ochino was exhorting people to abolish 'displays' and 'whims'.[37] Domenico Beccafumi's religious beliefs are not clear, as can be seen from the two versions of the altarpiece with the *Archangel Michael Turning the Rebel Angels out of Paradise*. The version in the church of San Niccolò al Carmine, now without the original predella, contrasts the terror of the angels falling headlong into the

Domenico Beccafumi,
Archangel Michael Turning the Rebel Angels out of Paradise, detail.
San Niccolò al Carmine, Siena.

p. 372
Domenico Beccafumi, *Archangel Michael Turning the Rebel Angels out of Paradise*.
San Niccolò al Carmine, Siena.

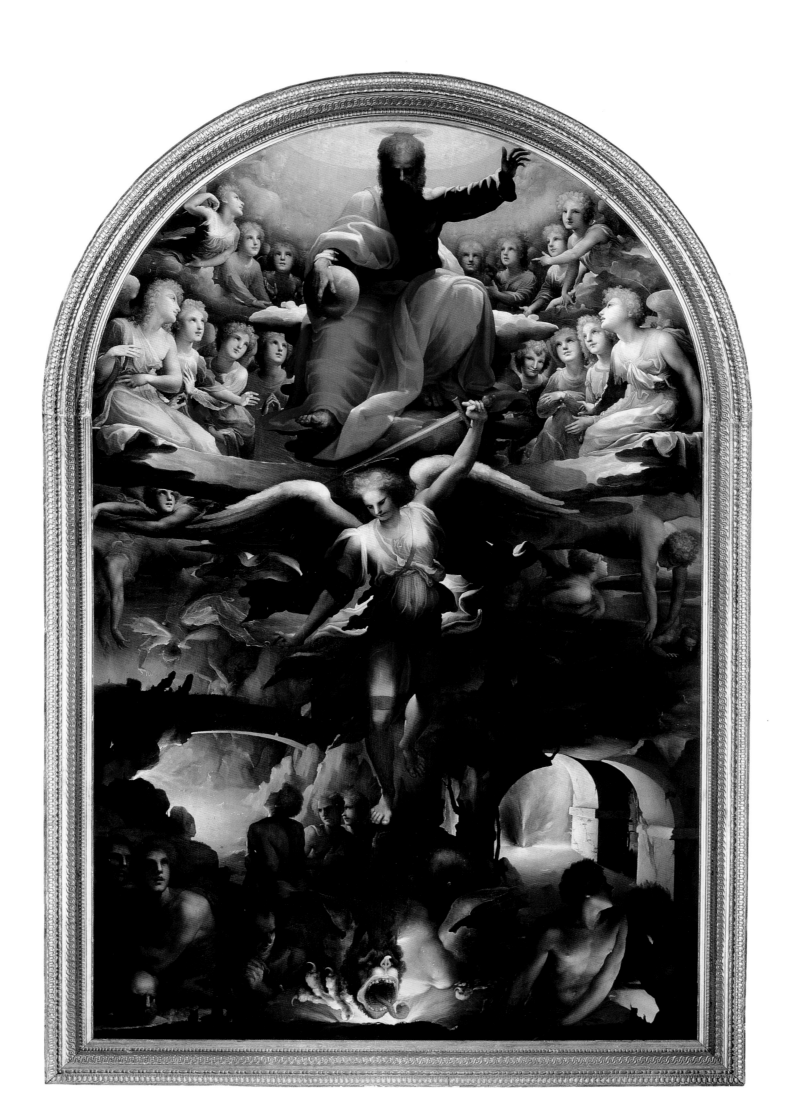

flames with the serene grace of the angels admitted to enjoy the beatific vision of God eternally. Beccafumi experimented with another version of the same subject (Pinacoteca, Siena). According to Vasari, the first version had been ordered from Beccafumi by the Carmelite friars for their church. It was never completed and, again according to Vasari, was placed in the Ospedale di Santa Maria della Scala in 'a room near the high altar at the top of the stairs'.

In the first *Archangel Michael Turning the Rebel Angels out of Paradise* Beccafumi accentuates the distressing aspects of the story. He concentrates on the terrible defeat of the devil who, according to Revelations (20:10), was 'thrown into the lake of fire and sulphur, where the beast and the false prophet are, and their torture will not stop, day or night, for ever and ever'. Meanwhile the thrones and 'those who are given the power to be judges' are only minor elements of the composition, represented in the transparent sky. Beccafumi's interpretation emphasizes the moment of condemnation. It was painted shortly after Raphael's version of the same subject, which had been sent by Leo X to Francis I of France in order to encourage him to oppose the Lutheran heretics. Beccafumi's style in

the first version continues the use of the unusual elements present in the *Death of the Virgin*. These include the enormous silhouette of God the Father who seems to grasp the protagonists and who is reminiscent of the figure of Christ in the *Death of the Virgin*. Does this painting constitute a personal response to Mannerism or is it a reaction to the religious events of the time? The lower part of the composition was influenced by Michelangelo, in particular the nude figures hurling and twisting themselves, clinging to each other, and unified in their shouts of pain. The figures are inspired by the *Crucified Haman* in the last pendentive of the Sistine Chapel. The nude at the bottom of the painting who emerges from the bowels of the earth seems to repeat the gesture of Laocoön in the famous classical sculpture in Rome.[38]

In the second version of the *Archangel Michael Turning the Rebel Angels out of Paradise* both pain and happiness are expressed within the same composition. The style is also calmer, with greater emphasis given to colour. Vasari described the painting by saying that it represented 'God upon the clouds, surrounded by angels. In the middle is St Michael in armour, pointing as he flies to Lucifer, who is

Domenico Beccafumi, *Archangel Michael Turning the Rebel Angels out of Paradise*, detail. San Niccolò al Carmine, Siena.

driven to the centre of the earth amid burning walls, falling rocks and a flaming lake, with angels in various postures and nude figures swimming about and suffering torment, the whole done with such style and grace that the place seems illuminated by the fire.'

While the first version concentrates on drawing, light is the dominant element in the second painting. Evidence of Beccafumi's continued interest in light can also be found in the *Santo Spirito Altarpiece*, probably painted *c.* 1528. In this work he painted a baldachin that has the effect of filtering the light. Changing shadows fall over the Virgin, the Child and St Catherine and illuminate the ochre yellow, red and violet of the saints' clothes. In the *Archangel Michael Turning the Rebel Angels out of Paradise* the light distributes a fine dust of silver on the red cloak of God the Father, making the emerald clothes of the left-hand angel turn yellow and the yellow clothes of the right-hand angel turn pink. Beccafumi's study of the archangel's face also reveals this treatment of light in the way in which red and black are knitted together, demonstrating once again the extent to which the use of coloured drawing contributed in giving form to the painting.

The relationship with the *Santo Spirito Altarpiece* means that the second version of the *Archangel Michael Turning the Rebel Angels out of Paradise* was probably painted a little before 1528. This was a crucial time in the religious and cultural history of Siena. After the plot of the Republican Party (the *libertini*), the killing of the leader of the Nove, Alessandro Bichi, and the victory of Camollia in 1526 over the Papal league (formed by England, France and Venice)[39] came the first cases of religious disagreement. The dissension was fuelled by the works of Erasmus and was marked by a desire both for renewal within the Church and for the unification of the Christian and humanist messages.[40] These events must have affected both artists and commissioners but it is difficult to trace any direct impact. The event that did have a visible effect on Sienese art was the Sack of Rome by the Holy Roman Emperor Charles V in 1527. The devastating influence on patronage in Rome led some Sienese artists to return to the city of their birth.

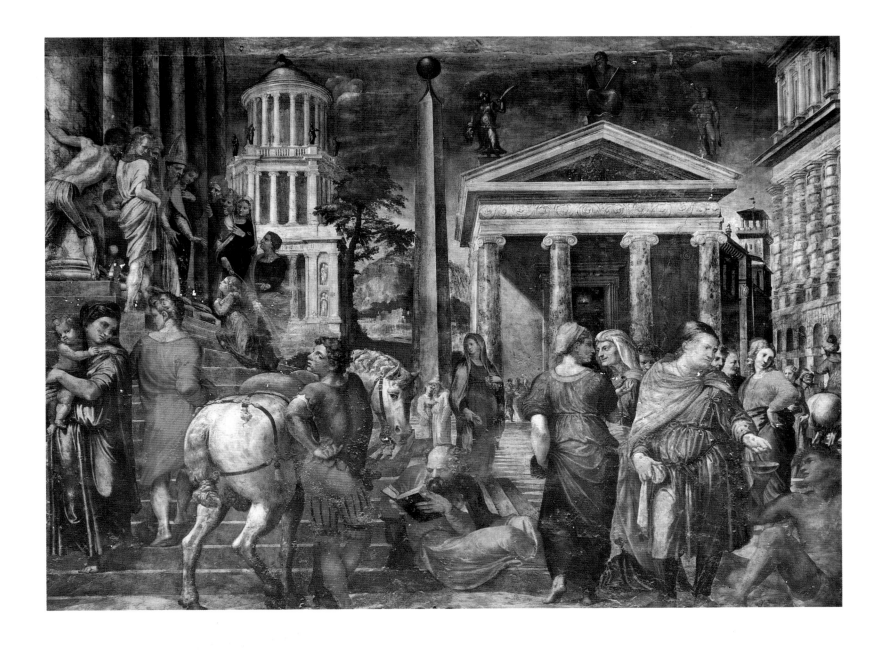

Baldassarre Peruzzi,
Presentation of Mary in the Temple.
Santa Maria della Pace, Rome.

p. 376
Sodoma, *Swoon of St Catherine*.
St Catherine Chapel,
San Domenico, Siena.

The Aftermath of the Sack of Rome

Among the artists who returned to Siena, the most famous and experienced was the architect and painter Baldassarre Peruzzi. In Rome he had contributed to the decoration of the Villa Farnesina, painting a ceiling with an astrological theme in the Loggia of Galatea. Between 1516 and 1518 he had also decorated the most important room in the villa – the Sala delle Prospettive. Here Peruzzi displayed his mastery of illusionistic perspective, following the decorative style described by Vitruvius rather than the current taste for grotesques. The room was painted in a naturalistic style in which the walls of the galleries were treated as a series of windows on nature, showing 'villas, porticoes and parks, groves, copses, hills, fishponds, straits, rivers [and] shore'.[41] Although much of Peruzzi's work in Rome is undocumented, the commissions that he executed there had a notable impact in humanist circles. These included the apse of the Ponzetti Chapel in Santa Maria della Pace and the slightly later *Presentation of Mary in the Temple* for the same church (commissioned by the Sienese Filippo Sergardi), as well as the lunettes and compartments in the gilded vault of the Palazzo della Cancelleria in Rome. Peruzzi took much of his inspiration from descriptions by Pliny and Vitruvius and from a knowledge of classical buildings and ancient history. In Siena, despite the burden of numerous architectural commissions, including the fortification of the city, Peruzzi continued to influence Sienese painting and to contribute to the renewed interest in classical culture.

In 1526 Sodoma painted the frescoes in the St Catherine Chapel in San Domenico in Siena in which he was inspired by classical sculpture. He took note of the new developments in Rome, above all Raphael, but was not directly influenced by Michelangelo's paintings there, although elements of the latter's work would have reached him filtered through the work of Raphael. Vasari's view was correct when he quoted Baldassarre Peruzzi as saying that in the *Swoon of St Catherine* 'he had never seen anyone express the affections better'.

Sodoma, *Ecstasy of St Catherine*.
St Catherine Chapel,
San Domenico, Siena.

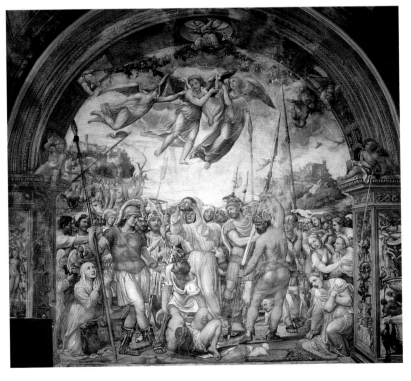

Sodoma, *Execution of Nicolò di Tuldo*.
St Catherine Chapel,
San Domenico, Siena.

p. 378
Sodoma, *Execution of Nicolò di Tuldo*,
detail. St Catherine Chapel,
San Domenico, Siena.

p. 379
Sodoma, *Death of Lucrezia*.
Galleria Sabauda, Turin.

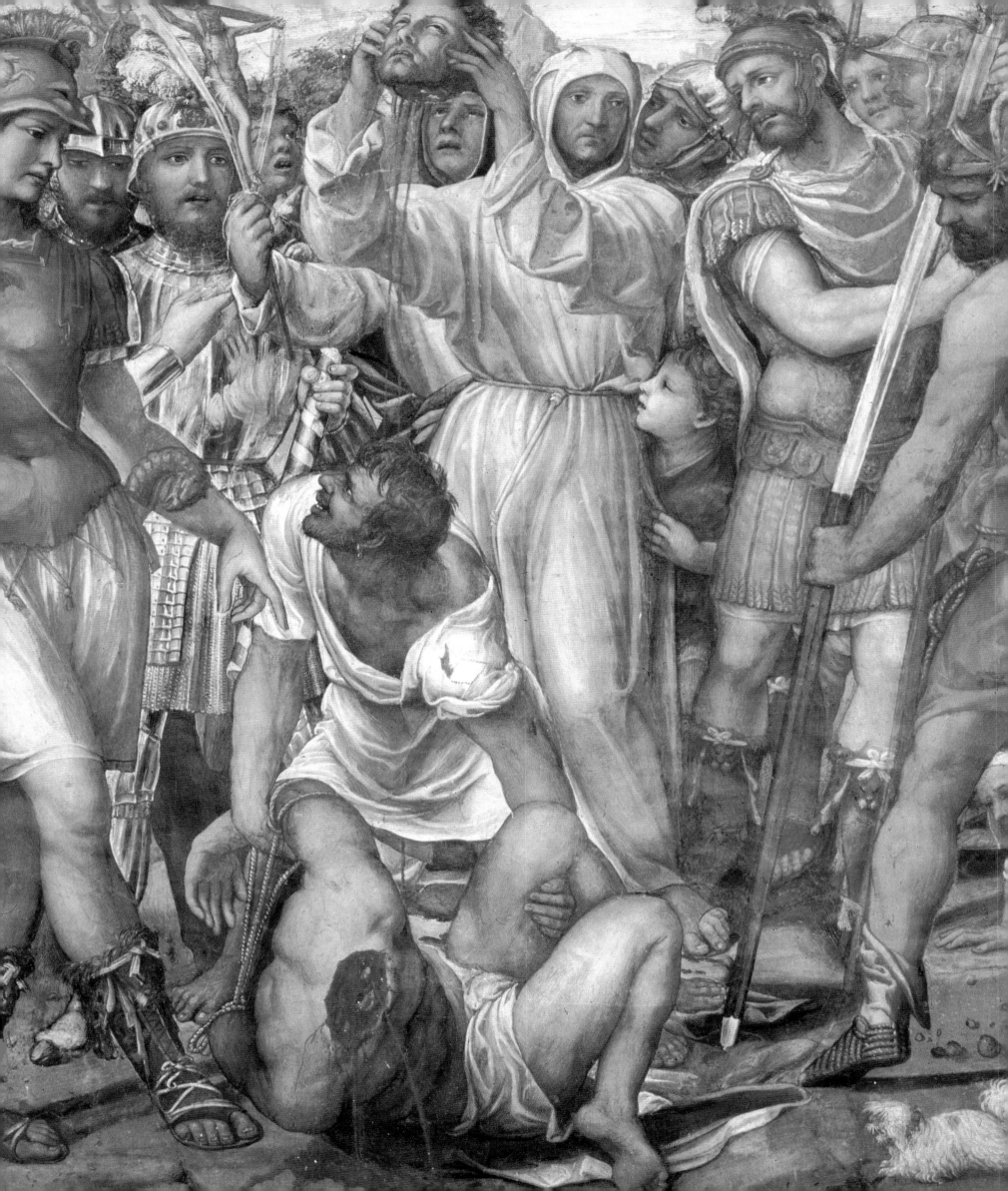

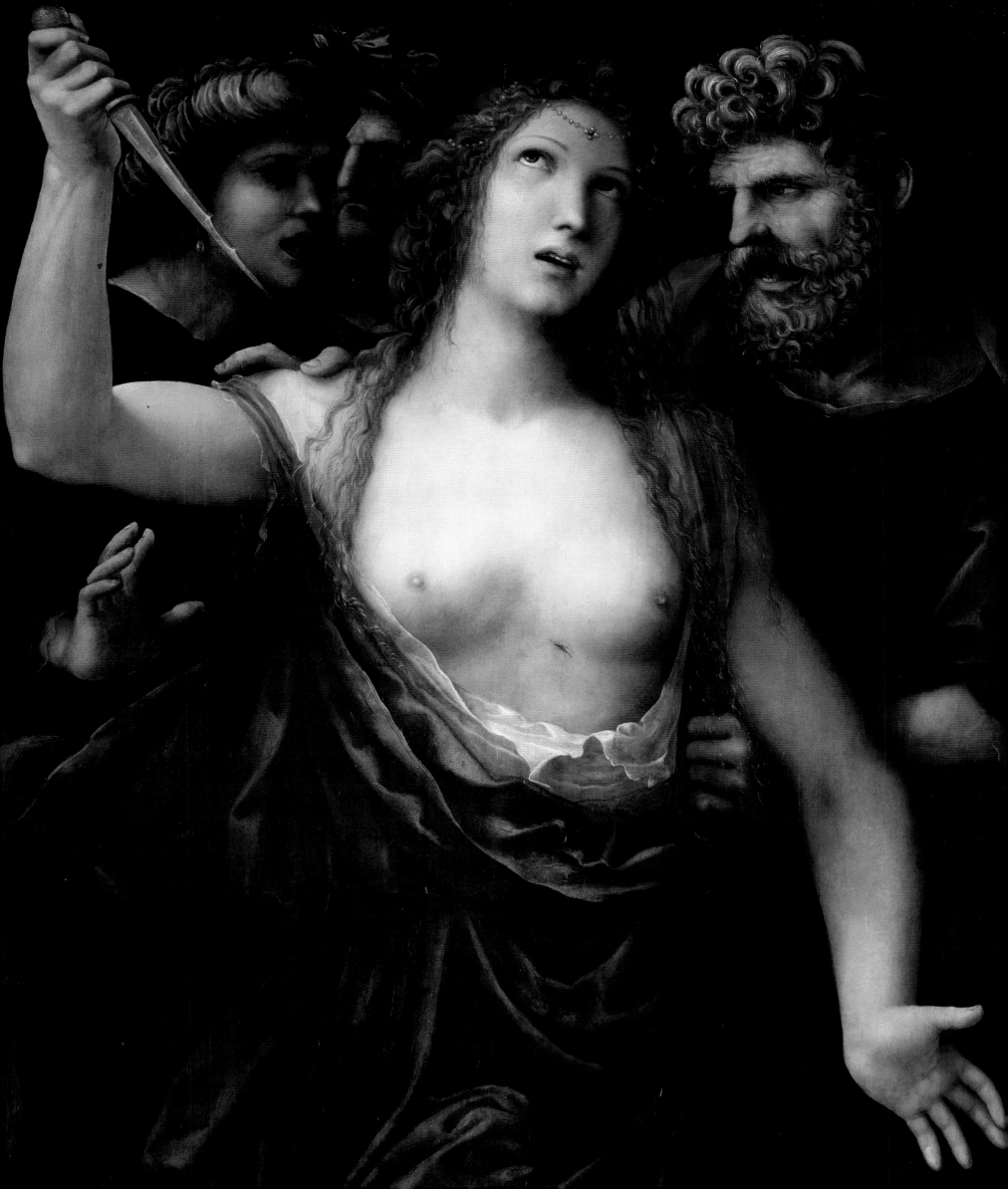

Sodoma painted the episodes from the life of St Catherine of Siena with the same elevated tone that he had used in the scenes of St Anne and St Benedict. Once again he chose to use grotesques (see, for example, the *Philosophers* under the arch), which were by that time bearing strong traces of Raphael and his followers. Sodoma also used a number of classical citations based on discoveries made in Rome. Only two examples survive to clarify the way he used classical models to achieve a persuasive elegance. In the *Execution of Nicolò di Tuldo*, the headless body of Nicolò is carried to the foreground by one of his executioners, witnessed by soldiers who are dressed in classical Roman costume. Sodoma's drawing of the corpse was inspired by a study of the *Belvedere Torso*. His use of classical detail in the scenes from the life of St Catherine of Siena is similar to the classicism in his *Death of Lucrezia* (Galleria Sabauda, Turin). Here, the stoic tale of the Roman heroine is conveyed with the help of antique classical statuary, as can be seen by a comparison between the figure on the right and the colossal *Jupiter of Versailles*, which had just been rediscovered in the villa of Cardinal Francesco Armellini.[42]

While Sodoma was drawing new inspiration from classical art and Beccafumi was continuing his experiments with light and colour, other Sienese artists found their niche between the two. It is probable that a number of other artists returned to Siena from Rome at around the same time as Baldassarre Peruzzi, resulting in a period of change in Siena. The approaches to humanist culture developed and the academies flourished – the Grand Academy, the Intronata and that of the Rozzi. In these establishments, the elite of the city concerned themselves with linguistic, poetical or theatrical questions.[43] They employed artists to construct scenery or ephemeral displays and also asked them to work in the rooms, porticoes and loggias of their palaces, which they sought to ennoble with decorations echoing the antique. For example, Bernardino Francesconi alla Lizza had the vault of a small room in his house, attributed by Fabio Chigi to Baldassarre Peruzzi, decorated with eight painted candelabra and a scroll containing his name and the date 1527. The work was strongly influenced by contemporary Roman painting and it is clear that the painter was deliberately following the naturalism of Giovanni da Udine in the Vatican Loggias. However,

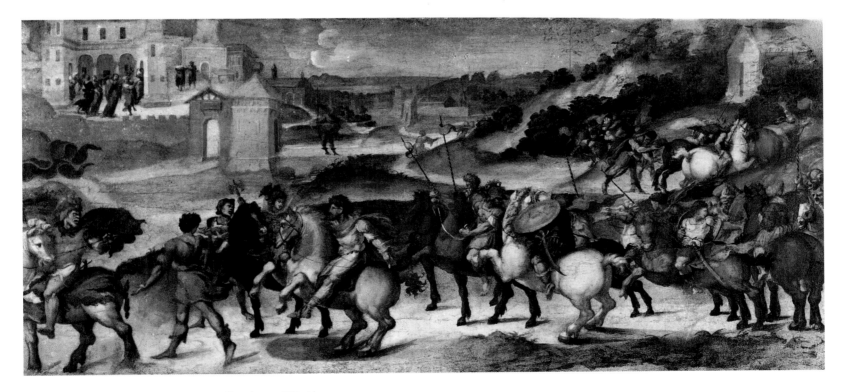

p. 380
Bartolomeo di David,
vault decorated with grotesques.
Palazzo Francesconi, Siena.

Bartolomeo di David,
Procession of Soldiers.
Galleria Colonna, Rome.

the Sienese painter at work in Bernardino Francesconi's house was inspired by an imagination that induced him to paint elements recalling the intertwining griffins, masks and fauns around the candelabra painted by Sodoma in Monte Oliveto Maggiore. Consequently the festoons of greenery and fruit and the birds which Giovanni da Udine liked to study are a model more honoured in the breach than directly copied. No documentary information survives to identify the painter who decorated Bernardino Francesconi's palace but a comparison with the *St Honofrius*, the *Madonna and Child with St John the Baptist*, the *Pietà* and the *St Andrew*, identified as parts of the bier that Bartolomeo di David painted in 1532 for the Compagnia di Sant'Onofrio,[44] makes it seem probable that he was the author of the ceiling decoration.[45] The panel presenting a *Procession of Soldiers* (Galleria Colonna, Rome), which had been attributed to Peruzzi in the old inventories, has also been ascribed to Bartolomeo di David.

In the Piccolomini Mandoli's house, which was part of the Palazzo Chigi Saracini in via di Città, Fabio Chigi reported 'a small portico by Giorgio, the collaborator of Giovanni da Udine'. Chigi was referring to Giorgio di Giovanni, who is documented from 1538 and who died in 1559. Mancini records Giorgio di Giovanni's collaboration with Giovanni da Udine in the Vatican Loggias in Rome.[46] The fruit, greenery and animals which Mancini also mentions belong to a repertory that relates to the decoration of the Vatican Loggias. However, the heavy repainting of the Piccolomini Mandoli portico in the nineteenth century makes a judgment on stylistic grounds difficult. Also disfigured by nineteenth-century 'restorations', the decorations of the loggias in Belcaro Castle, acquired in 1525 by the banker Crescenzio Turamini, derive from the Vatican Loggias and can therefore be connected to Giorgio di Giovanni. Baldassarre Peruzzi was employed on the reconstruction of the castle. The last part to be decorated was the chapel, which has an inscription bearing the date of 1535. Fabio Chigi scornfully attributed the *Madonna* and the scenes in the apse to Beccafumi. However, the surprising affinity with Peruzzi's frescoes in the Loggia of Galatea, with figures characterized by their sharp relief, may mean that Giovanni di Giorgio was also responsible for the chapel. The frescoes, although inspired by

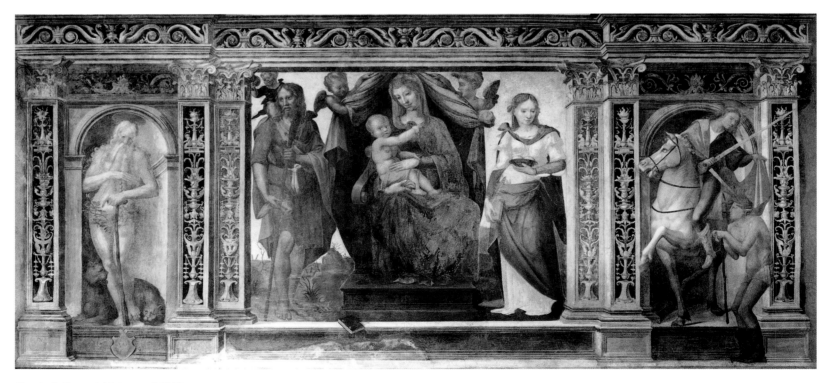

Giorgio di Giovanni, *Madonna and Child Enthroned with SS. Christopher and Agatha*. San Lorenzo, Sovicille.

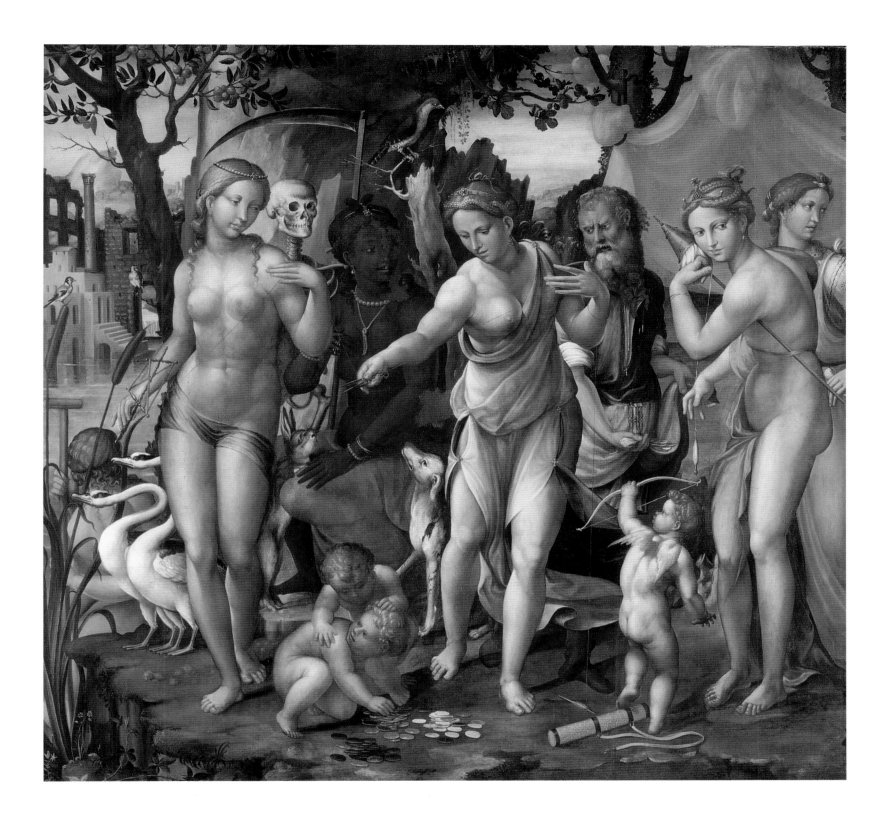

Marco Bigio, *Three Fates*. Galleria
Nazionale d'Arte Antica, Rome.

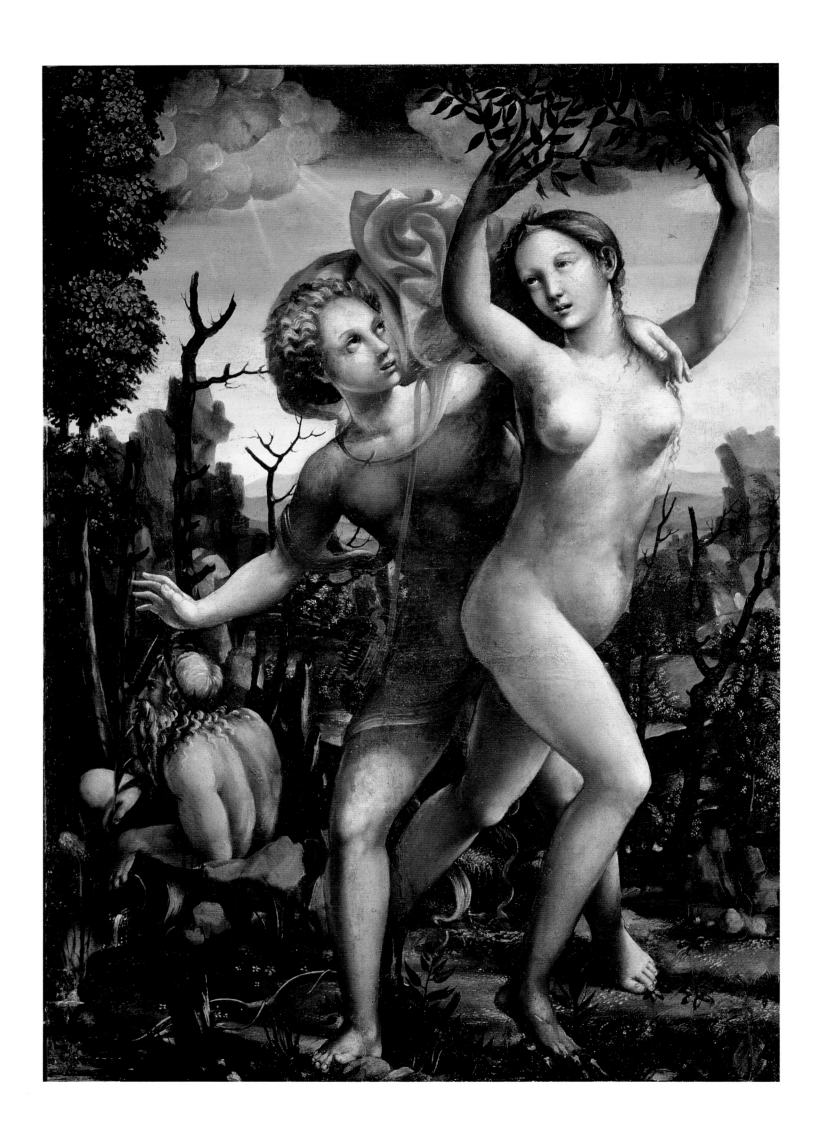

Peruzzi's work, are not merely tired repetitions of ideas first formulated in Rome.

The fresco of the *Madonna and Child Enthroned with SS. Christopher and Agatha* recovered in 1875 from the right wall of the nave in the church of San Lorenzo in Sovicille shares a number of affinities with the decoration of the apse of the chapel in Belcaro Castle. The fresco is surrounded by a framework decorated with friezes and candelabra; flanking the main fresco two niches struggle to contain *St Honofrius* and *St Martin Giving his Cloak to the Beggar*. At the bottom left, almost illegible, is the coat of arms of the Ciglioni family. Similarities with the apse of the Belcaro Chapel are found mainly in the figures, in the angels and putti, and in the faces of the saints. They are most noticeable, however, in St Martin's horse, whose coat is made brighter by cutting white lights, a technique that is used in the majority of the Belcaro figures. Under the influence of Peruzzi, both religious and profane themes are depicted with a classicizing language. The *Three Fates* (Galleria Nazionale d'Arte Antica, Rome) and the *Apollo and Daphne* (Chigi Saracini Collection, Siena) also bear references to Peruzzi's classicizing style. They have been attributed to Marco Bigio, a painter about whom little is known, not even the dates of his birth or death. Mancini mentions his private commissions and Della Valle believed that the *Fates* were the result of a collaboration between Bigio and Tozzo.[47]

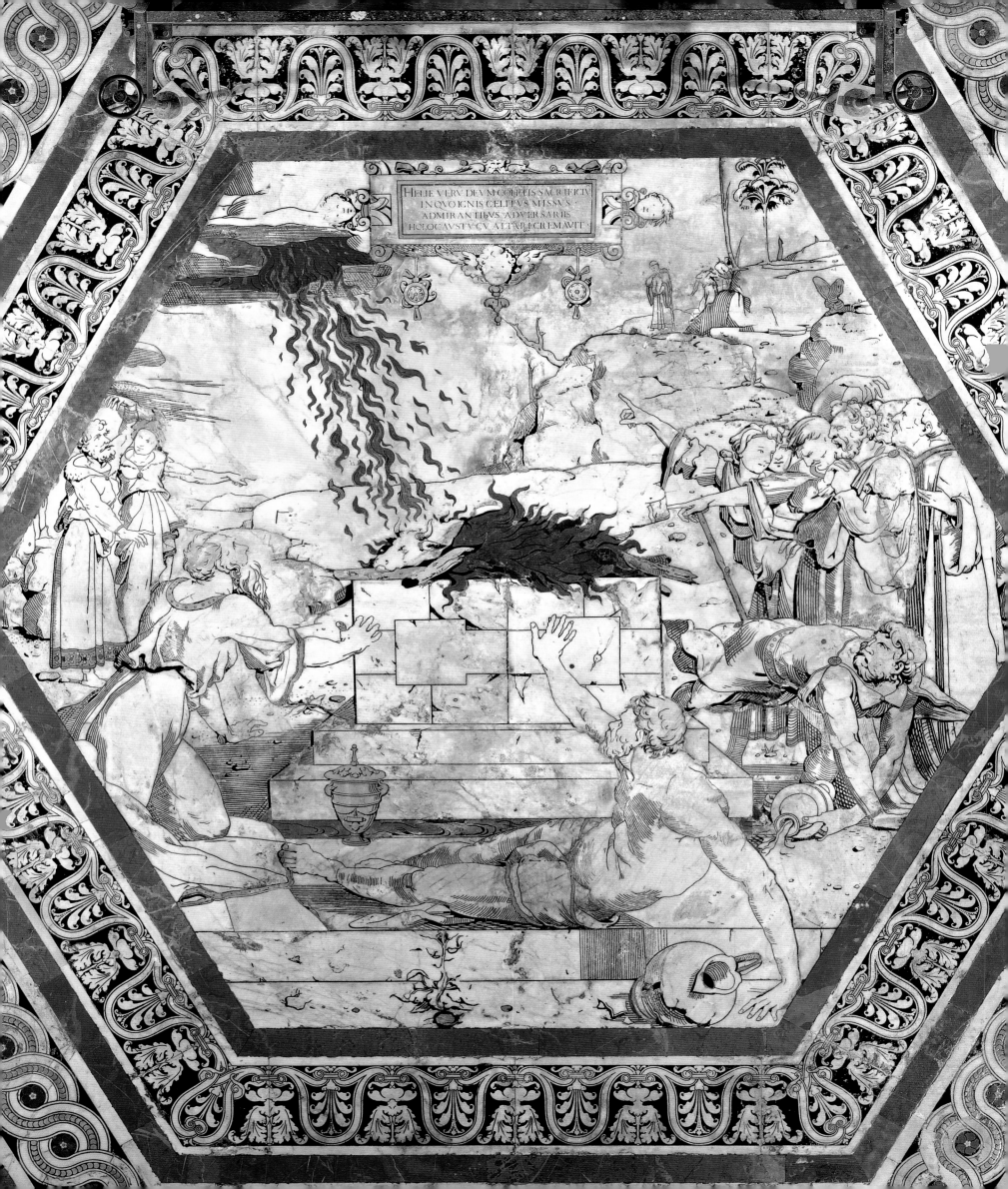

HELIE VERV DEVM COLLENS SACRIFICIV
INQVO IGNIS CELITVS MISSVS
ADMIRANTIBVS ADVERSARIIS
HOLOCAVSTV CV ALTARI CREMAVIT

Domenico Beccafumi and the Spread of Mannerism

Peruzzi's gentle academic style differs greatly from Beccafumi's use of classical inspiration in his designs for the cathedral floor. The pavement programme was one of the largest undertakings in Siena and its iconography was thematically complex. Beccafumi was paid for the cartoons of the *Scenes of Moses on Mount Sinai* in 1531 but the work must have been started in 1529. The inscription on the border states that work was begun during the period of office of the *operaio* Antonio d'Agostino del Vescovo, between 1525 and 1529, and that it was paid for in 1531 by Francesco Tolomei. The *Scenes of Moses on Mount Sinai* are separated from the *Scenes of Ahab and Elijah* by means of a frieze depicting *Moses Drawing Water from the Rock*. They represent key moments in the foundation of Christianity. Beccafumi composed the scenes with more thought than an examination of any single stylistic characteristic may suggest. The scene of *Moses Drawing Water from the Rock* is closely related to antique friezes and painted façades while the *Scenes of Moses on Mount Sinai*

make use of the iconographic precedent of Cosimo Rosselli's fresco in the Sistine Chapel. The dramatic climax of the scenes is the figure of Moses in the act of receiving the divine law from the heavens.[48] Moses is also represented at the centre of the base of the composition where he breaks the tablets of the law in a fit of anger. Beccafumi follows the text of Exodus from the rise of idolatry to its punishment, placing scenes to the left and right of the central axis.

While progress of the earlier project for the *Scenes of Elijah and Ahab* cannot be traced, cartoons still survive for the Moses scenes (Pinacoteca, Siena).[49] These extraordinary designs contain figures defined by a lively use of line that was inspired by Michelangelo. The protagonists are depicted in areas where watercolour has been used to define lighting effects. All of this was competently translated, or perhaps accentuated, in the marble intarsia by various stonemasons, among whom were the stonecutters Bernardino di Jacomo, Bartolomeo di Pietro Galli and Giovanni d'Antonio Marinelli.[50]

p. 386
Domenico Beccafumi,
Sacrifice of Elijah.
Pavement, Siena Cathedral.

pp. 388–389
Domenico Beccafumi,
ceiling decoration. Sala del
Concistoro, Palazzo Pubblico, Siena.

It is worth considering the circumstances in which this project was completed because of the complex combination of motivating forces behind the pavement. It is possible that the intarsia was commissioned for Charles V's projected visit to Siena during his journey to Italy of 1529 to 1530. This may have affected both the iconography of the various parts of the pavement as well as the way in which Beccafumi confronted the dramatic themes of the programme. Beccafumi was working in the cathedral at a time when its decoration and furnishing were being altered. Under the supervision of Baldassarre Peruzzi, the transformation extended to the area of the main altar and later as far as the apse. The plan must have been to integrate the new classicizing decoration with the existing works. The changes were probably determined by liturgical requirements that had evolved concurrently with developments in the field of music: the growth of the cathedral school, the birth of the role of the master of the chapel and the increase of polyphony.[51] The connection between Beccafumi's work and these phenomena supports the idea that there was a liturgical significance in the scenes that he designed for the cathedral floor. The strong political and

religious motivations behind the commission did not, however, restrict Beccafumi's artistic freedom. The inspired facial features of Moses and the women in the Old Testament scenes bring to mind the Gothic *Sibyls* and *Prophets* of Giovanni Pisano's sculptures on the façade of the cathedral.[52] Beccafumi uses the Gothic style to accentuate the strong expressive character of the biblical figures without completely abandoning the humanist aspect.

Beccafumi reached a turning point in his art during these years. While working on the Moses stories he was commissioned to paint a cycle of frescoes in the Sala del Concistoro in the Palazzo Pubblico. The cycle contained complex themes taken from Greek and Roman history. The commission was given to him in 1529 on the understanding that it would be completed within eighteen months. Although the frescoes may have been wanted for Charles V's projected visit, they were still not finished in 1532, when work on them was interrupted only to be resumed in 1535. The break determined a stylistic change that dominated the entire cycle, giving it accents of solemn eloquence. One external element that contributed to a substantial change in Beccafumi's style

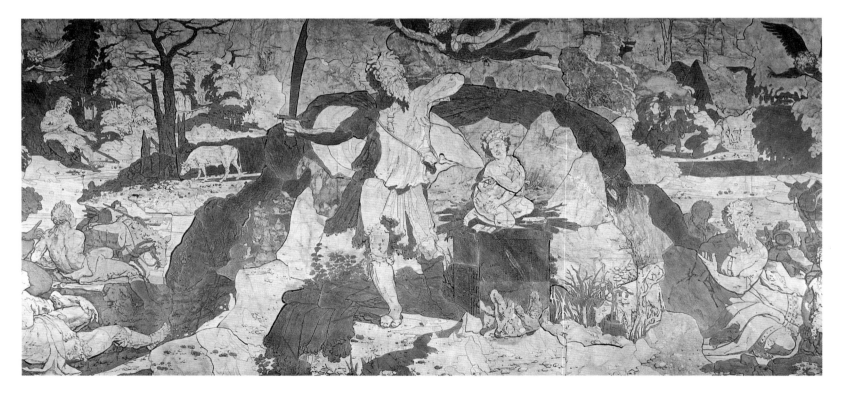

Domenico Beccafumi,
Sacrifice of Abraham.
Pavement, Siena Cathedral.

was his stay in Genoa from 1533 to 1534 when Beccafumi, in the service of Andrea Doria, had the opportunity of encountering a variety of artists. Among them was Perin del Vaga who had worked on the ceilings of the Doria's palace where he had formulated his ideal of 'grace', which was influenced by the theories of Castiglione. His solemn style can best be appreciated in dramatic themes such as the *Fall of the Giants*. The subject relates directly to the contemporary political situation, for it was during this period that the various Italian courts had to adapt to the heavy authority of the Holy Roman Emperor Charles V.

The frescoes in the Sala del Concistoro take up the themes that Beccafumi had already dealt with in the vault of the Palazzo Venturi. Once again the iconographic programme is taken from Valerius Maximus's *Factorum et dictorum memorabilium libri*. The examples chosen are those that serve to exalt justice and the virtues necessary for good government. They also refer to the doctrines put forward by Cicero in the *De officiis*.[53]

In harmony with the other cycles in the Palazzo Pubblico, from Ambrogio Lorenzetti's *Good Government* to Taddeo di Bartolo's *Uomini Illustri*, the programme is linked with the tradition of republican politics. The theme was clear to Vasari who described the ceiling as containing 'large seated figures of men who have defended the state and kept the laws'. This interpretation was destined to remain in the historiographic tradition since it was reiterated in the eighteenth century by Lanzi and given patriotic sentiments by Francesco Gori Gandellini, the unfortunate friend of Vittorio Alfieri.[54] The anonymous author of the iconographic programme used rhetorical means to portray a series of linked events. The fulcrum of the programme is contained in the central band of the vault where *Justice*, *Love of the Fatherland* and *Mutual Goodwill* are represented. They are connected by the scenes relating tortures, suicides and murders, which in turn are related to the figures in the semicircles in the corners.

Most of the episodes were taken from events in the history of the Roman Republic, although the examples of virtues are given universal significance by the inclusion of some non-Roman examples. There are scenes of terrible internal conflict such as that depicting the story of Postumius

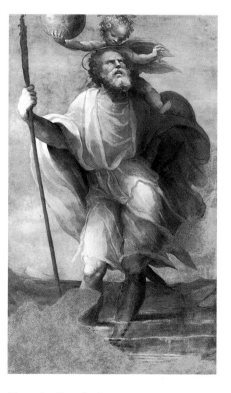

Domenico Beccafumi,
St Christopher. Monastery
of Monna Agnese, Siena.

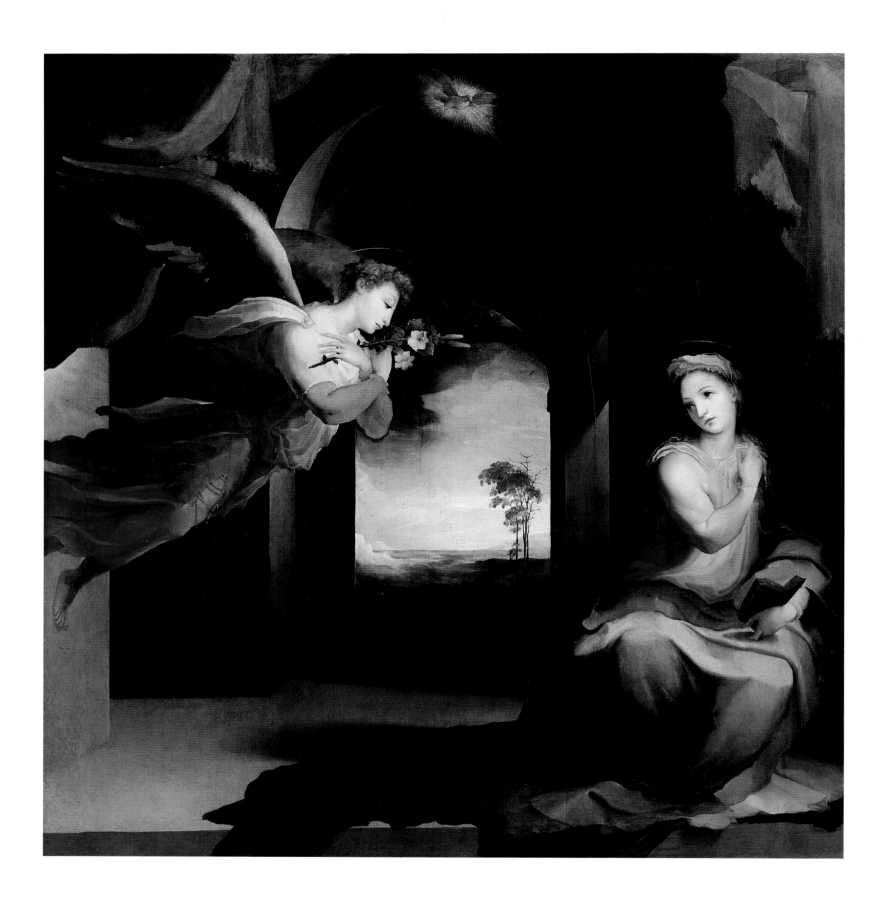

Domenico Beccafumi,
Annunciation. San Martino
e Santa Vittoria, Sarteano.

Tubertus, who had his only son put to death because he had gone against the orders of his superiors and attacked the enemy. There are also scenes relating to the conflict between friendship and public duty, such as the one representing Publius Mucius who had his three fellow tribunes killed because they were scheming against the Roman Republic. Beccafumi's choice of a solemn pictorial language can be seen in the large painting depicting the story of the Athenian Codrus who, having consulted the oracle of Apollo and learnt that the war would be won by the people whose commander was killed, dressed himself as a peasant and went into battle in the front line. In the various scenes Beccafumi employs a narrative technique that places the main action in the centre of the composition. For example, Codrus is shown undressing in the foreground while the gestures, looks and poses of his commanders direct the onlooker to the background scene of the battle and of Codrus's death.

Soon after the completion of the Sala del Concistoro, Beccafumi's style began to change. The panels for the tribune of Pisa Cathedral are full of the varying effects of light that prelude Beccafumi's final phase. However, they also maintain the majestic composition of the scenes depicted in the Palazzo Pubblico, as seen in the figure of Moses, who shows great affinity to that previously executed in the pavement of Siena Cathedral.

Beccafumi's work in the cathedral represents his last artistic phase.[55] From 1531 onwards Baldassarre Peruzzi directed his attention to the reconstruction of the main altar and in 1535 Beccafumi received the first payments for the decoration of the apse, which consisted of frescoes and work in stucco. Beccafumi was also commissioned to design the marble intarsia for the floor around the main altar. The payment documents clarify the chronology of this last important intarsia work in the cathedral. From a stylistic point of view, the intarsias are connected with the frescoes and with the eight bronze angels that Beccafumi started to cast in 1548 and that were to have been placed against the pilasters in the cathedral. In 1544 Beccafumi was paid for three friezes as well as for the *Sacrifice of Abel* and the *Sacrifice of Melchizedek* and in 1547 he was paid for the *Sacrifice of Abraham*. The programme revolves around the theme of the sacrifice of the eucharist, following the text of the Mass.[56]

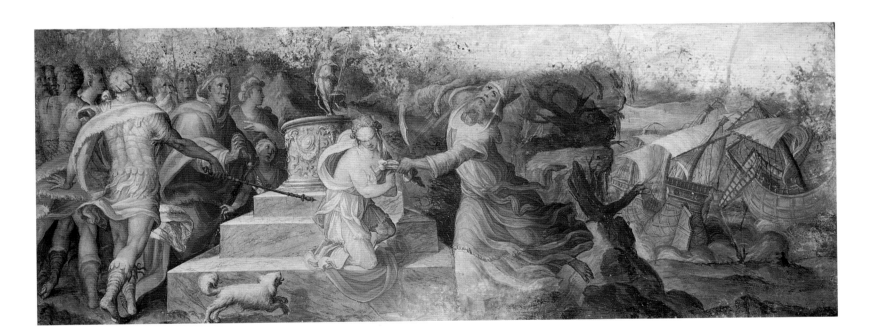

Marco Pino, *Sacrifice of Iphigenia*. Ceiling, Palazzo Mignanelli, Siena.

The subject matter also includes *Adam and Eve* and, therefore, the representation of sin, which made possible the *Incarnation of Christ* and the *Redemption of Humanity*. Beccafumi carries the work to its conclusion with the message of redemption that had begun with *Hermes Trismegistos* and the theme of ancient wisdom. The dominant pictorial idea in the area around the main altar and in the apse is to integrate the massive volumes with an emphasis on colour that results from an accentuated chiaroscuro imbued into the materials. The concept gave birth to the powerful figures of the apostles in the apse as well as to the technical virtuosity of the marble structure of the *Sacrifice of Abraham*. The marble tesserae of the latter seem to merge into a stain in which it is not possible to decide whether the forms are melting or solidifying. During Beccafumi's last phase, at the turn of the fifth decade of the sixteenth century, he executed the monochrome fresco of *St Christopher* in the ancient monastery of Monna Agnese and the *Annunciation* in the church of San Martino e Santa Vittoria in Sarteano. The former joins Beccafumi's knowledge of the treatment of light to the effects with which he had experimented in the bronze angels for Siena Cathedral. The *Annunciation* shows the influence of Michelangelo's *Last Judgment* in the gestures. Beccafumi also uses light in an extreme manner – the shadows that stain the architecture have substance and provide a contrast to the figures, while the low lights are tinted once again with the reddish glare of the sunset.[57]

Beccafumi's impact on Sienese painting increased in the second half of the sixteenth century and his works were often imitated. Before his death both Bartolomeo di David and Marco Pino – who was born in Siena in 1521 and died in Naples after 1582 – were strongly influenced by Beccafumi. Marco Pino's adherence to Beccafumi's style was asserted by Mancini and confirmed by Bartolini's reconstruction of his activity before he moved to Rome. During his time in Siena, Marco Pino painted a number of versions of the *Madonna and Child*. Among them are one in Altenburg and another in the Pinacoteca in Siena. Although Sanminiatelli attributed the *Holy Family* in Argiano to Beccafumi, relating it to his Pisan works,[58] I believe it to have been painted by Marco Pino. It is executed by a painter who strove to imitate the elegant Mannerism of the works that Beccafumi executed in Pisa and Genoa, which had been strongly influenced by Perin del Vaga. The little that we can reconstruct of Marco Pino's artistic career shows a restless painter who looked towards Rome for inspiration. The *Sacrifice of Iphigenia*, which is in the centre of a ceiling in a small room in the Palazzo Mignanelli in Siena, was attributed to Marco Pino by Sanminiatelli.[59] It contains figures that are planned according to proportional modules and follows compositional schemes influenced by Perin del Vaga's and Salviati's work in Rome. Taken from Euripides, the story of Iphigenia offering herself as a sacrificial victim to placate Artemis and allow the fleet to set sail and reach Troy focuses on the theme of the voluntary sacrifice of an innocent person in order to save her country. It is connected with the painting tradition that had reached its height in Beccafumi's Sala del Concistoro. Beccafumi's influence, however, is limited to the way in which the paint is laid down and to some typologies, such as the physiognomy of Agamemnon who resembles Beccafumi's Zaleucus of Locris. The remaining part of the scene revolves around the stag who substitutes for Iphigenia in the sacrifice. It is influenced by the cold colour schemes and the forced arrangement of the frescoes in the Sala Paolina, in particular the *Meeting of Alexander the Great with the High Priest*. It is probable that the fresco was painted when Marco Pino had left Beccafumi's workshop and was alternating between Sienese and Roman commissions.[60]

Notes

1 G. Briganti, *La Maniera italiana* (1961), Florence 1985, pp. 5–16.

2 A. Angelini, 'Gerolamo del Pacchia' in *Domenico Beccafumi e il suo tempo*, Milan 1990, pp. 276–289.

3 M. Maccherini, 'Andrea del Brescianino' in *Domenico Beccafumi*, p. 311.

4 M. Maccherini, 'Andrea del Brescianino' in *Da Sodoma a Marco Pino*, Florence 1988, p. 72.

5 S. Moscadelli, 'Domenico Beccafumi "Pictor de Senis" nel 1507' in *Mitteilungen des Kunsthistorischen Institutes in Florenz*, 1989, XXXIII, pp. 394–395.

6 F. Sricchia Santoro, 'Gerolamo Genga' in *Domenico Beccafumi*, pp. 254–270.

7 A. Bagnoli, in *Domenico Beccafumi*, pp. 79–83.

8 A. De Marchi, in 'Beccafumi e la sua "maniera": difficoltà del disegno senese' in *Domenico Beccafumi*, pp. 412–518; especially cat. no. 85, pp. 426–427.

9 S Padovani (ed.), *L'Età di Savonarola. Fra' Bartolomeo e la scuola di San Marco*, Florence 1996.

10 C. Fischer, *Fra Bartolomeo. Master Draughtsman of the High Renaissance*, Rotterdam 1990, pp. 156–167.

11 F. Sricchia Santoro, '"Ricerche Senesi". 5. Agli inizi del Beccafumi' in *Prospettiva*, 1982, 30, p. 65; R. Bartalini, 'Domenico Beccafumi 1513–1518' in *Domenico Beccafumi*, p. 85.

12 A. Bagnoli, 'Bartolomeo di David' in *Domenico Beccafumi*, p. 312. On the rediscovery of Bartolomeo di David, see F. Bisogni, 'Del cataleto di Sant'Onofrio ossia di Bartolomeo di David' in *Scritti in onore di Federico Zeri*, Milan 1984, I, pp. 375–388; F. Sricchia Santoro, '"Ricerche senesi". 3. Bartolomeo di David' in *Prospettiva*, 1982, 29, pp. 32–40.

13 A. Conti, *Pontormo*, Milan 1995, pp. 62–64.

14 R. Förster, 'Die Hochzeit des Alexander und der Roxane in der Renaissance' in *Jahrbuch der Königlich preussischen Kunstsammlungen*, 1894, XV, pp. 199–201; R. Bartalini, *Le occasioni del Sodoma. Dalla Milano di Leonardo alla Roma di Raffaello*, Rome 1996, p. 79.

15 K. Oberhuber, *Raffaello*, Milan 1982, p. 148; R. Bartalini, *Le occasioni*, pp. 79–80.

16 L. Martini, 'L'Oratorio di San Bernardino' in *Domenico Beccafumi*, pp. 600–621.

17 H. Voss, *Die Malerei der Spätrenaissance in Rom*, Berlin 1920.

18 A. Angelini, 'Domenico Beccafumi 1519–1527' in *Domenico Beccafumi*, pp. 126–131.

19 B. Sanminiatelli, *Domenico Beccafumi*, Milan 1967, pp. 85–86.

20 R. Bartalini, in *Domenico Beccafumi*, pp. 132–135.

21 ASS, Curia del Placito, 275, fol. 11.

22 M. Ciatti, in *Mostra di opere restaurate nelle province di Siena e Grosseto*, 1981, II, pp. 140–141.

23 F. Bisogni, 'La Pittura a Siena nel primo Cinquecento' in *La Pittura in Italia. Il Cinquecento*, Milan 1988, II, p. 734.

24 A. Angelini, in *Da Sodoma a Marco Pino*, pp. 60–61.

25 L. Lanzi, *Storia pittorica dell'Italia*, edited by M. Capucci, Florence 1968–1970, I, pp. 225–226.

26 A. Angelini, 'Il Beccafumi e la volta dipinta della Camera di Casa Venturi: l'artista e i suoi committenti' in *Bullettino senese di storia patria*, 1990, pp. 371–383.

27 ASS, Vicariati, Caldana no. 7. Two sheets of the family accounts of Ms Pavolo Agustini give details of the birth of his children up until 1514, the year in which his last child Marcello was born. Marcello must have died in the early months of 1571. as can be inferred from ASS, Vicariati, Caldana no. 1.

28 See A. Angelini, 'Il Beccafumi e la volta dipinta', p. 371. Also see ASS, Vicariati, Caldana no. 15, which is a certificate of nobility issued by Alessandro Rocchigiani and the notary Giacomo Turellini on 15 August 1631. From the genealogical tree attached, it appears that Marcello Agostini was married to 'Sulpitia Piccolomini G'.

29 A. Pinelli, 'Il picciol vetro' e il "maggior vaso". I due grandi cicli profani di Domenico Beccafumi in Palazzo Venturi e nella Sala del Concistoro' in *Domenico Beccafumi*, pp. 630–631.

30 R. Guerrini, *Studi su Valerio Massimo* (with a chapter on the fate of humanist iconography with regard to Perugino, Beccafumi and Pordenone), Pisa 1981.

31 BCS, S.III.2, fol. 29r.

32 D. Sanminiatelli, *Domenico Beccafumi*, pp. 34–35.

33 A. Angelini, in *Domenico Beccafumi*, p. 146.

34 M. Collareta, '"Pittura commessa di bianco e nero". Domenico Beccafumi

nel pavimento del Duomo di Siena' in *Domenico Beccafumi*, pp. 652–676.

35 R. Guerrini, 'Le Divinae Institutiones di Lattanzio nelle epigrafi del Rinascimento: Il collegio del Cambio di Perugia ed il Pavimento del Duomo di Siena (Ermete Trismegisto e Sibille)' in *Annuario dell'Istituto Storico Diocesano di Siena*, 1992–1993, I, pp. 1–38.

36 This is a drawing in the Gabinetto dei Disegni e delle Stampe (Prints and Drawings Department) in the Uffizi (6517 F) which depicts a baby who also appears in the background of the *Killing of the Priests of Baal*. See J. Cox Rearick, *The Drawings of Pontormo*, Cambridge (Mass.) 1964, I, p. 370.

37 M. Collareta, '"Pittura commessa"', p. 666.

38 N. Dacos, 'Beccafumi e Roma' in *Domenico Beccafumi*, pp. 48–49.

39 This is referred to in a panel of the *Virgin of the Immaculate Conception Protecting the Sienese at the Battle of Camollia* by Giovanni di Lorenzo. Giovanni di Lorenzo (Siena, 1494?–documented until 1551) is an interesting contemporary of Sodoma, Peruzzi and Beccafumi. See A. Bagnoli, 'Giovanni di Lorenzo' in *Domenico Beccafumi*, pp. 330–343.

40 V. Marchetti, *Gruppi ereticali senesi del Cinquecento*, Siena 1975, pp. 25–30. The religious position of the humanist Aonio Palerario is worthy of note.

41 E.H. Gombrich, 'The Renaissance Theory of Art and the Rise of Landscape' in *Norm and Form: Studies in the Art of the Renaissance*, London 1966, p. 113.

42 W. Loseries, 'Precisazioni per il Sodoma' in *Kunst des Cinquecento in der Toskana*, Munich 1992; idem, 'Sodoma e la scultura antica' in *Umanesimo a Siena. Letteratura, arti figurative, musica*, conference proceedings edited by E. Cioni and D. Fausti, Siena 1994, pp. 358–359.

43 F. Glénisson Delannée, 'Rozzi e Intronati' in *Storia di Siena dalle origini alla Repubblica*, Siena 1995, pp. 407–422.

44 F. Bisogni, 'Del cataleto di Sant'Onofrio', pp. 375–388.

45 F. Sricchia Santoro, 'Beccafumi e Siena' in *Domenico Beccafumi*, pp. 33–34; A. Bagnoli, 'Bartolomeo di David' in *Domenico Beccafumi*, pp. 312–329.

46 P. Bacci, *L'Elenco delle pitture, sculture e architetture di Siena, compilato

nel 1625–26 da Mons. Fabio Chigi, poi Alessandro VII, secondo il ms. Chigiano I.I.11'* in *Bullettino senese di storia patria*, 1939, p. 334; G. Mancini, *Considerazioni sulla pittura (1617–1621)*, edited by A. Marucchi and L. Salerno, 2 vols, Rome 1956–1957.

47 F. Sricchia Santoro, 'Marco Bigio' in *Da Sodoma a Marco Pino*, pp. 135–141; A. Cornice, 'Marco Bigio' in *Domenico Beccafumi*, pp. 376–383.

48 R.H. Hobart Cust, *The Pavement Masters of Siena (1369–1502)*, London 1901.

49 Ibid., p. 97.

50 A. Landi, *'Racconto' del Duomo di Siena*, edited by E. Carli, Florence 1992, pp. 61–62.

51 F.A. D'Accone, 'La Musica a Siena nel Trecento, Quattrocento e Cinquecento' in *Umanesimo a Siena*, pp. 455–480.

52 Alessandro Bagnoli has already noted that the candelabra in the apse of the cathedral recall, apart from the usual classical references, the columns of the main door of Siena Cathedral. See A. Bagnoli, 'Domenico Beccafumi e gli scultori di Siena' in *Domenico Beccafumi*, p. 522.

53 Jenkins was the first to notice that Cicero's *De officiis* was the source for the iconography of the frescoes. See M. Jenkins, 'The Iconography of the Hall of Concistory in the Palazzo Pubblico, Siena' in *The Art Bulletin*, 1972, LIV, pp. 430–451. It was Guerrini who recognized that the episodes are taken from Valerius Maximus. See R. Guerrini, *Studi su Valerio Massimo*, pp. 111–128. Also A. Pinelli, in *Domenico Beccafumi*, pp. 622–651.

54 B. Sani, '"La virtù sconosciuta": Vittorio Alfieri, Francesco Gori Gandellini e i migliori dipinti di Siena' in *Bullettino senese di storia patria*, 1992, IC, Siena 1994, pp. 92–108.

55 A. De Marchi, in *La Tribuna del Duomo di Pisa. Capolavori di due secoli*, edited by R. Paolo Ciardi, Milan 1995, pp. 78–105.

56 M. Collareta, '"Pittura commessa"', p. 661.

57 For Beccafumi's last works, see C. Alessi, 'Domenico Beccafumi 1537–1551' in *Domenico Beccafumi*, pp. 192–219.

58 B. Sanminiatelli, *Domenico Beccafumi*, pp. 112–113, note 61.

59 Ibid., p. 188.

60 R. Bartalini, 'Marco Pino' in *Da Sodoma a Marco Pino*, pp. 178–196.

The Second Generation of Mannerists

The deaths of Sodoma in 1549 and of Beccafumi in 1551 coincide with the beginning of a period of stagnation in Sienese artistic production. The city saw its own independence waver together with the Republic's government and the siege of 1554 delivered the final blow to the few commissions still possible. Artists had been leaving the city for some time. From 1542 Marco Pino ceases to appear in Sienese documents and in 1544 he is recorded in Rome where he paid his entrance fee for the Accademia di San Luca. His work is almost unrecognizable in the monumental *Visitation* in Santo Spirito in Sassia which Mancini believes to be his first work in Rome. It can be deduced that it was executed around 1545 from the date written on the predella of the wooden tabernacle of the *Conversion of St Paul* by Francesco Roviale, which was its pendant on the entrance wall of the church. The *Visitation* shows that Marco Pino was deeply influenced by Michelangelo, although he continued to use Beccafumi's colour scheme of pinks, oranges and violets, but without the latter's constantly changing colour effects.[1] However, almost as if to signal the work's Sienese origins, Pino placed two signs of Beccafumi's influence at the base of the columns of the tabernacle in the form of delicate monochromes showing the *Annunciation* and the *Presentation in the Temple*.[2]

In 1552, the most inventive Sienese goldsmith of the sixteenth century, Pastorino, began his travels through the courts of Northern Italy. He defaulted on the commission given to him by the officials of the Mercanzia in Siena to decorate the vaults of their fifteenth-century loggia. The stuccoed and painted decoration of the loggia was an unusual project for Pastorino who preferred to dedicate his career to wax portraits and to making medals. The unfinished loggia commission was completed by Lorenzo Rustici after the end of the war.[3]

After the fall of Siena in 1555 and the last rout at Montalcino in 1560, artists continued to leave the city. Among them was Bartolomeo Neroni, also known as il Riccio

(documented in Siena from 1532, died in 1571), who went to live in Lucca for about a decade. When commissions started once more to filter through from Siena, patrons turned to Neroni as though he represented the guarantee of a secure tradition. Neroni's style was deeply influenced by Sodoma whose daughter Faustina he had married and whose art collection he had inherited. Bartolomeo Neroni had also appeared together with his father-in-law in the verses of the *Dialogo amoroso di Phylolauro di Cave*, which the poet had dedicated in 1533 to Alfonso Piccolomini, duke of Amalfi. His name, together with those of Sodoma and of Beccafumi, was included in this work in order to update the list of Sienese painters. In 1568 Vasari remembered him in the appendix to the life of Sodoma as a painter who was 'quite practical and worthy'. Neroni's conservative style won him the few Sienese commissions to be awarded after the fall of the Republic. He was given the job of designing the scenery for Alessandro Piccolomini's *Hortensio* in the Intronati theatre. The performance was planned for Cosimo I de' Medici's visit in 1560. A few years later, as Siena showed the first signs of recovery, Neroni was given a few commissions from lay associations who wanted to combine their renewed religious fervour with the desire to illustrate the sacred stories with the necessary decorum. In 1562 the Compagnia della Santissima Trinità considered a letter in which Neroni refused to paint the large chapel belonging to the company because he was then living in Lucca.[4] They decided that they 'would not wait any longer for suitable masters, but they would decorate the chapel with those who could do it best… and with as little expenditure as possible'.[5] The Compagnia di Santa Caterina showed a greater willingness to spend money following the bequest of Domenico Grassi in 1562. The brothers undertook the decoration of the Oratory of the Crucifix under the direction of three *operai*. One of these, the painter and ceramist Giovan Battista Sozzini, was responsible for the formation and execution of the decorative programme. Sozzini

was a pupil of Neroni and had also worked with Beccafumi on the *Scenes from the Life of Elijah* for the pavement of Siena Cathedral. He had kept the cartoons for these, which were then sold to the Spannocchi family. He was more of an amateur than a professional and his academic approach led him to attempt to revive the splendour of the Sienese artistic tradition of the first half of the sixteenth century. Sozzini was not directly in charge of the decorative programme in the Oratory of the Crucifix, which seems to have been arranged by Neroni after his return to Siena. However, Neroni did not to contribute much to the execution because he died in 1571, when the work was still in its early stages.[6] During his career Neroni proved himself to be an extremely versatile artist, capable of reorganizing, restoring, preparing and designing palaces as well as of painting miniatures, executing oils on canvas and of frescoing walls.

Neroni's first known work is in the convent of Monte Oliveto Maggiore. Payments start in the 1530s and continue until 1540. He modelled his art on the work of Sodoma but simplified his compositions and used extremely cold colours that presuppose a knowledge of Pontormo's scenes of the Passion of Christ in the charterhouse just outside Florence. These inspired the *Way to Calvary*, the *Adoration of the Magi*, the *Missions of Maurus and Placidus* and also the miniatures in the antiphonaries for the Olivetan convent in Finalpia (Biblioteca Berio, Genoa). The renewal of the liturgical manuscripts in Finalpia started in 1530 when Abbot Angelo di Albenga, who had become general of the order, decided to decorate eighteen choir books with painted miniatures. Of these, twelve must have been executed by Neroni. He probably carried out the work on the miniatures in Monte Oliveto since he accurately copied motifs from Sodoma's frescoes. He adopted a language that was sometimes archaic and characterized by a simple elegance. Vasari relates that Neroni was working with Peruzzi on the frescoes for the altar of Santi Quattro Coronati at the same time as he was completing the miniatures. The Santi Quattro Coronati frescoes were commissioned by the *Arte dei Maestri di Pietra* (Stonemasons' Guild) in 1534. The surviving fragments of the *Martyrdom of*

the Saints, the *Madonna and Child* and a half bust of a martyred saint are very close in style to the frescoes in the Ponzetti Chapel in Santa Maria della Pace in Rome. The strong three-dimensionality of the forms is evidence of Peruzzi's influence. Neroni's early works are therefore influenced by two very different artists – Sodoma and Peruzzi.

As his career progressed Sodoma became the more dominant influence. A large canvas of the *Resurrected Christ* (Chigi Saracini Collection, Siena), painted for the church of the Concezione in Camollia, has always divided art historians over the question of its attribution. I believe that it should be ascribed to Neroni, but it was previously attributed to Sodoma in the 1819 *Relazione* of the Galleria Saracini.[7] Baldinucci, Pecci and Romagnoli also believed it to have been painted by Sodoma, while Fabio Chigi and Della Valle ascribed it to Neroni.[8] The canvas, whose colours have considerably altered, has a cohesive style that places it among some of Neroni's best works. The subject is one that had been painted twice by Sodoma in 1535 – in a fresco in the Palazzo Pubblico and in a panel now in the Museo di Capodimonte in Naples. Neroni's version, which has a lightly emphasized elegance, is a final and refined re-elaboration of the thoughts that germinated in a drawing in pen and bistre (no. 567E, Uffizi, Florence). The work must have been painted during Neroni's early career. His works matured into a style that is less linear, as can be seen in the *Madonna and Child with SS. John, Joseph and an Angel* (Chigi Saracini Collection, Siena). Two drawings in pen and bistre in the Uffizi depicting *St Catherine of Alexandria* and *St Dorothy* (nos. 15037F and 15039F) contain old inscriptions identifying them as being by 'Riccio da Siena' and 'Riccio S'. These elegant drawings reveal the formal process that underlies the three-dimensionality of the figures and recall, in places, the work of Beccafumi.

For Neroni, drawing was a key moment in the conception of a work of art, one in which he often demonstrated his greatest talents, endowing the work with a value of its own. This is the case with the pen drawing of the *Adoration of the Shepherds*, which is identified at the base as being by 'Riccio'

(Kupferstichkabinett, Berlin). The drawing can be connected with the *Adoration of the Shepherds* in the Carmelite church only in the general layout of the composition. The refined laying-in of the brown ink indicates that the drawing was intended for a collector, a practice that was spreading in Siena at this time. The *Adoration of the Shepherds* provides a focal point in the development of Sienese painting after the fall of the Republic. It is now on the right nave wall in the Carmelite church, without the predella, which has been attached to an altarpiece by Girolamo del Pacchia. The sources do not unanimously attribute the work to Neroni. The seventeenth-century author Mancini believed the painting to be by Neroni, while Ugurgieri Azzolini thought that it was by Arcangelo Salimbeni. Mancini recorded that the *Adoration of the Shepherds* had not been finished, leading Cornice to attribute the design to Neroni and the execution to Arcangelo Salimbeni. Cornice's solution seems to be the most likely. The *Adoration of the Shepherds* would not be Salimbeni's only intervention in a work left unfinished by Neroni. Payments from 1578 and 1579 show that the Compagnia di Santa Caterina commissioned him to complete the *Mystic Marriage of St Catherine* in their oratory, previously the kitchen of her family house, which had been blocked in by Neroni in 1572.[9] During the translation of Neroni's sketch into Salimbeni's painting, the Carmelite altarpiece of the *Adoration of the Shepherds* lost the perspectival layout and classical elements, still influenced by Peruzzi, that can be seen in the drawing. Instead Salimbeni accentuated tortuous spaces and stylized natural forms. He followed models that abolish all spatial rationality and used natural elements deriving from Flemish painting, such as those found in Marco Pino's *Adoration of the Shepherds* in the church of Santi Severino e Sossio in Naples.

The predella previously attached to the *Adoration of the Shepherds* contains brushwork that is much freer and softer, with inventive variations. It has greater affinity with Beccafumi's methods than the spaces and the pictorial layout of the main panel. Neroni's works were influenced by both Sodoma and Peruzzi, while Arcangelo Salimbeni (1536?–1579) took Beccafumi as his model, as did the artists who gathered around Ippolito Agostini.[10] In the Carmelite *Adoration of the Shepherds* the two diverse styles are the result of the intervention of two different artists.

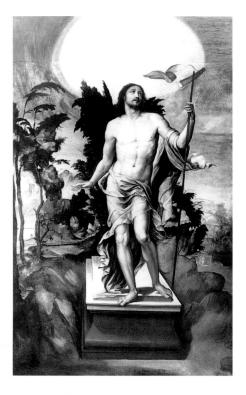

Bartolomeo Neroni,
Resurrected Christ. Chigi
Saracini Collection, Siena.

Until he was commissioned to complete the *Adoration of the Shepherds*, Arcangelo Salimbeni had probably spent most of his career outside Siena. He paid his entrance fee for the Accademia di San Luca in Rome in 1561–1562, which was then under the consul Taddeo Zuccari.[11] The document confirms what Mancini relates about Salimbeni, that he was a man 'of quite good taste because he had been in Rome for a long time and had helped Federico Zuccari'.[12] When Neroni died, the brothers of Santa Caterina did not immediately think of Salimbeni and instead tried to employ a painter living in Naples. They did not specify his name but it is possible that it was Marco Pino, who had returned to Naples after his second stay in Rome in 1571. It was only after this that they turned to Salimbeni. Salimbeni's *Annunciation* (Museo Civico, Colle Val d'Elsa), signed and dated 1574, and his *Meeting on the Road to Emmaus* painted for the Compagnia di Santa Caterina della Misericordia in Serre di Rapolano, signed and dated A. JUBILEI MDLXXV. ARCANGELUS SALIMBENI, both show a certain awkwardness in their adhesion to the style of painting that had been adopted in Rome at this time. The *Meeting on the Road to Emmaus*,

commissioned for the jubilee of the confraternity, does not reveal Salimbeni's individual characteristics as a painter. In the *Mourning over the Dead Christ* (Monte dei Paschi, Siena), commissioned by the Monte Pio in 1576, Salimbeni took motifs from Zuccari to which he competently added elements of Beccafumi's style. Mancini's testimony regarding Salimbeni's relationship with Federico Zuccari, as well as the links with Marco Pino, mean that Salimbeni appears to be a painter with two different styles. On the one hand he reveals close links to Beccafumi and the local Sienese tradition and on the other he is strongly influenced by late Roman Mannerism. Beccafumi's influence can be seen in the small panel of the *Ecstasy of St Catherine* (Chigi Saracini Collection, Siena).[13] The work has been attributed to Salimbeni on the basis of a comparison with the Carmelite *Adoration of the Shepherds* and with the *Carrying of the Body of the Baptist to the Sepulchre* (Monte dei Paschi, Siena). The main idea for the composition derives from Sodoma's *Swoon of St Catherine* in San Domenico. The painting is executed in a subtle, delicate and almost miniaturist manner, that matches the Biccherna panels of 1574 and 1576 traditionally attributed to Arcangelo Salimbeni. These

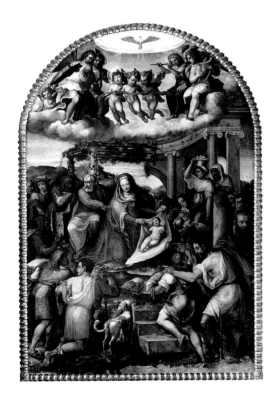

Bartolomeo Neroni
(completed by Arcangelo Salimbeni),
Adoration of the Shepherds.
San Niccolò al Carmine, Siena.

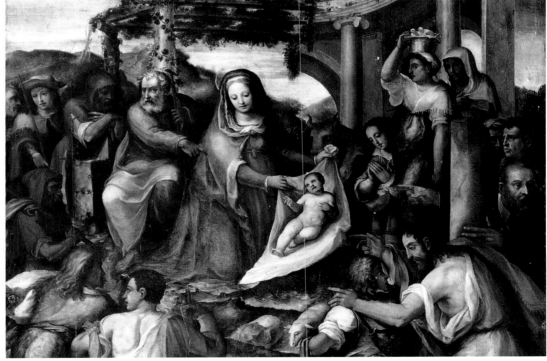

Bartolomeo Neroni
(completed by Arcangelo Salimbeni),
Adoration of the Shepherds, detail.
San Niccolò al Carmine, Siena.

panels show the *Virgin and Saints Venerated by the Camarlingo in Military Dress* and the *Annunciation*.

Salimbeni was a pivotal figure who succeeded in juxtaposing Beccafumi's style and contemporary Roman art, an achievement that is best appreciated in the Oratory of the Standard. Arcangelo's stepson Francesco Vanni benefitted more from his teachings than his real son Ventura. The inventory of Arcangelo Salimbeni's goods compiled by the notary Flaminio Micheli on 30 August 1580 lists a print of Michelangelo's *Last Judgment* and a print of a battle by Raphael, as well as the drawings Francesco Vanni made from the frescoes in the Sala del Concistoro.[14] Both Salimbeni's works and the inventory underline Beccafumi's influence which was then transmitted to his stepson and pupil.

Newly discovered documents show that Arcangelo Salimbeni's workshop was central to artistic activity in Siena in the 1570s. In 1567 Salimbeni married Battista Focari, Eugenio Vanni's widow. She was related to the famous goldsmith Giuliano Morselli and was the mother of Francesco Vanni. A copy of the agreement between Battista Focari and Salimbeni's heirs, written after the death of the painter,

throws further light on the circle in which he moved.[15] The house in via della Cerchia, which belonged to Battista and in which she lived, was let partially to Scipione Cibo. Scipione was a member of the Cibo Malaspina family, who were lords of Massa, and correspondence kept in the Biblioteca Comunale in Siena demonstrates that Scipione had links with Ippolito Agostini. He is best known for his political activities overseas but must also have spent some time collecting, as can be deduced from a letter he received from the painter Tullio India.[16] The agreement between Salimbeni's heirs not only documents the relationship between Salimbeni and a non-Sienese collector but also indirectly demonstrates his links with Agostini. The document is therefore evidence of a renewal in Siena's cultural life.

One of the artists to enter Siena at this time was Lattanzio Bonastri, a mysterious painter who originally came from Lucignano in Val d'Arbia and of whom few works are known. According to Mancini, he studied in Rome with El Greco. In Siena his only remaining work is the *Conversion of those Condemned to Death* in the Oratory of St Catherine, for which payments were made by the Compagnia di Santa Caterina in

Arcangelo Salimbeni,
Ecstasy of St Catherine.
Chigi Saracini Collection, Siena.

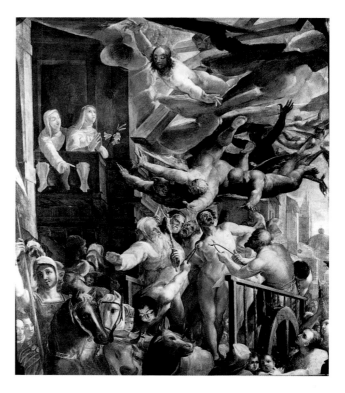

Lattanzio Bonastri,
Conversion of those Condemned to Death.
Oratory of St Catherine, Siena.

1578 and 1580.[17] Bonastri worked with Titian-like brushstrokes in the composition but his figures are executed in a Mannerist style. The scene is filled with bodies that fall from the sky chased by devils. One of the devils was directly inspired by the figure of Christ reaching out from the sky in Beccafumi's *Death of the Virgin* in the Oratory of St Bernardino. Bonastri has depicted the sharp cries of pain provoked by the red-hot tongs, the faces of the bystanders twisting in horror and the friars' fanatical attempts at conversion. It is only the prayers of St Catherine of Siena, however, that cause the thieves to convert. In the foreground the executioner blows on the coals to breathe new life into the fire and heat the tongs. The motif is similar to that used by El Greco in his *Boy Lighting a Candle* and proves that Bonastri had met El Greco while in Rome. The similarity is so close that one of the copies of El Greco's painting has been attributed to Bonastri.[18] Given the scarcity of documentation, it is difficult to date Bonastri's paintings or to construct a relative

chronology for them. If, as Mancini affirms, Bonastri was in El Greco's workshop in Rome, this can only have been between 1570 and 1572. Yet documents tell us that Bonastri was already a master in 1572. Mancini also records that Bonastri worked in the palace belonging to Cardinal Altemps in Rome, a theory that has been partially confirmed by recently discovered documents. Again according to Mancini, the painter died when he fell from scaffolding. In 1572 and 1573 the Altemps registers list the colours and other materials used by Bonastri for the fresco painting of one room and the painters who worked under his supervision. The decoration was executed in the 'first room in the duke's apartment', which is probably the Sala delle Prospettive. The room still contains fragments of frescoes, among which some small putti and a fictive tapestry with hunting motifs can be related to Lattanzio Bonastri's only securely documented work, the *Conversion of those Condemned to Death* in the Oratory of St Catherine.[19]

Lattanzio Bonastri,
Conversion of those Condemned to Death,
detail. Oratory of St Catherine, Siena.

Lattanzio Bonastri,
Conversion of those Condemned to Death,
detail. Oratory of St Catherine, Siena.

Notes

1 E. Borea, 'Grazia e furia in Marco Pino' in *Paragone*, 1962, 151, p. 27, note 5.

2 These are reproduced but not commented on in A. Zezza, 'Tra Perin del Vaga e Daniele da Volterra: alcune proposte, e qualche conferma, per Marco Pino a Roma' in *Prospettiva*, 1994, 73/74, pp. 144–145.

3 C. Acidini Luchinat, 'Due episodi della conquista Cosimiana di Siena' in *Paragone*, 1978, 345, pp. 3–26.

4 A. Cornice, in *L'Arte a Siena sotto i Medici. 1555–1609*, edited by F. Sricchia Santoro, Rome 1980, pp. 27–47.

5 ASS.PR. 1844, fol. 81rv, in P.A. Riedl, *Die Fresken der Gewölbezone des Oratorio della Santissima Trinità in Siena*, Heidelberg 1978, pp. 12–13.

6 W. Chandler Kirwin, 'The Oratory of the Sanctuary of Saint Catherine in Siena' in *Mitteilungen des Kunsthistorischen Institutes in Florenz*, 1972, XVI, 2, pp. 199–220.

7 *Relazione in compendio delle cose più notabili nel Palazzo e Galleria Saracini in Siena*, Siena 1819, pp. 47–48.

8 See A. De Marchi, 'Bartolomeo Neroni detto il Riccio' in *Da Sodoma a Marco Pino*, Siena 1988, pp. 165–167.

9 P.A. Riedl, in *Die Kirchen von Siena*, Munich 1992, 2, 1.1, pp. 208–209.

10 F. Sricchia Santoro, 'Arcangelo Salimbeni' in *L'Arte a Siena*, pp. 48–51; idem, 'Arcangelo Salimbeni' in *Da Sodoma a Marco Pino*, pp. 172–177.

11 R. Guerrini, 'Il Creato di Baldassarre Peruzzi. Testimonianze su Francesco da Siena ed altri artisti senesi del Cinquecento' in *Bullettino senese di storia patria*, 1982, LXXXIX, pp. 155–195.

12 G. Mancini, *Considerazioni sulla pittura*, Rome 1956, I, p. 209.

13 R. Bartalini, *Le occasioni del Sodoma. Dalla Milano di Leonardo alla Roma di Raffaello*, Rome 1996, pp. 29–30.

14 G. Milanesi, *Documenti per la storia dell'arte senese*, Siena 1854–1856, III, pp. 225–226.

15 ASS, Archivio Notarile Antecosimiano, 3292, fols. 235 bis r and 235 ter v, in L. Bonelli, *Nuovi documenti sulla vita e sulle opere di Francesco Vanni*, thesis, Siena

University 1994–1995. The agreement always refers to Giuliano Morselli. The surname Morelli, often given to him, is therefore erroneous.

16 BCS, D.V.4, fols. 4rv and 9rv.

17 P.A. Riedl, in *Die Kirchen*, pp. 209–211.

18 R. Longhi, 'Il Soggiorno romano del Greco' in *L'Arte*, 1914, XVII, pp. 301–330, now published in *Scritti giovanili*, I, I, pp. 108–109.

19 F. Scoppola (ed.), *Palazzo Altemps. Indagini per il restauro della fabbrica Riario, Soderini, Altemps*, Rome 1987, pp. 20 and note, 27, 28, 30 and notes, 32, 33, 51, 141, 204, 208, 209, 221 and note 13, 270, 271 and 272.

The Palazzo Agostini Academy and the New Devotional Painting

Ippolito Agostini's Palace and Villa

The fall of the Sienese Republic brought about a period of crisis within the city and, as a consequence, a certain stagnation in artistic production within the city. However, writing at the end of the eighteenth century, Lanzi claimed that it was not long before the city began to 'like the new government, which, through the astuteness of Cosimo [de' Medici], appeared not so much a new government as a reform of the old'.[1] The first signs of artistic and economic recovery were noticeable in the 1570s. While humanism had been the motivating force behind the painting of the 1530s and 1540s, the art of the 1570s served the purposes of the lay confraternities.[2] There were new projects for oratories and churches and the arrival of new political protagonists contributed to the development of collecting.

The Agostini family, especially Marcello Agostini and his son Ippolito, played an important role in the development of Sienese art during these years.[3] A testimonial of the family's nobility based on the memories of Celso Cittadini records their fourteenth- and fifteenth-century fortunes. Paolo Agostini, the father of Marcello, was Pandolfo Petrucci's chancellor. Marcello became the first lord of Caldana, a title he received as a reward for his support of the Medici regime, and he was given the title of marquis in 1564 by Cosimo I de' Medici.[4] He married Sulpitia Piccolomini and their son Ippolito became the most important figure in Sienese cultural life in the second half of the sixteenth century. Ippolito was well versed in contemporary scientific knowledge and was in contact with the greatest naturalists of his age, such as Ulisse Aldovrandi and Ferrante Imperato.[5] He formed ethnographic and scientific collections in his palace and accumulated paintings, sculpture and curiosities. The palace was a meeting place for scholars and seventeenth-century sources record the presence of Giambattista Marino.[6] Ippolito's scientific interests were shared by the Sienese doctor Giulio Mancini, who also had a passion for the arts.[7] In his *Considerazioni sulla pittura*, Mancini assigns Ippolito Agostini a pivotal role in Sienese patronage and says that he attracted young artists to the city. These included the sculptor Prospero Antichi, known as il Bresciano because he had originally come from Brescia, and the painter Alessandro Casolani. Casolani made a thorough study of the works of Antichi and Beccafumi that were in the Palazzo Agostini. The palace was richly decorated with frescoes, yet, in his description written between 1625 and 1626, Fabio Chigi only records the room painted by Beccafumi and, on the first floor, paintings by Cristofano Roncalli also known as the Cavalier Pomarancio.[8]

Mancini's testimony, together with those of Chigi and Landi, has led scholars to suppose that an academy had been organized in the Palazzo Agostini where artists could practise drawing using the work of Beccafumi as an example.[9] Various letters to Ippolito Agostini (Biblioteca Comunale, Siena) demonstrate that he was in contact with a number of artists, including some from outside Siena. The letters mention Vanni, Sorri, Roncalli and Ventura Salimbeni. They also discuss the cost of drawings, prints and paintings, indicating that Agostini was actively forming a collection in collaboration with Deifebo and Giulio Mancini and also acting as a broker.[10] The three artists whose names are most frequently mentioned in the sources are the sculptor Prospero Antichi and the painters Cristofano Roncalli and Alessandro Casolani.

Cristofano Roncalli arrived in Siena around 1574. In 1576 he painted the altarpiece with the *Madonna and Child*

and St John the Baptist with SS. Anthony Abbot and Agatha (Museo dell'Opera del Duomo, Siena) for Siena Cathedral for which Ippolito Agostini stood as guarantor. According to Ugurgieri, Casolani painted a now-lost *Resurrection* as the crowning piece of the altar. The altarpiece was strongly influenced by Beccafumi's style and differs greatly from the other works that Roncalli executed in Siena. One of these is the ceiling of a ground-floor room in Ippolito Agostini's palace. In an inventory of the palace's goods compiled at the time of Ippolito's death in 1603,[11] the room is called the 'music room' because it contained frescoes whose subjects related to music in the ancient world. The frescoes, which are almost illegible because of their poor state of conservation, are framed by stucco decorations with herms, grotesque heads and classical scenes, including *Mercury Killing Argus* and *Apollo Killing Python*. The stucco decoration was probably executed by Prospero Antichi, an attribution that is supported by a comparison with his Roman works.[12] A drawing in the Biblioteca Comunale (cod. S.III.2, fol. 18r) directly corresponds with the stucco scene depicting *Mercury Killing Argus* and shows similarities with another two drawings in the same collection

(S.III.2, fol. 13r and S.III.2, fol. 22) that have both been attributed to Prospero.[13] These two drawings are of a comparable quality but their style differs to the linearity of the stucco. Affinities between a negro head and a drawing in Casolani's notebook (cod. S.IV.13, fol. 157r, Biblioteca Comunale, Siena) suggests a possible collaboration between Casolani and Prospero Antichi.

This conclusion is supported by examining a tondo with a female figure playing a lute depicted against a background in perspective. The tondo has links with the work of Beccafumi. The lute player has the solidity and compactness of Roncalli's figures but the head of the angel has the delicate animation of the little angels that Casolani drew in the notebook now in the Biblioteca Comunale, and this once again confirms an exchange of ideas between Antichi, Roncalli and Casolani. Prospero Antichi and Cristofano Roncalli moved definitively to Rome but, according to Mancini, Casolani went there under the protection of Agostini and then returned to Siena.

As described in a recently discovered inventory, the Palazzo Agostini was notable for the wealth of its decoration

Cristofano Roncalli,
*Madonna and Child and St John the Baptist
with SS. Anthony Abbot and Agatha.* Museo
dell'Opera del Duomo, Siena.

Cristofano Roncalli,
oculus in perspective.
Palazzo Venturi, Siena.

and the erudition of its owner. Inside some rooms were beds with painted headboards, silk baldachins and stamped leather and paintings on the walls, while other rooms had velvet hangings. Two libraries, one old and one new, contained books about mathematics, architecture, antiquities and literature. Paintings and sculptures were on display and there were caskets containing medals and collections of antique and modern vases. Finally, in keeping with current fashion, two galleries displayed paintings, statues, curiosities and collections of marbles. All of this denotes a very wide sphere of intellectual and cultural interests, including mathematics, natural science, music, theatre and, above all, drawing. In almost every room hung pictures that the compiler of the inventory defines as having been drawn, and as though that were not enough, an entire coffer full of drawings stood in the upper gallery. The names of the artists are rarely mentioned, with the exception of works believed to be by Beccafumi. In the new library there were two large framed canvases depicting a *Bull Hunt*. One of these may be the painting now in the Monte dei Paschi collection that forms a pair with a review of the *Sienese Contrade*. The initial 'I' which

marks the list of the *Sienese Contrade* links the work to Ippolito Agostini. The name Vincenzo Rustici is written on the back of the *Bull Hunt*, implying that the painter was Casolani's brother-in-law. The taste for paintings of battles, displays and festivals had arisen in Florence and was embraced with enthusiasm by Ippolito Agostini. In the Palazzo Vecchio, the Medici has given their decorative commissions to Flemish artists and the trend spread to Siena, where Ippolito Agostini and Scipione Chigi competed to employ Flemish artists. Ippolito favoured the taste for 'documentary and commemorative representation' to which the Flemish artist Jan van der Straet had been the leading contributor in Florence. This type of art concentrated on detail; its influence on Sienese painters therefore was different from that of Domenico Beccafumi. Flemish painting enjoyed great success in Siena from the 1570s. We can gauge the popularity of such art from Bernard Rantwyck's contributions to the Palazzo Patrizi in via di Città, which was at that time owned by the Piccolomini family, and to the Palazzo Chigi alla Postierla, where he may have worked together with Dirck de Quade van Ravesteyn.[14]

Prospero Antichi,
Mercury Killing Argus, stucco.
Palazzo Venturi, Siena.

Prospero Antichi (?),
Mercury Killing Argus (?).
Cod. S.III.2, fol. 13r,
Biblioteca Comunale, Siena.

The first Sienese painters to be strongly influenced by the Flemish use of detail were the Rustici, a family descended from Lorenzo Brazzi da Piacenza who died in 1572. He was the father of the painters Vincenzo and Cristofano and of Aurelia, wife of Alessandro Casolani. The majority of his work seems to have consisted of collaborations with his brother-in-law Alessandro Casolani and with his son Francesco. Vincenzo Rustici's early works were strongly influenced by Flemish art, as can be seen in the canvases of the *Bull Hunt* and the *Sienese Contrade* from the Palazzo Agostini (Monte dei Paschi, Siena), both of which mark key points in the artist's career. That these paintings must have been executed in the 1590s cán be confirmed by their presence in the Palazzo Agostini at that time.[15] Vincenzo's brother Cristofano Rustici, who signed a miniature of the *Madonna della Neve* in the eighth *Libro dei leoni* (fol. 52) from July–August 1589, was deeply influenced by Bernard Rantwyck, who signed some miniatures in the same book.

Cristofano Rustici's representation of the *Madonna della Neve* constitutes a slight, but important, point of reference for the study of the painted decoration of the chapel of the Villa Bartalini, previously Villa Agostini, in Monastero. The small chapel is covered by two cross vaults decorated with grotesques in which compartments contain scenes from the *Life of the Virgin*. On the sidewalls are two scenes from the *Life of the Blessed Franco da Grotti* and the *Life of St Anthony Abbot*. In the eighteenth century, Della Valle attributed all the paintings in the chapel to Cristofano Rustici and his opinion was seconded by Romagnoli in the early nineteenth century. Romagnoli also believed Rustici to be the author of two frescoes that were destróyed during nineteenth-century restorations. He attributed the rest of the work to Cristoforo Roncalli, which may have been an error made owing to the similarity of the two names.[16] The affinities between Rustici's miniature of the *Madonna della Neve* and the fresco of the same subject in the Bartalini Chapel make me believe that his contribution to the decoration of the chapel was substantial. Unfortunately, the loss of the greater part of Cristofano's documented works means that it is not possible to rely on stylistic arguments. It seems probable that the decoration of the Bartalini Chapel was the result of a collaboration within the Rustici family that included Alessandro Casolani, the

Alessandro Casolani (?),
Vision of the Virgin to a Knight.
Bartalini Chapel, Monastero, Siena.

brother-in-law of Vincenzo and Cristofano. The cycle contains clear references to contemporary Roman art. The grotesques, for example, are reminiscent of those by Francesco Salviati in Santa Maria dell'Anima. Some of the scenes in the vaults seem to reinterpret the work of the Cavalier d'Arpino, especially the setting and the arrangement of the figures in the *Flight into Egypt* (Galleria Borghese, Rome). The scenes on the chapel walls were influenced by the type of landscape that the Flemish artist Brill had introduced to Rome. Ippolito Agostini's continuing contacts with Rome for political, economic and cultural reasons help to explain these influences. Later sources mention that Alessandro Casolani undertook a journey to Rome but there is no contemporary documentation for this. The hypothesis that Casolani participated substantially in the decoration of the Bartalini Chapel[17] finds partial confirmation in a notebook

attributed to Casolani in the Biblioteca Comunale in Siena. The notebook contains the figure of an old beggar (S.IV.13, fol. 11r) that is similar, although differently arranged, to the old female beggar who appears in the Bartalini Chapel's *Vision of the Virgin to a Knight*. The extremely beautiful *Angel with an Olive Branch* (S.IV.13, fol. 26r) is repeated more modestly among the grotesques around the *Presentation of Mary in the Temple*. The same elegant figure can be considered as the initial idea for the *Angel with the Palm* (alluding to the annunciation of the death of the Virgin) and the *Angel with an Olive Branch* (alluding to the annunciation of Christ's birth). The style of the the chapel's decoration supports the hypothesis of an extended stay in Rome during which Casolani could have studied, apart from the great artists of the early sixteenth century, Raffaellino da Reggio, Giovanni De Vecchi and Marco Pino.

Alessandro Casolani

Alessandro Casolani (1552/1553–1607) was one of the most interesting artists working in Siena after the fall of the

Republic. He was probably born at Mensano in the territory of Casole d'Elsa in *c.* 1552–1553 and had contacts with

Alessandro Casolani,
A Beggar with a Holy Image.
Cod. S.IV.13, fol. 11r,
Biblioteca Comunale, Siena.

Alessandro Casolani,
Angel with an Olive Branch.
Cod. S.IV.13, fol. 26r,
Biblioteca Comunale, Siena.

Cristoforo Roncalli, a painter from Pomarance near Volterra, who introduced him into Siena. In the mid-seventeenth century, Ugurgieri Azzolini recounted that Alessandro entered Arcangelo Salimbeni's workshop,[18] but there is no documentary evidence to confirm this. However, if Ugurgieri's information is correct Casolani would have been trained within a workshop that was strongly influenced by the art of Beccafumi. Mancini records that Casolani went to Rome with the backing of Ippolito Agostini.[19] This helps to explain Casolani's development and his early move away from the local Sienese painting tradition. Two altarpieces executed in the 1580s demonstrate this turning point in Casolani's art. These are the *Adoration of the Shepherds* from the church of Santa Maria dei Servi, which was probably in position by 1585, and the *Birth of the Virgin* in San Domenico. The *Adoration of the Shepherds* bears a tenuous relationship to early sixteenth-century *Nativity* scenes. Mannerist formulae are recognizable in the anatomical study of the shepherd on the right who, in profile, kneels before the Christ Child. Everything dissolves into a sweetness and grace of form, which can best be appreciated in the glory of angels in the

sky, who spread divine light over the natural light of the hilly landscape. Although Casolani was still strongly influenced by Beccafumi, the painting also demonstrates his interest in the graceful protagonists depicted by Raffaellino da Reggio, a northern Italian artist working in Rome in a late Mannerist style.

The *Birth of the Virgin* was commissioned in 1584 by Sister Onesta Longhi, a Dominican tertiary, for the church of San Domenico. It owes much to Beccafumi, as can be seen by the way in which the composition is arranged, with the busily occupied women in the foreground who lend an air of domesticity to the work. The painting demonstrates the influence of the elegant style of Giovanni De Vecchi and Raffaellino da Reggio and the skilful colour effects are variations rather than repetitions of those used by Barocci. Although Casolani's colours do not approach the iridescence achieved by Barocci, the harmony of the whites, yellows and reds is clearly influenced by him. Casolani attempted to master simple and immediate narrative methods, that were often devotional, by softening both the tonality of the painting and the application of the paint. This

Alessandro Casolani,
Adoration of the Shepherds.
Santa Maria dei Servi, Siena.

Alessandro Casolani,
Adoration of the Shepherds, detail.
Santa Maria dei Servi, Siena.

p. 409
Alessandro Casolani, *Birth of
the Virgin*. San Domenico, Siena.

can be seen in a series of paintings destined for domestic devotional purposes, to which I would like to add a previously unpublished *Holy Family with St Catherine of Siena* (private collection, Parma). The softness of the Virgin's veil and of her sandals is directly reminiscent of Beccafumi, while the beautiful figure of Joseph relates indirectly to him through the work of Marco Pino. Cristoforo Roncalli had by this time become completely subservient to Roman art and late Mannerist formulae but Casolani was still influenced by Sienese artists. He used the late Mannerist proportional system, often elongating the figures, but dissolved the whole in a soft painting technique that recalls Marco Pino's work.

1584 was an important year for Alessandro Casolani. Besides painting the two altarpieces just discussed, he entered two confraternities in the city. On 17 June 1584 he was admitted into the Confraternita di Santa Caterina in Fontebranda and on 23 August he joined the Confraternita di San Girolamo, in which he held the position of sacristan in 1586.[20] This information helps to clarify Casolani's position with regard to the religious climate in Counter Reformation Siena. His membership of the two confraternities not only

demonstrates his religious fervour but also confirms his link with Ippolito Agostini. Some years before, on 29 November 1577, Ippolito had also been accepted into the Confraternita di San Girolamo. He had undertaken the duties of superior and *camarlengo* a number of times and had encouraged the confraternity to accept people linked to him, such as his Flemish servant Francesco Chimpio.

In the years leading up to 1584 Casolani does not appear in Sienese documents and it is possible that, as claimed by Mancini, he went to Rome under the protection of Agostini. On his return to Siena Casolani dedicated himself to austere religious painting. Casolani's links with the Palazzo Agostini were not purely humanist, even though Marino's verses in *La Galleria* mention this aspect, relating Alessandro to a fable featuring Apollo and Mercury and a story about Lot and his daughters.[21] Ippolito Agostini was at the centre of a circle that reflected intensely on religious matters, as is demonstrated by Casolani's drawing entitled *Meditation on Death*. The composition was translated into an engraving by Andrea Andreani in 1591. It was dedicated to Ippolito's wife, Eleonora Montalvo, who was a member of one of the most important families in

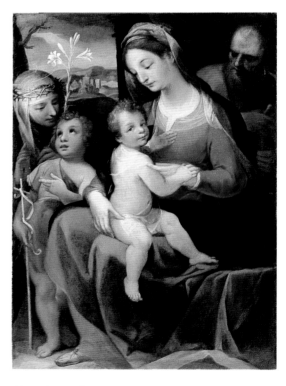

Alessandro Casolani,
*Holy Family with St Catherine
of Siena*. Private collection, Parma.

Alessandro Casolani,
Young Woman with a Skull. Statens
Museum for Kunst, Copenhagen.

Florence. Casolani emphasizes the sentimentalism of the subject, which is also apparent in the *Young Woman with a Skull* (Statens Museum for Kunst, Copenhagen). The latter contains similarities to the *Birth of Mary* in San Domenico and to the engraving and can therefore be dated to the 1590s.[22]

Alessandro Casolani's art is characterized by a 'devotional naturalism' similar to that of many other artists in Italy. Like Teodoro d'Errico's painting in Naples, it descends from the art of Caprarola. Casolani removed Mannerist elements from his work and was strongly affected by the Flemish attention to detail. The theme of meditation led him to include some sentimental elements that were still unusual in Italian painting in the last decade of the sixteenth century. In the 1590s Casolani painted a bier for the Compagnia del Beato Andrea Gallerani (Museo Diocesano d'Arte Sacra, Monteriggioni). The two panels belonging to this work are the *Meditation in front of the Crucifix* and *Giving Alms to the Poor*. The paintings support the message of the Catholic Reform by strongly emphasizing the value of works of charity. To communicate this, Casolani uses strong contrasts of light and shade, simple gestures and small, soft brushstrokes.

In 1597 Cardinal Federico Borromeo stayed in Siena and visited Ippolito Agostini's gallery. In doing so he encountered the devotional painting that had developed in the city. According to Giulio Mancini, Casolani was given work in Pavia through Borromeo. Casolani went there in 1599 with Pietro Sorri, but his contribution to the frescoes in the lantern and in the sacristy of the charterhouse can hardly be discerned because of nineteenth-century restorations.

In 1604 Alessandro Casolani signed a large altarpiece for the Carmelite church of San Niccolò. The work is widely considered to be Casolani's masterpiece and depicts the *Martyrdom of St Bartholomew*. The painting was influenced by contemporary Florentine and Northern Italian art rather than by the works that Casolani must have seen in Rome. On 20 January 1607 Casolani died, leaving some works still unfinished, among them the *Nativity* in San Raimondo al Refugio, which was finished by Francesco Vanni. Other paintings were completed by Casolani's brother-in-law Vincenzo Rustici and by his son Ilario. A *Dinner at Emmaus* remains unfinished and shows the enervated severity with which Casolani treated the biblical event.

Alessandro Casolani, *Meditation in front of the Crucifix* from the bier of the Blessed Andrea Gallerani. Museo Diocesano d'Arte Sacra, Monteriggioni.

Alessandro Casolani, *Giving Alms to the Poor* from the bier of the Blessed Andrea Gallerani. Museo Diocesano d'Arte Sacra, Monteriggioni.

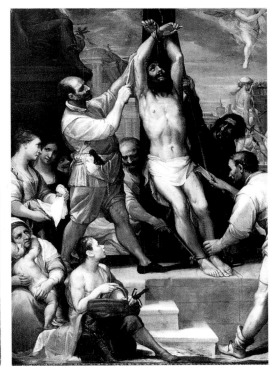

Alessandro Casolani, *Martyrdom of St Bartholomew*. San Niccolò al Carmine, Siena.

Pietro Sorri

More than any other contemporary Sienese artist, Pietro Sorri's (1556?–1630) painting shows traces of his many cultural experiences and his constant journeys to Venice, Lucca, Genoa, Florence, Pavia and Rome. An anonymous biography of the painter mentions a phase of apprenticeship under Arcangelo Salimbeni, in whose workshop Sorri would have encountered Alessandro Casolani.[23]

Sources relating to Sorri's life mention a journey to Venice with Domenico Cresti, known as il Passignano, and some letters written by Giovanni Andreozzi in Lucca relate that Sorri, like his contemporary Casolani, had ties with the Palazzo Agostini.[24] According to the letters, Ippolito Agostini wanted to take advantage of Sorri's knowledge of Lucca to help him sell marble from his quarry in Caldana. Sorri had gone to Lucca in 1593 and two years later he signed the *Martyrdom of St Fausta* in the church of San Frediano. The letters from Giovanni Andreozzi to Agostini serve to document a further stay in Lucca in 1596. Sorri was awaiting payment for the *Assumption of the Virgin* which had been

painted for Lucca Cathedral. On 14 September he was still in the city but seems to have been preparing to transport a painting to Florence. The documents clearly show that Sorri had ties with Florence throughout much of his career. His style, based on the combination of accurate drawing and a pleasing use of colour, was intended to satisfy the requests of religious and private patrons who favoured devotional simplicity over daring imagination.

Giovanni Andreozzi, an intellectual who had connections with bookmakers and printers, was a collector for whom Sorri painted a *St Francis* and a *St Jerome*.[25] In a letter that he wrote to Ippolito Agostini in 1596, Andreozzi mentioned Sorri's success in Lucca and also remarked that he was 'a man of great merit'.

It is difficult to individuate stylistic relationships between Sorri and his Sienese contemporaries, even those with whom he collaborated, such as Casolani. One of Sorri's earliest canvases in Siena is that of *St Catherine of Siena Curing a Possessed Woman*. It was sent from Venice in 1587 for the Oratory of

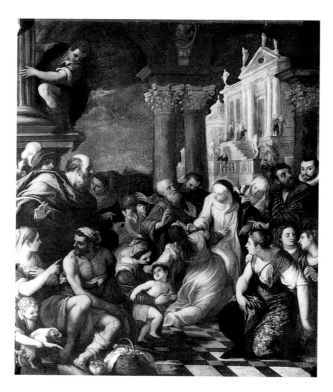

Pietro Sorri,
St Catherine of Siena Curing a Possessed Woman. Oratory of St Catherine, Siena.

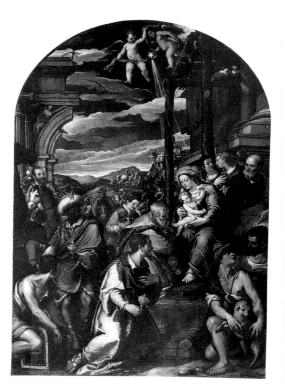

Pietro Sorri,
Adoration of the Magi.
Siena Cathedral.

St Catherine, formerly the kitchen used by the saint's family. Veronese's painting and Tintoretto's use of light effects

influence both this composition and Sorri's great *Adoration of the Magi* in Siena Cathedral.

Francesco Vanni

Francesco Vanni was perhaps the most famous Sienese painter working at the turn of the seventeenth century. His compositions demonstrate continuous research into a pictorial language capable of expressing mystic aspects of the lives of the saints while still retaining some elements of sentimentality. Vanni's domination of Sienese art was due to an extremely successful workshop, which secured not only the most important commissions within Siena, but also a number of prestigious commissions from outside the city. Vanni's numerous investments in houses and land testify to a success that led him to nourish ambitions of making himself and his family members of the nobility. He also had connections with the most important religious figures in Siena and in Italy, which induced him to formulate an intensely spiritual artistic language that was very different from the style of Casolani. Vanni's sense of beauty was inspired by mysticism

which brought him stylistically closer to Federico Barocci, from whom he derived a painting technique that was both 'emotional and ecstatic'.[26]

Both Francesco Vanni and his stepbrother Ventura Salimbeni have been described by art historians as painters who followed in the footsteps of Barocci. However, the development of Vanni's style and events in his life attenuate such an absolute definition. Vanni was born in Siena on 5 January 1564,[27] the son of Eugenio, a rich merchant who dealt in secondhand cloth, and of Battista Focari, who was related on her mother's side to Giuliano Morselli, the famous goldsmith and friend of Beccafumi. After the death of Eugenio Vanni, Battista Focari married the painter Arcangelo Salimbeni, who was to become Francesco's first teacher. Vanni was trained in the style of Beccafumi but his stepfather, Arcangelo Salimbeni, was a member of the Accademia di San Luca

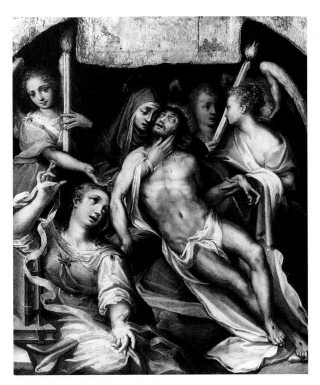

Francesco Vanni, *Mourning over the Dead Christ* from the bier of the Blessed Ambrogio Sansedoni. Monte dei Paschi, Siena.

Francesco Vanni, *Blessed Ambrogio Sansedoni Persuades Pope Clement IV to Revoke the Excommunication of Siena* from the bier of the Blessed Ambrogio Sansedoni. Monte dei Paschi, Siena.

in Rome and this could have affected the art that Vanni came into contact with and therefore his style. Furthermore, Deifebo and Giulio Mancini's correspondence with Ippolito Agostino proves that Vanni was in contact with them and, therefore, with the new forms of collecting and studying art. The letters support Giulio Mancini's affirmation that 'being sixteen years old he [Vanni] went to Rome where he studied the works by Raphael'.[28] Vanni must have gone to Rome in *c.* 1580, shortly after the death of his stepfather. Just before leaving Siena, Vanni may have been employed in completing works that had been interrupted by Salimbeni's death. These included the chapel vault for the Compagnia di San Bernardino in Siena, a commission given to Salimbeni but which, according to the documents, was completed after his death. The vault is painted in a style close to that of Arcangelo Salimbeni, with the usual formulae taken from Beccafumi. The *Archangel Michael* in San Gregorio al Celio – attributed to Vanni by Wegner, who linked it with the painting recorded by Ugurgieri Azzolini and Baldinucci as being commissioned by the Roman Camaldolese monks – is also close in style to the vault painted for the Compagnia di San Bernardino.[29]

According to Mancini, Vanni was the student of Giovanni De Vecchi and the friend of the Cavalier d'Arpino when he was in Rome. These painters influenced the style of Vanni's first known work after his return to Siena – the bier of the Blessed Ambrogio Sansedoni. According to the documents the bier was donated in 1584 by Jacopo Tondi and Vanni painted the headpieces in the second half of 1585.[30] The paintings on the bier, which contain numerous allusions to Sienese and Roman art and in particular to Federico Zuccari, were executed a few months after *Christ Giving St Catherine of Siena a Divine Heart*, for which Vanni was paid in the first half of 1585. This small painting is above the entrance door of the oratory kitchen, next to the bench for the governors of the Compagnia di Santa Caterina. The figures of Christ and of St Catherine of Siena resemble the types used by Barocci whose influence can also be traced in Vanni's treatment of the softly falling drapery. Vanni may have had the opportunity to study Barocci's art in Rome but the paintings executed immediately after his return to Siena, such as the *Baptism of Constantine* in the church of Sant'Agostino commissioned by Antonio Fondi in 1586, bear no evidence of

p. 415
Francesco Vanni,
Annunciation.
Santa Maria dei Servi, Siena.

such study.[31] Barocci's influence, however, is extremely important in assessing Vanni's art. If it was present throughout his career then it is possible, as proposed by Riedl, that the *Baptism of Constantine*, documented as being by Vanni, was later substituted with another work. If, however, the influence of Barocci is not a stable component in Vanni's art, then the genesis of the *Baptism of Constantine* must stem from other Roman influences.

The *Annunciation* in the Servite church in Siena is the painting in which Barocci's influence over Vanni is most evident. It was painted for the altar entrusted to Virgilio Cancelli in 1586 on the condition that he gave one hundred *scudi* for the decoration of the altarpiece. Vanni uses Barocci's colours and a composition that recalls his *Vision of St Francis*, which can be dated between 1574 and 1576. Vanni's use of light effects is reminiscent of Beccafumi's painting and allows him to accentuate the mysticism of the figures. His awareness of the visionary nature of Barocci's art, gained from the works that he had seen in Rome, may have prompted his interpretation of the scene that was in tune with the new religious consciousness which centred on the figure of St Catherine of

Siena. Vanni used this figure again in his *St Catherine Drinking the Blood of Christ* from the convent of San Girolamo in Siena, where the influence of Barocci is mixed with Mannerist elements.

In the *St Catherine Drinking the Blood of Christ*, Francesco Vanni created a powerful and impressive icon and drew attention to the mystical theme.[32] When considering this painting, it should be kept in mind that Vanni, while very young, joined the Congregazione del Sacro Chiodo in 1580. Vanni therefore played an active part in the moral and religious renewal of the Counter Reformation. The confraternity was founded by Father Matteo Guerra on the model of St Philip Neri's oratory. Matteo Guerra's contact with Philip Neri in Rome was useful in the diffusion of his work, which gained the support not only of nobles and scholars, but also of some of the protagonists of the Catholic Reform movement, such as Federico Borromeo, Cardinal Emilio Sfondrato, Cardinal Baronio and Cardinal Tarugi.

In 1600 Francesco Vanni went to Rome for the Holy Year with a fellow member of the confraternity, Girolamo Turbanti, who was the prior of Bibbiano. In Rome he met

Francesco Vanni,
Death of St Cecilia.
Torre di San Giovanni,
Vatican City, Rome.

Matteo Guerra, who probably put him in contact with Cardinals Baronio and Sfondrato. Shortly afterwards he must have started the altarpiece for the church of Santa Maria degli Angeli, which Cardinal Baronio had begun to build in 1600 in Sora, his native city. Vanni painted the *Madonna della Vallicella Worshipped by St Francis and St Restituta*. An early plan, which can be seen in a drawing in the Pinacoteca in Siena, included the figure of a cardinal at the bottom of the composition. This led Ugurgieri Azzolini, who evidently had not seen the finished altarpiece in Sora, to describe Cardinal Baronio's presence in the painting. It must have been at this time that Vanni painted the portrait of Cardinal Baronio.

The paintings for the Roman commissioners, Cardinals Baronio and Sfondrato, open a complex chapter in Vanni's career.[33] Thanks to the intervention of Cardinal Baronio at the end of 1602, Vanni was given the commission to paint an enormous altarpiece on slate depicting the *Fall of Simon Magus* for the basilica of St Peter's. The theme, the dimensions and the context in which the painting was placed (Roncalli, Passignano, Cigoli, Castello and Baglione also worked on the decoration of the small naves) induced Vanni's extremely virtuoso execution of the composition. The influence of Barocci, which had weakened towards the end of the century, as can be seen from the subjects painted on the bier of St Catherine of Siena, has almost disappeared. The success of this painting induced Clement VIII to give Francesco Vanni the honorary title of Knight of Christ (*Cavaliere di Cristo*). It seems that the painting was also the butt of a number of jokes among artists in Rome. A sonnet found among the Cavalier d'Arpino's papers contains the following lines:

> *Perduta hai l'inventione et il disegno*
> *Da te è fugito et tutti n'hai beffato*
> *Si come il Pomarancio senza ingegno.*

> (You have lost your invention and your drawing technique,
> It has run away from you and you have fooled all of them,
> Just like brainless Pomarancio [Cristoforo Roncalli])[34]

Among the paintings that Vanni executed for Cardinal Sfondrato was the *Death of St Cecilia*. The subject was popular in Rome at the time due to the disinterment of the saint's body in 1599. The painting is known in two versions, one in

Francesco Vanni,
St Catherine Drinking the Blood of Christ.
Convent of San Girolamo, Siena.

Francesco Vanni, *St Catherine Drinking the Blood of Christ*, detail.
Convent of San Girolamo, Siena.

pp. 418–419
Ventura Salimbeni,
Music-making Angels. South vault,
Oratory of the Holy Trinity, Siena.

QVANTA MANDAVIT PA
TRIB¯NOS¯ 1s NOTA FACE E FIIS
SVIS

MILLIA MILLIVM
MINISTRABNT
EI
7

IN OMNE TERRA EXVIT
SONVS EORVM. PS 18

DECIES MILLIVM
CINTENA MILLI
ASSISTEBAT
EI

the form of a lunette (Santa Cecilia, Rome) and the other in a rectangular format (Torre di San Giovanni, Vatican City, Rome). The latter is of a higher quality but both seem to be the basis for an engraving that carried the inscription '*Vanius inv*' (Vanni made this). In the *Death of St Cecilia*, Vanni's style has completely changed. The subject is executed in a more naturalistic manner, with accentuated areas of light and dark and surfaces that are less unified.[35] The rectangular version recalls the *St Catherine Drinking the Blood of Christ* in San Lorenzo in Miranda in Rome, which has been attributed to the beginning of Vanni's career when he was still with Giovanni De Vecchi.[36] The clothes of St Catherine are reminiscent of Beccafumi, which supports both the attribution to Vanni and the dating. However, when this composition is compared with the painting of the same subject in San Girolamo in Siena it can be seen that the Barocci-influenced delicate pictorialism accentuates the mystic and sensual aspects of the Sienese version. Both the *St Catherine Drinking the Blood of Christ* in San Lorenzo in Miranda and the *Death of St Cecilia* in the Vatican were, therefore, probably painted subsequently, around 1603. They form part of a trend in Vanni's painting in

which mystic fervour is attenuated in favour of an interpretation of the life of the saints that tends more towards a solemn re-evocation. Vanni's stylistic development can be better appreciated when the Roman paintings are compared to the imposing *Crucifixion* in San Giorgio in Siena. This was executed shortly after the death of Matteo Guerra and can therefore be dated *c.* 1602.[37] The *Crucifixion* includes a portrait of Guerra, in profile with his hands joined in prayer, which is similar to that of an unknown person who appears in the *St Catherine Drinking the Blood of Christ* in San Lorenzo in Miranda. The change in Vanni's style, which the *Death of St Cecilia* in the Vatican helps to explain, coincides with the period in which Rutilio Manetti, Vanni's best pupil, started to break away from his master. Manetti painted a series of compositions that are influenced by Vanni but that contain more deeply saturated colours, perhaps a debt to Caravaggio.

In 1593 Deifebo Mancini wrote to Ippolito Agostini about a painting that had been commissioned from Vanni but not yet delivered. He remarked: 'I feel very unwilling for Vanni to keep the painting until after the festivals but I am more contented with this than to have it botched'.[38]

Ventura Salimbeni,
Apostles. South vault,
Oratory of the Holy Trinity, Siena.

Mancini's opinion indicates that Vanni had a tendency to produce works of varying quality.

Francesco Vanni's stepbrother, Ventura Salimbeni (1568–1614), was also strongly influenced by Barocci. Like Vanni, Ventura received his initial training from his father Arcangelo Salimbeni. According to Mancini, he went to Lombardy after his father's death in order to study Correggio. Then, after a brief return to Siena, he travelled to Rome. His presence there is confirmed by contemporary documents. On 21 November 1591 Ventura was called as a witness in the trial brought by the Perugian painter Domenico Angelini against Orlando Landi, whom he accused of stealing paintings. In his testimony Ventura claims to have been working for Angelini 'more than a year ago' in Sant'Agostino and to have helped him in various paintings. Agostino Marcucci, a Sienese painter, also submitted his testimony on 21 November, declaring himself to be working in Ventura's workshop in Parione, opposite the church of San Tommaso.[39] From this we can deduce that Ventura Salimbeni was already a master in 1591 with his own workshop and that he employed someone to help him. An examination of a letter from Deifebo

Mancini to Ippolito Agostini dated in Rome on 29 July 1594 sheds more light on the matter. In the letter Deifebo promises to obtain information about Salimbeni in order to establish his suitability for a commission. He writes: 'I will obtain information about the worth of Messer Ventura and I will sound him out again about it [the proposed commission]. I do not believe this will be difficult because I will look out for him where he works and I will advise Your Holiness about the conditions and the price'. The first part of the letter refers to a project to decorate a palace in fresco and it seems clear that Mancini needed to know whether Ventura was capable of painting in fresco as well as the price that he would charge.[40] In his *Considerazioni sulla pittura*, Giulio Mancini mentions a number of places in which Salimbeni worked in Rome including the church of the Gesù and the basilica of Santa Maria Maggiore. Baglione reports Salimbeni's participation in commissions for the Vatican Loggias, in the Vatican Library and in the Palazzo del Latterano. These sources have allowed a partial reconstruction of Salimbeni's activity in Rome,[41] where he may have also participated in the frescoes for the Holy Steps.[42] The uncertainties surrounding

Ventura Salimbeni,
Miracle of St Hyacinth.
Santo Spirito, Siena.

Ventura Salimbeni,
Virgin and Child.
Galleria Borghese, Rome.

Salimbeni's activity in Rome have been complicated by recent studies about Rome during Sixtus V's pontificate. The *Two Episodes from the Library of Athens* from the Sistine *salone* in the Vatican Library have been withdrawn from Salimbeni's catalogue and rightly given back to Ferraù Fenzoni.[43] The *Library of Jerusalem* is another fresco ascribed to Salimbeni on the basis of a comparison with his *Allegory of Peace* engraved by Villamena.[44] Without repeating the complex attributional history of the Roman frescoes, we can note a certain uniformity in the Sistine cycles, which makes it difficult to distinguish the hand of Ventura Salimbeni from that of Ferraù Fenzoni and Andrea Lilio. I believe that a more complete knowledge of Salimbeni's activity in Rome would be gained from a close inspection of the works he produced immediately after his return to Siena. It would then be possible to make deductions about Salimbeni's style in Rome. For example, there is a clear affinity between the frescoes in the Oratory of the Holy Trinity in Siena and the two ovals in the Trinity Chapel in the church of the Gesù in Rome which depict *Abraham and Three Angels* and *God in Glory*.

Immediately after his return to Siena, Ventura started work on the oratory for the Compagnia della Santissima Trinità for which payments to him are documented from 1595 to 1601.[45] Salimbeni painted the two main vaults, the small vault above the altar and the majority of the half-lunettes on the walls. One of the two vaults represents the heavenly assembly and in the other are angels, apostles, patriarchs and martyrs. The lunettes contain scenes from the Apocalypse. The cycle's theological message was rare in Siena, even after the Council of Trent.[46] The preference was usually for the narration of the lives of Sienese saints and blesseds. The frescoes contain rich colours and are still closely linked to the influences that Salimbeni had encountered in Rome.

One of these influences, the work of Raphael, can be seen in the *St Catherine* (previously owned by Agnew's, the London art dealer), painted *c.* 1604–1605, and in the women who appear on the left of the *Miracle of St Hyacinth* (Santo Spirito, Siena), which can be dated *c.* 1600. A reliance on Raphael also leads me to accept Longhi's attribution of the *Virgin and Child* in the Galleria Borghese in Rome to Ventura Salimbeni.[47] The *Andromeda* in the Zeri Collection also demonstrates the 'pre-Mannerist' grace that bears the influence of Raphael. The painting has affinities with the work of Rutilio Manetti in its iconography, evident in the details of the shells, the dolphin, the whale and Perseus flying on his horse. However, the materials and the delicate technique support the attribution to Salimbeni while he was under the influence of the Cavalier d'Arpino. As his career progressed Salimbeni became increasingly indebted to the Cavalier d'Arpino, Poccetti and Passignano, employing more monumental compositions and proportions in his consistently delightful paintings. The development is clear in the apse of Siena Cathedral, where in 1610 Salimbeni signed and dated the *Esther and Ahasuerus*, the *Fall of Manna* and the *Sienese Saints*. Towards the end of his life, Salimbeni's painting became more imaginative and inspired. Evidence of his late style can be found in the scenes of St Galganus in the church of the Santuccio.

Salimbeni's style was perpetuated in Siena by Sebastiano Folli (1569–1621), whose art can be distinguished from Salimbeni's because of his slightly heavier way of working. Folli entered the Compagnia di Santa Caterina in 1584 and held various positions within it. In 1598 he worked on the decorative programme in the Sala del Capitano del Popolo, today the Sala del Consiglio. The programme attempted to evoke important aspects of Sienese history. The lunette depicting *Charles IV Renewing Siena's Privileges as a University City* and the representation of the *Sienese Defeating the Army of Charles VII* have been attributed to Folli.[48] The largest commission he undertook was for the frescoes for the Compagnia di San Sebastiano in Camollia in 1606, which present *St Sebastian in Glory with Virtues and Angels* in the vault of the oratory and *St Sebastian before the Emperor Diocletian* on the wall. After Ventura Salimbeni's death, Folli turned to Rutilio Manetti for inspiration.

p. 422
Ventura Salimbeni,
Esther and Ahasuerus.
Apse, Siena Cathedral.

Notes

1 L. Lanzi, *Storia pittorica dell'Italia*, edited by M. Capucci, Florence 1968, 1, p. 246.
2 V. Marchetti, *Gruppi ereticali senesi del Cinquecento*, Florence 1975, pp. 17–35.
3 Until recently it was believed that Marcello Agostini had commissioned Beccafumi to paint the vault of a room in his palace on via dei Pellegrini. However, Angelini pointed out that the palace belonged to the Venturi, who commissioned Beccafumi's ceiling decoration. See A. Angelini, 'Il Beccafumi e la volta dipinta della Camera di Casa Venturi: l'artista e i suoi committenti' in *Bullettino senese di storia patria*, 1990, pp. 371–383.
4 ASS, Concistoro 2654, ins. 6; ASS, Concistoro 2656, fol. 3v; Aurieri, *Famiglie nobili di Siena*, MS.A15, fols. 4v–5r.
5 A. Nannizzi, 'Due lettere inedite del naturalista napoletano Ferrante Imperato al senese Ippolito Agostini' in *Bullettino senese di storia patria*, 1922, pp. 211–221.
6 A. Landi, *'Racconto' del Duomo di Siena*, edited by E. Carli, Florence 1992, pp. 50–51.
7 M. Maccherini, *Annibale Carracci e i 'bolognesi' nel carteggio familiare di Giulio Mancini*, unpublished thesis, Siena University 1994–1995.
8 P. Bacci, 'L'elenco delle pitture, sculture e architetture di Siena, compilato nel 1625–26 da Mons. Fabio Chigi, poi Alessandro VII secondo il ms. Chigiano I.I.11' in *Bullettino senese di storia patria*, 1939, p. 333.
9 W. Chandler Kirwin, 'The Life and Drawing Style of Cristofano Roncalli' in *Paragone*, 1978, 335, pp. 18–62.
10 BCS, D.V.3; letters from Deifebo Mancini to Ippolito Agostini dated from 1593 to 1598; in the same manuscript there are also the letters of Giovanni Andreozzi da Lucca.
11 ASS, Curia del Placito, 275, fols. 97–108; see B. Sani, *Per la storia del collezionismo senese. L'Inventario de' mobili di Ippolito Agostini*, in press.
12 W. Chandler Kirwin, in *Disegni dei Toscani a Roma (1580–1620)*, Florence 1979, p. 21; A. Bagnoli, 'Vincenzo Rustici' in *L'Arte a Siena sotto i Medici 1555–1609*, Rome 1980, pp. 259–260; B. Sani, *Per*

la storia del collezionismo senese; idem, *Riflessioni sull'attività grafica di Prospero Bresciano*, in press.
13 A. Bagnoli, 'Vincenzo Rustici' in *L'Arte a Siena*, pp. 259–260.
14 S. Padovani, 'Bernardo van Rantwyck' in *L'Arte a Siena*, pp. 193–208; N. Dacos, 'Dirck de Quade van Ravesteyn avant Prague: des Pays-Bas à Fontainebleau et à Sienne' in *Kunst des Cinquecento in der Toskana*, Munich 1992, pp. 292–307.
15 A. Bagnoli, 'Vincenzo Rustici' in *L'Arte a Siena*, pp. 87–93.
16 E. Romagnoli, *Biografia cronologica de' bellartisti senesi dal secolo XII a tutto il XVIII* (before 1835), anastatic edition, Florence 1976, IX, pp. 342 and 343–344.
17 A. Bagnoli, *L'Arte a Siena*, p. 68.
18 I. Ugurgieri Azzolini, *Le Pompe sanesi*, Pistoia 1649, II, p. 375.
19 G. Mancini, *Considerazioni sulla pittura*, edited by A. Marucchi and L. Salerno, Rome 1956, I, pp. 208–209.
20 ASS, Patrimonio dei Resti 908, fol. 184r. Casolani had been proposed on 20 May. The Confraternita di San Girolamo listed Ippolito Agostini among its members.
21 G.B. Marino, *La Galleria*, edited by M. Pieri, Padua 1979, I, pp. 29 and 52.
22 N. Fargnoli, in *L'Arte a Siena*, p. 230; A. Bagnoli, ibid., p. 76.
23 L. Martini, *Itinerario di Pietro Sorri*, Genoa 1983; idem, 'Pietro Sorri' in *L'Arte a Siena*, pp. 94–119; idem, 'Aggiunte a Pietro Sorri' in *Annali della Fondazione Longhi*, 1984, I, pp. 87–113.
24 BCS, D.V.3, letters from Lucca on 14, 19 and 21 September 1596 and on 18 October 1596.
25 G. Giusti Maccari, 'Pietro Sorri' in *La Pittura a Lucca nel primo Seicento*, Pisa 1994, pp. 125–130.
26 A. Blunt, *Artistic Theory in Italy 1450–1600*, Oxford 1940, p. 135.
27 ASS, Biccherna 1137, fol. 26v. L. Bonelli, 'Documenti per il giovane Francesco Vanni' in *Prospettiva*, 1996, 82, pp. 95–96.
28 G. Mancini, *Considerazioni sulla pittura*, I, pp. 209–210. The letters from Deifebo Mancini to Ippolito Agostini can be found in BCS. D.V.3, fols. 5rv–6rv, letter of 17 December 1593: '*Sento malvolentieri che il Vanni trattenga il quadro a doppo le feste*

pure mi contento più di questo che di averlo ciabattato. Ma mi fa risolvere tuttavia più che è meglio chi vuol delle pitture che se ne compri delle fatte perché in quella guisa non ha se non un pensiero che il trovar denari ma in questo modo spesse volte si ha un tormento di molti mesi forse con più spesa e con risico di non esser servito. Ho carissimo che il Vanni acquisti riputatione et che il trattamento nostro dependa da causa utile e honorata a lui.' (I feel very unwilling for Vanni to keep the painting until after the festivals but I am more contented with this than to have it botched. However it makes me even firmer in my opinion that it is better for the person who wants some paintings to purchase them from among those already made because in that way there is no trouble attached except for a thought about the cost, but in this way one often has to suffer many months of torment and perhaps unforeseen expenses and with the risk of not being delivered the paintings in the end. I am very keen for Vanni to gain a reputation and [hope] that the way he is treating us is because of something that is honorable and useful for him [that is, he is not keeping us waiting for nothing].); ibid., letter of 7 August 1596 and of 17 December 1596.
29 L. Wegner, 'Further Notes on Francesco Vanni's Works for Roman Patrons' in *Mitteilungen des Kunsthistorischen Institutes in Florenz*, 1979, XXIII, pp. 313–324.
30 L. Bonelli, *Nuovi documenti sulla vita e le opere di Francesco Vanni*, unpublished thesis, Siena University 1994–1995; A. Bagnoli, 'Gli inizi di Francesco Vanni' in *Prospettiva*, 1996, 82, pp. 84–94.
31 P.A. Riedl, *Das Fondi Grabmal in S. Agostino zu Siena*, Heidelberg 1979; idem, in *Die Kirchen von Siena*, Munich 1985, I.1, pp. 101–102.
32 B. Santi, in *Catherine de Sienne*, Avignon 1992, p. 233; idem, in *Panis vivus*, Siena 1994, p. 224.
33 For the relationship between Francesco Vanni and Cardinals Baronio and Sfondrato, see A. Zuccari, in *La Regola e la fama*, Milan 1995, pp. 487, 521–523 and 533; M. Pupillo, in ibid., pp. 504–506.
34 ASC, Archivio della Camera Capitolina, Credenzone XIV, 107,

Processo Criminale contro Giuseppe d'Arpino Pittore, fols. 360v–362r.
35 L. Barroero, 'Schede seicentesche: Finoglio, Vaccaro, Vanni e il Maestro degli Annunci' in *Scritti in onore di Giovanni Previtali*, II, in *Prospettiva*, 1989–1990, 57–60, pp. 217–221.
36 F. Zeri, *Pittura e Controriforma*, Turin 1957, p. 71.
37 A. Bagnoli and D. Capresi Gambelli, 'Disegni dei barocceschi senesi (Francesco Vanni e Ventura Salimbeni)' in *Prospettiva*, 1977, 9, pp. 82–86.
38 BCS, D.V.3, letter from Deifebo Mancini to Ippolito Agostini of 17 December 1793. See note 28.
39 A. Bertolotti, 'G.D. Angelini' in *Giornale di erudizione artistica*, 1876, V, pp. 73–75.
40 BCS, 29 July 1594, letter from Deifebo Mancini to Ippolito Agostini: '*Mi informarò di quello che meriti Ms Ventura e ne tastarò lui anchora il che credo non mi sarà difficile perché ne spiarò dove lavora et con che conditioni et a che prezzo e ne avvisarò V.S.*'
41 G. Scavizzi, 'Note sull'attività romana del Lilio e del Salimbeni' in *Bollettino d'arte*, 1959, XLIV, pp. 33–40; idem, 'Su Ventura Salimbeni' in *Commentari*, 1959, X, pp. 115–136.
42 Idem, 'Gli affreschi della Scala Santa ed alcune aggiunte per il tardo manierismo', I, in *Bollettino d'arte*, 1960, I–II, pp. 11–122; idem, 'Gli affreschi della Santa Scala', II, in *Bollettino d'arte*, 1960, IV, pp. 325–335.
43 A. Zuccari, *I Pittori di Sisto V*, Rome 1992.
44 B. Catani, *La Pompa funebre fatta dal Cardinal Montalto nella trasportazione dell'ossa di Sisto V*, Rome 1591.
45 A. Bagnoli and D. Capresi Gambelli, 'Disegni dei barocceschi', p. 86.
46 P.A. Riedl, *Die Fresken der Gewölbezone des Oratorio della Santissima Trinità in Siena*, Heidelberg 1978.
47 R. Longhi, 'Precisioni nelle gallerie italiane. La Galleria Borghese' in *Vita artistica*, 1926, now published in *Saggi e Ricerche 1925–1928*, Florence 1967, p. 347, pl. 302.
48 D. Capresi Gambelli, 'Sebastiano Folli' in *L'Arte a Siena*, pp. 163–167.

Painting from Nature

Giulio Mancini: Witness of the Revival of Sienese Painting

The third decade of the seventeenth century was a period of change for Sienese artists. They began to adapt to the classicism and naturalism which were already influencing painting in other parts of Italy and, following this, they started to take on board the Baroque style. It was also a difficult moment for the fragile economy of Siena and although the Medici strove to maintain the crumbling institutional forms of the state, they were unable to resolve the crisis. Maria Maddalena of Austria persuaded her son, Ferdinand II, to hand the difficulties of governing the Sienese state to a member of his family. In 1627 he named Catherine, who was the sister of Cosimo II and the widow of Ferdinando Gonzaga, as governor and when she died two years later of smallpox, Ferdinand gave the position to his young brother Mattias.[1]

The economic and political events outlined above were reflected in the careers and styles of Sienese artists. As governor of Siena, Mattias furnished his palace in a sumptuous manner.[2] His brother Leopoldo, who substituted for Mattias during his absences on military campaigns, was a great collector. Leopoldo was on friendly terms with members of various noble Sienese families, including the Cavalier Lodovico De Vecchi and Flaminio Borghesi, and collected a number of drawings with their help.[3] The Medici presence in Siena gave Sienese artists the opportunity to improve their knowledge specifically of Florentine art and more generally of Tuscan art; however, this did not weaken the ties with Rome. The flow towards Rome of craftsmen, scholars and theorists grew, culminating in 1655 with the election of the Sienese Fabio Chigi as Pope Alexander VII.

The links with Rome gave Sienese artists the chance to keep abreast of the latest technical and theoretical developments. Unfortunately, this is not always clear from the documents, which are scarce for the decades preceding the development of the Baroque. The descriptions and comments of contemporary witnesses are more helpful. The testimony of the Sienese Giulio Mancini (1558–1630), a passionate supporter of artists from his native city, follows the fortunes of Sienese artists during this period as they took on the challenges of naturalistic painting. Mancini, who trained as a doctor, reached the height of his career when he was given the post of chief physician by Urban VIII. Nicio Erithraei described Mancini's character with some humour.[4] In somewhat racy Latin, Erithraei spoke of Mancini's authoritarian character and of his gifts as a connoisseur, which enabled him to buy and sell paintings in Rome, without hesitating to snatch good compositions away from those who were in charge of them. Mancini's education and tastes are addressed at length in his *Considerazioni sulla pittura*. The book offers important information about Caravaggio and other artists from the seventeenth century.[5] Mancini was a magnet for Sienese artists and collectors and his writings are always well informed about contemporary Sienese art. The social situation in Rome at the time was conducive to collaborations among artists from the same city as well as to patrons commissioning works of art from their compatriots. At the start of his career Mancini had enjoyed the protection of the Patrizi, a family of Sienese origin, and when he became successful he in turn helped colleagues who came to Rome from Siena. We only have accurate information about a Sienese

doctor, Teofilo Gallaccini (1564–1641), who wrote a book entitled *Trattato sugli errori degli architetti* (Tract on the Errors of Architects).[6] Gallaccini reciprocated Mancini's help by obtaining information about Caravaggio during a journey to Naples.[7]

Mancini wrote his *Considerazioni sulla pittura* between 1617 and 1621. Among the Sienese artists still living, he named Pietro Sorri, Rutilio Manetti, Sebastiano Folli, Francesco Rustici, Stefano Volpi and Astolfo Petrazzi. He also recorded that Antiveduto Grammatica, of Sienese origin, was highly respected in Rome. The exclusion of Raffaello Vanni, too young to be considered a master, and of Vincenzo Rustici, a lesser artist than his son, shows Mancini's ability to evaluate artists accurately. Mancini's *Considerazioni* also provides important information on Sienese collections, which is useful in establishing to what extent the work of Caravaggio was known by Sienese artists.[8]

It is widely agreed that Rutilio Manetti was the first Sienese artist to be affected by the trend for naturalism in painting. Mancini relates that Manetti was trained in Francesco Vanni's workshop. He was born in 1571 and must already have been a well-established master by the time that Mancini was writing. It would therefore seem strange that Mancini mentions the hopes that Manetti kindled unless Manetti was on the verge of a decisive change of style. This transformation – which took place at the end of the second decade of the seventeenth century – led to a more naturalistic style of painting based on the works of Caravaggio and was highlighted by Fabio Chigi in his 'Elenco di pitture, sculture e architetture di Siena' written in 1625–1626.[9]

Rutilio Manetti

Manetti, the son of the tailor Lorenzo di Jacomo, was baptized in 1571. His godparents were Donato di Austino, a butcher, and Francesca, wife of Pietro the tailor.[10] We know remarkably little about Manetti's training. Romagnoli's nineteenth-century theory that Manetti contributed to the decoration of the Sala del Consiglio in the Palazzo Pubblico

cannot be proved.[11] His first work was probably the standard painted for the Compagnia di San Giovannino in Pantaneto, commissioned for the Holy Year of 1600 and therefore executed some time during the preceding year. The documents relating to the commission do not mention the artist. Twenty-five years later, however, Fabio Chigi informs us that

Manetti's altarpiece for the church was a standard, depicting *Christ with the Young St John the Baptist* on one side.

Chigi relates that the standard was remodelled to fit a new altar, which allows us to identify it with the two canvases in the oratory of the Compagnia di San Giovannino. One canvas represents the *Baby Jesus Blessing the Young St John the Baptist* and the other shows the *Baptism of Christ* and they differ greatly from one another. The first, executed with a shimmering painting technique that employs visible touches of the brush, is similar to Francesco Vanni's work. The other, which was enlarged and retouched in 1639, has very few areas that still show Manetti's original painting technique.[12] The *Baby Jesus Blessing the Young St John the Baptist* indicates that Manetti had trained with Francesco Vanni, as claimed by Mancini. He may have worked in Vanni's workshop over a long period of time, which would account for documents not mentioning Manetti before 1600, even though he must have been fully trained by the turn of the century. He probably encountered difficulties in distancing himself from Vanni's workshop and only began to emerge as an autonomous artistic personality with the dawn of the new century, when there were a number of commissions from the various Sienese confraternities who were planning journeys to Rome. One such commission was for the standard of the Compagnia di Sant'Antonio. Between 1623 and 1624 Rutilio Manetti was procurator for this confraternity and was probably already a member at the start of the seventeenth century.[13]

Manetti's first works, strongly influenced by Francesco Vanni, culminate in the standard painted for the lay Compagnia di San Rocco (San Pietro alle Scale, Siena). The standard is mentioned by Chigi in the seventeenth century and by Squarci in the eighteenth century.[14] The front face depicts *SS. Roch and Job Interceding with the Virgin for the City of Siena*, while the back represents *SS. Catherine of Siena and Roch*. The painting adapts Barocci's rich and refined colours, using them to create solid forms in a pyramidal composition. Both the canvases contain hilly landscapes that appear to be based on direct studies. Manetti depicts particular lighting conditions that reflect Bartolomeo Cesi's *Assumption* from the charterhouse in Maggiano (Siena Cathedral). The standard must have been painted *c.* 1605, when Manetti signed and dated the frescoes in the first bay of the Oratory of St Roch.

Rutilio Manetti, *SS. Roch and Job Interceding with the Virgin for the City of Siena*, recto of the standard for the Compagnia di San Rocco. San Pietro alle Scale, Siena.

Rutilio Manetti, *SS. Roch and Job Interceding with the Virgin for the City of Siena*, detail of the recto of the standard for the Compagnia di San Rocco. San Pietro alle Scale, Siena.

p. 428
Rutilio Manetti, *SS. Catherine of Siena and Roch*, verso of the standard for the Compagnia di San Pietro alle Scale, Siena.

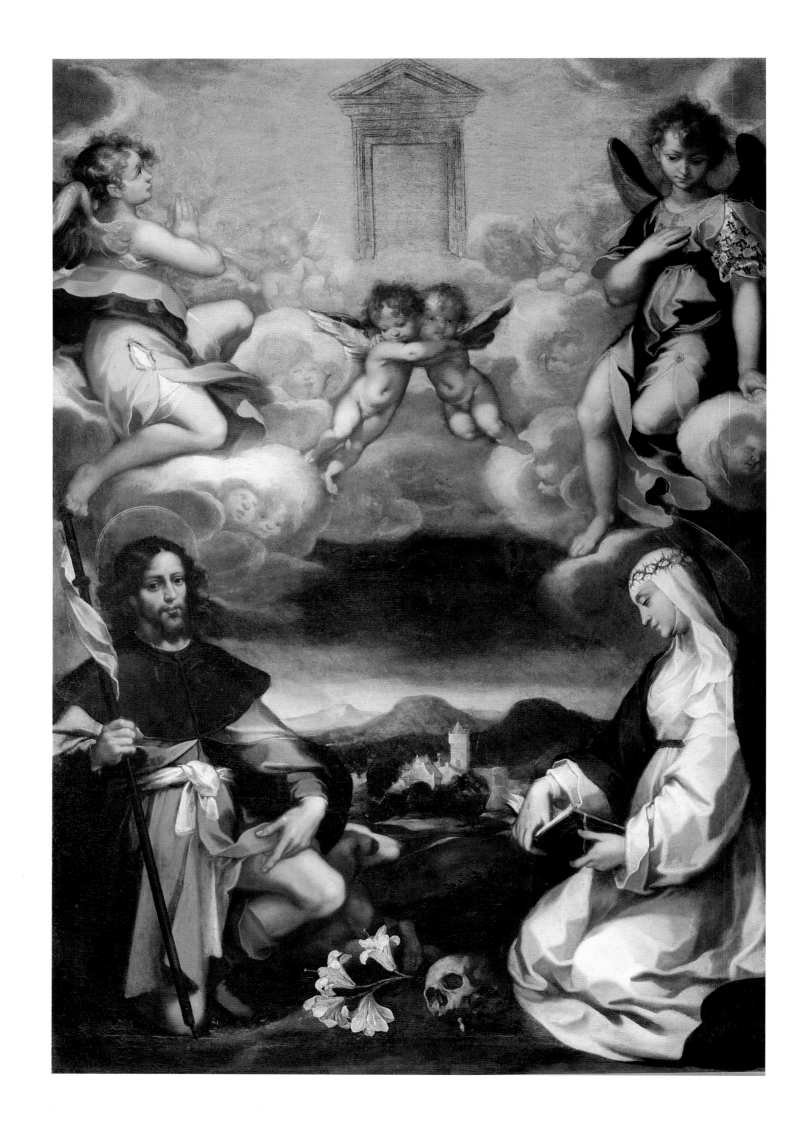

The frescoes in the oratory depict scenes from the life of St Roch and constitute Manetti's first large-scale commission. The scenes were executed between 1605 and 1610, as can be deduced from the dates inscribed on the various compositions. The representation of works of piety, such as caring for the ill, followed the directives of the Catholic Reform. Manetti's interest in such matters is evident in the fresco of *St Roch Caring for Plague Victims*. The cycle also demonstrates that Manetti employed stylistic characteristics that despite being well known in Siena were not Sienese in origin, such as the citation from Brill in the landscape background of *St Roch, Struck by Plague, Being Comforted by his Dog*. There are also elements that come from the Florentine art of the Catholic Reform, known in Siena through Bernardino Poccetti's frescoes in the charterhouse in Pontignano.[15]

It is towards the end of the first decade of the seventeenth century that the first signs of interest in Caravaggio can be detected, although not yet in the form of naturalism. The influence of Caravaggio is evident in the *Sacred and Profane Love* (Israel Museum, Jerusalem) which was in Agostino Chigi's palace in the seventeenth century. It is mentioned in

the inventory compiled in 1644 for the Roman relations to whom Chigi had left his estate. The inventory attributes the painting to Francesco Vanni and values it at sixty *scudi*. A drawing in the Biblioteca Comunale in Siena (S.III.10, fol. 36r), a study for the composition, contains two inscriptions that appear to confirm the attribution in the inventory. One is in an eighteenth-century hand and reads 'fr. Vanni' while the second – 'Francesco Vanni Pavoli' – is older and appears on the back of the study. The style of the painting is somewhat different from the drawing, with changing colours derived from Barocci and Mannerist forms providing dramatic touches, which are stressed by the use of a natural olive colouring. This is particularly evident in the figure of Profane Love and has induced Bagnoli to propose an attribution to Rutilio Manetti.[16] Despite the inscriptions, I believe that the preparatory drawing has similarities to Manetti's style. The inscriptions could therefore document that the drawing came from Vanni's successful workshop rather than being executed by Vanni himself. The painting reflects a theme that had been addressed by Baglione for Cardinal Benedetto Giustiniani in competition with Caravaggio. It demonstrates

Rutilio Manetti,
St Roch Caring for Plague Victims.
Oratory of St Roch, Siena.

Rutilio Manetti,
St Roch Caring for Plague Victims, detail.
Oratory of St Roch, Siena.

that Manetti was aware of contemporary Roman painting and should therefore be dated to the beginning of the seventeenth century, when Manetti was an important figure in Rome. Manetti's figure of Profane Love, who has been cast to the ground, reflects Bartolomeo Manfredi's figure in the *Chastisement of Cupid* in Chicago. Manfredi's painting is one of the first to show Caravaggio's influence and probably contributed in bringing the new style to Siena.[17] Besides being mentioned in the previously cited inventory of Agostino Chigi's goods,[18] Mancini also refers to the composition, stating that in Chigi's collection in Siena was a work by Manfredi, which he describes as being 'perhaps the best thing that he did'.[19]

The *Rest during the Flight into Egypt* (San Pietro alle Scale, Siena) was painted in 1621 by Manetti for the church of Santa Maria in Portico di Fontegiusta and is Manetti's most famous work.[20] The figures of the protagonists have a soft naturalism that was influenced by the work of Guercino.[21] The *Rest during the Flight into Egypt* combines motifs from the local Sienese tradition, such as the Beccafumi-inspired angels dancing in a circle, with a clear naturalism and yet does not

renounce the strongly drawn construction of the figures. Manetti never abandoned the use of drawing in his compositions, even when his naturalism became more defined, his strongest use of which is found in paintings such as *Roger and Alcina*, commissioned by Cardinal Carlo de' Medici for the Casino Mediceo between 1623 and 1624. The scene of *Roger and Alcina* is taken from Ariosto's *Orlando Furioso* and demonstrates the influence of the nocturnal scenes imported into Florence by Honthorst in *c.* 1620. The night setting of the moment in which Roger and Alcina discover their love for one another translates the sense of mystery and magic that pervades the verses before and after the following extract, to which the subject of the painting refers:

> *Facean, sedendo in cerchio, un giuoco lieto:*
> *Che ne l'orecchio l'un l'altro domande,*
> *Come più piace lor, qualche secreto.*

> (The company assembles in a ring,
> And there a merry game begins to play,
> Whereby, each to the other whispering,
> Mysterious and secret words they say.)[22]

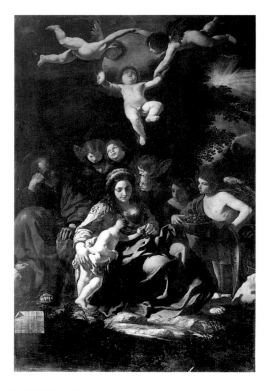

Rutilio Manetti,
Rest during the Flight into Egypt.
San Pietro alle Scale, Siena.

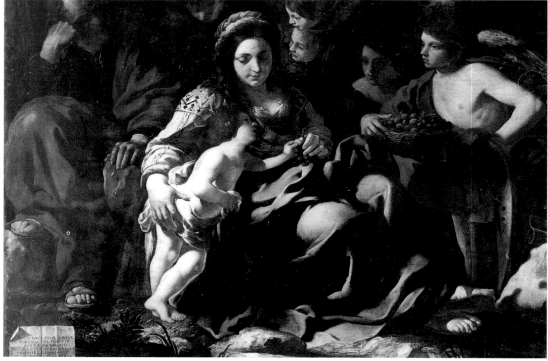

Rutilio Manetti,
Rest during the Flight into Egypt,
detail. San Pietro alle Scale, Siena.

The foreground figures are an early and direct citation of Simone Vouet's *Birth of the Virgin* in San Francesco a Ripa. The painting therefore indicates Manetti's receptiveness to new influences at this time in his career.

Manetti's familiarity with the artistic styles discussed above can be explained by what we know of his life. For example, his contacts with Virgilio Malvezzi, son of the governor of Siena, gave him the opportunity to become acquainted with painting in Bologna. Manetti also had links with the charterhouse in Florence and with the Medici collectors. This gave him access to the works of some of the painters gravitating around the court and city of Florence, among whom was Artemisia Gentileschi. There is no documentary proof of Manetti's links with Rome, although these are evident in his paintings. If one considers the recurrence of possible Roman motifs in the work of Manetti, it seems that his main inspiration came from the French followers of Caravaggio living in Rome. This is true of the study for a soldier in the Biblioteca Comunale in Siena, which shows clear affinities to the *Soldiers Casting Lots for Christ's Clothes* by Valentin (private collection, Geneva).[23]

Manetti's *Ecstasy of St Jerome* (Monte dei Paschi, Siena) was signed and dated 1628. It confirms Manetti's Roman connections in its echoes of Valentin's figure of *St Jerome* and of Caravaggio's version of the same subject (Galleria Borghese, Rome), the source of the two later paintings. The *Musicians and Card Players*, *Draughts Players* and *Chamber Music* (Chigi Saracini Collection, Siena) all also demonstrate the influence of the French followers of Caravaggio.[24] These compositions were intended for private rooms and the theme of recreation is treated in a lively manner, even if Manetti sometimes descends into unseemly details and employs masks or types. The works are also a reminder of Callot's influence.[25]

In the last ten years of his life Manetti, affected by elements in the works of both Reni and Lanfranco, started to paint the complex and severe compositions that were taken up and repeated by his son Domenico (1609–1663), his close collaborator. They include vast canvases, such as the *Blessed Virgin with the Prophets David and Isaiah* in the church of San Niccolò degli Alienati, and canvases painted for private use, mostly for the Del Taja family. This type of production reached its climax in the *St Bernardino* in which the use of

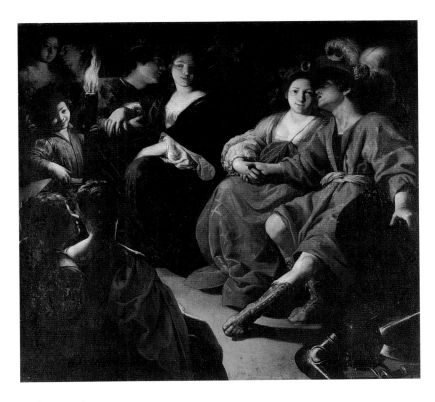

Rutilio Manetti,
Roger and Alcina. Galleria Palatina,
Palazzo Pitti, Florence.

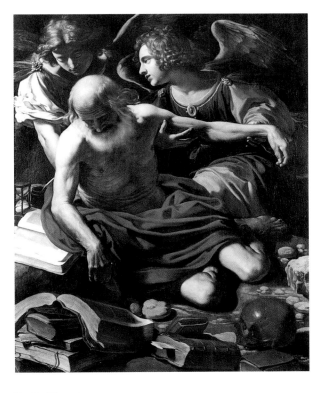

Rutilio Manetti,
Ecstasy of St Jerome.
Monte dei Paschi, Siena.

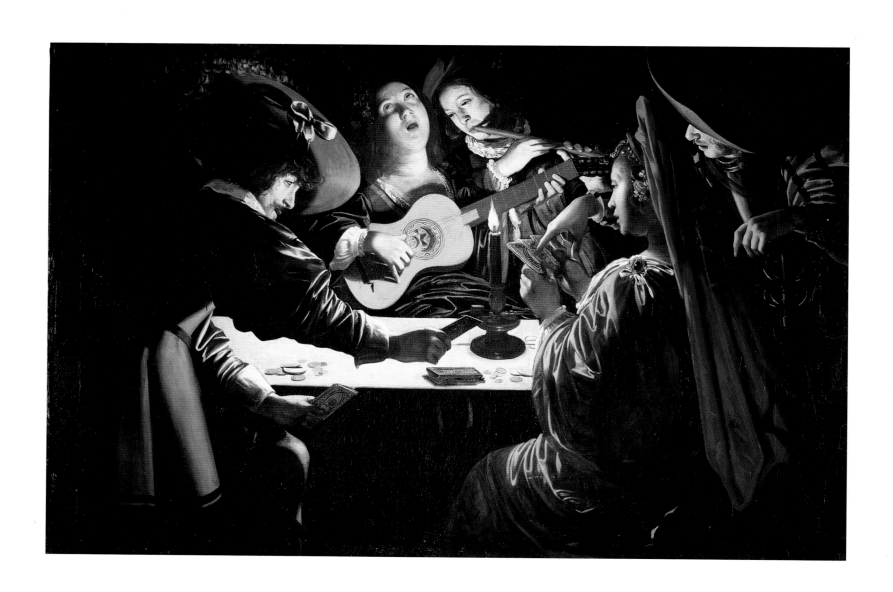

Rutilio Manetti,
Musicians and Card Players.
Chigi Saracini Collection, Siena.

light and the expression of emotion are combined in an extremely moving composition.[26] The painting experiments with tones of bronze and black, contrasted against a background which divides into areas of darkness and light. The saint is shown turning to the spectator and indicating the monogram of Christ.

Francesco Rustici

Manetti's artistic personality is extremely complex and a number of questions relating to his career remain unanswered. Alongside him, Francesco Rustici (1592–1626) risks being overshadowed. Rustici adopted the new naturalistic manner of painting in an intelligent and personal way. He was the son of Vincenzo and the nephew of Cristofano Rustici and Alessandro Casolani.

Francesco must have trained with his father and his works show him to have been strongly influenced by Barocci and his followers, by late Roman Mannerism, and by Flemish painting and its offshoots. All of these components were present in Casolani and Rustici's workshop. The *Beheading of St John the Baptist* in the St John Chapel in Siena Cathedral shows these influences. It is one of three paintings depicting episodes from the life of the Baptist for which Vincenzo Rustici was paid by the Opera del Duomo on 15 October 1616. The softly shaded colour and the free and elegant proportions of the figures have rightly induced Bagnoli to attribute the composition to Francesco Rustici.[27] The attribution is supported by the testimony of Fabio Chigi, who relates that the most modern paintings in the chapel were those by Francesco Rustici. The composition takes elements from Alessandro Casolani's *Beheading of the Baptist* from Casteldelpiano,[28] one of the artist's last works, but there are closer ties with the *Beheading of the Baptist* from the Carthusian church in Pontignano. Although the authorship of the Pontignano *Beheading of the Baptist* is uncertain, its extreme elegance links it with the workshop of Casolani and Rustici.

Francesco Rustici's *St Charles Borromeo* (Archivio di Stato, Siena) was painted in 1619. The use of strong contrasting

Francesco Rustici,
Baptism of Christ. Museo
dell'Opera del Duomo, Siena.

Francesco Rustici,
Madonna and Child.
Amorosa, Sinalunga.

colours and the harmony in the rendering of the figures signal Rustici's move towards naturalistic painting, which was probably prompted by his early visit to Rome mentioned by Mancini.

Bagnoli has already compared Francesco Rustici's use of white with that of Orazio Gentileschi.[29] It is worth including other aspects of the two artists' work in the comparison which proves most informative as long as Francesco Rustici's mature works are taken into consideration. A standard painted for the Compagnia di San Giovannino (Museo dell'-Opera del Duomo, Siena) comprises a canvas painted by Rutilio Manetti with the *Baptist Preaching* and a canvas painted by Rustici depicting the *Baptism of Christ*. The latter seems to have been influenced by Gentileschi's *Baptism of Christ* in the Olgiati Chapel in Santa Maria della Pace, just as Rustici's *Madonna and Child* in the Amorosa in Sinalunga recalls Gentileschi's *Virgin of the Rosary* in the church of Santa Lucia in Fabriano. The naturalistic layout, however, contrasts with the late Mannerist elegance of the figures, suggesting a comparison between the two angels in the *Baptism of Christ* and Raffaellino da Reggio's *Tobit and the Angel*.

Francesco Rustici's Florentine paintings give further proof that his conversion to naturalistic themes and forms cannot be considered absolute. The *Olindo and Sophronia*, commissioned by Cardinal Carlo de' Medici before 1624, contains none of the new naturalistic elements. The *Death of Lucrezia*, commissioned by Maria Maddalena of Austria for Poggio Imperiale, and the *Dying Magdalen*, conserved in two versions in the Uffizi (one of which is the painting recorded in the 1625 inventory of Poggio Imperiale),[30] develop the theme of candlelit night scenes in a way that is strongly reminiscent of Honthorst's work. In the first part of 1624 it appears that Rustici resided in Siena; in fact he was elected vicar of the Compagnia di San Domenico and he was charged with collecting funds for the jubilee pilgrimage and with painting the confraternity's standard. By the end of the year his presence in Rome can be proved by letters exchanged between the Florentine ambassador in Rome, Francesco Niccolini, and the grand duke's secretary. In 1625, Francesco is mentioned in the records of the parish of San Lorenzo in Damaso in Rome. He had probably made regular visits to Rome in previous years, perhaps beginning

Francesco Rustici,
Death of Lucrezia.
Uffizi, Florence.

in 1621, because in 1622 and 1623 he is only recorded in Siena in documents relating to payment of fees to the Compagnia di San Domenico. In Rome, Francesco lived in the house of Monsignor Tantucci, the bishop of Grosseto, in vicolo delle Stelle. The engraver Orazio Brunetti, Sienese by birth and twenty-eight years old, and a certain Bastiano Granucci, also Sienese and also a painter or aspiring painter but only eighteen years old, lived with him.[31] The parish records allow us to reconstruct Rustici's alternating stays in Siena and Rome and confirm his connection with the engraver Brunetti, who formed part of Bernardino Capitelli's circle.

Orazio Brunetti engraved some of Francesco Rustici's works, among which are the two versions of *St Sebastian Tended by St Irene*. One version of the engraving is in a private collection in Florence and three examples survive of the other (Galleria Borghese, Rome; Narbonne, France; and Gallerie di Firenze, Florence).[32] Brunetti's engravings indicate that the paintings must have been executed at the very end of the artist's career and they reflect a profound exploration of Roman art. The vein of sentimentality, noticeable in Rustici's first works, is accentuated by the ample and solemn forms and by the slow rhythm of the composition. These aspects suggest that Rustici had studied Bolognese painting.

The Influence of Classicism

Classicism offered Sienese painters a way to represent nature with moderation and in accordance with certain rules, which accounts for its continuing influence in Siena. It was employed in different ways and with varying levels of involvement, according to the temperament of the artist, but was never formulated in a coherent manner. The Sienese collectors and scholars who formed part of Ippolito Agostini's circle – among them Giulio Mancini, Costanzo Patrizi, Father Giovanni Battista Ferrari and Pandolfo Savini – encouraged artists to embrace classicism, a style they clearly admired. Little is known about the effect this had on collecting in Siena, however, and there are only a few documented instances of a Sienese collector looking to acquire paintings in this style. Savini, for example, did everything in his power to purchase a painting by Poussin, using the Jesuit Father Ferrari as a mediator.[33] The Gori family employed Reni to paint their altarpiece of the *Circumcision* in the church of San Martino, which he sent to them in 1636.[34] The altar had been endowed by Silvio Gori in 1621. Francesco Vanni painted a copy of Guido Reni's *Circumcision*, which testifies to his classical influences.[35]

Michelangelo (1585–1672) and Raffaello (1595–1673), the two sons of Francesco Vanni, both formed strong ties with Rome. They turned towards Reni, who had been so close to Francesco as to use one of his drawings for the tondo of the *Coronation of SS. Cecilia and Valerian*. Giulio Mancini acted as a mediator in organizing Raffaello's move to Rome. The letters from Giulio Mancini to his brother Deifebo provide accurate information about the dates and circumstances of the move. Francesco Vanni died on 26 October 1610. A few months later Giulio Mancini wrote to report that he had tried to find accommodation for Raffaello in Guido Reni's house. This not being possible, Reni invited Raffaello to stay in his studio, out of respect for his father and his brother Michelangelo. Mancini then turned to Antonio Carracci, a neighbour and friend of Reni, hoping that Raffaello would be able to learn from both painters. By 2 February 1612 Raffaello was staying with Carracci. However, it seems that this was not an ideal arrangement due to Carracci's mood swings.[36]

Raffaello arrived in Rome just in time to be able to see Reni complete the frescoes in the Annunciation Chapel in the Palazzo di Montecavallo on the Quirinal Hill and the frescoes in the Paoline Chapel in Santa Maria Maggiore. The slow rhythm of Reni's designs provided Raffaello with a model for composing scenes in a solemn style and enabled him to break away from Francesco Vanni's sentimentality. Nothing is known about Raffaello's work before the 1620s and it is therefore difficult to gauge to what extent he was influenced by Antonio Carracci's decorative schemes. Ugurgieri Azzolini refers to a visit to Venice about which

little is known, but a piece of writing in Raffaello's *Job Scolded by his Wife* in the Oratory of St Roch in Siena indicates that it must have been painted while Raffaello was in Venice. On the two faces of the base on which Job is lying, one can read 'I BONA SUSCEPIMUS DE MANU DEI MALAQUAR NON SUSTINEAM II' and 'RAPH VANNIUS FECIT MDCXXIIVEN'. The first part is a biblical verse referring to the story of Job, who was tested by God through Satan, and the second contains the signature of the painter. In a somewhat disjointed composition, Vanni combines the various elements of the story: Job suffering with sores; his wife who encourages him to curse against God and to die; Satan having been overcome; the words sculpted into the stone; the clouds; the meteors; the dry branch that sprouts; and, finally, with the intention of giving form to the words 'Then Job died, old and wise with the days', the edifying vision of Job being carried to heaven by angels. The work is surprising in that it does not reflect the classicism of Raffaello's Roman training.

The journey to Venice, also proved by documents relating to the transport from Venice via Florence of the altarpiece with *Job Scolded by his Wife*, constituted a brief break amid Raffaello Vanni's stays in Rome.[37] The terms of his admission to the Congregazione dei Santi Chiodi in Siena in 1624 demonstrate the length of those stays – he was exempted from the noviciate due to his commitments in Rome. It is possible that Raffaello Vanni originally went to Rome to work for Cardinals Sacchetti and Santacroce, for the duchess of Gravina and for the Marquis Patrizi.[38] His engagements in Siena and Rome appear to alternate so closely that it is difficult to ascertain whether works for patrons in Siena were painted in Siena or in Rome. Vanni has been attributed with some allegorical figures – *Liberality*, *Munificence*, *Prayer* and *Fortitude* – in the Palazzo Peretti Fiano.[39] Their style is similar to that of Grimaldi but the figure types also strongly resemble those in Vanni's *Death of Cleopatra*, *Death of Dido* and also in his *Rape of Helen*. The last two are mentioned in an inventory of Mariano Patrizi's goods. The paintings demonstrate Vanni's classical education in the strongly drawn outlines of the figures, in their ample three-dimensionality and in the solemnity of their poses.

In Palazzo Santacroce, Vanni painted compositions that are similar in style to his documented Sienese works, as

exemplified by the tondo of the *Exaltation of the Cross*, which is similar to the *Last Judgment* in San Niccolò in Sasso in Siena, painted in 1637.[40] The frescoes in Palazzo Santacroce were completed during the period in which Vanni executed some of his best work for the ceiling of San Vigilio in Siena. The church was run by the Jesuits from 1561 until its suppression by Leopoldo di Lorena in 1773. The rectangular and octagonal canvases contain a cycle focusing on sin and redemption. The subjects include the *Last Judgment*, the *Fall of the Rebel Angels* and the *Expulsion of Adam and Eve from Paradise*. It is not known whether Raffaello Vanni painted the canvases in Siena or sent them there from Rome. They were completed after 1634, the year in which Giuliano Periccioli decorated the ceiling of San Vigilio with empty compartments.[41] After this commission Vanni painted some frescoes in Palazzo Patrizi which the family purchased in 1642. In 1649 Ugurgieri Azzolini recorded that Vanni frescoed the rooms and installed oil paintings above the doors. Raffaello Vanni's hand has been identified in seven rooms of the Palazzo Patrizi, in the scenes from the Old Testament.[42] The quality of the frescoes is not always consistent, suggesting that Vanni may have employed an assistant, perhaps his brother Michelangelo. A hand other than Raffaello's can be discerned in the *Finding of Moses*, in the *Sacrifice of Moses* and in the *Judgment of Solomon*. A comparison with a compartment in the vault of the church of the Madonna della Grotta in Siena, which can be attributed to Michelangelo, demonstrates that he worked on the scene of *Samson and Delilah* and therefore probably on other compartments as well.[43] The figures of the *Virtues* are the most successful part of the programme and their style is entirely consistent with Raffaello Vanni's. However, they are somewhat different from the allegorical figures in Palazzo Peretti Fiano and in Palazzo Santacroce due to the influence of Pietro da Cortona.

Baglione's comments in his *Vite* testify to the success of Raffaello Vanni's career.[44] He records that Vanni 'succeeded very well' and that he had 'a good school and many disciples' and provides a long list of the works that Vanni undertook in Rome. These range from the '*cupola del Popolo*' (the dome of Santa Maria del Popolo) to the paintings for Santa Maria della Pace, for Santa Croce di Gerusalemme and for St Peter's. It appears from a letter sent by Vanni to Clement IX that he

had collaborated with Pietro di Cortona in the cupolas of the Chapels of the Holy Sacrament[45] and of St Sebastian.[46] Vanni went on to ask Clement IX for a similar commission for the cupola of the Santissimo Crocifisso. Pietro da Cortona's involvement in the decoration of St Peter's lasted from 1652 until 1668. His designs were translated into mosaic by various artists, among them Abbatini who has also been attributed with the designs for the St Sebastian Chapel that I believe should be ascribed to Raffaello Vanni. The St Sebastian Chapel shows Pietro da Cortona's direct influence on Vanni.

In the 1620s and 1630s Sienese and Roman collectors expressed more eclectic requests, which echoed the position of the post-Reformation Church as the cultural guide of Christianity. The protection of Pope Alexander VII allowed Vanni to paint works in Rome and Siena that create a strong impact on the spectator and demonstrate a heavy reliance on Pietro da Cortona. This can be seen in the *St Helen and the True Cross* in the church of Santa Maria in Publicolis in Rome and in the *Fall of Christ under the Cross* in the church of San Giorgio in Siena. Raffaello Vanni, a competent follower of Pietro da Cortona, used some Baroque elements in his paintings, but his works are marred by a lack of imagination and by his training within an academic culture that tended towards eclecticism.

Genre Painting and Astolfo Petrazzi

Astolfo Petrazzi (1580–1653) incorporated various elements of Sienese painting in his brightly coloured altarpieces, such as the *Adoration of the Magi* in San Sebastiano in Valle Piatta, where his use of warm colours is reminiscent of Cigoli's paintings.[47] Petrazzi's luminous colours can also be seen in the *Nativity* and the *Ascension* from San Niccolò in Sasso.[48]

Besides the altarpieces, Petrazzi also painted a series of works for private rooms. These contained sacred subjects but in a smaller format and often recall the compositions of the Rustici and of Ventura Salimbeni.

Local sources mention a great number of still-life paintings in Sienese houses, often attributing them to Petrazzi.

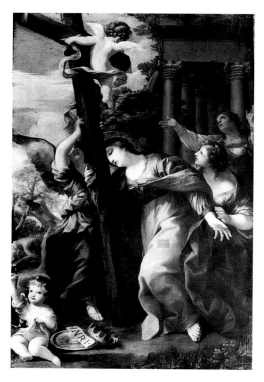

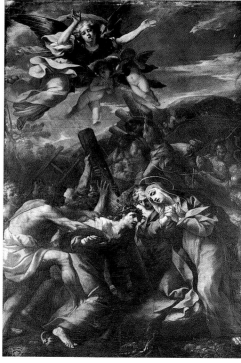

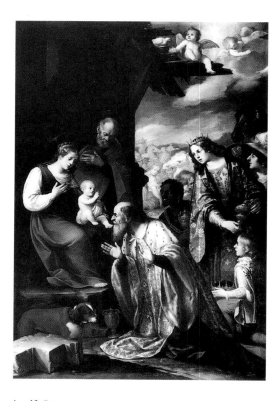

Raffaello Vanni,
St Helen and the True Cross.
Santa Maria in Publicolis, Rome.

Raffaello Vanni,
Fall of Christ under the Cross.
San Giorgio, Siena.

Astolfo Petrazzi,
Adoration of the Magi. San
Sebastiano in Valle Piatta, Siena.

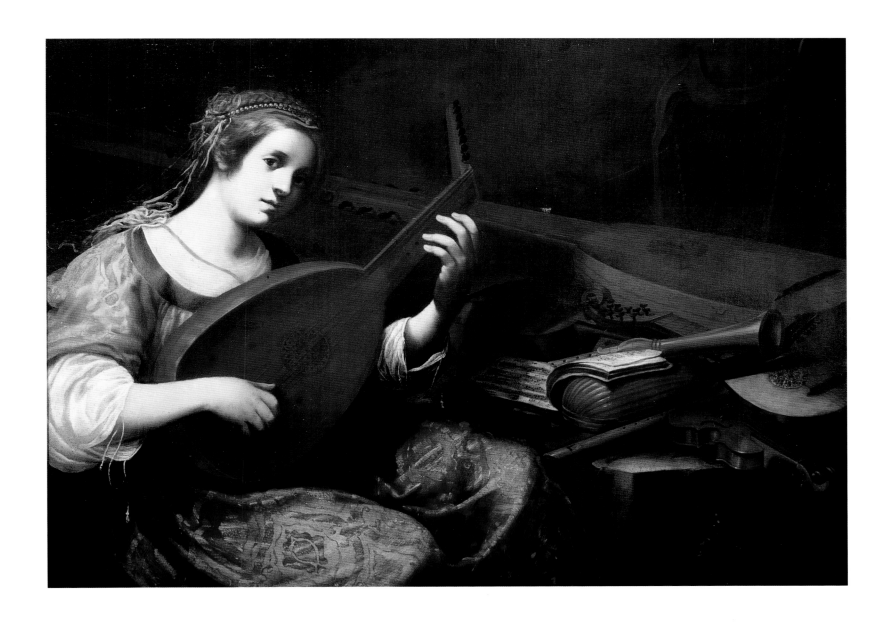

Astolfo Petrazzi,
*Lute Player with a Still Life of Musical
Instruments*. Pinacoteca, Siena.

During his stay in Rome in the 1630s, Petrazzi had been influenced by the recent developments in genre painting. Despite the documentation, Petrazzi's activity as a genre painter is still not widely known but the *Lute Player with a Still Life of Musical Instruments* (Pinacoteca, Siena) confirms his great ability.[49] The composition unites a soft and iridescent colouring, reminiscent of Beccafumi, with areas of painting derived from the naturalistic tradition. Petrazzi achieves an almost architectonic arrangement of the musical instruments. The flute and the violin on the table seem to force the delicate lute player towards the left of the composition.

The still lives mark an evolution in the taste of the principal Sienese families, who began to furnish their houses with objects produced in Rome – gold, fabrics, genre paintings and frames. The trend for Roman goods even extended to food and horses. The Baroque style was enjoying increasing success in Rome during this period, and in the wake of Bernini, Petrazzi was involved in various types of art that aimed to transform the city and the houses of the nobility.

Only a few public works were undertaken in Siena during the same period, culminating in the construction of the Chapel of the Madonna del Voto in the cathedral. The chapel was planned by Bernini in the early 1660s. It contained a number of reliefs and statues by his pupils as well as two sculptures by Bernini himself – *Mary Magdalen* and *St Jerome* – which became models for subsequent Sienese artists. The rarity of public commissions meant that families sought to adopt the Roman Baroque taste in private commissions. The fashion for the Baroque can be seen in the series of letters between Cardinal Flaminio Del Taja, a judge working at the papal court of the Rota, and his brother Stefano.[50] The correspondence describes how the cardinal bought luxury objects for his family. The election of Fabio Chigi as Pope Alexander VII consolidated the wealth of the families associated with the Chigi. There was a call for beautifully finished works of art, which narrated stories and fables that were no longer always taken from classical Greek or Latin sources. Consequently Sienese painters were encouraged to look outside Siena for inspiration. In the Rome of Alexander VII, Sienese painters were involved mainly in painting altarpieces and smaller private works rather than decorating ceilings and cupolas.

p. 441
Niccolò Tornioli,
Crucifixion. San Niccolò
in Sasso, Siena.

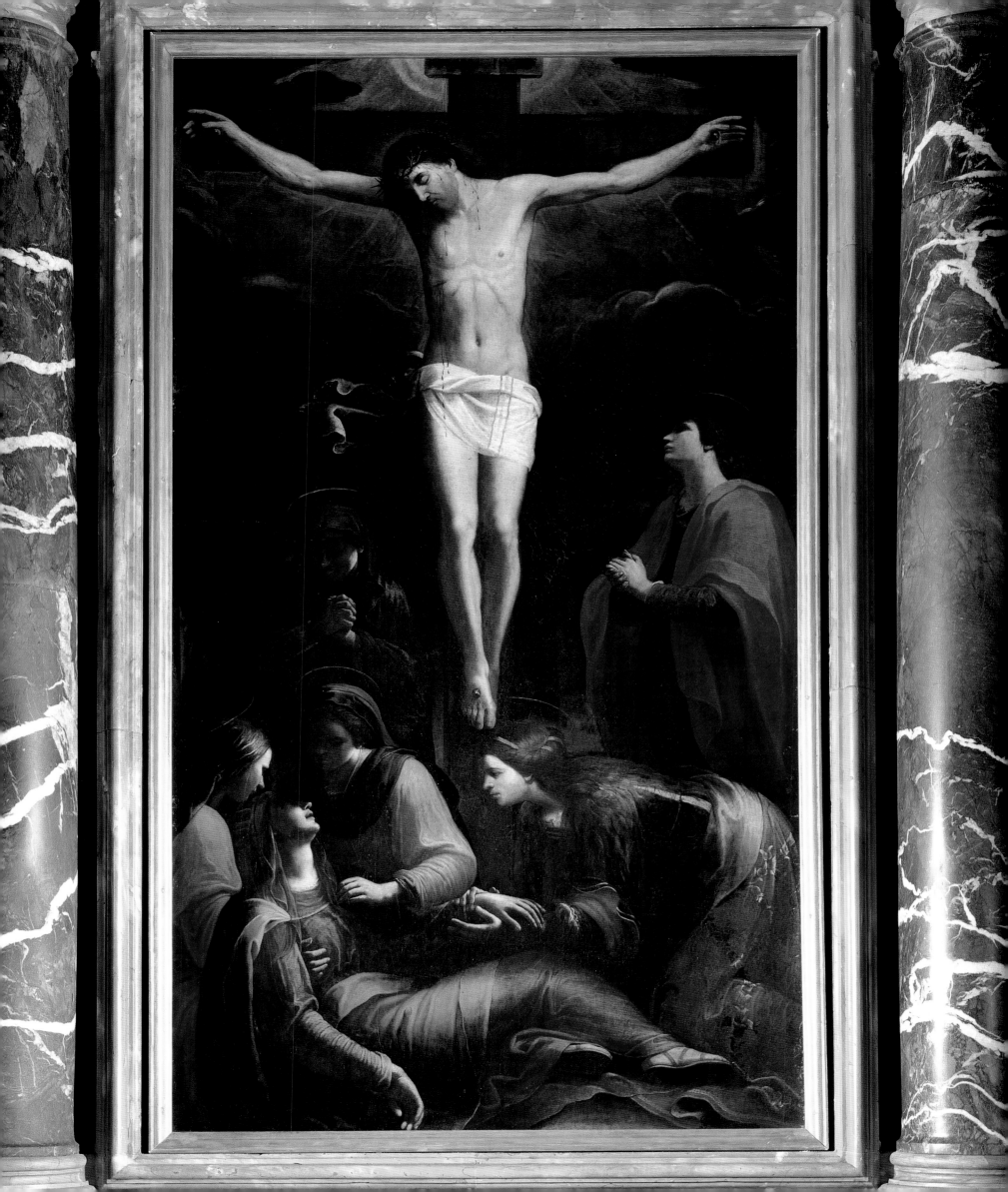

The Birth of the Baroque: Niccolò Tornioli

Niccolò Tornioli (1598–1651/1652) was the first Sienese artist to make the journey to Rome after Petrazzi's return to Siena. Tornioli's first work in his native city was the *Crucifixion* for the church of San Niccolò in Sasso. The canvas contains classical elements and Christ's body in particular recalls the work of the Carracci. However, Tornioli used a palette of soft and changing colours inspired by Francesco Vanni. The *Crucifixion*, Tornioli's only known work in Siena, was commissioned on 15 May 1631 and the final payment was made on 21 March 1632.[51] On 16 December 1630 Tornioli signed a contract to paint the *Ecstasy of the Blessed Gioacchino Piccolomini* for the Servites but he defaulted and the Servites then gave the contract to Rutilio Manetti who painted the existing altarpiece. All that remains of Tornioli's project is a delicate sketch with deep shadows that are in complete contrast to the harshness of Manetti's shading. The style of the sketch and the *Crucifixion* in San Niccolò in Sasso indicate that Tornioli trained with Rustici and not Rutilio Manetti. Tornioli, like Rutilio Manetti and Raffaello Vanni, seems to have broken free from his master's style in his thirties. Ugurgieri Azzolini, writing in the mid-seventeenth century, relates that Niccolò was taken to Rome by Count Federico Borromeo under whose protection he was able to study and work but unfortunately the exact date of the move is unknown. There is evidence that Tornioli may have had other contacts in Rome. In 1611 a certain Carlo Tornioli, perhaps a relation, had given funds to the Compagnia di Santa Caterina in via Giulia, which was the centre of Sienese spiritual and social life in Rome.[52] Every reference to the works painted for Federico Borromeo has been lost, but we do have information about Tornioli's relationships with other prelates, in particular Cardinal Maurizio of Savoy and Cardinal Virgilio Spada. Maurizio of Savoy must have employed Tornioli immediately after he came to Rome. In 1637 he commissioned Tornioli to design twelve illustrations, to be engraved by Luca Ciamberlano, for a volume

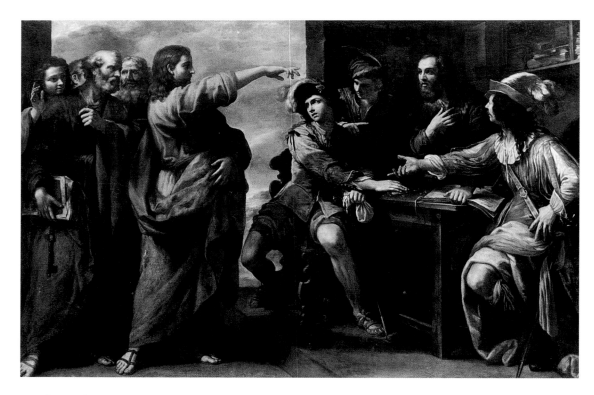

Niccolò Tornioli,
Calling of St Matthew. Musée
des Beaux-Arts, Rouen.

dedicated to the festivities ordered by the cardinal in honour of the election of Emperor Ferdinand III.[53]

Tornioli's *Calling of St Matthew* (Musée des Beaux-Arts, Rouen) is important when reconstructing his career in Rome. The work was executed for the customs house in Siena.[54] Tornioli received the commission in 1634 and was paid for the canvas and the frame in 1635. The money was given to his father, Lorenzo Tornioli, indicating that the painter was not in Siena at the time. The *Calling of St Matthew*, which has a 'Roman-style frame',[55] was set in place between 1637 and 1638. The painting is completely different from the *Crucifixion* in San Niccolò in Sasso. Tornioli has broken away from the influence of Barocci and Carracci and depends instead on the naturalism of Caravaggio and his followers, including Manfredi and perhaps Cecco del Caravaggio. Not all the elements of Tornioli's artistic language, however, can be linked to the tradition of Caravaggio – the *Calling of St Matthew* uses soft colours taken from Pietro da Cortona's art.

The influences of Caravaggio and of Pietro da Cortona are confirmed in a series of paintings (Galleria Spada, Rome) that has been reconstructed by Zeri on the basis of style and documentary information in inventories.[56] Zeri believes that Tornioli enjoyed the protection of Cardinal Bernardino Spada, but documents recording payments to Tornioli mention his privileged relationship with Cardinal Virgilio Spada.[57] In 1645 Cardinal Virgilio bought two paintings from Tornioli, a *Cain and Abel* and some *Philosophers*. The latter can be identified with the *Astronomers* now in the Galleria Spada. The painting, perhaps Tornioli's best work, shows a group of astronomers gathered around two female figures who probably have an allegorical significance. On the basis of Cesare Ripa's *Iconologia*, first published in Rome in 1593, the figure on the right, who carries a square and a compass, can be interpreted as Moderation. However it is more difficult to believe that the woman resting her hands on a globe represents Science. The mirror and the triangle that Ripa also lists among Science's attributes are missing. A reading centred on the two female allegories confirms the interpretations of Ciampolini and Cannatà who believe the male figures to be ancient and modern scientists. To the left are Aristotle, Copernicus and Ptolemy and to the right is a representative of the new Galilean science. The painting could therefore

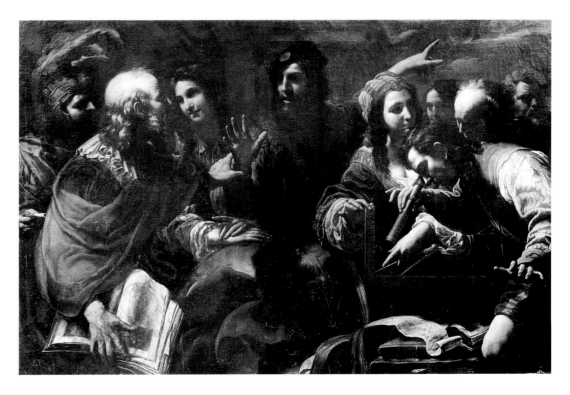

Niccolò Tornioli,
Astronomers. Galleria
Spada, Rome.

constitute a comparison of ancient and modern science. It complements the astrological and astronomical interests of the two Spada brothers, especially Virgilio, a collector of medals, cameos and coins, who would have appreciated the trimmings of the figures, who are clothed more in a sixteenth- than a seventeenth-century manner. Caravaggio's influence, which may have been transmitted through the works of Bartolomeo Manfredi or Mattia Preti, continues in this painting.

Shortly afterwards Tornioli's work became more classically inspired, as witnessed in the *Cain and Abel* and the *Jacob Wrestling with the Angel* in the choir chapel of San Paolo in Bologna. They are the first of a series of canvases that decorates the presbytery. The imposing and balanced compositions accompany Alessandro Algardi's great marble group of the *Beheading of St Paul* on the altar. It was Cardinal Virgilio Spada's idea to erect the high altar in the form of an enormous shrine. Its columns are arranged in a semicircle that frames the two figures, carved in the round, of the executioner and the saint. Virgilio Spada's concept was given visual form in the drawings of Bernini.

The two canvases were unveiled on 30 April 1648.[58] They had been executed at the same time as Algardi's bronze bas-relief of the *Beheading of St Paul* placed at the centre of the altar frontal.[59] Tornioli's paintings therefore form part of the imposing altar complex and are directly related to the central relief, especially in their more classicizing elements. In the *Jacob Wrestling with the Angel*, Tornioli drew his inspiration from Guido Reni, while in the *Cain and Abel* his main source was the painting of the same subject now in the Gallerie di Firenze, which has been attributed to both Orazio Riminaldi and Bartolomeo Manfredi.[60] Tornioli maintained an academic arrangement of the nudes and removed all the elements taken from Caravaggio which appear in the painting in Florence. Tornioli used paint in a fragmented manner that demonstrates the influence of Venetian painting. His admission to the Accademia di San Luca and his commissions of 1644 and 1645, in addition to the important Venetian input,[61] led Tornioli to discard the influence of Caravaggio, which pervaded his works until the 1640s.

The contribution to the Baroque style made by the Sienese painters just discussed seems to have been more the

Bernardino Mei,
impresa of Monsignor Pietro Cerretani,
engraving. Biblioteca Comunale, Siena.

result of chance than any clearly defined intention. It appears to have been dictated by circumstance rather than being a natural progression within the sphere of the Sienese artistic tradition. For example, Raffaello Vanni began his career as a follower of the Carracci only to change his style completely after his collaboration with Pietro da Cortona in Rome. Niccolò Tornioli was also profoundly influenced by his time in Rome which led him to formulate a Baroque style that nevertheless still incorporated classically inspired elements. The Baroque style was extremely powerful in Rome and, under the influence of Roman commissioners, a number of

Sienese artists encountered and imported it back to Siena where it was introduced to church interiors and to works purchased by the nobility for their picture galleries. A great number of these galleries were formed in the seventeenth century and they tended to specialize in late Mannerist and Baroque art. Art collections were formed by a large proportion of the major noble families including the Bandinelli, the Borghesi, the Venturi Gallerani, the Sergardi Bindi and the Gallaccini. In addition to these, divided between Siena and Rome, were the collections that belonged to the Del Taja and the Chigi families.

Bernardino Mei

Bernardino Mei (1612–1676) was strongly influenced by Baroque art. His paintings were mentioned by Della Valle in the eighteenth century and by Romagnoli in the nineteenth century. His style comprises a number of different components,[62] with some of his works adopting a soft light influenced by Mattia Preti, others demonstrating links with Sacchi and Maratta and yet others relating closely to Baroque

sculpture. Mei's origins remain obscure. His first securely documented commission was in 1634, when he signed three miniatures in the tenth *Libro dei leoni*, a series of registers in which the names of the Sienese magistrates were recorded. The miniatures consist of a scene in the upper part of the composition and feature the magistrates' coats of arms in the lower part. The three miniatures completed by Mei are the

Bernardino Mei,
Martyrdom of the Servite Fathers in Prague,
miniature from the *Libro dei leoni*.
Archivio di Stato, Siena.

Bernardino Mei,
Martyrdom of the Servite Fathers in Prague,
detail of a miniature from the *Libro dei leoni*.
Archivio di Stato, Siena.

Resurrection, a *Procession in the Campo* and the *Virgin of the Assumption with Saints and Blesseds*. They form part of the illustrative tradition that had descended from the Flemish painter Bernard Rantwyck and from the Sienese Cristofano Rustici to be continued by Antonio Gregori. There is a strong heraldic component and an insistence on small views of Siena. Both elements had enjoyed centuries of success in Siena in the Biccherna panels, which were sometimes works of significant quality. The most successful of Mei's three miniatures is the *Virgin of the Assumption with Saints and Blesseds*. In it he used the brush with unexpected enthusiasm, allowing the Virgin and saints to break through the lines of the upper framing scroll and making the various coats of arms appear to float upwards. The work exemplifies Baroque decorative and compositional taste.

In 1636 Bernardino Mei engraved the *impresa* of Monsignor Pietro Cerretani, who belonged to the Accademia degli Intronati under the name of Avvertito. The heraldic device comprises two cornucopias that bend to form an ellipse around a tower standing on a large grassy area. The bases of the two cornucopias curl around the Accademia's emblem – a gourd. An olive branch emerges from the left of the gourd and a palm branch from the right to form a Baroque motif.[63] The engraving, apart from documenting an activity of which few examples survive, allows us to attribute another unsigned miniature to Mei, which is in the *Libro dei leoni* for the year 1637.[64] The upper part of the miniature contains a representation of the *Martyrdom of the Servite Fathers in Prague*. In an approximated Renaissance building the Servite fathers, enclosed in a room, are about to be burnt to death. The figures recall the saints in the miniature with the *Virgin of the Assumption with Saints and Blesseds*, but the scene is painted with a greater delicacy of tones and materials. It is set in an almost elliptical framework, which assumes the form of a large mask supported at the base by little angels reminiscent of those in the Oratory of St Bernardino, which have been attributed to Mei.[65] The lower part of the miniature is spared an overabundance of coats of arms; only the most important are displayed so as not to obscure the ample grassy landscape.

The work demonstrates that Mei was aware of contemporary painting both in Tuscany and in Rome. The motifs of the large mask and the ellipse, testifying to a pronounced Baroque taste, seem at first sight to be taken from an engraving by Jacques Callot, the *Eventail*, which depicts festivities ordered by Cosimo II in 1619. Callot's engraving is framed with an elliptical form in the shape of a large mask with volutes. However, the way the Sienese miniature seems to be quivering with life directly relates it to the plaque on the pedestal of Bernini's *Apollo and Daphne*. There are a number of other examples of this type of frame – rich, gilded and almost overblown – in Sienese art, especially in miniatures or other small-scale works. One example is a plate attributed to Rutilio Manetti[66] (Chigi Saracini Collection, Siena) in which one detects traces of Mei's brilliant idea.[67]

Bernardino Mei's activity as an engraver indicates his familiarity with the work of the great Tuscan engravers. The references to Roman art in his works imply that he must have made a brief journey to the city early in his career, but this cannot be confirmed by documentary evidence. However, Mei was associated with the painter and engraver Bernardo Capitelli (1590–1639) who had been in Rome between 1627 and 1629. Capitelli was an excellent painter who formed part of Rutilio Manetti's circle. He also engraved a number of Manetti's works as well as those of Ventura Salimbeni. In 1639, Mei was paid for the *Procession of the Relics of St Bernardino* for the Oratory of St Bernardino. In the background of this work there is a description of the city and its customs that is repeated in Capitelli's engravings, particularly in the *Interior of Siena Cathedral*, which is dated either 1631 or 1635, and in the *Festival in the Piazza* of 1632. In Rome, Capitelli had collaborated in Cassiano del Pozzo's Museum Chartaceum. In 1633 he engraved the series of *Allegorical Chariots* of the six *contrade* of Siena, which are inspired by the Baroque style.[68] However, Capitelli did not recreate the rich vein of fantasy shown in Mei's work. The comparisons with Capitelli confirm the hypothesis that Mei was trained in the workshop of Rutilio Manetti. They also support the possibility that he had encountered Roman art early in his career,

particularly the naturalism descended from Caravaggio and the Baroque style.

The *SS. Cosmas and Damian* (private collection), a work that was signed and dated in 1644,[69] and the *St Jerome*, signed and dated in 1646,[70] contain direct references to Caravaggio's work that cannot be explained merely by Mei's having trained in Manetti's workshop. The *SS. Cosmas and Damian* can probably be identified with a 'painting composed of half figures representing two saints who contemplate the skull of a dead man' recorded by Romagnoli in the house of Giulio del Taja.[71] The composition takes account of the new iconography used by Battistello Caracciolo in the beautiful painting now in Berlin, but bears a closer resemblance to the version in a private collection mentioned by Bologna.[72] The painting is evidence of the links between Mei and the Sienese Del Taja family, which were reinforced when the artist was in Rome, as is demonstrated by the correspondence between Cardinal Flaminio Del Taja and his brother Stefano and by the correspondence between Stefano and the cardinal's secretary.[73] Mei's knowledge of Battistello's work affected not only his iconography but also his style. This can be seen in the *St John the Evangelist*, a painting that also contains references to the work of Guido Reni.[74] Mei's use of gesture, such as the tight grasp of the poison-filled chalice or the evangelist's lifting his eyes to the sky, adds to the pathos of the painting. The dark-brown background and the shadows which cut across the scene and stain the evangelist's skin have a naturalistic aspect, even if they do contribute to the creation of an icon.

One of the most important aspects of Mei's works is the attention he pays to the texts – the Bible, Latin or Greek classics and Italian literature – from which his subjects are drawn. Mei's half figure of *Ghismonda* demonstrates this attention to detail in a subject that derives from a story narrated by Boccaccio. Ghismonda clasps in her fist the heart of her lover Guiscardo, whose murder her father had arranged after discovering their love for one another. Mei's depiction of Ghismonda portrays her as a heroine on a level with Judith. The composition reflects Ghismonda's embittered soul in the statuesque line of her figure and in her elegant pose. Mei's faithfulness to the literary text comes from Baroque art rather than from the classical notion that painting should be like poetry, '*ut pictura poesis*'.

p. 448
Bernardino Mei,
St John the Evangelist.
Pinacoteca, Siena.

p. 449
Bernardino Mei,
Ghismonda.
Pinacoteca, Siena.

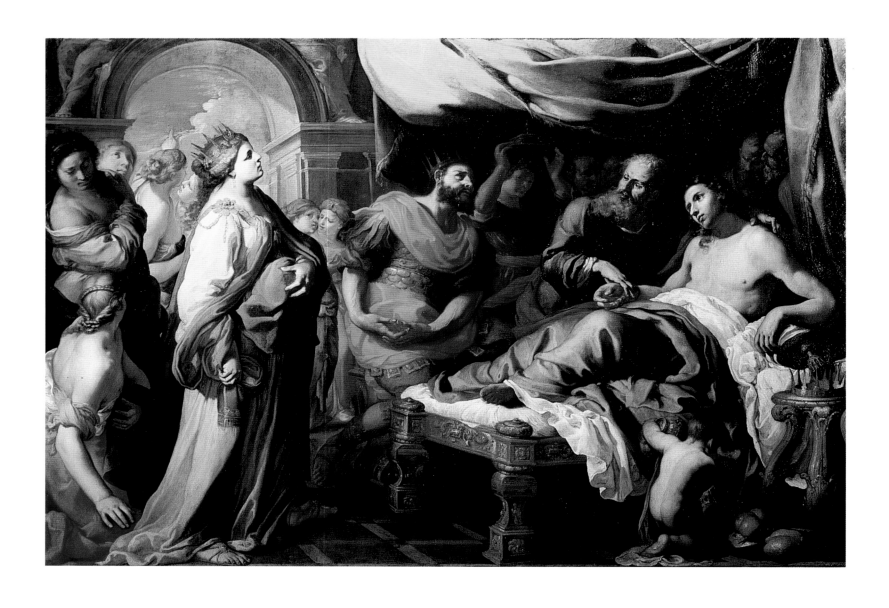

Bernardino Mei,
Antiochus and Stratonice.
Monte dei Paschi, Siena.

Mei's works owed a great deal to contemporary sculpture and especially to Bernini: Ghismonda's parted lips recall those in Bernini's bust of Costanza Bonarelli and Ghismonda shows similarities to the reclined head of *Charity* in his monument to Urban VIII. This is all the more striking given that no clear links exist with painters who depicted Ghismonda. However, there are some stylistic similarities to the work of Salvator Rosa, a painter and poet who was in Siena in 1641.[75] Towards the end of the 1640s Mei's art centred on the link between painting and poetry which led to many private commissions in which a classical subject was narrated as a love story or tragedy. Examples include *Love Healed by Time with Waters from the River Lethe*, *Fortune between Necessity and Virtue*, *Orestes Killing Clytemnestra*, *Artemisia Drinking the Ashes of King Mausolus* and *Antiochus and Stratonice* which takes its story from Valerius Maximus's *Factorum et dictorum memorabilium* and is narrated not as an example of indulgence but as a tale of love.[76] Mei's inspiration for these paintings included sculpture, poetry, oratory and the decorative arts, which enriched his paintings with both symbolic and decorative content. This can be seen in the *Nativity* in the Archivio di Stato in Siena. The work was given to the Concistoro by Giovan Battista Fraticelli in 1653 in memory of his accession to public duties. It has an imposing frame containing the heraldic symbols of the Fraticelli family. At the top singing cocks puff their chests out while at the base of the frame they curl around themselves to either side of the family motto – *ne moriamur* (lest we should die). The painting contains motifs that recall both Sienese and the most recent Roman art. In the foreground of the work, Mei was probably inspired by the *Adoration of the Shepherds* from the Servite church, painted by Casolani more than fifty years earlier. This is most evident in the shepherd on the right. The background consists of statues that are barely touched by the brush. The figures in the foreground stand out three-dimensionally, imbued with a sculptural quality, and are wrapped in a sweet and glowing light. The resulting effect obscures the figures in the middle ground, some of whom appear to be direct citations from other artists. For example, the head of the old man on the right in the middle ground, with dried-out skin and eyes turned to the sky, bears a strong resemblance to some of Leonardo da Vinci's figures.[77]

p. 452
Bernardino Mei,
Nativity. Archivio di Stato, Siena.

p. 453
Bernardino Mei,
Charlatan. Monte dei Paschi, Siena.

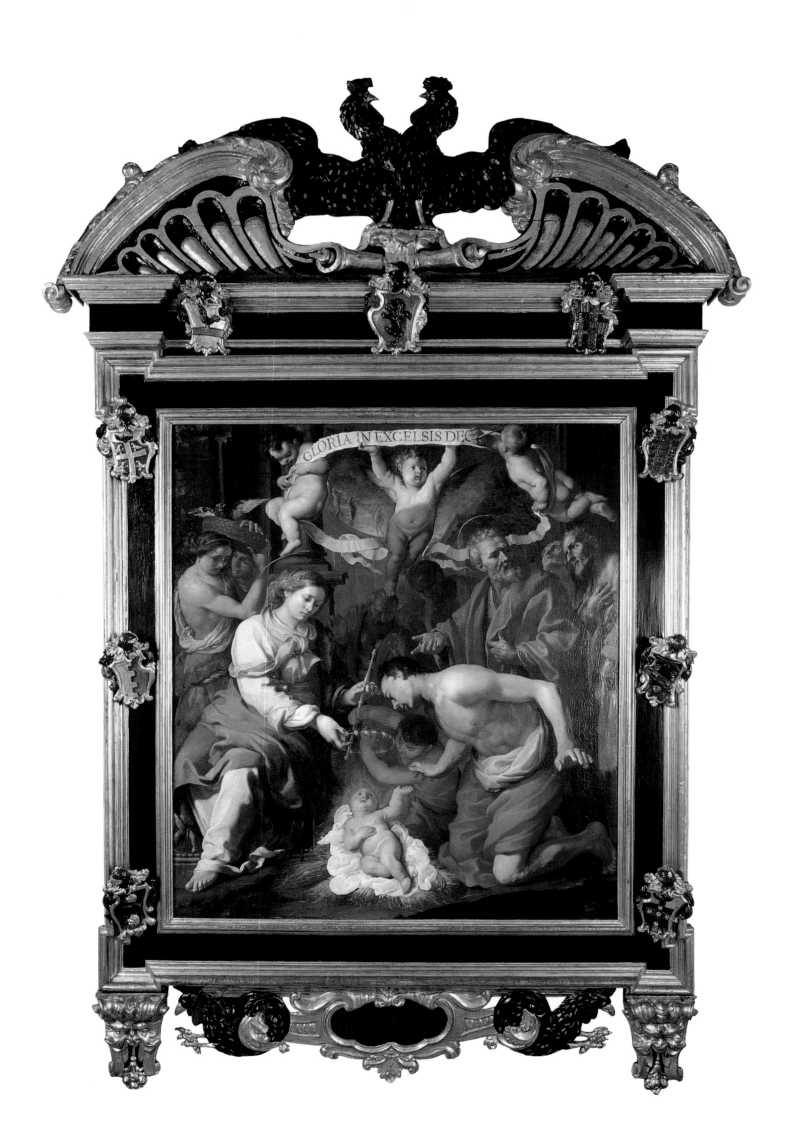

GLORIA IN EXCELSIS DEO

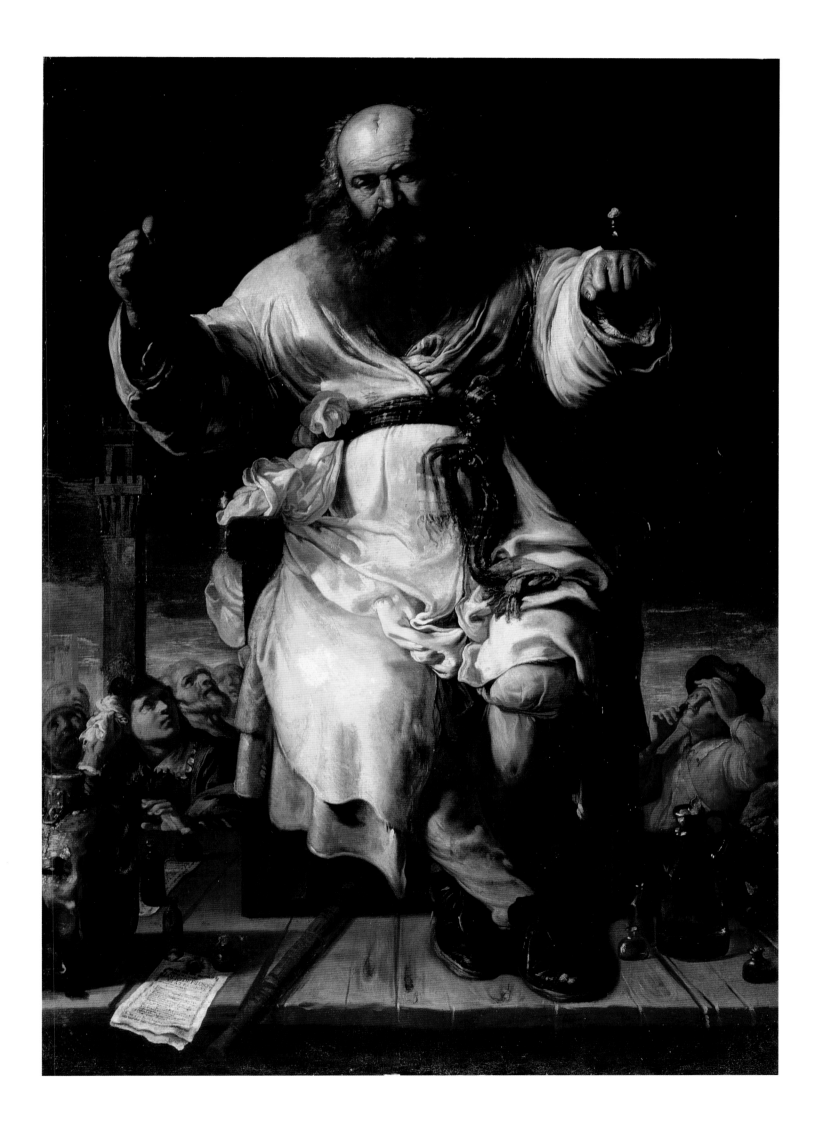

Bernardo Mei also experimented with painting in monochrome. The technique was popular in Siena in the sixteenth and seventeenth centuries and was not limited to being a mere development of the sketch. Francesco Vanni, Ventura Salimbeni and Rutilio Manetti were the painters who used monochrome to the best advantage. Yet Mei ventured further and developed autonomous sketches into large monochrome paintings, such as the extremely beautiful *Allegory of Peace* (Pinacoteca, Siena). Some of Mei's best monochrome compositions are the four panels painted in dark brown that are mentioned in guides to the basilica in Provenzano from the eighteenth century onwards. They depict *Jael Killing Sisera*, the *Story of Judas Maccabeus*, the *Mass of St Gregory the Great* and an episode related to the popular Sienese tradition of the *Prophecy of Brandano*. The paintings seize the viewer's attention without forcing the compositional effects. Mei's influence here appears to be the Baroque as interpreted by Mattia Preti, rich with fluttering lights. This adds a complexity to his works that was not present in the two pendant paintings that he executed a little before his move to Rome in 1657.[78] The two compositions are iconographically

complicated. One of them has been published by Del Bravo as an *Allegory of War*, although Bisogni believed it to be an *Allegory of Injustice*. The pendant, dated 1656, is probably a representation of *Justice*. The paintings come from the residence of the Del Taja family. Romagnoli saw them there and described them as allegories of law and war.[79] Mei treated the figure of Injustice almost as a genre subject, but the muted and almost monochrome colouring combined with the treatment of light means that the figure retains some dignity in its bearing. Mei used the same pictorial means in 1656 with his *Charlatan*, a painting in which an elderly vendor of filters and potions sits on a stage in front of a crowd that throngs the Campo. It is a daring painting owing to the arrangement of the scene and to the prominence it gives to the charlatan, which is achieved, as in the *Allegory of Injustice*, by the use of delicate and transparent colours and softened tones. Both the figures of Injustice and of the charlatan can be compared with certain types of poor people who appear in the work of Eberhard Keil (1624–1687), the painter of Danish origin who, after having travelled in Lombardy and the Veneto, moved to Rome in 1656.[80] A consideration of Mei's

Bernardino Mei,
Prophecy of Brandano.
Santa Maria di Provenzano, Siena.

p. 455
Bernardino Mei,
Rest During the Flight into Egypt with Angels and the Instruments of the Passion.
Santa Maria del Popolo, Rome.

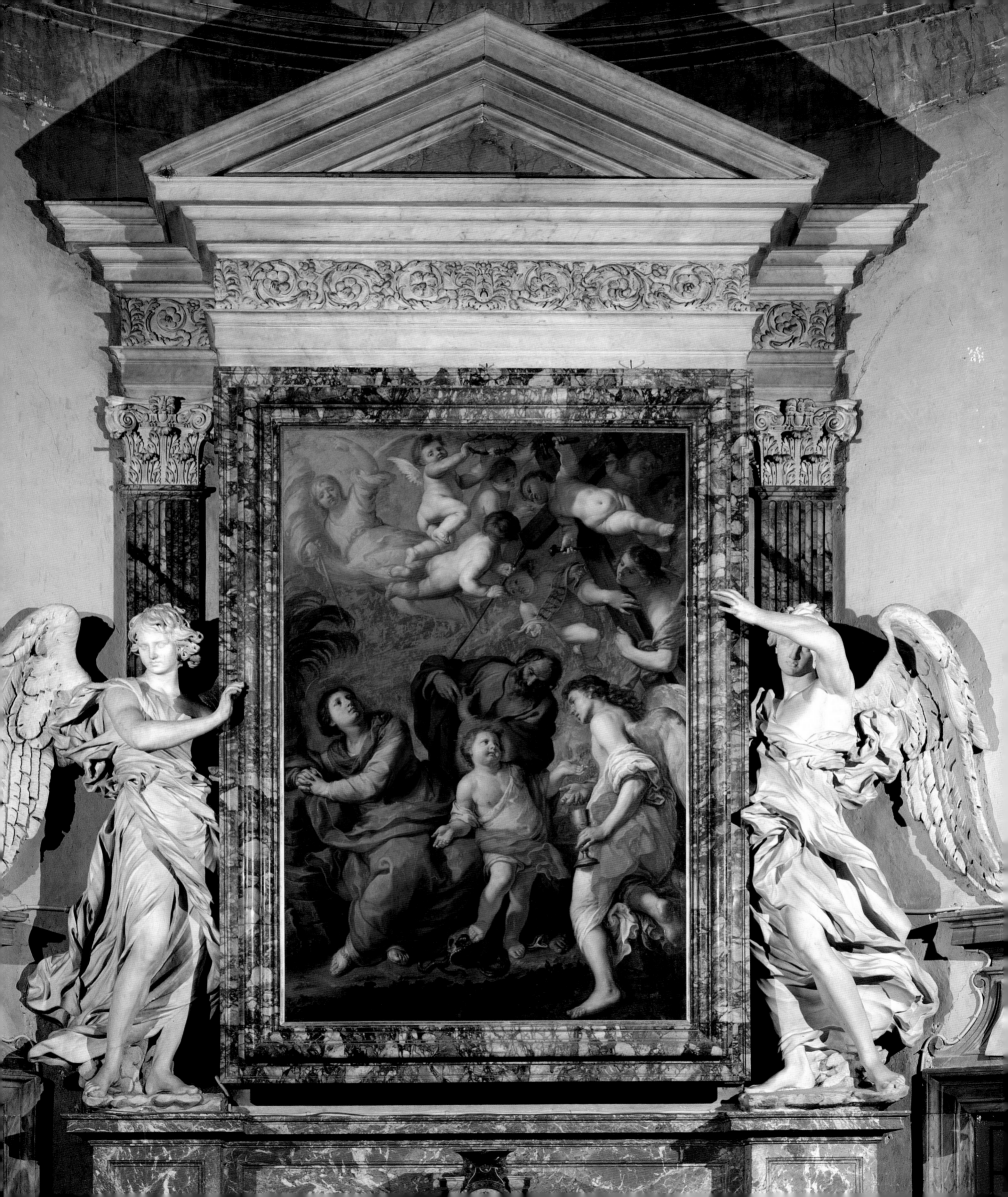

paintings indicates that his influences were extremely diverse, ranging from sculpture to genre painting.

When Fabio Chigi became Pope Alexander VII in 1655, some of Mei's most important Sienese protectors, Flaminio Del Taja and Volumnio Bandinelli, moved to Rome. Bernardino Mei followed them and remained in Rome from 1657 until his death. The most famous works executed during this period are those commissioned by the Chigi family for Santa Maria della Pace, for Santa Maria del Popolo and also for the cathedral of Ariccia. Some of Mei's Roman works have been lost, including the paintings ordered by Cardinal Flavio Chigi for his private rooms in his palace in Santi Apostoli. The pontificate of Alexander VII provided the possibility of important commissions for Sienese painters in Rome. Raffaello Vanni was also working in Santa Maria della Pace, in Santa Maria del Popolo and at Ariccia during this period. In 1658 he attained the prestigious position of head of the Accademia di San Luca, a year after Mei's admission.[81]

Mei's Roman paintings are a fitting conclusion to his career. In the *Rest During the Flight into Egypt with Angels and the Instruments of the Passion* in Santa Maria del Popolo, Mei abandoned the use of dark tones and delineated the main protagonists against a light background. The composition is almost sculptural and complements the white marble angels who support the polychrome marble frame of the altarpiece. Del Bravo has emphasized the similarity between the two marble figures, wrapped in elegant drapery, and the figures in the altarpiece. This demonstrates the interaction between the sculptor, probably Antonio Raggi, and Mei. The two may also have worked on the altarpieces in the transept of Santa Maria del Popolo under the direction of Bernini. Other artists who took part in the undertaking were Gaulli, who did the drawings for the statues, Ferrata, Mari and Giardè.[82] The *Rest During the Flight into Egypt with Angels and the Instruments of the Passion* shows the influence of Bernini, more than at any other point during Mei's earlier career. References to Bernini are also evident in Mei's drawings and his few engravings, especially if one compares, for example, the 1656 engraving of *Atlas and Hercules Holding up the World* with Claude Mellan's engraving taken from Bernini's 1632 drawing of *David Strangling the Lion*. Mei's approach to Bernini, to the Baroque and to sculpture can be seen in its most immediate

Bernardino Mei,
Male Nude from the Rear.
Chigi Saracini Collection, Siena.

form in his drawings in which Mei transforms an academic exercise into an intense expression of three-dimensionality.[83] See, for example, the *Male Nude from the Rear*, the *Young Nude Man Touching his Foot* and the *Male Seated Nude*.

Bernardino Mei died in Rome in 1676, nine years after the death of his great Sienese protector, Alexander VII. During his career, Mei was able to make a profound contribution to Baroque art. After the fall of the Republic, Sienese art had risked impoverishment, had endured the devotional forms imposed during the years of the Catholic Reform, had been influenced by the naturalism of Caravaggio and his followers and had also succeeded in contributing significantly to Baroque art. Mei, strongly influenced by art in Rome but never totally abandoning naturalistic elements, became the pictorial interpreter of the art of metamorphosis, of theatricality and of illusionistic decoration.

Bernardino Mei,
Male Seated Nude.
Chigi Saracini Collection, Siena.

Notes

1 S. Moscadelli, 'Organi periferici di governo e istituzioni locali a Siena dalla metà del Cinquecento all'Unità d'Italia' in *Il Palazzo della Provincia a Siena*, Rome 1990, pp. 15–54.

2 F. Bisogni, 'Mattias de' Medici governatore di Siena' in *Il Palazzo della Provincia a Siena*, pp. 149–174.

3 G. Chiarini De Anna, 'Leopoldo de' Medici e la formazione della sua raccolta di disegni' in *Omaggio a Leopoldo de' Medici, parte I, Disegni*, Florence 1976, pp. 26–39.

4 J.N. Erithraei (G.N. Rossi), *Pinacotheca imaginum illustrium*, 3 vols, Cologne 1645–1648.

5 G. Mancini, *Considerazioni sulla pittura*, edited by A. Marucchi and L. Salerno, 2 vols, Rome 1956–1957.

6 T. Gallaccini, *Trattato sopra gli errori degli architetti*, Venice 1767.

7 D. Mahon, *Studies in Seicento Art and Theory*, London 1947.

8 G. Mancini, *Considerazioni*, p. 96.

9 P. Bacci, 'L'Elenco delle pitture, sculture e architetture di Siena, compilato nel 1625–26 da Mons. Fabio Chigi, poi Alessandro VII, secondo il ms. Chigiano I.I.11' in *Bullettino senese di storia patria*, 1939, pp. 197–213 and 297–337.

10 As well as the Biccherna record published by C. Brandi, *Rutilio Manetti*, Siena 1931, p. 157, note 1, the actual record of baptism has been found. See ASS, San Giovanni, Battezzati 56: '*1570* [according to the Sienese calendar, i.e., 1571] *Rutilio figlio di Lorenzo di Jac.° Manetti sarto si battezzò il dì p.° di Giennaio fu compare Donato di Austino macellaro e m.a Francesca donna di Pietro sarto*'.

11 E. Romagnoli, *Biografia cronologica de' bellartisti senesi dal secolo XII a tutto il XVIII* (before 1835), anastatic edition, Florence 1976, X, pp. 411 and 520–522.

12 A. Bagnoli, 'Aggiornamento di Rutilio Manetti' in *Prospettiva*, 1978, pp. 23–42. The most thorough consideration of Rutilio Manetti's works remains A. Bagnoli (ed.), *Rutilio Manetti*, exhibition catalogue, Siena 1978.

13 The documents relating to Manetti and the Compagnia di Sant'Antonio are ASS, Patrimonio dei Resti 42, Compagnia di Sant'Antonio, fol 193v, and ASS,

Patrimonio dei Resti 42, Compagnia di Sant'Antonio, fol. 207 for the year 1624.

14 E. Squarci, 'Correzioni al Diario Sanese di Girolamo Gigli spettanti alle belle arti dettate dal Cav. Re Ercole Squarci professore nell'Università di Siena' in U. Benvoglienti, *Miscellanee*, BSC, C.V.4, fol. 322r.

15 A. Bagnoli, 'Aggiornamento', pp. 27–29.

16 A. Bagnoli, 'Rutilio Manetti' in *L'Arte a Siena sotto i Medici 1555–1609*, Rome 1980, pp. 176–184.

17 M. Gregori, 'Dal Caravaggio al Manfredi' in *Dopo Caravaggio. Bartolomeo Manfredi e la Manfrediana Methodus*, Cremona 1987, pp. 13–25.

18 A. Moir, 'Cupido punito da Marte' in *Caravaggio e il suo tempo*, Naples 1985, pp. 161–163.

19 G. Mancini, *Considerazioni*, II, p. 251.

20 G. Della Valle, *Lettere Sanesi*, 1786, III, p. 442.

21 A. Bagnoli, 'Rutilio Manetti' in *L'Arte a Siena*, pp. 97–98.

22 Ariosto, *Orlando Furioso*, translated by B. Reynolds, Harmondsworth 1975, I, p. 247.

23 A. Bagnoli, 'Aggiornamento', p. 38.

24 *Relazione in compendio delle cose più notabili nel Palazzo e Galleria Saracini di Siena*, Siena 1819, pp. 59 and 60.

25 C. Del Bravo, 'Su Rutilio Manetti' in *Pantheon*, January–February 1966, pp. 43–50.

26 R. Spinelli, in *Pitture senesi del Seicento*, Turin 1989, pp. 48–51.

27 A. Bagnoli, 'Francesco Rustici' in *L'Arte a Siena*, p. 185.

28 A. Bagnoli, 'Vincenzo Rustici' in *L'Arte a Siena*, p. 88.

29 A. Bagnoli, 'Francesco Rustici' in *L'Arte a Siena*, p. 185.

30 E. Fumagalli, 'Pittori senesi del Seicento e committenza medicea. Nuove date per Francesco Rustici' in *Paragone*, 1990, 479–481, pp. 69–82.

31 Rome, ASV, Parrocchia di S. Lorenzo in Damaso, Stato delle Anime, envelope 64 (1623–1625), fol. 31rv (1625): '*Vicolo delle Stelle. Monsignor* […] *Tantucci, vescovo di Grosseto/ S.r Demetrio Tantucci senese fr.llo*

25/ Domenico Begotti genovese fr.llo 25/ Niccolò Cardelli lucchese 25/ Lorenzeo […] *cocchiero fio.no 30/ Orazio Brunetti senese intagliatore 28/ Bastiano Granucci senese pittore 18.*' (Vicolo delle Stelle. Monsignor […] Tantucci, bishop of Grosseto/ Signor Demetrio Tantucci of Siena, [his] brother, 25 [years old]/ Domenico Begotti of Genoa, [his] brother, 25 [years old]/ Niccolò Cardelli of Lucca, 25 [years old]/ Lorenzeo […], coachman of Florence, 30 [years old]/ Orazio Brunetti of Siena, engraver, 28 [years old]/ Bastiano Granucci of Siena, painter, 18 [years old].)

32 M. Ciampolini, in *Pitture senesi*, pp. 18–20.

33 D. Freedberg, 'Poussin et Sienne' in *Nicolas Poussin 1594–1665*, Paris 1994, pp. 62–68.

34 F. Torchio, in *Mostra di opere d'arte restaurate nelle province di Siena e Grosseto*, 1983, III, pp. 212–214.

35 Rome, Archivio Segreto Vaticano, Patrizi 218, fols. 135v–145v, in E. Fumagalli, 'Raffaello Vanni in Palazzo Patrizi a Roma' in *Paragone*, 1989, pp. 129–148. See also C. Sica, *La Collezione Patrizi. Vicende di una quadreria*, thesis, Siena University 1990–1991.

36 I have taken this information from M. Maccherini, *Annibale Carracci e i 'bolognesi' nel carteggio familiare di Giulio Mancini*, thesis, Siena University 1994–1995, which I hope will soon be published. ASS, Patrimonio dei Resti 1610, fol. 127.

37 The documents relating to the altarpiece for the Oratory of St Roch have been traced by Costanza Cinughi De Pazzi and are commented upon in her thesis.

38 E. Romagnoli, *Biografia cronologica*, X, pp. 185–186, 198 and 233.

39 A. Negro, 'Appunti sulla fase precortonesca di Raffaello Vanni' in *Paragone*, 1989, pp. 109–121.

40 M. Pierini, 'Documenti' in E. Carli (ed.), *La Chiesa di San Niccolò in Sasso a Siena*, p. 87.

41 L. Galli, 'Raffaello Vanni' in *Bernardino Mei e la pittura barocca a Siena*, Florence 1987, pp. 83–107.

42 E. Fumagalli, 'Pittori senesi del Seicento e committenza medicea', pp. 109–121.

43 G. Mazzoni, *Appunti su Michelangelo Vanni pittore*, in press.

44 Rome, Biblioteca Angelica, Aut. 3.12, p. 111.

45 Niccolò Tornioli, a painter whom I will discuss later in the text, also worked on the mosaics in the Chapel of the Holy Sacrament between 1647 and 1649, although not very successfully. For the relative documents, see R. Cannatà, in *Laboratorio di restauro*, Rome 1988, 2, pp. 170–181.

46 ASS, Archivio Tolomei, 31 loose papers.

47 C. Del Bravo, '"Una figura con natura morta" del Seicento Toscano' in *Studi di storia dell'arte in onore di Roberto Longhi*, in *Arte antica e moderna*, 1961, 13/16, pp. 322–323.

48 A.M. Guiducci, in *Mostra di opere d'arte restaurate nelle province di Siena e Grosseto*, 1981, II, pp. 218 and 220.

49 A. Avanzati, in *Pitture senesi*, pp. 24–27. On Petrazzi's still lives, see C. Del Bravo, 'Due nature morte di Astolfo Petrazzi' in *Paragone*, 1961, 139, pp. 58–59.

50 ASS, Correspondence of Cardinal Flaminio Del Taja in Rome to his brother Stefano 1657–1664, Archivio Grisaldi Del Taja, envelope 36; ASS, Correspondence between Stefano Del Taja and Sebastiano Perissi, the secretary of Cardinal Flaminio, 1657–1668, Archivio Grisaldi Del Taja, envelope 37.

51 A. Bagnoli, in *Mostra di opere d'arte restaurate*, pp. 212–214.

52 F. Catastini, *La Pietà dei Senesi in Roma a proposito dell'arciconfraternita di Santa Caterina*, Rome 1890, p. 34.

53 L. Manzini, *Applausi fatti in Roma per l'elezione di Ferdinando III al regno de' Romani dal Ser.mo Pic. Maurizio Card. Di Savoia descritti al Ser.mo Francesco D'Este Duca di Modana*, Rome 1637. M. Di Macco, '"L'origine del Principe". Cultura figurativa di Maurizio di Savoia (1619–1627)' in G. Romano (ed.), *Le Collezioni di Carlo Emmanuele I*, Turin 1995, pp. 350–374.

54 P. Rosenberg, *Rouen. Musée des Beaux-Arts. Tableaux français du XVII^ème et XVIII^ème siècles*, Paris 1966, pp. 206–207.

55 M. Ciampolini, in *Bernardino Mei e la pittura barocca*, pp. 109–121.

56 F. Zeri, *La Galleria Spada in Roma*, Florence 1954, pp. 134–139.

57 R. Cannatà, in *Laboratorio di restauro*, pp. 170–181; idem, 'Il Collezionismo di cardinale Bernardino Spada' in R. Cannatà and M.L. Vicini, *La Galleria di Palazzo Spada. Genesi e storia di una collezione*, Rome n.d., pp. 25–70; idem, 'Il Collezionismo di Virgilio Spada' in ibid., pp. 73–103.

58 M. Ciampolini, in *Bernardino Mei e la pittura barocca*, p. 120.

59 J. Montagu, *Alessandro Algardi*, New Haven and London 1985, pp. 49–58.

60 E. Borea, *Caravaggio e Caravaggeschi nelle Gallerie di Firenze*, Florence 1970, p. 73; M. Gregori, 'Note su Orazio Riminaldi e i suoi rapporti con l'ambiente romano' in *Paragone*, 1972, 269, pp. 35–66; G. Merlo, in *Dopo Caravaggio. Bartolomeo Manfredi*, pp. 82–83.

61 R. Cannatà, in *Laboratorio di restauro*, pp. 174 and 178.

62 C. Del Bravo, 'Presentazione di Bernardino Mei' in *Pantheon*, September–October 1966, pp. 294–302; F. Bisogni, in *Bernardino Mei e la pittura barocca*, pp. 139–199. See also Bisogni's introduction to the catalogue.

63 M. Ciampolini, 'Introduzione al disegno senese del seicento' in *Pitture senesi*, pp. 130, 136 and 156–157.

64 This book was in proof when the following was published: M. Ascheri (ed.), *I Libri dei Leoni. La nobiltà di Siena in età medicea (1557–1737)*, Milan 1996. The book shows a general agreement on the attribution of the miniature. I am sorry that I was not able to take account of it here.

65 R. Spinelli, in *Pitture senesi*, p. 86.

66 C. Ravanelli Guidotti (ed.), *Maioliche italiane*, exhibition catalogue, Florence 1992, pp. 214–215.

67 A later frame similar to that of the miniature in the *Libro dei leoni* can be seen in a drawing showing a *Triumph of Neptune* (Janos Scholz Collection, New York) attributed to Mei by Vezzosi in A. Vezzosi, 'A favore di Bernardino Mei' in *Prospettiva*, 1992, 65, pp. 76–77.

68 P. Bonaccorso and P. Pallassini (eds), *La Bufalata del 20 ottobre 1632. Nelle incisioni di Bernardino Capitelli*, Siena 1984; P. Bonaccorso (ed.), *Bernardino Capitelli*, exhibition catalogue, Siena 1985.

69 F. Bisogni, in *Bernardino Mei e la pittura barocca*, pp. 148 and 180; A. Bagnoli, 'La pittura del Seicento a Siena' in *La Pittura in Italia. Il Seicento*, Milan 1989, pp. 306–318.

70 G. Pagliarulo, in *Pitture senesi*, pp. 91–94.

71 E. Romagnoli, *Biografia cronologica*, X, p. 471.

72 F. Bologna, 'Altre aggiunte a Battistello Caracciolo' in *Paragone*, 1960, 129, pp. 45–48.

73 The following is a summary of the results of archival research on the links between Mei and the Del Taja family. The references to Bernardino Mei can be found in the correspondence from the year 1665. Cardinal Flaminio was living in Rome where he had been made a judge of the Rota by Alexander VII. Mei was also resident in Rome at this time and seems to have been on good terms with him. ASS, Correspondence between Stefano del Taja and Sebastiano Perissi, the secretary of Cardinal Del Taja (1657–1658), Archivio Del Taja. These are thirty-seven letters relating to clothing made out of '*taffettas rasato*' (sateen taffeta) which Mei wanted from a certain '*Ms Jalamone*' in Siena, for which the Del Taja were intermediaries and guarantors. Perhaps Mei was very attached to luxury goods but could not be trusted when it came to paying for them? Of particular interest is a letter of 11 July 1665 containing the following information: '*Se Ms Jalamone accennasse a V.S. Ill. Ma ch'io gli ho scritto di certo taffettas rasato per fare un abito da Camera per Mons.re sappia che la commissione me la fa fare il S. re Bernardino Mei, non acciò Ms Jalamone me lo proveda buono ho trovato la scusa che ha da servire per Mons.re.*' (If Mr Jalamone should mention to Your Most Illustrious Holiness that I have written about a certain sateen taffeta to make a dressing gown for Monsignore, he should know that the commission is for Signor Bernardino Mei. I have used the excuse that it [the taffeta] is for Monsignore so that Mr Jalamone will provide me with good quality material.) There are also letters in which Mei appears to be the cardinal's art advisor. For example, a letter of 19 September 1665: '*Mons. Mio si scandalizza di cotesti ghiottoncelli pittori da scatole anzi il signor Mei che è stato qui da noi et ha sentito questa stima, et haveva veduti I quadri si è maravigliato di questo modo di fare et il pensiero di Monsignor nostro era che restassero costì in casa, ma il pittore che è l'istesso che ha fatto le battaglie e le musiche dice che se cotesti pittori gli vogliono fare una trentina di coteste copie a quaranta giuli l'una gli vuol mandare il denaro quest'altra settimana, ma siano di cotesta maniera e non acciabattate.*' (My Monsignor is shocked by these worthless and greedy painters. In fact, Signor Mei, who has been here with us and who has heard this opinion and has seen the pictures, was amazed at this way of going about things. The intention of Monsignor was that they [the pictures] would stay here in the house, but the painter [Mei] – the same who did the battle paintings and the musical subjects – says that if these painters want to make him thirty or so of these copies at forty *giuli* each [a *giulio* was a coin first minted by Pope Julius II], he will send them the money the following week, but they must be just so and not done carelessly.) In addition, there is a letter from the start of 1665 containing advice relating to the family altar in the church of San Vigilio in Siena, '*il signor Mei vorrebbe si facessero due statue di marmo*' (Signor Mei would like them to make two marble statues), and a letter perhaps from 9 May 1665: '*essendo fatto il modello di creta s'aspetta di poterlo aggiustare con le misure che ci mandano per farne poi il getto o farlo battere nelle piastre come più piacerà al signor Mei e a questi maestri che manipolano.*' (We are waiting to be able to adjust the model, being made out of clay, according to the measurements that they are sending us so that then [we can] complete the model or cast it as will be most pleasing to Signor Mei and to those masters who do the modelling.)

74 C. Del Bravo, *Presentazione di Bernardino Mei*, pp. 294–302.

75 G. Pagliarulo, in *Pitture senesi*, pp. 89–90.

76 R. Guerrini, 'Bernardino Mei, Antioco Malato. Fonti letterarie classiche e tradizione iconografica' in *Antioco malato. Forbidden Loves from Antiquity to Rossini*, Florence 1990, pp. 335–340.

77 Although it cannot be taken as direct proof that Mei was influenced by sixteenth-century painting, it is significant that Sodoma's *Rape of the Sabine Women* entered the collection of the Chigi family in 1660 through Mei's mediation. See R. Bartalini, *Le occasioni di Sodoma. Dalla Milano di Leonardo alla Roma di Raffaello*, Rome 1996, p. 112, note 12. Mei's involvement in the sale concerned various sixteenth-century paintings, among which was a head of *St John* by Brescianino, a *Nativity* by Sodoma that had been retouched by Ventura Salimbeni, a portrait by Dossi and a *Virgin Mary*, '*macchietta in tavola*' (a sketch on panel), by Beccafumi. See V. Golzio, *Documenti artistici sul Seicento nell'Archivio Chigi*, Rome 1939, p. 282, note 3455.

78 L. Ozzola, 'L'Arte alla corte di Alessandro VII' in *Archivio della Società Romana di storia patria*, 1908, fasc. I–II, p. 59.

79 An inventory of the furniture in the Del Taja Palace, carried out in 1882 on the death of Carlo Grisaldi Del Taja, mentions the following: '*514 La Giustizia tela a olio con cornice 50/ 515 Quadro con una figura distesa per terra con un foglio in mano 30*' (514 Justice painted in oil on canvas with frame, 50/ 515 Painting with a figure lying on the ground with a piece of paper in its hand, 30). The inventory, even though compiled by the inspector of the Accademia di Belle Arti, Francesco Borgi, does not mention the names of the artists, but the paintings seem to correspond to the pair under discussion.

80 R. Contini, in *Pitture senesi*, p. 103.

81 The archives of the Accademia di San Luca mention a painting of *St Martina* which Vanni had in his possession. Rome, Archivio dell'Accademia di San Luca L. Liber Accademiae Sancti Lucae, Congregationi 1634–1674, reg. 43: '*die martii 1674. Fu detto che si procuri di recuperare il quadro di Santa Martina di mano del cavalier Ottavio Leoni essistente appresso il cavalier Raffaello Vanni.*' (on the ... day of March 1674. It was decided to try to retrieve the painting of St Martina, which is now with the Cavalier Raffaello Vanni, through the offices of Cavalier Ottavio Leoni.) Vanni had died in Siena in 1673 and the Accademia was trying to recover one of his paintings, which was probably in his house in Rome.

82 J. Montagu, *La scultura barocca romana*, Turin 1991, pp. 140–141.

83 F. Bisogni, in *Bernardino Mei e la pittura barocca*, pp. 191–197.

Bibliography

MANUSCRIPTS

G.G. Carli, *Notizie di belle arti* (18th century), Biblioteca Comunale, Siena, MS. C.VII.20.

G. Bichi, *Risieduti nell'ordine del popolo*, 1713, Archivio di Stato, Siena.

A.M. Carapelli, *Notizie delle chiese e cose riguardevoli di Siena*, 1718, Biblioteca Comunale, Siena, MS. B.VII.10.

E. Squarci, *Correzioni al diario Sanese di Girolamo Gigli spettanti alle belle arti dettate dal Cav. re Ercole Squarci professore nell'Università di Siena, 1723–1756*, in U. Benvoglienti, *Miscellanee* (18th century), Biblioteca Comunale, Siena, MS. C.V.3.

PRINTED BOOKS

1510
F. Albertini, *Opusculum de mirabilibus novae et veteris urbis Romae*, Rome 1510.

1591
B. Catani, *La Pompa funebre fatta dal Cardinal Montalto nella trasportatione dell'ossa di Sisto V*, Rome 1591.

1637
L. Manzini, *Applausi festivi fatti in Roma per l'elezione di Ferdinando III al regno de' Romani dal Ser.mo Pric. Maurizio Card. Di Savoia, descritti al Ser.mo Francesco D'Este Duca di Modena*, Rome 1637.

1645
A. Libanori, *Vita del Glorioso S. Galgano*, Siena 1645.

1645–1648
J.N. Erithraei (G.V. Rossi), *Pinacotheca imaginum illustrium*, 3 vols, Cologne 1645–1648.

1649
I. Ugurgieri Azzolini, *Le Pompe sanesi*, 2 vols, Pistoia 1649.

1677
F. Bocchi and G. Cinelli, *Le Bellezze della città di Firenze*, Florence 1677.

1733
'Diarj scritti da Allegretto Allegretti delle cose sanesi del suo tempo' in L.A. Muratori, *Rerum italicarum scriptores*, Milan 1733, XXIII, pp. 765–860.

1752
G.A. Pecci, *Relazione delle cose più notabili della città di Siena*, Siena 1752.

1754
G. Richa, *Notizie istoriche delle chiese fiorentine*, Florence 1754.

1767
T. Gallaccini, *Trattato sopra gli errori degli architetti*, Venice 1767.

1769
G. Targioni Tozzetti, *Relazioni d'alcuni viaggi*, Florence 1769, III.

1782–1786
G. Della Valle, *Lettere sanesi di un socio dell'Accademia di Fossano, sopra le belle arti*, 3 vols, Rome 1782–1786.

1785
Acta Sanctorum, Antwerp 1785, V, pp. 203–222.

1790
V. Fineschi, *Memorie istoriche che possono servire alle vite degli uomini illustri del Convento di Santa Maria Novella dall'anno 1221 al 1320*, Florence 1790.

1809
L. Lanzi, *Storia pittorica dell'Italia* (1795–1796), Bassano 1809, I.

1819
Relazione in compendio delle cose più notabili nel Palazzo e Galleria Saracini di Siena, Siena 1819.

1843
Vespasiano da Bisticci, 'Lamento d'Italia per la presa di Otranto fatta dai Turchi nel 1480' in *Archivio storico italiano*, 1843, IV, pp. 452–468.

1846
F. Bonaini, *Memorie inedite intorno alla vita e ai dipinti di Francesco Traini*, Pisa 1846.

1854–1856
G. Milanesi, *Documenti per la storia dell'arte sense*, 3 vols, Siena 1854, I–II; Siena 1856, III.

1859
G. Milanesi, 'Della vera età di Guido pittore senese e della sua celebre tavola in San Domenico a Siena' in *Giornale storico degli archivi toscani*, 1859, III, pp. 3–13.

1864
J.A. Crowe and G.B. Cavalcaselle, *A New History of Painting in Italy*, London 1864, II.

1876
A. Bertolotti, 'G.D. Angelini' in *Giornale di erudizione artistica*, 1876, V, pp. 73–75.

1878
G. Cugnoni, *Agostino Chigi il Magnifico*, Rome 1878.

1882
A. Franchi, 'Le Palais du Magnifico à Sienne' in *L'Art*, 1882, pp. 147–152 and 181–185.

1888
H. Thode, 'Studien zur Geschichte der Italienischen Kunst im XIV Jahrhundert' in *Repertorium für Kunstwissenschaft*, 1888, XI, pp. 1–22.

1889
F. Wickhoff, 'Über die Zeit des Guido von Siena' in *Mitteilungen des Institutes für Österreiche Geschichtsforschung*, 1889, X, 2, pp. 244–286.

1890
F. Catastini, *La Pietà dei senesi in Roma a proposito dell'arciconfraternita di Santa Caterina*, Rome 1890.

1894
R. Förster, 'Die Hochzeit des Alexander und der Roxane in der Renaissance' in *Jahrbuch der Königlich preussischen Kunstsammlungen*, 1894, XV, pp. 199–201.
A. Toti, 'La chiesa di San Francesco in Siena ed i Piccolomini' in *Bullettino senese di storia patria*, 1894, I, pp. 77–97.

1897
F. Brogi, *Inventario generale degli oggetti d'arte della Provincia di Siena* (compiled between 1862 and 1865), Siena 1897.
L. Tanfani-Centofanti, *Notizie di artisti tratte dai documenti pisani*, Pisa 1897.

1898
S. Borghesi and L. Bianchi, *Nuovi documenti per la storia dell'arte senese*, Siena 1898.

1901
R.H. Hobart Cust, *The Pavement Masters of Siena (1369–1562)*, London 1901.
V. Lusini, *Il San Giovanni di Siena e i suoi restauri*, Florence 1901.

1902
G. Cagnola, 'Di un quadro poco noto del Lorenzetti' in *Rassegna d'arte*, 1902, II, p. 143.
P. Lugano, 'Il "Sodoma" e i suoi affreschi a Camprena' in *Bullettino senese di storia patria*, 1902, IX, pp. 239–249.

1903
R. Langton Douglas, 'A Forgotten Painter' in *The Burlington Magazine*, 1903, III, pp. 306–318.

1904
F.M. Perkins, 'Di alcune opere poco note di Ambrogio Lorenzetti' in *Rassegna d'arte*, 1904, IV, pp. 186–191.
F.M. Perkins, 'The Sienese Exhibition of Ancient Art' in *The Burlington Magazine*, 1904, V, pp. 581–584.

1905
B. Berenson, 'Tesori artistici in un villaggio dilapidato della provincia di Grosseto' in *Rassegna d'arte*, 1905, V, pp. 102–103.
W. Suida, 'Einige florentinische Maler aus der Zeit des Übergangs vom Duecento ins Trecento' in *Jahrbuch der Königlich preussischen Kunstsammlungen*, 1905, XXVI, pp. 28–39.

1906
C. Gamba, 'Di alcune pitture poco conosciute della Toscana' in *Rivista d'arte*, 1906, VI, pp. 45–47.

1907
F.M. Perkins, 'Quattro tavole inedite del Sassetta' in *Rassegna d'arte*, 1907, VII, pp. 45–46.
A. Venturi, *Storia dell'arte italiana*, Milan 1907.

1908
L. Ozzola, 'L'Arte alla corte di Alessandro VII' in *Archivio della Società Romana di Storia Patria*, 1908, XXXI, fasc. I–II, pp. 5–91.
P. Schubring, 'Das Blutbad von Otranto in der Malerei des Quattrocento' in *Monatshefte für Kunstwissenschaft*, 1908, II, pp. 593–601.

1909
B. Berenson, *A Sienese Painter of the Franciscan Legend*, London 1909.

1911
G. De Nicola, review of C.H. Weigelt, *Duccio di Buoninsegna*, in *Bullettino senese di storia patria*, 1911, XVIII, pp. 431–439.
V. Lusini, *Il Duomo di Siena*, Siena 1911, I.

1912
L. Ghiberti, *I Commentari*, edited by J. von Schlosser, Berlin 1912.

1913
M. Carmichael, 'An Altarpiece of Saint Humility' in *The Ecclesiastical Review*, 1913, 49, pp. 429–444.
L. Dami, 'Neroccio di Bartolomeo Landi' in *Rassegna d'arte*, 1913, XIII, pp. 137–143 and 160–170.
A. da Seggiano, *Seggiano. Castello del Montamiata*, Florence 1913.
G. De Nicola, 'Sassetta between 1423 and 1433' in *The Burlington Magazine*, 1913, XXIII, I, pp. 208–215; II, pp. 276–283; III, pp. 332–336.

1914
Various authors, *Le Musée Jacquemart-André*, Paris 1914.

1917–1918
B. Berenson, 'Ugolino Lorenzetti' in *Art in America*, 1917, V, pp. 259–275; 1918, VI, pp. 25–52.

1918
P. Toesca, 'Un dipinto di Girolamo da Cremona' in *Rassegna d'arte*, 1918, XVIII, pp. 141–143.

1919
G. De Nicola, 'Studi sull'arte senese' in *Rassegna d'arte*, 1919, XIX, pp. 95–102.

1920
F.M. Perkins, 'Some Sienese Paintings in American Collections' in *Art in America*, 1920, VIII, pp. 272–287.
H. Voss, *Die Malerei der Spätrenaissance in Rom*, 2 vols, Berlin 1920.

1922
G. De Nicola, 'Il Soggiorno fiorentino di Ambrogio Lorenzetti' in *Bollettino d'arte*, 1922, II, pp. 49–58.
A. Nannizzi, 'Due lettere inedite del naturalista napoletano Ferrante Imperato al senese Ippolito Agostini' in *Bullettino senese di storia patria*, 1922, XXIX, pp. 211–221.

1922–1923
M. Salmi, 'Girolamo da Cremona miniatore e pittore' in *Bollettino d'arte*, 1922–1923, II, pp. 385–404 and 461–478.

1923–1938
R. Van Marle, *The Development of the Italian Schools of Painting*, 19 vols, The Hague 1923–1938.

1924
G. Soulier, *Les Influences orientales dans la peinture toscane*, Paris 1924.

1926
L. Gielly, *Les Primitifs siennois*, Paris 1926.

1927
P. Bacci, 'Il Barna o Berna, pittore della Collegiata di San Gimignano, è mai esistito?' in *La Balzana*, 1927, I, pp. 245–253.
P. Bacci, 'Una tavola inedita e sconosciuta di Luca di Tommè con alcuni ignorati documenti della sua vita' in *Rassegna d'arte senese e del costume*, 1927, I, pp. 51–62.
A. Lisini, 'Elenco dei pittori senesi vissuti nei secoli XIII e XIV' in *La Diana*, 1927, II, pp. 295–306.
P. Toesca, *Il Medioevo*, Turin 1927, II.

1928
E. Cecchi, *Trecentisti senesi*, Rome 1928.
G. De Nicola, 'Studi sull'arte senese, I – Priamo della Quercia' in *Rassegna d'arte*, 1928, V, pp. 69–74.
G. De Nicola, 'Priamo della Quercia. Appendice' in *Rassegna d'arte*, 1928, V, pp. 153–154.

1928–1929
M. Salmi, 'Gli affreschi della Collegiata di Castiglion Olona – II' in *Dedalo*, 1928–1929, X, pp. 3–30.

1929
E.T. Dewald, 'Pietro Lorenzetti' in *Art Studies*, 1929, VII, pp. 131–166.
F.M. Perkins, 'Affreschi poco conosciuti di Ambrogio Lorenzetti' in *La Diana*, 1929, IV, pp. 261–267.

1930
B. Berenson, 'Missing Pictures of the Sienese Trecento' in *International Studio*, 1930, pp. 31–32.
E.T. Dewald, *Pietro Lorenzetti*, Cambridge (Mass.) 1930.
P. Toesca, 'Trecentisti toscani nel Museo di Berna' in *L'Arte*, 1930, XXXIII, pp. 5–15.
C.H. Weigelt, 'The Madonna Rucellai and the Young Duccio' in *Art in America*, 1930, XVIII, pp. 3–25 and 105–120.

1930–1931
B. Berenson, 'Quadri senza casa. Il Trecento senese' in *Dedalo*, 1930–1931, XI, pp. 263–284, 329–362, 957–988 and 1039–1073.

1931
P. Bacci, 'Il pittore Mattia Preti a Siena. Notizie e documenti, 2, La predicazione

di San Bernardino' in *Bullettino senese di storia patria*, 1931, new series, II, fasc. I, pp. 1–16.
C. Brandi, 'Affreschi inediti di Pietro Lorenzetti' in *L'Arte*, 1931, IV, pp. 332–347.
C. Brandi, *Rutilio Manetti*, Siena 1931.
M. Meiss, 'Ugolino Lorenzetti' in *The Art Bulletin*, 1931, XIII, pp. 376–397.
C.H. Weigelt, 'Minor Simonesque Masters' in *Apollo*, 1931, XIV, pp. 1–13.

1932
C. Brandi, 'Niccolò di Ser Sozzo Tegliacci' in *L'Arte*, 1932, XXXV, pp. 223–236.
R. Offner, 'The Works and Style of Francesco di Vannuccio' in *Art in America*, 1932, XX, pp. 89–114.

1933
C. Brandi, *La Regia Pinacoteca di Siena*, Rome 1933.
A. Grunzweig, 'Una nuova prova del soggiorno di Ambrogio Lorenzetti in Firenze' in *Rivista d'arte*, 1933, XV, pp. 249–251.

1934
F. Saxl, *La Fede astrologica di Agostino Chigi. Interpretazione dei dipinti di Baldassarre Peruzzi nella sala di Galatea della Farnesina*, Rome 1934.

1935
W.R. Valentiner, *Tino di Camaino. A Sienese Sculptor of the Fourteenth Century*, Paris 1935.

1936
M. Meiss, 'Bartolomeo Bulgarini altrimenti detto "Ugolino Lorenzetti"?' in *Rivista d'arte*, 1936, XVIII, pp. 113–136.
M. Meiss, 'The Earliest Work of Giovanni di Paolo' in *Art in America*, 1936, XXIV, pp. 137–143.
F.M. Perkins, 'Segna di Buonaventura' in U. Thieme and F. Becker, *Allgemeines Lexikon der Bildenden Künstler*, Leipzig 1936, XXX, pp. 449–450.
G. Pudelko, 'The Early Works of Fra' Filippo Lippi' in *The Art Bulletin*, 1936, XVIII, pp. 104–112.
St Bernardino, *Prediche volgari*, edited by P. Bargellini, Milan and Rome 1936.

1937
G. Vigni, *Lorenzo di Pietro detto il Vecchietta*, Florence 1937.

1938
L. Ragghianti, 'Notizie e letture' in *La Critica d'arte*, 1938, III, pp. XXII–XXV.

1939
P. Bacci, 'L'Elenco delle pitture, sculture e architetture di Siena, compilato nel 1625–26 da Mons. Fabio Chigi, poi Alessandro VII, secondo il ms. Chigiano I. I. 11' in *Bullettino senese di storia patria*, 1939, XLVI, pp. 197–337.
T. Fecini, *Cronaca senese* (post 1479), (B.C.S.A. VII. 9), edited by A. Lisini and F. Jacometti, in *Rerum italicarum scriptores*, XV, part VI, Bologna 1939.
V. Golzio, *Documenti artistici sul Seicento nell'Archivio Chigi*, Rome 1939.
J. Pope-Hennessy, 'Panel Paintings of Pellegrino di Mariano' in *The Burlington Magazine*, 1939, LXXIV, pp. 213–218.
J. Pope-Hennessy, *Sassetta*, London 1939.

1940
A. Blunt, *Artistic Theory in Italy 1450–1600*, Oxford 1940.
A. Péter, 'Giotto and Ambrogio Lorenzetti' in *The Burlington Magazine*, 1940, LXXVI, pp. 3–8.

1941
P. Bacci, 'Documenti e commenti per la storia dell'arte' in *Le Arti*, 1941, IV, I, pp. 12–13.

C. Brandi, 'Giovanni di Paolo' in *Le Arti*, 1941, III, 4, pp. 230–250 and 316–341.

1943
A.S. Weller, *Francesco di Giorgio 1439–1501*, Chicago 1943.

1944
P. Bacci, *Fonti e commenti per la storia dell'arte senese*, Siena 1944.
J. Pope-Hennessy, 'The Development of Realistic Painting in Siena' in *The Burlington Magazine*, 1944, LXXXIV–LXXXV, I, pp. 110–119; II, pp. 139–145.

1946
E. Carli, *I Capolavori dell'arte senese*, exhibition catalogue, Florence 1946.
E. Carli, *Vetrata duccesca*, Florence 1946.
R. Niccoli, 'Scoperta di un capolavoro' in *I Capolavori dell'arte senese*, Florence 1946.

1947
C. Brandi, *Giovanni di Paolo*, Florence 1947.
D. Mahon, *Studies in Seicento Art and Theory*, London 1947.
J. Pope-Hennessy, *Lorenzo Vecchietta and Giovanni di Paolo. A Sienese Codex of the Divine Comedy*, London 1947.

1948
E. Cecchi, *Trecentisti senesi*, Milan 1948.
A. Graziani, 'Il Maestro dell'Osservanza' (1942) in *Proporzioni*, 1948, II, pp. 75–88.
R. Longhi, 'Ancora del Maestro dei Santi Ermagora e Fortunato' in *Arte Veneta*, 1948, II, pp. 41–43.
R. Longhi, 'Postilla' (on the essay by A. Graziani on 'Il Maestro dell'Osservanza') in *Proporzioni*, 1948, II, pp. 87–88.
G. Paccagnini, 'An Attribution to Simone Martini' in *The Burlington Magazine*, 1948, XC, pp. 75–80.

1949
C. Brandi, *Quattrocentisti senesi*, Milan 1949.
L. Coletti, 'The Early Works of Simone Martini' in *Art Quarterly*, 1949, XII, pp. 291–308.

1950
J. Pope-Hennessy, 'Matteo di Giovanni's Assumption Altarpiece' in *Proporzioni*, 1950, III, pp. 81–85.
P. Rotondi, *Il Palazzo ducale di Urbino*, Urbino 1950.
F. Zeri, 'Una pala d'altare di Gerolamo da Cremona' in *Bollettino d'arte*, 1950, XXXV, pp. 35–42.

1951
C. Brandi, *Duccio*, Florence 1951.
P. Toesca, *Il Trecento*, Turin 1951.
C. Volpe, 'Ambrogio Lorenzetti e le congiunture fiorentine-senesi nel quarto decennio del Trecento' in *Paragone*, 1951, 13, pp. 40–52.
C. Volpe, 'Proposte per il problema di Pietro Lorenzetti' in *Paragone*, 1951, 23, pp. 13–26.

1953
O. Oertel, *Die Frühzeit der Italienischen Malerei*, Stuttgart 1953.
C. Wolters, 'Ein Selbstbildnis des Taddeo di Bartolo' in *Mitteilungen des Kunsthistorisches Institutes in Florenz*, 1953, pp. 70–72.
F. Zeri, 'Reconstruction of a Two-sided Reliquary Panel by Pietro Lorenzetti' in *The Burlington Magazine*, 1953, XCV, p. 245.

1954
F. Bologna, 'Miniature di Benvenuto di Giovanni' in *Paragone*, 1954, 51, pp. 15–19.
C. Volpe, 'Preistoria di Duccio' in *Paragone*, 1954, 49, pp. 4–22.
F. Zeri, *La Galleria Spada in Roma*, Florence 1954.

1955
E. Carli, *Dipinti senesi del contado e della Maremma*, Milan 1955.
M. Meiss, 'Nuovi dipinti e vecchi problemi' in *Rivista d'arte*, 1955, XXX, pp. 107–145.

1956
M. Laclotte, *De Giotto à Bellini. Les primitifs italiens dans les musées de France*, Paris 1956.
J. Pope-Hennessy, 'Rethinking Sassetta' in *The Burlington Magazine*, 1956, XCVIII, 643, pp. 364–370.
F. Santi, *III Mostra di opere restaurate*, Perugia 1956.
K. Steinweg, 'Beitrage zu Simone Martini und seiner Werkstatt' in *Mitteilungen des Kunsthistorischen Institutes in Florenz*, 1956, XVII, pp. 161–168.

1956–1957
G. Mancini, *Considerazioni sulla pittura*, edited by A. Marucchi and L. Salerno, 2 vols, Rome 1956–1957.

1957
E. Carli, *Sassetta e il Maestro dell'Osservanza*, Milan 1957.
R. Rubinstein, *Pius II as Patron of Art, with a Special Reference to the History of the Vatican*, higher degree thesis, Courtauld Institute of Art, London University 1957.
F. Zeri, *Pittura e Controriforma*, Turin 1970.

1958
C. Brandi, *Pietro Lorenzetti*, Rome 1958.
L. Marcucci, *I Dipinti toscani del secolo XIII*, Rome 1958.
G. Rowley, *Ambrogio Lorenzetti*, Princeton 1958.
R. Rubinstein, 'The Political Significance of the Frescoes by Ambrogio Lorenzetti and Taddeo di Bartolo in Palazzo Pubblico in Siena' in *Journal of the Warburg and Courtauld Institutes*, 1958, XXI, pp. 179–207.
C. Volpe, 'Deux panneaux de Benedetto di Bindo' in *La Revue des arts*, 1958, VIII, pp. 172–176.
F. Zeri, 'Sul problema di Niccolò Tegliacci e Luca di Tommè' in *Paragone*, 1958, 105, pp. 3–16.
F. Zeri, 'Un polittico di Segna di Buonaventura' in *Paragone*, 1958, 103, pp. 63–68.

1959
E. Castelnuovo, 'Avignone rievocata' in *Paragone*, 1959, 119, pp. 28–51.
V. Koudelka, 'Spigolature dal memoriale di Niccolò Galgani, O.P.' (1424) in *Archivium fratrum praedicatorum*, 1959, XXIX, pp. 111–147.
G. Scavizzi, 'Note sull'attività romana del Lilio e del Salimbeni' in *Bollettino d'arte*, 1959, XLIV, pp. 33–40.
G. Scavizzi, 'Su Ventura Salimbeni' in *Commentari*, 1959, X, pp. 115–136.
C. Volpe, 'Un'opera di Matteo Giovannetti' in *Paragone*, 1959, 119, pp. 63–66.

1960
F. Bologna, 'Altre aggiunte a Battistello Caracciolo' in *Paragone*, 1960, 129, pp. 45–51.
F. Bologna, 'Ciò che resta di un capolavoro giovanile di Duccio. (Nuovi studi sulla formazione del maestro)' in *Paragone*, 1960, 125, pp. 3–31.
E. Carli, *Il Pintoricchio*, Milan 1960.
C. Del Bravo, 'Liberale a Siena' in *Paragone*, 1960, 129, pp. 16–38.

1961
R. Longhi, 'Il Soggiorno romano del Greco' (in *L'Arte*, 1914, XVII) in *Opere complete di Roberto Longhi*, I/1, *Scritti giovanili*, Florence 1961, pp. 107–109.

1955
E. Carli, *Dipinti senesi del contado e della Maremma*, Milan 1955.

1960
R. Offner, 'Reflexions on Ambrogio Lorenzetti' in *Gazette des Beaux-Arts*, 1960, LVI, pp. 235–238.
G. Previtali, 'L'Ambrogio Lorenzetti di George Rowley' in *Paragone*, 1960, 127, pp. 70–74.
G. Scavizzi, 'Gli affreschi della Scala Santa ed alcune aggiunte per il tardo manierismo', I, in *Bollettino d'arte*, January–June 1960, XLV, I–II, pp. 11–122.
G. Scavizzi, 'Gli affreschi della Scala Santa', II, in *Bollettino d'arte*, October–December 1960, IV, pp. 325–335.
C. Volpe, 'Precisazioni sul "Barna" e sul "Maestro di Palazzo Venezia"' in *Arte antica e moderna*, 1960, 10, pp. 149–158.
C. Volpe, 'Nuove proposte sui Lorenzetti' in *Arte antica e moderna*, 1960, 11, pp. 263–277.

1961
G. Coor, *Neroccio de' Landi 1447–1500*, Princeton 1961.
M. Davies, *National Gallery Catalogues – The Earlier Italian Schools*, 2nd rev. edn, London 1961.
C. Del Bravo, '"Una figura con natura morta" del Seicento toscano' in *Arte antica e moderna*, 1961, 13–16, pp. 322–324.
C. Del Bravo, 'Due nature morte di Astolfo Petrazzi' in *Paragone*, 1961, 139, pp. 58–59.
L. Marcucci, 'La Data della Santa Umiltà di Pietro Lorenzetti' in *Arte antica e moderna*, 1961, 13–16, pp. 21–26.

1962
F. Bologna, *La Pittura italiana delle origini*, Rome 1962.
E. Borea, 'Grazia e furia in Marco Pino' in *Paragone*, 1962, 151, pp. 24–52.
E. Castelnuovo, *Un Pittore italiano alla corte di Avignone. Matteo Giovannetti e la pittura in Provenza nel secolo XIV*, Turin 1962.
G. Cecchini and E. Carli, *San Gimignano*, Siena 1962.
R. Longhi, 'Tracciato orvietano' in *Paragone*, 1962, 149, pp. 3–14.
F. Zeri, 'Un appunto su Bartolo di Fredi' in *Paragone*, 1962, 151, pp. 55–57.

1963
E. Carli, *Il Palazzo Pubblico di Siena*, Rome 1963.
R. Longhi, 'Piero della Francesca' (Rome 1927) in *Opere complete di Roberto Longhi*, III, *Piero della Francesca*, Florence 1963.

1964
E. Castelnuovo, 'Barna' in *Dizionario biografico degli italiani*, Rome 1964, VI, pp. 410–413.
J. Cox Rearick, *The Drawings of Pontormo*, Cambridge (Mass.) 1964, I.
M. Levi D'Ancona, 'Postille a Girolamo da Cremona' in *Studi in onore di Tammaro De Marinis*, Rome 1964, III, pp. 45–104.
M. Meiss, 'The Yates Thompson Dante and Priamo della Quercia' in *The Burlington Magazine*, 1964, CVI, pp. 403–412.
G. Previtali, 'Un "San Giacomo Minore" del Vecchietta' in *Paragone*, 1964, 177, pp. 43–45.
J.H. Stubblebine, *Guido da Siena*, Princeton 1964.
B. Toscano, 'Bartolomeo di Tommaso e Nicola da Siena' in *Commentari*, 1964, XV, I–II, pp. 37–51.

1965
L. Marcucci, *I Dipinti del secolo XIV*, Rome 1965.
P. Scarpellini, *Pintoricchio alla Libreria Piccolomini*, Milan 1965.
S. Symeonides, *Taddeo di Bartolo*, Siena 1965.

1966
F. Bologna, 'Simone Martini' in *I Maestri del colore*, Milan 1966, 119.
E. Carli, *Pienza, città di Pio II*, Rome 1966.
C. Del Bravo, 'Su Rutilio Manetti' in *Pantheon*, January–February 1966, XXIV, pp. 43–50.
C. Del Bravo, 'Presentazione di Bernardino Mei' in *Pantheon*, September–October 1966, XXIV, pp. 294–302.
B.B. Fredericksen and D.D. Davisson, *Benvenuto di Giovanni, Girolamo di Benvenuto. Their Altarpieces in the J. Paul Getty Museum*, Malibu 1966.
B.B. Fredericksen, 'The Earliest Painting by the Stratonice Master' in *Paragone*, 1966, 197, pp. 53–55.
E.H. Gombrich, *Norm and Form: Studies in the Art of the Renaissance*, London 1966.
P. Rosenberg, *Rouen. Musée des Beaux-Arts. Tableaux français du XVII^ème siècle et italiens des XVII^ème et XVIII^ème siècles*, Paris 1966.
C. Volpe, *Simone Martini e la pittura senese. Da Duccio ai Lorenzetti*, Milan 1966.

1967
E. Carli, 'La Madonna dei Quattro Venti' in *Carta Canta*, special number published by the Contrada della Tartuca to celebrate their victory in the Palio on 2 June 1967.
C. Del Bravo, *Liberale da Verona*, Florence 1967.
R. Longhi, 'Precisioni nelle gallerie italiane. La Galleria Borghese' (in *Vita artistica*, 1926–1927) in *Opere complete di Roberto Longhi*, II, *Saggi e ricerche*, Florence 1967, pp. 265–366.
G. Moran and A.C. Seymour Jr., 'The Jarves St. Martin and the Beggar' in *Yale University Art Gallery Bulletin*, 1967, 2, pp. 28–39.
B. Sanminiatelli, *Domenico Beccafumi*, Milan 1967.
G. Vasari, *Le Vite de' più eccellenti pittori, scultori e architettori* (Florence 1568), edited by P. Della Pergola, L. Grassi and G. Previtali, Novara 1967. Translated into English by A.B. Hinds as *The Lives of the Painters, Sculptors and Architects,* London and New York 1966.

1967–1968
C.L. Frommel, *Baldassarre Peruzzi als Maler und Zeichner*, Vienna 1967–1968.

1968
B. Berenson, *Italian Pictures of the Renaissance. Central Italian and North Italian Schools*, London 1968.
F. Bologna, *Simone Martini. Affreschi di Assisi*, Milan 1968.
P. Donati, 'Aggiunte al "Maestro degli Ordini"' in *Paragone*, 1968, 219, pp. 67–70.
R. Longhi, 'Ricerche su Giovanni di Francesco' (in *Pinacotheca*, 1928, I) in *Opere complete di Roberto Longhi*, IV, *'Me pinxit' e Quesiti caravaggeschi*, Florence 1968, pp. 21–36.
L. Vertova, 'Testimonianze frammentarie di Matteo Giovannetti' in *Festschrift Ulrich Middeldorf*, Berlin 1968, pp. 45–51.

1968–1970
L. Lanzi, *Storia pittorica della Italia dal Risorgimento delle Belle Arti fin presso al fine del sec. XVIII*, edited by M. Capucci, 3 vols, Florence 1968–1970.

1969
F. Bologna, *I Pittori alla corte angioina di Napoli (1266–1414),* Rome 1969.
E. Borsook, *Gli Affreschi di Montesiepi*, Florence 1969.
P. Brieger, M. Meiss and C.S. Singleton, *Illuminated Manuscripts of the Divine Comedy*, 2 vols, Princeton 1969.

E. Carli, *Lippo Vanni a San Leonardo al Lago*, Florence 1969.
I. Hueck, 'Una Crocifissione su marmo del primo Trecento e alcuni smalti senesi' in *Antichità viva*, 1969, VIII, 1, pp. 22–34.
M. Laclotte, 'Le Maître des Anges Rebelles' in *Paragone*, 1969, 237, pp. 3–14.
C. Maltese, 'Il protomanierismo di Francesco di Giorgio Martini' in *Storia dell'arte*, 1969, 4, pp. 440–446.
A. Petrioli Tofani, 'Per Girolamo Genga' in *Paragone*, 1969, 229, pp. 18–36.

1970
F. Arcangeli, 'La "Maestà" di Duccio a Massa Marittima' in *Paragone*, 1970, 249, pp. 4–14.
E. Borea, *Caravaggio e Caravaggeschi nelle Gallerie di Firenze*, exhibition catalogue, Florence 1970.
C. Del Bravo, *Scultura senese del Quattrocento*, Florence 1970.
M.C. Gozzoli, *L'Opera completa di Simone Martini*, Milan 1970.
R. Longhi, 'Ancora per San Galgano' in *Paragone*, 1970, 241, pp. 6–8.

1971
Various authors, *Mostra del restauro delle opere delle provincie di Pisa e Livorno*, Pisa 1971.
A. Conti, 'Appunti pistoiesi' in *Annali della Scuola Normale di Pisa*, 1971, III, I, 1, pp. 109–124.
F. Zeri, *Diari di lavoro*, Bergamo 1971.

1972
M. Baxandall, *Painting and Experience in Fifteenth-Century Italy*, Oxford 1972.
L. Bellosi, 'Jacopo di Mino del Pellicciaio' in *Bollettino d'arte*, 1972, LVII, 2, pp. 63–73.
C. Bertelli, 'Vetri e altre cose nella Napoli angioina' in *Paragone*, 1972, 263, pp. 89–106.
W. Chandler Kirwin, 'The Oratory of the Sanctuary of Saint Catherine in Siena' in *Mitteilungen des Kunsthistorischen Institutes in Florenz*, 1972, XVI, 2, pp. 199–220.
M.G. Ciardi Dupré, *I Corali del Duomo di Siena*, Milan 1972.
D. Gallavotti Cavallero, 'Gli affreschi quattrocenteschi della Sala del Pellegrinaio nello Spedale di Santa Maria della Scala in Siena' in *Storia dell'arte*, 1972, XIII, pp. 5–42.
M. Gregori, 'Note su Orazio Riminaldi e i suoi rapporti con l'ambiente romano' in *Paragone*, 1972, 269, pp. 35–66.
I. Hueck, 'Le Matricole dei pittori fiorentini prima e dopo il 1320' in *Bollettino d'arte*, 1972, LVII, pp. 114–121.
M. Jenkins, 'The Iconography of the Hall of Consistory in the Palazzo Pubblico, Siena' in *The Art Bulletin*, 1972, LIV, pp. 430–451.
C. Monbeig-Goguel, *Musée du Louvre. Cabinet des dessins. Inventaire général des dessins italiens. I, Vasari et son temps, Maîtres toscans nés après 1500, morts avant 1600*, Paris 1972.

1973
F. Bisogni, 'Liberale o Girolamo?' in *Arte illustrata*, 1973, VI, pp. 400–408.

1974
Various authors, *European Paintings in the Collection of the Worcester Art Museum*, Worcester 1974.
M.C. Bandera, 'Qualche osservazione su Benvenuto di Giovanni' in *Antichità viva*, 1974, XIII, 1, pp. 3–17.
L. Bellosi, *Buffalmacco e il trionfo della morte*, Turin 1974.
E. Carli, *Il Museo di Pisa*, Pisa 1974.
E. Carli, *Il Sodoma a Sant'Anna a Camprena*, Florence 1974.

R. Longhi, 'Due resti di un paliotto di Ambrogio Lorenzetti' (in *Paragone*, 1951, 13) in *Opere complete di Roberto Longhi*, VII, '*Giudizio sul Duecento' e ricerche sul Trecento nell'Italia centrale*, Florence 1974, pp. 116–117.
R. Longhi, 'Giudizio sul Duecento' (in *Proporzioni*, 1948, II) in *Opere complete di Roberto Longhi*, VII, '*Giudizio sul Duecento' e ricerche sul Trecento nell'Italia centrale*, Florence 1974, pp. 1–53.
D. Mahon, *Studies in Seicento Art and Theory*, London 1947.
H. van Os, *Vecchietta and the Sacristy of the Siena Hospital Church, a Study in Renaissance Religious Symbolism*, New York 1974.
M. Righetti, 'Indagine su Girolamo da Cremona miniatore' in *Arte Lombarda*, 1974, 41, pp. 32–42.
F. Zeri, 'Pietro Lorenzetti: quattro pannelli della Pala del 1329 al Carmine' in *Arte illustrata*, 1974, 58, pp. 146–156.

1975
L. Bellosi, 'La Mostra di Arezzo' in *Prospettiva*, 1975, 3, pp. 55–60.
R. Longhi, 'Fatti di Masolino e di Masaccio' (in *La Critica d'arte*, 1940, XXV–XXVI) in *Opere complete di Roberto Longhi*, VIII/1, *'Fatti di Masolino e di Masaccio' e altri studi sul Quattrocento*, Florence 1975, pp. 3–65.
R. Longhi, 'Il Maestro di Pratovecchio' (in *Paragone*, 1952, 35) in *Opere complete di Roberto Longhi*, VIII/1, *'Fatti di Masolino e di Masaccio' e altri studi sul Quattrocento*, Florence 1975, pp. 99–122.
H.B.J. Maginnis, 'Pietro Lorenzetti's Carmelite Madonna: A Reconstruction' in *Pantheon*, 1975, 33, pp. 10–16.
V. Marchetti, *Gruppi ereticali senesi del Cinquecento*, Florence 1975.
G. Schoenburg Waldenburg, 'Problemi proposti da un messale della Biblioteca di Siena' in *Commentari*, 1975, XXIV, 3–4, pp. 267–275.
M. Trionfi Honorati, 'Antonio e Andrea Barili a Fano' in *Antichità viva*, 1975, XIV, 6, pp. 35–42.
V. Wainwright, 'The Will of Ambrogio Lorenzetti' in *The Burlington Magazine*, 1975, CXVII, 869, pp. 543–544.

1976
F. Bisogni, 'Risarcimento del "Ratto di Elena" di Francesco di Giorgio' in *Prospettiva*, 1976, 7, pp. 390–391.
A. Caleca, 'Tre polittici di Lippo Memmi, un'ipotesi sul Barna e la bottega di Simone Martini e Lippo, 1' in *Critica d'arte*, 1976, 150, pp. 49–59.
E. Carli, *L'Arte a Massa Marittima*, Siena 1976.
E. Carli, 'Luoghi ed opere d'arte senesi nelle prediche di Bernardino del 1427' in *Bernardino predicatore nella società del suo tempo*, conference proceedings from the Centro di Studi sulla Spiritualità Medievale, XVI, 9–12 October 1975, Todi 1976, pp. 153–182.
G. Chiarini De Anna, 'Leopoldo de' Medici e la formazione della sua raccolta di disegni' in *Omaggio a Leopoldo de' Medici, parte I, Disegni*, exhibition catalogue, Florence 1976.
C. De Benedictis, 'Il Polittico della Passione di Simone Martini e una proposta per Donato' in *Antichità viva*, 1976, XV, 6, pp. 3–11.
G. Moran, 'Is the Name Barna an Incorrect Transcription of the Name Bartolo?' in *Paragone*, 1976, 311, pp. 76–80.
G. Moran and S. Fineschi, 'Niccolò di Ser Sozzo Tegliacci o di Stefano?' in *Paragone*, 1976, 321, pp. 58–63.

E. Romagnoli, *Biografia cronologica de' bellartisti senesi dal secolo XII a tutto il XVIII* (before 1835), anastatic edition, Florence 1976.
E. Skaug, 'Notes on the Chronology of Ambrogio Lorenzetti and a New Painting from his Shop' in *Mitteilungen des Kunsthistorischen Institutes in Florenz*, 1976, XX, pp. 301–332.
C. Volpe, 'Su Lippo Vanni da miniatore a pittore' in *Paragone*, 1976, 321, pp. 53–57.
F. Zeri, *Italian Paintings in the Walters Art Gallery*, 2 vols, Baltimore 1976.

1977
A. Bagnoli and D. Capresi Gambelli, 'Disegni dei barocceschi senesi (Francesco Vanni e Ventura Salimbeni)' in *Prospettiva*, 1977, 9, pp. 82–86.
L. Bellosi, 'Moda e cronologia. B) Per la pittura di primo Trecento' in *Prospettiva*, 1977, 11, pp. 12–26.
F. Bologna, *Napoli e le rotte mediterranee della pittura. Da Alfonso il Magnanimo a Ferdinando il Cattolico*, Naples 1977.
J. Brink, 'Francesco Petrarca and the Problem of Chronology in the Late Paintings of Simone Martini' in *Paragone*, 1977, 331, pp. 3–9.
A. Caleca, 'Tre polittici di Lippo Memmi, un'ipotesi sul Barna e la bottega di Simone Martini e Lippo, 2' in *Critica d'arte*, 1977, 151, pp. 55–80.
G. Chelazzi Dini, 'Lorenzo Vecchietta, Priamo della Quercia, Nicola da Siena: nuove osservazioni sulla "Divina Commedia" Yates Thompson 36' in *Jacopo della Quercia fra Gotico e Rinascimento*, conference proceedings edited by G. Chelazzi Dini, Siena 1975, Florence 1977, pp. 203–228.
B. Cole and A. Medicus Gealt, 'A New Triptych by Niccolò di Buonaccorso and a Problem' in *The Burlington Magazine*, 1977, CXIX, pp. 184–187.
A. Luchs, 'Ambrogio Lorenzetti at Montesiepi' in *The Burlington Magazine*, 1977, pp. 187–188.
N.E. Müller, 'Ambrogio Lorenzetti's Annunciation: A Re-examination' in *Mitteilungen des Kunsthistorischen Institutes in Florenz*, 1977, XXI, pp. 1–12.
P. Torriti, *La Pinacoteca nazionale di Siena. I dipinti dal XII al XV secolo*, Genoa 1977.

1978
Various authors, *Rutilio Manetti*, exhibition catalogue edited by A. Bagnoli, Siena 1978.
C. Acidini Luchinat, 'Due episodi della conquista Cosimiana di Siena' in *Paragone*, 1978, 345, pp. 3–26.
A. Bagnoli, 'Aggiornamento di Rutilio Manetti' in *Prospettiva*, 1978, 13, pp. 23–42.
M. Boskovits, 'Ferrarese Painting about 1450: some New Arguments' in *The Burlington Magazine*, 1978, CXX, pp. 370–385.
W. Chandler Kirwin, 'The Life and Drawing Style of Cristofano Roncalli' in *Paragone*, 1978, 335, pp. 18–62.
R. Longhi, 'Un apice espressionistico di Liberale da Verona' (in *Paragone*, 1955, 65) in *Opere complete di Roberto Longhi*, X, *Ricerche sulla pittura veneta*, Florence 1978, pp. 135–141.
H. Loyrette, 'Une Source pour la reconstruction du polyptyque d'Ugolino da Siena à Santa Croce' in *Paragone*, 1978, 343, pp. 15–23.
M. Meiss, *Painting in Florence and Siena after the Black Death* (Princeton 1951), Princeton 1978.
K. Oberhuber, 'The Colonna Altarpiece in the Metropolitan Museum and Problems of the Early Style of Raphael'

in *Metropolitan Museum Journal*, 1978, XII, pp. 55–90.

P.A. Riedl, *Die Fresken der Gewölbezone des Oratorio della Santissima Trinità in Siena*, Heidelberg 1978.

M. Seidel, 'Die Fresken des Ambrogio Lorenzetti in S. Agostino' in *Mitteilungen des Kunsthistorischen Institutes in Florenz*, 1978, XXII, 2, pp. 185–252.

M. Seidel, 'Wiedergefundene Fragmente eines Hauptwerks von Ambrogio Lorenzetti. Ergebnisse der Restaurierungen im Kloster von San Francesco in Siena' in *Pantheon*, 1978, 36, pp. 119–127.

C. Sisi, 'Le Tarsie per il coro della cappella di San Giovanni: Antonio Barili e gli interventi senesi di Luca Signorelli' in *Antichità viva*, 1978, XVII, 2, pp. 33–42.

V. Tàtrai, 'Gli affreschi di Palazzo Petrucci a Siena. Una precisazione iconografica e un'ipotesi sul programma' in *Acta historiae artium academiae scientiarum hungaricae*, 1978, pp. 177–183.

1979
Various authors, *Disegni dei Toscani a Roma (1580–1620)*, Florence 1979.

Various authors, *Gli Uffizi. Catalogo generale*, Florence 1979.

E. Carter Southard, *The Frescoes in Siena's Palazzo Pubblico, 1289–1539: Studies in Imagery and Relations to other Communal Palaces in Tuscany*, New York and London 1979.

A. Chastel, *I Centri del Rinascimento. Arte italiana. 1460–1500*, Milan 1979. Translated into English from the French by J. Griffin as *The Golden Age of the Renaissance: Italy 1460–1500*, London 1965.

A. Chastel, *La Grande officina. Arte italiana 1460–1500*, Milan 1979. Translated into English from the French by J. Griffin as *The Studios and Styles of the Renaissance: Italy 1460–1500*, London 1966.

E. Cioni Liserani, 'Alcune ipotesi per Guccio di Mannaia' in *Prospettiva*, 1979, 17, pp. 47–58.

C. De Benedictis, *La Pittura senese. 1330–1370*, Florence 1979.

A.M. Maetzke, *Arte nell'aretino*, Florence 1979.

G.B. Marino, *La Galleria*, edited by M. Pieri, Padua 1979, I.

P.A. Riedl, *Das Fondi Grabmal in S. Agostino zu Siena*, Heidelberg 1979.

F. Rusk Shapley, *Catalogue of the Italian Paintings of the National Gallery of Art*, 2 vols, Washington, D.C. 1979.

P. Scapecchi, *Chiarimenti intorno alla pala dell'Arte della Lana*, Siena 1979.

M. Seidel, 'Die Fresken des Francesco di Giorgio' in *Mitteilungen des Kunsthistorischen Institutes in Florenz*, 1979, XXIII, pp. 4–108.

M. Seidel, 'Gli affreschi di Ambrogio Lorenzetti nel Chiostro di San Francesco a Siena: ricostruzione e datazione' in *Prospettiva*, 1979, 18, pp. 10–20.

S. Settis, 'Iconografia dell'arte italiana, 1100–1500: una linea' in *Storia dell'arte italiana*, Turin 1979, III, pp. 173–270.

J.H. Stubblebine, *Duccio di Buoninsegna and His School*, Princeton 1979.

V. Tàtrai, 'Il Maestro della storia di Griselda e una famiglia di mecenati dimenticata' in *Acta historiae artium academiae scientiarum hungaricae*, 1979, XXV, pp. 27–66.

C. Volpe, 'Francesco di Vannuccio' in *Petit Larousse de la peinture*, Paris 1979, p. 655.

L. Wegner, 'Further Notes on Francesco Vanni's Works for Roman Patrons' in *Mitteilungen des Kunsthistorischen Institutes in Florenz*, 1979, XXIII, pp. 313–324.

J. White, *Duccio. Tuscan Art and the Medieval Workshop*, London 1979.

F. Zeri, 'Girolamo di Benvenuto: il completamento della "Madonna delle Nevi"' in *Antologia di belle arti*, 1979, III, 9–12, pp. 48–54.

1979–1983
Various authors, *Mostra di opere d'arte restaurate nelle province di Siena e Grosseto*, Genoa 1979, I; Genoa 1981, II; Genoa 1983, III.

1980
Various authors, *L'Arte a Siena sotto i Medici. 1555–1609*, exhibition catalogue edited by F. Sricchia Santoro, Rome 1980 (with contributions by A. Bagnoli, D. Capresi Gambelli, A. Cornice, N. Fargnoli, L. Martini, S. Padovani and F. Sricchia Santoro).

M. Boskovits, 'Su Niccolò di Buonaccorso, Benedetto di Bindo e la pittura senese del primo Quattrocento' in *Paragone*, 1980, 359–361, pp. 3–22.

E. Carli, *Gli Scultori senesi*, Milan 1980.

E. Carli, *Le Storie di San Benedetto a Monteoliveto Maggiore*, Milan 1980.

A. Conti, review of J. White, *Duccio. Tuscan Art and the Medieval Workshop* (London 1979), in *Prospettiva*, 1980, 23, pp. 98–101.

G. Martines, 'Francesco di Giorgio a Gubbio in tre documenti d'archivio rinvenuti e trascritti da Pier Luigi Menichetti' in *Ricerche di storia dell'arte*, 1980, II, pp. 67–69.

J. Pope-Hennessy, 'A Misfit Master' in *New York Review of Books*, 1980, XXVII, 18, pp. 45–47.

F. Zeri, *Sienese and Central Italian Schools. A Catalogue of the Collection of the Metropolitan Museum of Art*, Vicenza 1980.

1981
L. Bellosi, 'Per Luca della Robbia' in *Prospettiva*, 1981, 27, pp. 62–72.

E. Carli, *La Pittura senese del Trecento*, Venice 1981.

A. Conti, *La Miniatura bolognese. Scuole e botteghe, 1270–1340*, Bologna 1981.

G. Corti, 'La Compagnia di Taddeo di Bartolo con Gregorio di Cecco, con altri documenti inediti' in *Mitteilungen des Kunsthistorischen Institutes in Florenz*, 1981, XXV, pp. 373–377.

S. Danesi Squarzina and G. Borghini (eds), *Il Borgo di Ostia da Sisto IV a Giulio II*, exhibition catalogue, Rome 1981.

M. Eisenberg, 'The First Altarpiece for the "Cappella de' Signori" of the Palazzo Pubblico in Siena: … tales figure sunt adeo pulcre' in *The Burlington Magazine*, 1981, CXXIII, pp. 134–148.

G. Freuler, 'Die Fresken des Biagio di Goro Ghezzi in S. Michele in Paganico' in *Mitteilungen des Kunsthistorischen Institutes in Florenz*, 1981, XXV, pp. 31–58.

F. Fumi, 'Nuovi documenti per gli angeli dell'altar maggiore del Duomo di Siena' in *Prospettiva*, 1981, 26, pp. 9–25.

R. Guerrini, *Studi su Valerio Massimo*, Pisa 1981.

E. Neri Lusanna, 'Un episodio di collaborazione tra scultori e pittori nella Siena del primo Quattrocento: la "Madonna del Magnificat" di Sant'Agostino' in *Mitteilungen des Kunsthistorischen Institutes in Florenz*, 1981, XXV, pp. 325–340.

J. Polzer, 'The "Master of the Rebel Angels" Reconsidered' in *The Art Bulletin*, 1981, LXIII, II, pp. 563–584.

1982
Various authors, *Il Gotico a Siena*, exhibition catalogue, Florence 1982 (with contributions by L. Bellosi, F. Bologna, G. Chelazzi Dini, G. Damiani and C. Volpe).

C. Acidini Luchinat, 'La grottesca' in *Storia dell'arte italiana*, Turin 1982, 11, pp. 159–200.

G. Agosti, 'Precisioni su un "Baccanale" perduto del Signorelli' in *Prospettiva*, 1982, 30, pp. 70–77.

A. Angelini, 'Da Giacomo Pacchiarotti a Pietro Orioli' in *Prospettiva*, 1982, 29, pp. 72–78.

A. Angelini, 'Pietro Orioli e il momento "urbinate" della pittura senese del Quattrocento' in *Prospettiva*, 1982, 30, pp. 30–43.

L. Bellosi, '"Castrum pingatur in palatio". 2. Duccio e Simone Martini pittori di castelli senesi "a l'esemplo come erano" in *Prospettiva*, 1982, 28, pp. 41–65.

L. Bellosi, *Pietro Lorenzetti ad Assisi*, Assisi 1982.

H. Belting, 'The "Byzantine" Madonnas: New Facts about their Italian Origin and some Observations on Duccio' in *Studies in the History of Art*, 1982, XII, pp. 7–22.

J. Cannon, 'Simone Martini, the Dominicans and the Early Sienese Polyptych' in *Journal of the Warburg and Courtauld Institutes*, 1982, XLV, pp. 69–93.

R. Guerrini, 'Il Creato di Baldassarre Peruzzi. Testimonianze su Francesco da Siena ed altri artisti senesi del Cinquecento' in *Bullettino senese di storia patria*, 1982, LXXXIX, pp. 155–195.

K. Oberhuber, *Raffaello*, Milan 1982.

J. Pope-Hennessy, 'A Shocking Scena' in *Apollo*, 1982, 241, pp. 150–157.

B. Santi, *Il Pavimento del Duomo di Siena*, Florence 1982.

M. Seidel, '"Castrum pingatur in palatio". 1. Ricerche storiche e iconografiche sui castelli dipinti nel Palazzo Pubblico di Siena' in *Prospettiva*, 1982, 28, pp. 17–40.

F. Sricchia Santoro, '"Ricerche senesi". 1. Pacchiarotto e Pacchia' in *Prospettiva*, 1982, 29, pp. 14–23.

F. Sricchia Santoro, '"Ricerche senesi". 2. Il Palazzo del Magnifico Pandolfo Petrucci' in *Prospettiva*, 1982, 29, pp. 24–31.

F. Sricchia Santoro, '"Ricerche senesi". 3. Bartolomeo di David' in *Prospettiva*, 1982, 29, pp. 32–40.

F. Sricchia Santoro, '"Ricerche senesi". 4. Il giovane Sodoma' in *Prospettiva*, 1982, 30, pp. 43–58.

F. Sricchia Santoro, '"Ricerche Senesi". 5. Agli inizi del Beccafumi' in *Prospettiva*, 1982, 30, pp. 58–65.

1983
Various authors, *L'Art gotique siennois*, Florence 1983 (with contributions by G. Chelazzi Dini and D. Thiebaut).

Various authors, *Il Palazzo Pubblico di Siena. Vicende costruttive e decorazione*, edited by C. Brandi, Milan 1983.

Various authors, *Il Quattrocento a Viterbo*, Rome 1983.

M. Boskovits, 'Il gotico senese rivisitato: proposte e commenti su una mostra' in *Arte Cristiana*, 1983, LXXI, 698, pp. 259–276.

M.G. Ciardi Dupré Dal Poggetto (ed.), *Codici liturgici miniati dei benedettini in Toscana, I corali del Duomo di Chiusi*, Florence 1983.

M.P. Di Dario Guida, 'Itinerari per la Calabria' in the guide from *L'Espresso*, Rome 1983.

H.J. Eberhardt, *Die Miniaturen von Liberale da Verona, Girolamo da Cremona und Venturino di Milano in der Chorbüchern des Doms von Siena. Dokumentation, Attribution, Chronologie*, dissertation, Berlin 1972, Munich 1983.

M. Laclotte and D. Thiebaut, *L'École d'Avignon*, Paris 1983.

C. Acidini Luchinat, 'La grottesca' in *Storia dell'arte italiana*, Turin 1982, 11, pp. 159–200.

M. Lonjon, 'Quatre médaillons de Simone Martini: la reconstitution du retable de l'église San Francesco à Orvieto' in *Revue du Louvre*, 1983, XXXIII, pp. 199–211.

L. Martini, *Itinerario di Pietro Sorri*, Genoa 1983.

J. Pope-Hennessy, 'Some Italian Primitives' in *Apollo*, 1983, CXVIII, pp. 10–15.

C. Volpe, 'Il lungo percorso del "dipingere dolcissimo e tanto unito"' in *Storia dell'arte italiana*, Turin 1983, 5, pp. 229–304.

1983–1984
G. Chelazzi Dini, 'Un capolavoro giovanile di Simone Martini (Studi in onore di Luigi Grassi)' in *Prospettiva*, 1983–1984, 33–36, pp. 29–32.

1984
Various authors, *Gli Uffizi, Studi e ricerche. 7. La 'Presentazione al Tempio' di Ambrogio Lorenzetti*, Florence 1984.

Various authors, *Pienza e la Val d'Orcia, opere d'arte restaurate dal XIV al XVII secolo*, Genoa 1984.

Various authors, *Le Biccherne. Tavole dipinte delle magistrature senesi (secoli XIII–XVIII)*, Rome 1984.

F. Bisogni, 'Del cataletto di Sant'Onofrio ossia di Bartolomeo di David' in *Scritti in onore di Federico Zeri*, Milan 1984, I, pp. 375–388.

P. Bonaccorso and P. Pallassini (eds), *La Bufalata del 20 ottobre 1632. Nelle incisioni di Bernardino Capitelli*, Siena 1984.

M. Collareta, 'Encaustum vulgo smaltum' in *Annali della Scuola Normale di Pisa*, 1984, XIV, 2, pp. 757–769.

F. Deuchler, *Duccio*, Milan 1984.

L. Martini, 'Aggiunte a Pietro Sorri' in *Annali della fondazione di studi di storia dell'arte Roberto Longhi*, 1984, I, pp. 87–113.

E.S. Piccolomini, *Commentarii (before 1464)*, edited by L. Totaro, Milan 1984, IX.

M. Seidel, 'Signorelli um 1490' in *Jahrbuch der Berliner Museen*, 1984, XXVI, pp. 181–256.

C.B. Strehlke, 'La Madonna dell'Umiltà di Domenico di Bartolo e San Bernardino' in *Arte Cristiana*, 1984, LXXII, 705, pp. 381–390.

1985
Various authors, *Bernardino Capitelli*, exhibition catalogue edited by P. Bonaccorso, Siena 1985.

Various authors, *Caravaggio e il suo tempo*, exhibition catalogue, Naples 1985.

Various authors, *Simone Martini e 'chompagni'*, exhibition catalogue, Florence 1985 (with contributions by A. Bagnoli, F. Bologna, C. De Benedictis, G. Previtali and M. Seidel).

C. Alessi and P. Scapecchi, 'Il Maestro dell'Osservanza: Sano di Pietro o Francesco di Bartolomeo?' in *Prospettiva*, 1985, 42, pp. 13–37.

J. Beck, 'A New Date for Pinturicchio's Piccolomini Library' in *Paragone*, January, March and May 1985, 419, 421 and 423, pp. 140–143.

G. Briganti, *La Maniera italiana* (Rome 1961), Florence 1985.

L. Cateni, 'Testimonianze sul "Guidoriccio" anteriori al Della Valle' in *Prospettiva*, 1985, 41, pp. 46–50.

L. Cateni, 'Un polititco "too remote from Ambrogio" firmato da Ambrogio Lorenzetti' in *Prospettiva*, 1985, 40, pp. 62–67.

G. Chelazzi Dini, 'Alcune miniature di Pietro Lorenzetti' in *Antichità viva*, 1985, 1–3, pp. 17–20.

A. Colombi Ferretti, *Girolamo Genga e l'altare di S. Agostino a Cesena*, Bologna 1985.

A. Conti, 'Gli affreschi di San Rocco a Seggiano hanno un padre' in *Nuovo Amiata*, 1985, p. 3.

A. Ferrari, R. Valentini and M. Viti, 'Il Palazzo del Magnifico a Siena' in *Bullettino senese di storia patria*, 1985, XCII, pp. 107–153.

D. Gallavotti Cavallero, *Lo Spedale di Santa Maria della Scala in Siena: Vicenda di una committenza artistica*, Pisa 1985.

M. Laclotte, 'Une prédelle de Pietro di Giovanni d'Ambrogio' in *Paragone*, 1985, 419, 421 and 423, pp. 107–112.

J. Mongellaz, 'Réconsidération de la distribution des rôles à l'intérieur du groupe des Maîtres de la Sacristie de la Cathédral de Sienne' in *Paragone*, 1985, 427, pp. 73–89.

J. Montagu, *Alessandro Algardi*, New Haven and London 1985.

M. Paoli, 'Documento per Priamo della Quercia' in *Critica d'arte*, 1985, L, 6, pp. 98–101.

G. Ragionieri, *Simone e non Simone*, Florence 1985.

C.B. Strehlke, 'Sienese Painting in the Johnson Collection' in *Paragone*, 1985, 427, pp. 3–15.

M. Tazartes, 'Anagrafe lucchese. II. Michele Ciampanti: il Maestro di Stratonice?' in *Ricerche di storia dell'arte*, 1985, 26, pp. 18–27.

E. Testi (ed.), *La Miniatura italiana tra Gotico e Rinascimento I*, proceedings from the II Congresso di Storia della Miniatura Italiana, Cortona, 24–26 September 1982, Florence 1985.

1986

E.H. Beatson, N.E. Muller and J.B. Steinhoff, 'The St. Victor Altarpiece in Siena Cathedral: A Reconstruction' in *The Art Bulletin*, 1986, LXVIII, 4, pp. 610–631.

L. Bellosi and A. Angelini (eds), *Sassetta e i pittori toscani tra XIII e XV secolo*, Siena 1986.

M. Boskovits, 'Considerations on Pietro and Ambrogio Lorenzetti' in *Paragone*, 1986, 439, pp. 3–16.

S.A. Fehm Jr., *Luca di Tommè. A Sienese Fourteenth-Century Painter*, Carbondale and Edwardsville 1986.

I. Hueck, 'Die Kapellen der Basilika San Francesco in Assisi: die Auftraggeber und die Franziskaner' in *Patronage and Public in the Trecento* (Styria 1984), Florence 1986.

G. Kreytenberg, *Tino di Camaino*, Florence 1986.

J.D. Rowland, '"Render Unto Caesar the Things Which are Caesar's": Humanism and the Arts in the Patronage of Agostino Chigi' in *Renaissance Quarterly*, 1986, XXXIX, 4, pp. 673–731.

F. Zeri, 'Diari di lavoro 3. Giovanni di Paolo e Martino di Bartolomeo: una proposta' in *Paragone*, 1986, 435, pp. 6–7.

1987

Various authors, *Antichi maestri pittori. 18 opere dal 1350 al 1520*, Turin 1987.

Various authors, *Bernardino Mei e la pittura barocca a Siena*, exhibition catalogue edited by F. Bisogni and M. Ciampolini, Florence 1987 (with contributions by F. Bisogni, M. Ciampolini and L. Galli).

Various authors, *Dopo Caravaggio. Bartolomeo Manfredi e la Manfrediana Methodus*, exhibition catalogue, Cremona 1987 (with contributions by M. Gregori and G. Merlo).

Various authors, *La Pittura in Italia. Il Quattrocento*, 2 vols, Milan 1987.

Various authors, *Scultura dipinta. Maestri di legname e pittori a Siena. 1250–1450*, exhibition catalogue, Florence 1987 (with contributions by A. Bagnoli, R. Bartalini and L. Bellosi).

A. Angelini, review of D. Gallavotti Cavallero, *Lo Spedale di Santa Maria della Scala. Vicenda di una committenza artistica* (Pisa 1985), in *Bullettino senese di storia patria*, 1987, pp. 458–465.

L. Bellosi, 'Ancora sul Guidoriccio' in *Prospettiva*, 1987, 50, pp. 49–55.

C. Bertelli, 'Masolino e il Vecchietta a Castiglione Olona' in *Paragone*, 1987, 451, pp. 26–47.

J. Cannon, 'Pietro Lorenzetti and the History of the Carmelite Order' in *Journal of the Warburg and Courtauld Institutes*, 1987, L, pp. 18–28.

K. Christiansen, 'The S. Vittorio Altarpiece in Siena Cathedral' in *The Art Bulletin*, 1987, LXIX, p. 467.

D. Gallavotti Cavallero, 'Pietro, Ambrogio e Simone, 1335, e una questione di affreschi perduti' in *Prospettiva*, 1987, 48, pp. 69–74.

M. Laclotte and E. Mognetti, *Avignon, Musée du Petit Palais. Peinture Italienne*, Paris 1987.

H. van Os, 'Painting in a House of Glass: the Altarpiece of Pienza' in *Simiolus*, 1987, 17, pp. 23–40.

J. Pope-Hennessy, *Italian Paintings in the Robert Lehman Collection*, New York 1987.

F. Scoppola (ed.), *Palazzo Altemps. Indagini per il restauro della fabbrica Riario, Soderini, Altemps*, Rome 1987.

D. Thiébaut, *Ajaccio, Musée Fesch. Les primitifs italiens*, Paris 1987.

R. Toledano, *Francesco di Giorgio Martini pittore e scultore*, Milan 1987.

E. Trimpi, *Matteo di Giovanni. Documents and a Critical Catalogue of his Panels Paintings*, Ph.D. thesis, University of Michigan, Ann Arbor 1987.

1988

Various authors, *Da Sodoma a Marco Pino*, exhibition catalogue edited by F. Sricchia Santoro, Florence 1988 (with contributions by A. De Marchi, M. Maccherini, R. Bartalini and F. Sricchia Santoro).

Various authors, *Laboratorio di restauro*, exhibition catalogue edited by D. Bernini, Rome 1988, II.

Various authors, *La Pittura in Italia. Il Cinquecento*, Milan 1988, II.

Various authors, *La Sede storica del Monte dei Paschi di Siena. Vicende costruttive e opere d'arte*, edited by L. Bellosi, G. Briganti, F. Gurrieri and P. Torriti, Florence 1988 (with contributions by E. Avanzati, R. Bartalini and A. De Marchi).

Various authors, *Siena tra Purismo e Liberty*, exhibition catalogue, Rome 1988.

Various authors, *Simone Martini*, conference proceedings, Siena, 27–29 March 1985, Florence 1988 (with contributions by A. Bagnoli, L. Bellosi, F. Enaud, A. Garzelli, I. Hueck, G. Kreytenberg and G. Previtali).

A. Angelini, 'Francesco di Giorgio pittore e la sua bottega. Alcune osservazioni su una recente monografia' in *Prospettiva*, 1988, 52, pp. 10–24.

A. Bagnoli, 'Un "Compianto sul Cristo" e alcune osservazioni per il Sodoma di Monteoliveto' in *Prospettiva*, 1988, 52, pp. 68–74.

M. Boskovits, *Frühe Italienische Malerei, Gemäldegalerie Berlin*, catalogue of the paintings, Berlin 1988.

M. Faietti and K. Oberhuber, 'Jacopo Ripanda e il suo collaboratore (il maestro di Oxford) in alcuni cantieri romani del primo cinquecento' in *Ricerche di storia dell'arte*, 1988, 34, pp. 58–64.

C. Frugoni, *Pietro e Ambrogio Lorenzetti*, Florence 1988.

H.B.J. Maginnis, 'The Lost Facade Frescoes from Siena's Ospedale di S. Maria della Scala' in *Zeitschrift für Kunstgeschichte*, 1988, 2, pp. 180–194.

A. Martindale, *Simone Martini*, Oxford 1988.

G.A. Pecci, *Memorie storico-critiche della città di Siena che servono alla vita civile di Pandolfo Petrucci dal MCCCCLXXX al MDXII* (1755), Siena 1988, I.

Tableaux italiens. Catalogue raisonné de la collection de peinture italienne XIV–XIX siècles, Musée de Grenoble 1988.

F. Viatte, *Musée du Louvre. Cabinet des dessins. Inventaire général des dessins italiens. III, Dessins toscans XVI–XVIII siècle*, I, 1560–1640, Paris 1988.

F. Zeri, 'The Beginnings of Liberale da Verona' (in *The Burlington Magazine*, 1951, XCIII) in *Giorno per giorno nella pittura. Scritti sull'arte dell'Italia settentrionale dal Trecento al primo Cinquecento*, Turin 1988, pp. 61–63.

1988–1989

A. Angelini, 'Resti di un "cenacolo" di Pietro Orioli a Monte Oliveto (Scritti in ricordo di Giovanni Previtali)' in *Prospettiva*, 1988–89 (1990), 5356, pp. 290–298.

1989

Various authors, *La Pittura in Italia. Il Seicento*, Milan 1989.

Various authors, *La Pittura senese nel Rinascimento 1420–1500*, Siena 1989 (with contributions by K. Christiansen, L.B. Kanter and C.B. Strehlke). Originally published in English as *Painting in Renaissance Siena, 1420–1500*, New York 1988.

Various authors, *La Scultura bozzetti in terracotta, piccoli marmi e altre sculture dal XIV al XX secolo, Siena, Palazzo Chigi Saracini*, exhibition catalogue, Florence 1989.

Various authors, *Pitture senesi del Seicento*, exhibition catalogue edited by G. Pagliarulo and R. Spinelli, Turin 1989 (with contributions by A. Avanzati, M. Ciampolini, G. Pagliarulo and R. Spinelli).

Various authors, *The Early Sienese Paintings in Holland*, Florence 1989.

A. Angelini, 'Intorno al "Maestro di Griselda"' in *Annali della fondazione di studi di storia dell'arte Roberto Longhi*, 1989, II, pp. 5–15.

G.S. Aronow, *A Documentary History of the Pavement Decoration in Siena Cathedral, 1362 through 1506*, Ph.D. thesis, New York Columbia University 1985, Ann Arbor 1989.

A. Bagnoli, 'Donatello e Siena: alcune considerazioni sul Vecchietta e su Francesco di Giorgio' in *Donatello Studien*, Munich 1989, pp. 278–291.

S. Dale, 'Ambrogio Lorenzetti's Maestà at Massa Marittima' in *Source*, 1989, II, pp. 6–11.

E. Fumagalli, 'Raffaello Vanni in Palazzo Patrizi a Roma' in *Paragone*, 1989, 18 (477), pp. 129–148.

L. Kanter, *The Late Works of Luca Signorelli and his Followers, 1498–1559*, Ph.D. thesis, New York University 1989.

P. Leone de Castris, *Simone Martini*, Florence 1989.

H.B.J. Maginnis, 'Chiarimenti documentari: Simone Martini, i Memmi e Ambrogio Lorenzetti' in *Rivista d'arte*, 1989, XLI, pp. 3–23.

S. Moscadelli, 'Domenico Beccafumi "Pictor de Senis" nel 1507' in *Mitteilungen des Kunsthistorischen Institutes in Florenz*, 1989, XXXIII, pp. 394–395.

A. Negro, 'Appunti sulla fase precortonesca di Raffaello Vanni' in *Paragone*, 1989, 18 (477), pp. 109–121.

M. Seidel, 'Francesco di Giorgio o Ludovico Scotti? Storia della "Pala Tancredi" in San Domenico a Siena' in *OPD*, 1989, 1, pp. 31–36.

M. Seidel, 'Sozialgeschichte des Sieneser Renaissance Bildes. Studien zu Francesco di Giorgio, Neroccio de' Landi, Benvenuto di Giovanni, Matteo di Giovanni und Bernardino Fungai' in *Städel Jahrbuch*, 1989, XII, pp. 71–139.

C.B. Strehlke, 'Three Notes on the Sienese Quattrocento' in *Gazette des Beaux-Arts*, 1989, 114, pp. 278–280.

C. Volpe, *Pietro Lorenzetti*, edited by M. Lucco, Milan 1989.

1989–1990

L. Barroero, 'Schede seicentesche: Finoglio, Vaccaro, Vanni e il Maestro degli Annunci (Scritti in onore di Giovanni Previtali, II)' in *Prospettiva*, April 1989–October 1990, 57–60, pp. 217–221.

1990

Various authors, *Domenico Beccafumi e il suo tempo*, exhibition catalogue, Milan 1990 (with contributions by G. Agosti, C. Alessi, A. Angelini, A. Bagnoli, R. Bartalini, M. Collareta, A. Cornice, N. Dacos, A. De Marchi, V. Farinella, S. Fraschetti, M. Maccherini, L. Martini, A. Pinelli and F. Sricchia Santoro).

Various authors, *Il Palazzo della Provincia a Siena*, Rome 1990 (with contributions by F. Bisogni and S. Moscadelli).

Various authors, *Pittura di luce, Giovanni di Francesco e l'arte fiorentina di metà Quattrocento*, exhibition catalogue, Florence 1990.

A. Angelini, 'Il Beccafumi e la volta dipinta della Camera di Casa Venturi: l'artista e i suoi committenti' in *Bullettino senese di storia patria*, 1990, IIIC, pp. 371–383.

C. Fischer, *Fra Bartolommeo. Master Draughtsman of the High Renaissance*, exhibition catalogue, Rotterdam 1990.

E. Fumagalli, 'Pittori senesi del Seicento e committenza medicea. Nuove date per Francesco Rustici' in *Paragone*, 1990, 479–481, pp. 69–82.

R. Guerrini, 'Bernardino Mei, Antioco Malato. Fonti letterarie classiche e tradizione iconografica' in *Antioco Malato. Forbidden Loves from Antiquity to Rossini* (Annali della Facoltà di Lettere e Filosofia), Siena University 1990, XI, pp. 335–340.

H. van Os, *Sienese Altarpieces. 1215–1460*, Groningen 1984, I; 1990, II.

A. Tonnenesmann, *Pienza Städtebau und Humanismus*, Munich 1990.

1990–1991

C. Sica, *La Collezione Patrizi. Vicende di una Quadreria*, archaeology and history of art thesis, Faculty of Letters, Siena University 1990–1991.

1991

Various authors, *'Manifestatori delle cose miracolose'*, exhibition catalogue, Lugano 1991.

Various authors, *Le muse e il principe, arte di corte nel Rinascimento padano*, exhibition catalogue edited by A. Mottola Molfino and M. Natale, Milan 1991.

Various authors, *Prima di Leonardo cultura delle macchine a Siena nel Rinascimento*, edited by P. Galluzzi, Milan 1991.

L. Bellosi, 'Per un contesto cimabuesco senese: a) Guido da Siena e il probabile Dietisalvi di Speme' in *Prospettiva*, 1991, 61, pp. 6–20.

L. Bellosi, 'Per un contesto cimabuesco senese: b) Rinaldo da Siena e Guido di Graziano' in *Prospettiva*, 1991, 62, pp. 15–28.

G. Chelazzi Dini, 'Andrea di Bartolo' in *Enciclopedia dell'arte medievale*, Rome 1991, I, pp. 594–595.

467

J. Montagu, *La Scultura barocca romana*, Turin 1991. Originally published in English as *Roman Baroque Sculpture*, Yale 1989.
C. Pizzorusso, 'Sul "Battesimo" di Piero della Francesca' in *Artista*, 1991, pp. 130–132.
F. Zeri, 'Ricerche sul Sassetta: La Pala dell'Arte della Lana (1423–26)' (in *Quaderni di emblema*, Bergamo 1973, 2) in *Giorno per giorno nella pittura. Scritti sull'arte toscana dal Trecento al primo Cinquecento*, Turin 1991, pp. 189–198.
F. Zeri, 'Towards a Reconstruction of Sassetta's Arte della Lana Triptych' (in *The Burlington Magazine*, 1956, 635, XCVIII) in *Giorno per giorno nella pittura. Scritti sull'arte toscana dal Trecento al primo Cinquecento*, Turin 1991, pp. 183–188.

1992
Various authors, *Catherine de Sienne*, exhibition catalogue, Avignon 1992.
Various authors, *Die Kirchen von Siena*, edited by P.A. Riedl and M. Seidel, 3 vols, Munich 1985, I; 4 vols, Munich 1992, II.
Various authors, *Kunst des Cinquecento in der Toskana*, Munich 1992.
Various authors, *Maioliche italiane*, exhibition catalogue edited by C. Ravanelli Guidotti, Florence 1992.
Various authors, *Sienne en Avignon*, exhibition catalogue edited by E. Moench-Scherer, Avignon 1992.
F. Aceto, 'Pittori e documenti della Napoli angioina: aggiunte ed espunzioni' in *Prospettiva*, 1992, 67, pp. 53–65.
C. Alessi, 'Le pitture murali della zona presbiteriale del Battistero di Siena: storia, studi e restauri' in *OPD*, 1992, 4, pp. 9–27.
A. Angelini, 'Giovanni di Stefano e le lupe marmoree di Porta Romana a Siena' in *Prospettiva*, 1992, 65, pp. 50–55.
L. Bellosi, 'Il paesaggio nella pittura senese del Trecento' in *Uomo e natura nella letteratura e nell'arte italiana del Tre-Quattrocento*, interdisciplinary conference proceedings, Ospedaletto 1992, pp. 105–123.
L. Bellosi (ed.), *Una Scuola per Piero. Luce, colore e prospettiva nella formazione fiorentina di Piero della Francesca*, Florence 1992.
F. Bologna, 'Duccio' in *Dizionario biografico degli italiani*, Rome 1992, XLI, pp. 742–749.
A. De Marchi, *Gentile da Fabriano. Un viaggio nella pittura italiana alla fine del Gotico*, Milan 1992.
V. Farinella, *Archeologia e pittura a Roma tra Quattrocento e Cinquecento*, Turin 1992.
S. Hansen, *La Loggia della Mercanzia in Siena* (1988), Siena 1992.
A. Landi, *'Racconto' del Duomo di Siena* (1655), edited by E. Carli, Florence 1992.
H. van Os, *Studies in Early Tuscan Painting*, London 1992.
B. Sani, '"La virtù sconosciuta": Vittorio Alfieri, Francesco Gori Gandellini e i migliori dipinti di Siena' in *Bullettino senese di storia patria*, 1992, IC, pp. 92–108.

P. Santucci, *La Pittura del Quattrocento*, Turin 1992.
G.E. Solberg, 'A Reconstruction of Taddeo di Bartolo's Altarpiece for S. Francesco a Prato, Perugia' in *The Burlington Magazine*, 1992, 134, pp. 646–656.
A. Vezzosi, 'A favore di Bernardino Mei' in *Prospettiva*, 1992, 65, pp. 76–77.
A. Zuccari, *I Pittori di Sisto V*, Rome 1992.

1992–1993
R. Guerrini, 'Le Divinae Institutiones di Lattanzio nelle epigrafi del Rinascimento: Il collegio del Cambio di Perugia ed il pavimento del Duomo di Siena (Ermete Trismegisto e Sibille)' in *Annuario dell'Istituto Storico Diocesano di Siena*, 1992–1993, I, pp. 1–38.
A.M. Romaldo, 'Corpus Titulorum Senensium, le Divinae Institutiones e il pavimento del Duomo di Siena' in *Annuario dell'Istituto Storico Diocesano di Siena*, 1992–1993, I, pp. 51–79.

1993
Various authors, *Francesco di Giorgio architetto*, exhibition catalogue edited by F.P. Fiore and M. Tafuri, Milan 1993.
Various authors, *Francesco di Giorgio e il Rinascimento a Siena. 1450–1500*, exhibition catalogue, Milan 1993 (with contributions by G. Agosti, A. Angelini, C. Alessi, A. Bagnoli, R. Bartalini, L. Bellosi, L. Cavazzini, A. De Marchi, M. Folchi, S. Fraschetti, A. Galli, G. Gentilini, M. Maccherini, M. Parisi, F. Sricchia Santoro and C. Zarrilli).
M. Ascheri (ed.), *Antica legislazione della Repubblica senese*, Siena 1993.
G. Chironi, 'Politici e ingegneri. I Provveditori della Camera del Comune di Siena negli anni '90 del Quattrocento' in *Ricerche storiche*, 1993, 2, pp. 375–395.
D. Gordon, 'The Reconstruction of Sassetta's Altarpiece for S. Francesco, Borgo San Sepolcro, a Postcript' in *The Burlington Magazine*, 1993, CXXXV, pp. 620–623.
A.F. Iorio, *The Paintings of Francesco di Giorgio: a Reassessment*, Ph.D. thesis, University of Virginia 1993.
D. Norman, 'The Commission for the Frescoes of Montesiepi' in *Zeitschrift für Kunstgeschichte*, 1993, LVI, pp. 289–300.
L. Pardekooper, 'Due famiglie rivali e due pale di Guidoccio Cozzarelli per Sinalunga' in *Prospettiva*, 1993, 72, pp. 51–65.
G. Previtali, *Giotto e la sua bottega* (Milan 1967), Milan 1993.
C.B. Strehlke, 'Exhibition Reviews' in *The Burlington Magazine*, 1993, CXXXV, pp. 499–502.

1994
Various authors, *Hommage à Michel Laclotte. Étude sur la peinture du Moyen Age et de la Renaissance*, Rome 1994 (with contributions by M. Lonjon, P. Lorentz and E. Mognetti).
Various authors, *Nicolas Poussin 1594–1665*, exhibition catalogue edited by P. Rosenberg and L.A. Prat, Paris 1994, pp. 62–68.
Various authors, *Panis vivus. Arredi e testimonianze figurative del culto eucaristico dal VI al XIX secolo*, exhibition catalogue, Siena 1994.
Various authors, *Umanesimo a Siena. Letteratura, arti figurative, musica*, conference proceedings edited by E. Cioni and D. Fausti, Florence 1994 (with contributions by A. Angelini, R. Bianchi, F.A. D'Accone, N. Dacos, G. Fioravanti, W. Loseries and A. Pinelli).
L. Bellosi, 'Duccio di Buoninsegna' in *Enciclopedia dell'arte medievale*, Rome 1994, V, pp. 738–750.
P. Giusti Maccari, 'Pietro Sorri' in *La Pittura a Lucca nel primo Seicento*, Pisa 1994, pp. 125–130.
A. Leoncini, *I Tabernacoli di Siena arte e devozione popolare*, Siena 1994.
P. Palladino, '"Pittura in una casa di vetro": un riesame e una proposta sul programma decorativo di Pio II per la cattedrale di Pienza' in *Prospettiva*, 1994, 75–76, pp. 100–108.
P. Zambrano, 'A New Scene by Sodoma from the Ceiling of Palazzo Chigi at Casato di Sotto, Siena' in *The Burlington Magazine*, 1994, CXXXVI, pp. 609–612.
A. Zezza, 'Tra Perin del Vaga e Daniele da Volterra: alcune proposte, e qualche conferma, per Marco Pino a Roma' in *Prospettiva*, 1994, 73–74, pp. 144–158.

1994–1995
L. Bonelli, *Nuovi documenti sulla vita e sulle opere di Francesco Vanni*, degree thesis, Faculty of Letters, Siena University 1994–1995.
M. Maccherini, *Annibale Carracci e i 'bolognesi' nel carteggio familiare di Giulio Mancini*, archaeology and history of art thesis, Faculty of Letters, Siena University 1994–1995.

1995
Various authors, *Ambrogio Lorenzetti. Il Buon Governo*, Milan 1995.
Various authors, *Arte, committenza ed economia a Roma e nelle corti del Rinascimento, 1420–1530*, edited by A. Esch and C. Liutpold Frommel, Turin 1995.
Various authors, *La Regola e la fama. San Filippo Neri e l'arte*, exhibition catalogue, Milan 1995 (with contributions by M. Pupillo and A. Zuccari).
Various authors, *La Tribuna del Duomo di Pisa. Capolavori di due secoli*, exhibition catalogue edited by R. Paolo Ciardi, Milan 1995.
Various authors, *Restauri e recuperi in terra di Siena*, Siena 1995.

Various authors, *Storia di Siena dalle origini alla Repubblica*, Siena 1995, I.
R. Bartalini, 'Maso, la cronologia della cappella Bardi di Vernio e il giovane Orcagna' in *Prospettiva*, 1995, 77, pp. 16–35.
E. Carli (ed.), *La Chiesa di S. Niccolò in Sasso a Siena*, Siena 1995.
G. Chelazzi Dini, 'Un bassorilievo di Tino di Camaino a Galatina' in *Dialoghi di storia dell'arte*, 1995, 1, pp. 28–41.
A. Conti, *Pontormo*, Milan 1995.
M. Di Macco, '"L'ornamento del Principe". Cultura figurativa di Maurizio di Savoia (1619–1627)' in *Le collezioni di Carlo Emanuele I*, edited by G. Romano, Turin 1995, pp. 350–374.
L.S. Dixon, 'Giovanni di Paolo's Cosmology' in *The Art Bulletin*, 1995, 67, pp. 603–613.
P. Pertici, *La Città magnificata. Interventi edilizi a Siena nel Rinascimento*, Siena 1995.
F. Polcri, 'Un nuovo documento su Niccolò di Segna autore del polittico della Resurrezione di Sansepolcro' in *Commentari d'arte*, 1995, 2, pp. 35–40.

1996
Various authors, *L'Età di Savonarola. Fra' Bartolomeo e la scuola di San Marco*, exhibition catalogue edited by S. Padovani, Florence 1996.
M. Ascheri (ed.), *I libri dei Leoni. La nobiltà di Siena in età medicea (1557–1737)*, Milan 1996.
A. Bagnoli, 'Gli inizi di Francesco Vanni' in *Prospettiva*, April 1996, 82, pp. 84–94.
R. Bartalini, *Le occasioni del Sodoma. Dalla Milano di Leonardo alla Roma di Raffaello*, Rome 1996.
L. Bonelli, 'Documenti per il giovane Francesco Vanni' in *Prospettiva*, April 1996, 82, pp. 95–96.
G. Chelazzi Dini, *Pacio e Giovanni Bertini da Firenze e la bottega napoletana di Tino di Camaino*, Florence 1996.

IN PRESS

G. Chelazzi Dini, 'Niccolò di Buonaccorso' in *Enciclopedia dell'arte medievale*, Rome.
G. Chelazzi Dini, 'Luca di Tommè, Lippo di Vanni, Niccolò di Buonaccorso, Niccolò di Ser Sozzo' in *Enciclopedia dell'arte medievale*, Rome.
G. Mazzoni, *Appunti su Michelangelo Vanni pittore*.
B. Sani, *Per la storia del collezionismo senese. 'L'Inventario de' mobili' di Ippolito Agostini*.
B. Sani, *Riflessioni sull'attività grafica di Prospero Bresciano*.

n. d.
R. Cannatà and M.L. Vicini, *La Galleria di Palazzo Spada. Genesi e storia di una collezione*, Rome.

Index of Names

Photo Credits

Accademia Carrara, Bergamo
Alte Pinakothek, Bayerische Staatsgemäldesammlungen,
 Munich
Jörg P. Anders, Berlin
Arte Fotografica Srl, Rome
Associazione Cittadina per la Salvaguardia e il Restauro
 dei Monumenti di Norcia e del suo Territorio,
 Norcia (Perugia)
Foto Bani Franco, Città di Castello (Perugia)
Enrico Bertinelli, Fognano (Parma)
Biblioteca Augusta, Perugia
Bibliothèque Nationale de France, Paris
British Library, London
Bulloz (art photography), Paris
Collection of the Frick Art Museum, Pittsburgh
Fotoflash, Cannaregio (Venice)
Frick Collection, New York
Israel Museum, Jerusalem
John G. Johnson Collection, Philadelphia Museum of
 Art, Philadelphia
Lensini (industrial and editorial photography), Siena
Lindenau Museum, Altenburg
Metropolitan Museum of Art, New York
Monumenti Musei e Gallerie Pontificie, Vatican City
Musée des Beaux-Arts, Rouen
Musée du Mans, Le Mans
Museo Poldi Pezzoli, Milan
Museum of Fine Arts, Boston
Museum van het Boek, Museum Meermanno-
 Westreenianum, The Hague
National Gallery, London
National Gallery of Art, Washington, D.C.
Board of Trustees of the National Museum & Galleries
 on Merseyside, Walker Art Gallery, Liverpool
Niedersächsisches Landesmuseum Hannover, Hanover
Nicolò Orsi Battaglini, Florence
Pinacoteca Comunale, Città di Castello (Perugia)
Putnam Foundation, Timken Museum of Art, San Diego
Antonia Reeve Photography, Edinburgh
Service de Documentation Photographique de la
 Réunion des Musées Nationaux, Paris
Ghigo Roli Photo Library, Castelvetro (Modena)
Sammlungen des Regierenden Fürsten von
 Liechtenstein, Vaduz
Scala, Istituto Fotografico Editoriale, Antella (Florence)
Statens Museum for Kunst, Copenhagen
Szépmüvészeti Muzeum, Budapest
Foto Vasari, Rome
Veneranda Biblioteca Ambrosiana, Milan
Yale University Art Gallery, New Haven

Acknowledgments

We would like to give our special thanks to Alessandro
Bagnoli, Pietro Bartalini, Roberto Bartalini, Luciano
Bellosi, Patrizia and Bruno Coli Bizzarrini, Lucia
Conenna Bonelli, Anna Maria Guiducci, Laura Martini,
Ubaldo Morandi, Petra Pertici, Giovanni Pratesi, Bruno
Santi and Grazia and Alberto Terzani.

Thanks are also due to the Archivio di Stato, Siena;
Biblioteca Comunale, Siena; Kunsthistorisches Institut,
Florence; Biblioteca della Facoltà di Lettere, Siena
University; Chigi Saracini Collection, Siena; Monte
dei Paschi, Siena; Soprintendenza per i Beni Artistici
e Storici, Siena; Palazzo Pubblico, Siena; Contrada della
Lupa, Siena; church of San Francesco, Assisi; Galleria
Colonna, Roma; Soprintendenza per i Beni Artistici
e Storici, Rome; Soprintendenza per i Beni Artistici
e Storici, Turin; Soprintendenza per i Beni Artistici e
Storici, Naples; the parish of the church of Santa Maria
del Popolo, Rome; Civici Musei Veneziani d'Arte
e di Storia di Venezia; Galleria Antiquaria Bertogalli,
Parma; Soprintendenza per i Beni Artistici e Storici
delle Province di Firenze, Pistoia e Prato; Berenson
Collection, Settignano; Musée Jacquemart-André,
Paris; Scottish National Portrait Gallery, Edinburgh;
Louvre, Paris; Dr Erich Schleier of the Gemäldegalerie
Staatliche Museen and the Preussicher Kulturbesitz,
Berlin; Pinacoteca Giuseppe Stuard, Parma; Galleria
Sabauda, Turin; Museo Nazionale di San Matteo, Pisa;
Museo Civico, Sansepolcro (Arezzo); Galleria Nazionale
dell'Umbria, Perugia; Palazzo Civico, San Gimignano;
and Museo Diocesano, Cortona.

The majority of the photographs in this book were taken
by Fabio Lensini.